WILLIAM MERRITT CHASE

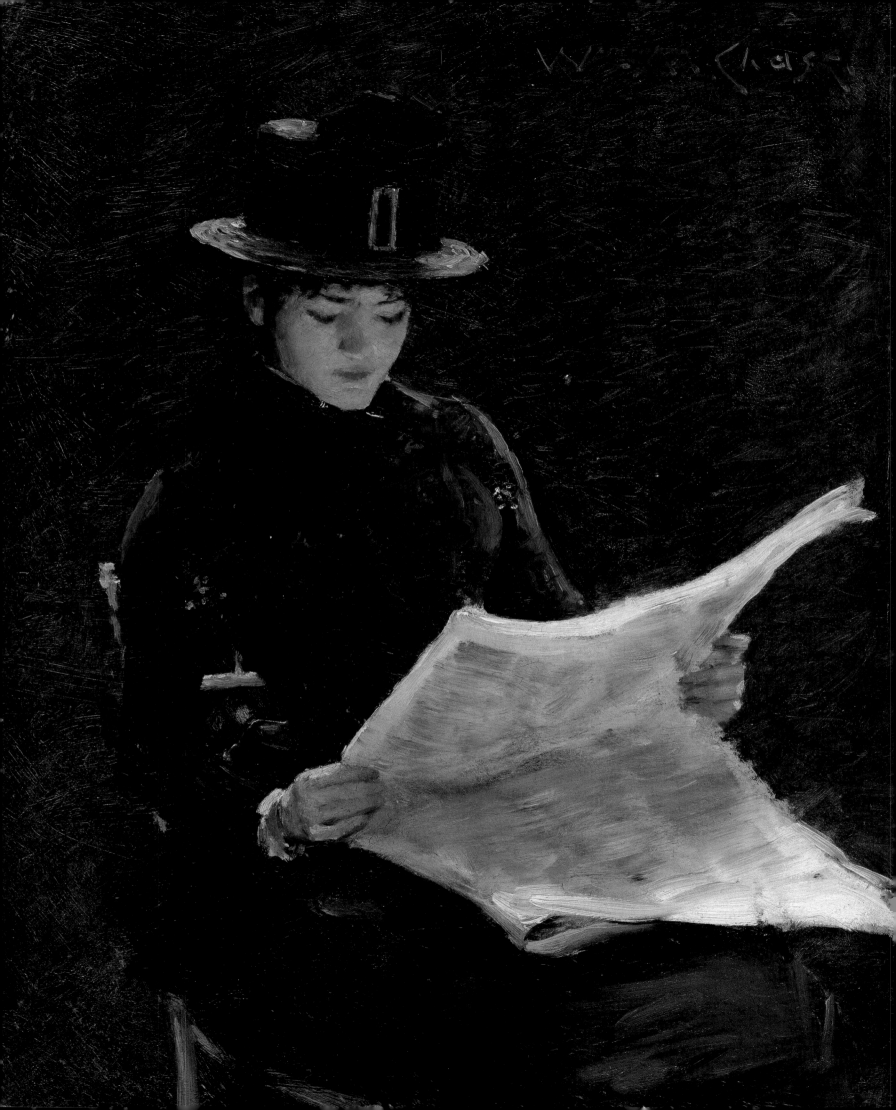

WILLIAM MERRITT CHASE

Portraits in Oil

VOLUME 2

The Complete Catalogue of Known and Documented Work
by William Merritt Chase (1849–1916)

Ronald G. Pisano
Completed by Carolyn K. Lane and D. Frederick Baker

Yale University Press/New Haven and London

The Pisano/Chase files on which this catalogue is based are jointly owned by The Anna-Maria and Stephen Kellen
Archives Center of Parsons School of Design, New School University, and the Archives of American Art.

Designed by Bruce Campbell

Set in Bembo with Arts and Crafts display by Aardvark Type

Printed in Singapore by CS Graphics

Volume 2 ISBN 978-0-300-11021-0

10 9 8 7 6 5 4 3 2 1

Library of Congress Cataloging-in-Publication Data

Pisano, Ronald G.

The complete catalogue of known and documented work by William Merritt Chase (1849-1916) / Ronald G. Pisano ;
completed by D. Frederick Baker.

 v. cm.

Includes bibliographical references and index.

Contents: v. 1. William Merritt Chase : the paintings in pastel, monotypes, painted tiles and ceramic plates, watercolors, and
prints.

ISBN 0-300-10996-2 (v. 1 : hardcover)

1. Chase, William Merritt, 1849-1916—Catalogues raisonnés. I. Chase, William Merritt, 1849-1916. II. Baker, D. Frederick.
III. Title.

N6537.C464A4 2006

760'.092—dc22 2005003959

This volume is dedicated to
HENRY LUCE III (1925–2005),
publisher and philanthropist, for his
support of American art scholarship

CONTENTS

ACKNOWLEDGMENTS

This catalogue, the second volume of a projected four-volume catalogue, is based on the life's work of Ronald G. Pisano (1948–2000), noted American art historian. After his untimely death, the Pisano/Chase Catalogue Raisonné Project was established to oversee the completion of Ron Pisano's magnum opus. The foundation directors, Betty Krulik, Fred Baker, Erica Bell, and Robin Chase, again wish to acknowledge the honorary directors and funding foundations that have supported this monumental effort:

Honorary Directors
Karen H. Bechtel
Abigail Booth Gerdts, distinguished American art historian
William H. Gerdts, Professor Emeritus of Art History, Graduate School of the
 City University of New York
Mr. and Mrs. Raymond Horowitz (deceased)
Elizabeth L. Watson
James D. Watson, Ph.D., Nobel Laureate, 1962

Major Funding Foundations/Contributors
Karen H. Bechtel Foundation, New York
The Ronald H. Cordover Family Foundation, Wayne, New Jersey
The Estate of Ronald G. Pisano
Armand Hammer Foundation, Santa Monica, California
The Henry Luce Foundation, New York
The Lunder Foundation, Portland, Maine
Peter J. Sharp Foundation, New York

Additional Funding Contributors
Mr. Jeffrey W. Boys
Mr. David Cleveland
Mr. and Mrs. John Greener
Dr. and Mrs. James D. Watson

An endeavor such as this is dependent upon help and support in the form of information, references, biographical backgrounds of sitters, photographs, and historical documents, as well as ongoing encouragement and cooperation from many sources that need to be thanked: Richard Boyle; Annette Blaugrund, Director, National Design Museum; Susan Hobbs; Bruce Weber, Fred Hill, and Jim Berry-Hill, Berry-Hill Galleries; Lois Wagner;

Hollis Taggart and Vivian Bullaudy, Hollis Taggart Gallery; Thomas Colville; Martha Fleischman; Jeffrey Boys; Percy North; David Cassedy; Trudy Kramer, Alicia Longwell and Chris MacNamara, Parrish Art Museum; Dick Lynch, Hammer Galleries; Clark Marlor; Kathy Kienholtz, Archivist, American Academy of Arts and Letters; Kathleen Foster, Robert L. McNeil, Jr. Curator of American Art and Director of the Center for American Art, Philadelphia Museum of Art; Ira Spanierman and Lisa Peters, Spanierman Gallery, LLC; the American Paintings departments of Christie's and Sotheby's; Orion Neumann, University of Michigan Museum of Art; the Reverend J. Douglas Ousley, Church of the Incarnation, New York; Kenyon B. FitzGerald, Jr., Seventh Regiment Fund, New York; Charles B. Harding; Frederick E. Fochtman; George F. Kenly; John W. Coffey, Chairman, Curatorial Department, Curator of American and Modern Art, North Carolina Museum of Art; Richard V. West; Schweizer Gallery; Cissy Cochran Hubbard; Trudy Rosato Fine Art; Anne James Howell, U.S. Department of the Interior Museum, Washington, D.C.; Mr. and Mrs. James Brandi; Melanie Bower, Collections Access Associate, Museum of the City of New York; Michael Klauke, Assistant Registrar for the Permanent Collection, North Carolina Museum of Art; Nicole Semenchuk, Inventories of American Painting and Sculpture; Rosanne Sasso, Artsystems; Audrey Lewis, Research Assistant, Philadelphia Museum of Art; Linda Ehman, Registrar and Collections Manager, Rollins College; Barbara Lehman Smith; Jake Milgram Wien; Jessica Nicoll; Wilhemina K. Waller; M. P. Naud, Hirschl and Adler Galleries; Mrs. H. S. Fenimore Cooper; N. Lee Stevens, Senior Curator, Art Collections, State Museum of Pennsylvania; Mrs. William Short; Myron J. Oliver; David T. Owsley; Katherine Lochridge; Mary Lou Swift; James Shields; Harriet Warkel, Associate Curator, American Painting and Sculpture, Indianapolis Museum of Art; John Redmond; Jody Borie; Stacey Epstein; Catherine Ross; M. W. Tilghman; Ryan Grover, Curator, Biggs Museum of Art, Dover, Delaware; Charles Mather III; Howard Godel; Asbjorn R. Lunde; Sarah E. Rusk; Richard D. Shepardson; former governor of Pennsylvania William Scranton; Ellen Schall, Curator, Maier Museum of Art; Mrs. E. H. Hillman; Paul J. Bans; Mrs. Dudley D. Johnson; Pierre Ulman; Remak Ramsey; Mrs. Esdras J. Lanois; Warren Adelson; Sandy Williamson; Gary Brenner; Marjory Cascio; Edward Shein; and Beverly Rood and Betrina Snively, who for many years worked with Ron Pisano to set up the files on which this catalogue is based.

As was the case for the first volume, the personal library of Dr. William H. Gerdts was, and continues to be, a valuable source of rare and extraordinary information concerning not only the life and work of William Merritt Chase, but the American art scene of the late nineteenth and early twentieth centuries. Ready access to the New York Public Library, the Frick Art Reference Library, and the New York Archives of American Art Center cannot be underappreciated—and they exemplify yet another reason to celebrate the rich art resources of New York City.

Thanks also to friends and family whose unwavering support and patience throughout this project have been crucial.

One ventures into uncharted waters when readying a catalogue such as this. But the experience of working with Patricia Fidler, Publisher, Art and Architecture; Kate Zanzucchi, Senior Production Editor, Art Books, and Managing Editor, Special Projects; Mary Mayer, Art Book Production Manager; and John Long, Photo Editor and Assistant

Production Coordinator, all of Yale University Press, has made the journey easy and most enjoyable. From the beginning of our relationship in preparing volume one for publication, I felt assured that the project was in capable hands and I thank them for their patience and fellowship. Thanks also to Bruce Campbell, who guided the overall design of the catalogue, and to freelance copyeditor Jonathan Munk, proofreader June Cuffner, and indexer Kathleen Friello.

While this volume includes every known and documented portrait identified by surname as well as works with unidentified figures and the term portrait in their titles, the authors decided to balance the volume sizes by including a number of figure pieces in volume 4. This final volume will contain interiors, figures, still lifes, copies, and drawings. Key figure paintings in volume 4 will include *A Comfortable Corner [The Blue Kimono]* [The Parrish Art Museum, Southampton, New York], *The Little Red Box* and *A Lady in Black* [both location unknown], and *Girl in Japanese Costume* and *Study of a Girl in Japanese Dress* [both Brooklyn Museum], among other works.

Upon its completion, all archival material will be housed at The Anna-Maria and Stephen Kellen Archives Center, Parsons New School of Design, New York, under a joint ownership agreement with the Smithsonian Archives of American Art, Washington, D.C. This arrangement was facilitated by X. Theodore Barber, Director of the Kellen Archives. The Parsons New School of Design was founded in 1896 as The Chase School by William Merritt Chase.

Carolyn K. Lane and D. Frederick Baker

INTRODUCTION

One of the earliest paintings by William Merritt Chase is an oil portrait of his maternal grandfather, Moses Swaim. William was eighteen years old, and while it may have been a reasonable likeness, like most of his early portraits it is stiff and flat. Yet it undoubtedly served as a kind of sign to his family that he would become an artist—he was always, or so family tradition has it, drawing and painting. Still, who would have even guessed that this work would presage a long and distinguished career in the genre?

It was at the Royal Munich Academy during the years 1872–78 that Chase first emerged as having a particular talent in portrait painting. No doubt, the professors were instrumental in teaching Chase the mechanics of capturing not only the likeness, but the living and breathing energy of a sitter—under strict guidance and supervision Chase and his fellow students at the academy produced a number of dynamic portraits, mainly of fellow students, models, and townspeople. The technique involved fully loaded paintbrushes and fancy brushwork. And while Chase could sling paint with the best of them, many of his portraits of these years reveal sensitive modeling and fine, smooth brushwork quite different from the "wild" bunch. Karl von Piloty, who became director of the school in 1874, commissioned Chase to paint the portraits of his five children. News of this prestigious commission was printed in several art journals and newspapers at the time (that today, after nearly 130 years and two World Wars, two of these five portraits have recently surfaced is nothing less than astonishing). Among his most beautiful early works of this period is *Ready for the Ride,* an enchanting costume period piece, though not strictly speaking a portrait, that was exhibited to great acclaim in 1878 at the inaugural exhibition of the Society of American Artists in New York; the painting was extremely well received and helped to establish Chase, newly arrived on the scene, as an artist of the first rank.

After Chase returned to the United States and established his first important studio in New York, he painted a number of portraits of leading citizens, including Peter Cooper, President Benjamin Harrison, and President Rutherford B. Hayes. Certainly the Cooper portrait was a marketing ploy to attract the patronage of other potential portrait commissions, as Chase needed to make money to support his rapidly expanding lifestyle. But the portrait also served to firmly establish his position as a portraitist of note.

During the 1880s Chase played an ever larger role in the New York art community. His work was widely exhibited, and his first one-person exhibition held in Boston (1886) expanded on his celebrity. In fact, the decade was one of the most dynamic in American art, what with returning European-trained American artists forming clubs, joining various art organizations, challenging the hegemony of the National Academy of Design, and creating a vital, new, modernist art movement. Life was very good at the top of the

artistic food chain and Chase was always angling to play a prominent role. After his marriage and the first of his children was born, it was even more important that his frantic activities also yield a comfortable income. He was becoming well known as a sensitive, perceptive, and beloved teacher, and while this afforded him a base salary, he needed income from other sources, and portrait painting would play an important role in providing such additional income. A few known prices for portraits include $500 for a bust-length, posthumous portrait painted after a photograph of William Skinkle in 1892; $2000 for a full-length, standing portrait of Irene Dimock, ca. 1900; and $1000 for a waist-length portrait of Dr. John Sparhawk Jones in 1906. In 1891, with the establishment of his Shinnecock Summer School of Art, he began, in effect, to teach nonstop. And while he continued to honor portrait-commission contracts, the decade of the 1890s would bring him lasting fame as a landscape artist. His renditions of the countryside and beaches of Shinnecock Hills, Long Island, New York, are now acknowledged to be amongst the most beautiful and accomplished works of his career.

He had begun teaching in Philadelphia at the Pennsylvania Academy of the Fine Arts in 1896, the same year he established The Chase School in New York. And he taught at the academy for twelve years, eventually securing a studio in Philadelphia for painting portraits. His friend, the Philadelphia-based artist Thomas Eakins, was also very active in the early years of the twentieth century as a portraitist, but his notoriety somewhat limited his clientele. As a result, Chase had many portrait commissions in these years; the artist Elizabeth Sparhawk-Jones—whose father, John, had Chase paint his portrait in 1906—claimed that one year Chase completed fifty portraits. While this number seems somewhat ambitious, it is clear that Chase was called upon by many of the leading businessmen and civic leaders in and about Philadelphia to paint their portraits, and often those of their wives. Many of these paintings appear to be perfunctory and, while undoubtedly faithful in terms of likeness, somewhat rote in character—he was also called upon to paint posthumous portraits based on photographs and, not to put too fine a point on it, most of these works are deadly. But, every so often, one can come upon a portrait in which the subject appears animated and the brushwork, so far as one can ascertain from a photograph, exciting. It is clear that Chase never strayed too far from the dynamic in his approach to art, be it landscape, figure pieces, still life, or portraiture. Some of his finest paintings are those depicting members of his family, particularly his wife, Alice Gerson, of whom he painted over twenty portraits in oil, beginning early in their courtship and continuing until the final days of his life, when he began painting a double portrait of Alice and their son Roland Dana Chase—left unfinished, it was completed by his friend, the artist Irving R. Wiles. Chase enjoyed painting all of his children, but his eldest daughter, Alice Dieudonnée, was one of his favorite sitters, accounting for over twenty portraits and figure pieces. When questioned as to why he painted so many portraits of his daughter Alice, Chase said it was because she reminded him of his wife. Two of his other daughters were also the subjects of many portraits, as he painted fourteen images of Dorothy and twelve of Helen. His firstborn son, Robert, sat for four portraits, his son Roland Dana for seven (though both would also appear in other paintings by Chase). Around 1875, while studying at the Royal Munich Academy, Chase painted the first of twelve self-portraits. And while he would also include himself in paintings of interiors and even landscapes (*A Subtle Device,* painted while on the 1880 Tile Club summer

painting excursion, being the prime example), he painted only one other self-portrait in the nineteenth century. In 1908 he completed a self-portrait commission for the portrait gallery of the Uffizi Gallery in Florence. This undoubtedly inspired him to paint six similar self-portraits in the following years. His last self-portrait was completed in 1916, the year of his death.

The last completed portrait he painted was of A. B. Gwathmey in 1916. Mr. Gwathmey's name was associated with an ambulance donated to the American Field Service in France, ca. 1917, by the New York Cotton Exchange—likely through the efforts of his sons, one of whom was president of the exchange. At Chase's death, uncompleted portraits and portrait commissions were turned over to Irving R. Wiles.

As this catalogue is being completed in the early twenty-first century, some one hundred years after most Chase portraits were painted, it is instructive to note that Chase kept no records of any sort, specifically no list of portrait commissions—at least nothing that has survived. A checklist of works was compiled by Wilbur Peat and included in the catalogue of the "Chase Centennial Exhibition" he organized for the John Herron Art Museum, Indianapolis, in 1949. On this list were the names of sitters and titles of other portrait studies—for the most part this was a heroic job, but the list was not anywhere near complete and included paintings that have been subsequently determined not to have been painted by Chase. This list of portrait sitters, along with identified portraits sent to exhibitions or included in auctions during Chase's lifetime, was used, however, to help construct this catalogue. Ron Pisano's files also included many works that had been uncovered by family members of sitters or were hanging in boardrooms or put away in storage facilities of various businesses and organizations. Use of the Internet was extremely helpful in uncovering information about many of the sitters.

From Moses Swaim, in 1866, until A. B. Gwathmey, in 1916, Chase painted portraits. The list spans fifty years. It was a privilege and honor to have gathered their likenesses and have them published in this manner. They represent a lifetime's work in the genre.

USING THE CATALOGUE

For the most part, titles by sitter surname, as would be expected, remained with the portraits; unnamed figure portraits occasionally presented a problem in that such titles were sometimes changed—either by Chase (with simple title variants) or by subsequent owners. The catalogue is based, whenever possible, on the original titles of each and every painting. For untitled works, descriptive titles have been assigned to help distinguish one portrait from another. All known physical properties are, of course, included for each entry.

Each catalogue entry includes all published exhibition and auction references dating from Chase's lifetime (the key to exhibition and auction references is appended). These references appear after each exhibition or auction citation. For some works, references after 1916 are included to help document certain aspects of a particular work. Similarly, all periodical references published during the artist's lifetime are included for each work, especially those magazine and newspaper articles in which a work was either described or illustrated. In some cases, references after 1916 are included to reinforce an attribution. All material used to construct the lifetime history of each work, including full or partial periodical and book references, is available for study at The Anna-Maria and Stephen Kellen Archives Center, Parsons New School of Design, New York, The Pisano/Chase

Catalogue Raisonné Project Papers. Copies of all materials should also be available through the Smithsonian Institution, Archives of American Art, Washington, D.C. There was no attempt to trace ownership of a work beyond what was necessary to confirm the identification of sitters. And it was decided not to reconstruct a continuous ownership history for every painting—today only a few portraits remain in the family of the sitter.

There are, of course, unlocated works, some known only by title in lifetime exhibitions or auctions. It is understandable that many portraits were never exhibited or auctioned during Chase's lifetime, as they went directly from the artist's easel to the walls of homes or organizations. And as he kept no known list of portrait commissions, they will continue to be unlocated until such time as they appear in the marketplace or present owners make them known. Finally, it must be emphasized that this four-volume record is not by any means perfect, but rather represents the best efforts of everyone who undertook the demanding task of documenting the life's work of William Merritt Chase. Identification of errors, omissions, and additions we leave to the enterprise of future art historians.

PORTRAITS IN OIL

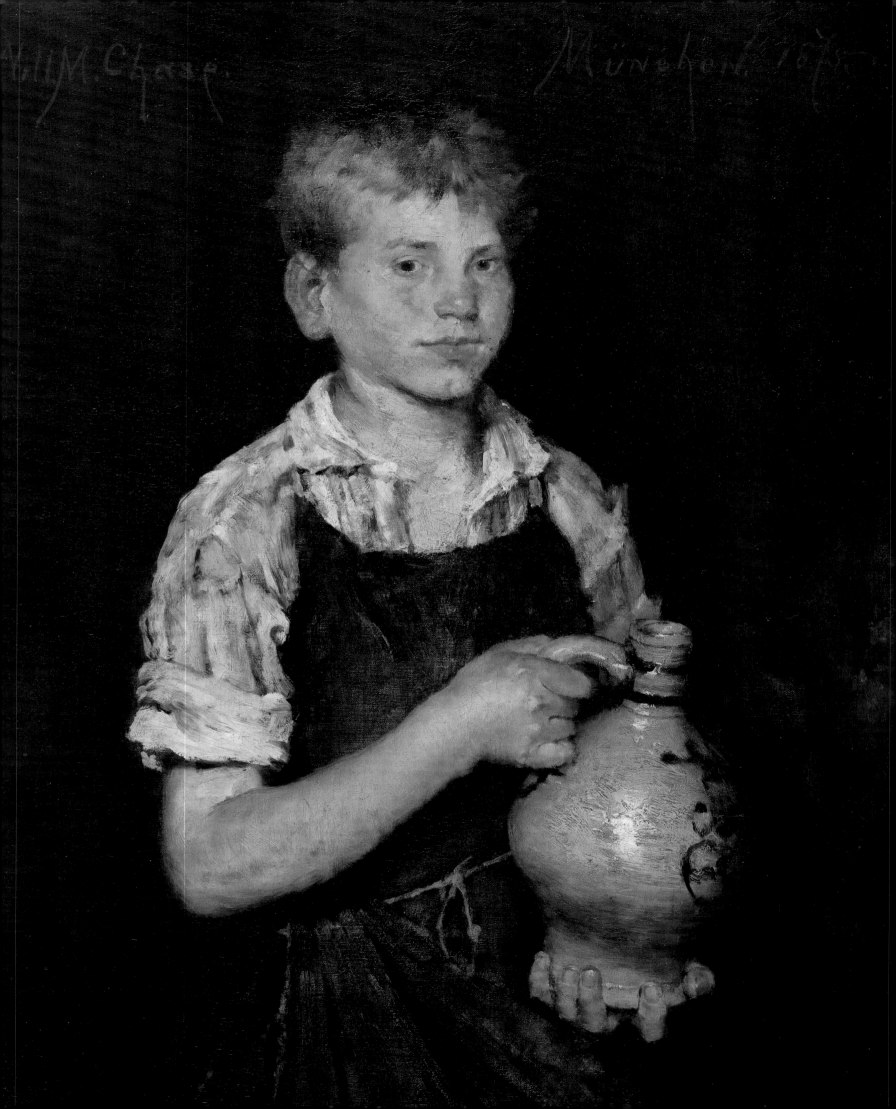

STUDENT YEARS, 1868–1878

The earliest-known portraits in oil by William Merritt Chase were made in St. Louis and include portraits of family members and friends. While not fully accomplished works of art, they have a certain self-assured charm and likely captured the likeness of the sitter fairly well. One only can surmise that the sitters were flattered by the earnest attempts of the young, untutored dabbler. Within a few years, Chase began to study art seriously, for a short while at the National Academy of Design in New York, and starting in 1872 at his true alma mater, the Munich Royal Academy, where his talents flourished. Many of the works from this period display the slapdash brushwork taught at the academy in Munich, certainly captured in his exuberant *Portrait of Mr. Drindel* (OP.44) and his intense character study of *The Wounded Poacher* (OP.54). But Chase also was developing his own style, which incorporated fine, exquisite modeling and subtle gesture, most notably apparent in his wonderful portrait studies *Ready for the Ride* (OP.47), *Apprentice* (OP.36), and *Portrait of a Woman* (OP.57)—all works of commanding presence. Most important, he was asked by the director of the Munich Royal Academy, Karl Theodore von Piloty (1826-1886), to paint portraits of his five children, a commission that was reported in the *New York Times*—surely a public relations coup for the young Chase. It set the stage for his move back to the United States as a promising artist of recognized talent.

OP.1

Moses Swaim, ca. 1866

Oil on canvas; 27¼ x 19⅛ in. (69.2 x 48.6 cm)

Indianapolis Museum of Art. Mr. and Mrs. Julius F. Pratt Fund (74.243)

Chase painted this portrait of his maternal grandfather when he was only eighteen years old. Moses Swaim was born in 1796 in North Carolina, lived for a while in Kentucky, and finally settled on a farm in Morgan County, Indiana. David Chase, the artist's father, lived in Brown County when he began courting Sarah Swaim (b. 1825), who would become his wife and the mother of William Merritt Chase. This painting is a very untutored work by the young, aspiring artist, and is best described as primitive in nature. Yet, it does demonstrate the supreme confidence of young Chase, who seemed never to lack much in the way of confidence throughout his distinguished career.

OP.2

Portrait of Emma Swaim Carpenter, ca. 1866

Oil on canvas; 18 x 14 in. (45.7 x 35.6 cm)

Location unknown

Emma Swaim Carpenter was a Chase cousin on his mother's side. According to a descendant, the sitter, approximately four years old, was very ill at the time the portrait was painted and was not expected to survive; indeed, someone had to hold the dress up in front of her while Chase painted. Fortunately, she recovered, as documented by a photograph of her as a young adult, likely taken in the 1880s, in the Chase Archives, Parrish Art Museum, Southampton, Long Island, New York.

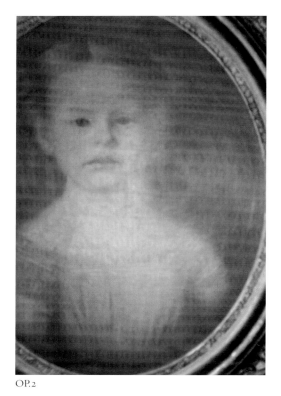

OP.2

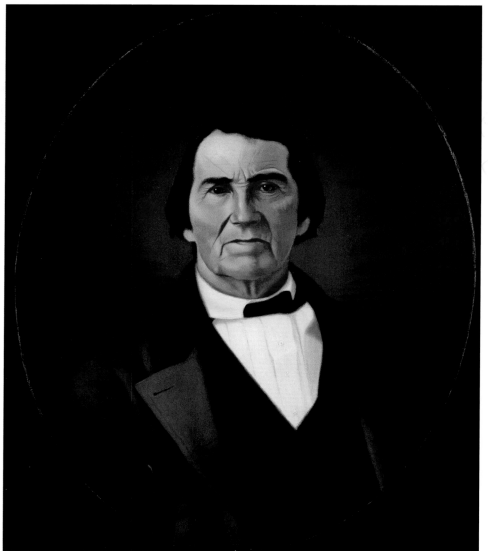

OP.1

OP.3

James B. McFadden, ca. 1866

Oil on canvas; 30 x 25 in. (76.2 x 63.5 cm)

Location unknown

James McFadden was a lawyer, as was another portrait sitter, William Munson, in Franklin, a town near Indianapolis where Chase was living with his family. Chase had not adopted the more fluid brushwork that would so inform his mature work, and it is likely that his portrait of McFadden is a more studied attempt to "get" the image correct. In Peat's 1949 checklist, the work was said to have been owned by James B. McFadden, Shelbyville, Indiana, although given the year, it was nearly impossible for the sitter to have still been alive (perhaps the owner was James B. McFadden, Jr.).

OP.4

Benjamin F. Love, ca. 1866

Oil on canvas; 30 x 25 in. (76.2 x 63.5 cm)

Mrs. Prudence Douglas, Shelbyville, Ind.

This work is an early portrait by Chase done while he was living in Indianapolis. As such, it is likely similar to another male portrait done in the same year of William Gurley Munson. The portraits of this period are somewhat static in rendition, though probably true to the likeness of the sitter. The painting is included in Peat's 1949 checklist of known work by Chase.

OP.5

William Orbison, ca. 1866

Medium/support/dimensions unknown

Location unknown

Based on the presumed date of this work, it is one of several portraits Chase painted when living in Indianapolis. These works tend to be studied and most likely offer the closest resemblances to a given sitter that Chase was capable of at the time—certainly evidence of his young artistic prowess, but without the bravura brushwork that he later learned while studying in Munich.

OP.6

William Gurley Munson, 1868

Oil on canvas; 30 x 25 in. (76.2 x 63.5 cm)

Indianapolis Museum of Art. Bequest of Gladys Munson Wurzburg (57.101)

This is one of the earliest Chase portraits, completed while he was still living with his parents in Indianapolis; the artist was but nineteen years old. William Munson was a young lawyer and a family friend who most likely felt the need to encourage the fledgling art career of Chase (Chase also painted the portrait of James B. McFadden, Munson's law partner); while the portrait of William Gurley Munson has certain static qualities, the forthright pose and unsentimental approach to portrait painting that would so characterize the mature work of Chase can be glimpsed in this early portrait. The painting is included in Peat's 1949 list as being owned by Mrs. Felix Wurzburg, Berkeley, California.

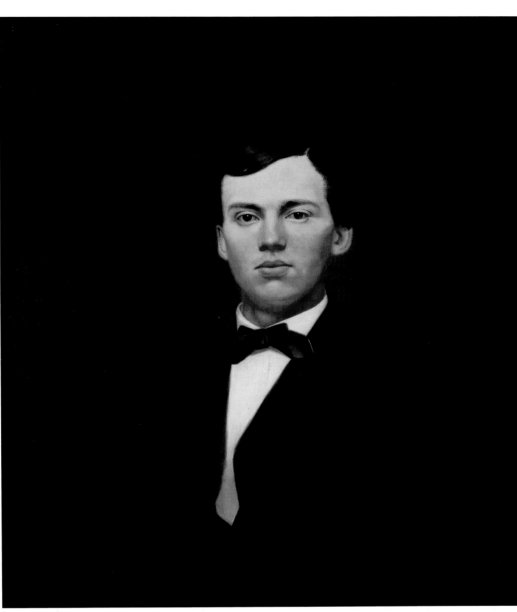

OP.6

OP.7

Portrait (W. F. Macy?), ca. 1870

Physical properties unknown

Location unknown

Exhibitions: NAD '71 #367 [W. F. Macy—owner].

Because W. F. Macy lent this work to the National Academy of Design exhibition of 1871, there is the tacit assumption that it is a portrait of him. In fact, there was a William Ferdinand Macy who was an artist, perhaps a student at the National Academy of Design, who also began to exhibit there in 1872. As he was born in 1852, he would have been about eighteen when this portrait was painted by Chase.

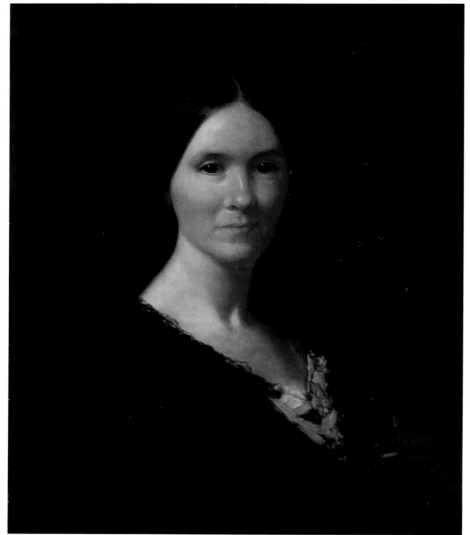

OP.8

OP.10

Head, Cabinet Size, ca. 1871

Medium/support/dimensions unknown

Location unknown

Exhibitions: **StLA&M '71** (first premium diploma and $20 awarded to Will M. Chase, St. Louis).

This is the first Chase portrait known to have been entered into an exhibition. Chase had begun submitting works to the St. Louis Agricultural and Mechanical Association the previous year, when two of the three works entered won prizes. The title *Head, Cabinet Size* implies it was a small work, likely of a friend or family member, although it is tempting to hope that it might have been an early self-portrait yet to be discovered.

OP.11

Man Wearing Gold Rimmed Glasses, ca. 1873

Oil on canvas; 13¼ x 9⅝ in. (33.7 x 24.5 cm)
Signed: Chase (u.l.)

Collection of Howard H. Bristol, Jr.,
New Hartford, Conn.

OP.8

Portrait of Margaret Creighton Bateman of Shelter Island, New York, ca. 1870

Oil on canvas; 24 x 20 in. (61 x 50.8 cm)

San Diego Museum of Art. Gift of Mrs. Eleanor B. Parks

Chase was commissioned to paint the portrait of Mrs. Horatio Bateman (1817–1891) while a student at the National Academy of Design, perhaps in the early months of 1870 before he completed his studies at the academy and returned home to St. Louis. A letter from Mrs. Eleanor Parks to Reginald Poland (Chase archives) states that the portrait was painted in the early 1870s when the sitter was approximately fifty years old, although she does not appear to be that old in the painting. The work was included on the 1949 Peat checklist as owned by the Fine Arts Gallery of San Diego.

OP.9

George "Cap" Shepardson, 1871

Oil on canvas; dimensions unknown
Signed, dated, and noted: WMChase [conjoined] 1871 NY [location unknown]

Collection of Richard D. Shepardson

This appears to be a very early portrait by Chase while a student at the National Academy of Design. About this time, he was advised by one of his teachers, Joseph O. Eaton, to seek portrait commissions in Yonkers, on the northern outskirts of New York City, where the older artist lived—no doubt the commissions would have been awarded on the recommendation of Eaton. It is certainly possible that this portrait of Mr. Shepardson was one of these commissions. The signature style with the conjoined initials WMC is unique to this piece. It likely demonstrates Chase's intention to create a unique signature style.

OP.9

OP.11

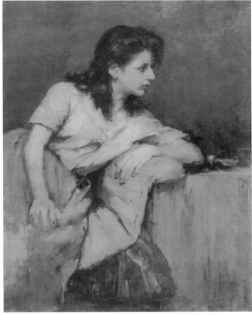

OP.13

OP.13

Portrait of a Girl, 1874

Medium/support/dimensions unknown

Location unknown

The only extant image of this portrait is in a photograph in the Chase Archives, Parrish Art Museum, Southampton, Long Island, New York. The photograph is labeled "Munich 1874" and indicates this work dates to Chase's study in that city. The sitter's identity is not known.

OP.14

The Dowager, 1874

Oil on canvas; 36½ x 29¼ in. (92.7 x 74.3 cm)
Signed: Will M. Chase (u.r.)
Inscribed: München / 1874 (u.r.)

Location unknown

Exhibitions: **NAD '75 #408 (FS); ULC '86 #63** [lent by Eastman Johnson]; **NAC '10 #121** [lent by Mrs. Eastman Johnson]; **MMA '17 #1** [lent by Mr. Joseph S. Auerbach].

Historically, *The Dowager* is one of Chase's most significant paintings of the Munich period. It was completed while Chase was studying in Munich and owes much to the style—and costumes—of the Old Masters, to whose work the artist was heavily exposed at that time. Chase had sent *The Dowager* home from Munich to

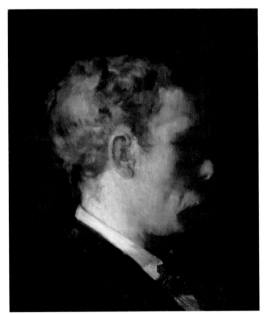

OP.12

OP.12

Profile of a Man in Shadow, ca. 1873

Oil on canvas; 16 x 13 in. (40.6 x 33 cm)
Signed and inscribed: Chase / Munich (u.l.)

Collection of Howard H. Bristol, Jr.,
New Hartford, Conn.

OP.14

St. Louis to patron W. R. Hodges as part of his contractual obligation to his sponsors. The painting was then exhibited at the National Academy in 1875, where it caught the attention of the artist Eastman Johnson, who purchased it immediately. In the Baker/Pisano Collection, there is a print of a very similar work (or a variation of the painting), which is signed and dated in the plate (in reverse): "J. Reneviev / Mai 1875." In the margin it is inscribed by the artist [J.R.] to Chase.

Marianna G. Van Rensselaer would write of *The Dowager,* "Professing to be no more than a careful 'Academy picture,' it is in fact a clever and forcibly rendered portrait of an individuality [*sic*]. In spite of the evident travesty of costume, we feel sure we have the real woman before us. In conception and as portraiture it may rank with the best of Mr. Chase's work, but technically it is not so complete as most of those dating from a later period" ("William Merritt Chase," *American Art Review* 2, no. 1 [January 1881]: 94). She makes further mention of *The Dowager* in her second article on Chase, "William Merritt Chase," *American Art Review* 2 (February 1881): 135. Kenyon Cox refers to the work as being "strongly stamped with the Munich style" and "vigorous and striking" (Kenyon Cox, "William M. Chase, Painter," *Harper's New Monthly Magazine* 28 [March 1889]: 551). Finally, in 1916 the work is mentioned in "William M. Chase," *Fine Arts Journal* 34 (November 1916): 99. Sometime between 1910 and 1915, the painting was sold by Eastman Johnson to Mr. Joseph S. Auerbach, New York, and the work thereafter descended in the Auerbach family. *The Dowager,* owner unknown, is included on Peat's 1949 checklist of Chase's known work.

OP.15

Portrait of a Man, ca. 1875

Oil on canvas; 25 x 20½ in. (63.5 x 52.1 cm)
Inscribed and signed: Miss Kibbe / En souvenir de / W. M. Chase (l.r.)

Albright-Knox Art Gallery, Buffalo. Fellows for Life Fund, 1926

It is somewhat affected for Chase to inscribe a work in French; perhaps he was following the fashion of the day. This work is included in Peat's 1949 checklist with several titles, including *A Russian* and *A Russian Type.* However, Chase never exhibited a work with either of these titles.

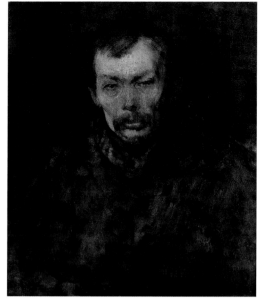

OP.15

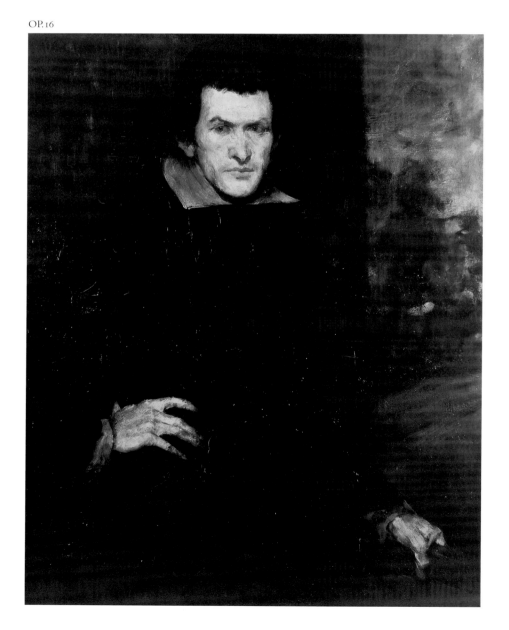

OP.16

OP.16

J. Frank Currier, ca. 1875

Oil on canvas; 38 x 30 in. (96.5 x 76.2 cm)

Location unknown

Exhibitions: **PPIE '15 #3755.**

This portrait of J. Frank Currier (1843-1909) was painted while both Currier and Chase were students at the Munich Royal Academy in the 1870s. It is mentioned as hanging in the inner studio of Chase's Tenth Street Studio in an article written by W. A. Cooper, "Artists in Their Studios," *Godey's Magazine* 30 (March 1895): 296. The work was also illustrated in the Newhouse Gallery book that accompanied an exhibition of the same name, *Paintings by William Merritt Chase* (1927), no. 40. In the 1949 Peat checklist of known paintings, Louis W. Alston, Baltimore, was listed as the owner.

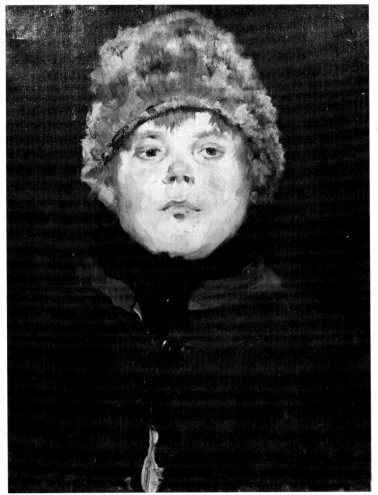

OP. 17

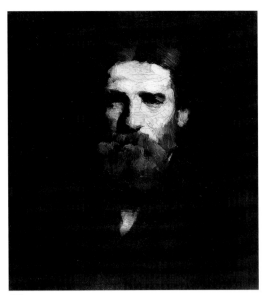

OP. 19

OP. 17

Boy in Fur Cap, 1875

Oil on canvas; 19 x 13½ in. (48.3 x 34.3 cm)
Signed: William Chase (u.l.)
Inscribed and dated: Munich / 1875 (u.r.) [signature difficult to read in photograph]

Deerfield Academy, Mass.

This work was included in Peat's 1949 checklist as being owned by Mrs. Lucius D. Potter, Greenfield, Massachusetts.

OP. 18

Old Cavalier, A Study, ca. 1875

Oil on canvas; 23¾ x 19 in. (60.3 x 48.3 cm)
Signed: Will M Chase (u.l.)
Noted: A Study (u.r.)

Morgan State College, Murphy Fine Arts Center, Baltimore

Exhibitions: **MMA '17 #2** [lent by August Janssen].

This is a work done while Chase was a student at the Munich Royal Academy. It is included in Peat's 1949 checklist as being owned by August Janssen (1917).

OP. 18

OP. 19

Leslie Pease Barnum

Oil on canvas; 21½ x 17½ in. (54.6 x 44.5 cm)
Signed: W. M. Chase (u.l.)

Location unknown

Leslie Pease Barnum (1844–1918) was a critic and writer on art subjects. He lived in Munich in the 1870s and it was there that he met Chase, as well as Frank Duveneck and Walter Shirlaw, both of whom also painted his portrait. Barnum served as groomsman at the wedding of Edwin Austin Abbey, and served as vice consul of Venice. Although the signature is indistinguishable in the photograph, the painting appears to be an early work, possibly done in Munich while Chase was a student. It is included in Peat's 1949 list of known works by Chase as being owned by Babcock Galleries, New York. It was later part of the Benjamin Sonnenberg Collection, with a provenance that included Babcock Galleries and Norbert Heerman.

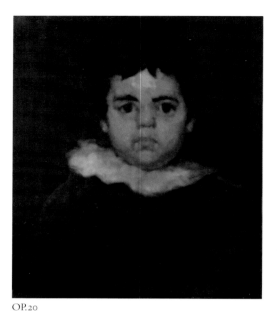

OP.20

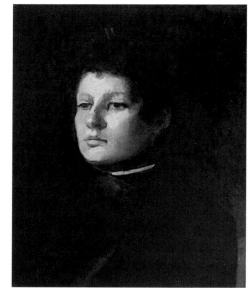

OP.21

Young Girl, 1875

Oil on canvas; 39 x 24 in. (99.1 x 61 cm)
Signed: Will M. Chase (u.l.)
Inscribed: München 1875 (u.r.)
Label verso: Exhibited in the Boston Art Club by
the Artist

Location unknown

Exhibitions: **BAC '79 #98** [lent by F. P. Vinton].

This painting was completed during Chase's
period of study in Munich between 1872 and
1878. The artist Frederick Porter Vinton
(1846–1911) trained in Munich with Chase in
1874 and early 1875, and likely befriended the
artist at that time. According to a letter from
a Vinton descendent, the above painting was a
gift from Chase. Vinton would leave Munich to
study in Paris in 1875, so perhaps Chase gave

OP.20

Untitled (Portrait of a Young Boy), 1875

Oil on canvas; 17 x 15 in. (45.7 x 38.1 cm)
Signed, noted, and dated: Will M. Chase /
München—1875

Private collection

This work was painted while Chase was a
student at the Royal Munich Academy.

OP.21

Portrait of a Young Girl, 1875

Oil on canvas; 20 x 16 in. (50.8 x 40.6 cm)
Label verso: Sammlung Georg Schafer Shweinfurt

MB Fine Art LLC, Los Angeles

Portrait of a Young Girl was created during Chase's
period of study in Munich (1872–78). Its size,
20 by 16 inches, is one that he favored for his
bust-length informal portraits and figure studies.
Its casual, candid nature and broadly painted and
swiftly executed brushstrokes suggest that, rather
than a commissioned work or exhibition piece,
it was an informal work done for the artist's own
pleasure or for personal reasons. It was said to have
been acquired for the collection of Dr. Georg
Schafer, Munich, circa 1900.

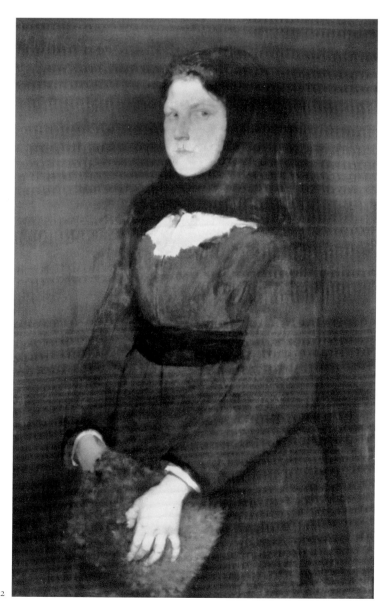

OP.22

him this painting as a going-away gift. When Vinton returned to Boston in 1879, he exhibited *Young Girl* at the Boston Art Club. The work descended in the Vinton family for many years.

OP.23

OP.23

The Whistling Boy, 1875

Oil on canvas; 32 x 16½ in. (81.3 x 41.9 cm)
Signed, inscribed, and dated: Wm. M. Chase
München 1875

The Detroit Institute of Arts. City of Detroit
Purchase

Chase completed at least three other portraits of young working-class boys in 1875 while a student at the Royal Munich Academy, where works of this nature were very popular among the students of the academy, the subject no doubt encouraged by school instructors, perhaps even to fulfill an assignment of some sort.

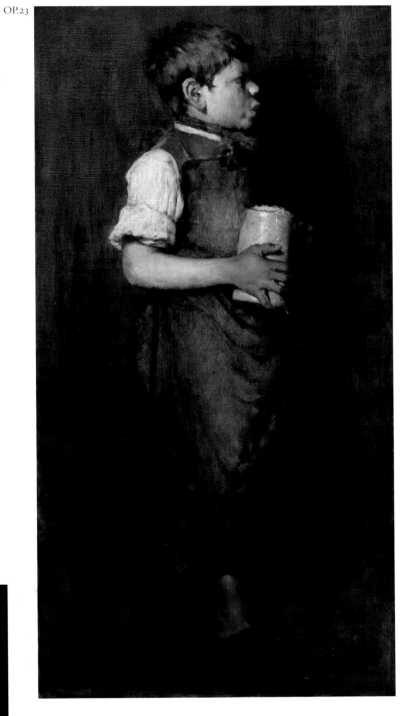

OP.24

OP.24

Portrait of an Old German Man, ca. 1875

Oil on canvas; 23 x 19¼ in. (58.4 x 48.9 cm)
Signed: W M Chase (u.l.)
Inscribed: Munich (u.r.)

Collection of Drs. Noble and Jean Endicott

Throughout his career, Chase painted portraits of old, bearded men, likely the result of his painting works such as *Portrait of an Old German Man* while a student at the Royal Munich Academy.

OP.25

Early Sketch of the Artist (Self-Portrait), ca. 1875

Oil on canvas; 15¾ x 13 in. (40 x 33 cm)
Signed: Chase (u.l.)

Hirshhorn Museum and Sculpture Garden, Smithsonian Institution, Washington, D.C.

Auctions: **Csale '96 #1159.**

This is the earliest recorded self-portrait of the artist. The only definitive exhibition record for the painting is the 1948 show, "William M. Chase 1849-1916: A Selected Retrospective Exhibition of Paintings," American-British Art Center, New York, November 9–December 4, 1948 (no. 26), where it appeared as *Self-Portrait.* Although the lender was not identified, Pisano's records state it was lent by "members of the Chase family." The work was reproduced in a review of the exhibition in *Art Digest* 23, no. 4 (November 15, 1948): 31, in which the painting is criticized: "the warm tones of the flesh glowing from the canvas, but the form almost indistinguishable from its dark setting." The work is included in Peat's 1949 checklist as *Self Portrait* (A), and as being owned by Roy Ireland, New York (presumably having just been purchased from "members" of the Chase family). There is, however, another small early self-portrait lent by Virginia Gerson, the artist's sister-in-law, to the "Exhibition of the Works of William Merritt Chase," American Academy of Arts and Letters, New York, April 26–July 15, 1928 (no. 43), described as "this little self-portrait of Mr. Chase was presented by him to Miss Gerson shortly before his death." It appears on Peat's 1949 checklist as *Self Portrait* (C), 14 by 12 in., and as being owned by Virginia Gerson, New York. Obviously there is a slight difference in dimensions between *Self-Portrait* (A) and *Self-Portrait* (C); however, until *Self-Portrait* (C) surfaces, it is not unreasonable to posit that they are one and the same painting.

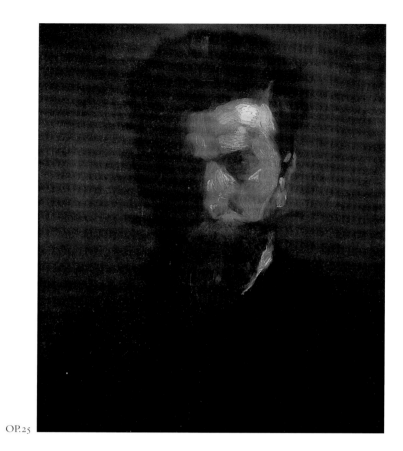

OP.25

OP.26

Hugo von Habermann, 1875

Oil on canvas; 29½ x 24 in. (74.9 x 61 cm)
Signed and dated: Will. M. Chase / 1875 (u.l.)

The Nelson-Atkins Museum of Art, Kansas City, Mo. Gift of Mrs. and Mrs. Albert R. Jones (33-1599)

OP.26

Hugo von Habermann was a fellow art student when Chase was studying at the Royal Munich Academy. In Katharine Metcalf Roof's 1917 biography of Chase, she writes that "Chase painted a brilliant and striking portrait of him [von Habermann] which has been often exhibited." However, there are no contemporary exhibition records that include a work so identified. It is possible, of course, that the work was exhibited as simply *Portrait,* in which case it would be difficult to determine if, in such instances, these works were in fact Chase's portrait of von Habermann. Included in Peat's 1948 checklist of known work.

OP.27

Hugo von Habermann, 1875

Oil on canvas; 19½ x 15 in. (49.5 x 38.1 cm)
Signed and dated: w. CHASE 75 (l.l.)

Stadtische Galerie im Lenbachhaus, Munich

This portrait, so very different in style from the portrait of von Habermann (also painted in 1875) in the Nelson-Atkins Museum of Art, is said to have been painted in the style of the sitter, apparently a common practice at the Royal Munich Academy. Von Habermann was, along with Chase, studying at the academy in the mid-1870s. It does illustrate a more rough-hewn surface that Chase was likely exposed to at the academy—in contrast to the Nelson-Atkins Museum painting, in which the image is more carefully crafted and refined.

OP.27

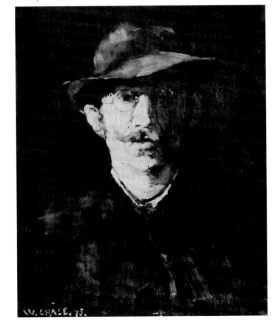

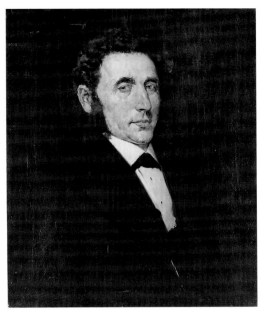

OP.28

OP.28

The Art Dealer Otto Fleischmann, ca. 1875

Oil on canvas; 26 x 21 in. (66 x 53.3 cm)
Signed, inscribed, and dated: Will. M. Chase / Munchen 187[5?] (u.r.)

Bowdoin College Museum of Art, Brunswick, Maine. Gift of Dr. and Mrs. Max Hirshler

Otto Fleischmann (1834–1883) was a Munich art dealer. Chase, in fact, purchased a work from the dealer painted by one of his professors at the Royal Munich Academy, Wilhelm Leibl (1844–1900). Or, perhaps, he bartered this portrait of the art dealer for the painting.

OP.29

The Artist Eduard Grutzner, ca. 1875

Oil on canvas; 34¼ x 29 in. (87 x 73.7 cm)
Signed: Chase (u.l.)

Rudolf Neumeister, Munich

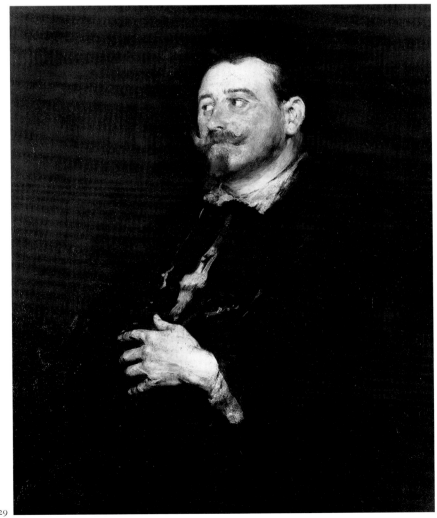

OP.29

Eduard Grutzner (1846–1925) was a fellow art student at the Royal Munich Academy. He became a painter of genre and an illustrator, and, like Chase, was a particular favorite of Karl von Piloty, eminent academy professor.

OP.30

Duveneck in His Study (Portrait of Frank Duveneck/The Smoker), 1875

Physical properties unknown—the image is known only through an etching made of the painting by William Unger (ca. 1880)
Signed and dated: W M Chase '75
Said to have been destroyed in a fire

Exhibitions: **BAA '78 #113** as *Duveneck in His Study;* **SAA '79 #82** as *Portrait of Mr. Frank Duveneck;* **PS '81 #439** as *Un Fumer*—honorable mention; **MCP '83 #349** as *Port. Des malers Duveneck*—honorable mention; **WENO '84/85 #360** as *The Smoker;* **SAA '92 #455** (retrospective exhibition) [lent by C. F. Wildey, Esq.].

The short exhibition history of this work belies its importance as a key early painting. It is, of course, a portrait of the American painter Frank Duveneck (1848–1919), fellow student with Chase at the Royal Munich Academy in the 1870s. However, the work is believed to have been destroyed in a fire, sometime after it was last exhibited in 1892. When the work appeared in the Society of American Artists Exhibition of 1879, it was reviewed in the *Aldine—The Art Journal of America* 9, no. 9 (1879): 281, as being a good picture, pleasing, carefully painted, and well finished: "The modeling and coloring of flesh in the portrait [of Duveneck] was excellent. It may be a question of taste whether a man shall have his portrait painting sitting sidewise in a high-backed chair, his face just appearing above the top of it, smoking a long-stemmed clay pipe like an ancient Knickerbocker." The first appearance of the Unger print of the work was in an article by William C. Brownell, "The Younger Painters of America," *Scribner's Monthly* 20, no. 1 (May 1880): 9. Mr. Brownell set the tone for many subsequent reviews of Chase's work in general noting that, "His canvases have a life, an élan, a movement and an artistic interest in the highest degree noteworthy. . . . They attract, stimulate, provoke a real enthusiasm at times for their straightforward directness, their singleness of aim, their absolute avoidance of all sentimentality" (p. 14). The Unger print next appeared in *American Art Review* 2, pt. 1 (January 1881) facing p. 91. Eight years later the work was included in *American Art and American Art Collections,* vol. 1

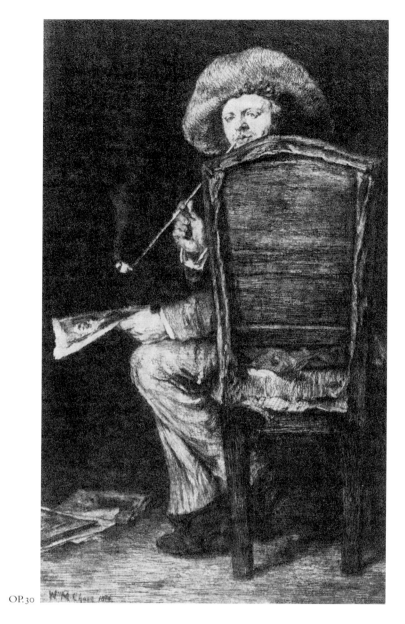

OP.30

(Boston: E. W. Walker and Co., 1889) facing p. 209, and in *American Artists and Their Works by Leading American Art Writers,* vol. 1 (Boston: Esten and Lauriat, 1889) facing p. 113. Kenyon Cox, in his article "William M. Chase, Painter," *Harper's New Monthly Magazine* 78 (March 1889), claims that the "'Portrait of Mr. Duveneck' was painted in Venice before his [Chase's] return to this country." Samuel Isham's monumental *The History of American Painting* (New York: Macmillan, 1905), 383, noted that "'Portrait of Duveneck,' the unconventional attitude of which, the head only showing above the back of the chair, shocked some critics as a sort of indecorum." Isham also claimed the canvas was painted in Venice, perhaps recalling the Cox article. It was mentioned in "William M. Chase," *Bulletin of the Brooklyn Institute of Arts and Sciences* 3, no. 18 (January 8, 1910): 460, as having received honorable mention at the Paris Salon of 1881 and at the Exposition in 1883, and the last recorded reproduction of the Unger print during Chase's lifetime was in

an article by Arthur Hoeber, A.N.A., "American Artists and Their Art," *Woman's Home Companion* 37 (September 1910): 50. There is, however, some confusion as to when and where the painting was done. According to Katharine Metcalf Roof in her 1917 biography of Chase, it was painted in Munich in 1875: "Chase had bought an old chair that had fascinated him. He exhibited it upon its arrival to Duveneck with his enthusiasm. 'Just look at it, man! Isn't it a wonderful thing, a beautiful thing?' And feeling he must paint it at once, he commanded his friend: 'Here, sit down there a minute, I want to see how it looks.' Duveneck sat carelessly on the arm of the chair, his long pipe in his hand. Liking the way it looked, Chase set to work at once to paint it. 'The chair, of course,' Duveneck explained; 'I was of no importance, merely an accessory.'" But both Cox and Isham state the work was painted in Venice. It is unlikely, given the presumed nearly life-size (based on the relative size of the signature in the Unger painting) of the

work, that Chase would have chosen to begin such an undertaking in Venice. His known work in Venice consisted of street scenes, interiors, and harbor views—a few large works, but mainly small works, most likely painted *en plein air*. He had arrived in Venice sometime in May 1877, and that winter he became very ill, and did not recover until the spring of 1878, when he returned to Munich prior to leaving for New York late in the summer. Given Roof's reference to the work having been done in Munich, one possible scenario is that the work was begun in Munich in 1875 and Chase took the painting (likely rolled up) to complete it in Venice. At any rate the work had been finished by the spring of 1878, as it appeared at the Brooklyn Art Association in April of that year. Even this exhibition venue presents a problem as there is a *small* painting also said to be that of Duveneck in his studio—was this the work in the 1878 Brooklyn exhibition? At any rate, as the Unger print clearly includes the date of 1875, it is most reasonable to date the work from that year, even though changes may have been made later when and if Chase brought the work to Venice in 1877.

OP.31

Untitled (Portrait of a German Boy), ca. 1875

Oil on board; 18 x 15 in. (45.7 x 38.1 cm)

Private collection

This portrait study was painted while Chase was a student at the Royal Munich Academy in the 1870s, perhaps as a classroom assignment.

OP.31

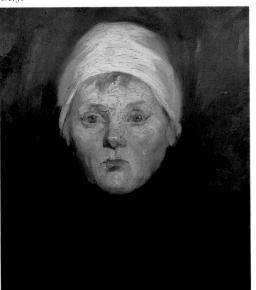

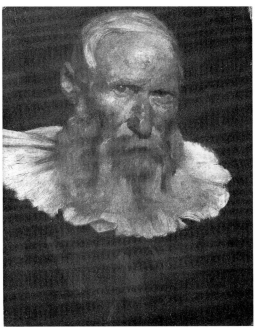

OP.32

OP.32

Portrait of Elderly Man Wearing Large White Collar, ca. 1875

Oil on canvas; 19 x 14½ in. (48.3 x 36.8 cm)
Signed: W. M. Chase (u.l.)

Smith College Museum of Art, Northampton, Mass. Gift of Mr. Bertram M. Newhouse and Mrs. William M. Chase in memory of William M. Chase

The sitter of this painting has been identified as E. Loyal Field (1856-1914), an artist active in the New York art community around the turn of the twentieth century. However, there is no record of Chase having painted a portrait of Field. Both Field and Chase were members of the Salmagundi Club, and it is most likely that they knew each other. Wilbur Peat in his 1949 checklist dates the work to 1875 (collection of Smith College Museum of Art), when Field would have been nineteen years old, and thus not at all the portrait sitter. Chase was studying at the Munich Royal Academy in 1875; Field would later study in Paris.

OP.33

Portrait of Charles Ulrich, Artist

Oil on canvas; 21 x 17 in. (53.3 x 43.2 cm)
Estate seal

Location unknown

Auctions: **Csale '17 #82** (The subject is presented squarely facing the front, looking the spectator in

the eye. He is seen head and shoulders, wearing a coat or perhaps working blouse buttoned up to the neck—above it appears the ends of his standing collar, open at the front. The coat is sketched in neutral tones, olive, brown and buff, and [in] back of his shoulders the background is dark brown, while [in] back of his head it is a light yellow. The light from above throws his deep-set eyes into partial shadow. A direct studio sketch).

Nine years younger than Chase, Charles Frederic Ulrich was born in New York City in 1858, but after his studies at the Royal Academy in Munich, he, too, worked in the heavy, brushy style promulgated by the school. And like Chase he incorporated elements of the Dutch masters in his work. But unlike Chase, Ulrich lived in Europe for most of his life, returning to New York only for visits. Without an image of the work to determine the age of the sitter, it is difficult to place the work in Chase's career, but it was likely done in Munich. This work, owner unknown, is included on Peat's 1949 checklist of Chase's known work.

OP.34

The Patrician, 1875

Oil on canvas; 21¾ x 18 in. (55.2 x 45.7 cm)
Signed: Wm. M. Chase (u.l.)

The Minneapolis Institute of Arts. Gift of Emerson G. Wulling (78.73)

While Chase was a student at the Royal Munich Academy, he painted, no doubt as school assignments, several "portraits"—this may be a copy done after another painting, as it lacks the kind of spontaneity associated with Chase's portraits.

OP.34

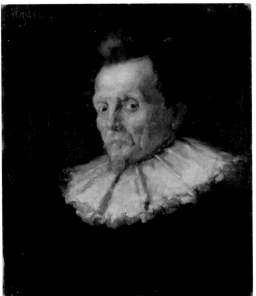

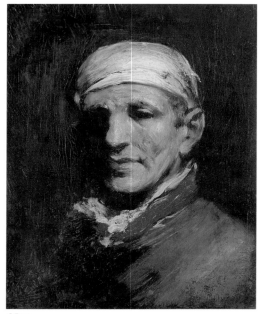

OP.35

OP.35

Man with Bandana, ca. 1875

Oil on panel; 10 x 8 in. (25.4 x 20.3 cm)
Signed: Wm. M. Chase (u.l.)

Private collection

This work was likely painted while Chase was a
student at the Royal Munich Academy.

OP.36

Apprentice, 1875

Oil on canvas; 37 x 23 in. (94 x 58.4 cm)
Signed: Will M. Chase (u.l.)
Inscribed and dated: München 1875 (u.r.)

Collection of Mr. Bruce Lueck

Exhibitions: **SAA '78 #57** [for sale, $300] (*New York
Times,* March 7, 1878, p. 4; Clarence Cook, [Review
of the SAA exhibition], *New York Daily Tribune,* March
16, 1878, p. 5, "This lady's [*Ready for the Ride*] neighbor
[*Apprentice*] is at the other end of the social ladder, and
looks as if he never could climb to her level, nor
would ever desire to. . . . I wish the *Apprentice* could be
purchased by the Society of American Artists as the
nucleus of a collection"; H. C. Brenner, "The Society
of American Artists," *Puck* 3, no. 55 [March 27, 1878]:
16, illus. in cartoon fashion as *Apprentice [with an
appetite]*); **LCE '78 #42** ("Art at the Lotos," *New York
Herald,* April 21, 1878, p. 8: "Among those we note . . .
W. M. Chase's bold *Apprentice* which hung in the
Exhibition of the Society of American Artists");

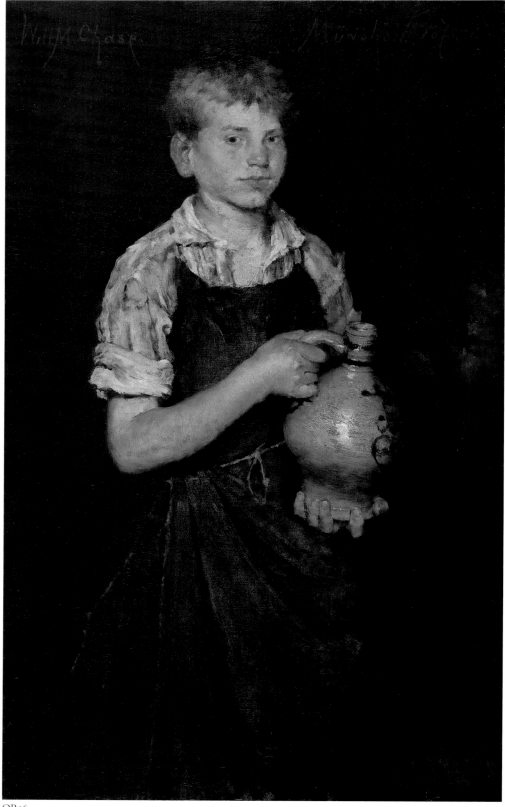

OP.36

MMA '17 #3 (fully described and noted as having
been exhibited at the Society of American Artists,
1878) [Collection of Edwin Lefèvre].

Chase painted several different works of appren-
tice boys while a student at the Royal Munich
Academy. While there has been some confusion
as to exactly which apprentice painting was
exhibited at the Society of American Artists in
1878, a cartoon version of the work in a spoof
review of this exhibition appeared in *Puck* mak-
ing it abundantly clear that this is, indeed, the
painting included in this exhibition, the first time
Chase exhibited with the Society of American

Artists. Three years later Marianna G. Van Rensselaer would discuss the work in "William Merritt Chase: First Article," *American Art Review* 2 (January 1881): 95, "The *Apprentice* was the most striking [portrait in the SAA exhibition]. . . . The handling was broad to excess and the canvas was full of life and 'go,'—aggressively so, if I may use such a word to contrast between this bit of intense, if unbeautiful reality, and the rapid discretion, the smooth nothingness, the sickly conventionality, of portrait studies to which our public has been most accustomed." The work was also noted in Clement and Hutton's *Artists of the Nineteenth Century and Their Works,* vol. 1 (1884, reprint St. Louis: North Point, 1969), 133, and in Katharine Metcalf Roof's 1917 biography, *The Life and Art of William Merritt Chase* (New York: Charles Scribner's Sons, 1917), 42.

OP.37

The Apprentice, 1875

Oil on canvas; 37 x 23 in. (94.1 x 58.4 cm)
Signed: Will M. Chase (u.l.)
Inscribed and dated: München 1875 (u.r.)

Wadsworth Atheneum Museum of Art, Hartford, Conn. Purchased through the gift of James Junius Goodwin (1927.169)

Chase completed several paintings of apprentice boys while a student at the Royal Munich Academy. *The Apprentice* was first illustrated in "Present Tendencies in American Art," *Harpers New Monthly Magazine* 58 (March 1879): 492. Several years later it was illustrated in S.G.W. Benjamin, *Art in America* (New York: Harper Bros., 1881), 201. It was later illustrated in the *New York Herald,* April 4, 1909.

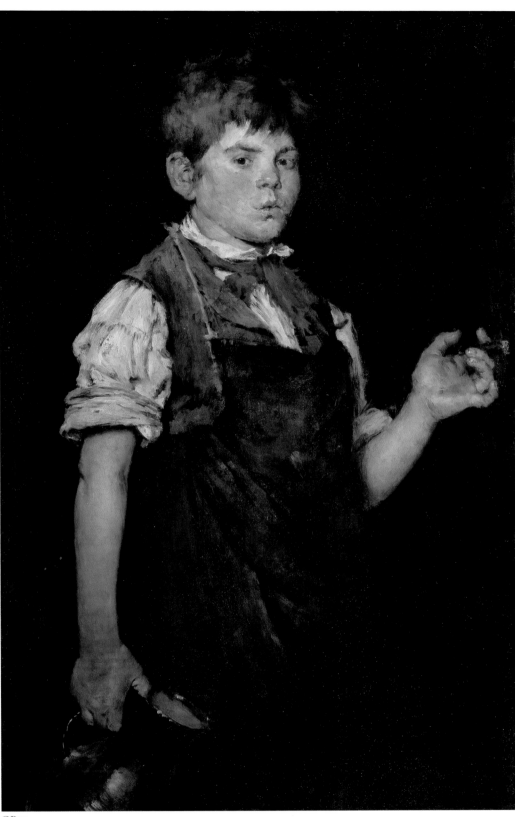

OP.37

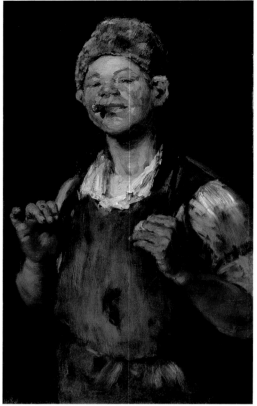

OP.38

OP.38

Impudence, ca. 1875

Oil on canvas; 26¼ x 15¾ in. (66.7 x 40 cm)
Signed: Wm M. Chase (u.l.)—removed

Addison Gallery of American Art, Phillips Academy, Andover, Mass. Gift of anonymous donor (1931.1)

This painting, although never known to have been exhibited during the artist's lifetime, was illustrated in *Art Journal* 6 (Spring 1880): 106. It was discussed in the accompanying article: "Similar excellences are manifest in the present figure of the boy smoking a cigar . . . 'Impudence,' as he terms it . . . 'Impudence' is the property of Mr. Ingalls, proprietor of 'The Studio,' a well-known artists' resort in [*sic*] Sixth Avenue." Chase was a member of the Art Club, 232 Sixth Avenue, founded in 1879, and it is likely that the Studio referenced in the above article was, in fact, the Art Club. Two years later it was illustrated in a book by George William Sheldon, *Hours with Art and Artists* (New York: D. Appleton and Co., 1882), 133. At some point, the painting became the property of the William MacBeth Gallery, New York, and a letter from Henry Miller, vice-president of the gallery, to Mr. E. C. Shaw (April 5, 1923) explains what happened to the signature: "This morning I called on Mrs. Chase taking 'The Leader' [as

the painting had been retitled] with me and upon showing the picture to her in a second she said it was by her husband and was a very fine example. She is willing to write a letter to you personally about it, but there is one thing she would urge you to do before she does this; that is, have me take the picture to our restorers, Beers Bros. 110 West 30th St., this city, and have them take off the signature. This is not her husband's but has been added by someone at some time." Unfortunately, Mrs. Chase did not recognize the legitimate, early Munich "style" signature. The work entered the collection of the Addison Gallery of American Art with the later title, *The Leader.*

OP.39

Normannisches Mädchen (Girl in the National Dress of Normandy), 1876

Oil on canvas; 21¾ x 18 in. (55.3 x 45.7 cm)
Stamped verso: "Carpentier," Paris

Location unknown

Exhibitions: **MCP '76 #1.**

Chase completed *Normannisches Mädchen* during his period of study in Munich from 1872 to 1878.

OP.40

Portrait of Eilif Peterssen, 1876

Oil on canvas; 24 x 19 in. (61 x 48.3 cm)
Signed and dated: [signature trace] / 1876 (u.l.)

Sterling and Francine Clark Art Institute, Williamstown, Mass. Gift of Mr. Asbjorn R. Lunde (1980.43)

The subject of this portrait is Eilif Peterssen (1852–1928), a Norwegian painter who studied in Munich at the same time as Chase did. It was painted while Chase was a student at the Royal Munich Academy. The work is signed by Peterssen on the back of the canvas: "Will. Chase pinx. / Eilif P." Identity of the sitter and confirmation of the inscription on the reverse come from a curator of the National Gallery in Oslo, Norway (letter, February 21, 1977, from Asbjorn R. Lunde to Ronald G. Pisano [Pisano/Chase Catalogue Raisonné Project files]). The painting was sold by Peterssen's estate in Oslo in 1931 to Alf S. Bjerke, who in turn sold the work to Mr. Asbjorn R. Lunde in 1968.

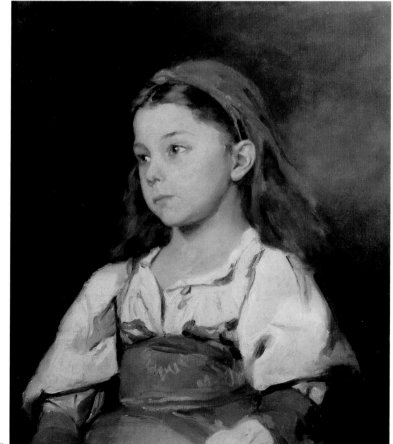

OP.39

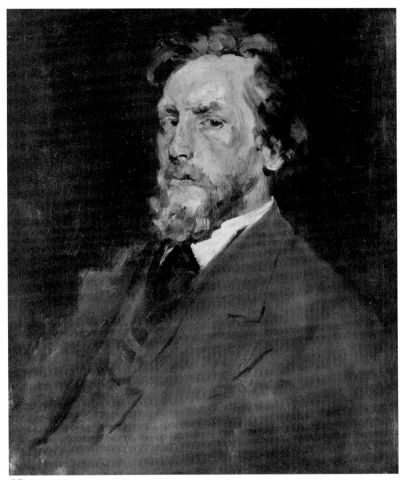

OP.40

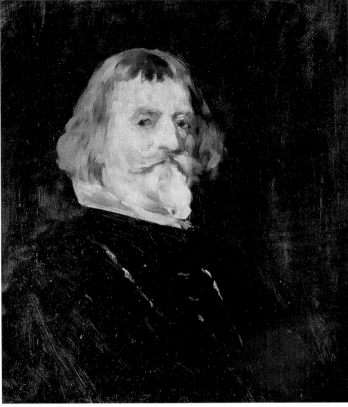

OP.41

OP.41

Munich Head, ca. 1875

Oil on canvas; 27¼ x 22½ in. (69.2 x 57.2 cm)

Location unknown

OP.42

Boy Eating an Apple (The Apprentice Boy), 1876

Oil on canvas; 18 x 13 in. (45.7 x 33 cm)
Signed and dated: Wm M. Chase 1876 (l.r.)

The Museum of Fine Arts, Houston. Wintermann
Collection of American Art, gift of Mr. and Mrs.
David R. Wintermann (84.444)

This painting is a smaller version of *The Apprentice Boy* (OP.43). Both paintings are dated 1876, and thus painted while Chase was a student at the Royal Munich Academy, such subject matter being very popular with the students during these years.

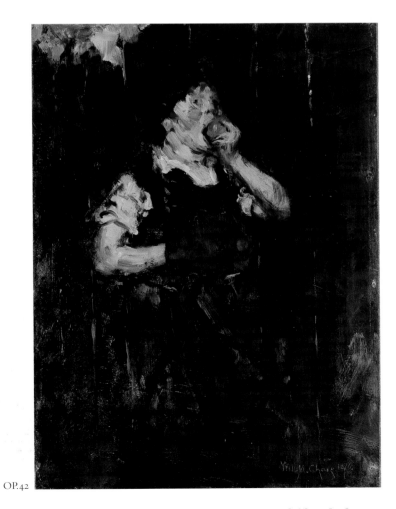

OP.42

OP.43

The Apprentice Boy, 1876

Oil on canvas; 37 x 24½ in. (94 x 62.2 cm)
Signed and dated: Wm. M. Chase 1876 (l.r.)

Private collection

While many of the students at the Royal
Munich Academy painted "portraits" of local
working-class boys, Chase was especially prolific
in this regard, as he is known to have painted
seven works of this subject—an additional
related work, *The Boot Black,* circa 1879 (OP.64),
was completed in New York. All these works
reflect the dashing brushwork so prized in the
Munich school. But they also capture the
endearing personalities of the various boys—
cocksure, confident, and proud. There is cer-
tainly an immediacy to the images, some nearly
130 years after they were painted. *The Apprentice
Boy* was illustrated in S.G.W. Benjamin, *Our
American Artists* (Boston: D. Lothrop and Co.,
1886), 65.

OP.44

Portrait of Mr. Drindel, 1876

Oil on canvas; 22 x 18 in. (55.9 x 45.7 cm)
Signed, dated, and noted: Wm. M. Chase 1876 /
Munich (u.r.)
Noted and dated (verso): München 1876 / Chase /
Portrait of Mr. Drindel

Collection of Fred and Peg Fochtman

There are no auction or exhibition records of
Chase having done a portrait of a Mr. Drindel,
who may have been a fellow student at the
Royal Munich Academy at the time.

OP.45

Laughing Boy, ca. 1877

Oil on canvas; 19 x 15¼ in. (48.3 x 38.7 cm)

Location unknown

A photograph of this painting (with the
impressed stamp of a Munich photographic
studio) descended in the Chase family. The
work was part of the inventory of European
art galleries, including Galerie Thannhauser,
Luzern, Switzerland, and Galerie Heinemann,

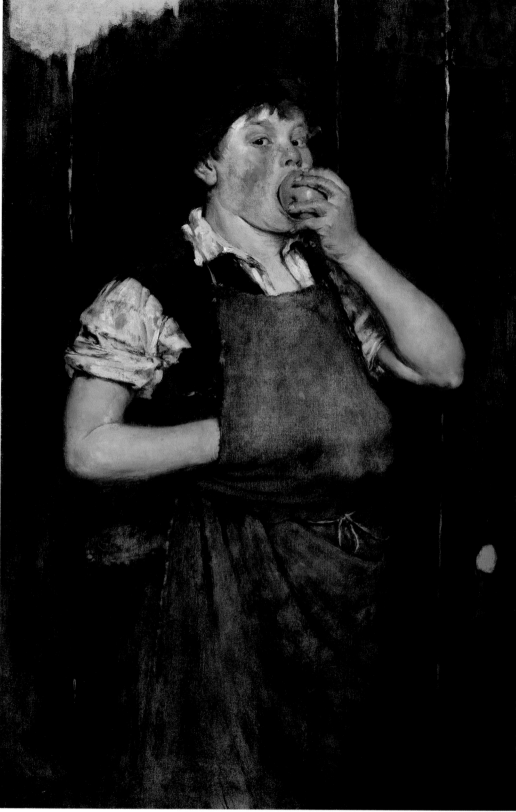

OP.43

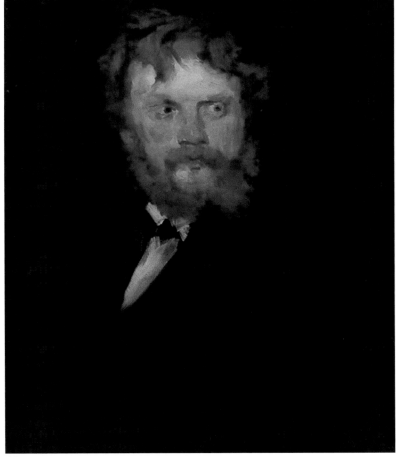

OP.44

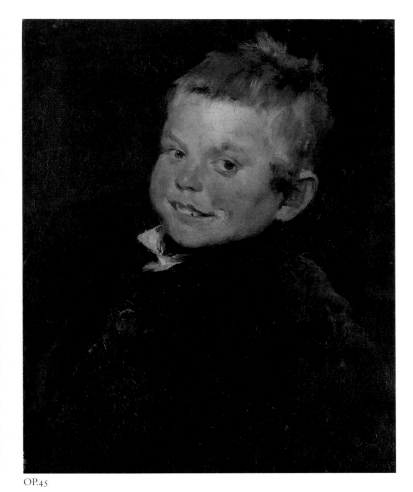

OP.45

Munich, and was identified as having been painted by William Chase. The work was included in Peat's 1949 checklist as being owned by E. D. Levinson, New York.

OP.46

Portrait of a Nun, 1877

Oil on canvas mounted on Masonite; 24 x 30 in. (61 x 76.2 cm)
Signed: W M Chase 1877 (u.r.)
On back of Masonite: 1982.26 (probably owner's catalogue number)
Label on back of frame: 2977 X 138

Location unknown

Chase painted this depiction of a nun in 1877 during his period of study in Munich (1872–78). There are no extant exhibition references.

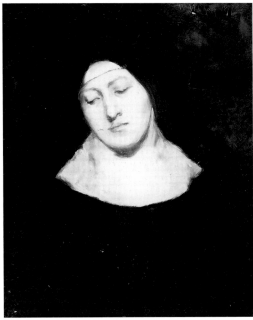

OP.46

OP.47

Ready for the Ride, 1877

Oil on canvas; 54 x 34 in. (137.2 x 86.4 cm)
Signed: W M Chase (u.r.)
Inscribed: München 1877 (u.r.)

Union League Club, New York

Exhibitions: **SAA '78 #55** [lent by S. P. Avery] ("Society of American Artists," *New York Times,* March 7, 1878, p. 4); **SAA '92 #465** [lent by the Union League Club, New York, N.Y.]; **NAC '10 #41** [lent by the Union League Club] (J.B.T., "Chase at the National Arts Club," *American Art News* 8 [January 19, 1910]: 6 [described]; "The Chase Exhibition," *Outlook* 94 [January 29, 1910]: 230); **NAD '16 #268; MMA '17 #5** [lent by the Union League Club, artist deceased].

Chase left for Munich in 1872 to study art and to act as a buying agent for his benefactors at home. The impact of Chase's study in Munich, and his exposure to the work of the Old Masters, is evident both in the dark coloring of the work and the way in which the figure emerges from the dimly lit background, her face bathed in light.

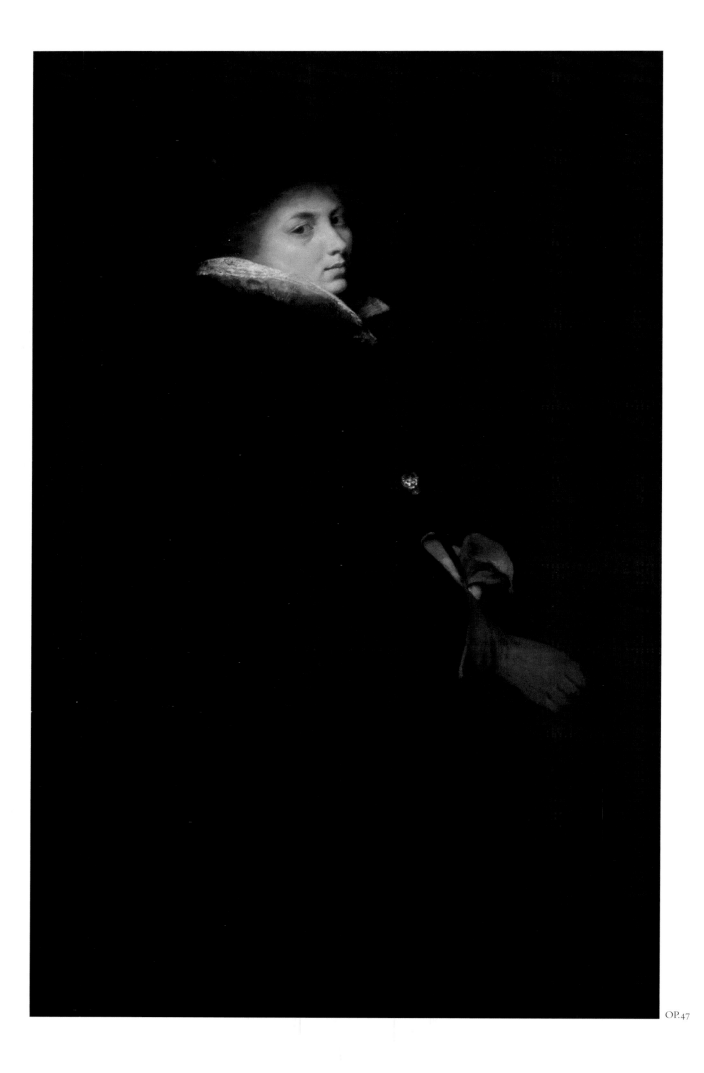

OP.48

in an article reviewing the sale, which refers to the work as Chase's "strongest female portrait" ("The Chase Sale," *Art Amateur* [April 1887]: 100). Another writer lauded the work as a "splendidly drawn, beautifully modeled and finely colored portrait of a young woman in riding costume, which might be called an American old master, [and] is still perhaps his best work in portraiture" (*American Art News,* January 19, 1910, 6). An anonymous reviewer of the work at the National Academy also commended it, writing, "The subject is a woman in a highly picturesque riding costume, with a tall black hat, a black gown and yellow gloves, one of which she is in the act of drawing on. It would be difficult to exaggerate the beauty of the painting, over which time has already drawn a delicate veil of tone. The blond hair floating about the forehead has a quality to be envied by all but the masters of painting, the delicate modeling about the eyes and about the charming mouth, the firm free drawing of the figure, the simple, manly, solid workmanship throughout—what promise of great accomplishment to give at the opening of a career!" ("William M. Chase," *Fine Arts Journal* [November 1916]: 100-101). Even at the end of Chase's life, *Ready for the Ride* was still considered "equal to any portrait ever painted by an American" (anonymous, "William M. Chase—Painter," *Art World* [December 1916]: 156). Included on Peat's 1949 checklist as *Ready for the Ride,* and as being owned by the Union League Club, New York.

OP.48

Portrait of a Young Lady (Portrait of Piloty's Daughter), 1877

Oil on canvas; 39⅜ x 30¾ in. (100 x 78 cm)
Signed: W. M. Chase 1877 (u.l.)

Collection of Paul Byron Bowman, North Bergen, N.J.

A portrait of another of Piloty's three daughters, and the only one to have been located; Chase completed portraits of five of the Piloty children (OP.48-52). She stands against a dark background—a typical Chase device during his stay in Munich (1872-78)—facing a quarter-turn to her right. Her hands are clasped before her and she looks out at the viewer. She wears a gray, double-breasted coat with large buttons; her ruffled white shirt peaks out from the cuffs of her coat and at her neck. A pink scarf that appears to be tied in a bow at her neck draws the viewer's eye upward to the girl's face and her delicate loop earrings.

Chase's success with this painting significantly advanced his career, and may have persuaded his teacher Karl von Piloty to commission Chase to paint portraits of his five children.

When he returned to the United States in 1878 he accepted a position at the Art Students League and was one of the founders of the Society of American Artists, a new organization created as a rebellion against the conservative National Academy of Design. One of the uses of the Society of American Artists was to provide an alternative exhibition space for American artists, particularly those returning from study abroad. *Ready for the Ride,* which had already been purchased by prominent art dealer Samuel P. Avery (1847-1920), was one of the four paintings Chase exhibited at the inaugural exhibition of the Society of American Artists held in 1878. It was very well received by the critics and really served to help establish his reputation as one of the top American artists.

Renowned critic Marianna G. Van Rensselaer mentioned *Ready for the Ride* in two articles in the *American Art Review.* In the second, she named it "by far the most interesting picture of the year. . . . It is a fascinating canvas, very sympathetically imagined, and full of undeniable pathos. More than any other of Mr. Chase's pictures it charms the feelings and excites the imagination" ("William Merritt Chase: Second and Concluding Article," *American Art Review* 2 [February 1881]: 135-36). The work was included in the loan exhibition at the 1887 Chase sale, although it was not listed in the catalogue, as documented

OP.49

OP.50

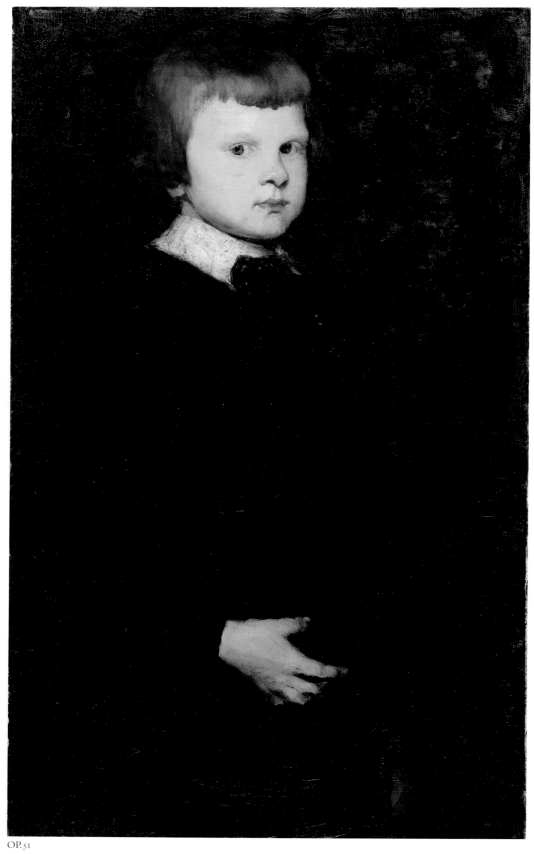

OP.51

OP.49

Portrait of a Young Girl (Piloty), 1877

Oil on canvas; dimensions unknown

Location unknown

A three-quarter-length portrait, now lost, of another of Karl von Piloty's daughters. A photograph of the work descended through the Chase family. References to Chase's commission by Piloty to paint portraits of his children are made in A. Hoeber, "American Artists and Their Work: II / William M. Chase," *Woman's Home Companion* 37 (September 1910): 51, and "William M. Chase Dead," *American Art News* 15 (October 1916): 3. Chase completed portraits of five of the Piloty children during his stay in Munich (OP.48–52). He later completed a portrait of a Mrs. Piloty who does not appear to be related to Karl von Piloty (see OP.367).

OP.50

Portrait of a Young Girl (Piloty Child), 1877

Oil on canvas; dimensions unknown
Signature not visible

Location unknown

While Chase was studying at the Munich Royal Academy he was commissioned by the director of the Bavarian Academy of Fine Arts, Karl von Piloty (1826–1886), to paint portraits of his five children (three daughters and two sons) (OP.48–52). Piloty had joined the faculty of the academy in 1856 and was appointed director in 1874 (the same year Chase entered his master class). This was a very prestigious commission for Chase. After Piloty died, each of the pictures was said to have been given to the child it depicted. The pictures remained in Germany during Chase's lifetime and were never exhibited in the United States. Chase would use the circumstances of this commission as part of the marketing plan to advance his celebrity in the New York art community after he returned home in 1878. There are innumerable references in periodicals and books pointing to this commission, but none of the Piloty children's names was mentioned.

This portrait depicts one of Piloty's daughters. The painting has not been located, but a photograph of it descended in the Chase family. As both portraits of the male Piloty children have been documented, the sitter for the present work—despite the boyish haircut—must have been one of the three female Piloty children (one of the other portraits of the Piloty daughters has been located, OP.48).

OP.51

Portrait of Piloty's Son, 1877

Oil on canvas; 32½ x 19⅝ in. (82.6 x 19.6 cm)
Signed and dated: W. M. Chase 1877 (u.r.)

Location unknown

This is one of five portraits done in Munich of the children (two sons and three daughters) of Karl Theodore von Piloty (1826–1886) while Chase was a student at the Royal Munich Academy (OP.48–52). Piloty had joined the faculty of the academy in 1856 and was appointed director in 1874, the same year that Chase entered his master class. And it was Piloty who acted as sort of a mentor to Chase, whom he believed to be his best student. In fact, Piloty asked Chase, after completing his studies in 1877, to stay on as an instructor at the school; Chase declined, returning to New York to start his distinguished career. Piloty gave the portraits to each of the children, and, except for the publicity value that Chase mined for having painted them, the portraits remained in Germany and were never exhibited in the United States. In 1879 Chase did a dry-point etching after one of the Piloty son paintings, which was exhibited at the "Third Annual Exhibition of Black and White Art under the Auspices of the Salmagundi Sketch Club," held at the National Academy of Design, New York, December 18, 1880–January 1, 1881 (no. 154); however, this print has never surfaced. Thus it is impossible to determine if the image is of the above-cited portrait, or after the portrait of the other Piloty son. The *Portrait of Piloty's Son* was illustrated in an article written by Katharine Metcalf Roof, "William M. Chase: The Man and the Artist," *Century Magazine* 93 (April 1917): 836.

OP.52

Son of Karl von Piloty, 1877

Medium, support, and dimensions unknown
Signature not visible

Location unknown

One of the oft-told stories about Chase was the commission he was given as a student at the Munich Royal Academy by the director of the Bavarian Academy of Fine Arts, Karl von Piloty, to paint portraits of his children. The *New York Times* reported at the time that the commission

OP.52

consisted of six portraits; however, it was later reported that Chase completed portraits of only five of the Piloty children (OP.48–52), as well as a later work thought to be of their mother (OP.367). Regardless, it was a prestigious commission for the twenty-eight-year-old Chase. Chase also was said to have completed an etching of one of the Piloty sons, no doubt after one of the paintings; this image, however, has never surfaced (though it is tempting to surmise that this image is the basis for the missing etching). A photograph of this painting, titled "One of the Piloty children / Munich 1877," descended through the Chase family and was reproduced in an article, "William Merritt Chase: His Art and His Influence," *International Studio* 60, no. 240 (February 1917): cviii, by Katharine Metcalf Roof—the article was obviously a forerunner of her biography of Chase that appeared the same year, *The Life and Art of William Merritt Chase* (New York: Charles Scribner's Sons, 1917), where the image is illustrated on page 40. After the death of Piloty, the five paintings of his children were said to have been given to each sitter.

OP.53

Mr. Muhrman, ca. 1877

Physical properties unknown

Location unknown

This work is known only by a passing reference in Marianna G. Van Rensselaer, "William Merritt Chase," *American Art Review* 2 (February 1881): 139, "The same reality, the same sympathy with and clear interpretation of *to-day*, are visible in other works by Mr. Chase . . . in some of his simplest portraits, such as the one of Mr. Muhrman." The sitter is probably Henry Muhrman (1854–1916), a fellow student in the 1870s at the Royal Munich Academy, and thus the painting was likely executed at the academy. Muhrman spent most of his career in Europe, but he widely exhibited his work to great acclaim, winning many awards, one of the earliest being a gold medal for a work at the Munich Academy of Fine Arts.

OP.54

OP.54

The Wounded Poacher, 1878

Oil on canvas; 24 x 18¾ in. (61 x 47.6 cm)
Signed, noted, and dated: W. M. Chase / München / 1878

Collection of Fran and James W. McGlothlin

Exhibitions: **SAA '78 #56,** $250 (*New York Times,* March 7, 1878, p. 4; this work was illustrated in *Puck* 3, no. 55 [March 27, 1878]: 16, as "*The Wounded Poacher* or [*Blown to Blazes*]"); **GAAE '79.**

This work was painted the year Chase returned to the United States, having completed his studies at the Royal Munich Academy. However, the date on the painting appears to read "1898," surely a "slip" of the brush as it was clearly exhibited in 1878 at the Society of American Artists Exhibition of that year, as well as the following year in Gill's Second Annual Art Exhibition, Springfield, Massachusetts. The painting later appeared under the title *The Veteran* when it was sold at auction in 1929 (American Art Association, sold on behalf of Herman Simon [property of Mrs. Elizabeth M. Simon], Easton, Pennsylvania, April 12, 1929, lot no. 65). This work is included as *The Veteran* in Peat's 1949 checklist as being owned by Charles T. Davies, Wyomissing, Pennsylvania.

OP.55

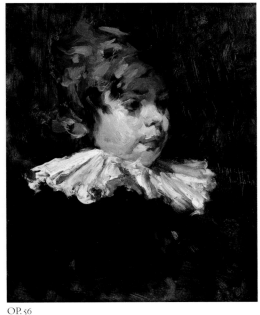

OP.56

Portrait of a Woman, along with *Ready for the Ride* (OP.47), represent the high point of Chase's Munich period (1872–78). They combine a subtle balance of articulated brushstroke and deliberately delineated detail. Both works reflect Chase's interest in the Old Masters of the seventeenth century, as is evident in the costumes of the figures and the dark palette. In *Portrait of a Woman* Chase pays homage to Wilhelm Leibl (1844–1900) and was clearly inspired by the latter's *Kokotte (Die Cocotte) (The Young Parisienne)* of 1869 [Wallraf-Richartz Museum, Cologne] (OP.59A). However, Chase alters the subject matter and pose to create a work that would be acceptable to the American public. In contrast to Leibl's depiction of *Die Cocotte,* in which the woman is smoking while reclining on a luxurious couch, Chase portrays his model holding a book in her lap and sitting upright in a sturdy chair. Included on Peat's 1949 checklist of Chase's known work as *Portrait of a Woman,* and as being owned by the Wadsworth Atheneum, Hartford, Connecticut.

OP.55

Portrait of a Bearded Gentleman, ca. 1878

Oil on canvas; 25½ x 21½ in. (64.8 x 54.6 cm)
Signed: W. M. Chase (l.l.)

Rafael Gallery, New York

A label on the back of the frame reads as follows: "Giuseppe Biascutti / ??so La Regia Academ?? / N 1024 Venezia / Deposito Oggert?? / Pintura Per e Disgno." The work is assigned a date circa 1878.

OP.56

Head of a Boy, 1878

Oil on canvas; 18¼ x 15½ in. (46.4 x 39.4 cm)
Signed, noted, and dated: W M Chase / New York [1]878 (c.r.)

Location unknown

This is one of the first completed works Chase painted after returning to New York from his studies abroad.

OP.57

Portrait of a Woman, 1878

Oil on canvas; 26⅛ x 15⅞ in. (66.4 x 40.3 cm)
Signed: W. M. Chase (u.l.)
Inscribed: München (u.l.); 1878 (u.r.)

Wadsworth Atheneum Museum of Art, Hartford, Conn. Bequest of Mrs. Clara Hinton Gould (1948.209)

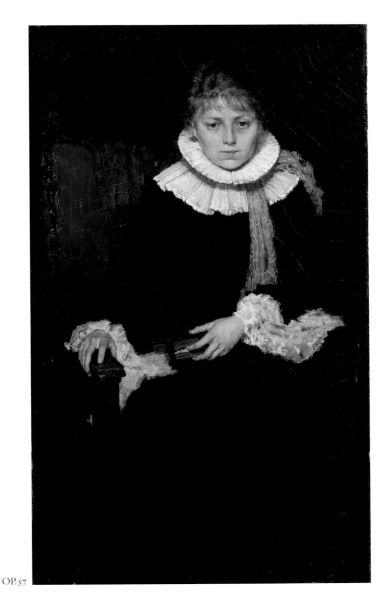

OP.57

Early Years in New York and Europe, 1878–1890

For many American artists at this time, the lack of patronage by the growing upper class in the United States was a simple fact of life. The walls of the wealthy's newly constructed mansions usually were hung with paintings by European artists, many of dubious authorship, brought back from their travels abroad. However, American artists sometimes could carve out a living painting portraits, since it likely was easier for sitters to attend to such matters in the United States rather than while traveling abroad. Consequently, when Chase returned from his studies abroad, he wisely snagged prominent quarters in the famous Tenth Street Studio Building in New York and began painting portraits—many on speculation, or at no cost, provided the sitter allow him to showcase the painting in prominent exhibitions, as did Elsie Leslie Lyde, whom Chase painted in her Broadway role as Little Lord Fauntleroy (OP.158). One of the most extraordinary portraits from these years was of Dora Wheeler (OP.101), a tour de force of color that must certainly have turned heads when it was exhibited in the Paris Salon of 1883. Among his patrons (if indeed they could be called that) was Frederick Howell, who commissioned Chase to paint portraits of his wife (OP.133), their sons (OP.135 and OP.136), and daughter (OP.134)—works that, while demonstrating his dramatic flair for the outré, no doubt also captured the likeness of the sitters. During the decade of the 1880s, Chase played a leading role among young contemporary American artists. As he also spent most summers traveling in Europe during these years, he was familiar with all that was happening in the various art centers of the Old World. This too undoubtedly added to his luster as a portraitist of the first rank.

OP. 58

OP. 58

Portrait of the Artist, 1878

Oil on canvas; 18¾ x 15¾ in. (47.6 x 40 cm)
Signed: Chase (l.r.)

Location unknown

Exhibitions: **BAC '86 #7,** possibly this work—listed under "Portraits in Oil."

This painting was said to have been done shortly after Chase returned from his studies at the Royal Munich Academy in 1878. There is no title of an exhibited work during these early years that clearly describes the painting; it could very well have been exhibited in the early 1880s under the general title *Portrait.* In 1886 Chase was given his first major retrospective exhibition at the Boston Art Club. Included in this exhibition was *Portrait of the Artist* (a pastel self-portrait; see vol. 1, P.13). However, the same title was used for a work in the section "Portraits in Oil," naturally leading one to assume it, too, was a self-portrait. As the signature style is not at all like the signature style used in 1878 (the acknowledged date of the work), it was obviously signed later. It is tempting to conclude that it was indeed signed in 1886 prior to its inclusion in the Boston show. It was purchased directly from Chase by Samuel T. Shaw, noted collector of American art, perhaps as a result of its appearance in Boston. It was included in the sale of the "Samuel T. Shaw Collection of American Paintings," American Art Association, Inc., New York, January 21, 1926, lot no. 47 (fully described). The painting was reproduced in *Art News* (January 30, 1926): 12, in a review of the Shaw sale; the photograph caption noted that the work "was bid in by the Muller Art Gallery." In 1927 it was offered by Newhouse Galleries, St. Louis, Missouri, as they included the portrait in their 1927 book of paintings by Chase, published in connection with a sale of the artist's work (illus. no. 29). The following year, it was included in an exhibition

mounted by the American Academy of Arts and Letters, New York, "Exhibition of the Works of William Merritt Chase," April 26–July 15, 1928, no. 23, described as "early, upon return from Munich / once owned by Samuel Shaw, lent by Mr. Edwin B. Lindsay." Presumably Mr. Lindsay purchased the work from Newhouse Galleries. He is listed as the owner as late as 1949, in Peat's checklist of known works by the artist, where it is given as *Self Portrait* (B)—however, the list of owners often refers to the last known owner, not necessarily the current owner circa 1949.

OP. 59

Portrait of a Woman, 1879

Oil on canvas; 24 x 21 in. (61 x 53.3 cm)
Signed: W M Chase (l.r.) (script)
Dated: Feb. '79 (l.r.)

Collection of Barbara Guillaume, Atlanta

Another early work executed in the style and palette of the Old Masters, betraying the still-strong influence of Chase's study in Munich (1872–78), is *Portrait of a Woman.* Chase's work not only reflects the impact of his study of the Old Masters, but also is informed by the example of Wilhelm Leibl (1844–1900), whose work was popular at the time Chase was studying in Munich. Leibl's significance to Chase is underscored by the fact that Chase, a young artist struggling to support himself, chose at the time to purchase two paintings by Leibl, including *Kokotte,* 1869 (OP. 59A).

Robert M. Pennie, the first to own this painting after Chase himself, was an artist born in Albany, New York, in 1854. He likely studied with Chase at the Art Students League in New York City, where Chase began teaching in the fall of 1878. Pennie may have received *Portrait of a Woman* as a gift from the artist or purchased it from Chase to take back with him to Albany in 1880.

OP. 59

OP. 59A. Wilhelm Leibl, *Kokotte (Die Cocotte) (The Young Parisienne),* 1869. Oil on wood, 25⅜ x 20⅝ in. (64.5 x 52.5 cm). Wallraf-Richartz Museum, Cologne

OP.60

The pattern he creates gives the image a sense of dynamism and energy as it plays against the pink background. Her pose and expression here are quite similar to those in Chase's other portrait of Ayer (OP.68), now in the collection of the California Palace of the Legion of Honor, San Francisco. Ayer's biographers note that Chase completed two portraits of Ayer in this dress, one of which is now in the collection of the Parrish Art Museum, Southampton, New York. Unfortunately, the other has not been located.

OP.61

The Coquette (A Coquette), 1879

Oil on canvas; 20 x 15 in. (50.8 x 38.1 cm)
Signed: Wm. M. Chase (u.l.)
Dated: 1879 (u.l.)

Location unknown

Exhibitions and Auctions: **NAD '79 #471** [lent by Thomas B. Clarke] ("Review of National Academy of Design Exhibition," [New York] *Herald,* March 30, 1879, 41; *New York Times,* April 7, 1879, p. 5); **TCE '83 #24; AIC '89 #84** as *A Coquette;* **TCE '91 #37** (fully described); **FAAG '94,** no catalogue [lent by Thomas B. Clarke] ("A Summer Art Exhibition: Fifth Avenue Art Galleries," *Art Amateur,* 1894); **TBCsale '99 #49,** sold to A. Steckler, $150.

OP.60

Portrait of Harriet Hubbard Ayer, 1879

Oil on canvas; 48⅛ x 32¼ in. (122.2 x 81.9 cm)
Signed: Wm. M. Chase (l.r.)
Dated: 1879 (l.r.)

The Parrish Art Museum, Southampton, Long Island, N.Y. Museum Purchase

Harriet Hubbard Ayer (1849-1903) was born in Chicago, married at the age of sixteen, and lived the life of a wealthy society matron until 1882. Chase painted this portrait of her, one of two he would complete, in 1879. He depicts her in a fashionable dress created by designer Charles Frederic Worth (1825-1895)—one of her purchases from her first trip to Paris; a photo of Ayer in her biography (Margaret Ayer and Isabella Taves, *The Three Lives of Harriet Hubbard Ayer* [Philadelphia: Lippincott Company, 1957]) shows her modeling the dress (OP.60A). Chase makes subtle changes to the dress in his composition, giving it a lighter feel by making the chest and sleeve material slightly translucent.

OP.60A. Photograph of Harriet Hubbard Ayer wearing the same dress as in the painting

A Coquette is described in detail in the catalogue entry for the Pennsylvania Academy exhibition in 1891 as follows: "A portrait study of a comely Dutch girl, of the better class, whose national headdress and costume lend picturesqueness to her natural piquancy of beauty and expressiveness of feature. One of the artist's early successes at the National Academy of Design." As with Chase's *Portrait of a Woman* (OP.57), the subject matter of the present work is likewise derived from German artist Wilhelm Leibl's (1844-1900) *Kokotte (Die Cocotte) (The Young Parisienne)* of 1869 (OP.59A). Leibl's style reflected those of the Realist painters Gustave Courbet and Édouard Manet. Although Chase never formally studied with Leibl, he admired him sufficiently to purchase the latter's works for his personal collection. *The Coquette* was purchased in 1879 by the important American art collector Thomas B. Clarke, and it remained part of his collection until his death in 1899. Included on Peat's 1949 checklist of Chase's known work as *The Coquette,* owner unknown, and erroneously dated circa 1884.

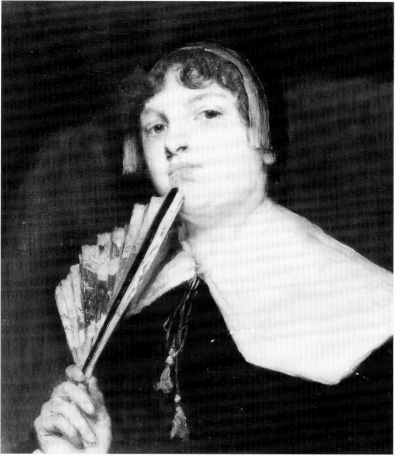

OP.61

Portrait of the Actress: Linda Dietz Carlton, ca. 1879

Oil on canvas; 35 x 29¼ in. (88.9 x 74.3 cm)

Newark Museum, N.J. Purchased by the Carl and Dorothy Badenhausen Foundation Trust Fund, 1954

Auctions: **Csale '17 #97** (fully described).

Linda Dietz Carlton (d. 1920) was a well-known actress at the time Chase painted her portrait. He probably painted the work on speculation in hopes that she would purchase it, but apparently she did not, since it ended up being sold in the 1917 estate sale. He never exhibited the work as *Portrait of the Actress: Linda Dietz Carlton.* He may have shown it as one of the many works entitled *Portrait of a Lady,* but that cannot be confirmed. Chase's portrait of Carlton appears in several photographs of the interior of Chase's Tenth Street Studio taken by George Collins Cox (1851–1903). Cox had been a photographer for the Metropolitan Museum of Art in the late 1870s, while running a commercial practice in Orange, New Jersey. Cox took photos of different areas

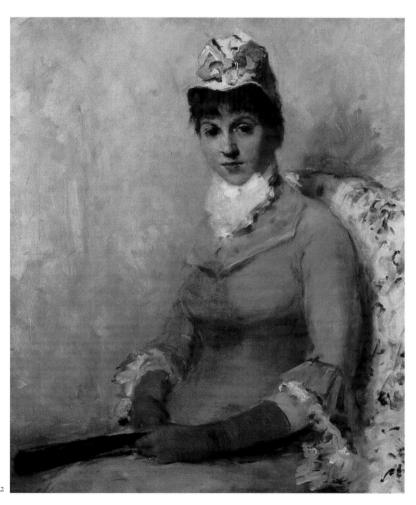

OP.62

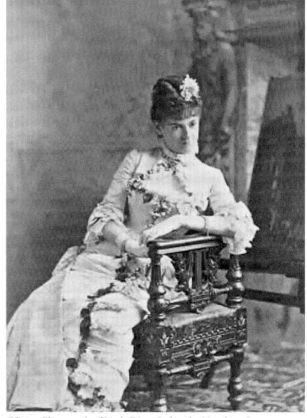

OP.62A. Photograph of Linda Dietz Carlton by Napoleon Sarony

of Chase's studio during the period of 1879–83. Carlton traveled back and forth between New York and England over the years. She went back to England in 1879 and didn't return to the United States until 1887, so it is likely that Chase painted her portrait sometime early in 1879 before she left. OP.62A is an undated Cabinet photograph of the actress by well-known photographer Napoleon Sarony (1821–1896). In contrast to Sarony's depiction of the actress garbed in an elaborate gown in a rather dramatic pose, Chase captures her seated dressed demurely, as if she were about to go out to shop for the day. It is perhaps of interest that unlike his more theatrical images of Little Lord Fauntleroy and Hilda Spong, Chase gives no indication of her role as an actress in this portrait. This painting is included in Wilbur Peat's 1949 checklist of known works by Chase as *Portrait of an Actress (Linda Dietz Carlton),* and as being owned by the Whitney Museum of American Art, New York. Peat dates the work to 1890, but its appearance in the photos by Cox suggests the earlier date of 1879. *Portrait of the Actress* was owned at one time by Mrs. W. Irving Clark of Worcester, Massachusetts, of whom Chase also painted a portrait (OP.198).

OP.63

Study (Bavarian Peasant), ca. 1879

Medium/support/dimensions unknown

Location unknown

This portrait study was reproduced in the *Art Journal* 6 (April 1880): 107, and in the *New York Herald,* April 14, 1909, as *Bavarian Peasant.*

OP.63

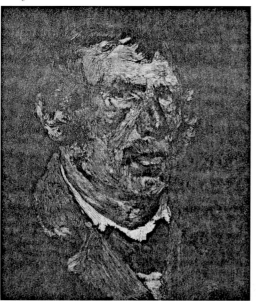

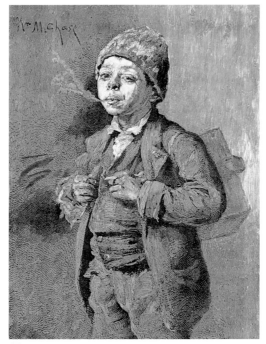

OP.64

OP.64

The Boot Black, ca. 1879

Presumably oil on canvas; dimensions unknown
Signed: Wm. M. Chase (u.l.)

Location unknown

Exhibitions: **SAA '80 #121** (as an engraving by Fred Juengling; illus. in the *Century Gallery,* so noted on otherwise unidentified clipping, New York Public Library).

OP.65

Portrait of F. S. Church, ca. 1879

Physical properties unknown

Location unknown

Exhibitions: **SAA '79 #43** [Mr. Frank Waller—owner].

The American artist Frederick Stuart Church (1842–1923) was a close friend of Chase. It was Church who introduced him to Alice "Posie" Gerson, who would become Chase's wife. In fact, Church was godfather to their first child, Alice Dieudonnée Chase. Alas, while Church was an active member of the New York art community, his work never rose beyond the fanciful. He was, however, a founding board member of the Art Students League and was no doubt instrumental in hiring Chase as a teacher upon his return from studies in Munich. Frank Waller

(1842–1923), who lent the portrait to the Society of American Artists exhibition, was also associated with the league in its early years, serving as president in 1877 and 1878 and again in 1885.

OP.66

Priam, the Nubian Ganymede, 1879

Oil on canvas; 36 x 20 in. (91.4 x 50.8 cm)
Signed: Chase (u.l.)

Montana Museum of Art & Culture, University of Montana, Missoula. Donated by Albert Hendler. Permanent Collection

Exhibitions: **SSC '80 #261** as *Ganymede* [lent by Sarony]; **SAA '80 #154** (engraving by Frederick Juengling).

This portrait is of a servant engaged by members of the famous Tile Club on their 1879 expedition up the Hudson River. The trip was recounted in the article "The Tile Club Afloat," *Scribner's Monthly* 19, no. 5 (March 1880), and *Priam, the Nubian Ganymede* was illustrated on page 649. They hired the man, dubbed "Priam" after the last king of ancient Troy, at West Troy where their barge had tied up. He was described as "a prepossessing young man . . . [with] qualities of

OP.66

mind and person that were not unworthy of the distinguished name he bore." It is tempting to think that the work had been acquired by the photographer Napoleon Sarony, friend and fellow member of the Tile Club, and among the members on the 1879 summer excursion. While the exhibition at the 1880 Salmagundi Sketch Club—Black and White Art would seem to exclude paintings of this sort, club rules of the day were often disregarded for many different reasons. It is also possible that Chase did an as yet undiscovered drawing of Priam and it is that work which was given to Sarony and included in the Sketch Club exhibition. The painting was illustrated in Katharine Metcalf Roof's 1917 biography facing p. 80.

OP.67

Girl with Doll, 1880

Oil on canvas; 30½ x 24⅛ in. (77.5 x 61.3 cm)
Signed: Wm. M. Chase / 1880 (l.l.)

Location unknown

The style and signature of the present work are both typical of Chase's work of the early to mid-1880s. The Japanese motif of the fabric on which the girl is seated, its mustard tones and turquoise and rose highlights, also appears as the backdrop of Chase's *Portrait of a Woman*, circa 1882 (OP.98), and again in *Portrait of Miss Dora Wheeler*, circa 1883 (OP.101). The little doll cradled in the arms

of the sitter was also used in an early still life, *The Japanese Doll*, circa 1882 (see vol. 4), and may be the same doll (described as a "Japanese doll") held by Erla Howell in Chase's pastel *Portrait of Little Miss H.*, circa 1889 (see vol. 1). Unquestionably, *Girl with Doll* was painted in Chase's Tenth Street Studio, where the artist stored the many fabrics that appear in his paintings.

Although the painting was at one point erroneously recorded as *The Artist's Daughter*, the work could not be a depiction of one of Chase's daughters, as the work is dated prior to the artist's marriage in 1886. *Girl with Doll* was likely a commissioned portrait, and as such it would have gone directly into the collection of that patron, perhaps accounting for the absence of any exhibition records for the work.

OP.68

Portrait (Portrait of a Lady; Portrait of Harriet Hubbard Ayer), 1880

Oil on canvas; 27¼ x 22¼ in. (69.2 x 56.5 cm)
Signed: Wm. M. Chase (l.l.) (signature no longer visible)
Red wax estate seals were affixed to the back of the works in the estate sale (these have been invariably lost due to cracking and lifting).

California Palace of the Legion of Honor, Fine Arts Museums of San Francisco. Gift of Henry K. S. Williams (1942.1)

OP.67

Exhibitions and Auctions: SAA '80 #41 as *Portrait* ("Varnishing Day Scenes," *New York Times*, March 16, 1880, A5); IIEC '81 #501 as *Portrait of a Lady* (*Art Amateur* [November 1881]: 116, illus.); Csale '17 #91 as *Portrait of Harriet Hubbard Ayer*.

This is Chase's second portrait—or rather, a part thereof—of Chicago socialite Harriet Hubbard Ayer (1849–1903; see OP.60). Upon its exhibition at the Society of American Artists, one reviewer described the work as depicting a "young lady in a white bonnet with light blue strings. . . . Her pose is exceedingly restful, easy and natural as if she knew that dressed in such becoming clothes, and placed before such a charming background, every body would be pleased while looking at her" (*New York Times*, March 16, 1880, A5). Ronald Pisano and Annette Blaugrund have suggested on the basis of the sitter's costume, face, eyes, and hair that Ayer may also be the figure depicted in Chase's *In the Studio*, circa 1881 (see vol. 4).

Chase's portrait of Ayer, originally executed full-length (85 x 38 in.) as seen in the wood engraving by Frederick Juengling (OP.68A), was mentioned in Marianna G. Van Rensselaer's article "William M. Chase" published in *The American Art Review* 2, no. 1 (January 1881): facing p. 92—one of the first significant discussions of Chase's work to appear in print. It appears there was some question of using this portrait of Ayer in the article; at one point Chase suggested substituting his painting of "two of the Piloty children" (letter from Chase to Koehler, D30, frame 397, October 17, 1880, Archives of American Art, Smithsonian Institution, Washington, D.C.). However, Mrs. Van Rensselaer insisted and wrote to Koehler on September 7, 1880, that in spite of whatever Chase might have said, "I do hope I shall not be disappointed about Mrs. Ayer's picture as it makes such a good contrast to the Duveneck and the pictures themselves are so different that I wish to speak of them both in detail" (Archives of American Art, D 191, frame 16). When the article came out with Ayer's portrait included, Chase expressed his satisfaction to Koehler, writing to him on January 24, 1881, "The appearance of the article pleases me very much (D191, frame 403). The portrait was mentioned again in Rensselaer's second article, "William Merritt Chase," published in the *American Art Review* 2 (February 1881): 138. According to Ayer's biography (Margaret Hubbard Ayer and Isabelle Taves, *The Three Lives of Harriet Hubbard Ayer* [Philadelphia and New York: J. B. Lippincott, 1957], 84), Chase was commissioned by Ayer's father-in-law to paint the full-length portrait of Harriet, which reportedly was taking an inordinate amount of time to complete. Her husband

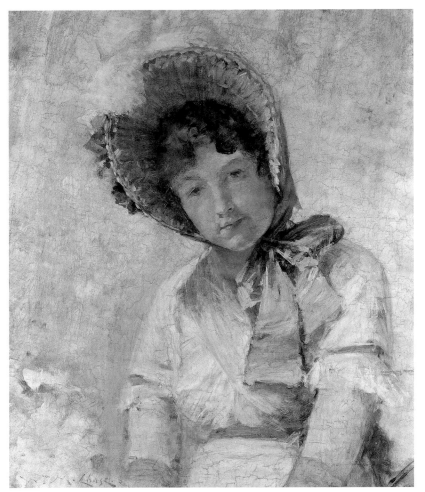

OP.68

City so she would have been able to model. The style of dress that Ayer models, popular in Paris in the 1880s, was a revival of the styles popular in the 1790s known as the "Directoire Period." The Directoire style dress is fairly flat in terms of the skirt, with minimal drapery, and the bodice is cut on the lines of a Directoire coat, flat and plain, with narrow sleeves almost tight to the arm. There are two very broad lapels, one crossing over the other on the upper portion of the dress with a wide folded sash around the waist. It is notable that several years after this portrait was completed Ayer divorced her husband and went to work. First she opened an "artistic furnishings and shopping business" (Margaret Ayer and Isabella Taves, *The Three Lives of Harriet Hubbard Ayer* [Philadelphia: J. B. Lippincott, 1957], 158). However, she soon moved on to her next endeavor and became a well-known businesswoman owning her own cosmetic company. Thomas William Herringshaw's *Encyclopedia of American Biography of the Nineteenth Century* of 1898 states: "The Recamier Company, of which [Mrs. Ayer] is the president and chief owner, now occupies a five-story building in New York city, and employs nearly a hundred people." The painting is included on Peat's 1949 checklist of Chase's known work in two entries, *Lady in a Directoire Dress,* owner unknown, and *Harriet Hubbard Ayer,* owned by the California Palace of the Legion of Honor, San Francisco. The reproduction of this work in the present catalogue shows the portrait in its current state. The painting is undergoing conservation to restore original details.

Herbert became suspicious and jealous (or so it was said) and when the work was finally finished and sent to him to preview, he insultingly told Chase that at least he got the feet right. Chase, outraged, is said to have cut off the bottom part of the painting (of her feet on a pillow) and sent it to her husband with his "compliments." This upper portion of the original portrait, now in the collection of the California Palace of the Legion of Honor, San Francisco, is the work under consideration. The middle portion remains unlocated, and the lower section depicting the blue slippers on a pillow was at some point given to Marianna G. Van Rensselaer, and was likely the item listed in her estate evaluation as "Fragment of a Picture," inscribed "to Mrs. M.G. Van . . . ? / souvenir / Wm. M. Chase," and now in a private collection.

The original full-length portrait was signed in the upper left-hand corner "Wm. M. Chase / 1880 / New York." When it was later cut down, removing the signature, Chase signed the now bust-length work "Wm. M. Chase" at the lower left.

The figure's costume appears to be the same as that which Ayer wears in Chase's painting *In the Studio.* Ayer frequently visited New York

OP.68A. Wood engraving by Frederick Juengling of the original full-length painting

OP.69

Susan Hopkins Smith, 1880

Oil on canvas; 45 x 34½ in. (114.3 x 87.6 cm)
Signed: Wm. M. Chase (u.r.)
Inscribed under signature: New York 1880 (u.r.)

Maine Historical Society, Portland

Susan Hopkins Smith (1810–1889) was born in Portland, Maine, and married Ezra St. John Smith (b. 1799), a director of the Casco Bank and first president of First National Bank, in 1845. Chase completed the portrait of Smith in 1880 in New York, while in Paris, in the same year, society portraitist John Singer Sargent painted a portrait of Smith's son, Henry St. John Smith (1852–1896).

OP.69

OP.70

OP.70

The Tamborine (Gypsy Girl), ca. 1880

Oil on canvas; 20½ x 15½ in. (52.1 x 39.4 cm)
Signed: W M Chase (u.r.)

Location unknown

Exhibitions: **BAA '80 #119** as *The Tamborine,* listed
for sale.

This is possibly the work *The Tamborine* exhib-
ited at the Brooklyn Art Association, which
would date the work to circa 1880. The yellow
backdrop used here appears in several Chase
paintings in the first half of the 1880s, including
his *Girl with Doll,* 1880 (OP.67); the present
work may date slightly later, to 1881, or follow-
ing the artist's return from Spain. Unfortunately,
the signature, so often helpful in dating a given
work, is too faint to be of use in the present case.

OP.71

Joseph Hodges Choate, ca. 1880

Oil on canvas; 30 x 25⅛ in. (76.20 x 63.82 cm)

Century Association, New York. Presented by the
Grandchildren of J. H. Choate, 1959

Based on the presumed age of the sitter, this
painting is one of the early New York portraits
by Chase after he returned from his studies
abroad at the Royal Munich Academy in 1878.
Joseph Hodges Choate (1832–1917) was a
Harvard-trained lawyer living in New York. He
was at one time president of the Century Club
(1912), and in 1899 he became ambassador to
Great Britain, and in this capacity he was very
involved with the Peace Convention at The
Hague following World War I.

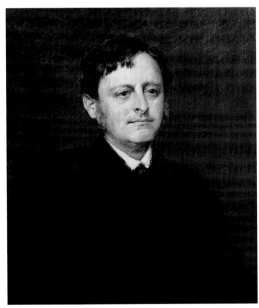

OP.71

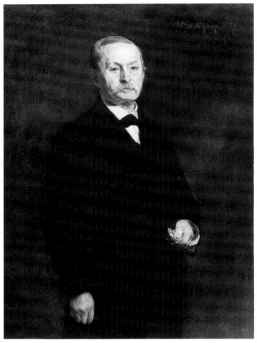

OP.72

OP.72

Portrait of William Whiteright, 1880

Oil on canvas; 48 x 34½ in. (121.9 x 87.6 cm)
Signed and dated: Wm. M. Chase 1880 (u.r.)

Location unknown

Although the date inscribed on this work by
Chase has been read as 1886, based on a photo-
graph submitted to Mr. Pisano, it is possible to
read the date as 1880. The signature style is
definitely prior to 1885, after which the lettering
assumed the distinctive horizontal slant so widely
associated with the artist's signature.

OP.73

General James Watson Webb, 1880

Oil on canvas; 36 x 31 in. (91.4 x 78.7 cm) (not
original size)
Signed and dated: Wm. M. Chase 1880 (u.l.) (lost
when painting was cut down)

Shelburne Museum, Vt. (27.1.1-1147)

Exhibitions: **SAA '80 #87; NAC '10 #80** [lent by
Major Creighton Webb].

General James Watson Webb (1802-1884) was a
journalist and diplomat, at one time serving as
minister to Brazil. He was the son of General
Samuel Blachley Webb. General Webb was the
grandfather of James Watson Webb, founder of

the Shelburne Museum. This is one of the earliest
portraits by Chase. It is recorded as being un-
signed; however, records also indicate that at
some point the painting had been cut down,
most likely losing that section of the canvas that
included the signature. A photograph of the
work, which descended through the Chase fam-
ily, shows the work to be signed and dated in the
upper left corner. The portrait as painted by
Chase was reproduced in *Harper's Weekly* (April
1880): 245. The work was discussed by Marianna
G. Van Rensselaer in her article "William Merritt
Chase," *American Art Review* 2 (January 1881): 97,
"*General Webb,* a fine and sympathetic rendering
of a finely picturesque and interesting subject.
For pose and vitality and powerful brush-work it
has not its superior—scarcely, in truth, its equal—
in our contemporary work. Again I must speak
of the hands as specimens of how far *virtuosité* of
the brush may be carried." She concluded in the
next month's issue (February 1881) on 138–39:
"Almost more than any other picture the artist
has painted, it strikes us as being unlike the work
of other men." The work is also mentioned by
E. Knaufft in "An American Painter—William
M. Chase," *International Studio* 12 (January 1901):
156. The work is included in Peat's 1949 check-
list as being in the collection of James Watson
Webb, New York.

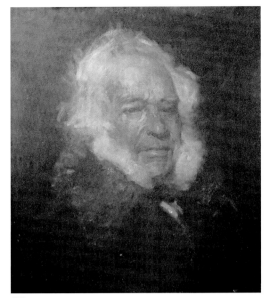

OP.74

OP.74

Portrait of Watson Webb, ca. 1880

Presumably oil; dimensions unknown

Location unknown

A photograph of this work, identified as *Portrait
of Watson Webb,* descended through the Chase

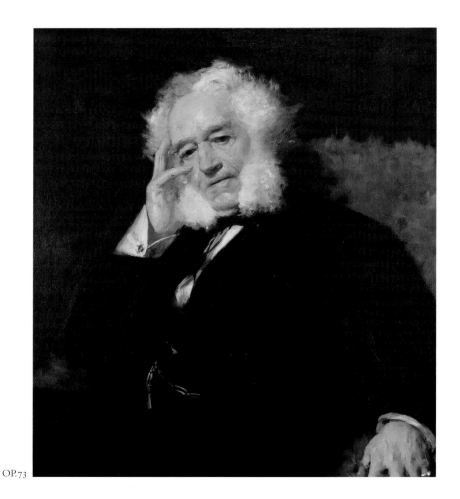

OP.73

family. It is obviously a portrait of General James Watson Webb, and was likely painted at the same time as Chase completed his half-length portrait of the general seated in a chair (OP.73).

OP.75

Tony, ca. 1880

Oil on canvas mounted on board; 15¼ x 11¼ in. (38.7 x 28.6 cm)

Location unknown

This work is in Peat's 1949 checklist of Chase's known work as being owned by Leslie Waggener, Dallas.

OP.76

Young Boy Wearing Cap and White Collar, ca. 1880

Oil on panel; 23 x 16¼ in. (58.4 x 41.3 cm)
Signed: Wm. M. Chase (u.r.)

Location unknown

OP.77

Head of a Man with a Ruff, ca. 1880

Oil on linen; 12 x 9 in. (30.5 x 22.9 cm)
Signed: Chase (c.r.—incised)

Location unknown

OP.78

Untitled (Man Wearing Long Beard), ca. 1880

Oil on canvas; 16 x 13 in. (40.6 x 33 cm)
Signed: Wm. M. Chase (c.l.)

Location unknown

In a letter discussing this work, Ronald Pisano noted, "The coloration, subject and brushwork suggest that it is an early work probably painted in the early 1880s shortly after Chase returned from his studies in Munich. It is more of a char-acter study than a portrait." The signature style is inconsistent with the date of the work—either it was signed later, or added later by a different hand.

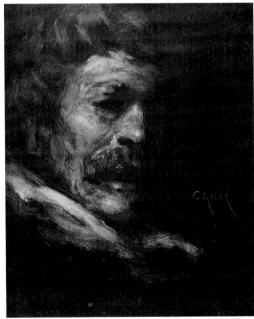

OP.75

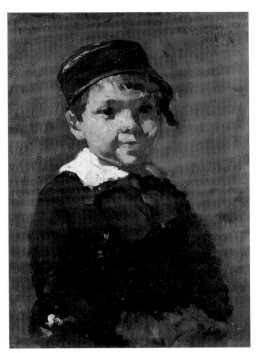

OP.76

OP.77

OP.78

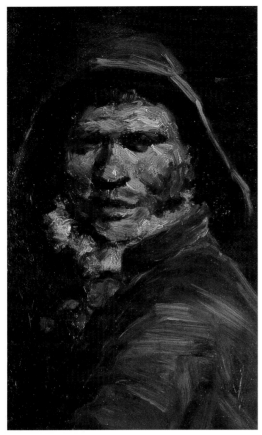

OP.79

the second contingent, but before reaching land were confronted with an enormous wave that set them reeling into the sea." To help commemorate this colorful excursion in the *Century Magazine,* the portrait Chase made of the captain was engraved for the article, appearing on page 484.

OP.80

Thomas Alexander Scott

Oil on canvas; 64 x 40 in. (162.6 x 101.6 cm)
Signed: Wm. M. Chase (l.l.)

Mercersburg Academy, Pa.

The painting was presented to the Mercersburg Academy, Pennsylvania, by the sitter's daughter, Mrs. Joseph E. Thropp, in 1907. Thomas Alexander Scott (1823–1881) worked for the Pennsylvania Railroad, serving as president of the line from

1874 to 1880. He was also president of the Union Pacific (1871–72) and the Texas Pacific Railroad (1872–80). During the Civil War he was assistant secretary of war, in charge of all government railroads and transportation lines. The painting is included in Peat's 1949 list of known work as being owned by the Mercersburg Academy.

OP.81

Leonard Scott, 1880

Oil on canvas; 30 x 25 in. (76.2 x 63.5 cm)
Signed and dated: Wm. Merritt Chase / 1880 (u.r.)

Pasadena Museum of History, Calif. Fenyes Mansion Collection

The sitter was a publisher with the firm Scott-Foreman.

OP.79

The Captain, 1880

Oil on canvas laid down on Masonite; 9⅞ x 5⅞ in. (25.1 x 14.9 cm)

Collection of Dr. and Mrs. James C. Naylor

In June 1880 the Tile Club, of which Chase was a member, embarked on a summer trip to visit the wreck of the ship *The Two Sisters,* beached on Sands Point, Long Island. They reached the area by a boat named *P. T. Casket,* owned by T. J. Coffin, Esq.—likely silly names given to enliven the article that described the excursion: "The Tile Club Ashore," *Century Magazine* 33, no. 4 (February 1882): 481-98. The article details various aspects of the adventure, which is also recounted in the definitive history of the club written by Ronald G. Pisano, *The Tile Club and the Aesthetic Movement in America* (New York: Harry N. Abrams, 1999), 45: "The journey did not begin well; it was an unbearably hot day as O'Donovan guided the captain of the ship to the selected site. Since there was no dock, the travelers were forced to board small boats to reach the shore. O'Donovan, Dielman, and Knauth made the first trip to shore without incident. Chase, Laffan, and Shinn made up

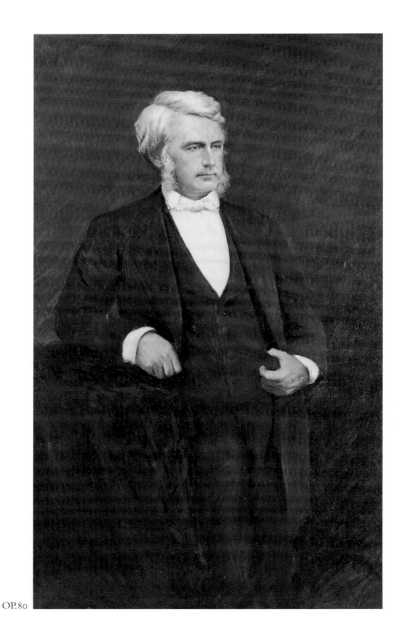

OP.80

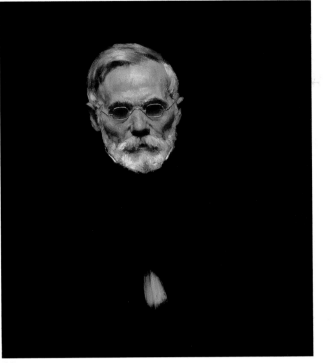

OP.81

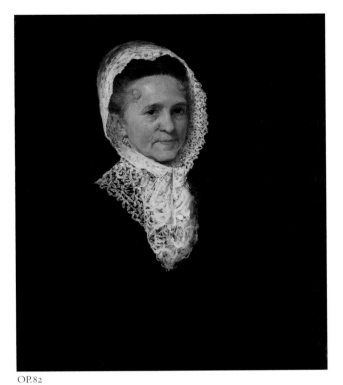

OP.82

OP.82

Mrs. Scott—Wife of Leonard Scott,
ca. 1880

Oil on canvas; 30 x 25 in. (76.2 x 63.5 cm)

Pasadena Museum of History, Calif. Fenyes Mansion Collection

This painting depicts Rebecca Briggs Scott, wife of Mr. Leonard Scott (1810–1895). Chase also completed a portrait of Mr. Scott, 1880 (OP.81). It is likely that Chase would have completed the portrait of his wife around the same time.

OP.83

Portrait, ca. 1880

Medium/support/dimensions unknown

Location unknown

Exhibitions: **SAA '80 #66** ("Varnishing Day Scenes," *New York Times,* March 16, 1880, A5).

No image of this painting currently exists. When in 1880 it was exhibited at the Society of American Artists, a *New York Tribune* critic described it as a "three-quarter-length of a lady—she is clad in a dress and bonnet of maroon color and is with successful audacity placed against a background of lighter red. She stands sideways to the spectator with hands clasped, and holding her gloves, while she looks in a most natural way over her shoulder . . . face exquisitely painted" ("Fine Art," *New York Daily Tribune,* March 5, 1880, p. 5). Because of its general title, it is impossible to confirm if it was exhibited elsewhere during the artist's lifetime or if it is included on Peat's 1949 checklist of the artist's known works (see OP.116).

OP.84

Portrait (Head of a Girl), ca. 1880

Oil on canvas; 8 x 6½ in. (20.3 x 16.5 cm)
Signed: Chase (l.r)
Verso: P. J. Aldrich's Artist's Materials cor. 12st, . . . Ave, NY

Location unknown

This portrait has a few atypical traits, among them the fact that most of Chase's paintings done on such a small scale were done on panels and that most of his portrait commissions usually had more open space. However, it also has several characteristic qualities that help to confirm its authenticity, including the use of a mahogany brown background with a dull dark green accent (which was typical for Chase in the early 1880s), the way in which the bangs of the girl's hair are brushed into the wet paint of the forehead, the heavy buildup of paint to create form in the features of the face, the casting of the face in bright

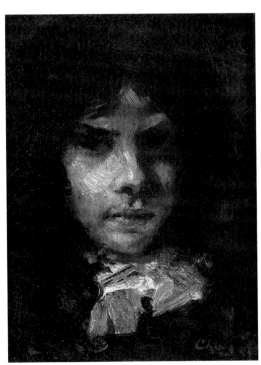

OP.84

light on one side and shadow on the other, and the freely painted collar or bow under the model's chin to enliven the composition. The style of the work and the signature-type used suggest a date between 1875 and 1883; a date circa 1880 seems appropriate since the portrait does not much resemble work from the Munich period (1872–78), yet it appears Chase was still using bitumen, which he abandoned about 1881–82.

OP.85

Portrait of Virginia Gerson, ca. 1880

Oil on canvas; 20¼ x 16½ in. (51.4 x 41.9 cm)
Signed: W. M. Chase (u.l.)

Location unknown

This painting depicts Virginia Gerson (1864–
1951), the sister of Chase's bride, Alice Gerson.
Chase met Alice and her two sisters, Virginia and
Minnie, in about 1880. The sisters were familiar
with Chase's painting *Ready for the Ride* (OP.47)
and were anxious to meet him. They were intro-
duced to Chase by one of their father's friends.
Their father, Julius Gerson, had been active in
the dry goods business but in recent years had
become a manager of the art department of the
prominent lithographic firm Louis Prang and
Company. He also was actively involved with
several of the city's social clubs, including both
the Palette Club and the Kit Kat Club, through
which he met people from a wide variety of
backgrounds, including a number of artists. The
Gerson home during the 1870s and early 1880s
became something of a salon where artists and
writers would congregate, and, after his intro-
duction to the Gerson family, Chase would
often attend. The Gerson sisters would also visit
Chase in his studio and occasionally posed for
the artist, as Virginia must have for this portrait.
This work is included on Peat's 1949 checklist as
Virginia Gerson (A), and as being owned by John
G. Rauch, Indianapolis.

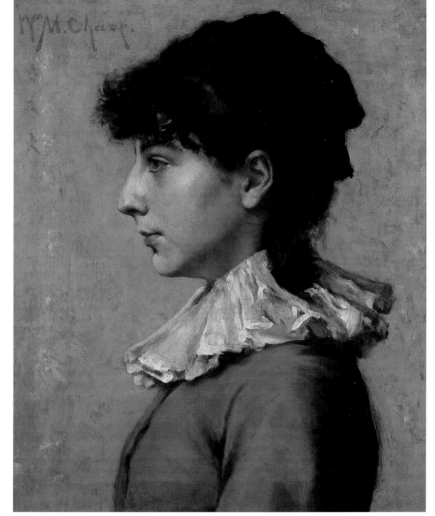

OP.85

OP.86

Portrait of a Youth, ca. 1880

Oil on canvas; 17 x 14 in. (43.2 x 35.6 cm)

Location unknown

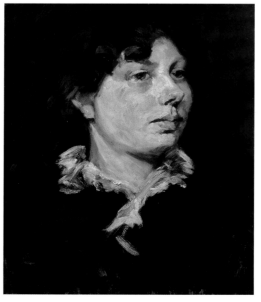

OP.86

This is a bust-length portrait of a girl dressed
in a shirt with a ruff collar. It is comparable to
Chase's *Boy in Fur Cap* (OP.17) and *Head of a
Boy* (OP.56). In all of these paintings Chase built
up his paint to create three-dimensional form,
with bold, sure, and simple strokes of the brush,
particularly in the area of the nose, ears, and lips.
Likewise, in all three paintings Chase offsets the
head of his model using less detailed and more
freely applied paint to suggest their clothing. The
two other works mentioned were completed
during Chase's study abroad in Munich in the
years 1872–78. This painting was probably exe-
cuted sometime after Chase's return to New
York. Its mahogany colored background is similar
to other works of the late 1870s and early 1880s.

OP.87

Portrait of a Lady, ca. 1881

Oil on canvas; 39 x 29¼ in. (99.1 x 77.3 cm)

Location unknown

The Chase family archives include a photo of a
framed *Portrait of a Lady*. The current location of
this work is unknown and, in addition to this
photo, the only other known record of the work
is its appearance in a photo of Chase's show-
place, the Tenth Street Studio, taken by George
Collins Cox (1851–1902) (OP.87A). Cox, who
had worked for the Metropolitan Museum of
Art as a photographer in the 1870s and also ran a
commercial practice in New Jersey, took several
photographs of the interior of Chase's Tenth
Street Studio during the years 1879–83. This
particular photo of Chase's Inner Studio was
used by Chapellier Galleries, Inc., New York, for
the back cover of their 1969 catalogue for the
Chase exhibition held there. Within this photo

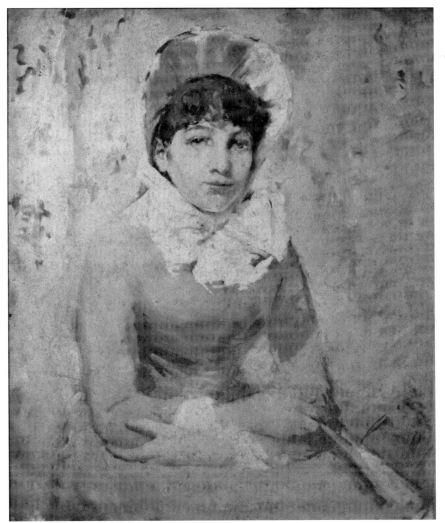

OP.87

one notes another Chase portrait of a woman, actress Linda Dietz Carlton (OP.62). Carlton's portrait is almost completely obscured behind the paintbrushes. In contrast, right next to Chase's picture of Carlton, sitting on the easel is the elaborately framed painting of a woman. Its prime placement makes it one of the focal points in the photo. Although the identity of the sitter cannot be confirmed, one possibility is that the work depicts actress Annie Russell (1864–1936). Russell was born in Liverpool. Russell's family went to Montreal when she was five, taking her from a Dublin convent, and putting her on the stage in 1872. She made her New York debut in 1879. A photograph of Russell (OP.87B) captures her in the play *Esmeralda,* a role which won for her considerable critical acclaim and success in New York in 1881. It would make sense that Chase would choose to depict the popular actress at this time. In addition, Chase's sister-in-law Virginia Gerson was friendly with Russell. Russell had inspired Gerson to start doing children's illustrations in about 1880 by sending her a copy of Kate Greenway's *Under the Window.* (The author wishes to thank Bruce Weber for providing this information.) Years later, Gerson designed costumes for Russell.

OP.87A. Photograph by George Collins Cox of Chase's Tenth Street Studio, New York

OP.87B. Photograph of Annie Russell

OP.88A. Carte de visite of Peter Cooper, ca. 1880

is still writ large in the cultural life of the country through the Cooper-Hewitt National Design Museum, part of the Smithsonian Institution. This portrait, owner unknown, is included on Peat's 1949 checklist of Chase's known work.

OP.89

The Critic, 1881

Oil on canvas; 18¼ x 11¾ in. (46.4 x 29.9 cm)
Estate seal

Location unknown

Auctions: **Csale '17 #175** (A sketch made at sea, at the time Mr. Chase and other artists were engaged in the work of decorating the interior of the steamship Belgenland, during the course of her voyage to Europe. The sketch shows a man in a white jumper with black trousers and black, soft hat, which is tilted back, standing with hand in pocket and pipe held before his chin, looking critically to the right, being seen in profile).

OP.90

Rutherford B. Hayes, 1882

Oil on canvas; 90 x 60 in. (228.6 x 152.4 cm)
Signed and dated: Wm. M. Chase 1882 (l.l.)

Harvard University Law School, Cambridge, Mass.

This portrait of the nineteenth president of the United States (1877–81), Rutherford B. Hayes (1822–1893), was given to Harvard College in 1883, by subscription. It was one of the first important portrait commissions for Chase.

OP.88

Portrait of Peter Cooper, ca. 1881

Physical properties unknown

Location unknown

Exhibitions: **PS '82 #554.**

It was Chase's acclaimed portrait of General James Watson Webb (1880) that led to other commissions, including that of Peter Cooper (1791–1883) as well as a portrait of former president Rutherford B. Hayes (1882). No doubt it was through portrait commissions such as these that Chase hoped to firmly establish his reputation as an artist of note. Chase was in Paris

during the summer of 1882, and with several artist friends, including Robert Blum, went to see his portrait of Peter Cooper at the Paris Salon. Obviously Chase thought highly enough of the work to have submitted it for exhibition at the Paris Salon. After several days in Paris, Chase, Robert Blum, and Frederick Vinton departed for Madrid. Peter Cooper was a New York businessman, inventor, philanthropist, and 1876 presidential candidate on the Greenback ticket. He is well known as the inventor and builder of the prototype locomotive "Tom Thumb," and he was the first American to patent the manufacture of gelatin, the basis for what eventually became Jell-O. He donated the money to establish the Cooper Union Institute, a free education program in New York City. His name

OP.91

James Buchanan (A)

Oil on canvas; 60 x 48 in. (152.4 x 121.9 cm)
Presumably signed

White House Historical Associate, Washington, D.C.
White House Collection (26)

The circumstances under which Chase painted
this portrait of the fifteenth president of the
United States (1857–61), James Buchanan
(1791–1868), are not clear. Most likely it was
a commission bestowed on Chase well after
the death of the sitter. Included in Katharine
Metcalf Roof's 1917 biography of the artist as
Robert [*sic*] Buchanan, in the collection of the
White House, and on the 1949 Peat checklist.

OP.92

James Buchanan (B)

Oil on canvas; 64 x 40 in. (162.6 x 101.6 cm)
Signed: Wm. M. Chase (l.r.)

Mercersburg Academy, Pa.

This portrait of the fifteenth President of
the United States (1857–61), James Buchanan
(1791–1868), was given to The Mercersburg
Academy of Pennsylvania by Mrs. Harriet Lane
Johnson in 1901. There is no information as to
why Chase painted the portrait, or how it came
to be that two portraits of President Buchanan
were painted. Included on Wilbur Peat's 1949
checklist.

OP.93

John Haven Cheever, 1882

Oil on canvas; 26 x 22 in. (66 x 55.9 cm)
Signed: Wm. M. Chase (u.r.)
Dated: 1882 (u.r.)

Collection of Cheever Tyler, New Haven, Conn.

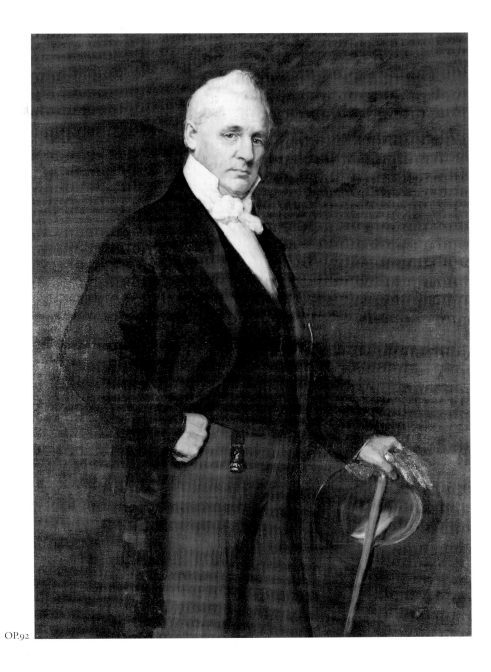

OP.92

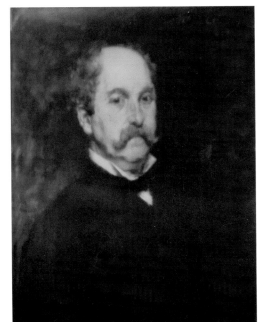

OP.93

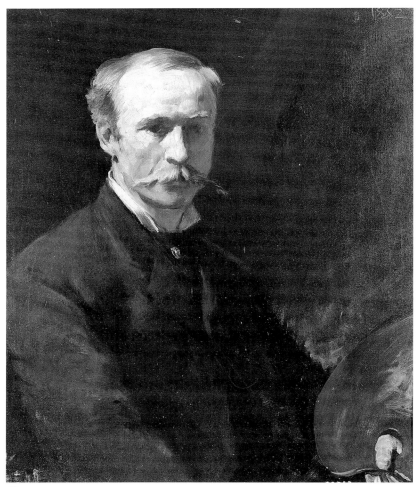

OP.94

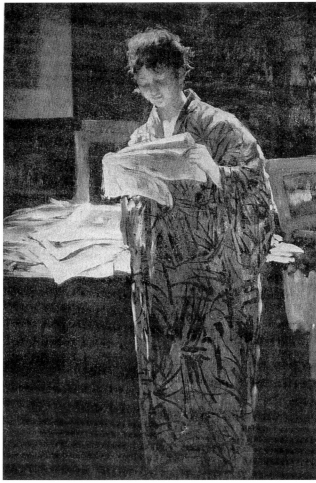

OP.95

OP.94

Frederick Dielman, 1882

Oil on canvas; 30¼ x 25 in. (76.8 x 63.5 cm)
Dated: 1882 (incised u.r.)

National Academy of Design, New York

Exhibitions: **NAC '16 #53.**

Frederick Dielman (1847-1935) was elected an
associate of the National Academy of Design in
1881, and this portrait was painted, supposedly
by both Chase and Frank Duveneck, to fulfill
membership requirements and presented to the
National Academy of Design on May 1, 1882.
What makes this so unusual is that neither
Chase nor Duveneck were members of the
National Academy of Design in 1882. One
might suspect a bit of political maneuvering on
the part of the artists, although the fact neither
signed the work is puzzling. In the early 1880s
Duveneck was living in Italy, although he visited
America in 1882, and it would have to have been
during this visit that he and Chase collaborated
on the portrait of their friend. Dielman later

served as president of the National Academy of
Design from 1889 until 1909. The work is
included in Peat's 1949 checklist; however, it is
not recorded as a collaboration with Duveneck.

OP.95

Girl Reading (Ella Wheeler Wilcox: Morning After the Ball), ca. 1882

Oil on canvas; 36 x 24 in. (91.4 x 61 cm)

Location unknown

Exhibitions: **SAA '82 #20** as *Girl Reading* ("Society
of American Artists," [New York] *Herald,* April 8,
1882, 5, col. 5); **PS '83 #507** as *Jeune fille lisant;*
MCP '83 #346 as *Mädchen, lesend / Girl Reading*
("The Munich Exhibition," *Art Amateur* 9, no. 5
[October 1883]: 92); **SLCAM '15 #14,** as *Ella
Wheeler Wilcox, Morning After the Ball* [ill.; lent by Mr.
David Sommers].

The sitter for this painting was Ella Wheeler
Wilcox (1850-1919) of Milwaukee, Wisconsin.
Her initial notoriety came with the rejection of

OP.95A. Photograph of Ella Wheeler Wilcox

her *Poems of Passion* by Jansen and McClurg publishers of Chicago on the ground that the volume was immoral. The story appeared in the Milwaukee newspapers, was widely reprinted, and served to insure the book a wide sale when it was published in 1883 by another company. On May 1, 1884, she was married to Robert Marius Wilcox (d. 1916), a manufacturer of works of art in silver, and went to live in Meriden, Connecticut. A son, born on May 27, 1887, lived only a few hours. Thereafter the Wilcoxes spent their winters in New York, entertaining many writers and artists. In examining the photo of Wilcox taken circa 1883 (OP.95A) and published in her *Poems of Passion,* it appears that Chase's depiction would date from around the same time. This work later became known as *Ella Wheeler Wilcox: Morning After the Ball.* However, it appears to have been titled *Girl Reading* when Chase completed it, as is suggested by a [New York] *Herald* review of the Society of American Artists exhibition. The author refers to a "young *Girl Reading* a paper as she stands in a blue Japanese robe by a table littered with other journals. The light falls from above and behind with nice effect, and the face is bent in shadow. Magazines and papers [are] suggestive of the literary tendency of the sitter" ([New York] *Herald,* April 8, 1882). A painting titled *Girl Reading* was also exhibited in Munich in 1883, and a reviewer described it as a "Japanese Lady," which implies a woman wearing a kimono and further supports the idea that this is the Chase painting of that name (*Art Amateur,* October 1883, 92). Chase sent *Girl Reading* to represent him at the Paris Salon in 1883, where it was positively received. One critic wrote, "Mr. William Merritt Chase is a painter pure and simple, and as such capable of holding his own in any competition. His portrait of Miss Wheeler was properly hung high up to give [pride of] place to his *Girl Reading.* . . . Its complexity of light and shade, the varied aspect of its different surfaces at different distances, its graduation of general and local color, and above all the happy way in which these elements blended into an effective whole at the proper distance . . . all this constituted a canvas perfectly capable of holding its own in the most difficult competition in the world" ("American Pictures at the Salon," *Magazine of Art* 6 [1883]: 494–95).

The painting appeared under other titles as well. It was illustrated in 1909 in the [New York] *Herald* on April 4 as *The Morning Paper.* In 1910 the work was illustrated as *Japanese Gown— Reading* in Gustav Kobbe, "The Artist of Many Studios," [New York] *Herald,* November 20, 1910. Included on Peat's 1949 checklist of Chase's known work as *Girl Reading,* owner unknown.

OP.96

Five Minute Portrait of Lucy Bennett (A Five Minute Sketch), ca. 1882

Oil on canvas; 9 x 6 in. (22.9 x 15.2 cm)
Signature: Chase (m.r.)

Collection of Mr. C. Thomas May, Dallas

A letter pertinent to this work reads, "This portrait was given to the mother of the present owner by Chase, as she was on her way to San Francisco by train for the Bankers ???? [*sic*] Convention in 1914. Included in the party were General Isimo Diaz, Lewis Clark, President American Exchange and National Bank and Wm. Merritt Chase and Lucy Bennett. On being introduced to Chase, Lucy Bennett remarked, 'you don't look like a painter.' Chase replied, 'sit down' and he proceeded to paint this very artistic portrait of her. On completion she asked Chase, 'What will I call it?' He replied 'A Five Minute Sketch.'" The sole element of the work incongruent with the details in the above story is Chase's signature, the style of which recalls that of many of his early works, circa 1880. He would not have signed a later work with an early-style signature. It is possible that Chase did indeed meet Lucy Bennett on the train to California to teach summer school in 1914. In addition, Bennett's story also makes sense in terms of the presence of Lewis [Latham] Clark (b. 1871), who had become president of the American Exchange National Bank in 1910 and would thus have likely attended the Bankers Convention in 1914. Chase may have completed a "five-minute sketch" of Bennett on the train, or perhaps Bennett purchased an earlier work by Chase upon her return to New York—in which case, this would be that painting. The style of the model's outfit corresponds to Chase's works of the early 1880s, lending further support to the notion that the work does not, in fact, date to 1914, but was rather executed some thirty-odd years earlier.

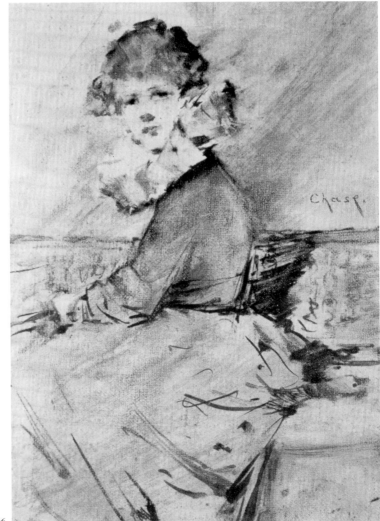

OP.96

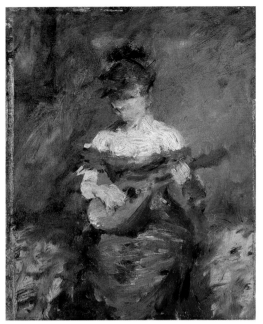

OP.97

OP.97

A Mandolin Player (A Sketch), ca. 1882

Oil on panel; 9½ x 7¼ in. (24.1 x 18.4 cm)
Verso, in pencil: #12907 / 9½ x 7¼ (u.r.); X No. 2
(l.r.)
Top Tag: Chas . . . 2097.13 / Lent by Rufus L.
Sewall / Harold . . . William (u.c.)
Bottom Tag: Museum of Fine Arts / X No. 2 (l.r.)

Location unknown

Exhibitions and Auctions: **BAC '86 #94;**
Csale '87 #87.

A Mandolin Player (A Sketch) is probably an
unfinished oil sketch painted in the early 1880s.
The catalogue for Chase's one-man exhibition
at the Boston Art Club listed several paintings as
being sketches and others as unfinished works.
Chase was always a "painter's painter," and took
pride in demonstrating his technique, as well as
the finished product. He succeeded in doing so
in this exhibition, which was greatly admired by
artists, but at the expense of being criticized by
Boston critics, who chastised Chase for his auda-
ciousness in showing unfinished paintings. It is
likely that this is the painting in this show titled
A Mandolyn [sic] Player—a sketch (no. 94). The
small painting is visible in the center of a photo
of the inner studio of Chase's Tenth Street Stu-
dio taken by George Collins Cox (1851–1903)
between the years 1879 and 1883 (Archives of
American Art, Washington, D.C.). Cox had been
a photographer for the Metropolitan Museum of
Art in the late 1870s, while running a commercial
practice in Orange, New Jersey. After building
up his business, Cox opened a studio in Man-
hattan and became known for his photographs,
particularly of those in artistic and literary circles.

OP.98

Portrait of a Woman (Portrait of the Artist's Sister-in-Law [Virginia Gerson]), ca. 1882

Oil on canvas; 21½ x 17 in. (54.6 x 43.2 cm)
Signed: Wm. M. Chase (l.c.)

Location unknown

This painting appears to be a likeness of the
artist's sister-in-law Virginia Gerson (1864–1951),
who posed for him on several occasions in the
early 1880s. Although the work conforms to
Chase's stylistic norms of the early 1880s, the
signature does not, suggesting that he added it
at a later date. Gerson is placed against a yellow
backdrop similar to the one he used in his por-
trayal of *Girl with Doll* (OP.67) and later in his
Portrait of Miss Dora Wheeler (OP.101). Included
on Peat's 1949 checklist as *Portrait of a Woman* (E),
and as being formerly owned by F. A. Lawlor,
New York.

OP.99

Street Dancer, Italy (Study of a Woman; Girl Dancing), ca. 1882

Oil on canvas; 26¼ x 15½ in. (66.7 x 39.4 cm)
Signed: Wm. M. Chase (u.r.)
Inscribed on label verso: Street Dancer / Italy / by
William Merritt Chase. Back bears Museum of Fine
Arts, Boston, label: 2 (or 7) 76.13

Emerson Gallery at Hamilton College, N.Y.

What appears to be the painting under consid-
eration is included (on the wall) in a view of
Chase's Tenth Street Studio painted by his student
Henry Grinnell Thomson in about 1882. If in-
deed this is the painting included in Thomson's
studio view, then considerable alterations were
made to it by the time it reached the Museum
of Fine Arts, Boston, in 1906. Unlike the simple,
unified oil sketch (likely left unfinished by Chase,
even though it is framed) included hanging on
the wall in Thomson's view of Chase's studio, the
painting today, for example, has a floor molding
separating the wall from the floor. Also, there is a
black receptacle added to the foreground. In addi-
tion, the signature appears to have been altered.
Perhaps the painting was an informal, on-the-
spot study by Chase, later worked up into the
more simplified and refined composition that
is the version seen on the wall in Thomson's

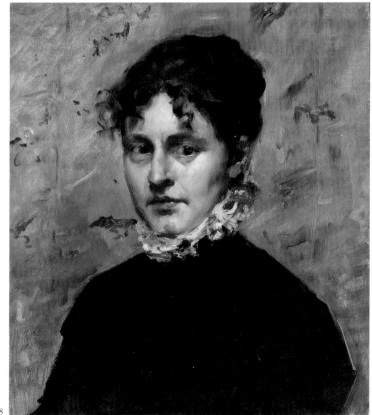

OP.98

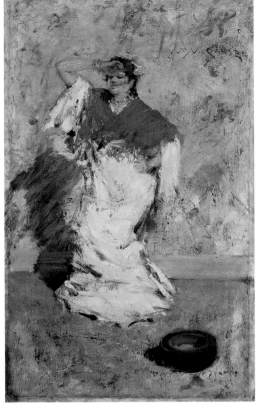

OP.99

painting and is presently unlocated. Conversely, the painting may be the one seen in Thomson's studio, but with changes made to it between 1882 and 1906 when it was deposited at the Museum of Fine Arts, Boston. Although the title of this work, *Street Dancer, Italy,* is inscribed on a label on the back of the work, the label was probably from an owner after the artist's death. In 1882 Chase was traveling in Spain, not Italy, so it might be a Spanish dancer, rather than an Italian one.

OP.100

Lady in Pink (The Artist's Wife), ca. 1883

Oil on canvas; 69½ x 39½ in. (176.5 x 100.3 cm)
Signed: Wm. M. Chase (l.r.)

Santa Barbara Museum of Art, Calif. Bequest of Margaret Mallory (1998.50.24)

Exhibitions: **BFAA '91** (no catalogue).

This painting depicts Chase's favorite model, his wife, Alice Gerson (1866–1927). Besides being an exquisitely feminine depiction of Alice dressed all in pink, the work also seems to be a formal study in color as reflected in the title *Lady in Pink.* Alice wears a pale pink dress and is standing against a pale pink background. Alice appears dressed in the

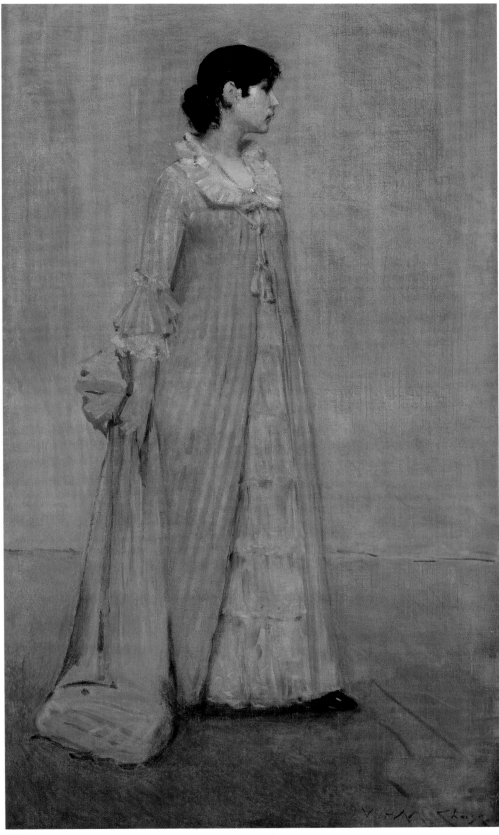

OP.100

same outfit in the painting *The Connoisseur—The Studio Corner* (volume 4), and this has helped to assign a date for *Lady in Pink* of circa 1883. The dress may have been designed by Alice, for both she and her sister Virginia would sometimes

model for Chase wearing their own creations, or Chase would provide them with costumes.

The size and subject matter of this work suggest that Chase intended it to be an exhibition piece, but interestingly there is just one reference

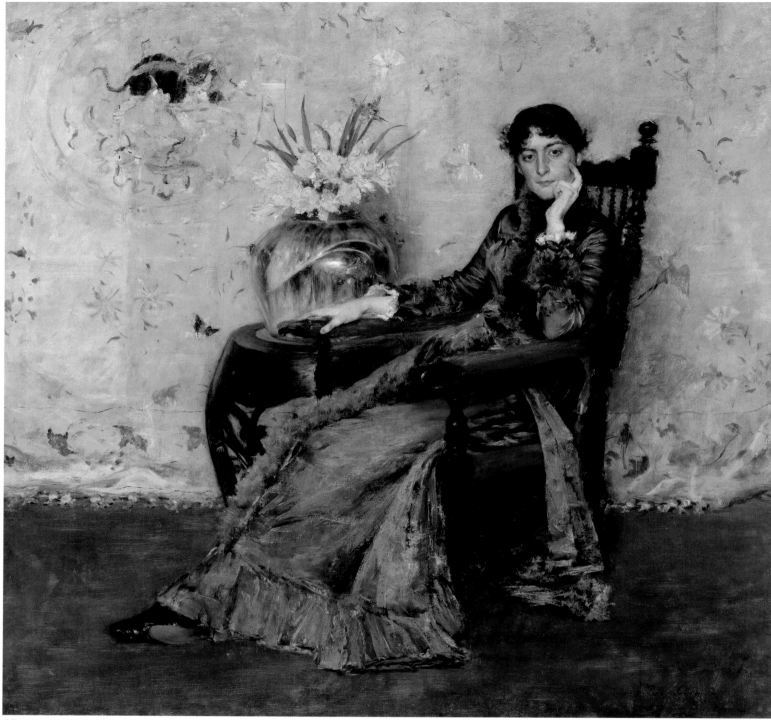

OP.101

to the work being shown during the artist's life-time. The painting is not mentioned by name, but rather a work described as "Mrs. Chase in a morning gown with pink background" is re-ferred to as being exhibited in an uncatalogued show in Buffalo, New York, in 1891 (J. R. Drake, "The Chase Picture Collection," *Buffalo Com-mercial,* 1891, n.p. [part of the Ronald Pisano clipping file]). Chase seems to have created *Lady in Pink* primarily to be enjoyed by his family. The bottom half of the painting appears in the background of a photo of around 1888 of the Chase's dining room (Photos from the William

Merritt Chase Archives, Parrish Art Museum, Southampton, Long Island, New York, 89.Stm.74). *Lady in Pink* may have traveled with the Chase family during the summers to Shin-necock Hills, Long Island.

A photo from the Chase Archives shows it hanging on the wall behind the stairwell leading to the second floor of the Chase home (Photos from the William Merritt Chase Archives, Par-rish Art Museum, Southampton, Long Island, New York, 77.Mc.5). Included on Peat's 1949 checklist as *Artist's Wife (Mrs. W. M. Chase),* and as being owned by Margaret Mallory, New York.

OP.101

Portrait of Miss Dora Wheeler (Portrait, Miss Dora Wheeler), ca. 1883

Oil on canvas; 62½ x 65¼ in. (158.8 x 165.7 cm)
Signed: W M Chase (l.r.)

The Cleveland Museum of Art. Gift of
Mrs. Boudinot Keith in Memory of Mr. and
Mrs. J. H. Wade, November 17, 1921 (1921.1239)

Exhibitions and Auctions: **PS '83 #506** as *Portrait of Mlle. Dora Wheeler,* Honorable Mention ("The Paris

exercise. Miss Wheeler counts for next to nothing in it, not only in lack of character . . . but in point of pure pictorial relation to her surrounding" (W. C. Brownell, "American Pictures at the Paris Salon," *Magazine of Art* 6 [1883]: 494, as *Portrait*). In contrast, a German critic, Pecht, who praised the work, complemented Chase's ability to express the sitter's personality, "as genuine an American as ever was, handsome moreover, and interesting also, though apparently gifted with more cleverness than feeling. The way in which she fixes her piercing look on you, without herself betraying anything, puts you in the mind of a sphinx" (Fr. Pecht, "A German Critic on American Art," *Art Amateur* [September 1884]: 78). Included on Peat's checklist as *Miss Dora Wheeler,* and as being owned by the Cleveland Museum of Art, Ohio.

Salon," *Art Amateur* [June 1883]: 2); **MCP '83 #347** as *Port. der Miss Dora Wheeler,* awarded Gold Medal ("The Munich Exhibition," *Art Amateur* 9, no. 5 [October 1883]: 92); **CCNY '84; SAA '84 #24** as *Portrait, Miss Dora Wheeler* ("Society of Artists," *New York Times,* May 25, 1884, 9; Montezuma, "My Note Book," *Art Amateur* 2 [June 1884]: 3; *Art Interchange* [1884]: 148); **BAC '86 #10** as *Portrait of Miss Dora Wheeler* ("A Boston Estimate of a New York Painter," *Art Interchange* [December 4, 1886]: 179, as *Portrait*); Csale '87 #115 [lent by Miss. Wheeler].

This painting depicts Dora Wheeler (1856–1940), who was one of the first women to study privately with Chase in his Tenth Street Studio following his return from Munich in the fall of 1878. She began her art education at the Art Students League in November 1878 and then studied with Chase in his studio in the years 1879–81. This photo, taken by Charles C. Cox, shows Wheeler as an artist holding her paintbrush and palette seated amidst several of her paintings in Chase's vast Tenth Street Studio (OP.101A). In contrast Chase captures Dora, not in his Tenth Street Studio, but rather in her art studio located in the building housing her mother Candace Wheeler's decorative firm, the Associated Artists, on 115 East 23rd Street, New York. In addition to pursuing her career as a fine artist, Dora designed embroidered textiles, and the elaborate, golden yellow, embroidered hanging behind her may have been Chase's way of pointing to her profession as a designer. In her autobiography, Candace Wheeler noted that "Chase had a passion for the beauty of textiles, and when 'The Associated Artists' came to their days of experiments in color he often dropped in to see what had been done that was new to him" (Candace Wheeler, *Yesterdays in a Busy Life* [New York: Harper and Bros., 1918]: 246).

Dora wears a fashionable blue silk dress lined with fur and black patent leather shoes. She is seated in an Elizabethan-revival chair upholstered in red plush. On the Chinese carved ebony taboret next to her is a blue ceramic vase filled with yellow narcisses, demonstrating his still-life expertise. By placing yellow flowers against a similarly colored background, Chase displays his refined color sense and skill in capturing subtle gradations of color. *Miss Dora Wheeler* was created as an "exhibition piece" advertising Chase's talents as a painter and was not a commissioned portrait. It was first exhibited at the Paris Salon of 1883 where it was awarded an honorable mention. From there it went straight to Munich where it was awarded a gold medal in the Crystal Palace Show. A critic commented on the positioning of the work in the exhibition in Munich versus Paris: "on the line is also Chase's *Portrait of Dora Wheeler* which looks much better than it did in the Salon this year where the color aspect was ruined by the hanging" (*Art Amateur,* October 1883, 92). In 1884 the painting returned to New York and appeared in the annual exhibition of the Society of American Artists. A critic for the *New York Times* commented that "the place of honor is held by Mr. Chase's portrait of Miss Dora Wheeler, a large picture showing a fine Japanese yellow curtain, chair, and a full-length portrait of a refined-looking young lady. It is Mr. Chase's most 'important' piece among the six canvases he contributes" (*New York Times,* May 25, 1884, 9). The critical reception of the work was mixed, with reviewers split as to whether or not Chase captured the sitter's personality or willfully did not, so as to better display his technical skills as a painter. W. C. Brownell, writing a review for the Paris Salon, saw the work as "an easy and frank

OP.102

Seated Gentleman, 1883

Oil on canvas; 47 x 38 in. (119.4 x 96.5 cm)
Signed and dated: Wm M. Chase 1883 (u.r.)

Location unknown

Although the sitter of this work was at one time identified as Chase's father, David Hester Chase, only one portrait of David Chase is known to have been painted by the artist (OP.224). The formal appearance of the seated gentleman, and even the large canvas size, suggest, however, that this was a very important commission for the young Chase, newly established as a formidable portraitist in New York City. In 1880 Chase painted his acclaimed portrait of General James

OP.102

Watson Webb, which led to other important commissions, including that of Peter Cooper and former president Rutherford B. Hayes. He had previously painted the portrait of President James Buchanan. His painting *Seated Gentleman* in many ways typifies the best of his male portraits: forthright, dignified, but with bravura elements such as the reflection off the spectacles hanging from the gentleman's jacket and the turned edge of his coat reflecting the silk underlining. Even the sensitive placement of the gentleman's hands reveals the humanizing touch that Chase would give to many of his commissioned portraits.

OP.103

Louis Prang, 1884

Oil on canvas; 41½ x 30 in. (105.4 x 76.2 cm)
Recorded as unsigned

Location unknown

Louis Prang (1824-1909) was a German-born lithographer and wood engraver who came to New York in 1850 and later moved to Boston. In the 1870s he introduced the Christmas card to America and began issuing color reproductions of famous paintings. *Art Interchange* (June 19, 1884): 148, notes: "Mr. Wm. M. Chase is just completing the portrait of Mr. L. Prang of Boston." The work is included on Peat's 1949 checklist as being owned by Doll and Richards, Inc., Boston.

OP.103

OP.104

Portrait of William M. Laffan, ca. 1884

Oil on canvas; 17 x 14 in. (43.2 x 35.6 cm)
Estate seal

Location unknown

Auctions: **Csale '17 #69** (Head and shoulders portrait of the successor to the Danas in the editorship and ownership of the [New York] *Sun,* painted when his hair, beard, and moustache were still brown—probably in the Tile Club days. He is facing the left, three-quarters front, looking full into a strong light, which illuminates the entire face, and he wears a dark green coat and standing collar. The background is a dull brownish-red).

William M. Laffan (1848-1909) was a friend and fellow member of the Tile Club, thus dating the work to the early 1880s. The painting, owner unknown, is included in Peat's 1949 checklist.

OP.105

Helen E. Coan, ca. 1884

Oil on canvas, lined; 20 x 16 in. (50.8 x 40.6 cm)
Signed: Wm. M. Chase (u.l.)

Richard Love and Signature Galleries, Chicago. 1975

Helen E. Coan (1859-1938) was born in Byron, New York, and grew up in Michigan. In 1883-84 she studied at the Art Students League under Chase and Frederick Freer. Then in 1884 she moved to California, where she remained. It would seem probable that this portrait of Coan would have been completed during the time she was studying with Chase in New York at the Art Students League. The signature type would support a dating of the work around 1884. Since Coan was living and working in California, it is possible that she studied with Chase again during the summer class he taught in Carmel-by-the-Sea in 1914.

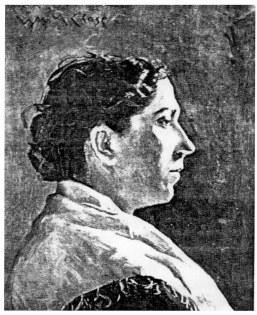

OP.105

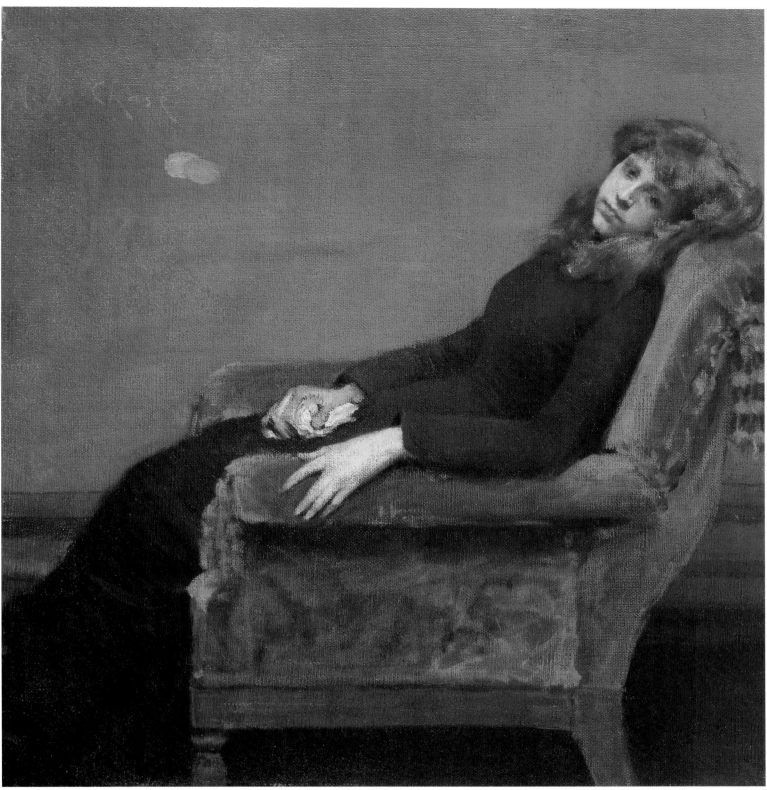

OP.106

OP.106

The Young Orphan (At Her Ease, Study of a Young Girl, An Idle Moment), ca. 1884

Oil on canvas; 44 x 42 in. (111.8 x 106.7 cm)
Signed: Wm. M. Chase (u.l.)

National Academy of Design, New York

Exhibitions and Auctions: **SAA '84 #28** as *The Young Orphan,* for sale for $800 ("Society of American Artists," *New York Times* [May 25, 1884]: 9; Montezuma, "My Note Book," *Art Amateur* 2 [June 1884]: 3; "The Society of American Artists," [New York] *Sun,* June 17, 1884, 3); **BLV '84** as *At Her Ease*; **BAC '86 #58** as *The Orphan*; **Csale '87 #35** as *The Orphan* ("The Chase Sale," *Art Amateur* 16, no. 5 [April 1887]: 100); **IIEC '89 #66** as *An Idle Moment*; **StLEx '90,**

either **#185 or #163,** both listed as *At Her Ease*; **AAG '90 #215** as *An Idle Moment*; **BFAA '91** (no catalogue); **Csale '91,** possibly lot #53, *Study of a Young Girl*; **NAD '94 #141,** priced at $350.

As noted by both Bruce Weber and Barbara Dayer Gallati, the painting is indebted stylistically and compositionally to Whistler's 1871 *Arrangement in Black and Gray, No. 1 (Portrait*

of the Artist's Mother) [Musée d'Orsay, Paris]. In both works the figure is seated parallel to the picture plane oriented to the right in a shallow space before a flat backdrop. Both figures are wearing a black dress and holding a handkerchief in one hand. But in contrast to Whistler's use of subtle colors, Chase chooses a bright red and terra-cotta. Chase's use of color is noted in an unidentified clipping regarding "The Chase Exhibition" at the Buffalo Fine Arts Academy in 1891, wherein the critic writes, "I turn from the full length of Whistler, who is not a beauty, to the young lady who is taking *dolce far niente* in the red arm chair on the opposite wall, and find a satisfaction I seldom experience in looking at a work of art, I dare say to the uninitiated in art, that is simply a picture of a beautiful girl; it is that to me but infinitely more. It is a harmony in red; yes, that's it—a consummate work by a master in every way, whether in composition, drawing, color or tone" (L. G. Sellstedt, unidentified clipping for an uncatalogued exhibition held in Buffalo in 1891, Chase Archives, New York). The intense red in the work was also noted by another critic, who described the work as a "girl in modified black, projected against so much redness" (*Art Interchange* [1884]: 149).

The work has been known by many titles: *The Young Orphan, Study of a Young Girl, An Idle Moment, Repose,* and *At Her Ease.* Another of Chase's works known as *A Comfortable Corner* also had the original title of *At Her Ease.* It is of course possible that both works had this title at some point. In the catalogue listing for the St. Louis Exposition held in 1890, catalogue numbers 163 and 185 both have the title *At Her Ease.*

Chase probably found the model for this work at the Protestant Half-Orphan Asylum, located at 67 West 10th Street, next door to the Tenth Street Studio building. This asylum specialized in caring for half-orphans, children with one surviving parent who was unable to care for the child alone. (The author wishes to thank Bruce Weber for information about the Half-Orphan Asylum.) When Chase first exhibited this painting in the spring of 1884 at the Society of American Artist's exhibition, he listed it under the title *The Young Orphan.* He then exhibited the work abroad in Belgium in June of the same year under the title *At Her Ease,* followed in 1886 in Boston as *The Orphan,* and then finally in 1887 he returned to *The Orphan.* It is interesting to note that at least one critic would appear to have been unconvinced that the girl was an orphan, writing "making believe very much, dressed in black, [she] is reclining in a red easy-chair placed in front of a red curtain" (*Art Amateur,* April 1887, 100). This was the last time Chase chose

to exhibit the work as *The Orphan.* Included on Peat's 1949 checklist as *Study of a Young Girl,* and as being owned by the National Academy of Design, New York.

OP. 107

Woman Holding a Bouquet of Flowers (Descriptive Title), ca. 1884

Oil on canvas; 20½ x 13¾ in. (52.1 x 34.9 cm)
Signed: Wm. M. Chase (u.l.)
Label on stretcher: P. J. Ulrich / Importers / Artists Materials / Cor. 12th / St. & 4th Ave / New York

Collection of Ronald Cordover, Wayne, N.J.

Exhibitions: **BAC '86, possibly #25,** as *Study of a Young Girl.*

Chase places a bouquet of vibrant flowers in the hands of his model to create a source of vital energy, a sort of igniting force, as if it were a torch providing light for his composition. In reference to Chase's treatment of flowers, one critic wrote, "His flowers suggest the very breath and essences scarcely less than the body life of flowers" ("A Boston Estimate of a New York Painter," *Art Interchange* 7 [December 4, 1886]: 179). This quotation is taken from a review of Chase's first one-man exhibition held at the Boston Art Club in November 1886. This show included 133 paintings, pastels, watercolors, and drawings and astounded both his peers and contemporary art critics. All were amazed by Chase's dexterity and his command over a broad range of subject matter. One writer declared: "The versatility of the painter, his admirable technique, his mastery over materials and his powerful color perception, were the astonishment, as well as the delight, of all who saw these pictures" ("The

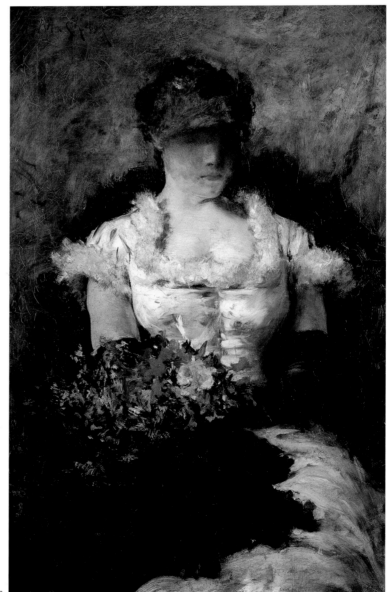

OP. 107

Chase Exhibition," *American Art Illustrator* [December 1886]: 99). Although critics praised both Chase's floral pieces and landscapes, "it is the figures and portraits," this writer maintained, "to which one naturally gives the most attention, and in them Mr. Chase's eye for artistic effects and his unerring touch are most conspicuous" ("A Boston Estimate of a New York Painter," 179). *Woman Holding a Bouquet of Flowers* may well have been included in this exhibition in Boston. Unfortunately, this painting, like many others in the show, has lost its original title and cannot be easily matched to a title listed in the exhibition catalogue. Regardless, the general praise can be aptly assigned to this work.

It is not uncommon to find paintings by Chase left in what appears an unfinished state; as early as 1886, Chase included such paintings in his exhibition at the Boston Art Club mentioned previously. Such paintings were even listed as being unfinished in the catalogue. Although the handling of the sitter's face in this work would appear to be unfinished, the fact that the artist signed the painting suggests that to his mind the work was indeed complete. Another possible reason for the treatment of the sitter's face is that at times Chase would go to great lengths to obscure the identity of his model; this was a means of stressing the purely aesthetic aspect of such works (as opposed to portrait commissions). Although some areas of the painting do not appear to be fully developed, others, such as the woman's gown, display a masterful technique (conveying various textures by means of the use of quick, sure, spontaneous brushwork.) The subject of the seated woman with a bouquet of flowers is one that Chase used in other figure studies, such as his *Young Girl with Flowers,* circa 1885 (OP. 121).

OP. 108

Portrait of James McNeill Whistler, 1885

Oil on canvas; 74⅛ x 36¼ in. (188.3 x 92.1 cm)
Inscribed, signed, and dated: To my friend Whistler / Wm. M. Chase / London 1885 (u.l.)

The Metropolitan Museum of Art, New York. Bequest of William H. Walker, 1918 (18.22.2)

Exhibitions: **BAC '86 #6; MAG '87 #111** (*Art Review* [February 1887]: 20, "a smoky vision which leaves a vivid impression of a long lank form, a Mephistophelean face surmounted by a white plumbe, and a long wand"; *Art Amateur* [April 1887]: 100, "At first sight the posture certainly does look like a caricature of Whistler's person as well as his method, but those who know the eccentric genius

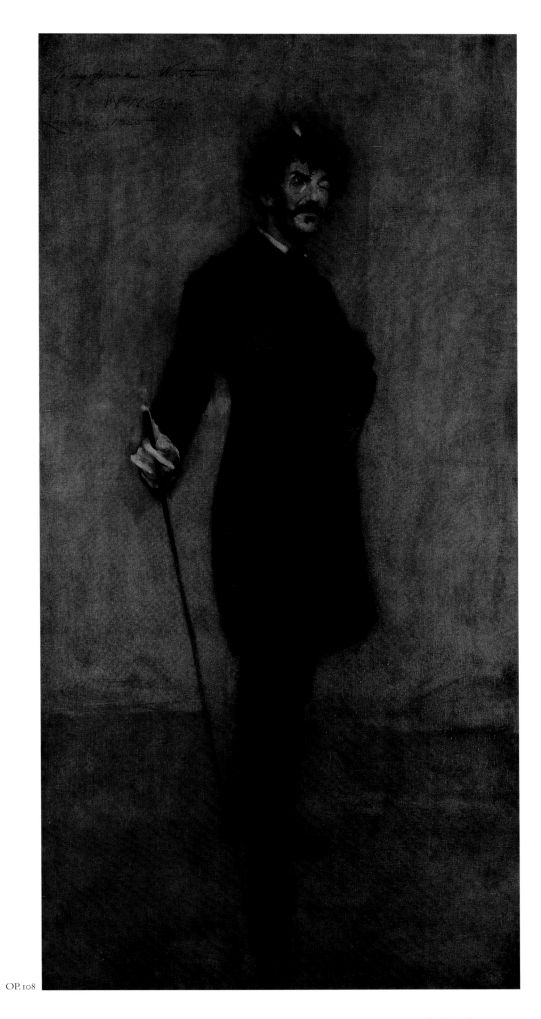

OP. 108

will recognize it to be the truth—the harsh truth—neither more or less"); **IIEC '88 #75; GWM '90 #26; GDRP '91** (Whistler recalls walking into Durand-Ruel Gallery, Paris: "and there I saw again the horrible 'lampoon' of Chase's—Shocking—I told them so," letter quoted in R. Anderson and A. Koval, *James McNeill Whistler: Beyond the Myth* [New York: Carroll and Graf, 1994]; **StLEx '92 #33; PAFA '96 #55; CM '08 #5** (illus.); **AAG '09 #24; NAC '10 #93; BPL '10** (seen in photograph of gallery installation—no known catalogue); **WAM '12 #8; PPIE '15 #3759** (illus. facing p. 26).

Chase's portrait of James McNeill Whistler (1834–1903) is an iconic tribute to a short-lived friendship. The much younger Chase visited Whistler in London in 1885 and they decided to paint each other's portraits. While Whistler's portrait of Chase has never surfaced (most likely the artist scraped it off his canvas in some sort of pique), Chase's portrait of Whistler not only survived but has become a signature work for the artist. In a letter dated September 22, 1885, Robert Blum wrote to Virginia Gerson (a close friend who would become Chase's sister-in-law): "Well I suppose you have seen Mr. Chase by this time, that is I suppose he has condescended to show himself. He must be quite unbearable since Whistler painted his portrait." Chase's portrait of Whistler was justly celebrated as capturing the elegant (some would also add arrogant) bearing of the man, and the painting was reproduced many times in various art publications: Clarence Cook, *Art and Artists of Our Time,* vol. 3 (New York: Selman Hess, 1888), 257; Spencer H. Coon, "The Work of Wm. M. Chase as Artist and Teacher," *Metropolitan Magazine* 5, no. 4 (May 1897): 312; *Academy Notes* (February 1909): 145; Katharine Metcalf Roof, "William Merritt Chase: An American Master," *Craftsman* 18 (April 1910): 40; and William M. Chase, "The Two Whistlers," *Century Magazine* 80 (June 1910): 218 (this last article written by Chase is the best rendition of the fractious relationship between the two artists, albeit from the viewpoint of Chase). Included in Peat's 1949 list of known work.

OP. 109

Albert Beck Wenzell

Oil on canvas; 20 x 16 in. (50.8 x 40.6 cm)
Inscribed and signed: To my [indistinct] / Wm. M. Chase (u.r.)

Location unknown

Albert Wenzell (1864–1917) was an artist known for his illustrations of fashionable society.

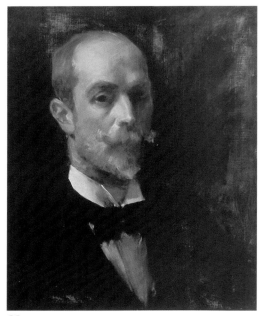

OP. 109

OP. 110

Mrs. J. C. Easton, 1885

Oil on canvas; 45¾ x 35½ in. (116.2 x 90.2 cm)
Inscribed verso: W.M. Chase
Noted and dated: New York 1885

West Virginia University, Morgantown

Chase was commissioned to paint portraits of both Sarah Johnson Easton (b. 1846) and her husband, Mr. Jason Clarke Easton. The paintings were probably hung in the Easton family home and were likely never exhibited during Chase's lifetime. Mrs. Easton stands dressed in a dark fur with white ruffles on her dress's cuffs and around the neck, a hint of landscape behind her. Included in Peat's 1949 checklist of Chase's known work as *Mrs. J. C. Easton,* and as being formerly owned by Mrs. F. L. Easton, La Crosse, Wisconsin.

OP. 111

Portrait of Jason Clarke Easton, 1885

Oil on canvas; 45¾ x 35¼ in. (116.2 x 89.5 cm)
Inscribed and dated (verso): New York 1885

West Virginia University, Morgantown

There is a companion portrait of Mrs. Easton, also dated 1885. It is curious, however, that neither work is said to have been signed, a fact very unusual for Chase. J. C. Easton owned the Southern Minnesota Railroad and several banks in Minnesota and Wisconsin. The town of Easton, Minnesota, was named after him. The painting, along with the pendant portrait of Mrs. Easton, sold at the AAA Anderson Galleries on May 18, 1933, property of Mrs. L. F. Easton (perhaps, given the date, a daughter-in-law). Included on Peat's 1949 list of known work, noting Mrs. L. F. Easton, New York, as the owner.

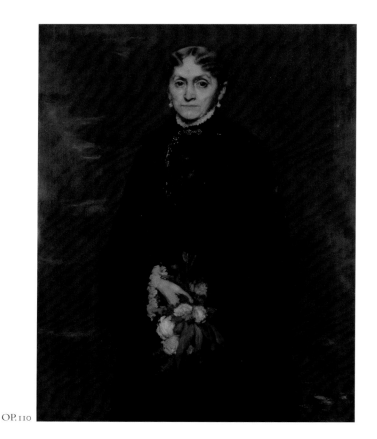

OP. 110

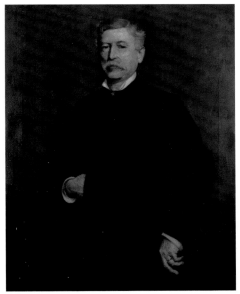

OP.111

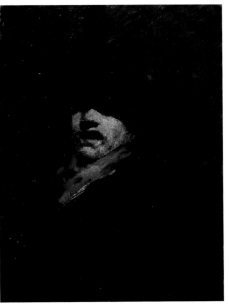

OP.112

OP.112

Untitled (Bust-Length Study of a Spanish Man), ca. 1885

Oil on canvas; 13¾ x 10 in. (34.9 x 25.4 cm)

Collection of Jane Monell and Oscar Chase

This work relates to a series of studies of Spanish "types" painted by Chase over several years in the 1880s. Many of these works were used as the basis for illustrations in an article, "Street Life in Madrid," *Century Magazine* (November 1889): 33-40. As the above-cited work is painted on canvas with a backstamp, "W. Schaus / Colorman / 19 Broadway," it is clear that Chase continued to paint Spanish subjects after he returned from one of his many trips to Spain.

OP.113

William C. Casey, ca. 1885

Oil on canvas; 66 x 41½ in. (167.6 x 105.4 cm)

Seventh Regiment Armory, New York

There is a William C. Casey who, in 1915, wrote *Masterpieces in Art,* and it would have been quite understandable as to why Chase would have painted his portrait. Either Casey was also a prominent member of the Seventh Regiment, New York, or there was another William C. Casey. This work is noted by Katharine Metcalf Roof in her 1917 biography of Chase, and by Peat in his 1949 checklist of known work as being in the collection of the Seventh Regiment Armory, New York.

OP.114

Seth Low, 1885

Oil on canvas; 57 x 37 in. (144.8 x 94 cm)
Signed: W. M. Chase (l.r.)

City of New York

Seth Low (1850-1916) was the mayor of Brooklyn from 1881 until 1885. The portrait was undoubtedly commissioned by the city to commemorate his term of office. The work is included in *Catalogue of the Works of Art Belonging to the City of New York* (1909), p. 62, illus. opposite p. 94. It is also noted in Katharine Metcalf Roof's 1917 biography of the artist, and appears on Peat's 1949 checklist of known work as owned by Borough Hall, Brooklyn; in fact it is owned by the City of New York, and was likely hanging in the Brooklyn Borough Hall in 1949.

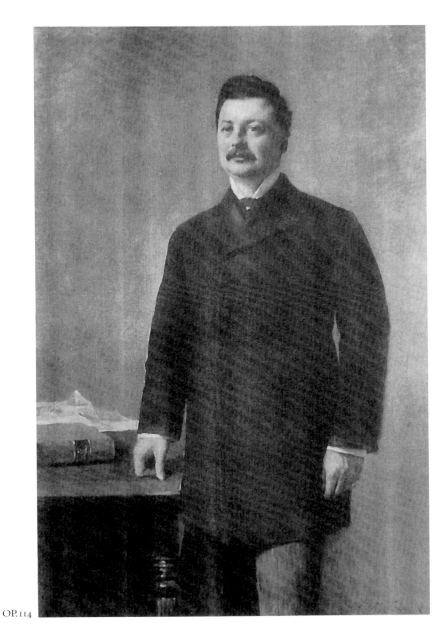

OP.114

OP.115

Dutch Orphan—Haarlem, ca. 1885

Oil on canvas; 30 x 27 in. (76.2 x 68.6 cm)
Signed: Wm. M. Chase (u.l.)
Seal from the Chase Estate Auction in 1917

Location unknown

Exhibitions and Auctions: **BAC '86 #76** as *Dutch Orphan—Haarlem*; **Csale '87 #60; Csale '17 #95.**

No image of this work is extant, so one is left to a description of it from the Chase estate auction, wherein it is described as a "figure of a young-mature woman with pinkish complexion and sandy hair, appearing at a little more than half-length, in the regulation costume of the Dutch orphans—effectively protecting them every-where in Holland—one sleeve red and the other black, black waist and skirt and white scarf and cap. She is turned toward the left, three-quarters front, with face in profile and right hand raised to her cheek. Buff background." Included on Peat's 1949 checklist as *Dutch Orphan,* and as being owned by J. B. Townsend, New York.

OP.116

Portrait of a Woman, ca. 1885

Oil on canvas; 24 x 18 in. (61 x 45.7 cm)
Signed: Wm. M. Chase (l.l.)

Location unknown

This is a painting thought to depict Chase's student Ellen Scripps Kellogg; however, Kellogg was not born until 1892, making such an

OP.116

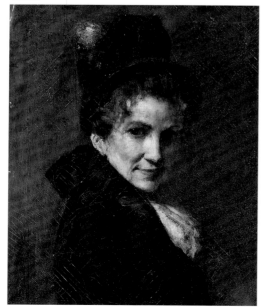

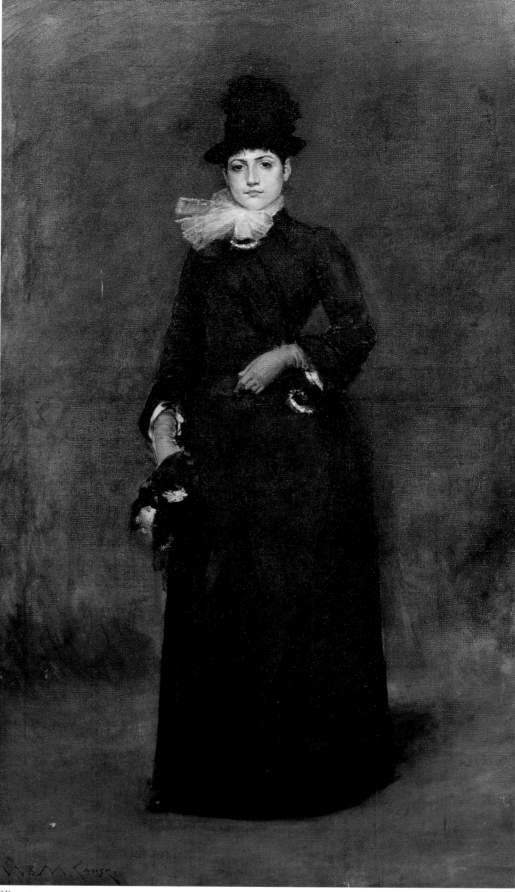

OP.117

attribution impossible. Scripps Kellogg was raised in Detroit, Michigan, and then moved to Pasadena, California, sometime prior to 1911. Her mother, Florence Scripps Kellogg, and a group of Pasadena women founded the Scripps Home for the Aged in 1911. After Ellen Scripps Kellogg died in 1983, her estate sold this work in 1984 to benefit this organization. Ellen Scripps Kellogg lived in California and studied with Chase during his 1914 summer class at Carmel-by-the-Sea, California. In an article about the Chase School in California, the author Eunice Gray mentions that Ellen Kellogg of Pasadena was awarded second prize by Chase in his first "board criticism" of the season in July 1914 (Eunice T. Gray, "The Chase School of Art at Carmel-By-The-Sea, California," *Art and Progress* 6, no. 4 [February 1915]: 120). Chase may have given her a painting as an award for her good work, but it is not clear which one. It is unlikely that Chase would have had this painting with him in California, so perhaps he sold it or gave it to her when she visited New York.

The dark tonal palette and style of the work suggest that it dates from the early to mid-1880s. However, it was probably cut down from a larger work in the late 1890s or 1900s, given that the painting extends beyond the confines of the present composition—and the fact that the signature type does not correspond with Chase's signature of the 1880s but rather with that of his mature period. It was not uncommon for Chase to cut down his early works later in life, in an attempt to make them appear "more modern," so as to affiliate them with the dramatic cropped images inspired by the French Impressionists. *Portrait of a Woman* matches the description given for the head and shoulders of the sitter portrayed in the three-quarter length *Portrait* (OP.83) and likely is this work cut down.

OP.117

Ready for a Walk (Beatrice Clough Bachmann), ca. 1885

Oil on canvas; 83½ x 47¼ in. (212.1 x 120 cm)
Signed: Wm. M. Chase (l.l.)

Terra Foundation for American Art, Daniel J. Terra Collection, Chicago (1992.26)

Exhibitions and Auctions: **BAC '86 #23** as *Ready for a Walk* [lent by the artist] ("A Boston Estimate of a New York Painter," *Art Interchange* 17 [December 1886]: 179); **Csale '87 #78; Csale '96 #1181** (sold for $40).

The title *Ready for a Walk* is reminiscent of Chase's earlier *Ready for the Ride* of 1877. In both

works a woman is dressed and ready to embark on her outing. Stylistically, Chase's earlier work was more informed by his study in Munich and the influence of Old Master styles, whereas *Ready for a Walk* reflects Chase's embrace of the more modern aesthetic embodied in the works of Whistler and Manet. Chase's work at the Boston Art Club received a favorable review, with one critic noting that "in catching, too, the seemingly unconscious or accidental grace of line in female costume and making it play a part in revealing the characteristic lines in the wearer's personality, he is altogether admirable" (*Art Interchange* 17 [December 1886]: 179). Included on Peat's 1949 checklist of Chase's known work as *Portrait of a Woman,* and as being owned by the William Rockhill Nelson Gallery of Art, Kansas City, Missouri.

OP.118

Spanish Girl, ca. 1885

Oil on panel; 10 x 7¾ in. (25.4 x 19.7 cm)
Signed: Wm. M. Chase (incised u.r.)
Labels (verso): Christie's; Nassau County Museum

Bernard Goldberg Fine Arts, LLC, New York

Auctions: **Csale '91 #32** [purchased by T. De Thulstrop, $55 (?)].

Chase began painting Spanish subjects during his first trip to Spain in 1881. Based on the signature style, however, this painting was completed around 1885. With such a nonspecific title it is difficult to confirm an exhibition history for the work. This could be the work *Spanish Girl* that

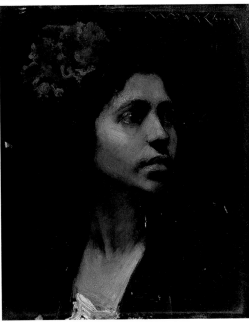

OP.118

appeared in the 1891 Chase estate sale, a supposition given credence by a review in the *New York Times* that discusses *Spanish Girl* as exemplary of Chase's penchant for adding a "color note on the lips in order to make it agree with the colors of fan or hat ribbons," or, as in the present work, a flower (*New York Times,* March 1, 1891, 12). The writer was impressed by *Spanish Girl,* commenting that it is "remarkable as a work in the broad way of Franz Hals; it comes together if regarded at a very respectable distance" (ibid., 12).

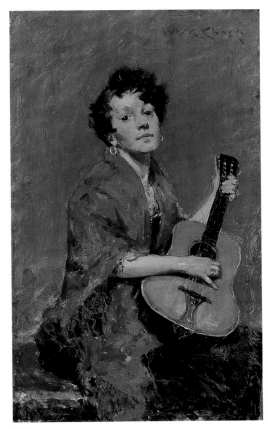

OP.119

OP.119

Woman with Guitar (Descriptive Title), ca. 1885

Oil on panel; 10⅛ x 6 in. (25.7 x 15.2 cm)
Signed: Wm. M. Chase (u.r.)

Location unknown

Chase visited Spain in the summers of 1881–83 and became enamored with Spanish painting and Spanish subjects. This is evident in the contents of his first major one-man exhibition in the United States held at the Boston Art Club in 1886, which included roughly a dozen paintings based on Spanish themes—some done while he was visiting Spain, others done from models

who posed for him in New York. This work probably falls into the latter category. Unfortunately, it has not been possible to identify each work that was in the show since they often have unspecific titles that have not remained with the artwork—such as *Study of a Spanish Girl, A Madrid Study,* and *Spanish Dancing Girl.* Chase's interest in this type of painting culminated in the painting of one of his most famous works, *Carmencita* (OP.172), a depiction of the famous Spanish dancer—"The Pearl of Seville"—who dazzled audiences both abroad and in America.

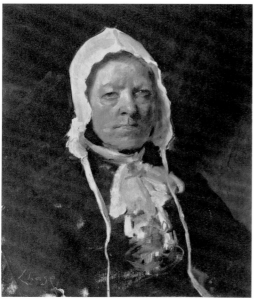

OP.120

OP.120

Woman with White Bonnet (Descriptive Title), ca. 1885

Medium/support/dimensions unknown
Signed: Chase (l.l.)

Location unknown

The only record of this work is a photograph of it that had descended within the Chase family. It appears to be a brisk study of a woman, probably completed as a demonstration piece before one of his classes. The signature style suggests a date of 1885 or later. Perhaps Chase completed it during his travels to Haarlem and Amsterdam in 1885.

OP.121

Young Girl with Flowers, ca. 1885

Oil on canvas; 23 x 13½ in. (58.4 x 34.3 cm)
Signed: Wm. M. Chase (u.r.)
Labels verso: Maxwell Galleries, 551 Sutter Street, San Francisco, "Corcoran Gallery of Art, June 13–August 31, 1972, ex. coll.: Mr and Mrs. Joseph H. Hennage," and "Bernard and S. Dean Levy, 981 Madison Avenue, New York"

Collection of Cheryl Chase and Stuart Bear

In November of 1886 Chase had his first one-man exhibition, which was held at the Boston Art Club. It is likely that *Young Girl with Flowers* was included in this exhibition. Unfortunately, this work, like many others in the show, has long since shed its original title and cannot easily be matched with those listed in the catalogue for the exhibition. One possibility would be that this painting was cat. no. 87, *Daydreams,* which was later offered for sale in the 1887 Chase estate sale as cat. no. 63. This is not a portrait in the sense of a commissioned work, but rather the unidentified model has posed for the painter to create a work of art for art's sake, in the manner of James McNeill Whistler—a modern concept underscored by the composition itself. Chase has severely cropped the bottom and sides of the composition, a technique favored by the French Impressionists to promote a sense of immediacy and candor typical of a photographic snapshot. Also, through placement of the elements of the composition so close to the foreground, Chase's technical mastery is highlighted. He is expert at capturing the qualities of texture and light, as may be seen in the subject's satin dress and the velvet pillows.

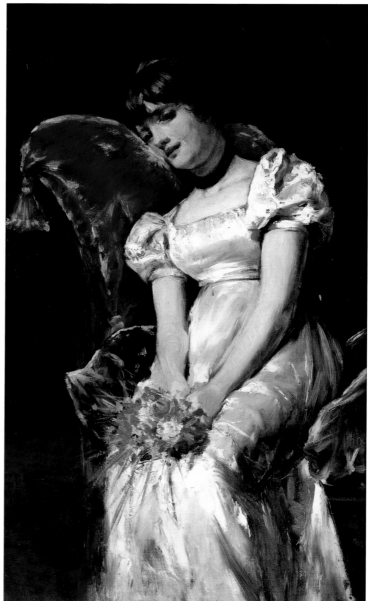

OP.121

OP.122

Portrait of My Sister (Hattie), 1886

Oil on canvas; 64¾ x 38 in. (164.5 x 96.5 cm)
Signed: Wm. M. Chase (l.r.)

Collection of Mr. and Mrs. Richard J. Schwartz

Exhibitions: **SAA '87 #30** as *Portrait of My Sister*
[lent by the artist] ("The Society of American
Artists," *Art Amateur* [June 1887]: 5); **IIEC '89 #105;**
CI '97 #47 [lent by the artist].

This portrait depicts Chase's sister Hattie (b. 1873)
and, like many of his works of young girls, betrays
the influence of James McNeill Whistler, in par-
ticular his *Harmony in Grey and Green: Miss Cicely
Alexander* (OP.122A). Here the debt to Whistler
is evident in the pose, the limited palette, and
the fluid brushstrokes delineating Hattie's dress,
though Chase's use of light and shadow strongly
reflect his recent training in Munich.

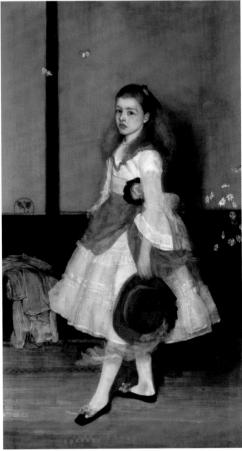

OP.122A. James McNeill Whistler, *Harmony in Grey and
Green: Miss Cicely Alexander,* 1872–74. Oil on canvas,
87¼ x 51⅛ in. (221.5 x 130 cm). Tate Gallery, London

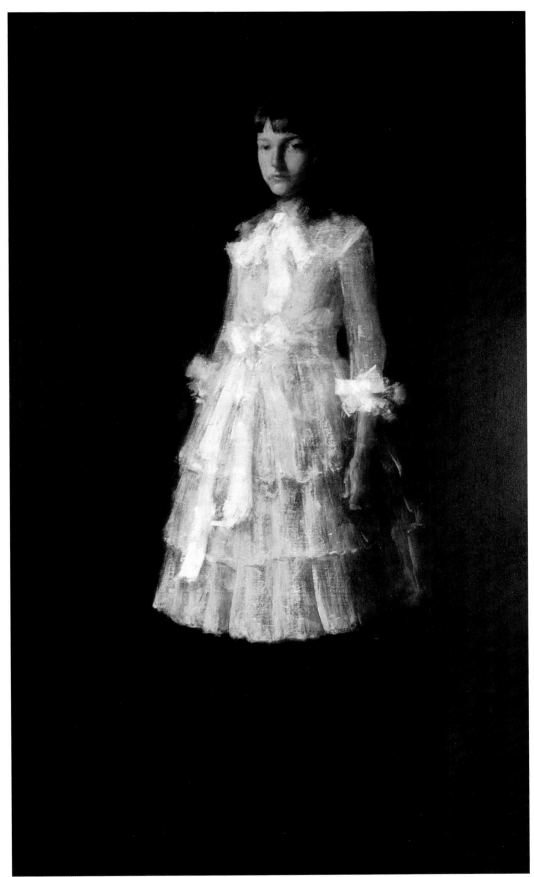

OP.122

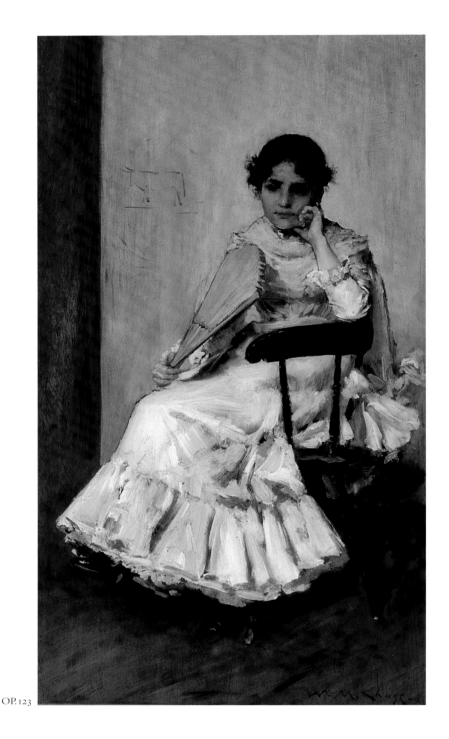

OP.123

OP.124

Portrait of Miss Juanita Miller, ca. 1886

Oil on canvas; 22 x 18 in. (55.9 x 45.7 cm)
Signed: Wm. M. Chase (l.l.)
There was an estate seal in red wax affixed to the back of the work for the sale (these seals have been invariably lost due to cracking and lifting).

Location unknown

Auctions: **Csale '17 #270** (purchased, D. J. Connoli, $60) (fully described).

This painting of Juanita Miller (1880-1970)—daughter of the well-known West Coast poet Joaquin Miller, and an artist and sculptor, though little known, in her own right—has not been located and there are no extant images of it. The work is described in the Chase estate sale catalogue as follows: "[She] is portrayed . . . head and bust, looking brightly at the spectator, with frank and keen blue eyes. Her complexion is fair and warm, and her hair a soft chestnut brown and decked with a pink and white bow. Her easy gown is in soft and delicate colors and she is in a full light against a light gray background." Chase also completed a pastel of Juanita entitled *Little Miss Miller,* circa 1885, present location unknown (see vol. 1). The latter work was illustrated in *Scribner's Magazine* (January 1892). Interestingly, according to Katharine Metcalf Roof's 1917 biography of Chase (p. 278), Juanita Miller also posed for Chase as the model for both figures in his interior scene *Hide and Seek,* circa 1888 (see vol. 4). Given the sitter's age, the portrait was likely executed sometime in the 1880s.

OP.125

Alice Gerson (Mrs. Chase), ca. 1886

Oil on canvas mounted on fiberglass; 36 x 28 in. (91.4 x 71.1 cm)
Signed: Wm. M. Chase (l.l.)

Location unknown

In this image Chase captures his wife dressed for the outdoors, wearing a hat and fur-lined wrap. There are faint suggestions of trees in the background. A dating for this painting circa 1886 is suggested by its soft, almost romantic, nature, as well as by the subtle flesh tones in the background. In terms of age of the sitter, Alice looks to be about the same age as she was in Chase's pastel *Meditation,* 1886 (see vol. 1). A dating to 1886 is further suggested by the fact that Alice is wearing a wedding band, indicating she and

OP.123

A Spanish Girl in White (A Spanish Girl, Portrait, A Spanish Lady), ca. 1886

Oil on panel; 26¾ x 15¼ in. (68 x 38.7 cm)
Signed: Wm. M. Chase (l.r.)

Wake Forest University, Middleton Collection, N.C. Gift of Philip and Charlotte Hanes

Exhibitions and Auctions: **Csale '87 #66** as *A Spanish Girl in White*; **AAG '90 #233** as *A Spanish Girl* [lent by Cottier and Co.]; **EFMSale '02 #6** as *Portrait* (purchased by S. Peters, $325) (illus. and fully described); **NAC '10 #109** [lent by Samuel T. Peters]; **MMA '17 #13** as *A Spanish Lady* [lent by Samuel T. Peters].

This painting depicts Chase's wife, Alice Gerson (1866-1927), whose yellow shawl and pink fan suggest the Spanish costumes to which Chase would have been exposed through his travels in Spain, the first of which was undertaken in 1881. Chase captures Alice dancing and wearing the same outfit in his *A Madrid Dancing Girl,* circa 1886 (see vol. 1). It is possible that Chase exhibited this painting for the first time as *Sketch of Spanish Girl in White* (cat. no. 93) in his one-man exhibition at the Boston Art Club in 1886. Included on Peat's 1949 checklist of Chase's known work as *Spanish Girl* (C); *Spanish Lady,* and as being owned by Victor D. Sparks, New York.

Chase had already been married at the time of the portrait. The signature on the portrait does not relate stylistically to the type Chase used in the 1880s but rather resembles a style he used later in life—it is likely that Chase added it at a later date, a practice not uncommon for him. Included on Peat's checklist as *Alice Gerson* (B) *(Mrs. W. M. Chase)*, and as being formerly owned by Newhouse Galleries, New York. It is also possible that this painting could be that referred to by Peat as *Portrait of Mrs. Chase* (B) *(Mrs. W. M. Chase)*, which was unsigned, and as being owned by Minnie Twining, Hollywood, California.

OP.126

Girl with Tamborine (The Tamborine), ca. 1886

Oil on panel; 16 x 10 in. (40.6 x 25.4 cm)
Signed: Wm. M. Chase (l.l.)
Inscribed: To My Friend Carlsen—Wm. M. Chase, New York, May 25, 1889 (l.l.); Sept. 90 With Compliments to Sylvia Gerrish (l.r.)
Label verso: Chapellier Galleries, New York, N.Y.

Mr. and Mrs. W. F. Goodman, Jr., Dallas

In *Girl with Tamborine* Chase used the same model he had for another work, *The Moroccan Girl* (OP.139). They were also likely done around the same time, circa 1886. Emil Carlsen (1853–1932) was an artist and director of the California School of Design beginning in 1887. In 1889 Carlsen found himself in financial difficulty and frustrated with teaching. He resigned and returned briefly to New York. Perhaps it was during this period that Chase gave him the painting (likely

OP.125

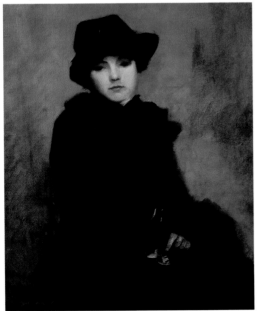

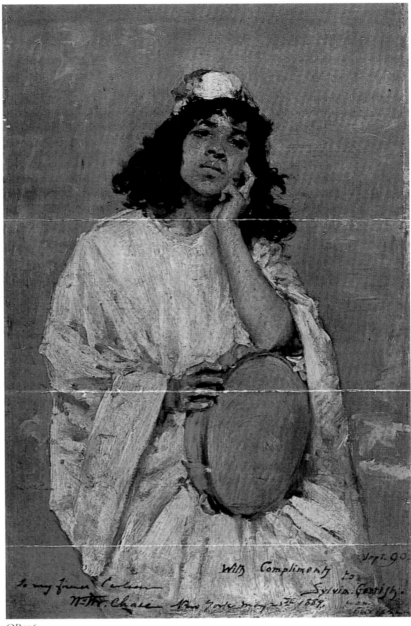

OP.126

on the date of the inscription, "May 25, 1889"), for several months later Carlsen returned to San Francisco and taught at the Art Students League there until 1892 (Edan Hughes, *Artists in California, 1786–1940*). The work was later given, presumably by Carlsen, to the actress Sylvia Gerrish (d. 1906), who became the wife of Henry Graham Hilton in March 1901. She had come to New York in the 1880s from San Francisco and become a popular comic opera actress (*Washington Post,* December 10, 1906, 2). Considering the exotic subject matter of the *Girl with Tamborine,* it is interesting to note that Gerrish was an avid collector of bric-a-brac, having in her collection "Exquisite old Moorish drinking cups of gold and silver, covered with the most beautiful incised work, old Persian vases, Japanese porcelains and Aztec pottery, all of which have been presents to her" (*Atlanta Constitution,* July 15, 1889, 7).

OP.127

Memories, ca. 1886

Oil on canvas; 51 x 36½ in. (129.5 x 92.7 cm)

Munson-Williams-Proctor Arts Institute, Museum of Art, Utica, N.Y. (57.305)

Exhibitions and Auctions: **BAC '86 #81; Csale '87 #61** ("The Chase Sale," *Art Amateur* 16, no. 5 [April 1887]: 100).

This is one of the vast number of paintings Chase did of his beloved wife, Alice Gerson Chase (1866–1927), as the model. The light streams in from a skylight above, softly illuminating the scene and casting shadows. Alice is standing in Chase's outer studio in front of a table covered with various artworks, a hat, and

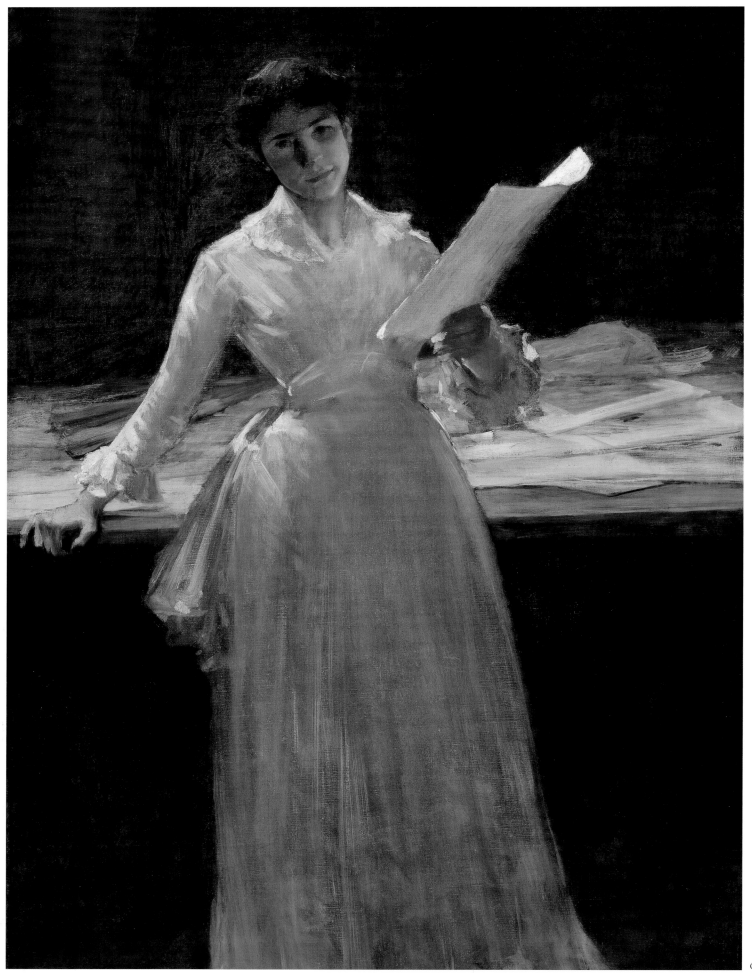

a fan. This fan is the one she held as she posed for Chase's *A Spanish Girl in White* (OP.123). It is likely that the dress (minus the yellow shawl) she wears in *Memories* is indeed the one she posed in for the other painting. A critic writing about the 1887 Chase sale praised this particular work, commenting, "*Memories* is a girl in white leaning against a table strewn with prints and drawings. She holds one in her hand, the light thrown back from which comes upon her face. One may imagine the difficulty of painting such a picture, but standing in front of it, one never thinks of difficulties" (*Art Amateur,* April 1887, 100). Included on Peat's 1949 checklist as *Memories,* and as being formerly owned by F. A. Lawlor, New York.

OP.128

Portrait of a Girl (Study of a Child with an Orange), ca. 1886

Oil on canvas; 20 x 12 in. (50.8 x 30.5 cm)

Location unknown

Exhibitions: **BAC '86 #22** as *Study of a Child with an Orange.*

A dating circa 1886 is suggested by the fact that this painting is likely the *Study of a Child with an Orange* that was exhibited in Chase's first one-

man exhibition held at the Boston Art Club in 1886. This work is of an unusual size and is unsigned; it is possible that it was initially 20 by 16 inches and was cut down at some point, eliminating the signature as well.

OP.129

The Morning Paper, ca. 1886

Oil on wood/panel; 19 x 14½ in. (48.3 x 36.8 cm)
Signed: Wm. M. Chase (u.r.)

Collection of Fayez Sarofim, Houston

Exhibitions and Auctions: **BAC '86 #71,** as *The Morning Prayer* [*sic*]; **Csale '87 #67; IIEC '89 #126** [lent by the artist]; **AAG '90 #218** [lent by the artist]; **Csale '91 #37** (purchased, Dr. Egbert Lefevre, $55).

The Morning Paper depicts Alice Gerson shortly before her marriage to Chase. She is dressed in a dark blue dress and a variation of a Pilgrim's hat. Chase would later depict his daughter Alice Dieudonnée wearing a similar hat in his portrait of her completed circa 1900 (OP.310). The work, owner unknown, is included in Peat's 1949 checklist, wherein the work is mistakenly dated circa 1900.

OP.129

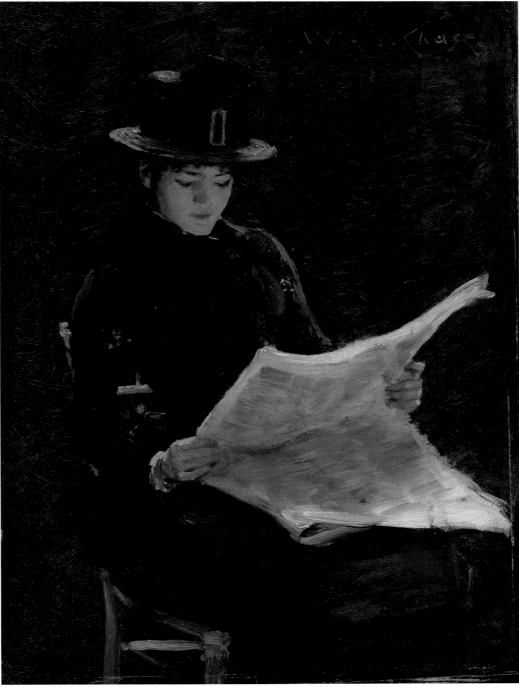

OP.128

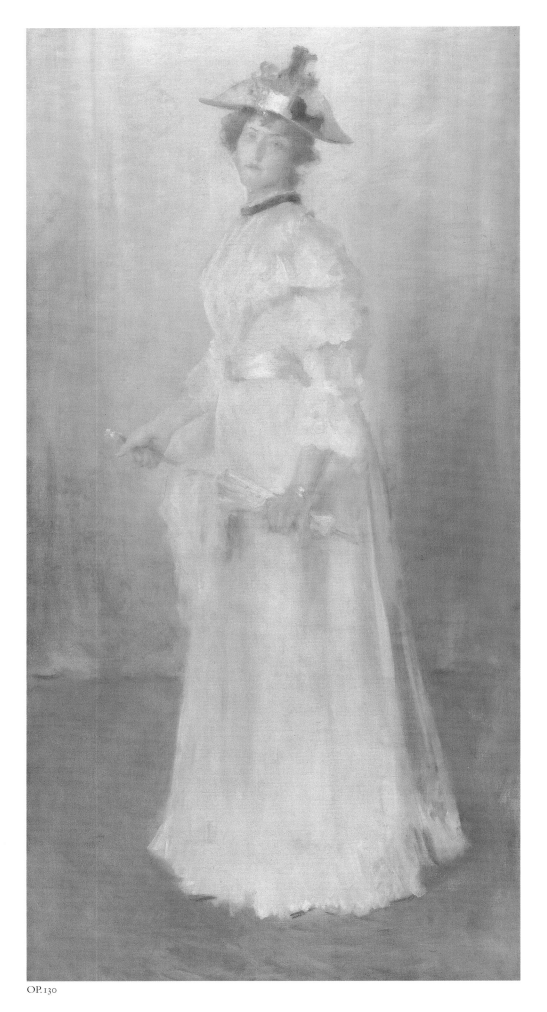

OP. 130

Portrait of a Lady against Pink Ground (Miss Virginia Gerson), ca. 1886

Oil on canvas; 72 x 36 in. (182.9 x 91.4 cm)
There was an estate seal in red wax affixed to the back of the work for the estate auction (these wax seals have been invariably lost due to cracking and lifting).

Charles and Emma Frye Collection, Frye Art Museum, Seattle. 1969

Exhibitions and Auctions: **BAC '86 #8** [lent by the artist]; **Csale '87 #113** [lent by Mr. Chase]; **Csale '17 #101** as Miss Virginia Gerson (fully described).

This large-scale painting of Chase's sister-in-law Virginia Gerson (1864–1951) was surely created as an exhibition piece. However, there are no exhibition records for this work during Chase's lifetime as "Miss Virginia Gerson," so it likely had another title. This is probably the painting *Portrait of a Lady against Pink Ground* that Chase exhibited at the Boston Art Club in 1886. *Portrait of a Lady against Pink Ground* was also included in the Chase estate sale of 1887, wherein it appeared for exhibition purposes only and was lent for that purpose by the artist. The painting reflects James McNeill Whistler's influence to the extent that it is as much a study in color, in this case pinks, as a proper portrait of the artist's sister-in-law. It was purchased by Mr. Douglas John Connah, Director of the Chase School for three years, at the Chase estate sale of 1917.

OP. 131

Portrait of a Lady in Street Costume (The White Hat), ca. 1886

Oil on canvas; 30 x 25 in. (76.2 x 63.5 cm)

Location unknown

Exhibitions and Auctions: **BAC '86 #11** as *Portrait of a Lady in Street Costume* [lent by the artist]; **Csale '87 #116** as *Lady in Street Costume* [lent by Mr. Chase]; **NAC '10 #14** as *The White Hat* [lent by Mr. Chase]; **Csale '17 #94.**

This painting is unlocated, and the only extant image of the work is this unlabeled photo from the Chase family archives. The portrait in the photo matches the descriptive title for the work *Lady in Street Costume* that was part of the Loan Exhibition of the Chase estate sale of 1887. A critic described it as "charming" (*Art Amateur,*

OP.131

OP.132

Portrait of Miss Rosalie Gill (Portrait de Miss Gill), ca. 1886

Medium/support/dimensions unknown

Location unknown

Exhibitions and Auctions: **SAA '86 #23** as *Portrait of Miss Rosalie Gill* [lent by Owen A Gill] (*Art Amateur* 15, no. 2 [July 1886]: 25); **BAC '86 #1** [lent by Owen Gill] ("Art Notes: Pictures, Studies and Sketches by Mr. William M. Chase," [Boston] *Evening Transcript,* November 23, 1886, n.p.; "A Boston Estimate of a New York Painter," *Art Interchange* [December 4, 1886]: 179); **Csale '87 #106** [lent by Mr. Owen A. Gill]; **ExUP '89 #56** as *Portrait de Miss Gill.*

This portrait depicts the short-lived Rosalie Gill (1867–1898), who studied with Chase at the Art Students League at age twelve. She is painted in full-length and wearing a black gown and standing before a peacock-blue plush curtain (*Critic,* March 5, 1887, 115). In the *Boston Evening Transcript*

the work was described as a "combo of black, steel gray with blue lights and violet. . . . The head is vital and full of character, the handling superb" (n.p.). One writer calls attention to her "exquisite costuming" (*Art Interchange,* 1886) and another to the painting's "rough canvas" (*Art Amateur,* 1886). Gill married abroad in 1897 and became the Comtesse de Chalon, dying the following year. No visual record of this work has been located.

OP.133

Portrait of Mrs. H. (Howell), ca. 1886

Oil on panel; 16 x 10½ in. (40.6 x 26.7 cm)
Signed: Wm. M. Chase (u.l.)

Mr. and Mrs. Edwin Allday, Houston

Exhibitions: **SAA '87 #28** as *Portrait of Mrs. H.* [lent by the artist] ("The Society of American Artists," *Art Amateur* [June 1887]: 5, as *Portrait*).

1887, 100); thereafter, the work was never exhibited under this title during the artist's lifetime. *Lady in Street Costume* may have been cut down —a practice not unprecedented in Chase's oeuvre—to form *The White Hat* from the Chase estate sale of 1917, a catalogue entry for which notes that it "depicts a half-length figure of a young woman whose face shows an interesting expression, who appears in outdoor costume facing the right, three-quarters front. Her low broad hat and rather tight-fitting jacket are gray-white, with creamy tones, and she wears a black and white lace boa or muffler around her neck and shoulders." The painting does not appear to be signed, which is unusual for Chase's full-length works.

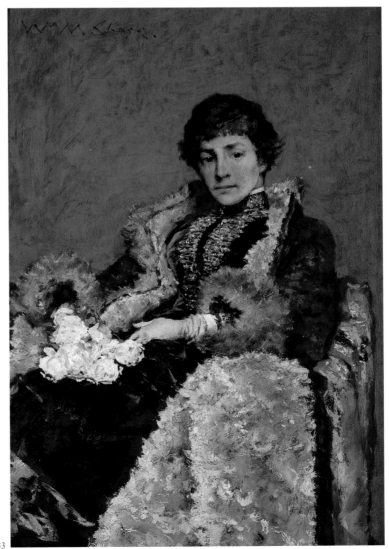

OP.133

This is a portrait of Mrs. Katherine Van Liew Howell. Chase was commissioned to paint the other members of the Howell family, as well, including her husband, Mr. Frederick Huntting Howell, her daughter Erla Louise Howell (OP.134), and her two sons, Benjamin Huntting Howell (OP.135) and James Rapelje Klotz Howell (OP.136). Chase captures Mrs. Howell wearing a lush, fur-trimmed, wine-red costume and holding a bouquet of white roses on her lap. She is seated in front of a red background, giving Chase the opportunity to demonstrate his mastery of color in the two shades of red, as well as his ability to paint textured materials like the fur. The portraits of the other members of the Howell family were large-scale, but this portrait of Mrs. Howell, measuring 16 by 10½ inches, is an intimate piece, almost like a keepsake for Mr. Howell. A critic at the 1887 Society of American Artists exhibition described the work as "a small half-length picture of a seated figure of a lady in gray furs gracefully arranged against a lively red wall" (*Art Amateur*, June 1887, 5).

OP.134

Portrait of Little Miss Howell (Portrait of Little Miss H.), ca. 1886

Oil on canvas; 65³⁄₁₆ x 39³⁄₁₆ in. (165.6 x 99.5 cm)
Signed: Wm. M. Chase (l.r.)

Private collection

Exhibitions and Auctions: **BAC '86 #4** as *Portrait of Little Miss Howell* [owned by Mr. F. H. Howell, N.Y.] ("Art Notes: Pictures, Studies and Sketches by Mr. William M. Chase," *Boston Evening Transcript*, November 23, 1886, 4); **Csale '87 #109** ("The Chase Sale," *Art Amateur* 16, no. 5 [April 1887]: 100); **NAD '90 #475** as *Portrait of Little Miss H.* [owned by Mr. F. H. Howell] ("The Academy Exhibition," *Art Amateur* [March 1890]: 113; "The Spring Academy," *New York Times*, April 7, 1890, 4, as *Little Miss. H.*; "The Academy Exhibition," *New York Evening Post*, April 14, 1890, 8).

Erla Louise Howell de Facci Negrati (1876-1975) was the daughter of Frederick Huntting Howell (1849-1929), an early collector of works by Chase. Chase also painted portraits of Erla's mother, Katherine Van Liew Howell (OP.133), and her two brothers, Benjamin Huntting Howell (OP.135) and James Rapelje Klotz Howell (OP.136). The Howell family dates back to the seventeenth century in New York State. Edward and Annie Howell were among the founders of the town of Southampton, Long Island. The Howells owned several paintings by

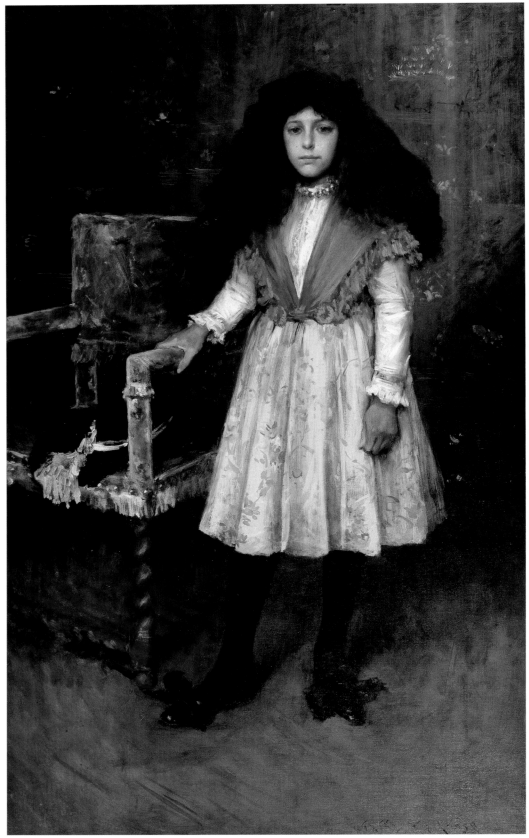

OP.134

Chase, including his pastel *Self-Portrait* (see vol. 1). Chase was probably introduced to the Howells by Frederick's brother Thomas, a resident of Brooklyn Heights, who by 1883 owned the Chase painting *In the Studio*, circa 1881 (see

vol. 4). The brothers operated B. H. Howell, Son and Co., Inc., a sugar refinery in Brooklyn. The portrait depicts Erla at about ten years old. She is wearing the costume of a Spanish gypsy with her black Spanish hat sitting on the chair

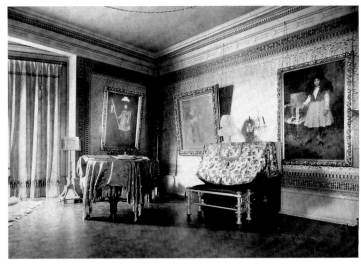

OP.134A. Park Brothers Studio, New York, *Frederick and Kate Howell's Residence at 49 West 46th Street,* ca. 1890. Private collection

of his wife, Katherine Van Liew Howell (OP.133), another son, James Rapelje Klotz Howell (OP.136), and a daughter, Erla Louise Howell de Facci Negrati (OP.134). A photograph of this work descended in the Chase family that shows Benjamin standing next to a dog, his right hand resting on the neck of the dog as if holding a leash. However, photographs from Chase family archives presumably later of the Howell residence in New York, and, later still, of the Howell home in London, show Benjamin holding a long staff or walking stick to which ribbons are affixed in his right hand—the dog is not visible in the photographs. Apparently Chase painted the dog out of the work and had to somehow account for the extended right arm. As a *Portrait of Master Howell* lent by Mr. F. H. Howell to the 1886

to her right. Chase includes the chair in the composition to give a sense of scale so the viewer is aware that Erla is a child. The grand scale of the painting is evident in a photo of the work in situ in the Howells' living room in their home on 49 West 46th Street (OP.134A). The portrait of Erla Howell was well received at the time. In 1890 when exhibited at the National Academy of Design as *Portrait of Little Miss H.,* one contemporary critic described it as "ingenious and interesting" (The Academy Exhibition, *Art Amateur* [March 1890]: 113). A writer for the *New York Times* commented on how the portrait "has a Spanish air, not merely because of the dark complexion and bush of dark hair, but of the accessories. It is a good piece of work" (*New York Times,* April 7, 1890, 4). A critic for the *New York Post* also made reference to the child's striking black hair, noting her "fine head of dark hair arranged like an infanta's wig" (*New York Post,* April 14, 1890, 8). A family photo of Erla and her two brothers illustrates that Chase apparently depicted her hair as it was without much embellishment. Included on Peat's 1949 checklist of Chase's known work as *Erla Howell,* and as being formerly owned by Newhouse Galleries, New York.

OP.135

Benjamin Huntting Howell, ca. 1886

Oil on canvas; 56 x 47 in. (142.2 x 119.4 cm) (estimated)
Signed: Wm. M. Chase (u.l.)

Location unknown

Benjamin Huntting Howell was the son of Frederick Huntting Howell, an early collector of works by Chase, who also painted a portrait

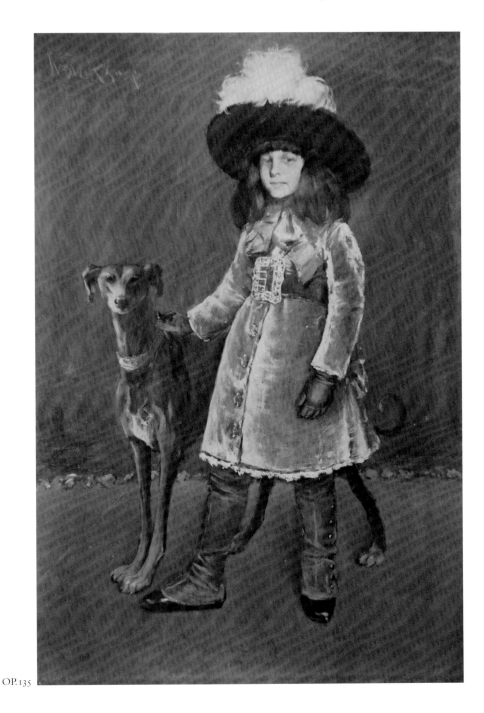

OP.135

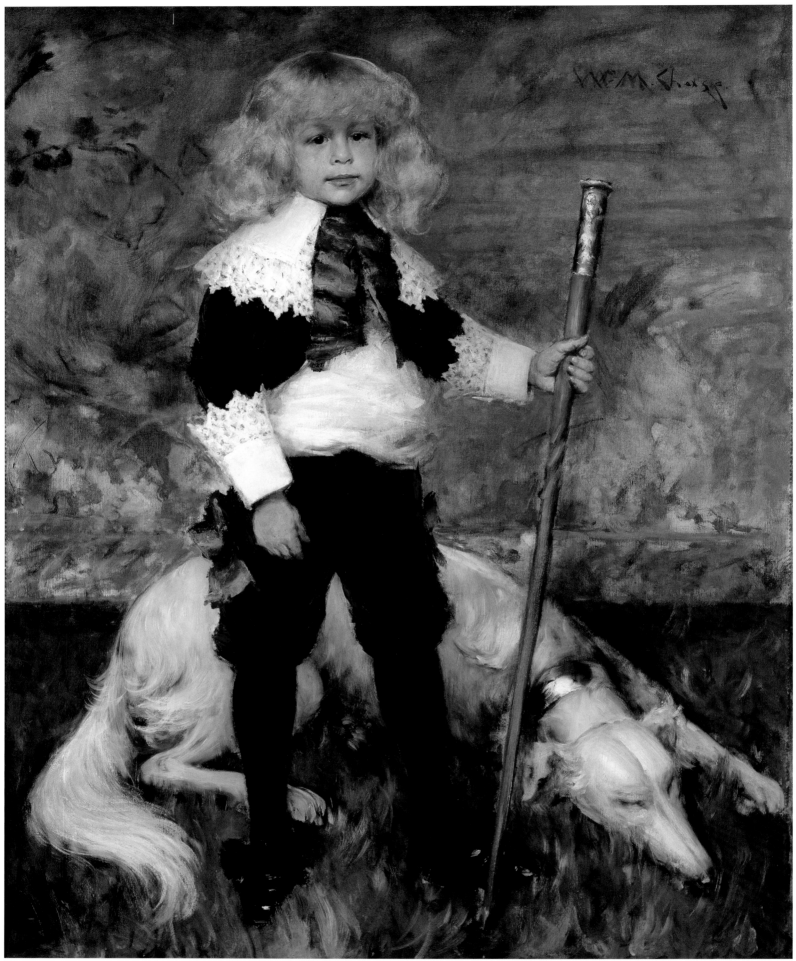

OP. 136

retrospective at the Boston Art Club was noted to be a portrait that included a dog, it was assumed that it was Chase's portrait of James Rapelje Klotz Howell. However, since the portrait of Benjamin also included a dog at one point, identification of exactly which portrait, that of James or Benjamin, was lent to this exhibition is less clear. For further discussion, see the entry for *Portrait of Master Howell* (OP.136).

OP.136

Portrait of Master Howell

Oil on canvas; 56 x 47 in. (142.2 x 119.4 cm)
Signed: Wm. M. Chase (u.r.)

Private collection

Exhibitions: **BAC '86 #5** [lent by Mr. F. H. Howell, New York]; **MAG '87 #110** [lent by Mr. F. H. Howell].

Frederick Huntting Howell was an early patron of Chase, who painted not only this portrait of his son, James Rapelje Klotz Howell (1878–1960), but portraits of his daughter Erla Louise Howell de Facci Negrati, a second son, Benjamin Huntting Howell, and his wife, Katherine Liew Howell. In a letter to Ronald G. Pisano (undated), James Howell's daughter, Mrs. Frederick H. Brandi, supplies information about her father and the history of the Howell family: James Howell was born, and lived most of his life, in New York City; however, he was a graduate of Trinity Hall at Cambridge, England, prior to graduation from Columbia Law School, New York. Mrs. Brandi dates the painting to 1883 when James was five years old; however, it is more likely the work dates to 1886. The Howell family dates back to the seventeenth century in New York State, specifically Long Island, where Edward and Anne Howell were among the founders of the Town of Southampton. Frederick Howell owned several other works by Chase, including Chase's pastel self-portrait, circa 1883 (vol. 1, P.13).

OP.137

Portrait of an Assyrian Girl, ca. 1886

Oil on canvas; 20 x 16 in. (50.8 x 40.6 cm)
Signed: Wm. M. Chase (l.r.)

Eckert Fine Art Galleries, Indianapolis

This painting reflects Chase's interest in exotic cultures, as may also be seen in his *The Moroccan Girl (A Study—Head)* (OP.139). *Assyrian Girl* is a

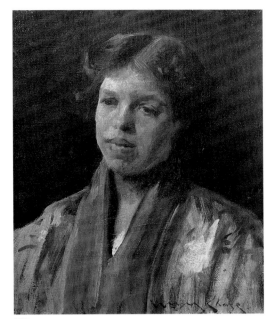

OP.137

thoughtful portrait capturing a person deep in thought. The signature on the present work suggests it was completed after 1885. There are no references to the *Assyrian Girl* having been exhibited during the artist's lifetime. Included on Peat's 1949 checklist of Chase's known work as *Assyrian Girl,* and as being owned by John Nixon, Centerville, Indiana.

OP.138

Study Head, ca. 1886

Oil on canvas; 20 x 16 in. (50.8 x 40.6 cm)

Indianapolis Museum of Art. Gift of Mary Y. Robinson (14.90x)

OP.138

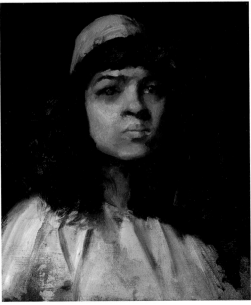

This work is closely related to Chase's *Girl with Tamborine* (OP.126), *The Moroccan Girl (A Study—Head)* (OP.139), and the pastel *Study of an Arab Girl* (see vol. 1). Chase appears to have used the same model for each, dressing her in a white robe and fez. Mary Yandes Robinson (b. 1862), born in Chicago, was a Chase student who had taken courses with him in New York at the Art Students League. Later she moved back to Indiana and was active as an artist there between 1900 and 1920.

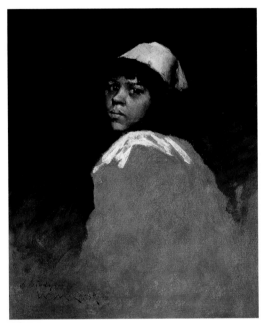

OP.139

OP.139

The Moroccan Girl (A Study—Head), ca. 1886

Oil on canvas; 24 x 18 in. (61 x 45.7 cm)
Inscribed: A Study / Wm. M. Chase (l.l.)

Location unknown

Exhibitions and Auctions: **BAC '86 #74; Csale '91 #9** as *A Study—Head* (purchased, G. J. Taylor, $55).

It is possible that this is the painting titled *A Study—Head* that was exhibited at Chase's first major one-man show at the Boston Art Club in 1886. This show comprised 133 works, a fair number of which were identified as "studies" or "sketches," but were to Chase's mind completed works. Chase used the same model for *Girl with Tamborine* (OP.126), and the paintings were likely executed around the same time, circa 1886.

OP.140

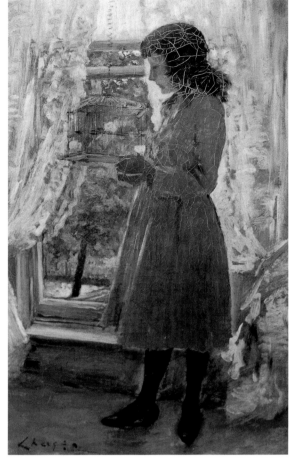

OP.141

OP.140

Sketch of a Spanish Girl (A Spanish Girl),
ca. 1886

Oil on panel; 24½ x 19¾ in. (62.2 x 50.2 cm)
Signed: Chase (u.l.)

Private collection

Exhibitions: IIEC '89 #72 as *Sketch of a
Spanish Girl.*

This painting is likely a "demonstration piece"
that Chase would have completed within the
course of one of his class sessions, as suggested
by the bravura brushstrokes and his use of the
signature "Chase" rather than the more formal
"William M. Chase." The sitter's dress, belt, and
the fan on her lap, as well as the chair, are all
reminiscent of Chase's depiction of his wife as
A Spanish Girl in White (OP.123). The backdrop
for this painting is one that appears in several
works during the early and mid-1880s. It is
possible that the sitter for this painting was also
Mrs. Chase since the model closely resembles
her as she appears in *The Tamborine Girl* (see
vol. 1); additionally, she seems to be wearing the
same hat. Because Chase did a number of works

with the title *A Spanish Girl,* it is difficult to
confirm an exhibition history prior to 1927
when the work was reproduced in *Art News*
(March 12, 1927): 9. However, a photo housed
in the Chase Archives, Parrish Art Museum,
Southampton, Long Island, New York, capturing
an installation view of the Chicago Industrial
Exhibition shows this work. Included on Peat's
1949 checklist as *Spanish Girl* (B), and as being
formerly owned by Harold Wakem, New York.

OP.141

The Pet Canary (The Pet Bird), ca. 1886

Oil on canvas; 19½ x 12 in. (49.5 x 30.5 cm)
Signed: Chase (l.l.)
Label on stretcher: Girl and Canary

Location unknown

Exhibitions and Auctions: BAC '86 #95 as *The Pet
Canary*; Csale '87 #22 (purchased, Frederick S.
Gibbs); FSGA '04 #60 as *The Pet Bird* (fully described
and illustrated) (purchased, T. L. Hamilton, $85).

This painting depicts Chase's sister Hattie (b. 1873)
peering into a canary's cage. She is standing in

front of the second-floor window of the Chase
house on Marcy Avenue, Brooklyn, New York.
Chase and Alice Gerson moved into this house
shortly after the birth of their first child, Alice
Dieudonnée, in 1887. There the newlyweds lived
with Chase's parents and Hattie. Chase would
paint another portrait of Hattie in 1886 (OP.122).
The Pet Canary was sold in the Chase sale of
1887 to Frederick Seymour Gibbs (1845–1903),
and the work is included in a book illustrating
the contents of Gibbs's private collection (*The
Private Collection of F. S. Gibbs* [New York:
Demsey and Carroll, 1899]). In 1899 the work
was shown as part of an exhibition of Gibbs's
private collection in New York.

OP.142

Portrait of Theodore Thomas

Oil on canvas; 20 x 14 in. (50.8 x 35.6 cm)
Signed: Wm. M. Chase (l.l.)

Private collection

In 1891 Theodore Thomas (1835–1904) was
appointed conductor of the Chicago Orchestra
(later the Chicago Symphony Orchestra), having

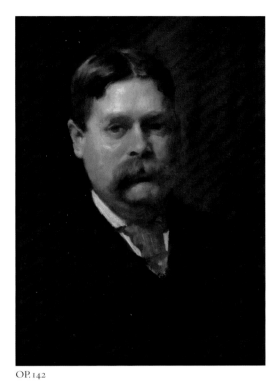

OP. 142

This is one of several paintings Chase did of elderly men—no doubt he delighted in painting the careworn faces of such models. The signature is in the style Chase usually employed for classroom demonstration pieces.

OP. 144

Study of a Head

Oil on canvas; 30 x 24 in. (76.2 x 61 cm)
Said not to have been signed

Newcomb Art Gallery, Tulane University, New Orleans (reported missing)

Without an image, it is difficult to confirm the authenticity of this painting. The large size suggests it may have been a bust-length portrait, perhaps a demonstration piece. Records from the Newcomb Art Gallery noted the painting was damaged in 1954, and reported missing in 1973. The work is included in Peat's 1949 checklist of Chase's known work as being in the collection of the Newcomb Art School, New Orleans.

OP. 145

Colbert Huntington Greer, Portrait Sketch, ca. 1886

Oil on canvas; 74 x 39 in. (188 x 99.1 cm)

Collection of Tim Hubbard, Ashtabula, Ohio

All that is known of Greer is his birthdate, April 20, 1858. His family lived in Painesville, Ohio (see OP. 162).

previously been a conductor of the New York Philharmonic Orchestra. This work is included in Peat's 1949 checklist of known work as being owned by Simon P. Blau, Indianapolis.

OP. 143

Elderly Bearded Man

Oil on canvas; 25 x 20 in. (63.5 x 50.8 cm)
Signed: Chase (c.l.)

Collection of Mr. David Vercammen

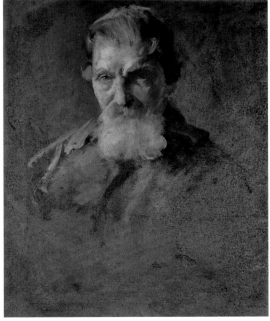

OP. 143

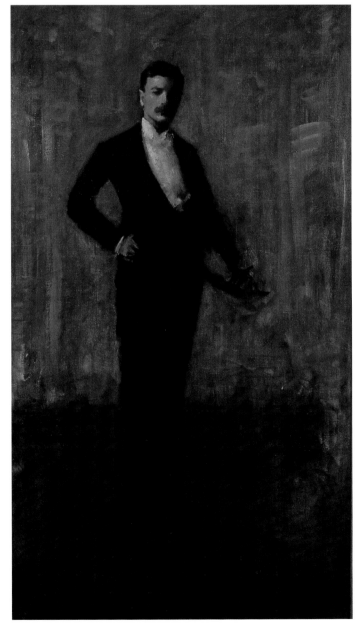

OP. 145

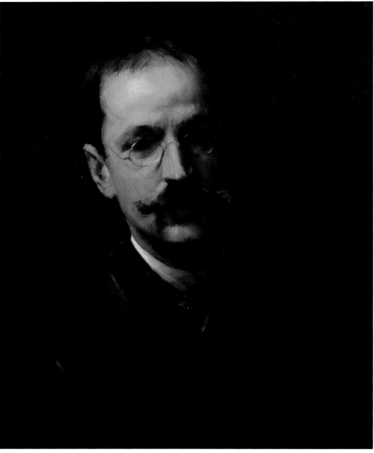

OP.146

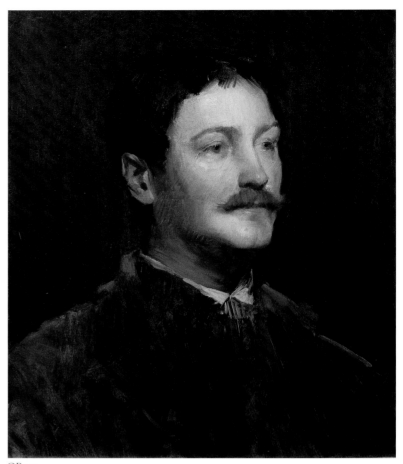

OP.147

OP.146

William Launt Palmer, 1887

Oil on canvas; 21 x 17 in. (53.3 x 43.2 cm)
Signed and dated: Chase / 1887 (u.r.)

National Academy of Design, New York

This work dates to 1887, the year Palmer (1854–1932) was elected an associate of the National Academy of Design, and was given to the organization to fulfill his membership requirements on April 9, 1888. It is included in Peat's 1949 checklist of known work.

OP.147

Thomas W. Dewing, 1887

Oil on canvas; 21 x 17 in. (53.3 x 43.2 cm)
Signed and dated: Chase / 87 (c.l.)

National Academy of Design, New York

Exhibitions: **NAC '16 #90.**

Chase painted this portrait of his friend Thomas Dewing (1851–1938) to fulfill Dewing's requirement to present a portrait of himself to the academy upon election as an associate in 1887. It is recorded as Dewing's ANA Diploma presentation March 5, 1888. The following year, Dewing was elected a full academician. This work is included in Peat's 1949 list of known work.

OP.148

Portrait of Mr. Orlando Cheeks, ca. 1887

Physical properties unknown

Location unknown

Exhibitions: **SAA '88 #15; StLEx '89 #181; PAFA '94 #63; NAC '10 #18.**

Obviously Chase thought highly of his portrait of Mr. Orlando Cheeks, exhibiting the work four times over the course of twenty-two years. At present there is no biographical information about the sitter.

OP.149

A Spanish Gypsy, ca. 1887

Medium/support/dimensions unknown

Location unknown

OP.149

For four years, beginning in 1881, Chase spent part of every summer in Spain, where he completed a number of landscapes and figure pieces, or painted similar subject matter back in the United States. Many of these works served to illustrate "Street Life in Madrid," *Century Magazine* 34, no. 6 (November 1889): 33–40, including *A Spanish Gypsy*, illustrated on page 40, engraved by Frederick Juengling, the engraving inscribed and dated "Munich 88." Chase would sometimes reuse titles and, indeed, the same title was given to a later work (OP.448).

OP.150

Feeding the Baby, 1887

Oil on panel; 21¼ x 14¾ in. (54 x 37.5 cm)
Signed: Wm. M. Chase (l.l.)
Verso: signed again and inscribed with title and price of $1,000 on an affixed old label

Location unknown

Exhibitions: **BFAA '07 #16** as *Feeding the Baby*.

This painting depicts the artist's wife, Alice Gerson Chase, feeding their firstborn child, Alice Dieudonnée Chase, born in February 1887. The work is one of a series depicting Chase's wife and his firstborn child. Others include *Mother and Child (The First Portrait, Mother and Daughter, His First Portrait),* 1887 (OP.151), *Happy Hours,* circa 1887 (see vol. 4), *A Mother's Joy,* circa 1889 (OP.164), and *Mother and Child (Mother's Love),* circa 1892 (OP.185). Although *Feeding the Baby* might have been exhibited under another title—

and was exhibited at least once under the present title—it is more likely that it hung in the Chase home while the larger works treating the same theme were exhibited and/or sold. The dark tonalities Chase employs here reflect the influence of his study in Munich (1872–78), and they are neatly complemented by the natural tones of the mahogany panel the artist has allowed to remain bare as his background; such panels appear often and to excellent effect in Chase's work.

OP.151

Mother and Child (The First Portrait, Mother and Daughter, His First Portrait), 1887

Oil on canvas; 70 x 40 in. (177.8 x 101.6 cm)
Signed: Wm. M. Chase (l.r.)

The Museum of Fine Arts, Houston. Gift of Ehrich-Newhouse Gallery, New York

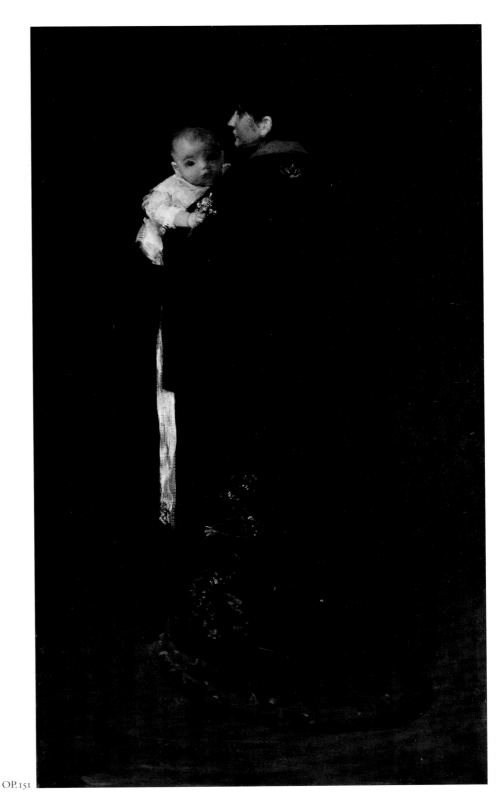

OP.151

OP.150

Exhibitions: **SAA '88 #16** as *Mother and Child* ("The American Artist's Exhibition," *Art Amateur* 18, no. 6 [May 1888]: 130, as *Mother and Child*); **ExUP '89 #53** as *Portrait: La Mere et L'enfant*; **BFAA '91** as *Mother and Child*; **PAA '91; StLEx '95 #202; AIC '97 #40** as *The First Portrait* [lent by the artist] (there is also a listing for *Mother and Child,* cat. #65, which is probably *Mother's Love,* ca. 1892 [OP.185]); **ISSPE '99,** not listed in catalogue, but mentioned in the Chase Memorial Exhibition as being exhibited there; **GBV&C '01** ("Portraits by Wm. M. Chase," *New York Times,* April 9, 1901, 9, as *Mother and Child*); **AAR '07 #9** as *Mother and Daughter*; **PAFA '08 #14** as *His First Portrait*; **BFAA '09 #14** as *His First Portrait* ("The Paintings by Mr. Chase," *Academy Notes* 4 [February 1909]: 144; *Times-Star,* October 13, 1909); **BPL '10; NAC '10 #15** as *His First Portrait*; **RAEx '11 #31** as *His First Portrait*; **MMA '17 #14** as *Mother and Child* [lent by Mrs. Chase].

This intimate painting depicts Chase's wife and their firstborn child, Alice Dieudonnée Chase (1887–1971). Alice holds a coral whistle and looks over the shoulder of her mother, who is dressed in a Japanese-inspired costume. This is one of a series of paintings Chase completed depicting his wife and their first child: *Mother and Child (Mother's Love),* circa 1892 (OP.185); *Feeding the Baby,* 1887 (OP.150); and *Happy Hours,* circa 1887 (see vol. 4). Although *Mother and Child* is a full-length portrait, Chase finished it particularly quickly. In an interview, he commented, "I painted that from top to bottom in a single sitting, a single afternoon, and when it was finished I was ready to retire" ([Chicago] *Tribune,* November 21, 1897, 39). Formally this painting is a study in tonal color harmonies as discussed by Chase's biographer Katharine Metcalf Roof: "The harmony is quiet and simple—blacks, low-toned whites, a touch of red, a note of smoky violet in the roll of the kimono at the feet, grayish figures on the black robe connecting the light tone of the baby's robe with the black ones, the intense note of the red in the neck-band of the kimono repeated more lightly in the handle of the baby's rattle and in the pattern on the violet border" (*The Life and Art of William Merritt Chase,* 283, facing p. 284, illus.). The painting was also illustrated in Kenyon Cox, "William M. Chase, Painter," *Harper's New Monthly Magazine* 28 (March 1889): 555, illus. p. 553 as *Mother and Child.* The work was mentioned in an article about the Bridgeport Library exhibition of 1910 ("Chase Collection an Admirable One," [Bridgeport, Conn.] *Daily Standard,* March 3, 1910, 3). The painting is further referenced in an article referring to an exhibition in Pittsburgh ("Recent Exhibition in Pittsburgh," *Art Amateur* [November 1891]: 146, as *Mother and Child*). Included on Peat's

1949 checklist of Chase's known work as *The First Portrait; Mother and Child,* and as being owned by the Museum of Fine Arts, Houston; Peat erroneously dates the work to 1886, though Alice Dieudonnée was not born until 1887.

OP.152

In the Garden, ca. 1887

Oil on canvas; 70 x 40 in. (177.8 x 101.6 cm)

Location unknown

Auctions: **Csale '87 #16** [purchased, Theron J. Blakeslee]; **FAAG '93 #78.**

There are no extant images of this work and its current location is unknown. The only description of the work is found in a *New York Times* review of an auction in which it was sold. The critic refers to *In the Garden* as a "bad title for a very charming figure of a young lady seated in profile against a flowered hanging. The paint is applied very thinly and with excellent decorative results" ("The Blakeslee Paintings," *New York Times,* March 31, 1893, 4), a description that could apply as well to Chase's *Portrait of a Lady in Pink,* circa 1889 (OP.167). Theron J. Blakeslee owned the Blakeslee and Company gallery on 665 Fifth Avenue in New York; in 1893 the gallery's entire inventory was liquidated, perhaps on account of financial pressures. The painting's large size suggests that Chase created it as an exhibition piece; however, there are no exhibition records for the work under this title.

OP.153

Fannita, ca. 1887

Oil on canvas; 15½ x 24½ in. (39.4 x 62.2 cm)

Location unknown

Auctions: **FAAG '93 #5.**

Chase's portrait *Fannita* was included in the New York auction of the Blakeslee and Company gallery inventory in 1893. There are no extant images of the work, but some sense of it is provided by a review of the auction, in which it is described as a "half-length [portrait] of a pretty young woman with an appealing face" ("The Blakeslee Paintings," *New York Times,* March 31, 1893, 4). There is no record of the

work having been exhibited during the artist's lifetime, though it is possible that it did appear somewhere under another title.

OP.154

Girl in Japanese Gown (The Japanese Gown), ca. 1887

Oil on canvas; 69 x 39 in. (175.3 x 99.1 cm)
There was an estate seal in red wax affixed to the back of the work for the estate auction (these wax seals have been invariably lost due to cracking and lifting).

Location unknown

Exhibitions and Auctions: **CI '10 #46** as *Girl in Japanese Gown*; **Csale '17 #193** as *The Japanese Gown* [purchased, Alfred Rose, $70].

The current location of this work is unknown. There is no extant image of the work, but a vivid catalogue entry written for it for the 1917 Chase estate sale describes it as follows: "Full-Length standing figure of a young woman of agreeable countenance, directly facing the front, wearing a yellowish-brown Japanese coat with a lime-green lining, and carrying a red fan which she holds in both hands in front of her with arms dropped at full length. The coat is thrown open, partly exposing the breasts and revealing a light buff skirt." Included on Peat's 1949 checklist of Chase's known work as *The Japanese Gown* (B), and as being formerly owned by Alfred Rose, New York.

OP.155

Portrait (Portrait of Miss H.; Portrait of a Lady in Brown), ca. 1887

Oil on canvas; 69¼ x 39½ in. (175.9 x 100.3 cm)
Signature not visible

Location unknown

Exhibitions: **SAA '87 #31** as *Portrait* ("The Society of American Artists," *Art Amateur* [June 1887]: 5); **IAA '88 #6** as *Portrait of Miss H.* [loaned by Mr. Hildreth, New York]; **IIEC '89 #90** as *Portrait of a Lady in Brown*; **PAA '91; CI '97 #17,** p. 9, illus. as *Portrait of Miss. H.* [lent by the artist].

The main visual record for this work is its illustration in the catalogue for the Second Annual Exhibition at the Carnegie Institute in 1897. The only other extant image of the painting is

OP.155

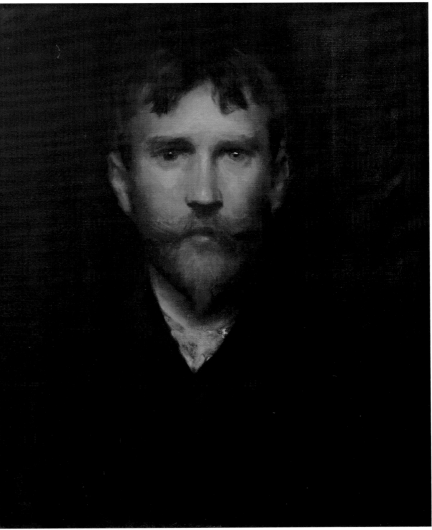

OP.156

in a photo that was part of an installation view of Chicago's Seventeenth Annual Inter-State Industrial Exposition held in 1889. Unfortunately, since this Chase painting was a study in browns, it is difficult to discern the details of the composition, but it depicts a woman standing, facing slightly right, wearing gloves and a bowler hat, and holding her closed umbrella in two hands across her waist. The painting was very well received by contemporary critics, as evinced in this review of the work when it appeared with two other Chase portraits at the Society of American Artists exhibition of 1887: the painting, "that of a lady in a walking dress[,] is one of the best he has ever painted. The color scheme is a sombre one, only dark browns being used, but the action and force of the figure and the rendering of texture cannot be too highly praised" (*New York World,* April 23, 1887, 2, col. 5). Another critic refers to the subject "in a walking costume, holding her umbrella in one of those natural spirited poses" (*Art Amateur,* June 1887, 5).

OP.156

Robert Blum, 1888

Oil on canvas; 21 x 17 in. (53.3 x 43.2 cm)
Signed: Chase (c.r.)
Dated (verso): 1888

National Academy of Design, New York

Exhibitions: **NAC '16 #86.**

There are two portraits of Robert Frederick Blum (1857–1903): this portrait, which was painted to fulfill Blum's membership obligation upon his election as an associate of the National Academy of Design in 1888 (the diploma presentation date was March 18, 1889), and another portrait of Blum, his arm resting on the back of a chair, ca. 1888 [Cincinnati Art Museum]. This work is included in Peat's 1949 checklist of known work as being owned by the National Academy of Design.

OP.157

Portrait of Robert Blum, ca. 1888

Oil on canvas; 24 x 19½ in. (61 x 49.5 cm)
Signed (on back of chair): Wm. M. Chase
Inscribed (verso): Robert Blum / by W. M. Chase

Cincinnati Art Museum, Ohio. Museum Purchase: Annual Membership Fund (1914.34)

Exhibitions: IIEC '89 #132 as *Portrait of Robert Blum, Esq.*; AAG '90 #200 as *Portrait of R. Blum*; BFAA '91 (no catalogue has surfaced for this exhibition; however, an 1891 review [unidentified Buffalo, New York, newspaper clipping] mentions Chase's portrait of Robert Blum); CAA '95 #196 as *Portrait of Mr. Robert Blum*; **New York, Berlin Photographic Gallery, "Memorial Loan Exhibition of the Works of Robert Frederick Blum," '13 #134** (illus. frontispiece of catalogue); CM '14 #6; ABAC '48 #8.

If any one artist could be described as a best friend to Chase it would have to be Robert

OP.157

Frederick Blum (1857–1903). Lifelong friends, they met each other around 1879, after which they both frequented the home of Julius Gerson, manager of the art department of Louis Prang and Company, his son and three daughters (one of whom, Alice, eventually became Mrs. Wm. M. Chase). Chase and Blum traveled to Spain in 1882 and to Holland in 1884. Both were instrumental in establishing the Society of Painters in Pastel. When Blum became an associate of the National Academy of Design in 1888, he was obliged to present a portrait of himself to the organization, and Chase painted the portrait. Chase likely painted this second portrait of his friend at the same time, which he kept in his personal collection until offering it (for sale) to the Cincinnati Art Museum in 1914. The work first appeared in Clarence Cook, *Art and Artists of Our Time* (New York: Selmar Hess, 1888), illus. p. 280 (unsigned). It next appeared in an article on Chase, Wm. J. Baer, "Reformer and Iconoclast," *Quarterly Illustrator* 2, no. 6 (1894): illus. p. 137 (unsigned). This article was reproduced in a publication of the Eastern Art League, *Essays on American Art and Artists* (New York: Temple Court, 1896), illus. p. 238. In 1915 the work was reproduced in Lorinda Bryant, *What Pictures to See in America* (New York: John Lane Co., 1915), illus. facing p. 300, as being by John White Alexander. This mistake, no doubt helped by the fact that the image was still unsigned, was repeated in Bryant's 1917 book, *American Pictures and Their Painters* (New York: John Lane Co., 1917), illus. facing p. 168. It is likely that Bryant was using an old photograph of the painting before Chase signed the work, most likely when he sold it to the Cincinnati Art Museum in 1914—just how she came to credit the painting as being by John White Alexander is a mystery. The painting is also reproduced, in its unsigned state, in Katharine Metcalf Roof's 1917 biography, and is included in Peat's 1949 checklist of known work. The pose is based on Frans Hals's portrait of Isaak Abrahamsz Massa [Art Gallery of Ontario].

OP.158

Elsie Leslie Lyde as "Little Lord Fauntleroy," ca. 1888

Oil on canvas; 69¼ x 39½ in. (175.9 x 100.3 cm)
Signed: Wm. M. Chase (l.r.)

Thyssen-Bornemisza Collection, Madrid. 1981

Exhibitions: **SAA '89 #31** ("The Society of American Artists. Eleventh Exhibition," [New York] *Sun*, May 19, 1889, 4; "The Society of American Artists," *Art Amateur* 21, no. 2 [July 1889]: 27); **IIEC '89 #85;**

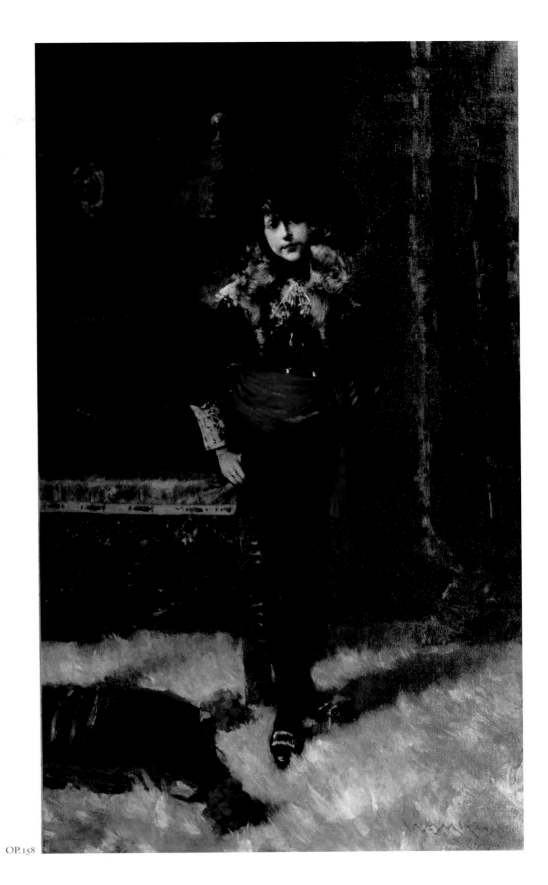

OP.158

StLEx '90 #166 as *Lesie* [*sic*] *Leslie Lyde* (*Art Amateur* [July 1890]: 3); **IAA '90; ULC '10** ("Actresses' Pictures at Union League," *New York Times*, January 14, 1910, 8).

In 1883 English-born American author Francis Hobson Burnett (1849–1924) published "Little Lord Fauntleroy" in serial form in *St. Nicholas Magazine,* with illustrations by Reginald B. Birch (1856–1943). In 1886 the story was published in book form to great popular success, and in 1888 it was staged in London and, later that year, in Boston. In the latter production, the lead role was played by seven-year-old Elsie Leslie—her stage name, as her surname was Lyde

(the part was eventually played by both girls and boys—in one traveling production, ten-year-old Buster Keaton played Little Lord Fauntleroy). The play moved to Broadway in December 1888 where it became a favorite of theatergoers and, much to the chagrin of upperclass boys, Little Lord Fauntleroy outfits became the rage. Certainly the illustrations of Burnett's book by Birch were extremely important in establishing the "Fauntleroy look." The style is described in *Godey's Lady's Book and Magazine* (September 1889, 244) as being "usually made of black velvet or velveteen, with a broad collar and cuffs of Irish point lace, with a sash of silk passed broadly around the waist and knotted on one side."

This basically describes Chase's portrait of the young Broadway star if one adds in her blonde ringlets and a large plumed hat. The plumed hat was actually Miss Lyde's own invention and became a standard prop in the play ("Elsie Leslie Lyde:'My Stage Life,'" *Cosmopolitan Magazine* 6 [February 1889]: 375). Chase attended the opening of the Broadway production of "Little Lord Fauntleroy" in December 1888, which probably sparked his interest in painting a portrait of Lyde. Chase asked a mutual friend W. H. Patten to write to Lyde's mother proposing the idea of a portrait and saying that if she liked the finished product the artist planned to give it to her. Arrangements were made, and Lyde modeled for Chase in his Tenth Street Studio. Chase presented Elsie with the portrait with the proviso that he could borrow it back for exhibitions. It was first exhibited in the 1889 exhibition of the Society of American Artists, where a critic commented, "For a so-called decorative portrait nothing could be better in scheme; and it is impossible to find a deficiency or pick a flaw in the audacious brushwork. No one bit is better or worse than any other; the whole thing is a marvel of dexterous, sympathetic brushwork, and yet the little face is not swamped by its surroundings, but holds the eye as it should, as the thing for which all the rest exists" ([New York] *Sun,* May 19, 1889, 4). Another reviewer of the Society of American Artists exhibition wrote, "Mr. Chase's Elsie Leslie Lyde as 'Little Lord Fauntleroy' standing by a big baronial chair is a more satisfactory portrait than any he has done in a long while" (*Art Amateur,* July 1889, 27). The painting hung for many years in the lobby of the Broadway Theater, on loan from Elsie Leslie Lyde, who eventually gave the painting to Mrs. Burnett, author of the play that made her famous. Chase enjoyed painting the portraits of performers and his works include portraits of the actresses Minnie Maddern Fiske and Hilda Spong, as well as professional dancers such as Carmencita (on the latter, see OP.172).

OP.159

Mrs. Union Samuel Betts Lawrence, ca. 1888

Oil on canvas; 28¼ x 19 in. (71.8 x 48.3 cm)

Location unknown

This portrait depicts Mrs. Union Samuel Betts Lawrence (Elizabeth Heart Jackson [b. 1842]). Chase also rendered a masterful portrait of the sitter's daughter, Angelica Hamilton Lawrence (*Portrait of Miss L. [Portrait of Miss Lawrence],* 1892 [OP.189]). The style and technique of the present work are characteristic of Chase's works of the mid- to late 1880s. In the summer of 1885, Chase visited Whistler in London, at which point the two artists painted each other's portraits. Under the influence of Whistler, Chase's

own approach to painting changed considerably, especially with regard to his application of paint. Although Chase's paintings of the period still display his bravura brushwork, the medium itself is used more sparingly and delicately at a time that he was also exploring the possibilities of pastel and watercolor. Although a portrait, in the sense that the sitter is clearly identified, Chase's approach to this work is predominantly an artistic one. Presumably this was a portrait commission, and the detailed concern for capturing the sitter's likeness is evident in Chase's careful rendering of Mrs. Lawrence's face and hands, which are more fully developed than the rest of the composition. However, it is in the treatment of the sitter's dress that Chase the artist fervently manifests his technical agility. The frenzied strokes of his brush are balanced only by the solid treatment of his sitter's face and the bold

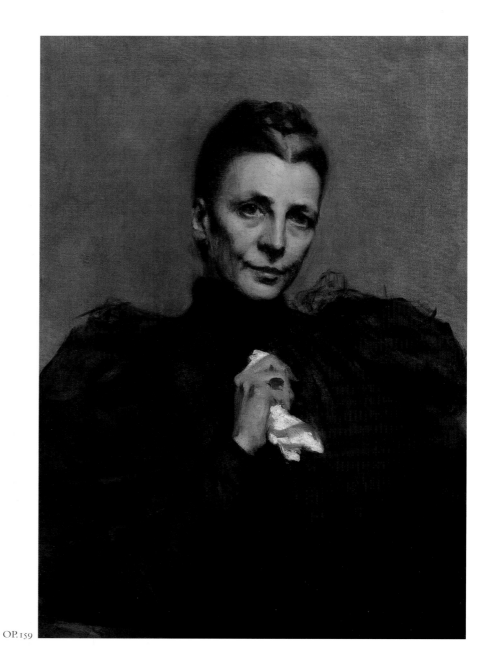

OP.159

highlighting of her hand grasping a white hand-kerchief. Although the painting may appear to be unfinished to the untrained eye, it is likely a work that Chase considered complete. This is suggested by the fact that the treatment of the background (the last area of the painting gener-ally addressed by the artist) appears to be fully developed. Also, highlights on the ear, eye, nose, and lips indicate finishing touches. The strong probing character of Chase's sitter is revealed in her expression as she gazes intently yet amusedly upon the viewer. Since the work presumably was commissioned and went into private hands, it is not surprising that it was never exhibited during Chase's lifetime. It is not clear, however, why he did not sign the work.

OP.160

Portrait of Little Miss K., ca. 1888

Physical properties unknown

Location unknown

Exhibitions: **NAD-A '88 #89** [lent by Mr. Freer].

The current location of this work is unknown. Mr. Freer is likely fellow artist and friend of Chase's Frederick Warren Freer (1849–1908) or Charles Lang Freer, a Detroit businessman and art collector who would eventually open the Freer Gallery of Art.

OP.161

Portrait of Mrs. C. (Portrait of a Lady in Black), ca. 1888

Oil on canvas; 74 x 36 in. (188 x 91.4 cm)
Signed: Wm. M. Chase (u.l.)

The Metropolitan Museum of Art, New York. Gift of William Merritt Chase, 1891 (91.11)

Exhibitions: **NAD-A '88 #315** as *Portrait of Mrs. C.* [lent by Mrs. C] ("Review of Seventh Annual Autumn Exhibition at the National Academy of Design," *Art Amateur* [January 1889]: 29); **ExUP '89 #55** [lent by the artist]; **StLEx '90 #180** [lent by the artist]; **AAG '90 #207** [lent by the artist] ("American Paintings," *New York Times* [April 10, 1890]: 4); **BFAA '91** (no catalogue).

This portrait depicts Mariette Benedict Cotton (1868–1947), a Chase pupil who also posed for his painting *Portrait of a Lady in Pink* (OP.167). Ms. Cotton is shown wearing a fashionable din-ner dress characteristic of the late 1880s with its

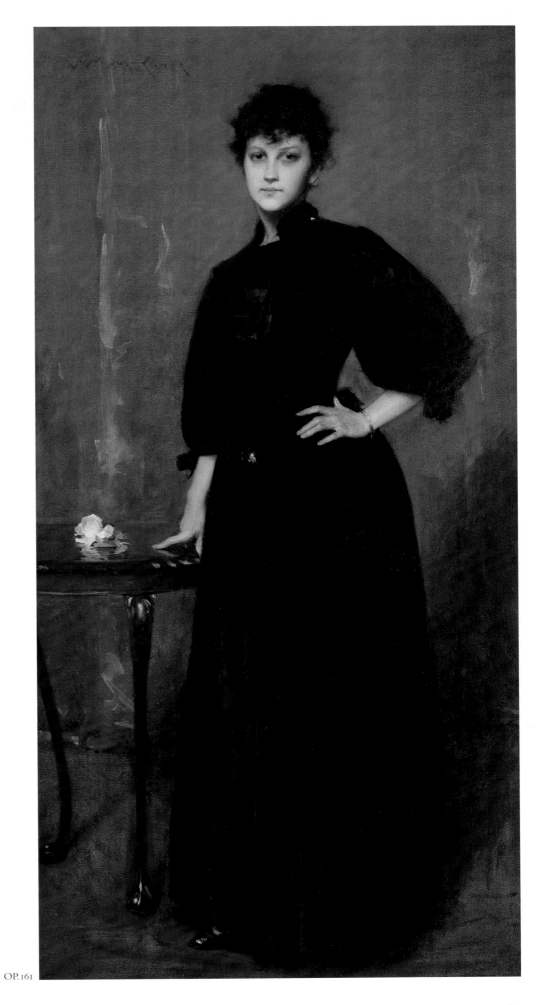

OP.161

reduced bustle and puffy sleeves. She stands with one hand on her waist and the other on a Colonial Revival table with a rose placed on top. The composition enabled Chase to demonstrate his mastery of both portraiture and still life. The *Portrait of Mrs. C.* was not commissioned, and Chase recalls the story of how he painted Ms. Cotton in his article entitled "How I Painted My Greatest Picture." He writes, "One morning a young lady came into my Tenth Street Studio, just as I was leaving for an art class in Brooklyn. She came as a pupil but the moment she appeared before me I saw her only as a splendid model. Half way to the elevated station I stopped, hastened back, and overtook her. She consented to sit for me; and I painted that day without interruption, till late in the evening" (William Merritt Chase, "How I Painted My Greatest Picture," *Delineator* 72 [December 1908]: 967). Chase's painting was certainly conceived as an exhibition piece and was shown frequently. It was first exhibited in the Seventh Annual Autumn Exhibition of the National Academy of Design, where a critic took note of it, writing, "Mr. Chase, the President of the Society of American Artists, makes much more of a show; in the South Gallery is his full-length portrait of Mrs. Leslie Cotton, in a black dress, narrow in the skirts and very full in the sleeves, with one hand on her hip and the other on the slim-legged table beside her" (*Art Amateur,* January 1889, 29). Another reviewer added that, "among the portraits, the best is that of Mrs. Leslie Cotton by William M. Chase, presumably a good likeness, but certainly painted in a most charming fashion. At a distance the outline of the waist and swelling skirts makes a contour of questionable beauty, but a nearer view reveals in the painting of the hands and face, more especially the hands, works of the greatest delicacy and distinction ("The Autumn Academy," *New York Times,* November 19, 1888, 4). The painting was listed as being owned by Mrs. C., but rather than referring to Mrs. Cotton, it was likely Mrs. Chase who lent the work given that in subsequent exhibitions the owner was listed as "the artist" (Mr. Chase). Also, it was Mrs. Chase who would be listed as giving the work to the Metropolitan Museum of Art in 1891. The work was awarded a second class medal at the Paris Exposition of 1889 (Wendy A. Cooper, "Artists in Their Studios," *Godey's Magazine* [March 1895]: 295 as *Lady in Black*). The next year, 1890, Chase exhibited his *Portrait of Mrs. C.* at the group exhibition held at the American Art Galleries, New York, and received positive accolades. In a review, one critic wrote, "Of the portraits that of 'Mrs. C-' in black, standing by a small table on which a rose is laid is perhaps the best"

(*Art Amateur* [March 1890]: 113). Chase had forty-seven works in the exhibition, and a reviewer for the *New York Times* commented upon this, writing, "In quality of work as well as quantity Mr. William M. Chase stands first in this very attractive display. The finest canvas is 'Portrait of Mrs. C.', a slender lady in black standing by a small mahogany table, on which lies a mermet rose. The background is of a greenish neutral tint and the fair lady looks gravely from the canvas, with one hand on her hip and the other resting lightly on the table. This latter, the black stuff of the dress, and the rose are delightfully painted, the rose being particularly well done. There is great charm in the face with its dark undersetting of the eyes and small fixed mouth" ("American Paintings," *New York Times* [April 10, 1890]: 4). In 1891 the work was exhibited at the Buffalo Fine Arts Academy, where, although there was no catalogue published, it was identified in a local review as having won a Silver Medal at the Paris Salon. The year 1891 also marks Mrs. Chase's gift of the portrait to the Metropolitan Museum of Art. In the *Art Amateur* of June 1891 the writer mentions Chase's *Lady in Black* as being among the new paintings on display at the Metropolitan Museum of Art (4). After the painting became part of the museum's collection, it does not appear to have been exhibited again. However, the work was illustrated frequently in books and periodicals including J. Walker McSpadden, *Famous Paintings of America* (New York: Thomas Crowell and Co., 1907), 342; C. H. Fiske, *Chautauguan* 50 (March 1908): 75; *Palette and Bench* 1 (October 1908): 3; L. Mechlin, *Studio* 48 (December 1909): 186; "American Figure Painters," *International Studio* 39 (January 1910): 186; W. S. Howard, *Harper's Monthly Magazine* 121 (September 1910): 590, an engraving after the painting executed by Henry Wolf; J. Howard, *Arts and Decoration* 1 (June 1911): 339; J. W. Alexander, *Art and Progress* 3 (May 1912): 577; and D. Phillips, "William M. Chase," *American Magazine of Art* 8, no. 2 (December 1916): 47. *Portrait of Mrs. C.* was also mentioned in articles in *Art News* (December 31, 1904): 2; *Art and Progress* 5 (1914): 346; and "Art, W. M. Chase," *Nation* 103, no. 2679 (November 2, 1916): 428. Included on Peat's checklist as *Lady in Black*.

OP.162

Portrait of Mrs. G., ca. 1888

Oil on canvas; 52 x 39 in. (132.1 x 99.1 cm)

Tim and Cissy Hubbard (by descent in the family), Ashtablula, Ohio

Exhibitions: **NAD '88 #337** [lent by the Lady] ("National Academy of Design 63rd Annual Exhibition," [New York] *Daily Tribune,* March 31, 1888, 4–5; "National Academy of Design 63rd Annual Exhibition," [New York] *Sun,* April 1, 1888, 16; "The Academy Exhibition," *Nation,* April 19, 1888, 330–31; "Spring Exhibition of the Academy and the Society," *Art Review* 3, no. 1 [July–August 1888]: 31).

This painting depicts Cornelia Rogers Huntington Greer (b. 1836) and was likely commissioned given that Chase also completed a portrait of Mrs. Greer's son Colbert (b. 1858) (OP.145). This painting was originally dated circa 1912 based on information provided by descendants of the sitter. However, several reviews of a work entitled *Portrait of Mrs. G.* that was exhibited once during the artist's lifetime—at the Spring Exhibition at the National Academy of Design in 1888—suggest an earlier date, as they seem to be describing the present portrait of Mrs. Greer. A critic for the *New York Daily Tribune* writes, "Mr. Chase's portrait of an elderly lady seated in a fur-trimmed blue robe, seen against hangings of a very pale blue, is a picture which has earned its honorable place not only by the cleverness of coloring, but also by the firmness and strength of the modeling" (*New York Daily Tribune* [March 31, 1888]: 4–5). A writer for the New York *Sun* comments, "More should be said for the portrait of an elderly lady in a dark blue gown against a curtain of lighter blue" ([New York] *Sun,* April 1, 1888, 16). A rave review and further description of the work is given in the *Nation,* which describes it as "dignified, of excellent style, and showing the artist's appreciation of quiet tones and his ability to harmonize the figure and costume, with the accessories, in a complete ensemble at its best" (*Nation,* April 19, 1888, 331). Finally, another critic discussing the exhibition writes that the *Portrait of Mrs. G* has been "treated with an eye to color likewise, but in a much quieter and more wholesome manner. There is more of the character of the sitter about it, and a reasonable concession to the needs of good portrait painting" (*Art Review,* July–August 1888, 31). Further supporting a date circa 1888 is that Chase painted the portrait of Greer's son Colbert circa 1886; it seems likely that he would have executed both portraits at around the same time. A further consideration is the age of the sitter, who would have been seventy-six years old in 1912 (the original dating), though in the portrait she appears to be much closer to the fifty-two years of age she would have been in 1888.

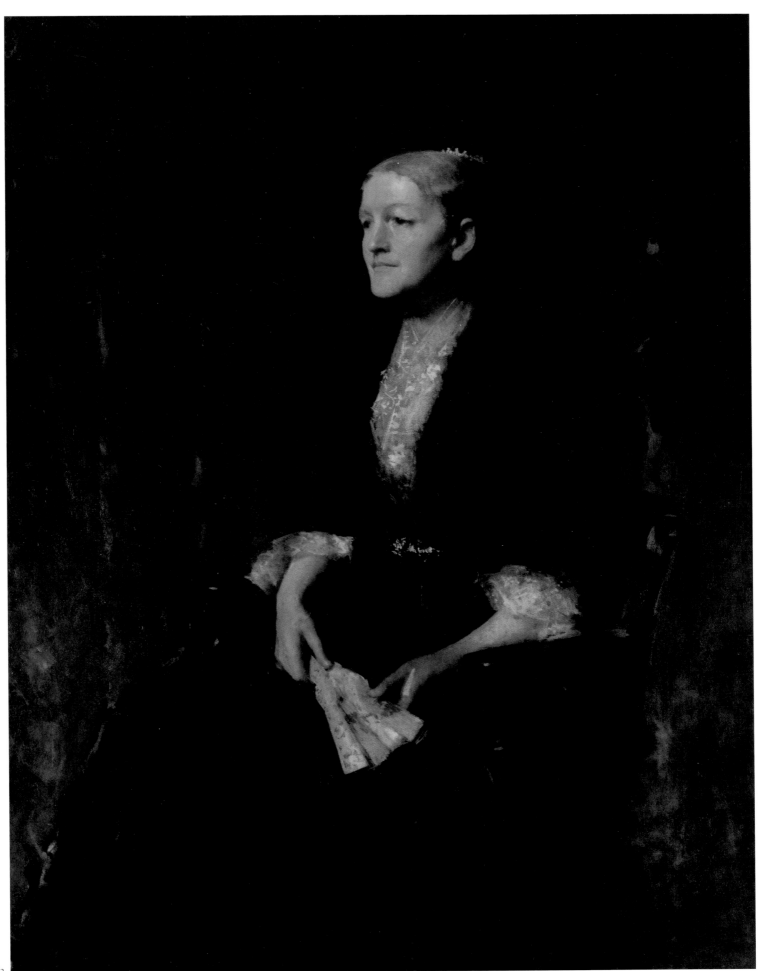

OP.162

OP.163

A Doge's Daughter, ca. 1889

Oil on canvas; 21½ x 15¼ in. (54.6 x 38.7 cm)

Location unknown

Exhibitions and Auctions: **IIEC '89 #78**; **AAG '90 #212** [lent by the artist]; **Csale '91 #30** [purchased, Mr. T. M. Lichtenauer]; **CAL '92 #55**; **AAG '13 #129** [purchased, Mr. Richmond, $65].

The current location of this work is unknown. It does appear in a photograph of an installation view of the 1889 Chicago Industrial Exposition.

OP.164

A Mother's Joy, ca. 1889

Medium/support/dimensions unknown

Location unknown

Exhibitions and Auctions: **SAA '89 #37** as *A Mother's Joy* [lent by the artist]; **IIEC '89 #91**; **StLEx '90 #137** [lent by the artist]; **AAG '90 #198** [lent by the artist]; **Csale '91 #64** [purchased, Franklin Murphy, $190].

There are no descriptions or illustrations of this painting, but it is likely that it depicts Alice Gerson Chase and her daughter Alice Dieudonnée. The date for the work may be earlier than 1889 since Alice Dieudonnée was born in 1887, but the former date was selected given that it marks the first exhibition record for the painting. It has been suggested that the present painting is the same work as *Feeding the Baby,* 1887 (OP.150), which does not appear to have been exhibited until 1907 at the Buffalo Fine Arts Academy exhibition. It is possible that the work was sold at the 1891 auction and then again became part of Chase's collection sometime prior to 1907, whereafter he might have retitled the painting. *Feeding the Baby* is, however, a relatively small work, measuring 21¼ by 14¾ inches, and likely would not have commanded the price ($190) paid for it at the Chase sale of 1891. See also *Mother and Child (The First Portrait, Mother and Daughter, His First Portrait),* 1887 (OP.151), *Mother and Child (Mother's Love),* circa 1892 (OP.185), and *Happy Hours,* circa 1887 (see vol. 4).

OP.165

A Turkish Woman, ca. 1889

Medium/support/dimensions unknown

Location unknown

Exhibitions: **StLEx '90 #172**; **AAG '90 #191**.

This work has not been located and there is no extant image; however, it was described in a contemporary review as "a girl in vermillion against a carmine background" ("Minor Exhibitions," *Art Amateur* [March 1890]: 113).

OP.166

Merritt, 1889

Oil on panel; 9½ x 6¼ in. (24.1 x 15.9 cm)
Titled and dated: Merritt / Aug 13 / 89

Jane Voorhees Zimmerli Art Museum, Rutgers, the State University of New Jersey

Auctions: **Csale '17 #169** (fully described).

While it might be assumed that this portrait is of Chase's firstborn son, William Merritt Chase, Jr., he was not born until June 5, 1890—dying shortly after his first birthday, July 4, 1891. The only possible Chase offspring is therefore Koto Robertine Chase, born January 5, 1889. On August 13 Koto would have been seven months old. The title "Merritt," if indeed that is the title and not some odd signature variant, is still confusing and unexplainable.

OP.167

Portrait of a Lady in Pink (Lady in Pink, Woman in Pink), ca. 1889

Oil on canvas; 70 x 40½ in. (177.8 x 102.9 cm)
Signed: Wm. M. Chase (u.l.)
Labels verso: World's Columbian Exposition; Chicago Exposition, 1889

Museum of Art, Rhode Island School of Design, Providence. Gift of Isaac C. Bates, April 1894

Exhibitions: **NAD '89 251** [lent by the artist] (Charles M. Kurtz, *National Academy Notes* [New

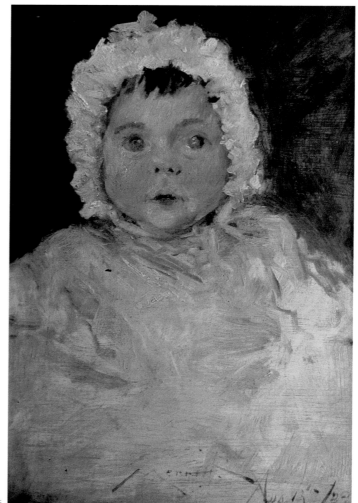

OP.166

York, 1889], 7, illus., 101); **IIEC '89 #80** [lent by the artist]; **StLEx '90 #182** as *Lady in Pink* [lent by the artist]; **AAG '90 #204** as *Portrait of a Lady in Pink* [lent by the artist] ("Review of Exhibition held at the American Art Galleries," *Art Amateur* [April 17, 1890]: 113; "American Paintings," *New York Times* [April 10, 1890]: 4); **CWCE '93 #251** as *Lady in Pink* [lent by the artist]; **StLEx '95 #205** as *The Lady in Pink*; **CAA '95 #205**; **NADLEx '95 #21** [lent by RISD]; **RISD '97 #16** as *Woman in Pink* [lent by RISD]; **RISD '13 #16** [lent by RISD].

This is the second of two portraits completed by Chase depicting Mariette Benedict Cotton (1868–1947), one of Chase's students. She would later go on to become a well-known portrait painter in her own right. Chase depicted her in the painting *Portrait of Mrs. C. (Portrait of a Lady in Black)* (OP.161); neither of these works was commissioned. *Portrait of a Lady in Pink* was certainly envisioned as an exhibition piece. It was shown frequently and received positive reviews. The *Lady in Pink* was complimented for Chase's "clever handling, harmonious coloring and a certain air of refinement" (*Art Amateur*, March 1890, 113). A critic for the *New York Times* offered a mixed review of the work, however, expressing displeasure with Chase's depiction of the face, noting the "rather grey-green [of the flesh tints] in contrast with the dress, which is superbly painted" ("American Paintings," *New York Times*, April 10, 1890, 4). Another review referred to the work as "a strong, suggestive piece of work, showing the painter's wonderful facility in marked degree, particularly in the artistic treatment of the dress" (Charles M. Kurtz, *National Academy of Design "Notes"* [New York: 1889], 101).

The work would seem to have been informed by Thomas Dewing's *Lady in Yellow*, 1888 [Isabella Stewart Gardner Museum, Boston], which Chase would have certainly seen in the 1888 Annual Exhibition of the National Academy of Design. Chase must have been very impressed by the work because he later had a reproduction of *Lady in Yellow* hanging on the wall of his Shinnecock Hills studio in Long Island. In a photograph from the Chase Archives, Dewing's *Lady in Yellow* may be seen hanging behind Chase as he sits in his studio. Similarities are evident in the profile views of the two women and in their elegant ball gowns. More than portraits, these works are explorations of form and color reflecting Whistler's aesthetic principle of art for art's sake. The painting was purchased by Isaac Comstock Bates (a prominent Providence businessman integrally involved in the founding of the Rhode Island School of Design and its museum collection) sometime in 1893, presumably after the World's

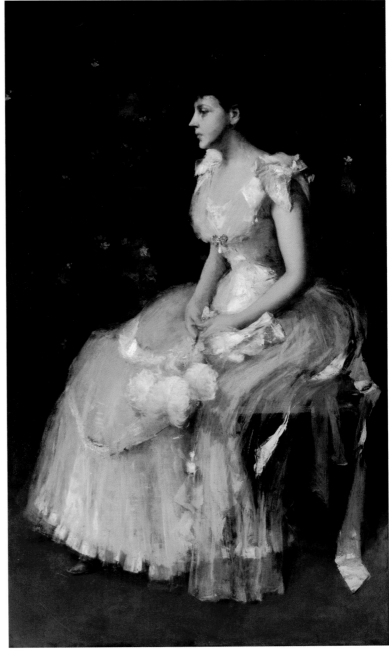

OP.167

Columbian Exposition in Chicago because the work was shown there with a loan attribution to the artist (Huger Elliot, "The Rhode Island School of Design and Its Museum," *Art and Progress* 1 [August 1910]: 297, illustrated). Bates would go on to serve as vice-president, president, and eventually trustee of the school. The selection of the work for the World's Columbian Exposition is mentioned in "Pictures Accepted in New York," *Art Amateur* (March 1893): 116, as *Portrait of Mrs. Leslie Cotton*. This portrait is included on Peat's 1949 checklist of Chase's known work as *Woman in Pink,* and as being owned by the Museum of Art, Providence, Rhode Island.

William Charles Le Gendre

Oil on canvas; 49½ x 30⅝ in. (125.7 x 77.8 cm)
Signed: Wm. M. Chase (l.l.)

Location unknown

Exhibitions: **NAD '90 #345** [lent by the Calumet
Club]; **NAC '10 #33A** [lent by the Calumet Club].

The sitter, William Charles Le Gendre (1856–
1926), was president of the Calumet Club and it
is this association that, no doubt, led to the por-
trait either being given to the club or commis-
sioned by the club. Mr. Le Gendre was the
assistant manager of the banking house Brown
Brothers in New York. During World War I he
was an advisor to President Wilson, and in 1915
he was a delegate to the Pan American financial
conference in Washington, D.C. He was also
treasurer of the American Social Science Associ-
ation, and a member of the Reform and Union
Club in New York. The painting was mentioned
in a review of the National Academy of Design
exhibition of 1910, "The Academy Exhibition,"
Art Amateur (December 1889).

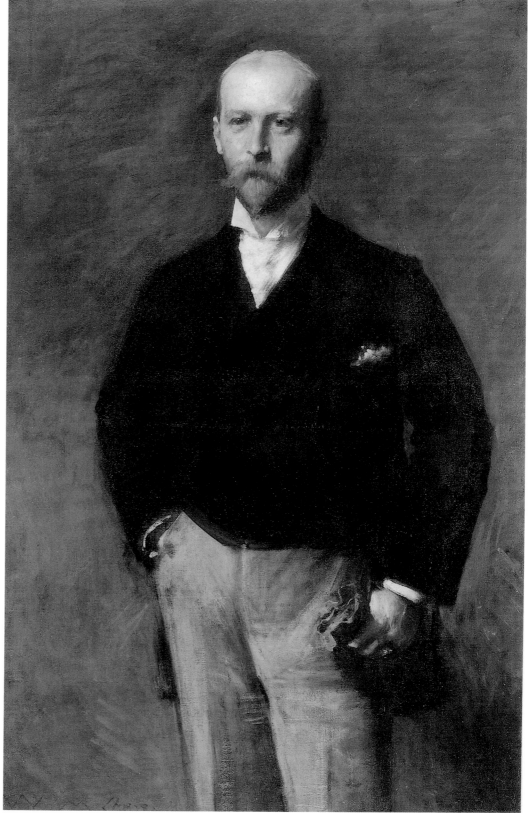

OP.168

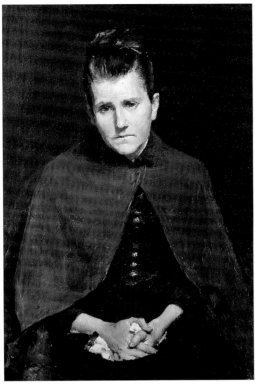

OP.169

OP.170

OP.169

Well, I Should Not Murmur, For God Judges Best, ca. 1890

Oil on wood panel; 12¼ x 7⅞ in. (31.1 x 20 cm)

Fine Arts Museums of San Francisco, Calif. Gift of Mr. and Mrs. John D. Rockefeller III (1979.7.28)

Exhibitions and Auctions: **AIC '90 #36** [lent by the artist]; **SAA '90 #42** [lent by the artist] ("Paintings and Pastels by Chase," *New York Times,* March 1, 1891, 12); **Csale '91 #50,** purchased by Charles Pepper Hovey of Concord, Mass.

This painting is said to depict Chase's mother, Sarah Swaim Chase (1825– ca. 1920), but this assertion seems dubious when one compares this work with Chase's portrait of her completed in 1892 (Op.190). There are records of this work being exhibited by Chase several times under the title *Well, I Should Not Murmur, For God Judges Best.* In a review of the Society of American Artists exhibition of 1890, the work was referred to as a "gray, strong study of the figure of a mourning woman" ("The Society of American Artists Exhibition," *Art Amateur* [June 1890]: 3). A writer for the *New York Times* described the work as "a widow with hands clasped in her lap and the hair pushed back from the forehead," and saw it as expressing "emotion of the painful sort" (*New York Times,* March 1, 1891, 12).

OP.170

Portrait of Mrs. Chase, ca. 1890

Oil on canvas; 17 x 15 in. (43.2 x 38.1 cm)
Signed: Chase (u.r.)

Hirshhorn Museum and Sculpture Garden, Smithsonian Institution, Washington, D.C. Bequest of Joseph H. Hirshhorn, 1981

This painting depicts Alice Gerson Chase (1866–1927). The signature "Chase" appears in the upper right-hand corner of the picture, but it was probably added after Chase's death given that the work is listed in Peat's 1949 checklist as being unsigned. There is a notarized photo of the work in the collection of the Frick Art Reference Library, New York, which reads, "This was painted by my husband, an interestingly painted head / November 25, 1925," signed Mrs. Wm. M. Chase. Included in Peat's 1949 checklist as *Portrait of Mrs. Chase* (E), and as being owned by Albert R. Jones, Kansas City, Missouri.

OP.171

Portrait of Mrs. C. (Portrait of Mrs. Chase; Portrait of Mrs. X; Mrs. X; Mrs. Z), ca. 1890

Oil on canvas; 72 x 48 in. (182.9 x 121.9 cm)
Signed: Wm. M. Chase (l.l.)

Carnegie Museum of Art, Pittsburgh, Pa. Purchase, 1910 (09.6)

Exhibitions: **AAG '90, possibly #202** as *Portrait of Mrs. X* [lent by the artist]; **PAFA '92, possibly #30** as *Portrait of Mrs. X (Lady in Black)* [lent by the artist]; **PAFA '94 #55** as *Mrs. X* [lent by the artist]; **NADLEx '94, possibly #69** as *Mrs. X* or **#70** as *Mrs. Z* [lent by William M. Chase, Esq.] ("Portraits of Women: Concluding Notice," *Art Amateur* [January 1895]: 45); **CAA '95, possibly #201** as *Portrait of Mrs. X;* **AIC '97 #47** as *Portrait of Mrs. C* [lent by the artist]; **SAA '02, possibly #62** as *Mrs. X;* **CAA '09 #11** [lent by the artist]; **CI '09 #44,** illus. as *Portrait of Mrs. C.* [lent by the artist]; **NAC '10 #28** [lent by Mr. Chase] (James William Pattison, "The Awarding of Honors in Art," *Fine Arts Journal* 23 [August 1910]: 81, 84, illus.); **PPIE '15, #3750** as *Portrait of Mrs. C.* [lent by the Carnegie Institute, Pittsburgh, Pa.]; **MMA '17 #24.**

Alice Gerson Chase (1866–1927) was one of her husband's favorite models. In this case, Chase captures her in grand scale in an elegant pose seated in a chair looking directly out at the

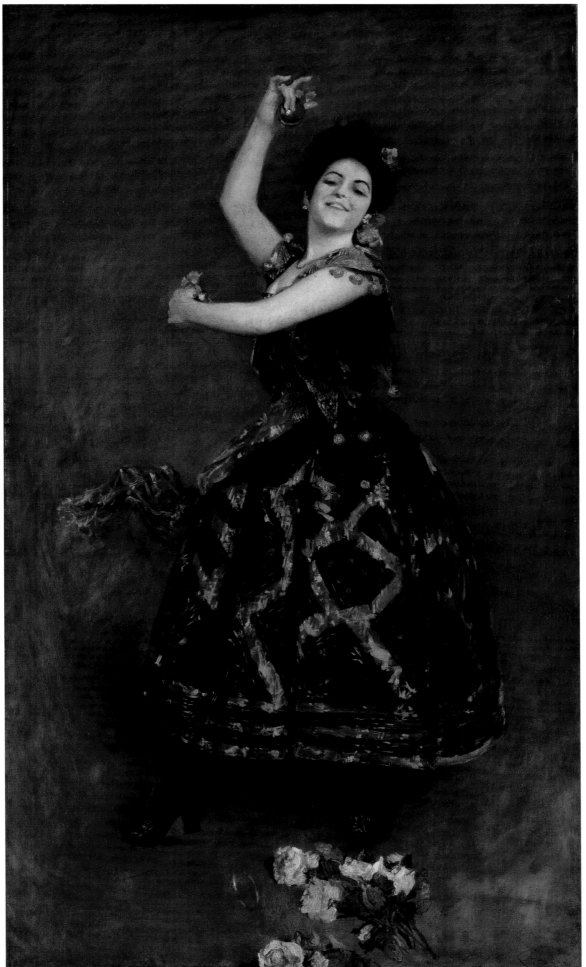

viewer. She wears a simple black evening dress draped with an opera cape around her shoulders and her opera glasses in her lap. The harmony of color and composition of the work are Whistler-esque, as is the way in which the forms emerge from a deep, dark background. It is now known that this is a *Portrait of Mrs. C. (Portrait of Mrs. Chase),* and there are records showing that it was exhibited as such beginning in 1909. However, since Chase painted the work around 1890, it seems likely that he would have exhibited such a showpiece earlier. A description of a work entitled *Portrait of Mrs. X* exhibited in 1894 at the National Academy of Design, New York, suggests that he did exhibit this portrait prior to 1909: "His *Portrait of Mrs. X* seated is . . . to be remarked especially for the careful proportioning of background to figure. The lady wears a black dress; a heavy fur mantle, lined with dull pink, is thrown back from her figure; a touch of red appears in her hair, an edge of white skirt beneath the black dress; the background is dark green and the floor cloth dull red" (*Art Amateur,* January 1895, 45). To make matters more confusing, a *New York Times* review of the same exhibition seems to be describing this work also, but refers to it as *Mrs. Z.* The critic writes of "Chase's portrait of *Mrs. Z.,* in black, with green cloak trimmed with fur, black eyes and hair ornamented with a red flower, on a dark-green background. The figure is seated, and faces one with a profoundly poetic expression. The simplicity of the work is admirable, and its effect is charmingly impressive" (*New York Times,* November 2, 1894, 8). Unfortunately, we cannot be certain which reference is correct. In addition, it is difficult to ascertain if the other references to both earlier and later exhibitions of a *Mrs. X* and a *Mrs. Z* are also portraits of *Mrs. Chase* because the artist may have used that title for several different works.

In December 1908, John W. Beatty (1850–1924), first director of the Carnegie Institute, visited an exhibition at the Corcoran Gallery in Washington, D.C., and greatly admired two paintings by his friend Chase. Returning to Pittsburgh, he immediately drafted a letter to Chase and extended a "special invitation" to exhibit these two paintings, *Portrait of Mrs. C.* and *Portrait of a Young Girl,* at the next Carnegie International. Beatty concluded his letter: "They are both fine pictures, and I should like our people to see them" (J. Beatty to W. Chase, Archives of American Art, Smithsonian Institution, Washington, D.C., December 11, 1908). Chase made the necessary arrangements and the paintings were included in the thirteenth Carnegie International exhibition, with *Portrait of Mrs. C.* honored as one of the few illustrations in the exhibition

catalogue. Beatty obviously had great admiration for this painting and on May 14, 1909, wrote Chase, "We are all much pleased with the *Portrait of Mrs. C.* Would you consider selling it to us, or exchanging it for the one we now own, painted by you?" The Chase painting already owned by the Carnegie Institute was *Did You Speak to Me?* (see vol. 4), which had been purchased by the museum from its showing in the third Carnegie International exhibition (1898). Over the next few months an agreement was reached whereby the Carnegie Institute received *Portrait of Mrs. C.* in exchange for *Did You Speak to Me?* and an additional sum of money. Twice after the museum acquired the *Portrait of Mrs. C.* did Chase request that the painting be allowed to travel to be included in exhibitions of his work: at the National Arts Club (1910) and the Pan-American Exposition (1915). Both requests were granted. This painting is included on Peat's 1949 checklist as *Portrait of Mrs. Chase* (A), and as being owned by the Carnegie Institute, Pittsburgh.

OP.172

Carmencita, 1890

Oil on canvas; 69⅞ x 40⅞ in. (177.5 x 103.8 cm)
Signed: Wm. M. Chase (l.r.)

The Metropolitan Museum of Art, New York. Gift of Sir William Van Horne, 1906 (06.969)

Exhibitions: **StLEx '91 #240;** *Illustrated Catalogue of the Private Collection of Modern Paintings . . . Collected by the Late Alexander Blumenstiel* **(1906), #104** (discussion of the work) [purchased, Sir William Van Horne, $220].

Chase visited Spain in the summers of 1881–83 and became enamored with Spanish painting and Spanish subjects. This can be evidenced in the contents of his first major one-man exhibition in the United States, at the Boston Art Club in 1886, which included about a dozen paintings treating Spanish themes—some executed in Spain, others done from models who posed for him in New York. Chase's interest in this type of painting culminated in the painting of one of his most famous works, *Carmencita,* the Spanish dancer known as "The Pearl of Seville," who dazzled audiences both abroad and in America.

Carmencita gave her first New York performance in 1889, but one of her most memorable was in Chase's Tenth Street Studio in April 1890. The backstory behind this remarkable evening is as follows: John Singer Sargent, who had seen her dance in Paris and was at work on her portrait [1890; Musée d'Art Moderne, Paris]

arranged for her to dance there for Isabella Stewart Gardner and some friends, perhaps hoping to sell his portrait of Carmencita to this prominent Boston art collector. Originally Sargent planned to have her dance in his studio, but then, realizing his space was too small and dark, he thought of Chase's studio and wrote to him, "Would you be willing to lend your studio for the purpose and be our host for next Tuesday or Thursday night? We would each invite some friends and Mrs. Gardner would provide Carmencita and I the supper or whatever expenses there might be. I only venture to propose this as I think there is some chance of your enjoying the idea and because your studio would be such a stunning place" (letter from Sargent to Chase, William Merritt Chase Papers, Archives of American Art, Washington, D.C.). Chase agreed and the date was set for April 1, 1890. The evening did not get off to a smooth start. Rosina Emmett Sherwood, a guest at the event, later recalled that when Carmencita arrived at the studio her makeup was garish and her hair wild. "Sargent and Chase made her rub the make-up off her face and brush her frizzed hair back from her forehead, and she was very beautiful and natural as a country girl dancing on the grass" (Katharine Metcalf Roof, *Life and Art of William Merritt Chase* [1917], 157–58). Another attendee, J. Caroll Beckwith, reported in his diary that the

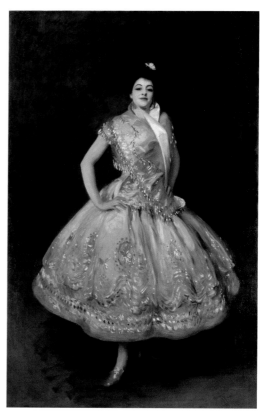

OP.172A. John Singer Sargent, *La Carmencita,* 1890. Oil on canvas; 91⅜ x 55⅞ in. (232 x 142 cm). Musée d'Orsay, Paris

audience was "stiffish" (James Carroll Beckwith, Diary, April 1, 1890, National Academy of Design, New York). But once Carmencita began to dance her energy mesmerized the audience and was intoxicating enough to inspire Chase to capture her in a portrait. Chase had the opportunity to see her perform again in his studio on April 24, 1890. John Singer Sargent also was inspired by this second Chase studio performance and created another portrait of the dancer, *Carmencita* (OP.172A), but the two artists' conceptions of the dancer were completely different. Sargent depicts Carmencita looking directly at the viewer, as if she were posing for a portrait (which, perhaps, she was). Chase, on the other hand, captures her in motion. Where Carmencita appears demure in Sargent's rendition, Chase conveys far more dynamism and energy, depicting her arms flying and her castanets clicking. The excitement of the moment is such that the women watching began throwing their jewelry at Carmencita's feet, and Chase captures the moment through his depiction of a bracelet in mid-flight, about to touch the floor.

Lorinda Munson Bryant, writing in *American Pictures and Their Painters* (New York: John Lane Co, 1917; reprinted 1920, 159-60) offers a comparison of Sargent's and Chase's portraits of the dancer. Chase's portrait is mentioned in G. Beal, *Scribner's* 61 (February 1917): 258, and illustrated in several periodicals, including *Cosmopolitan* (October 1906); *Palette and Bench* 1 (October 1908): 5; and *Literary Digest* 53 (November 11, 1916): 1252. Included on Peat's 1949 checklist of Chase's known work as *Carmencita,* circa 1890, and as being owned by the Metropolitan Museum of Art, New York.

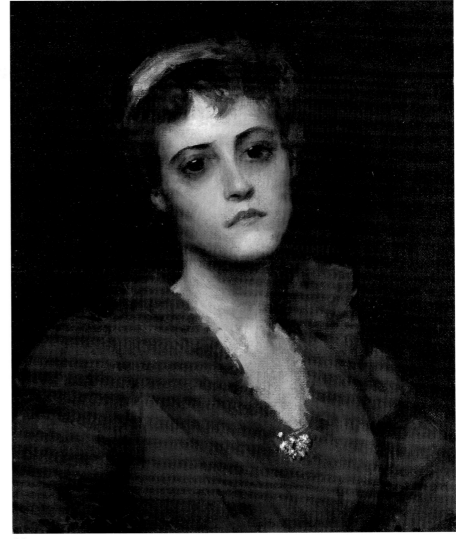

OP.173

OP.173

The Red Gown (Portrait of Miss C.),
ca. 1890

Oil on canvas; 20 x 16 in. (50.8 x 40.6 cm)
Signed: Wm. M. Chase (l.l.)

Location unknown

Exhibitions and Auctions: **NAD '92 #286** as *Portrait of Miss C.*; **AAG '21 #44** as *The Red Gown.*

Chase's painting titled *The Red Gown* depicts an unidentified sitter with blond hair and blue eyes wearing a bright red dress. A photograph, which descended within the Chase family, shows that the painting was originally a half-length portrait that appears to have been cut at some point during the artist's lifetime (OP.173A). No signature is evident in the photograph, so Chase must have added it after cutting the work. Chase often cropped his paintings so as to afford them a more "modern" look suggestive of the French Impressionists. However, there may be an additional reason why the work might have been subsequently cut. In its original form, as seen in the photograph, *The Red Gown* matches the description of the work *Portrait of Miss C.* given in a review of an exhibition at the National Academy of Design in 1892: "*Miss. C——,* with hands on hips, in red against a red background, does not attract us, except by the painting of the dress. The near forearm is very poorly modeled" ("The National Academy Exhibition," *Art Amateur* 26 [May 1892]: 141). It is interesting to wonder if Chase may have decided to eliminate the part of the composition that was criticized. At some point, the work was purchased by W. G. Peckham of Westfield, New Jersey. It was later illustrated as *A Portrait* in an article, "On the Buying and Care of Pictures," written by its owner, W. G. Peckham (*International Studio* 56,

OP.173A. Photograph of *The Red Gown* as a half-length portrait

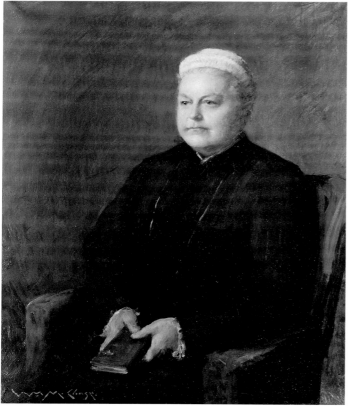

OP.174

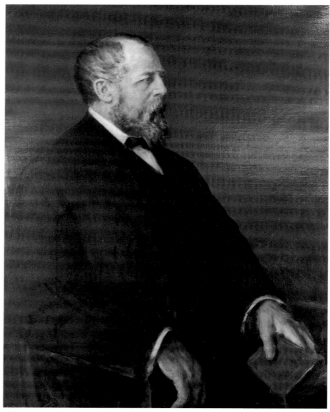

OP.175

Sup. [July–August 1915]: xi). The painting subsequently was sold in Peckham's estate sale, which was held in 1921 at the American Art Association, New York. This painting is included on Peat's 1949 checklist as *The Red Gown,* and as being formerly owned by Caio Galleries, New York.

OP.174

Portrait of Mrs. McCormick, ca. 1890

Oil on canvas; 36 x 29 in. (91.4 x 73.7 cm)
Signed: Wm. M. Chase (l.l.)

The State Museum of Pennsylvania, Harrisburg, Pennsylvania Historical and Museum Commission. Gift of the Historical Foundation of Pennsylvania, 1966

This portrait depicts Annie Criswell McCormick (b. 1843). She was one of the prominent matriarchs of the McCormick clan, an influential family in Dauphin County, Pennsylvania. She was married to Colonel Henry McCormick (b. 1831), of whom Chase also painted a portrait (OP.175). The portraits were probably commissioned as companion pieces to be hung side by side. Considering that the works probably went directly to the sitters' home, it is not surprising that they were not exhibited during the artist's lifetime. In a photograph of Annie McCormick housed

in the McCormick Family Papers at the Dauphin County Historical Society, she can be seen wearing the same outfit as that in Chase's portrait of her. Black was considered the appropriate color for an older woman in the late nineteenth century. Chase similarly depicts his mother garbed in a black dress with a white bonnet. Also, it may be noted that McCormick appears more animated in the photograph. Chase, however, chose to depict her gazing straight ahead, commanding and intent, in a manner befitting a family matriarch.

OP.175

Colonel Henry McCormick, ca. 1890

Oil on canvas; 36 x 29 in. (91.4 x 73.7 cm)
Signed: Wm. M. Chase (l.l.)

The State Museum of Pennsylvania, Harrisburg, Pennsylvania Historical and Museum Commission. Gift of the Historical Foundation of Pennsylvania, 1966

Colonel McCormick was a prominent Pennsylvania industrialist who lived in Harrisburg. During the Civil War he was commander of the First Regiment, Pennsylvania Reserves, at Antietam. Chase also painted a pendant portrait of Mrs. McCormick (OP.174).

OP.176

Portrait of a Girl in White (Portrait of a Young Girl), ca. 1890

Oil on canvas; 30⅝ x 25½ in. (77.8 x 64.8 cm)
Signed: Wm. M. Chase (l.r.)

Smithsonian American Art Museum, Washington, D.C. Gift of Mrs. Howard Weingrow, 1968

Exhibitions and Auctions: **StLEx '90 #169** as *Portrait of a Girl in White* [lent by the artist]; **Csale '17 #277** as *Portrait of a Young Girl.*

Here Chase captures a young girl seated sideways on a gold chair wearing a white ruffled dress with full sleeves and a gathered skirt. Chase's models for many of his paintings wear white, such as in his *Portrait of My Sister (Hattie),* 1886 (OP.122), and *Alice (Alice—A Portrait),* circa 1891 (OP.182). This dress, in particular, provided him with the opportunity to express different shades of white as well as the translucency of the lace sleeves. The subtly colored composition is enlivened by the touch of red in the flower in her hair.

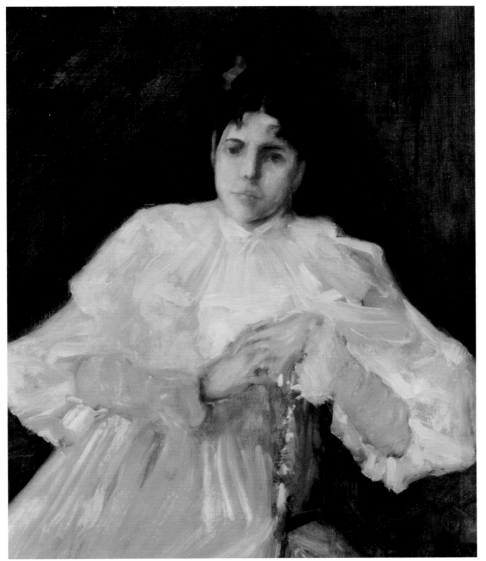

OP. 176

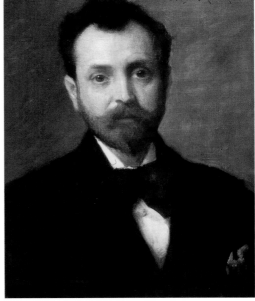

OP. 178

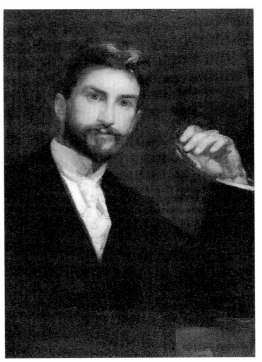

OP. 179

OP. 177

Happy Hours for the Little Ones, ca. 1890

Oil on canvas; 24 x 16 in. (61 x 40.6 cm)

Location unknown

Exhibitions: **ULC '90 #51; CAA '95 #214** [owned by M. Knoedler and Co.].

This work has not been located and no extant image exists. It is likely related to a larger painting entitled *Happy Hours* (see vol. 4), or, given Chase's propensity to retitle his works, may indeed be the same painting. The reason it is thought to be a separate painting is because Peat has listings for both paintings in his 1949 checklist of the artist's known works, each having different dimensions.

OP. 178

Unidentified Man

Oil on canvas; 20 x 16 in. (50.8 x 40.6 cm)
Signed: Wm. M. Chase (u.r.)

Location unknown

OP. 179

Man Holding a Cigar

Physical properties unknown

Location unknown

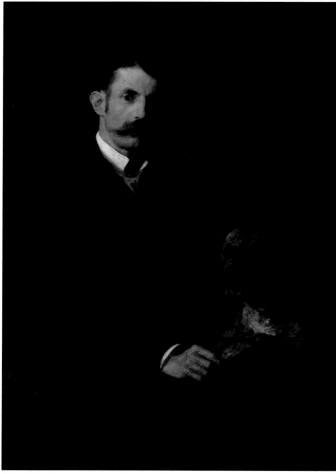

OP.180

OP.180

Portrait of a Man

Oil on wood panel; 45½ x 30½ in. (115.6 x 77.5 cm)

The David and Alfred Smart Museum of Art, The
University of Chicago. Gift of Mrs. Robert B. Mayer
(1974.49)

Robert Bloom Mayer (b. 1910) was a Chicago-
based collector.

OP.181

Worthington Whittredge, ca. 1890

Oil on canvas; 64¾ x 53¼ in. (164.5 x 135.3 cm)
Inscribed and signed: To my friend Whittredge /
Wm. M. Chase (u.r.)

Private collection

Exhibitions: **NAD '91 #118,** although the sitter was
not identified in the exhibition title, it is abundantly
clear in reviews of the exhibition that the portrait
is of Worthington Whittredge: "At the National
Academy's Exhibition (now open) [Chase's] likeness
of Mr. Whittredge is excellent" (Charles De Kay,
"Mr. Chase and Central Park," *Harper's Weekly,* May
2, 1891, 327); another review, though not mentioning
Mr. Whittredge, lauds the work, "one of Mr. Chase's
most serious pieces of painting is his three-quarter
length of an elderly artist, seated at his easel" (*Art
Amateur* [May 1891]: 145); *New York Times,* April 6,
1891, 4, in a review of the National Academy of
Design exhibition, mentions the work: "In the
North Gallery, portraits by Carroll Beckwith,
William M. Chase and E. D. Blashfield carry off the
honors. . . . Mr. Chase paints a well-known artist
seated before his easel and gives him just the right
twinkle and wise look combined. The different
shades of complexion on brow and cheek are capi-
tally told"; and the *New York Daily Tribune,* April 3,
1891, 6, in a review, notes that "William Chase ex-
hibits a very striking portrait of an old man, painted
with much power and manifest fidelity. It is in every
way a fine work and compares most favorably with
the examples of his works which were sold a short
time ago at public auction by Messr. Ortgies & Co."

Worthington Whittredge (1820–1910) was a
member of the second generation of the Hud-
son River School painters. In 1890 Chase was
elected an academician of the National Academy
of Design, and this portrait may well have been a
token of his respect for the elder artist and for-
mer president of the academy. Whittredge also
maintained a studio in the Tenth Street Studio
building as Chase's neighbor—and it was this
studio that undoubtedly served as the setting for
Chase's portrait of Whittredge. This painting is
included in Peat's 1949 checklist of known work
as being in the collection of W. C. Katzenbach,
New York.

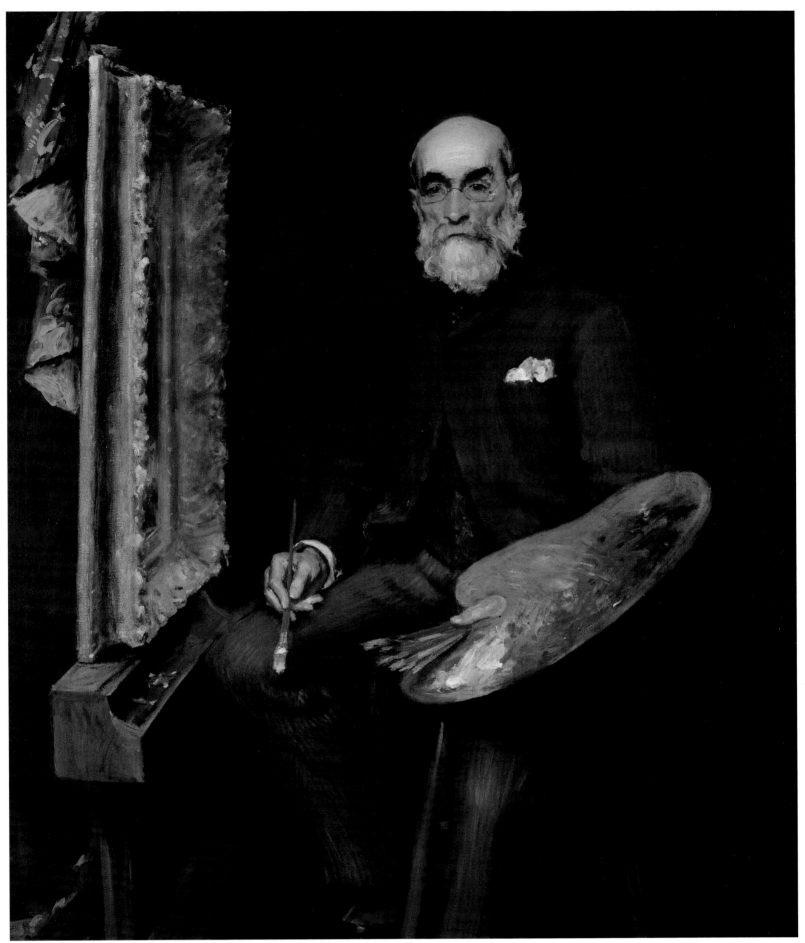

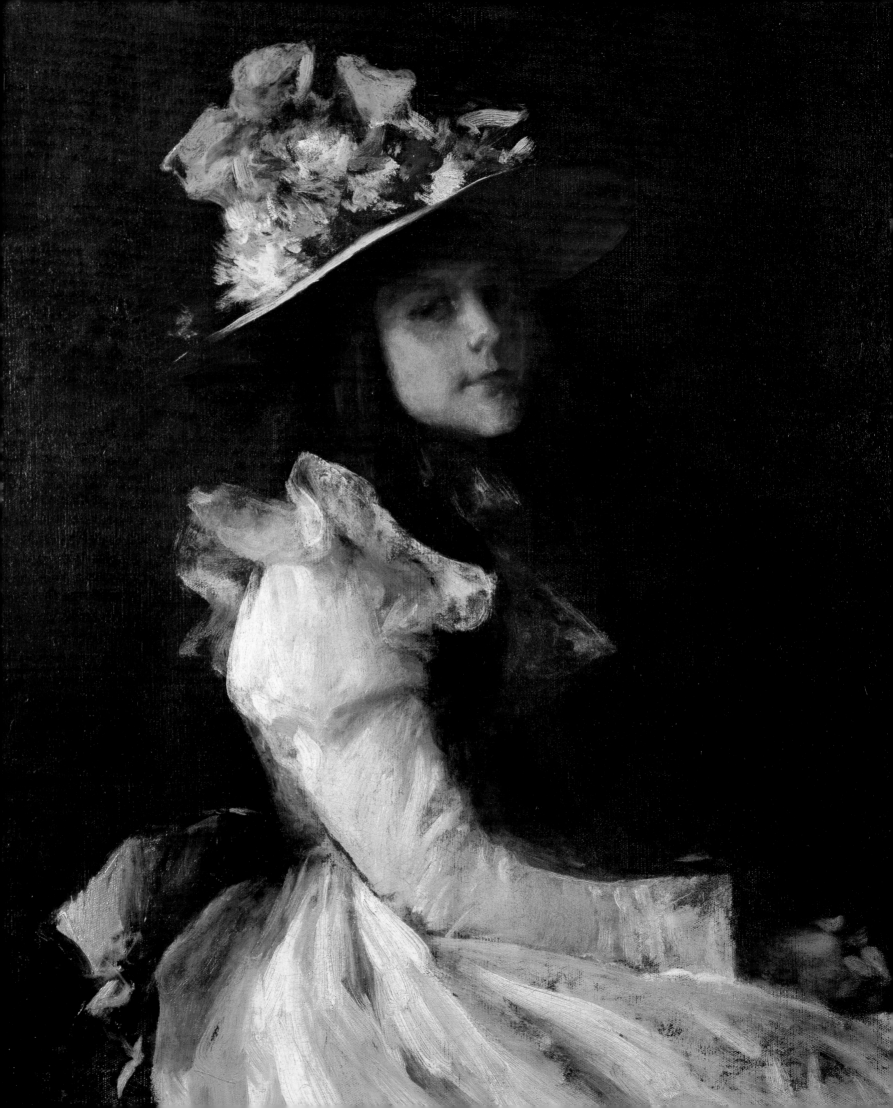

The Shinnecock Years, 1891–1902

Fall, winter, and spring in New York City, summers in Southampton, Long Island: life during the 1890s was idyllic for William Merritt Chase, who by then was recognized as one of America's most prominent artists—and its leading portraitist. These years saw the rapid expansion of his family and he delighted in painting their portraits. One of his magnificent portraits from this period is of his wife—a simple and loving rendition (OP.183)—and portraits of his daughters, Alice (OP.246) and Koto (OP.280), demonstrate his love for his children. He also painted portraits of many of his students, one of the most dramatic being his portrait of Lydia Field Emmet (OP.201). All this was in addition to his continuing business of painting portraits of luminaries and dignitaries. However, it is his many heartfelt portraits of family and friends, so infused with life and spirit, for which he will best be remembered.

OP.182

Alice (Alice—A Portrait), ca. 1891

Oil on canvas; 67⅝ x 49⅜ in. (171.8 x 125.4 cm)
Signed: Wm. M. Chase (l.r.)

The Art Institute of Chicago. Gift of Ernest A.
Hamill (1893.107)

Exhibitions: **SAA '91 #37** ("Society of American
Artists Exhibition," *Art Amateur* [June 1891]: 6;
"Society of American Artists," *New York Times,* April
26, 1891, 5); **BMFA '91 #29; PAA '91; MCPIE '92
#325** (*Catalogue Sixth Internationalen Kunst Austelling,
Konigl Glasspalaste, Munich* [1892], 94); **PAFA '92 #32;
CWCE '93 #253; TMA '12 #18,** illus.; **DMA '16
#23; AIC '18 #96,** illus.

In a letter dated February 11, 1965, Wilbur D. Peat,
then director of the Art Association of India-
napolis, wrote, "My notes on this picture state
that in 1949 I was informed by Mrs. Clifton
Wheeler (who lived in Indianapolis at that time)
that the subject of the picture was Alice Evans.
Mrs. Wheeler (Hilda Drake [b. 1878]) was a fellow
student of Alice Evans in one of Chase's classes
in New York" (Wilbur D. Peat File, Art Institute
of Indianapolis). It seems likely that Mrs. Wheeler
and Alice Evans would have been Chase students
several years after this portrait was completed,
given that Chase usually did not accept such
young students. In addition, there are no extant
records of Alice Evans or Mrs. Wheeler studying
in New York with Chase, though Mrs. Wheeler
is said to have accompanied Chase on one of
his trips to Europe; it is thus possible she was a
student of his, though not in New York.

There was some confusion, at times, regard-
ing this painting on account of its title, *Alice,*
which one would think referred to Chase's
daughter of that name; however, in addition to
the letter mentioned above, Chase's daughter
Alice would have been only about four years old
in 1891 when Chase painted the picture, whereas
the subject of the picture appears to be in her
teens. *Alice* was exhibited frequently and was
illustrated in numerous publications, receiving
mixed reviews. Upon its first showing at the
Society of American Artists exhibition in 1891
the work received a rave review from one critic,
who wrote, "The six sendings by the President
of the Society are headed by a full-length por-
trait of a young girl in short white dress pleated
in many folds. She throws her head up and back,
smiling the while with the most engaging frank-
ness and fun, while she holds the ends of a pink
ribbon that she has thrown about her neck. This
is an excellent piece of work. The members of
the Society have no cause to be ashamed of a

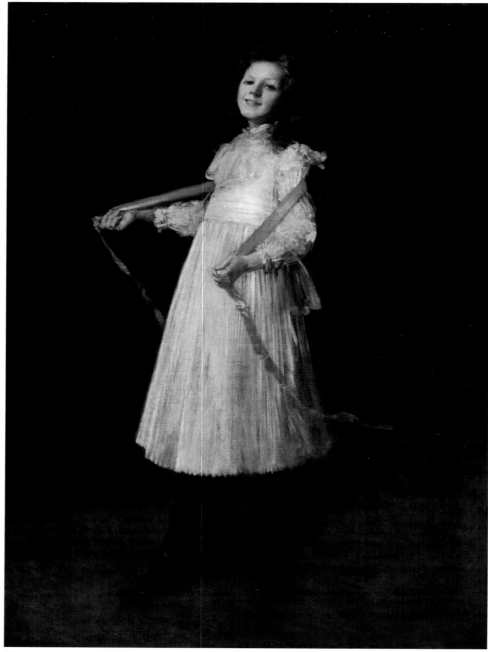

OP.182

President who can paint so well" ("Society of
American Artists," *New York Times,* April 26,
1891, 5). *Alice* was also included in an exhibition
in Pittsburgh, Pennsylvania, in 1891, as indicated
by a published reference to that effect ("Recent
Exhibitions in Pittsburgh," *Art Amateur* [Novem-
ber 1891]: 146). Once the painting became part
of the collection of the Art Institute of Chicago,
Chicago critics expressed a pride of ownership
when writing about the work: "The fascinating
portrait of 'Alice' which was presented to the
AIC after its success at the World's Fair by Ernest
Hamil [*sic*] is not included in the present gather-
ing of Mr. Chase's paintings, but fortunately it
is permanently in possession of the Institute and
a delight for all time to the people of Chicago"
([Chicago] *Herald Tribune,* November 28, 1897,

n.p.). (The donor is mistakenly identified as
Charles L. Hutchinson in Wendy Cooper,
"Artists in Their Studios," *Godey's Magazine*
[March 1895]: 204; the actual donor was Ernest
A. Hamill, correctly identified, despite the mis-
spelling, in the citation above.) As referenced in
the aforementioned review, *Alice* was not exhib-
ited in Chase's solo show at the Art Institute of
Chicago in 1897; however, the work was repro-
duced in the catalogue as having been acquired
by the museum. In addition, *Alice* was mistakenly
illustrated in *Brush and Pencil* [1898]: 259 as *Alice
C.,* which was the title for another painting
shown in the exhibition (see OP.231). Another
Chicagoan writing about the work almost fifteen
years later is still captivated by *Alice,* referring to
the work as "a capital example of his [Chase's]

style of work. Entering a gallery where *Alice* hangs, one's attention is drawn to it at once. That happy, smiling face and the buoyant attitude command attention. The flying ribbon, so graceful and so suggestive of motion, adds its own peculiar charm, and we wonder who this gracious maiden may be. No one could fail to detect the sense of tripping, graceful movement that the figure conveys. . . . Note the beauty of the carriage, the fine pose of the head, thrown slightly back, and the way in which the hands grasp the ribbon. Alice has a striking face, with its high, broad forehead, large, soft eyes and pretty teeth. All her features are finely shaped, and her smile is very pleasing" (Elsie May Smith, "A Girl that Everybody Likes," *School Arts* 12 [February 1913]: 370–71, illus.). *Alice* was also illustrated in *School Arts* 16 (February 1916): 402. William Howe Downes, in his article "William M. Chase, A Typical American Artist," published in December 1909, also expressed enthusiasm for "the fanciful portrait of 'Alice,' a little girl in white, whose dashing pose and fascinating smile are thoroughly spontaneous. Nothing more blithe and debonair in the way of a painting could well be conceived. The pretty pleated skirt, the long pink silk ribbon, held in both hands, it sends floating in the air, the buoyant dancing attitude—everything contributes to the impression of cheerfulness and charm which this light-hearted vision creates" (*International Studio* 39, no. 154 [December 1909]: 29–36, 29). While the energy of the work was praised universally, certain parts of the composition were criticized. For example, one critic writing about the Society of American Artists exhibition of 1891 said, "Mr. Chase has inspired 'Alice' with so much vitality of movement and grace of pose that one regrets that he did not at the same time devote a little more attention to the face" (*Art Amateur* [June 1891]: 6). In 1892 it was illustrated in "The Century Series of Pictures by American Artists," *Century Magazine* 45, no. 1 (November 1892): 29, and also in the *Art World* 2 (1895): 198. *Alice* also was illustrated in several books, including those of James William Pattison, *Painters Since Leonardo* (Chicago: Herbert S. Stone and Co., 1904), facing p. 240; J. B. Sherwood, *Childhood in Art* (1912), 67, illus.; Lorinda Munson Bryant, *American Pictures and Their Painters* (New York: John Lane Co., 1917; reprint, 1920), 114–15, fig. 25, illus.; and Katharine M. Roof's 1917 biography of the painter, *The Life and Art of William M. Chase* (New York: Charles Scribner's Sons; reprint, New York: Hacker Art Books, 1975), 166. The painting is included on, and illustrated in, Peat's 1949 checklist of known works by Chase as *Alice,* and as being owned by the Art Institute of Chicago.

OP.183

An Artist's Wife (The Artist's Wife; A Study), 1892

Oil on canvas; 20 x 16 in. (50.8 x 40.6 cm)
Signed: Wm. M. Chase (u.r.)

Collection of Fayez Sarofim, Houston

Exhibitions: SAA '93 #237 [lent by John F. Pupke (*sic*)]; CAA '95 #197 as *The Artist's Wife* [lent by Miss Papke (*sic*)].

An 1893 article detailing Chase on vacation in Long Island observed that "[Chase's] vacation is his busiest and his happiest time" (John Gilmer Speed, "An Artist's Summer Vacation," *Harper's New Monthly Magazine* [June 1893]: 3). The article reproduced several paintings, including *An Artist's Wife,* listed as *A Study* (ibid., 9). This painting presents Alice Gerson Chase seated in the summer studio in front of Chase's easel, upon which is placed another of his most important works, *A Fairy Tale* (see vol. 3). Chase cleverly created a painting within a painting. In the *Harper's* article, the work is described thus: "In the background [is] a framed picture within a picture, the painted gold of the frame of the pictured picture coming very close to the actual gold of the actual picture, while in the figure [there is] at once action and repose, and between the figure in the foreground and the picture in the background a definite sense of distance" (ibid., 6). Another writer was also struck by the same elements, noting that "here Mr. Chase has not only overcome the difficulty of painting the gold frame with sufficient skill to stand comparison with the real frame but has also kept a definite sense of distance between the figure in the foreground and the picture in the background. There is, also, in the figure a suggested action combined with a feeling of repose; while the face and the attitude tell plainly the simple story of the picture" (John Rummell and E. M. Berlin, *Aims and Ideals of Representative American Painters* [Buffalo, 1901], 93). The painting was also illustrated in Wendy A. Cooper, "Artists in their Studios," *Godey's Magazine* (March 1895): 295, as *The Artist's Wife.*

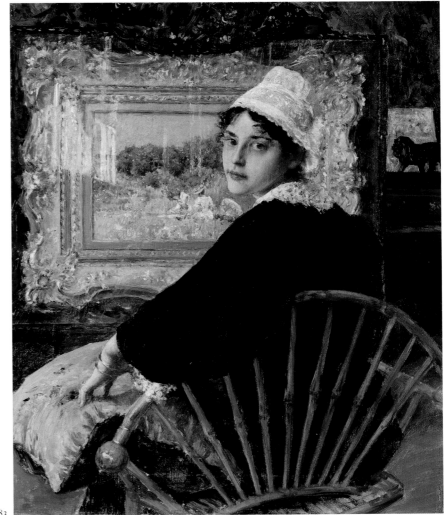

OP.183

Alice's dramatic over-the-shoulder pose is one that can be traced back to the Renaissance and was later perfected by Anthony Van Dyck. Upon careful study, however, it is clear that Chase's most direct inspiration for *An Artist's Wife* was Vermeer's *Girl with a Pearl Earring,* circa 1665–66 [Royal Cabinet of Paintings, Mauritshuis, The Hague]. Vermeer's masterwork had resurfaced in 1881, when it was purchased for The Hague by the astute collector Arnoldus Andreis des Tombe for a mere two guilders. Soon afterwards, this major discovery was displayed as one of the highlights of the collection. Chase visited Holland during the summers of 1881–84, and certainly would have seen the work.

Shortly after the work's appearance at the Cleveland Art Association in 1895, it disappeared for many years before its rediscovery in a private collection.

OP.184

Lady in Pink, ca. 1892

Oil on canvas; 22 x 18 in. (55.9 x 45.7 cm)
Signed: Wm. M. [partial signature] (u.r.; runs off canvas)

Westmoreland Museum of American Art, Greensburg, Pa. Gift in memory of G. Albert Shoemaker by his wife, Mercedes

It is thought that the model for the *Lady in Pink* might be Chase's sister-in-law Virginia Gerson (1864–1951). There is a strong resemblance to Chase's *Portrait of a Woman (Portrait of the Artist's Sister-in-Law [Virginia Gerson]),* circa 1882 (OP.98), particularly in the arch of the eyebrows

OP.184

OP.185

and the bridge of the nose. The fact that the painting remained in the family's possession for a long period of time (until 1980) further supports this theory. This portrait, owner unknown, is included on Peat's 1949 checklist of Chase's known work as *Lady in Pink* (A), circa 1892.

OP.185

Mother and Child (Mother's Love),
ca. 1892

Oil on canvas; 55½ x 26¼ in. (141 x 66.7 cm)
Signed: Wm. M. Chase (u.l.)

UNL–F. M. Hall Collection, Sheldon Memorial Art Gallery and Sculpture Garden, University of Nebraska–Lincoln. 1933

Exhibitions: **CAA '95 #202** as *Mother and Child*, won a prize; **NAD '95 #395** [lent by the artist]; **PAFA '96 #54**; **AIC '97 #65**; **CI '98 #11**; **BFAA '99 #64** [for sale, $1000]; **BFAA '09 #36** as *Mother's Love* ("The Paintings by Mr. Chase," *Academy Notes* 4 [February 1909]: 146); **VGB '09 #12**; **FAM '13 #11** as *Mother's Love*.

This painting is one of a number of works depicting Chase's wife, Alice Gerson, and their first daughter, Alice Dieudonnée. The other works include *Feeding the Baby*, 1887 (OP.150), *Mother and Child (The First Portrait, Mother and Daughter, His First Portrait)*, 1887 (OP.151), *Happy Hours*, circa 1887 (see vol. 4), and *A Mother's Joy*, circa 1889 (OP.164). *Mother and Child (Mother's Love)* was exhibited frequently and won an award in its first exhibition at the Cleveland Art Association exhibition in 1895. The painting was appreciated by critics, particularly for its touching subject matter, as demonstrated in this 1897 review of the work: "Intimate and charming is the portrait of the artist's wife and little daughter. The mother is seated and the child's arms clasped around her neck. In the woman's eyes beams the true love light of motherhood" ([Chicago] *Herald Tribune*, November 28, 1897). Chase creates an intimate depiction of his wife and daughter, in which the viewer's eye is drawn to the two faces that reflect the special relationship between mother and child. The focus of the scene is highlighted by the frame Cosy creates as she wraps her arms around her mother's neck. In a review of an exhibition of Chase's work held at the Albright Art Gallery in Buffalo in 1909, the critic praised the work's arrangement, technique, and color (*Academy Notes* [1909]: 146). Included on Peat's checklist as *Mrs. Chase and Cosy (Mrs. W. M. Chase): Mother's Love,* ca. 1892, and as being owned by the University of Nebraska Art Galleries, Lincoln.

OP.186

OP.186

Portrait of a Lady in a White Dress,
ca. 1892

Oil on canvas; 24½ x 18½ in. (62.2 x 47 cm)
Signed: Wm. M. Chase (l.r.)
Inscribed on front: To my friend Miss. Edith Newbold / Wm. M. Chase (l.r.)

Location unknown

This painting is most likely a portrait of Edith Newbold, to whom it is inscribed. It is probable that Miss Newbold served as a model for Chase and was given the painting as a gesture of his gratitude. Edith Newbold supervised the Shinnecock Hills Summer School of Art on eastern Long Island; the school, which held summer classes between 1892 and 1902, was the first major school of plein air painting in America. There is a dedication plaque in the Chase Archives at the Parrish Art Museum inscribed to Edith Newbold, "with gratitude and admiration of the Shinnecock Art Club / Christmas 1892," and signed by fifty-two individuals, presumably associated with Chase's summer school, including one Sarah Newbold, who may have been related to the sitter. This work has all of the immediacy, spontaneity, and verve of Chase's demonstration pieces, and was likely done in a single sitting to illustrate his painting technique to his students.

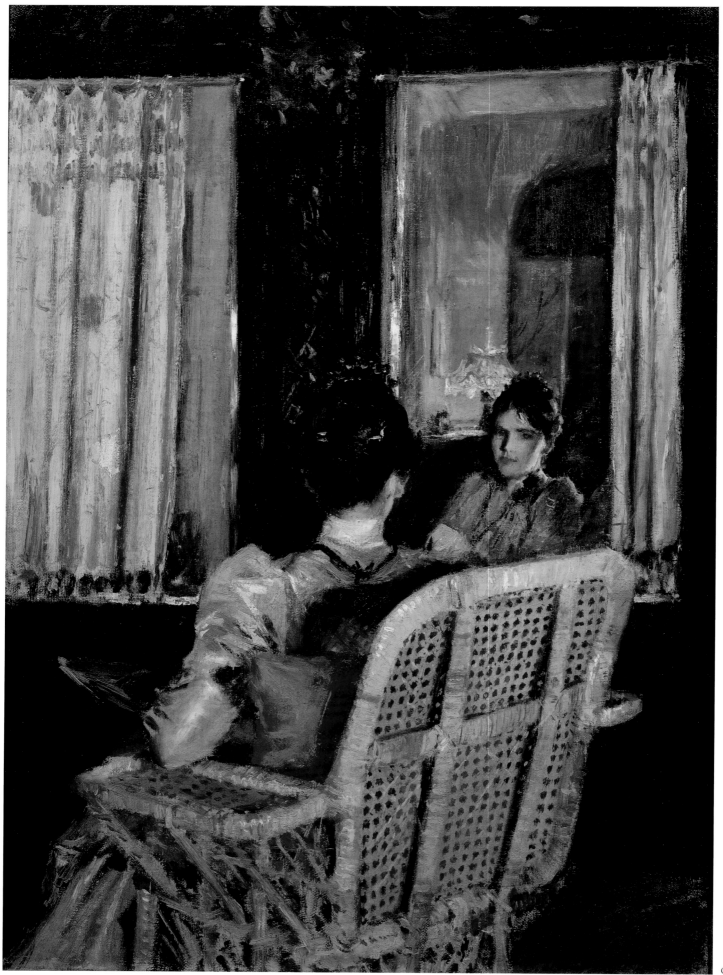

OP.187

Reflections (Reflection), ca. 1892

Oil on canvas; 22 x 16 in. (55.9 x 40.6 cm)
Signed: Wm. M. Chase (l.r.)

Collection of Margaret and Raymond J. Horowitz,
New York

Exhibitions and Auctions: **Csale '96 #1170** as
Reflection; SAA '94 #68 as *Reflections,* for sale for
$1000.

This interior depicts the artist's wife, Alice Gerson Chase (1866–1927). The setting is the large central hall of their summer home at Shinnecock Hills, Long Island, New York. Chase first lived in their house in Shinnecock Hills in the summer of 1891. He held summer school classes there each year for over a decade, with the last season being 1902. In this painting Mrs. Chase is seen seated in a wicker chair that also appears in another depiction of Alice, *In the Studio* (see vol. 4). In *Reflections* she sits in front of a large armoire, with her reflection appearing in the glass (or mirror) panel. Mirrors and mirrored images appear in several of Chase's Shinnecock scenes. For instance, Chase has depicted his reflected image in the same armoire in his pastel *Hall at Shinnecock* (see vol. 4). Chase creates a pictorially complicated composition expertly demonstrating his dexterity as a painter of light and reflections. The mirror also serves to create a sense of depth in the painting by leading the viewer's eye back to the reflected archway and into another room. Critics made note of Chase's use of the mirror in this work, writing, "It is useless to object to the picture that is a pun in paint. The lady is reflecting about some matter, we see her reflection in the glass. The picture is a good one, nevertheless; and those painters who speak most strongly against the 'literary sort of thing' cannot be kept from perpetrating such 'literature' as this" ("The Exhibition of the Society of American Artists," *Art Amateur,* April 1894, 127). *Reflections* is illustrated in William J. Baer's article "Reformer and Iconoclast," *Quarterly Illustrator* 2, no. 6 (1894): 137, which was reprinted in *Essays on American Art and Artists* (Temple Court, N.Y.: Eastern Art League, 1896), 238, illus.

OP.188

Shinnecock Indian Girl, ca. 1892

Oil on canvas; 16⅛ x 12¼ in. (41 x 31.1 cm)
Signed: Wm. M. Chase (u.l.)

Private collection

This work is the only know image by Chase of an individual of American Indian descent. The Shinnecock Indian Reservation was not far from Chase's summer school on Long Island, which he operated between 1891 and 1902. Initially the reservation was off limits for art students and local residents, but Chase was able to befriend the Indians and to obtain permission for him and his students to paint on the land. Chase even convinced some of the Indians to model, as in the present work, which depicts an indigenous girl named Romaine. Chase was concerned with the welfare of the Indians, and on one occasion even donated a painting to be auctioned for their benefit (Katharine Metcalf Roof, *The Life and Art of William Merritt Chase* [1917; reprint,

New York: Hacker Art Books, 1975], 187). *Shinnecock Indian Girl* has been dated to 1892 because it is illustrated in an article about Chase's Shinnecock Summer School of Art published in June 1893 (John Gilmer Speed, "An Artist's Summer Vacation," *Harper's New Monthly Magazine* [June 1893]: 8, 11 illus.). Speed wrote, "The one sketch of this kind that I most distinctly recall to have seen in Mr. Chase's studio was the head of a girl. In the features was to be seen a curious blending of the two types, Indian and African."

Chase gave this work to one of his students at the Shinnecock summer school, Mrs. G. H. Page, who, according to her granddaughter, was an amateur painter who maintained a studio in Paris until about 1900. Apparently Chase did not give the painting to Mrs. Page until after 1896 because the work is prominently placed next to Chase in a photograph of his Shinnecock studio, circa 1896 (Chase Archives, Parrish Art Museum, Southampton, Long Island, New York). The painting, owner unknown, is included on Peat's 1949 checklist of Chase's known work as *Shinnecock Indian Girl.*

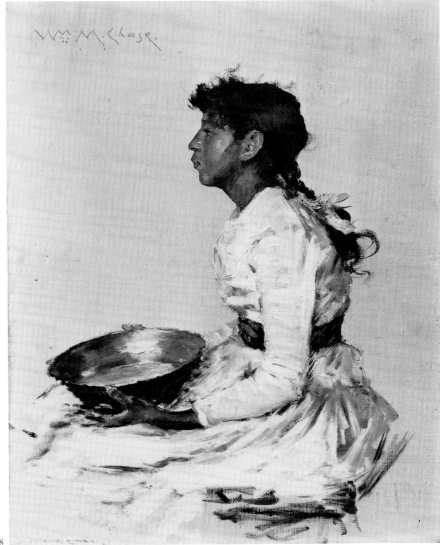

OP.188

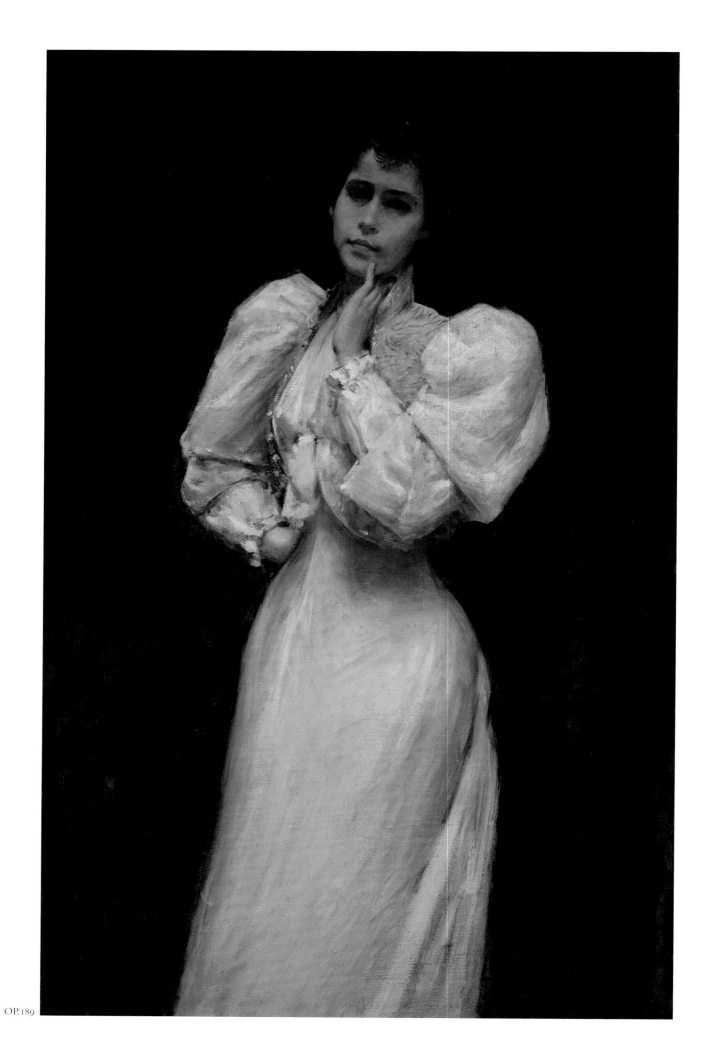

OP.189

OP.189

Portrait of Miss L. (Portrait of Miss Lawrence), 1892

Oil on canvas; 51¾ x 32¾ in. (131.5 x 83.2 cm)
Signed: Wm. M. Chase (l.r.)

Private collection

Exhibitions: **NAD '92 #80** [lent by the artist]; **CWCE '93 #252**, mistakenly identified as *Portrait of Mrs. L* [lent by the artist] (J. W. Buel, *The Magic City* [St. Louis: Historical Publishing Co., 1894]); **CAA '95 #210** [lent by the artist].

William M. Chase's masterwork *Portrait of Miss L.* (Angelica Hamilton Lawrence) was intended by Chase as a major "exhibition piece" rather than merely as a privately commissioned portrait. The sitter for the painting is Angelica Hamilton Lawrence (b. 1873); her mother, Mrs. Union Samuel Betts Lawrence, also had her portrait painted by Chase, circa 1888 (OP.159). Its importance as such was immediately acknowledged when it made its debut appearance at the National Academy of Design in 1892. At that time the work was described as depicting the sitter "standing with head and chin in a meditative pose," adding it "is one of the best things he has done in years" ("National Academy of Design [1st Notice]," *Art Amateur* [May 1892]: 141). A *New York Times* critic noted the "portrait of Miss Lawrence painted by William M. Chase, which is in some respects the best in the exhibition. The lady stands in white, with some gold embroidery about the body of her dress, and regards the world with a sweet but alert pensiveness very flattering to the artist's skill. A dark blue background throws out face and figure nicely" (*New York Times,* April 1892). Another reviewer praised "Miss Lawrence, a slender, nervous American girl in white with gold bodice, her hand on her face in an irresolute gesture, her eyes shadowy and thoughtful" ("Monthly Record of American Art," *Magazine of Art* 15 [December 1891–November 1892]: xxii). The work continued to receive accolades and Chase selected it as one of his paintings to be included in the important Chicago World's Columbian Exposition (referenced in "Pictures Accepted in New York," *Art Amateur* [March 1893]: 116, as *Portrait of Miss Lawrence*). Writing about Chase's work there, one article noted that "there is no more versatile talent in the American section . . . his portraits are often exceedingly clever" ("The World's Fair: American Paintings: Melchers, McEwen, Shirlaw, Chase, Marr, Duveneck," *Art Amateur* [August 1893]: 56).

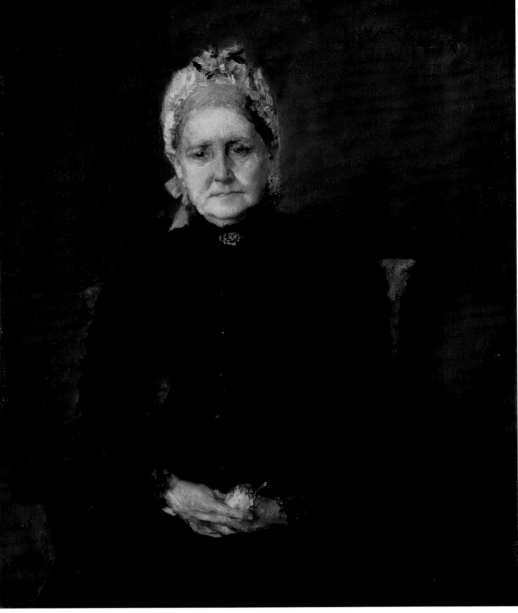

OP. 190

The work remained in Chase's possession at least until the time of the Cleveland Art Association exhibition of 1895, at which point the written record was dark until the painting's rediscovery, rolled up in a Newport, Rhode Island, attic in 1995. Since the sitter's identity was never in question, one can presume that Chase relinquished ownership of it sometime shortly after 1895, selling it to the sitter's family, through which it likely descended.

OP. 190

Portrait of My Mother (Portrait of the Artist's Mother), 1892

Oil on panel; 20 x 17 in. (50.8 x 43.2 cm)
Signed: Wm. M. Chase (u.r.)
Inscribed (verso): Portrait of My Mother, Wm. M. Chase

Indianapolis Museum of Art. Gift of Mrs. Carrie Chase Roberts (49.65)

Exhibitions and Auctions: **SAA '93 #191** as *Portrait of My Mother* (n.f.s.) [lent by the artist]; **PAFA '93 #306** [lent by the artist]; **NADLEx '94 #73** as *Portrait of the Artist's Mother* [lent by William M. Chase, Esq.] (*Art Amateur* [February 1894]: 77); **StLEx '95**

#192 as *Portrait of My Mother* [lent by the artist]; **CAA '95 #192** [lent by the artist]; **AIC '97 #64** [lent by the artist]; **McCG '05 #26** [lent by the artist]; **PAFA '08 #17** [lent by the artist]; **BFAA '09 #38** [lent by the artist] ("The Paintings by Mr. Chase," *Academy Notes* 4 [February 1909]: 146, as *Portrait of the Artist's Mother*); **VGB '09**, not listed in catalogue, but mentioned in undated clipping discussing the exhibition; **NAC '10 #106** [lent by the artist] ("The Chase Exhibition," *Outlook* 94 [January 29, 1910]: 230; "News and Notes of the Art World," *New York Times*, January 9, 1910, 14); **BPL '10** ("Chase Collection an Admirable One," [Bridgeport, Conn.] *Daily Standard*, March 3, 1910, 3); **DMA '16 #39** [lent by the artist]; **Csale '17 #362,** purchased by A. Rose, $250.

Chase executed portraits both of his mother, Sarah Swaim, and father, David Chester Chase. Katharine M. Roof, Chase's early biographer, describes the circumstances surrounding his painting of his mother's portrait. "Chase's mother was his first guest in his new home, and her portrait was the first thing he painted in his new studio. Mrs. Chase says that as she watched the progress of her portrait she wondered why a spot on top of her head was ignored by the painter. The next day, after a trip to town, he brought a dainty little lace cap and told her to put it on. Ever since that day she has worn a cap" (*The Life and Art of William Merritt Chase* [1917; reprint, New York: Hacker Art Books, 1975]: 186, illus. facing p.). The work was reproduced and praised in a *Harper's* article detailing Chase's vacation at Shinnecock: "In making the portrait of his mother the artist was at his best, for, even apart from the sympathetic affection natural towards the subject, the lady herself has a face that would inspire any one who admired beauty and character. Venerable rather by the calm, the peacefulness, and repose of her features than by any weight of years, Mr. Chase's mother, with folded hands, looks from the canvas as though a benediction were on her lips and approval of her gifted son in her eyes" (John Gilmer Speed, "An Artist's Summer Vacation," *Harper's New Monthly Magazine* [June 1893]: 5, 7, illus.).

Commenting on the present work, William Howe Downes stated that "the portrait of the artist's mother in a black silk dress with a white cap, showing her seated in an armchair, full front, two-thirds length, with the hands clasped in her lap, is simple in arrangement and sober in sentiment and, with its unaffected sympathy, contributes a fresh document to the long line of similar testimonies witnessing the worth of filial affection as an artistic asset" (William H. Downes, "William Merritt Chase, A Typical American Artist," *International Studio* 39, no. 154 [December

1909]: 29–36, descr. 30, illus. 33). Another critic viewed Chase's *Portrait of My Mother* as "a canvas full of deep sympathy with his sitter, and in it evinced a determination on the part of the painter to portray the individual at whatever cost of reconsideration, an unwillingness to let well enough alone, a manifest aspiration toward what is truest, regardless of any tricks or mannerisms" (Ernest Knaufft, "An American Painter —William M. Chase," *International Studio* 21, no. 93 [December 1900]: 155, 152, illus.). And still another critic thought that in Chase's portrait, "Love, peace and noble womanhood are . . . combined" ("William Merritt Chase—His Life and Work," *Arts for America* 7, no. 4 [December 1897]: 198).

Chase's choice of costume here is similar to that favored in his other portraits of older women—for instance, those of Mrs. G. B. Ely, 1895 (OP.232), and Mrs. Henry McCormick, circa 1890 (OP.174). Included on Peat's 1949 checklist of Chase's known work as *Artist's Mother, Portrait of My Mother,* and as being owned by Carrie Chase Roberts, Arlington, New Jersey.

OP.191

William Liggett Skinkle, 1892

Oil on canvas; 30 x 22¾ in. (76.2 x 57.8 cm)
Signed: Wm. M. Chase (u.l.)
Inscribed: After Photograph (u.l.)

Location unknown

This work, which had at one time been in the collection of the New Jersey Historical Society, was first identified as a portrait of J. B. Allen, based on a note attached to the back of the canvas: "Received from Mr. J. B. Allen $500— Five Hundred Dollars payment in full for a portrait painted by me in oil With Thanks, Wm. M. Chase Feb 11th 1892." The work was correctly identified as being a portrait of William Liggett Skinkle by Susan Gail Fuller who, in 1982, was a museum associate of the historical society. While it might not seem necessary to stress the fact that the painting was done after a photograph, it is instructive to point out that such portraits by Chase lack the brio generally associated with his work.

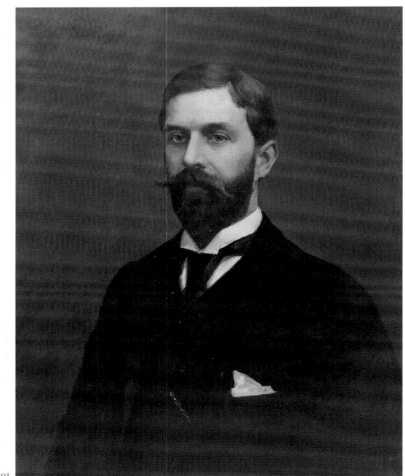

OP.191

OP.192

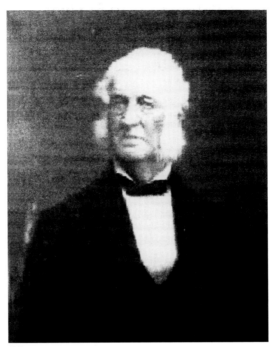

OP.193

OP.192

Richard Coxe McMurtie, ca. 1892

Oil on canvas; 34 x 36 in. (86.4 x 91.4 cm)
Signed: Wm. M. Chase (l.l.)

University of Pennsylvania Art Collection,
Philadelphia

Richard Coxe McMurtie (1819–1894) was born
in Burlington County, New Jersey. He served in
the Civil War and later became vice-provost of the
Law Academy of the University of Pennsylvania,
where he was well known for his acidic tongue.
In 1892 he received an honorary LL.D. from the
university, perhaps the occasion that prompted
this portrait. In his will he bequeathed his law
library to the University of Pennsylvania. The
work is included on Peat's 1949 checklist of
Chase's known work.

OP.193

Jacob Skinkle, 1892

Oil on canvas; 30 x 24 in. (76.2 x 61 cm)
Signed, inscribed, and dated: Wm. M. Chase / After
photograph / 1892

Location unknown

For unknown reasons, the sitter in the photo-
graph on which this painting is based had been
identified as possibly being Daniel Halsey.

However, the New Jersey Historical Society
art curator has since determined the sitter to be
Jacob Skinkle (1814–1890), the painting being
a posthumous portrait. Chase at the same time
painted a portrait of Jacob's son, William Liggett
Skinkle, also after a photograph (OP.191).

OP.194

Portrait of Mrs. C. (Mrs. C.; Woman with a White Shawl; Lady with a White Shawl), 1893

Oil on canvas; 75 x 52 in. (190.5 x 132.1 cm)
Signed: Wm. M. Chase (l.l.)

Pennsylvania Academy of the Fine Arts, Philadelphia.
Joseph E. Temple Fund, 1895 (1895.1)

Exhibitions: **PAFA '94 #68**, illus. [lent by the artist];
SAA '94 #240 (Sophia Antoinette Walker, "The
Society of American Artists," *Independent* 46, no. 2364
[March 22, 1894]: 9; "The Exhibition of the Society
of American Artists," *Art Amateur* [April 1894]: 127,
as *Portrait of Mrs. C.*); **NADLEx '94 #68** as *Mrs. C.*
("Art in the Portraits of Women," *New York Times,*
November 2, 1894, 8; Marianna G. van Rensselaer,
"A Study of the Portraits of Women," *World,* Nov-
ember 4, 1894, 18; "Portraits of Women: Concluding
Notice," *Art Amateur* [January 1895]: 45, as *Portrait of
Mrs. C.*); **CI '96** as *Woman with a White Shawl* [lent
by the artist] (*Art Amateur* [November 1896]: 104, as
Lady with a White Shawl); **IEFA '99 #58** as *Femme
Avec un Chale Blanc*; **ExUP '00 #121**, illus., as *Woman
with a White Shawl* [lent by the artist]; **PAEX '01**

#612 as *Portrait of Mrs. C.* [lent by the artist]; **CGA
'08 #13**; **NAC '10 #92** as *Lady with a White Shawl*
[lent by the P.A.F.A.] ("The Chase Exhibition,"
Outlook 94 [January 29, 1910]: 230, as *Lady with a
White Shawl*); **EIBA '10 #13** as *Retrato de la Senora C.*;
RAL '10 [lent by the P.A.F.A.] ("Masterpieces of
American Paintings" in *Selections of Photogravures after
Paintings Exhibited at Royal Academy of Art* [Berlin:
Berlin Photographic Co., n.d.], pl. 11, illus.); **RISD
'11 #3**, illus.; **WAM '11 #9** as *Lady with a White
Shawl* [lent by the P.A.F.A.] (*Bulletin of the Worcester
Art Museum* 2 [July 1911]: 183, illus.); **PPIE '15
#3766** as *Woman with the White Shawl* [lent by the
P.A.F.A.] (J. W. Pattison, "William M. Chase, N.A.,"
House Beautiful 25 [February 1909]: 56, as *Portrait of
Mrs. C.*; *Art and Progress* 5 [1914]: 346, as *Lady with a
White Shawl*; "Art, W. M. Chase," *Nation* 103, no.
2679 [November 2, 1916]: 28, as *Lady with a White
Shawl*; *Outlook* 114 [November 8, 1916]: 537).

This portrait by Chase depicts a "Mrs. Clark," a
somewhat mysterious figure in the Chase oeuvre,
and one whom Chase would describe as being
the quintessential model, writing, "She *was* a
model—and more. As she arose gracefully and
stood smiling before me I knew at once that
fortune had sent me the very subject I had long
hoped to find—a perfect type of American
womanhood. A clear-cut, classic face with splen-
did profile—a steadfast expression of sweetness,
loveliness, womanliness—and, above all else, dig-
nity and simplicity, these [are the] two greatest
elements of successful portraiture" (William
Merritt Chase, "How I Painted My Greatest
Picture," *Delineator* 72 [December 1908]: 969,
968 [illus. in an engraving by F. H. Wellington]).
At the time of its completion, Chase considered
Portrait of Mrs. C. to be his greatest work. Upon
its first public appearance at the Pennsylvania
Academy of the Fine Arts in 1894, the critics
uniformly praised both its stylistic and technical
merits: "Figure, dress and surroundings are sim-
plicity itself, yet unaffected. The face is exquisitely
modeled, as is the right hand.... The brushwork
is even and simple from top to bottom, never
hurried, never hesitating, never showing a desire
to exhibit the painter's cleverness by a bravura
passage; in fine, it is a masterpiece" ("A Dazzling
Picture Show," *New York Times,* March 11, 1894,
17). Marianna G. van Rensselaer eloquently
expressed her appreciation of Chase's creation,
noting that its "breadth, dignity, strength and
serenity in portrait painting could hardly be
more perfectly united than they are here. And
the compelling charm of the characterization
seems all the greater because the attractiveness
of the face does not reside chiefly in formal
physical beauty. Note how this very quiet can-
vas, this very quiet figure, dominates the whole
room and makes everything else seem a trifle

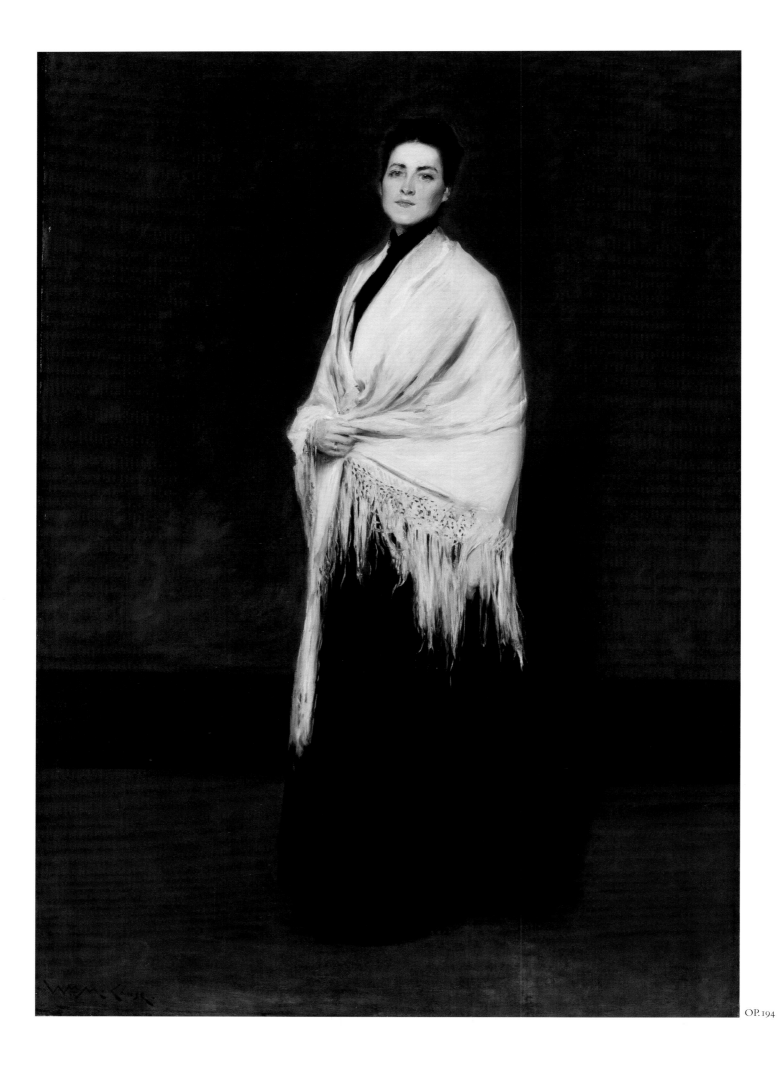

noisy or a trifle cheap. Truly—even apart from any question of Mr. Chase's masterly technique—is not this a model of the way a gentlewoman's portrait should be conceived?" (*World,* November 4, 1894, 18).

The painting was acquired by the Pennsylvania Academy of the Fine Arts in 1895 for $500, though Chase would continue to exhibit the work widely, including shows in Paris (1899 and 1900) and Berlin (1910). The painting was awarded a "place of honor" at the 1900 Exposition Universelle in Paris, whereupon a visiting art critic said of it: "Seen through the door from the room which contained the celebrated portraits by Sargent, it stood alone in the center of the wall, stately, dignified, aristocratic in pose, superb in reserved color . . . a delicious picture; and all the foreign artists returned to it many times to gaze at it" (Harrison Morris, *Confessions in Art* [New York: Sears Publishing Company, 1930], 97). And another accorded it a "place of honour in the American section of the Paris Exhibition," describing it as "one of the most monumental of Mr. Chase's portraits, one whose composition and simplicity seems to proclaim it an examplar [*sic*] for the younger portrait painters" (Ernest Knaufft, "An American Painter —William M. Chase," *The International Studio* 21, no. 93 [December 1900]: 156). Knaufft mentioned the portrait again years later in his article, "Sargent, Chase, and Other Portrait Painters," *American Review of Reviews* 36 (December 1907): 693. The painting was illustrated in *Brush & Pencil* 6 (June 1900): 134; *Century Magazine* 60 (1900): 920; O. Golwin, "Amerikanische Malerei," *Die Kunst für Alle* 16 (March 15, 1901): 276 (mentioned), 280 (illus.), as *Lady with a White Shawl*; *American Illustrated Magazine* 61 (December 1905): 200; Charles Caffin, *Story of American Painting* (New York: Frederick A. Stokes Co., 1907), 116 (illus.); *International Studio* 41 (September 1910): 183; "Ausstelling Amerikanischer Kunst," Königliche Akademie der Kunste, Berlin, 1910, pl. 11 (illus.); Helen Henderson, *The Pennsylvania Academy of the Fine Arts and Other Collections of Philadelphia* (Boston: L. C. Page and Company, 1911), facing p. 130 (illus.); D. Phillips, "William M. Chase," *American Magazine of Art* 8, no. 2 (December 1916): 50, 44, frontispiece (illus.); Katharine Metcalf Roof, *The Life and Art of William Merritt Chase* (New York: Charles Scribner's Sons, 1917): facing p. 232; Lorinda Munson Bryant, *American Pictures and Their Painters* (New York: John Lane Company, 1917; reprinted 1920), fig. 78, facing p. 115 (illus.); and John C. Van Dyke, *American Painting and Its Tradition* (New York: Charles Scribner's Sons, 1919), facing p. 202 (illus.). Included in Peat's 1949 checklist of Chase's known work as *Lady with a White Shawl; Mrs. Clark; Mrs. C.,* and as being owned by the Pennsylvania Academy of the Fine Arts, Philadelphia.

OP. 195

Mrs. Frederick Vinton, ca. 1893

Oil on canvas; 19½ x 15½ in. (49.5 x 39.5 cm)
Signed: Wm. M. Chase (l.l.)

Washington State University Museum of Art, Seattle

Frederick Porter Vinton (1846-1911) was a friend of Chase's and a fellow Munich-trained artist. In the summer of 1882, Chase, Vinton, and Robert Blum traveled together to Spain to study the work of the Spanish masters, that of Diego Velázquez in particular. Vinton's next trip to Europe came shortly after marrying Annie M. Peirce (1855-1929) of Newport, Rhode Island, on June 27, 1883. It is Mrs. Vinton whom Chase captures in this bust-length portrait. Frederick Vinton lived in Boston and was a sought-after painter, painting more than three hundred portraits over the course of his career. The date of the work is uncertain, though 1893 suggests itself on account of the fact that in that year Chase painted *Portrait of a Lady (A Lady in Evening Dress)* (OP.196), in which a woman is dressed in a similar fashion and similarly posed before a dark background. In a letter from Vose Galleries, Boston, dated August 12, 1974, S. Morton Vose II wrote regarding this painting that "the picture was ordered by the Boston Museum (of Fine Arts) from Chase, but was too small. The Museum ordered a larger one which they now own.

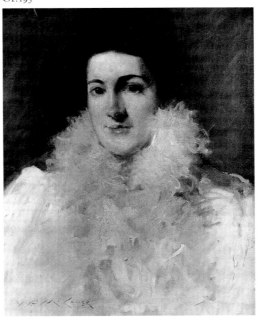

OP. 195

Frederick Vinton bought it (the smaller one) and owned it until his death" (Work File, Washington State University Museum of Art, Seattle). There are no references in the files at the Museum of Fine Arts, Boston, confirming this material. The only painting to which this letter could refer as a replacement for the portrait of *Mrs. Vinton* would be *Still Life,* circa 1900 (44½ x 56⅛ in. [113 x 142.6 cm]) (see vol. 4), which was purchased by the museum from Chase in 1908. Included on Peat's 1949 checklist of Chase's known work as *Mrs. Frederick Vinton,* and as being owned by the University of Washington, Pullman.

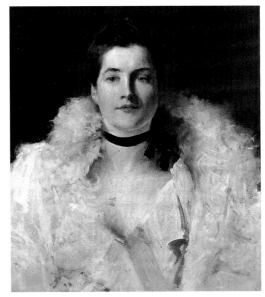

OP. 196

OP. 196

Portrait of a Lady (A Lady in Evening Dress), ca. 1893

Oil on canvas; 24 x 19¾ in. (61 x 50.2 cm)
Signed: Wm. M. Chase (u.r.)

Collection of Fayez Sarofim, Houston

The sitter for this portrait is said to be a Miss or Mrs. Clark, who posed for Chase on several occasions, as for *Portrait of Miss C. (Lady in Opera Cloak; Portrait of Mrs. Clark),* circa 1893 (OP.197). A letter in the files of the Vose Galleries, Boston, states that the Museum of Fine Arts, Boston, had ordered Chase to paint a canvas to become a part of the permanent collection of the museum. The present work was selected, but, according to the letter, when the museum hung the work it was decided that the canvas was too small; Chase was subsequently asked to paint another work

depicting the same model with the same costume on a larger scale. According to the author of the letter, George Peirce, a descendant of Chase's friend and fellow artist Frederick Porter Vinton, Chase complied. However, the information in the letter regarding the museum's request for a larger picture cannot be verified, and no similar work was acquired by the museum during the 1890s. Years later Vinton acquired the work and owned it until he died; the Museum of Fine Arts, Boston, purchased the work from Mrs. Vinton in 1922, through the Ellen Kelleren Gardner Fund; the work has since been deaccessioned.

Frederick Vinton also owned a Chase portrait of Vinton's wife, circa 1893 (OP.195) that closely resembles the work under discussion. In the former, the feather boa is wrapped around her so that you cannot see her neck or chest. There seems to be some confusion regarding the history of these two works. The Washington State University Museum has a letter from Vose Galleries relaying the same story, but with the portrait of *Mrs. Vinton* being the work rejected by the Boston Museum of Fine Arts Committee for being too small (Invoice Book, Vose Galleries, Boston). The exact story may remain a mystery, but we do know that the Vintons did own both of these works during their lifetimes. This painting is included on Peat's 1949 checklist as *Portrait of a Lady* (A), and as being owned by the Museum of Fine Arts, Boston. Peat dates the work to circa 1905, though circa 1893 seems more likely given that Chase did several other paintings featuring this model in that period.

OP.197

Portrait of Miss C. (Lady in Opera Cloak; Portrait of Mrs. Clark), ca. 1893

Oil on canvas; 48 x 48 in. (121.9 x 121.9 cm)
Signed: Wm. M. Chase (l.l.)

Grand Rapids Art Museum, Mich. Gift of Emily J. Clark

Exhibitions and Auctions: **SAA '93 #95** as *Portrait of Miss C. (owner)*; **AIC '97 #41** as *Lady in Opera Cloak*; **NAPP '15 #ix** as *Portrait of Mrs. Clark* [lent by the artist]; **CI '16 #7** as *Portrait of Mrs. Clarke* [*sic*]; **Csale '17 #371** as *Portrait of Mrs. Clark* [purchased, Amie T. Lang]; **AAA '23 #92**, mistitled *The Open Cloak* (fully described) [purchased, Macbeth Galleries, $450].

The present work was exhibited frequently and was well received by critics throughout the artist's lifetime. The painting highlights Chase's skill with both texture and color. An unidenti-

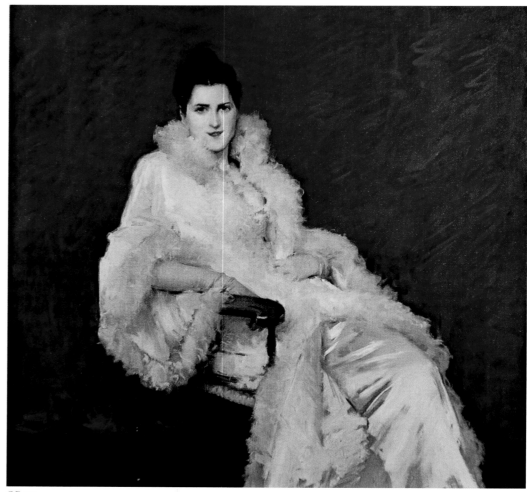

OP.197

fied news clipping found in a scrapbook of the Memorial Art Gallery, Rochester, New York, 1916, regarding the traveling exhibition of the National Society of Portrait Painters in 1915–16 states, "William M. Chase shows his *Master Roland*. The other portrait by Chase is from a much earlier period—a portrait of a lady in white posed against a difficult red background strongly suggesting Whistler's favorite problems in color." It has been proposed that the model for this painting was Emily Jewell Clark (1843–1929), who was benefactress of the Grand Rapids Art Museum, Michigan, to which she donated the work. However, this seems unlikely given the fact that in 1893 Emily Jewell Clark would have been fifty years old, while the sitter for the portrait is surely much younger. Emily Clark did not have any children, eliminating that possibility for a possible model. Another consideration pointing to Mrs. Emily J. Clark not being the model is that a society woman such as she would have likely commissioned Chase to paint her portrait, which was not the case considering that the work remained in Chase's possession until being auctioned in his estate sale in 1917. Regardless of the sitter's identity, she appears in several Chase paintings of the same

period, including *Portrait of Mrs. C. (Mrs. C.; Woman with a White Shawl; Lady with a White Shawl)* (OP.194), *Portrait of a Lady (A Lady in Evening Dress)* (OP.196), *Mrs. W. Irving Clark* (OP.198), and *Portrait of a Lady* (possibly *The Fur Wrap*) (OP.199). None of these works was exhibited as *Portrait of Mrs. Emily Clark* during the artist's lifetime.

Another possible identity of the sitter for these paintings is Minnie Clark, an Irish-American woman who modeled for Chase's fellow artists Thomas W. Dewing and James Carroll Beckwith. Unfortunately, very little is known about her, including whether or not Clark was her maiden or married name. To complicate matters further, this painting was first exhibited in 1893 at the exhibition of the Society of American Artists as *Portrait of Miss C.* rather than *Mrs. C.,* as it was subsequently known. A review of the exhibition confirms this is the present painting through its description, which refers to the "pink lined opera cloak, white gown and white feather trimming" (*Tribune*, April 22, 1893, n.p.). Included on Peat's 1949 checklist as *The Opera Cloak (Miss Emily Clark),* and as being owned by the Grand Rapids Art Gallery, Michigan.

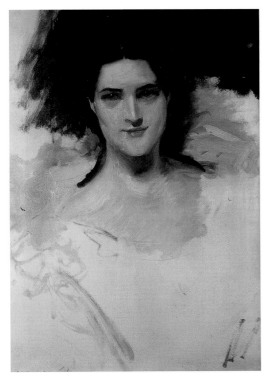

OP.198

OP.198

Portrait of a Lady (Sketch of a Head), ca. 1893

Oil on canvas; 24 x 17⅛ in. (61 x 43.5 cm)
Signed: Wm. M. Chase (l.l.)

Worcester Art Museum, Mass. Sarah C. Garver Fund

Auctions: **Csale '96 #1123** as *Sketch of a Head*

Chase executed several portraits of what appears to be the same model. These paintings are thought to depict a woman with the last name of Clark. This has created a good deal of confusion due to the fact that in two cases, including this work, the last name of the early owner of the painting was Clark, but this Clark may not necessarily be connected to the sitter Ms. Clark. The model used in these portraits is thought to be a Miss or Mrs. Emily Clark (see OP.197 and OP.208); Mrs. W. Irving Clark's first name was not Emily, but rather Elizabeth. She was born Elizabeth Hilliard Pratt (b. 1882), daughter of the artist Frederick Sumner Pratt (b. 1845), and was married to W. Irving Clark in 1906 in Worcester, Massachusetts. This was thirteen years after the painting was completed, making it unlikely that she was the model for this painting. It is possible that W. Irving Clark owned the work, but that it did not in fact depict his wife. Or perhaps W. Irving Clark was married once before to a woman named Emily, but there are not genealogical records to

confirm this. According to Chase, the sitter Clark was the original model for Charles Dana Gibson's "Gibson Girl" ("How I Painted My Greatest Picture," *The Delineator* 72 [December 1908]: 969). The present portrait of Clark, when it was included in Chase's 1896 sale as #1123, *Sketch of a Head,* was referred to as capturing the "Gibson Girl" as a model. A reviewer of the sale noted, "The most casual observer will be struck by the resemblance of the girl whose countenance appears in canvas No. 1123 to the model made so familiar to the public in the illustrative work by Charles Dana Gibson" (CMS, "Gallery and Studio: The Sale of William M. Chase's Belongings," *Brooklyn Daily Eagle,* January 5, 1896, p. 22).

Other paintings of the same period in which this model is thought to appear include *Portrait of Mrs. C.* (OP.194), *Portrait of a Lady (A Lady in Evening Dress)* (OP.196), *Portrait of Miss C. (Lady in Opera Cloak)* (OP.197), and *Portrait of a Lady (possibly The Fur Wrap)* (OP.199). The present painting is included on Peat's 1949 checklist of Chase's known work, possibly as both *Mrs. Clark (B), A Sketch,* owned by the Corcoran Gallery of Art, Washington, D.C., and *Mrs. W. Irving Clark,* formerly owned by Frederick S. Clark, Worcester, Massachusetts.

OP.199

Portrait of a Lady (possibly The Fur Wrap), 1893

Oil on canvas; 21 x 17 in. (53.3 x 43.2 cm)
Signed: Wm. M. Chase (l.r.)
Dated: 1893 (l.r.)

Location unknown

OP.199

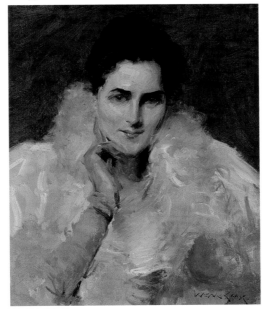

The sitter for the present work is thought to be the same model Chase used for other works of the same period: a Miss or Mrs. Clark. This work is a spontaneous and intimate work—indeed, given the similarities of costume, it may even be a study for *Lady in Opera Cloak; Portrait of Mrs. Clark* (OP.197).

The present work appears in a photograph capturing Chase's Tenth Street Studio in the Chase Archives, Parrish Art Museum, Southampton, Long Island, New York. This painting is placed against the wall of the curtained entryway connecting two of the rooms of the studio. Included on Peat's 1949 checklist of Chase's known work as *The Fur Wrap,* and as being owned by Gladys Lee Wiles (1890–1982), the daughter of Chase's friend and fellow artist Irving Wiles.

OP.200

Portrait of Miss Cromwell, ca. 1893

Oil on canvas; 30 x 24 in. (76.2 x 61 cm)
There was an estate seal in red wax affixed to the back of this work (these have been invariably lost due to cracking and lifting).

American Academy of Arts and Letters, New York. Gift of Archer M. Huntington, 1936

Exhibitions and Auctions: **PAFA '96 #49; Csale '17 #278** [purchased, F. A. Lawlor, $50].

Portrait of Miss Cromwell was one of the works selected to be exhibited at the World's Columbian Exposition in Chicago in 1893 ("Pictures Accepted in New York," *Art Amateur* [March 1893]: 116). However, for some reason it did not

OP.200

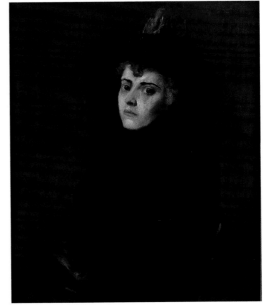

end up being included. Apparently, Chase's *Alice (Alice—A Portrait), circa 1891 (OP.182),* was shown instead. The catalogue for the Chase estate sale of 1917 describes the present work as follows: "A young lady with golden blond hair and dark eyes and eyebrows is seated in a small dark chair facing the left, with head turned toward the front, looking straight at the observer. A brilliant light brings out her well-turned features, from her broad dark hat and dark furs. She is shown at nearly three-quarters length against a background of dark brownish-red." This work does have the remnants of the seal from the 1917 estate auction, even as the painting is unsigned—unusual for Chase, particularly for a work that he exhibited. Included on Peat's 1949 checklist of Chase's known work as *Miss Cromwell,* and as being formerly owned by F. A. Lawlor, New York.

OP.201

Portrait of Lydia Field Emmet (Miss E.; Portrait of Miss E.), 1893

Oil on canvas; 71⅞ x 36 in. (182.6 x 91.4 cm)
Signed: Wm. M. Chase (l.l.)

Brooklyn Museum, N.Y. Gift of William Merritt Chase, February 18, 1915 (15.316)

Exhibitions: **CWCE '93 #255** as *Portrait of Mrs. [sic] E* [lent by Mrs. E.] (Charles M. Kurtz, ed., *World's Columbian Exposition, The Art Gallery Illustrated* [Chicago, 1893], 239, illus. as *Portrait of Miss M. [sic];* "Pictures Accepted in New York," *Art Amateur* [March 1893]: 116, as *Portrait of Miss Emmett [sic];* "The World's Fair: American Paintings: Melchers, McEwen, Shirlaw, Chase, Marr, Duveneck," *Art Amateur* [August 1893]: 56, as *Portrait of Miss M.);* **NADLEx '95 #68** as *Miss E.* ("New York Portrait Loan Exhibition," *Art Amateur* [December 1895]: 3, possibly as *Miss Q.);* **PAFA '96 #51** as *Portrait of Miss E.* [lent by the artist]; **CM '97 #18; AIC '97 #60** as *Miss E.* [lent by the artist]; **CM '02 #41** as *Portrait of Miss E.* [lent by the artist]; **PAFA '08 #16** as *Portrait of Lydia Emmett;* **BFAA '09 #4** as *Portrait of Miss E.* [owned by the artist] ("The Paintings by Mr. Chase," *Academy Notes* 4 [February 1909]: 148, as *Portrait of Miss E.);* **NAC '10 #9** as *Portrait of Lydia Field Emmet* [lent by the artist]; **BPL '10** ("Chase Collection an Admirable One," [Bridgeport, Conn.] *Daily Standard,* March 3, 1910, 3); **BAA '12 #71; FAM '13 #4** [lent by the artist]; **PPIE '15 #3741** as *Miss Emmet* [lent by the Brooklyn Museum] (John E. D. Trask, *Catalogue De Lux of the Department of Fine Arts Pacific International Exposition,* vol. 1 [San Francisco: P. Elder, 1915], 221, no. 3741); **MMA '17,** not in exhibition but listed as being one of the works in public galleries.

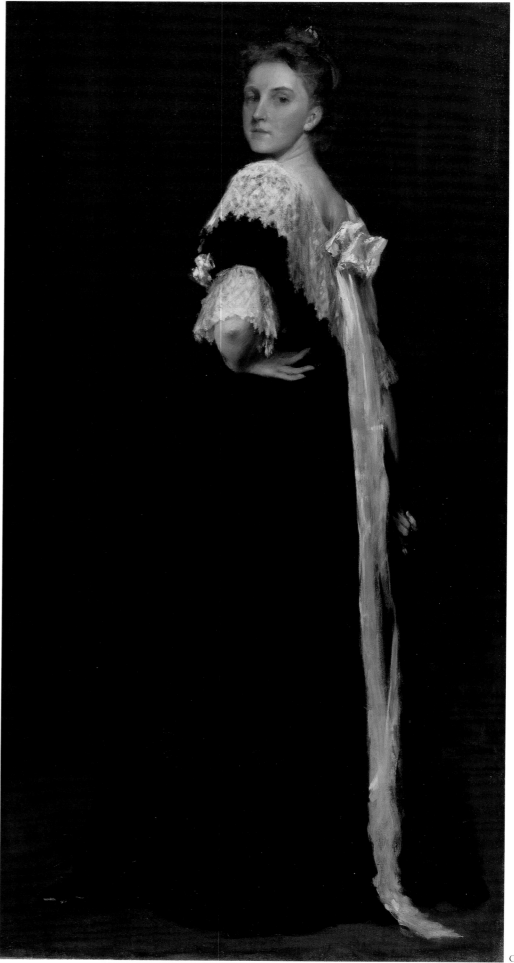

OP.201

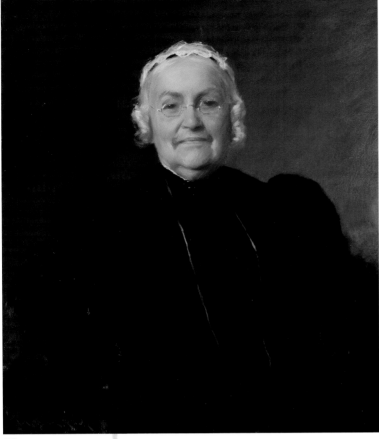

OP.202

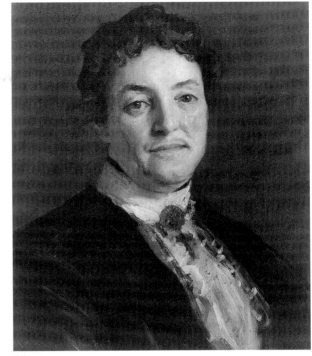

OP.203

The subject of the painting is Chase student and artist Lydia Field Emmet (1866-1952). She worked with him in New York for several years, and when Chase started his Shinnecock Summer School of Art in 1891, he asked her to head his "Preparatory Class." This painting was created as an exhibition piece and was shown frequently. When it was shown at the 1895 Loan Exhibition at the National Academy of Design, a critic observed, "Of Mr. Chase's half-dozen examples, we like best that which is best known to us, a full-length life size standing figure of a young lady in black who is looking over her shoulder at the spectator" (*Art Amateur* [December 1895]: 3). When questioned about his poses in an interview, Chase offered, "I do not think I ever did much better than the pose of that figure in the portrait of Miss. Emmet" ([Chicago] *Tribune*, November 21, 1897, n.p.). And writing about the work during the traveling exhibition of 1909, another critic commented, "The attitude of the figure is natural and the drawing and modeling are most excellent" (*Academy Notes* 4 [February 1909]: 148). The work was likewise praised when it was shown at the Bridgeport Public Library exhibition of 1910: "The artist is very fond of painting women's shoulders and a knowledge of this helps in appreciating the full figures. In the portrait of *Miss Q.* there is an opportunity to see what the artist can do with the back, shoulder,

and elbow. He has also kept the tightness and texture of the lace about the shoulders" (*Bridgeport Daily Standard,* March 3, 1910, 3, as *Miss Q.*). Included on Peat's 1949 checklist of Chase's known work as *Lydia Field Emmet; Miss E.,* and as being owned by the Brooklyn Museum of Art, New York.

OP.202

Sarah Redwood Parrish, ca. 1893

Oil on canvas; 30⅜ x 25½ in. (77.2 x 64.8 cm)
Signed: Wm. M. Chase (l.l.)
Marks verso on upper edge of frame: part of label reading "Sarah Red"

The Parrish Art Museum, Southampton, Long Island, N.Y. Gift of the Lee Family

A portrait of Sarah Redwood Parrish (1810-1895), mother of Samuel Longstreth Parrish, a friend of the artist and founder of the Art Museum at Southampton (now the Parrish Art Museum) in 1898. This was likely a commissioned portrait, and there are no records of it being exhibited during the artist's lifetime. It was probably completed between 1891 and the sitter's death in 1895; that is, in the first years Chase taught at his Shinnecock Hills Summer School of Art.

OP.203

Portrait of Mrs. William Fisher, ca. 1893

Oil on canvas; 20 x 16 in. (50.8 x 40.6 cm)
Signed: Wm. M. Chase (l.l.)

Location unknown

Mrs. Fisher was the wife of Chase's physician and close family friend, Dr. William Fisher. Chase also completed a pendant portrait of Dr. Fisher (OP.204), as well as paintings of their two daughters, Elizabeth and Esther. Members of the Fisher family appear in family photographs taken at Shinnecock, Long Island, New York, where they and the Chases spent their summer months. There are no exhibition records for this painting. Wilbur Peat dates the work circa 1905, though it seems more likely it would have been created nearer to the dates of her husband's portrait (ca. 1893) or her daughters' (ca. 1899). A date circa 1900 or earlier is further confirmed by a photograph from the Chase Archives, dated to around that year, that shows *Portrait of Mrs. William Fisher* on Chase's easel (Chase Archives, Parrish Art Museum, Southampton, Long Island, New York, no. 83.Stm.154). Included on Peat's 1949 checklist of Chase's known work as *Mrs. William R. Fisher,* owned by Elizabeth and Esther Fisher, Swiftwater, Pennsylvania.

OP.204

Dr. William R. Fisher, 1893

Oil on canvas; 20 x 16 in. (50.8 x 40.6 cm)
Signed: Wm. M. Chase (u.l.)
Inscribed: To my friend Dr. Fisher/Wm. M. Chase (u.l.)

Location unknown

Dr. Fisher, his wife, and children were close personal friends with the Chase family. There are several photographs of Chase with various members of the Fisher family, including Dr. Fisher, in the William Merritt Chase Archives, Parrish Art Museum, Southampton, Long Island, New York. The archive also includes a somewhat formal portrait photograph of Dr. Fisher, dated November 1900; in the photograph Dr. Fisher appears to be somewhat older than his visage in this portrait, which would seem to confirm a date of 1893, when this work was believed to have been painted. The Fishers owned several paintings by Chase, including *Alice (Sketch of His Daughter Alice; Alice on Sunday)* (OP.246), a portrait of young Alice Dieudonnée Chase, painted in 1896, which eventually came to be owned by Dr. Fisher's daughters, Elizabeth and Esther. Chase painted a pendant portrait of Mrs. Fisher, no doubt around the same time. This painting is included in the Peat 1949 checklist as being owned by Elizabeth and Esther Fisher, Swiftwater, Pennsylvania, and said to date from 1893.

OP.205

Henry Wolf, ca. 1893

Oil on canvas (presumably); dimensions unknown
Inscribed and signed: To my friend Henry Wolf /
Wm. M. Chase (u.r.)

Westmoreland County Museum of Art, Greensburg, Pa.

Exhibitions: **SAA '93 #210** as *Portrait* [lent by Henry Wolf, Esq.] ("The Exhibition of the Society of American Artists," *Art Amateur* [May 1893]).

Henry Wolf (1852–1916) was an artist and wood engraver. The Chase portrait was reproduced in the article "American Wood-Engravers: Henry Wolf," *Scribner's Magazine* 17 (January 1895): 20. In the American section of the Panama-Pacific International Exposition (San Francisco, 1915), Henry Wolf exhibited over 100 prints, for which he was awarded the Grand Prize in graphics. Included in this exhibition were five engravings after works by Chase: *Alice, Lady with the White Shawl, Gathering Autumn Leaves, A Lady in Black,* and *The Artist's Daughter.*

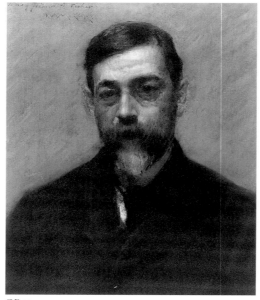

OP.204

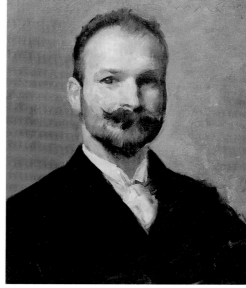

OP.205

OP.206

Jeremiah M. Rusk

Physical properties unknown

U.S. Department of Agriculture, Washington, D.C.

Jeremiah M. Rusk (1830–1893) was secretary of agriculture throughout the administration of Benjamin Harrison (1889–93).

OP.207

James E. Rhoads, M.D.

Oil on canvas; 45 x 37½ in. (114.3 x 95.3 cm)
Signed: Wm. M. Chase (l.r.)

Bryn Mawr College Art Collection, Bryn Mawr College, Pa.

Dr. Rhoads (1828–1895) was a trustee of Bryn Mawr College (1877–95) and served as president of the college from 1884 until 1894. It is possible that this work was painted upon his retirement as president in 1894. From the studied look of the portrait, it is also possible the work was painted from a photograph.

OP.208

Portrait of Mrs. C., ca. 1893

Oil on canvas; 40 x 29 in. (101.6 x 73.7 cm)
Signed: Wm. M. Chase (u.l.)

Collection of Meredith and Cornelia Long

OP.207

Exhibitions: **AIC '97 #50** as *Portrait of Mrs. M. C. of New York* [lent by the artist]; **BFAA '09 #2** as *Portrait of Mrs. C.* [lent by the artist] ("The Paintings by Mr. Chase," *Academy Notes* 4 [February 1909]: 146, illus.).

This is one of a number of paintings Chase executed circa 1893 that are thought to depict the same model; others include *Portrait of Mrs. C. (Mrs. C.; Woman with a White Shawl; Lady with a White Shawl)* (OP.194), *Portrait of a Lady (A Lady in Evening Dress)* (OP.196), *Mrs. W. Irving Clark* (OP.198), and *Portrait of a Lady (possibly The Fur Wrap)* (OP.199). None of these works was exhibited as *Portrait of Mrs. Emily Clark* during the artist's lifetime. Chase referred to the model as "Mrs. Clark, the Original Gibson Girl.

OP.209

OP.210

Mrs. Clark was the model who made Charles Dana Gibson, the creator of the Gibson girl, known all over the world. . . . I wish also to speak of the very high regard in which Mrs. Clark was held by Gibson, Beckwith, myself and the other artists for whom she posed" (*Delineator,* December 1908, 969). He never mentioned Mrs. Clark's first name. The Clark who modeled for Gibson, Beckwith, and Thomas Dewing was the Irish-American beauty Minnie Clark. However, over time a consensus developed that the model used by Chase in this and other portraits was an Emily Clark. This may have been the result of the fact that the Chase painting *Portrait of Miss C.* (OP.197) was owned by Emily J. Clark (1843–1929). It is possible, though not likely, that Chase used Emily Clark as his model, given that she would have been fifty years old at the time of the portrait, whereas the sitter is assuredly much younger. Further, Emily Clark was not the first Gibson girl. Yet another detail that may help to shed light on this issue is a description of a work in an exhibition review for Chase's show in 1897 at the Art Institute of Chicago, which reads, "Some of the most notable pictures of the collection are the portrait in the center of the

south wall of the lady gowned in lustrous white satin, her head erect and hair simply dressed, leaning her arms in their coverings of grey suede over the back of a chair" ([Chicago] *Chronicle,* November 28, 1897, n.p.). This writer seems to be referring to the present portrait, though the painting was titled *Portrait of Mrs. M. C. of New York*—Minnie Clark?—for that exhibition. *Portrait of Miss C. (Lady in Opera Cloak; Portrait of Mrs. Clark),* which also is thought to depict Mrs. Clark, was included in the exhibition also but does not conform to the description given in the *Chronicle*. Included on Peat's 1949 checklist as *Mrs. Clark* (C), *Mrs. C.* (E), and as being formerly owned by Harold Wakem, New York.

OP.209

Edward Guthrie Kennedy

Oil on canvas; 22 x 18 in. (55.9 x 45.7 cm)
Signed: Wm. M. Chase (l.l.)

The Metropolitan Museum of Art, New York. Gift of Mr. and Mrs. Raymond J. Horowitz (1973.342)

Exhibitions: **NADLEx '95 #64** [lent by E. G. Kennedy].

Edward Kennedy was for many years associated with the New York art gallery Wunderlich and Company, later renamed Kennedy Galleries. He was also a personal friend of Chase's, and acted as an intermediary between Chase and James McNeill Whistler—once quasi artist-compatriots who had a falling out. In a letter to Kennedy, dated May 22, 1896 [Whistler Papers, Manuscript Division, New York Public Library, New York], Chase asked him to convey his condolences to Whistler upon hearing of the death of his mother.

OP.210

Portrait of Jules Turcas, ca. 1894

Oil on canvas; 40 x 30 in. (101.6 x 76.2 cm)
Signed: Wm. M. Chase (l.l.)

American Academy of Arts and Letters, New York. Gift of Archer M. Huntington, 1936

Exhibitions and Auctions: SAA '94 #172; AIC '97 #46; NAC '10 #105; Csale '17 #286 (fully described).

Jules Turcas (1854–1917) was a landscape artist associated with the American Barbizon school. He was born in Cuba and is first listed as living in New York in 1893, around the time of his portrait by Chase, which, incidentally, was painted in the Tenth Street Studio. He died in Boston in 1917, and the 1917 Chase estate sale notes that fact by referring to the portrait as of the late Jules Turcas; it was purchased from this sale by Mr. F. A. Lawlor. Included in Peat's 1949 checklist as being the property of the American Academy of Arts and Letters, New York.

OP.211

Portrait of Mr. Lucas, ca. 1894

Medium/support/dimensions unknown

Location unknown

Exhibitions: CAA '95 #208.

OP.212

Portrait of Mrs. Lucas, ca. 1894

Oil on canvas; dimensions unknown

Location unknown

Exhibitions: StLEx '95 #208 [lent by the artist].

Chase also painted a portrait of Mr. Lucas (OP.211), the sitter's husband. There is no extant image or description of the work.

OP.213

Portrait of Joseph Lasell

Oil on canvas; 53½ x 35 in. (135.9 x 88.9 cm)
Signed: Wm. M. Chase (l.l.)

Private collection

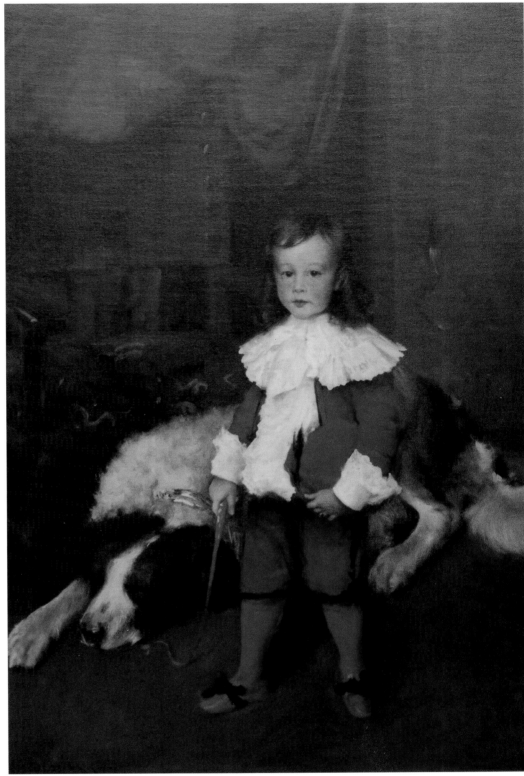

OP.213

A label attached to the back of this painting refers to an exhibition held at the Worcester Art Museum, April 15–May 10, 1914, and the painting titled *Boy in Red.* A letter was sent to the library of the Worcester Art Museum; however, there was no reply and a follow-up telephone call yielded no information regarding the exhibition. According to Ronald G. Pisano, the work "is undoubtedly a commissioned society portrait that was inspired by the work of Velázquez— most specifically his painting [*Prince*] *Baltasar Carlos as a Hunter* [Museo del Prado, Madrid], which portrays the young prince standing in front of a large dog sprawled out on the ground behind him." Only the setting is different, and the prince holds a rifle instead of a whip.

OP.214

OP.214

Lady in White, 1894

Oil on canvas; 72³⁄₁₆ x 36½ in. (183.4 x 92.7 cm)
Signed: Wm. M. Chase (l.l.)

Private collection, Paradise Valley, Ariz.

Exhibitions and Auctions: **PAFA '94 #61** ("The
Group Exhibition," *Art Amateur* [June 1894]: 3);
FASAG '94; Csale '96 #1180 [purchased, $90];
BPL '10; NAC '10 #50 [lent by Edward D. Page];
MMA '17 #24 [lent by Edward D. Page].

The painting's appearance at the Pennsylvania
Academy of the Fine Arts in 1894 drew one
critic to describe it as "reminiscent of Terburg
[*sic*] . . . though it is little more than a study of a
white satin dress against a dark background, for
the face is turned from the spectator" (*Art Ama-
teur* [June 1894]: 3). The painting is illustrated in
William J. Baer, "Reformer and Iconoclast,"
Quarterly Illustrator 2, no. 6 (1894): 135–41. This
article was then reproduced with *Lady in White*
illustrated in *Essays on American Art and Artists*
(New York: Eastern Art League, 1896), 138.
 Although the model for the painting was the
artist's wife, Alice Gerson Chase (1866–1927),
the work was clearly intended less as a portrait
than a study of a white satin dress. Included on
Peat's 1949 checklist of Chase's known work as
Lady in White, and as being formerly owned by
Edward D. Page circa 1917.

OP.215

Mrs. Z., 1894

Oil on canvas; 24 x 20 in. (61 x 50.8 cm)
Signed: Wm. M. Chase (u.l.)
Inscribed verso: Mrs. N. Lansing Zabriskie, Painted
by Wm. M. Chase, New York, 1894

Location unknown

Exhibitions: **PAFA '94 #59** as *Mrs. Z.*; **NADLEx '94
#70** [lent by William M. Chase, Esq.].

Likely a commissioned portrait of Louise Fidelia
Morgan Zabriskie (b. 1837), though the work
was still in Chase's possession at the time of the
1894 National Academy of Design Loan Exhibi-
tion. It is possible the work was delivered to the
sitter's family shortly after that exhibition, as
there are no extant exhibition records for this
work after that date.

OP.215

OP.216

OP.216

Portrait (possibly *Mrs. Millar*), 1894

Oil on canvas; 24 x 20 in. (61 x 50.8 cm)
Signed: Wm. M. Chase (u.l.)
Inscribed and dated verso (previous to lining): New
York / Jan. 1894

Collection of David Clark, New York

This work is thought to depict the wife of the
artist Addison Thomas Millar (1860–1913). Millar
received it as a gift from Chase, and it remained
in the artist's family for several generations. Addi-
son Millar moved to New York from Ohio in
1883 and studied at the Art Students League,
possibly taking courses with Chase; he is known

to have studied with Chase at the Shinnecock
Summer School of Art after 1892. Sadly the lives
of Mr. and Mrs. Millar were cut short when they
died in an automobile accident in 1913.

OP.217

Mona, Daughter of Mrs. R. (Mona), ca. 1894

Oil on canvas, 33 x 26 in. (83.8 x 66 cm)
Inscribed verso: Wm. M. Chase.

Collection of Mona Biddle Dick Wilson, Glen
Ellen, Calif.

Exhibitions: **AIC '97 #56** as *Mona, Daughter of
Mrs. R.* [lent by the artist]; **SAA '98 #42** [lent by the
artist]; **PAFA '98 #69** [lent by the artist as *Mona*];
NADLEx '99 #66 [lent by Mrs. W. Moncure
Robinson].

A black-and-white photograph of the work
that descended in the Chase family is labeled:
"Mona / about 1894 / Shinnecock." Mona was
actually Lydia Spencer Moncure Robinson,
daughter of a prominent railroad magnate,

whose family nickname was Mona. Mona and
her mother, Mrs. W. Moncure Robinson, trav-
eled to Shinnecock, Long Island, probably in the
summer of 1894 to have the former's portrait
painted by Chase. Chase depicts her with a pen-
sive expression, her hair parted in the middle,
and wearing two braids, each with a bow. Her
hands are clasped in her lap. She wears a kimono
tied with a wide band. The Robinsons seem to
have left the portrait in Chase's possession so
that he could exhibit it in 1897 at his solo exhi-
bition at the Art Institute of Chicago, as well as
several times in 1898.

OP.218

Portrait of Dorothy Chase (Study of a Girl's Head), ca. 1894

Oil on canvas; 20 x 16 in. (50.8 x 40.6 cm)
Signed: Chase (l.l.)

Location unknown

This painting of Dorothy Brémond Chase
(1891–1953) is probably a "demonstration piece"
that Chase would complete before one of his

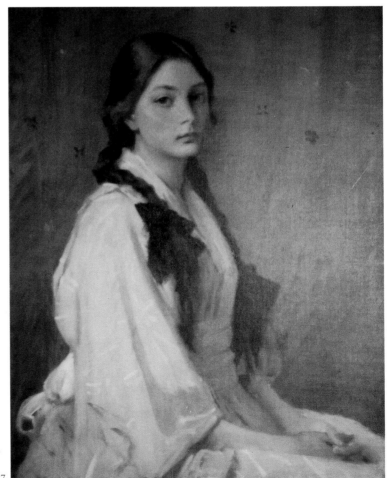

OP.217

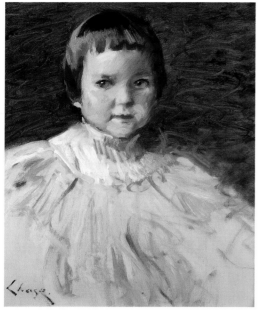

OP.218

The Detroit Institute of Arts. Gift of Mrs. Arthur McGraw, 1931

Exhibitions and Auctions: **SAA '94 #153** as *Portrait of my Little Daughter Dorothy* [lent by the artist] (*Art Amateur*, April 1894, 127); **CAA '95 #213; StLEx '95 #213** as *My Little Daughter Dorothy* [lent by the artist]; **AIC '97 #43** as *My Little Daughter Dorothy* [lent by the artist]; **SAA '97 #331** as *Dorothy* [lent by the artist]; **CM '06 #9**, illustrated as *My Daughter Dorothy* [lent by the artist]; **Csale '17 #374** as *My Little Daughter Dorothy,* sold to William Macbeth, $600.

Chase depicts his daughter Dorothy Brémond Chase (1891–1953) at about three years old. She is wearing a light tan hood, a cape, and a pelisse over a pink dress with white mittens on her hands. The painting was first exhibited in March 1894, so Chase probably completed the work early in that year. Part of a large, gold-framed painting is visible in the work, as is a small stool covered with a red tasseled cushion. These two elements give the viewer a sense of scale, showing how small Dorothy was at the time. A writer for *Arts for America* surmised that Dorothy "in her simple gray cloak and bonnet is either clad in garments new, or is about to go for a walk or drive. There is a suggestion of waiting in the attitude, but it is overshadowed by the bright glow of happiness and anticipation which radiates from the bright little face. No one can stand before such a painting without forgetting the trials of the day and entering at once into the unrestrained happiness of childhood" (*Arts for America* [December 1897]: 198). The painting was included in a photo of Chase's Tenth Street Studio in Wendy Cooper's article "Artists in Their Studios," published in *Godey's Magazine* in March 1895. Cooper writes, "On the easel is the finished portrait of Dorothy, the little daughter of Mr. Chase, charming as to pose and expression, as are all of his children's pictures" (*Godey's Magazine* [March 1895]: 296). According to the 1917 Chase estate sale catalogue entry for the

classes, usually in about an hour or so. Perhaps Chase kept this study of Dorothy and then either sold or gave it to his student Martha Walter (1875–1976); the work was part of Walter's estate when she died. Walter grew up in Philadelphia and studied with Chase at the Pennsylvania Academy of the Fine Arts. She was one of Chase's most promising students, winning the academy's Toppan Prize in 1902 and Cresson Traveling Scholarship in 1903. With the two-year traveling Cresson Scholarship, Walter visited France, Spain, Italy, and Holland and attended the Académie Grande Chaumière and the Académie Julian in Paris. In 1909, after having exhibited only four times in the academy's annual exhibitions, she won its Mary Smith Prize for the best painting by a resident female artist. Soon she was teaching at Chase's New York School of Art. Chase later executed a portrait of Walter that has a similarly sketchlike quality (OP.490). This painting, owner unknown, is included on Peat's 1949 checklist as *Dorothy (B) (Dorothy Chase); Study of a Girl's Head*.

OP.219

Portrait of My Little Daughter Dorothy (My Little Daughter Dorothy; Dorothy; My Daughter Dorothy), ca. 1894

Oil on canvas; 48 x 35 in. (121.9 x 88.9 cm)
Signed: Wm. M. Chase (l.r.)
Inscribed: my little daughter Dorothy (l.r., as well as verso).
There was an estate seal in red wax affixed to the back of the work (these invariably have been lost due to cracking and lifting).

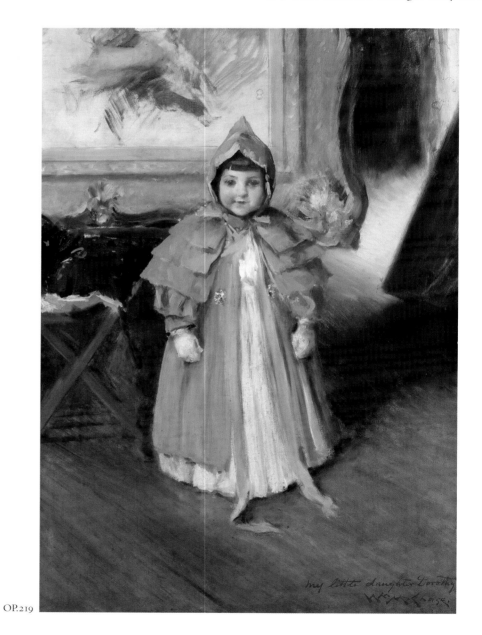

OP.219

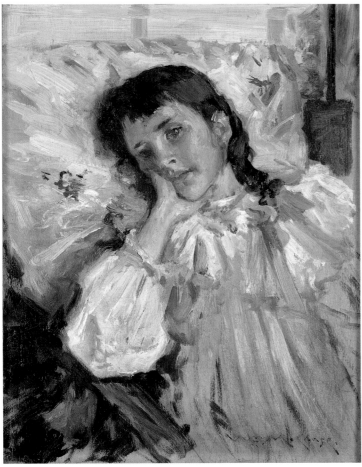

OP.220

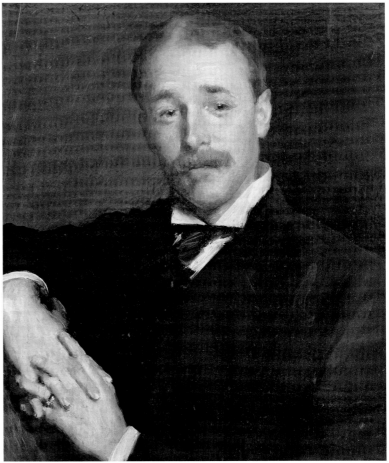

OP.221

work, the backdrop for the picture is Chase's Tenth Street Studio. However, there has been some discussion about the painting having been completed in Long Island at Chase's studio in Shinnecock Hills. The catalogue entry listed the dimensions incorrectly as being 54 by 36 inches. *My Little Daughter Dorothy* is included on Peat's 1949 checklist of known works by Chase, though Peat's dating to 1891 is incorrect given that that is the year Dorothy was born. Peat's dimensions for the work, 45 by 33 inches, are likewise incorrect.

OP.220

Tired, ca. 1894

Oil on panel; 13 x 9½ in. (33 x 24.1 cm)
Signed: Wm. M. Chase (l.r.)
Label verso: Tired

Private collection

Exhibitions and Auctions: **PAFA '94 #58** [lent by the artist]; **SAA '95 #70** [lent by the artist]; **Csale '96 #1147** [purchased, Mr. and Mrs. Robert McDougall].

The model for this work is most likely Chase's eldest daughter, Alice Dieudonnée (1887–1971),

known as "Cosy," who posed for Chase on many occasions in the 1890s. She was born in 1887 and would have been about seven or eight years old when this picture was painted. *Tired* was sold in the Chase Sale of 1896 to Mr. and Mrs. Robert McDougall. Chase completed a portrait of Mrs. McDougall in 1895 entitled *A Lady in Pink* (OP.230).

OP.221

Charles Henry Ault, 1895

Oil on canvas; 24 x 20 in. (61 x 50.8 cm)
Signed: Wm. M. Chase (u.l.)

Colby College Art Museum, Waterville, Maine.
Gift of Mr. and Mrs. Norman Hirschl

Exhibitions: **CAA '95 #194** as *Portrait of Chas. H. Ault*; **NAD '95 #104** as *Portrait of Mr. Ault* [lent by Mrs. Ault].

This painting, framed, is clearly visible in an extant photograph of Chase's Tenth Street Studio, titled "Mr. Chase's Large Studio" (W. A. Cooper, "Artists in Their Studios," *Godey's Magazine* 130, no. 777 [March 1895]: 293). Charles Henry Ault

was a Canadian-born artist and an active member of the New York art scene at the end of the nineteenth century—in fact he exhibited in the 1895 National Academy of Design exhibition and Chase most likely met him at that time.

OP.222

Portrait Study, ca. 1895

Oil on panel; 25½ x 21 in. (64.7 x 53.3 cm)
Signed: Chase (r.c.)

Location unknown

Auctions: **Csale '17, #275** (fully described).

This portrait study was sold in Chase's Estate Sale in 1917 as lot no. 275. The work was described in the catalogue entry as follows: "Head and shoulders of a blue eyed and pink cheeked woman with a mound of blond hair, dressed in black with a broad white collar, figure to the right, three-quarters front, her face turned toward the spectator." *Portrait Study* was purchased by Leroy Ireland (1889–1970), an artist and dealer, for $95. Unfortunately, there is no extant image of this painting.

OP.223

Portrait of Eugene F. Aucaigne

Oil on canvas; 20 x 16 in. (50.8 x 40.6 cm)

Location unknown

Eugene F. Aucaigne would have been very well known to Chase, as he was a member of the New York art community. Aucaigne was a bronze expert, associated with the casting foundry of Henry-Bonnard, New York. Chase also painted the portraits of Peter Bonnard and U.S. Senator (Montana) William A. Clark, who owned the Henry-Bonnard foundry. There was also a Philadelphia connection in that it was Aucaigne who supervised the casting of bronze doors for the Pennsylvania State Capitol. There are no extant images of this work. The painting is included in Peat's 1949 checklist of known work by Chase.

OP.224

Portrait of My Father, ca. 1895

Oil on canvas; 22 x 18 in. (55.9 x 45.7 cm)
Signed: Wm. M. Chase (l.l.)

Indianapolis Museum of Art. Gift of Mrs. Carrie Chase Roberts (49.66)

Auctions: **Csale '17 #363** (fully described) [purchased, Alfred Rose].

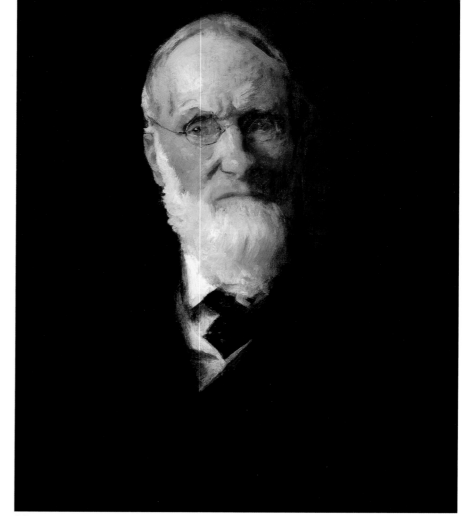

OP.224

This is the only known portrait Chase painted of his father, David Hester Chase. While it is curious that such a work would have been sold by the family in 1917, at least it ended up in the collection of Chase's sister Carrie, who also owned the better known and exhibited portrait of his mother. The work is included in Peat's 1949 checklist as being owned by Mrs. Carrie Chase Roberts, Arlington, New Jersey.

OP.225

Portrait of Dr. Mundé, ca. 1895

Physical properties unknown

Location unknown

Exhibitions: **NADLEx '95 #70** [Mrs. Mundé—owner]; **AIC '97 #51** as *Portrait of Dr. M.*

It is assumed that *Portrait of Dr. Mundé* and *Portrait of Dr. M.* are the same painting; perhaps it was simply a mistaken omission that Mrs. Mundé was not listed as the owner in the 1897 exhibition. Dr. Paul Fortunatus Mundé was born in Saxony in 1846, and received his medical degree from Harvard University in 1866. He became a well-known gynecologist who established his practice in New York.

OP.226

Reverend Arthur Brooks, ca. 1895

Oil on canvas; 32½ x 25 in. (82.6 x 63.5 cm)
Signed: Wm. M. Chase (l.l.)

Church of the Incarnation, New York

Reverend Brooks was rector of the Church of the Incarnation in New York City until his untimely death in 1895, which prompted this posthumous portrait to be commissioned. Most likely Chase worked from a photograph. The portrait was referenced by Katharine Metcalf Roof in her 1917 biography of Chase and by Peat in his 1949 checklist of known work as being in the collection of the Church of the Incarnation, New York.

OP.227

William Henry Howe, 1895

Oil on canvas; 21 x 17 in. (53.3 x 43.2 cm)
Signed: Wm. M. Chase (l.l.)
Noted (verso): W. H. Howe / painted by / Wm. M. Chase

National Academy of Design, New York

Exhibitions: **NAC '16 #77.**

William Henry Howe (1846-1929) became an associate of the National Academy of Design in 1894, and this portrait was likely finished the following year, when it was presented to the National Academy of Design on March 14, 1895.

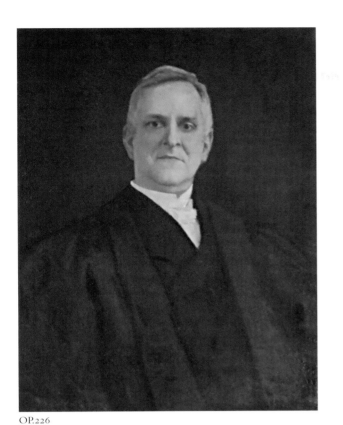

OP.226

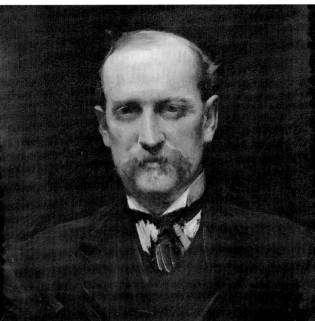

OP.227

Howe was a landscape painter, and though relatively unknown today, was a member of many art organizations and exhibited regularly at the prominent exhibition venues of his day. This work is included in Peat's 1949 checklist of known work.

OP.228

Mrs. Chase (The Yellow Blouse), ca. 1895

Oil on canvas; 20 x 16 in. (50.8 x 40.6 cm)
Signed: Wm. M. Chase (l.l.)

Location unknown

This is a portrait of the artist's wife, Alice Gerson Chase (1866–1927), in a yellow dress similar to the one she wore when she modeled for the well-known painting *A Friendly Call* (vol. 4). This work also bears close relation to Chase's portrait of another woman titled *The Golden Lady* (OP.248), in which one of his students is similarly posed in a yellow dress and wears a cross suspended from a ribbon. All three works were painted in the mid-1890s. The title *The Yellow Blouse* was probably not the original title, but rather assigned after the artist's lifetime.

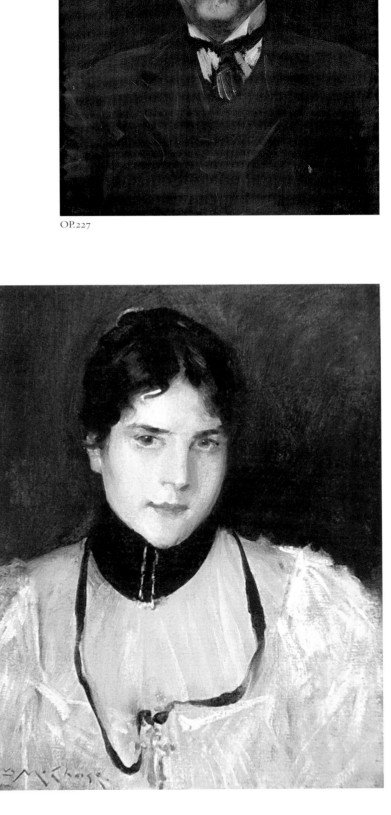

OP.228

OP.229

Portrait of a Lady, ca. 1895

Oil on canvas; 70 x 40 in. (177.8 x 101.6 cm)

Location unknown

Exhibitions: **BPL '10**, no catalogue.

This full-length portrait is unlocated, and the
only image available is in a photograph of the
Bridgeport Public Library exhibition. Details of
the painting are difficult to decipher, but it looks
to be a full-length portrait of a youthful Mrs.
Chase. She stands facing the viewer with hands
clasped before her. There appears to be a chair in
the background to the left.

OP.230

A Lady in Pink, 1895

Oil on canvas; 54 x 36 in. (137.2 x 91.4 cm)
Signed: Wm. M. Chase (u.l.)
Dated: 1895 (u.l.)
Label (verso): Society of American Artists "A Study
in Pink"

Location unknown

Exhibitions: **SAA '00 #42** as *A Lady in Pink* [lent by
Robert P. McDougall].

This painting of Ida McDougall (b. 1864)
was commissioned by her husband, Mr. Robert
P. McDougall, of Orange, New Jersey. The
McDougalls purchased another painting by
Chase, *Tired* (OP.220), in the 1896 Chase sale.

OP.231

Alice (Alice Dieudonnée Chase; Alice C.; The Red Sash), 1895

Oil on canvas; 32½ x 25½ in. (82.6 x 64.8 cm)
Signed: Wm. M. Chase (u.l.)
Dated: 1895 (u.l.)

Hirshhorn Museum and Sculpture Garden, Smith-
sonian Institution, Washington, D.C. Gift of Joseph
H. Hirshhorn, 1966 (66.879)

Exhibitions and Auctions: **NADLEx '95 #65** as
Alice Dieudonnée Chase [lent by Wm. M. Chase, Esq.]
("New York Portrait Loan Exhibition," *Art Amateur*
[December 1895]: 3); **AIC '97 #48** as *Alice C.*; **Csale
'17 #280** as *The Red Sash,* sold to Constance [*sic*;
Content] Johnson, $85.

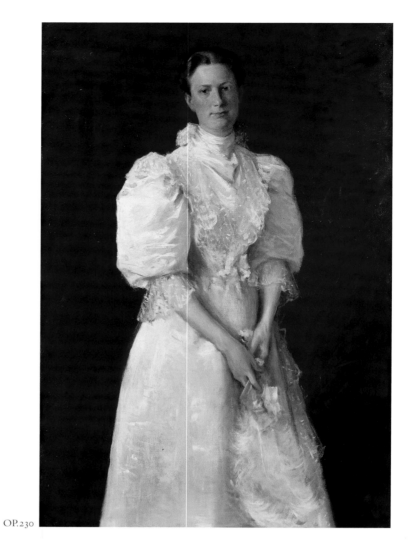

OP.230

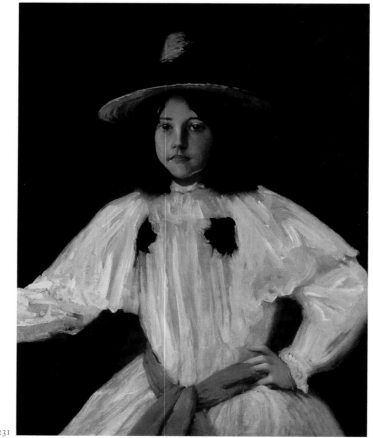

OP.231

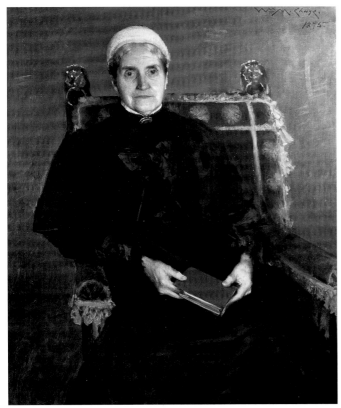

OP.232

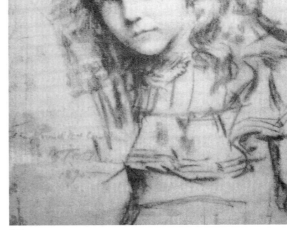

OP.233

This work was first reproduced in 1892 in the *Century Magazine* in the form of a wood engraving by Henry Wolf entitled *Alice*; the work appeared on exhibit three years later at the 1895 National Academy of Design exhibition. A review of that show describes the sitter's "gypsy hat, white dress and vermillion ribbons" (*Art Amateur* [December 1895]: 3). A reviewer of the 1897 exhibition at the Art Institute of Chicago remarked that "Alice C. is a fascinating portrait of a dark girl in a muslin frock over a vermillion slip. Her face is becomingly shadowed by her large yellow straw hat" ([Chicago] *Herald*, November 28, 1897, n.p.). The painting, like many treating his family, stayed in the artist's possession until his death in 1916. It was sold to former Chase student (and sitter; see OP.344) Content Johnson. Included on Peat's 1949 checklist of Chase's known work as *The Red Sash*, and as being formerly owned by Constance [*sic*] Johnson, New York.

OP.232

Mrs. G. B. Ely, 1895

Oil on canvas; 48 x 36 in. (121.9 x 91.4 cm)
Signed: Wm. M. Chase (u.r.)
Dated: 1895 (u.r.)

Location unknown

Exhibitions: **NADLEx '99 #62** as *Mrs. G. B. Ely* [lent by Mrs. G. B. Ely] (Ernest Knaufft, "The Portrait Exhibition," *Art Interchange* 42 [February 1899]: 28).

Catherine Boies Ely (1825 or 1826–1904) married George Ely (1826–1886) in 1848 and in 1851 moved with him to Hainesville, Wisconsin, where he established a law practice and was later elected district attorney. Appointed paymaster during the Civil War by President Abraham Lincoln, he and his family moved to Washington, D.C., where Mrs. Ely is known to have visited the wounded in the hospitals. At the outbreak of the Spanish-American War, Mrs. Ely wrote an article protesting it, recalling the horrors of war she had known.

The self-consciously regal, frontal seated pose seen here is one Chase used often in his portraits of women. The chair in which Mrs. Ely sits is likely one of several armchairs of seventeenth-century Spanish design to be found in Chase's elaborately furnished studio. The choice of a high-necked, black dress and a white head-covering enhanced the sense of a period portrait. One critic noted that "on the chin and around the mouth there is evidence of the artist's having struggled to get the expression he desired" ("American Studio Talk," *International Studio*, Supplement 1 [September 1898]: 10). Included on Peat's 1949 checklist of Chase's known work as *Catherine Boies Ely,* and as being owned by the Los Angeles County Museum.

OP.233

Portrait of a Little Girl, 1895

Oil on canvas; 18 x 14 in. (45.7 x 35.6 cm)
Inscribed: To My Friend Mrs. Cowden (?) Wm. M. Chase 1895

Location unknown

This work may depict the daughter of Nebraska-born painter Minnie Reed Cowden. The only extant image of the work is a photograph in the archives of the Vose Galleries, Boston.

OP.234

Mrs. G., ca. 1895

Medium/support/dimensions unknown

Location unknown

Exhibitions: **NADLEx '95 #69** as *Mrs. G.* [lent by John R. Glenny, Esq.].

There is no extant image or description of this portrait. It is possible that the sitter, "Mrs. G.," was Mrs. Glenny, the wife of the painting's owner at the time of its exhibition at the National Academy of Design in 1895.

OP.235

Mrs. Wm. M. Chase, ca. 1895

Oil on canvas; 20 x 16 in. (50.8 x 40.6 cm)
Signed: Wm. M. Chase (u.r.)
Verso: This painting is by my husband,
Wm. M. Chase / signed Mrs. Wm. M. Chase /
1923; notarized on June 10, 1927

The Detroit Institute of Arts. Gift of
Raymond C. Smith

Exhibitions: **NG '27 #13** as *Mrs. Wm M. Chase*
(*Art News* 26 [December 17, 1927]: 10, illus.).

This bust-length portrait of the artist's wife
beautifully captures the varying textures of her
velvet cape and the crisp, high, pink collar and
white dickey. The painting does not appear to
have been exhibited during the artist's lifetime,
though Mrs. Chase did confirm the authenticity
of the work in 1923 and her statement was nota-
rized on June 10, 1927. The painting was included
in the Chase Memorial Exhibition at the New-
house Galleries, St. Louis, Missouri, and illus-
trated in conjunction with the exhibition (*Art
News* 26 [December 17, 1927]: 10). The caption
underneath the illustration reads, "This portrait
has just been purchased by an important Detroit
collector from Gordon Beers of the Gordon
Galleries." The painting was later purchased by
Raymond C. Smith, who then donated the
painting to the Detroit Institute of Arts. *Portrait
of Mrs. Wm. M.,* owner unknown, appears on
Peat's 1949 checklist of Chase's known work.

OP.236

Portrait of a Woman (Portrait of Mrs. D.),
ca. 1895

Oil on canvas; 72 x 36 in. (182.9 x 91.4 cm)
Signed: Wm. M. Chase (l.l.)

The Detroit Institute of Arts. Gift of Henry Munroe
Campbell

Exhibitions and Auctions: **NAD '97 #317** as *Portrait
of Mrs. D.* [lent by Mrs. D.]; **AIC '97 #2** [lent by the
artist] (*International Studio,* Supplement [May 1897]:
12); **NAC '10 #66** [lent by Mrs. Davis]; **FAM '13
#12** [lent by the artist]; **Csale '17 #382** [purchased,
Alfred Rose, $170] (fully described).

Portrait of a Woman is likely the same painting
sold as no. 382 in the Chase estate sale of 1917,
wherein it was titled *Portrait of Mrs. D.* The two
paintings have the same dimensions and *Portrait
of Mrs. D.* is described in the auction catalogue

as a "full-length figure of a brown-haired young
woman with warm complexion, in a black gown
having elbow sleeves with broad puffs at the
shoulder. She has just arisen from a high-backed
armchair, and stands facing the observer with
hands lightly resting on its arms." The identity
of the sitter, whether the Mrs. Davis who owned
the painting circa 1910 or another woman
whose surname began with "D," has not been
determined. The painting was donated to its
present owner, the Detroit Institute of Arts, by
Mr. Henry Munroe Campbell, whose wife,
Mrs. (Isabella Lothrop) Campbell, was painted
by Chase when she was a student of his during
his summer course in Bruges, Belgium (OP.544).
This painting appears to have been listed twice
on Peat's 1949 checklist: once as *Mrs. D.,* for-
merly owned by Alfred Rose, New York, and
then again as *Portrait of a Woman,* owned by the
Detroit Institute of Arts.

OP.237

Portrait of a Young Woman, ca. 1895

Oil on canvas; 18¾ x 15⅜ in. (47.6 x 39.1 cm)
Signed: Wm. M. Chase (l.r.)

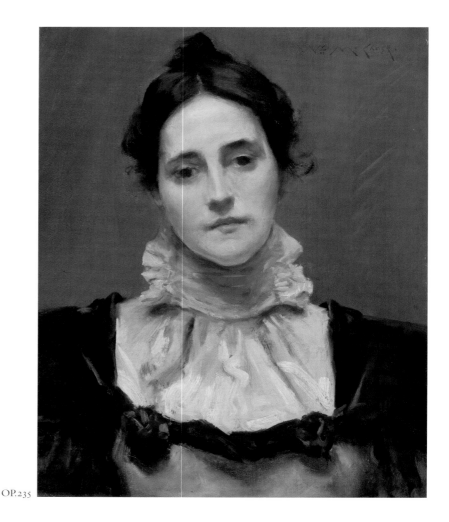

OP.235

Hickory Museum of Art, N.C. Gift of the L. C.
Gifford Family in memory of Mr. L. C. Gifford, 1977

The model for this work is probably Chase's
daughter Alice Dieudonnée, born 1887. She
appears to be approximately eight years old, dat-
ing the work to circa 1895. Efforts to compile a
comprehensive exhibition history are compli-
cated by the portrait's generic title. There is,
however, no known record of its having been
shown during the artist's lifetime.

OP.238

Portrait of Miss G., ca. 1895

Oil on canvas; 28¼ x 23½ in. (71.8 x 59.7 cm)
Signed: Wm. M. Chase (u.l.)

Location unknown

Exhibitions: **SAA '95 #27** as *Portrait of Miss G.* [lent
by the artist]; **AIC '97 #58** as *Portrait of Mrs. V. G.* [sic]
[lent by the artist].

In 1879, shortly after returning to New York
City from his studies in Munich, Chase was
introduced to Julius Gerson (b. 1824) and his

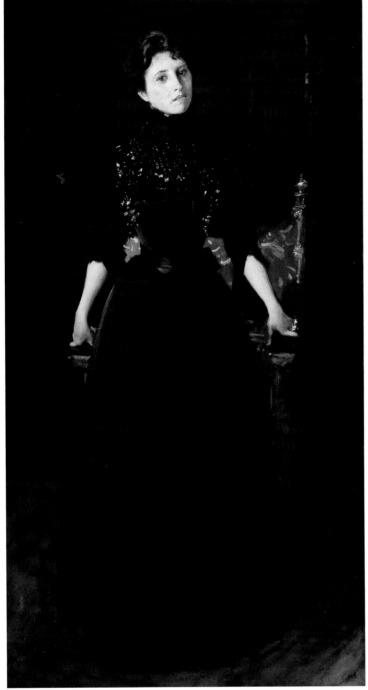

OP.236

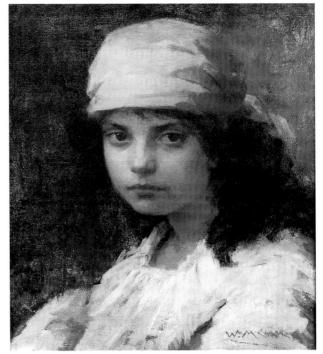

OP.237

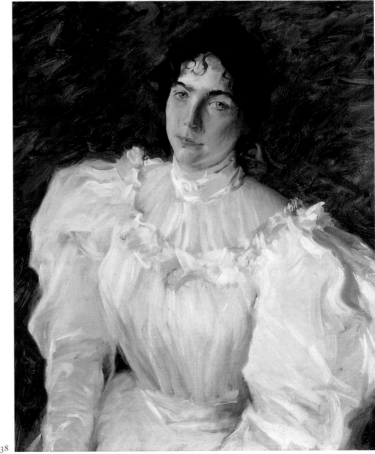

OP.238

family: three daughters, Minnie (1853–1927),
Virginia (1864–1951), and Alice (1866–1927),
and one son, Julius, Jr. (b. 1855). Mr. Gerson was
a patron of young artists returning from abroad,
many of whom gathered at his home to discuss
art and sketch. His daughters, particularly Vir-
ginia and Alice, often served as models—first
informally and then for major studio pictures.
Virginia, fondly known as Jennie, is the model
in the *Portrait of Miss. G.* She also appears in
Chase's well-known painting of 1880, *The Tenth
Street Studio* (see vol. 4), as well as in several
other important works done by Chase in the
1880s and 1890s. In this painting Virginia wears

OP.239

OP.239A. Photograph of *Portrait of Mrs. Chase,* ca. 1895. The Parrish Art Museum, Southampton, N.Y. William Merritt Chase Archives, Gift of Jackson Chase Storm (83.Stm.157)

a high-collared white dress with ruffles at the yoke, leg-o'-mutton sleeves and a tightly sashed waist. She is seated against a vibrantly painted green background.

Virginia Gerson, who would become Chase's sister-in-law, was also active in literary and theatrical circles; she was a close friend of the dramatist Clyde Fitch (of whom Chase also completed a portrait) and wrote several children's books that were published, including *The Happy Heart Family* (New York: Fox, Duffield and Co., 1898). These books, which include charming illustrations by her as well, were dedicated to Chase's children, and were most likely loosely based on the life of the Chase family. This painting is listed on Peat's 1949 checklist as *Virginia Gerson* (B), and as being owned by the Detroit Institute of Arts.

OP.239

Portrait of Mrs. C. (Mrs. William M. Chase), ca. 1895

Oil on canvas; 22 x 18 in. (55.9 x 45.7 cm)
Signed: Wm. M. Chase (u.l.)
Inscribed verso on Berry-Hill Galleries, Inc. (743 Fifth Avenue, New York, NY) label attached to backing: William Merritt Chase / Portrait of the Artist's Wife / Oil on canvas, 22 x 18 in. / Signed, upper left

Wichita Art Museum, Kans. Gift of the Sam P. Wallingford Foundation, Wichita

Exhibitions: NAC '10 #28, #61, or #96 is the present work, all listed as *Portrait of Mrs. C.* and owned by Mr. Chase; BPL '10, no known catalogue or checklist—work appears in installation photograph.

This portrait is one of the many paintings in which Chase depicts his wife, Alice Gerson (1866–1927). The painting appears to be a cut-down version of the painting that appears in

fuller size in a documentary photograph in the Chase Archives of the Parrish Art Museum, Southampton, Long Island, New York (OP.239A). The photograph, dating to circa 1895, was donated by the artist's grandson, Jackson Chase Storm (see "Photographs from the William M. Chase Archives at the Parrish Art Museum," Parrish Art Museum, Southampton, Long Island, New York, 1992, compiled by Ronald G. Pisano and Alicia Grant Longwell, ill. 563). Evidently the painting was cut down by the artist himself, since it appears (in its present form) in an installation photograph of an exhibition of Chase's work held at the Bridgeport Public Library, Connecticut, in March 1910.

OP.240

The Feather Fan, ca. 1895

Oil on canvas; 54 x 36 in. (137.2 x 91.4 cm)
Signed: Chase (l.r.)

Musée d'Orsay, Paris. Gift of Roland Knoedler

depicted wearing the same hat in a Shinnecock Hills landscape, *The Bayberry Bush,* circa 1895 (see vol. 4). In another photograph from the Chase Archives, the fan from the painting may be seen hanging behind Alice. *The Feather Fan* was not exhibited under that title during the artist's lifetime. It is included on Peat's 1949 checklist of Chase's known work as *The Feather Fan,* and as being formerly owned by M. Knoedler and Company, New York.

OP.241

Alice Gerson Chase, ca. 1895

Oil on canvas; 20 x 16 in. (50.8 x 40.6 cm)

Private collection, Huntington Beach, Calif.

This is one of the many paintings of Chase's wife, Alice Gerson Chase (1866–1927), whom he married in 1886. Judging from Mrs. Chase's age at the time and comparing the work to others of the period, a likely dating for the present work would be circa 1895. The work was unsigned, and thus likely intended for the private enjoyment of the Chase family.

OP.240

Auctions: **Csale '17 #291** [purchased, M. Knoedler and Company, New York, $250].

Chase here paints his eldest daughter, Alice Dieudonnée (1887–1971), seated and holding a feather fan in her lap. *The Feather Fan* was exhibited at the Musée d'Orsay and became part of its permanent collection. A photo of Alice with the painting *The Feather Fan* in the background is included in the Chase Archives, Parrish Art Museum, Southampton, Long Island, New York. Alice appears to be wearing the same dress in the photo as in the painting. However, Chase seems to have adapted her clothing to suit his needs by shortening the dress, adding a hat, and accentuating the ruffles on the sleeves. Alice is

OP.241

OP.242

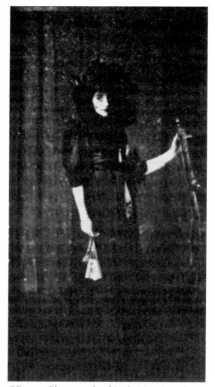

OP.242A. Photograph of *Little Miss C.* with chair

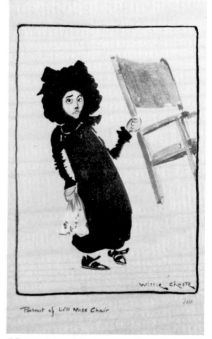

OP.242B. James Montgomery Flagg, *Portrait of Li'l Miss Chair*, 1899

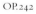

OP.242

Little Miss C. (Young Girl in Black; Portrait of Young Miss C.), ca. 1895

Oil on canvas; 60 x 36 in. (152.4 x 91.4 cm)

Hirshhorn Museum and Sculpture Garden, Smithsonian Institution, Washington, D.C. Gift of the Joseph H. Hirshhorn Foundation, 1966

Exhibitions and Auctions: **NADLEx '95 #66** as *Little Miss C.* [lent by Wm. M. Chase, Esq.] ("Later American Masters," *New England Magazine* [April 1896]: 135); **AIC '97, possibly #1,** *Young Girl in Black*; **SAA '98 #243** as *Portrait of Young Miss C.* (*Art Amateur* [May 1898]: 132, as *Portrait of Little Miss C.*); **DMA '16, possibly #11,** *Young Girl in Black*; **Csale '17 #190** as *Young Girl in Black* [purchased, H. R. Rittenberg, $90].

This painting depicts Chase's eldest daughter, Alice Dieudonnée Chase (1887–1971). The work remained in the artist's family during his lifetime, prior to its appearance in the 1917 Chase estate sale, whereupon it was sold to Henry Rittenberg (1879–1969), a former student of Chase's at both the Pennsylvania Academy of the Fine Arts and the Shinnecock Summer School.

There is a photograph of *Little Miss C.* in the Chase family archives that captures the painting, which at that time included a chair to Alice's right on which her left arm rested (OP.242A). Since the chair is not mentioned in the description of the painting in the catalogue for the 1917 Chase estate sale, it seems that Chase himself must have altered the painting at some point. Chase may have painted out the chair in the *Portrait of Young Miss C.* as a result of the high jinks of a group known as the Society of American Fakirs, who would create parodies of works exhibited by their mentors in the Society of American Artists exhibitions. One member of the organization, James Montgomery Flagg (1877-1960), created a caricature of the present work, calling it *Li'l Miss Chair* and crediting it to "Willie Chaste" (OP.242B). In it, Chase's model holds the chair as if she were about to throw it out of the composition—Flagg's not-so-subtle suggestion of how one might go about improving the work. This caricature of the painting was illustrated in *Century Magazine* 59 (December 1899): 321.

In Chase's portrait, Alice looks to be about eight or nine years old, which, given Alice's date of birth, would suggest the work was executed in 1895. Included on Peat's 1949 checklist of Chase's known work as *Young Girl in Black,* and as being formerly owned by H. R. Rittenberg. Peat mistakenly dates the work to circa 1915.

OP.243

Alice in the Mirror, ca. 1896

Oil on canvas; 35 x 32 in. (88.9 x 81.3 cm)

The Parrish Art Museum, Southampton, Long Island, N.Y. Littlejohn Collection

Alice in the Mirror captures Chase's firstborn daughter, Alice Dieudonnée (1887-1971). Chase was fascinated with mirrors and reflection and explored these themes in several of his works, including in a portrait of Mrs. Chase called *Reflections* (OP.187) and in another work entitled *The Mirror* (OP.321). Chase often used his children as models for his paintings, and in some instances these works were intended for the private enjoyment of the family and were thus left unsigned, as in this instance. It is interesting to note that Chase owned a picture by Berthe Morisot (1841-1895) entitled *Before the Mirror.* This picture by Morisot was auctioned in the 1896 Chase estate sale; that is, at approximately the same time as Chase completed *Alice in the Mirror.* The work was not exhibited during

Chase's lifetime under this title. It is included on Peat's 1949 checklist as *Alice in the Mirror (Alice Chase),* and as being owned by Newhouse Galleries, New York.

OP.244

Portrait of Molly Harden

Oil on canvas; 60 x 36 in. (152.4 x 91.4 cm)
Signed: Wm. M. Chase (l.l.)

Collection of Mrs. Frederick Robertson, Norfolk, Va.

According to a descendent, Molly Harden studied with Chase at Shinnecock, Long Island, sometime between 1891 and 1902, though the painting was likely commissioned a few years later. She wears a cream-colored dress and holds roses of a similar shade on her lap.

OP.244

OP.243

OP.245

Ready for the Ball, ca. 1896

Oil on canvas; 49 x 39 in. (124.5 x 99.1 cm)

Location unknown

Auctions: **Csale '96 #1178.**

The location of this work is unknown, and there is no extant image of it. There is no record of a work with this title being exhibited during the artist's lifetime. *Ready for the Ball* is included on Peat's 1949 checklist as measuring 52 by 42 inches, and as being formerly owned by Metropolitan Galleries, New York.

OP.246

Alice (Sketch of His Daughter Alice; Alice on Sunday), 1896

Oil on panel; 24 x 12 in. (61 x 30.5 cm)
Signed: Wm. M. Chase (l.r.)
Inscribed: To my friend Dr. Fisher from his friend / Xmas 1896

Private collection

This painting of Chase's daughter Alice Dieudonnée (1887–1971) was not exhibited during the artist's lifetime, and it is doubtful that Chase titled the work. Indeed, he gave it to his friend Dr. William R. Fisher shortly after completing it. It descended through the Fisher family until 1969, when Elizabeth and Esther Fisher sold the painting to or through Chapellier Galleries. It was exhibited at the gallery in an exhibition of works by Chase, cat. no. 12, illustrated in the accompanying catalogue, and titled *Alice on Sunday*. Included on Peat's 1949 checklist of Chase's known work as *Sketch of His Daughter Alice (Alice Chase),* and as being owned by Elizabeth and Esther Fisher, Swiftwater, Pennsylvania.

OP.247

Portrait of a Lady, 1896

Oil on panel; 14⅝ x 10½ in. (37.2 x 26.7 cm)
Signed: Chase '96 (l.r.)
Back of frame: SF? 42 26; MR 324 (u.c.)

Dixon Gallery and Gardens, Memphis, Tenn.
Bequest of Mrs. C. M. Gooch, 1980 (1980.2)

The sitter for this work remains unidentified and the generic title precludes discovery of its exhibition history, if, in fact, there is one.

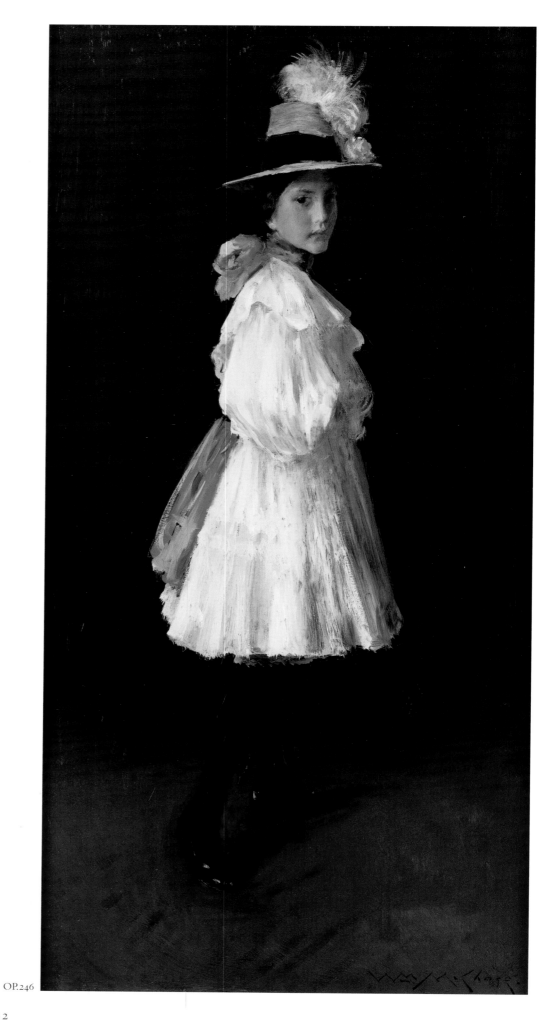

OP.246

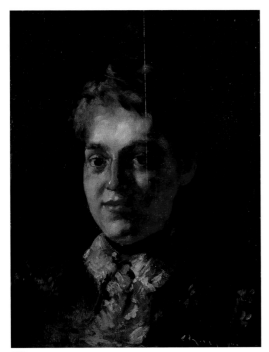

OP.247

OP.248

The Golden Lady, 1896

Oil on canvas; 40⅝ x 32¾ in. (103.2 x 83.2 cm)
Signed: Wm. M. Chase (u.r.)
Inscribed: Madrid, 1896 (u.r.)

The Parrish Art Museum, Southampton, Long
Island, N.Y. Littlejohn Collection

Exhibitions and Auctions: **AIC '97**, possibly
#57, *Lady in Yellow*; **Csale '17 #287** [purchased,
Mr. Symmers, Charlottesville, Va., $100].

Chase painted *The Golden Lady* during his trip
to Madrid in the summer of 1896, and the
model was likely one of his students, though her
identity is not known. Included on Peat's 1949
checklist of Chase's known work as *The Golden
Lady,* and as being owned by Mrs. James Keith
Symmers, Charlottesville, Virginia.

OP.249

Retrato de Señora C. (Portrait of Mrs. C.;
The Artist's Wife), ca. 1896

Oil on canvas; 32 x 25 in. (81.3 x 63.5 cm)
Signed: Wm. M. Chase (u.l.)

Location unknown

Exhibitions: **EIBA '10 #13** as *Retrato de Señora C.
(Portrait of Mrs. C.)* [lent by the artist]; **MMA '17**

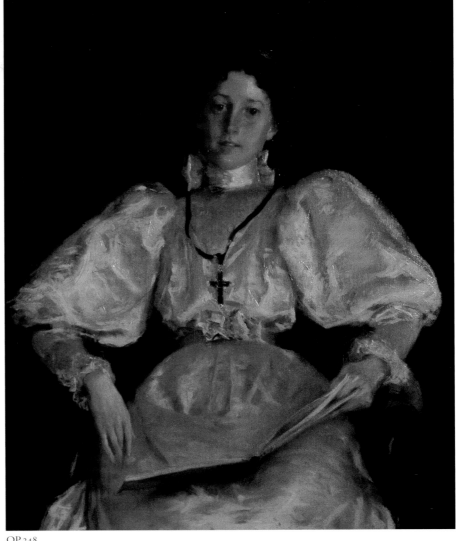

OP.248

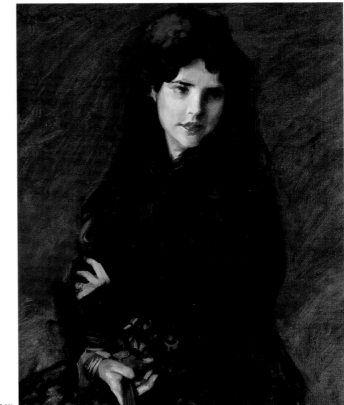

OP.249

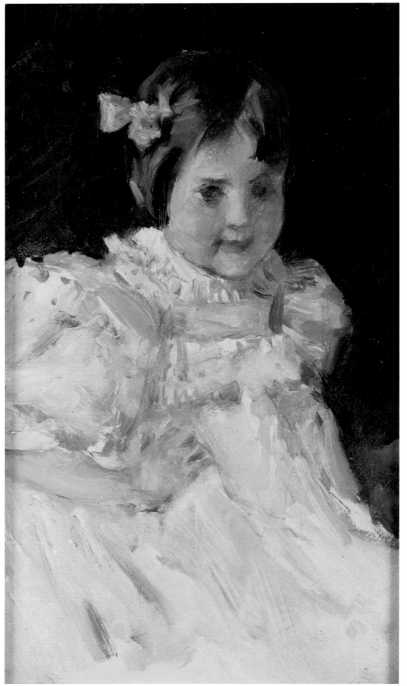

OP.250

OP.250

Study Head (Sketch of a Child; Portrait of Dorothy), ca. 1896

Oil on canvas; 10 x 5¾ in. (25.4 x 14.6 cm)
n.s.

Museum of Art, Rhode Island School of Design,
Providence. Bequest of Isaac C. Bates, 1913

Exhibitions: **RISD '97 #15** as *Study Head* [lent
by Isaac Bates, Esq.]; **RISD '13 #15** as *Sketch of
a Child*.

This painting depicts Chase's daughter Dorothy
Brémond Chase (1891–1953). Isaac Bates, a
prominent Rhode Island collector integrally
involved with the formation of the Museum
of the Rhode Island School of Design and in
building their collection, owned the work by
1896. It is possible that this is *Sketch of a Head*,
which sold in the 1896 Chase sale, although
the dimensions for the work in the auction are
listed as 8 by 6 inches rather than the dimen-
sions of this work. This painting is included
on Peat's 1949 checklist as *Sketch of a Child
(Dorothy Chase)*, and as being owned by the
Museum of Art [Rhode Island School of
Design], Providence.

OP.251

Dieudonnée (Alice Dieudonnée Chase; My Daughter Alice; Portrait of the Artist's Daughter; Miss Dieudonnee [sic]; Portrait of My Daughter), ca. 1896

Oil on canvas; 72 x 48 in. (182.9 x 121.9 cm)
Signed: Wm. M. Chase (l.l.)

The Cleveland Museum of Art. Gift of Mr. and Mrs.
Hermon A. Kelley in memory of their daughter,
Virginia Kelley Newberry, 1920 (1920.254)

Exhibitions and Auctions: **StLEx '98 #79; PAFA
'98 #71** as *Dieudonnée* [lent by the artist] (Charles
Caffin, *Harper's Weekly* [1898]: 102); **ISSPE '99 #1**,
illus. [lent by the artist]; **AAR '00 #86** as *Dieudonne*
[*sic*]; **MSFA '00 #28** as *Alice Dieudonnée Chase*;
NAC '10 #139 as *Miss Dieudonnee* [*sic*] [lent by the
artist]; **BPL '10** ([Bridgeport, Conn.] *Daily Standard*,
March 3, 1910, 3); **CM '12 #16** as *Portrait of the
Artist's Daughter*, illus.; **NAPP '12** as *My Daughter
Alice* (G. M. Marke, "National Association of Portrait
Painters," *Arts and Decoration* 2 [May 1912]: 259, 244,
illus.); **CGA '12 #68** as *Portrait of My Daughter*;
DMA '16 #15; TMA '16 #115; Csale '17 #387 as
Portrait of My Daughter, Alice.

#25 as *Mrs. Chase in Spanish Dress* (Katharine
M. Roof, *International Studio* [February 1918]: cv,
illus. as *The Artist's Wife*).

Chase first visited Spain in the summer of 1881
and became intrigued by Spanish subjects, an
interest that continued through the 1890s and
beyond. Chase's wife, Alice Gerson Chase (1866–
1927), was a model for many of these works. In
the summer of 1896 Chase escorted a group of
students to Madrid, and the trip likely inspired
him to create this painting at that time. Here, he
masterfully captures a variety of textures in black
from her hair to her veil, wrap, and dress. Small
patches of red in the flower, her lipstick, and the

handle of her fan in her lap move the viewer's eye
around the painting. Chase exhibited this work at
the Exposición Internacional de Bellas Artes in
Santiago, Chile, in 1910. According to the *American
Art Annual* 8, 106, Chase was awarded a Grand
Prize for this portrait; there were only two prizes
awarded for the exhibition. This is the only
recorded exhibition in which this painting was
shown during the artist's lifetime. This painting
is included in Peat's 1949 checklist as *Mrs. Chase
as a Spanish Girl*, and as being owned by Roland
Chase, Jackson Heights, Queens, New York. A
photo of the work as *Mrs. Chase as a Spanish Lady*
is part of the Chase Archives at the Parrish Art
Museum, Southampton, Long Island, New York.

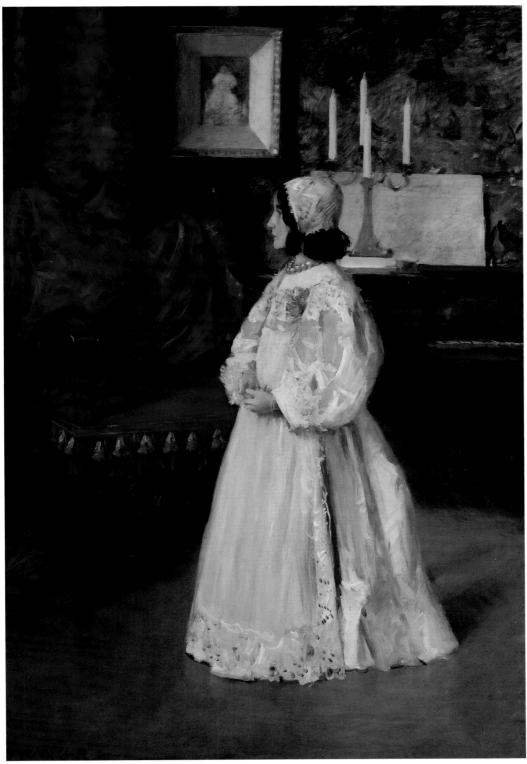

OP.251

England Magazine (April 1896): 135. A critic for the *International Studio* points to Chase's depiction of his eldest daughter as being "in a sombre key that prevents her from having the freshness of youth, but gives her a quaint air that is not without charm" (*International Studio,* Supplement [May 1897]: xi). Another adds enthusiastically, "There is a distinct charm in the portrait of the artist's daughter gowned for a fancy dress ball in a pink satin frock opening over a lace petticoat and a close-fitting pink satin cap. The appointments of the room in which the little maid stands are captivating; the handling of the textures is very fine" ([Chicago] *Herald Tribune,* November 28, 1897, n.p.). This painting is included on Peat's 1949 checklist as *My Daughter Alice (Alice Chase),* circa 1893, and as being owned by the Cleveland Museum of Art. Henry Wolf completed a wood engraving of this work; it is located at the California State Library, Sacramento.

OP.252

Portrait of an Artist

Oil on canvas; 22½ x 18¾ in. (57.2 x 47.6 cm)
Signed: Chase (l.l.)

Los Angeles County Museum of Art

Exhibitions: AIC '97 #15; McCG '05 #33; SAA '06 #376; AAG '09 #30; NAC '10 #102 [lent by Mr. Chase]; AAA&L '28 #23 as *A Violinist* (noting that the work was painted in Munich in 1875); NG'33 #12 as *Pablo Sarasate.*

This work has been retitled several times after 1916. During the artist's lifetime it was clearly titled *Portrait of an Artist*—this is confirmed in an article written in 1909 by James W. Pattison, "William Merritt Chase, N.A.," *House Beautiful* (February 1909): 51 (illus.), as *Portrait of an Artist.* The following year, the work was illustrated, also titled *Portrait of an Artist,* in a review of Chase's National Arts Club 1910 retrospective written by Katharine Metcalf Roof, "William Merritt Chase: An American Master," *Craftsman* 18 (April 1910): 33, illus. p. 42. In this article Roof notes that the painting, "done at a single sitting, belongs to this early [Dutch school style] period." Just how she came upon this information is not known, but as she, in 1917, wrote the first biography of the artist, it is likely that she personally knew Chase and his family. What is certain, however, is that the signature style is not early; in fact it dates to after 1885 and is the type usually given to classroom demonstration pieces. Either Roof is wrong in dating the work, or Chase signed the work some nearly thirty years after it was painted,

Chase painted many works depicting his daughter Alice Dieudonnée (1887-1971), some small and intimate and others large-scale exhibition pieces. In considering the size of this work (72 by 48 inches) and the compositional elements, such as Alice's beautifully rendered dress and the grand chair with the tassels and the rich fabric draped upon it, *Dieudonnée* was surely created for show, and Chase did indeed exhibit the work more than ten times. To judge from the piano and candelabra with the white board behind it in the background, this work was painted in the Chase home in Shinnecock, Long Island. Alice's outfit was noted by one writer as being "a quaint costume of the period of Charles I, designed by her mother" (Spencer H. Coon, *Metropolitan Magazine* [May 1897]: 307, 314, illus.). The work drew considerable attention from contemporary critics. The first reference to the work is in "Later American Masters," *New*

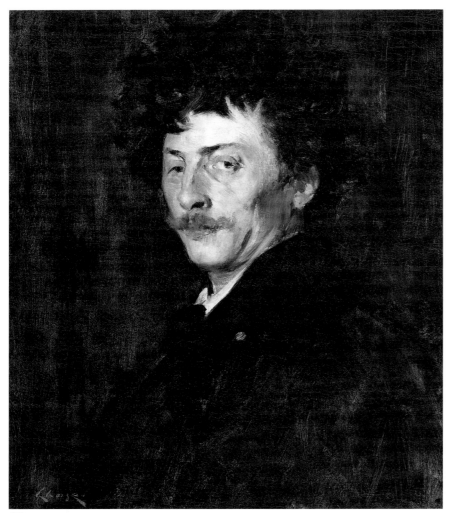

OP.252

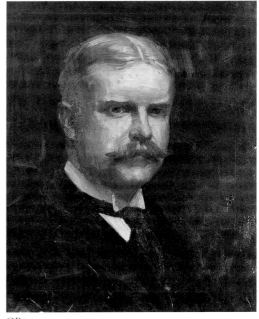

OP.253

Robert Ward Van Boskerck, 1897

Oil on canvas; 21 x 17 in. (53.3 x 43.2 cm)

National Academy of Design, New York

Robert Ward Van Boskerck (1855–1932) was a landscape painter, elected as an associate of the National Academy of Design in 1897, and this portrait was painted to fulfill his membership requirements. It was presented to the National Academy of Design on November 27, 1897. It is unusual for such a work to be unsigned.

OP.254

Dieudonnée, ca. 1897

Oil on canvas; 33 x 26 in. (83.8 x 66 cm)
Signed: W. M. Chase (l.l.)

Dallas Museum of Art. Dallas Art Association Purchase

Exhibitions and Auctions: **AIC '97 #19** as *Dieudonnée* ([Chicago] *Herald Tribune,* November 28, 1897, n.p.); **SAA '97 #274; GBV&C '01** (*New York Times,* April 9, 1901, 9); **K&C '03 #16** as *Diendonnie* [*sic*] [lent by the artist]; **Csale '17 #282** [purchased, Leroy Ireland, $180]; **DAA '22 #30.**

Chase's daughter Alice Dieudonnée (1887–1971) was one of his favorite models, and there are numerous paintings depicting her. There seems to be a particularly large group of works dating circa 1897–1900 that capture Alice seated in the

presumably prior to its first being exhibited at the Art Institute of Chicago in 1897 (if indeed this is one and the same painting). At any rate, the work appears with yet another title in the 1927 privately printed catalogue of Newhouse Galleries, St. Louis, Missouri, "Paintings by William Merritt Chase," pl. 41, as *Portrait of a Violinist.* The following year it is included in "Exhibition of the Works of William Merritt Chase," American Academy of Arts and Letters, no. 23, as *A Violinist.* And, in 1933, Newhouse Galleries, now located in New York, mounted another Chase exhibition, in which the work, no. 12, was titled *Pablo Sarasate.* In Peat's 1949 checklist it is once again retitled *Pablo de Sarasate,* dated 1909, and given as being in the collection of the Los Angeles County Museum of Art. In an unidentified typewritten document (most likely written for the Los Angeles County Museum of Art) in the files of Ronald G. Pisano, the work is described on the basis of several stylistic features as being done late in Chase's Munich period (1872–78). However, the document goes on to also note that the signature style is post-1885—most likely this information was supplied to the author by Mr. Pisano, in which case the work would have been signed at a later date. Also, the lapel rosette of the Legion of Honor indicates a later date, but again the author surmises that it, too, would have been added at a later date. These conclusions are most likely wrong, Roof's assertion withstanding; although it is clear that Chase, later in life, did sign early works, it seems curious that he would have used his informal "Chase" signature, which was usually used on sketches and school demonstration works. Also, adding the lapel rosette, while not impossible to imagine, seems an unlikely revision of the work. The most difficult aspect of the painting is the retitling—just how it came to be *Portrait of a Violinist,* or *Pablo de Sarasate,* is unknown. In fact, other than the belief that the portrait "bears a general resemblance to other images of the violinist [Sarasate]" (noted in the Los Angeles County Museum of Art document), there is no definite evidence that it is a portrait of Pablo Sarasate. What is clear, however, is that the portrait is beautifully painted, displaying the virtuoso brushwork for which Chase was so celebrated.

same pose and with a very similar expression on her face. The original date assigned to this work was 1899 based on its appearance in a view of Chase's studio, *New York Times Illustrated Magazine* (July 23, 1899): SM3. However, an earlier date for this work was determined by an 1897 review of the Chase exhibition at the Art Institute of Chicago that describes the work: "Charming also is *Dieudonnée* in her soft gray frock trimmed with black" ([Chicago] *Herald Tribune,* November 28, 1897, n.p.). This description is nearly identical to the one that was later used for this painting's entry in the 1917 Chase estate sale. Alice is described in that catalogue entry as wearing "a gray smock-gown, bound in black at neck, wrists and shoulders." The work was later included in a small exhibition of Chase's portraits at the galleries of Boussad, Valadon, and Company, and a *New York Times* writer of the time commented that this depiction of Dieudonnée is "very delightful," noting how "the black velvet collar brings out the subdued flesh tints capitally. The whole is 'gray in gray,' as the Germans phrase it, and yet the effect is totally charming," and the writer adds that *Dieudonnée* is a "pearl of a portrait" that demonstrates Chase to be "an extremely able craftsman who is at his best when managing delicate grades of low tones" (April 9, 1901, 9). This work is included on Peat's 1949 checklist as being owned by the Dallas Museum of Fine Arts.

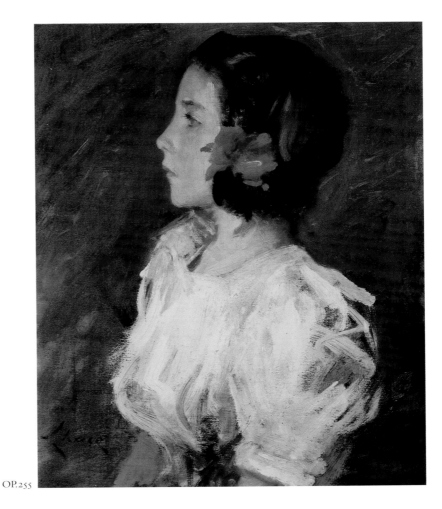

OP.254

OP.255

Dorothy, ca. 1897

Oil on canvas; 20 x 16 in. (50.8 x 40.6 cm)
Signed: Chase (l.l.)
Verso: Originally "Dorothy" penciled in artist's hand; however, this penciled name was lost during a later rebacking

Location unknown

Exhibitions and Auctions: **SAA '97, probably #331** as *Dorothy*; **CM '03 #5** [lent by the artist]; **BFAA '09 #23** ("The Paintings by Mr. Chase," *Academy Notes* 4 [February 1909]: 146; fully described); **BPL '10**; **MMA '17 #23** as *Dorothy* [lent by Mrs. W. M. Chase]; **Csale '17 #177,** purchased by L. M. Brumbach, $60.

The model for this painting is Chase's daughter Dorothy Brémond Chase (1891–1953). The painting was probably completed in the summer of 1897, when Dorothy was six years old. A photo of Dorothy from that year in the Chase Archives (Parrish Art Museum, Southampton, Long Island, New York [fig. 72, p. 34]) shows her

OP.255

in a similar dress to that depicted here with a flower in her hair. The work appears to have stayed in the artist's possession until his death. Louise Upton Brumback (1872–1929) was one of Chase's students at his Shinnecock Summer School in Long Island, and she is likely the "L. M. Brumbach" listed as purchasing the painting at the Chase estate sale of 1917 (the catalogue misprints the buyer's middle initial and gives an "h" instead of a "k" in her last name; it also mistakenly lists the signature as reading "Wm. M. Chase" instead of "Chase"). Included on Peat's 1949 checklist of Chase's known work as *Dorothy* (D) *(Dorothy Chase)*, and as being formerly owned by L. M. Brumback, New York.

OP.256

Portrait of the Artist's Daughter (Dorothy),
ca. 1897

Oil on canvas; 35½ x 25½ in. (90.2 x 64.8 cm)
Signed: Wm. M. Chase (l.r.)
Inscribed above signature: To my friend Clinedinst

Location unknown

This painting captures Chase's daughter Dorothy Brémond Chase (1891–1953) in an animated pose, as though she were trying on a new dress. Interestingly, Chase completed a number of depictions of girls in slightly varied white dresses in a range of poses throughout the 1890s, such as *Portrait of My Sister (Hattie)*, 1886 (OP.122), *Alice (Alice—A Portrait)*, circa 1891 (OP.182), *Alice (Alice Dieudonnée Chase; Alice C.; The Red Sash)*, 1895 (OP.231), and *Alice (Sketch of His Daughter Alice; Alice on Sunday)*, 1896 (OP.246), to name but a few. What is particularly unique in the present painting is its liminal position between pure portraiture and depiction of an interior scene. In most of the paintings referred to above, the figure stands in the foreground of the composition against a dark background; in this case, however, Dorothy poses in the middle of a room, standing near a screen that provides a sense of depth and scale in the room.

The painting's inscription refers to Benjamin West Clinedinst (1859–1931), a painter who grew up in Virginia and graduated from the Virginia Military Academy in 1880. In 1881 he entered the École Nationale des Beaux Arts, Paris, and when he returned to Baltimore he opened a studio there as a portrait painter. He moved to New York City in 1888, and devoted his time chiefly to genre painting and illustrating. He is best known for his *New Market Battle Painting*, which depicts the charge of the VMI corps of cadets in the Battle of New Market on

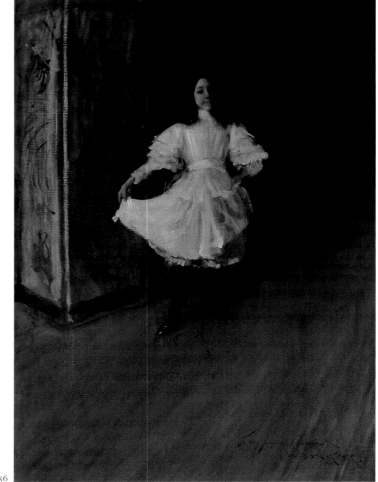

OP.256

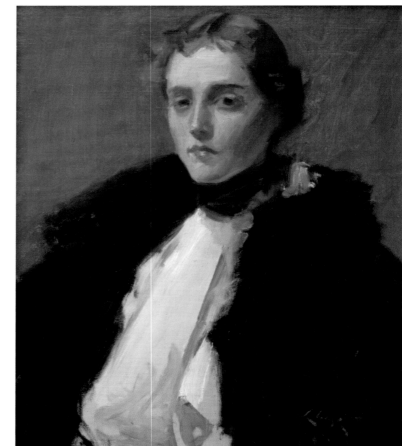

OP.257

May 15, 1864. Unveiled in 1914 and measuring 18 by 23 feet, it is located in VMI's Jackson Memorial Hall. Chase and Clinedinst likely became acquainted at the Society of American Artists and/or the National Academy of Design. In May of 1898 Clinedinst was elected a National Academician and it is possible Chase gave him the painting of Dorothy as a congratulatory gift. There are no references to the painting having been exhibited during the artist's lifetime.

OP.257

Portrait of Fra Dana, 1897

Oil on canvas; 19½ x 23½ in. (49.5 x 59.7 cm)
Signed: Chase (l.r.)

Montana Museum of Art & Culture, University of Montana, Missoula. Donated by Fra Dana. Permanent Collection, 1947

Fra M. Dana (1874–1948) first studied art at age fifteen at the Cincinnati Art Academy with J. H. Sharp. In 1893 she moved to Wyoming, where she met Edwin Dana (1865–1946), a Montana rancher, whose portrait was later painted by Chase (OP.534). Fra Dana insisted in the couple's prenuptial agreement that she be able to continue her formal art training, and so she was. A studio portrait photograph of Fra Dana was taken circa 1896, the year she married Edwin (OP.257A). A year later, she traveled to

OP.258

OP.257A. Studio portrait of Fra Dana, ca. 1896. Montana Museum of Art & Culture. Donated by Fra Dana

Illinois to study with Chase at the Art Institute of Chicago, where he was teaching for a semester following an important one-man exhibition of his work there in 1897.

This bust-length portrait of Fra Dana may have been completed as a demonstration piece during one of Chase's classes in 1897. Chase's painting of her is a study of white and brown, the sole note of color being a purple flower on the lapel of her coat that draws the viewer's attention to the sitter's face. Chase completed a portrait of Edwin Lester Dana circa 1912 (OP.534). According to exhibition records, the work was shown at the Brooklyn Art Association in 1912 before disappearing.

OP.258

Portrait of Caroline Allport, 1897

Oil on canvas; 24¼ x 20 in. (61.6 x 50.8 cm)
Signed: Wm. M. Chase (u.l.)
Inscribed verso: a poem that is not legible, and was apparently written by the sitter's father, a medical doctor and occasional poet
Dated verso: December 1897

Private collection, Michigan

The portrait captures Caroline Allport, the daughter of Dr. and Mrs. Walter H. Allport, and

was executed by Chase in Chicago in 1897, when the sitter was four years old. Dr. Allport further commissioned Chase to paint a portrait of Caroline's sisters, Katherine and Harriet Allport, the location of which is presently unknown.

OP.259

The Artist's Daughter, ca. 1897

Oil on canvas; 22½ x 18¼ in. (57.2 x 46.4 cm)
Signed: Wm. M. Chase (u.l.)

Columbus Museum, Ga. Museum purchase made possible by Friends of the Museum

Exhibitions: AIC '97 #42 as *The Artist's Daughter.*

Chase's daughter Alice Dieudonnée (1887–1971) was a favorite model for the artist, as evinced by the large number of paintings depicting her. He sometimes created a few versions of a given painting of her, each having slight variations of costume. Such is the case with the present work, and also with another created around the same time, *Portrait of the Artist's Daughter, Alice (Gitana),* circa 1899 (OP.276). Both works capture Alice in similar pose, with almost the same expression and the same flowers in her hair. In this work Alice wears a pink scarf around her neck; in the other, it is the dress that is pink. Chase demonstrates

OP.259

This painting most likely depicts Chase's daughter Dorothy Brémond Chase (1891–1953) and is characteristic of the many demonstration pieces executed by the artist for the benefit of his students. The work, however, is not signed "Chase," as was customary for most such pieces; it is possible that the student to whom he gave the work requested that he sign it "Wm. M. Chase." The main purpose for exhibiting work was to sell it: therefore, if the work went directly to a student then there is a good chance that it never was shown during the artist's lifetime. This would account for the absence of references in any exhibition records. There is a photograph of this painting in the Chase Archives at the Parrish Art Museum, Southampton, Long Island, New York, whereupon it is labeled as depicting another of Chase's daughters, Helen, though the resemblance to Dorothy seems more pronounced.

OP.261

Herbert Adams, 1898

Oil on canvas; 20 x 16 in. (50.8 x 40.6 cm)

Exhibitions: **NAD '99 #108; K&C '03 #19; NAC '16 #55.**

National Academy of Design, New York

his command of color in both works, juxtaposing different shades of pink and red in the flowers, on Alice's lips, and, in the present work, on the scarf. A critic, writing of the painting upon its appearance at the Art Institute of Chicago exhibition in 1897, wrote: "A word must be spoken in praise of the portrait of the child in a drab linen dress with a band of pink at her throat and two scarlet rosettes in her hair" ([Chicago] *Herald Tribune,* November 28, 1897, n.p.). There is a photograph of this work in the Chase Archives at the Parrish Art Museum, Southampton, Long Island, New York.

OP.260

Little Red Riding Hood (probably assigned later), ca. 1897

Oil on canvas; 20 x 16 in. (50.8 x 40.6 cm)
Signed: Wm. M. Chase (l.l.)

Delaware Art Museum. Gift of the Studio Group, 1961 (1961.11)

OP.260

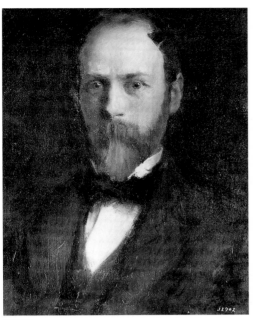

OP.261

OP.262

Rockwell Kent (1882–1971) summered with his family near Southampton in 1898 and 1899, at which time Kent studied with Chase at the Shinnecock Summer School of Art, and it was likely during one of these sessions that Chase painted his portrait as a classroom demonstration piece. Chase later completed another portrait of Kent, 1908 (OP.497).

OP.263

Portrait of Eugene Paul Ullman, ca. 1898

Oil on canvas; 20¼ x 16¼ in. (51.4 x 41.3 cm)
Signed: (l.l.)

Private collection

Eugene Paul Ullman (1877–1953) was a Chase student who eventually settled in Paris. In 1903, Ullman painted a commanding full-length portrait of Chase [Musée National de la Coopération Franco-Américaine, Bléroncourt].

Herbert Adams (1858–1945) was made an associate of the National Academy of Design in 1898, and elected full academician the following year. Upon election as an associate of the academy, each member was expected to give the organization a portrait of him or herself. Indeed, this painting was presented to the National Academy of Design on March 13, 1899. Adams, a sculptor, obviously prevailed upon Chase to paint his portrait to fulfill this membership obligation. Given the circumstances of its history, especially the fact that it was exhibited twice, it is curious that the work is not signed, nor does it appear to be finished. It may be, however, that the current state is due to its having been restored, and possibly cut down as is indicated in the National Academy of Design records for the painting. This work is included in Peat's 1949 checklist of Chase's known work.

OP.262

Portrait of Rockwell Kent, Artist, ca. 1898

Oil on canvas; 20 x 16 in. (50.8 x 40.6 cm)
Estate seal

Portland Museum of Art, Maine. Gift of Bernard A. Devine in memory of Jack London (1923.12)

Auctions: **Csale '17 #74** (The painter is limned as a young man of rugged type, with swarthy skin and rosy color, but with sensitive, full lips and brilliant and attentive brown eyes, and yellowish chestnut hair. He is presented head and shoulders, facing front, in a black coat disclosing a long and loosely flowing white scarf, against a background of varied olive notes).

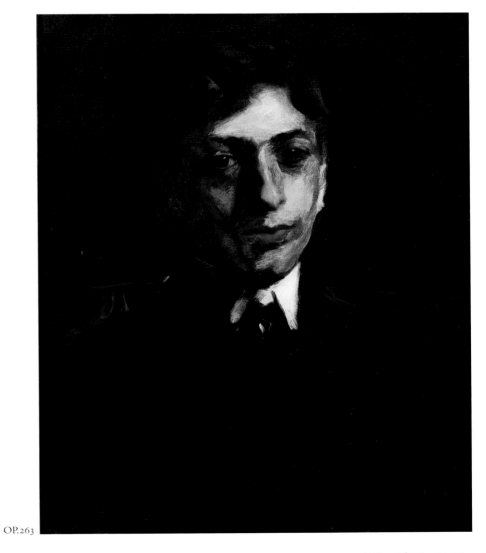

OP.263

OP.264

OP.264

Myra Reynolds, ca. 1898

Oil on canvas; 54½ x 43½ in. (138.4 x 110.5 cm)
Signed: Wm. M. Chase (l.l.)

The David and Alfred Smart Museum of Art, The
University of Chicago. University Transfer

Myra Reynolds (1853–1936) was professor of
English at the University of Chicago from 1895
to 1923. This portrait of her was commissioned
by "Friends" of the University. Chase has
expressed her scholarly vocation by depicting
her with a book, in which a finger marks her
place, as if Chase had just interrupted her read-
ing for a moment to take a photograph.

OP.265

Girl in White, 1898–1901

Oil on fabric; 84½ x 40½ in. (214.6 x 102.9 cm)
Signed: Wm. M. Chase (l.l.)

Akron Art Institute, Ohio. Bequest of Edwin
C. Shaw

Exhibitions: **GBV&C '01** ("Portraits by Wm. M.
Chase," *New York Times,* April 9, 1901, 9).

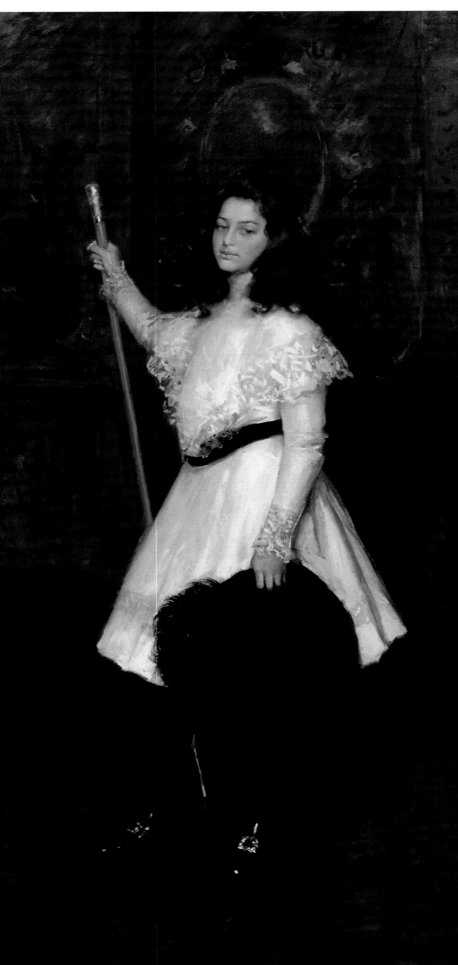

OP.265

A commissioned portrait of Florence Irene Dimock (1889–1962), daughter of Mrs. and Mr. Ira Dimock, a Connecticut-based silk merchant, and sister of Chase student Edith Dimock. Mr. Dimock's status as a direct descendant of one of New England's oldest colonial families may have influenced Chase's choice to depict Irene with the staff and feathered hat and in a pose strongly suggestive of historic portraiture.

Edith Dimock would eventually marry Mr. William Glackens. Mrs. Glackens and Mrs. Chase did not agree upon when the painting was created: Mrs. Chase dated it circa 1898 and Mrs. Glackens circa 1901. At the time of the work's exhibition in 1901, one critic wrote that *Girl in White* "is a standing portrait of little Miss Dimock of Hartford, in a white frock, against which her black, wide hat hangs advantageously. She supports one hand with a long cane, such as ladies used a century and a half ago. This is a charmingly composed and painted canvas" (*New York Times,* April 9, 1901, 9). The painting remained in the sitter's family until 1923, when it was sold or consigned to Mr. William Macbeth. In a letter to Mr. Macbeth dated January 26, 1923, Mrs. William Glackens recounted how her mother had "valued the canvas highly during her life." By 1923, however, she felt that the descendents had gone their separate ways and that the painting should be placed in a museum. She continued, writing that "Mr. Glackens considers it a very fine Chase and Mr. Chase himself was much interested in this subject, selecting a rather fanciful pose with an idea of its ultimate value as a work of art, rather than as a portrait." According to the letter, Chase received $2,000 for the painting, which was "his regular price for that size canvas" (letter from Edith Dimock [Mrs. William Glackens] to Mr. William Macbeth, January 26, 1923, Ronald Pisano Archives).

In 1923 *Girl in White* was shortened by seventeen inches: at the time of its purchase from Macbeth by Mr. Edwin Shaw of Akron, Ohio, who wanted a smaller painting but did not wish to cut the work down, nine inches of fabric off the top and eight off the bottom, including Chase's signature, were folded over the stretcher, this upon the advice of Charles Hawthorne, an artist who had studied with Chase, and Mr. Elliot Daingerfield (Mr. Edwin T. Shaw to Charles Hawthorne, 1923, Ronald Pisano Archives). After the work became part of the collection of the Akron Art Institute, Ohio, in 1955, it was restored to its original dimensions. Included on Peat's checklist as *Girl in White,* unsigned and with the pre-restoration dimensions of 67 by 40 inches, and as being owned by Caroline C. Shaw, Akron, Ohio.

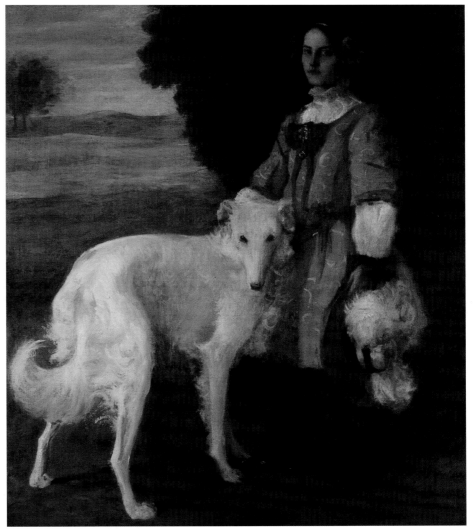

OP.266

OP.266

Alice with Wolfhound (Girl with a Dog), ca. 1898

Oil on canvas; 61 x 51 in. (154.9 x 129.5 cm)
Signed: Wm. M. Chase (l.r.)

The Parrish Art Museum, Southampton, Long Island, N.Y. Littlejohn Collection

Exhibitions: **GBV&C '01** ("Portraits by Wm. M. Chase," *New York Times,* April 9, 1901, 9); **AIC '04** as *Girl with a Dog* (*Century Magazine* 68 [June 1904]: 235, illus.; James Pattison, "Portrait Exhibition at the Art Institute of Chicago," *Art Bulletin* 4, no. 11 [January 7, 1905]: n.p.).

This work depicts Chase's daughter Alice Dieudonnée (1887–1971) posing with the family dog. There is a photograph circa 1901 housed in the Chase Archives of the Parrish Art Museum, Southampton, Long Island, New York, that captures Alice and the dog together, in which she wears a very similar outfit. The painting is dated

OP.266A. Photograph of what could be an early sketch for *Alice with Wolfhound*

circa 1898 given its reproduction in the *New York Times Illustrated Magazine* (July 23, 1899): 3. *Alice with Wolfhound* was reviewed favorably upon its appearance at the Art Institute of Chicago in 1904: "Wm. M. Chase holds an entire panel, which no one regrets, the *Girl with a Dog* which looks like a Velázquez, giving us sheer pleasure. Perhaps the standing boy on an ample canvas is the next best among all good things" (James Pattison, *Art Bulletin* [January 7, 1905]: n.p.). In his 1909 article on Chase, William Howe Downes refers to *Girl with a Dog* as "a full-length figure of a young person in a design of great carrying quality and fine decorative sweep" (*International Studio* 39, no. 154 [December 1909]: xxx). The painting has engendered some confusion with those by Chase entitled *Friends* or *Good Friends.* Chase created a pastel entitled *Good Friends,* circa 1889 (see vol. 1), which Peat incorrectly records as an oil on his 1949 checklist. Then around 1909 Chase painted an oil-on-wood depiction of a woman and dog, also titled *Good Friends,* now in the collection of the Hirshhorn Museum and Sculpture Garden at the Smithsonian Institution in Washington, D.C. There is a photograph of what could be an early sketch for *Alice with Wolfhound* that descended through the Chase family (OP.266A). It is interesting to note that in the photograph the sketch is framed, suggesting that Chase may have considered it to be a finished product, and may even have exhibited it.

OP.267

The Blue Kimono, 1898

Oil on canvas; 80 x 36 in. (203.2 x 91.4 cm)
n.s.

The Philbrook Museum of Art, Tulsa, Okla. Gift of Laura A. Clubb, 1947 (1947.8.1)

Exhibitions: **BFAA '18, possibly #18** as *The Blue Gown* [lent by Mrs. Chase]; **BMAG '19, possibly #113** as *The Blue Gown*; **CGA '23, possibly #15** as *The Blue Gown* [for sale, $5000]; **AAA&L '28 #1** as *The Blue Kimono* [lent by Mrs. L. A. Clubb].

The Blue Kimono has been mistaken for another unlocated and very similar painting by Chase, *The Flame,* 1914 (OP.562), which has created a measure of confusion about the date of composition of the former. When the present work was shown at the American Academy of Arts and Letters in 1928, it was described in the accompanying catalogue as "an example of Mr. Chase's portraiture painted in the late nineties" ("Catalogue for the Exhibition of the Works of William Merritt Chase" [April 26–July 15, 1928], 13). The listing for the work in the

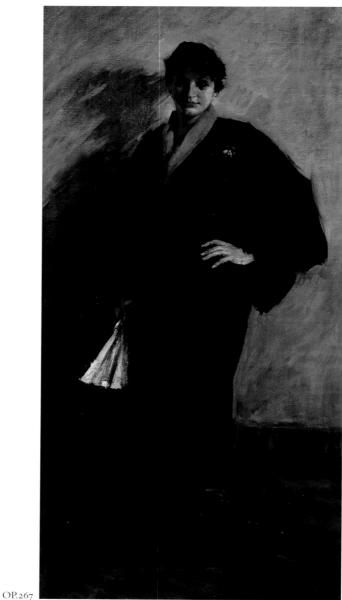

OP.267

1957 Chase exhibition at the Parrish Art Museum, Southampton, Long Island, New York, also dates it to the late 1890s. Yet in a letter dated 1925 that accompanied the painting to the Philbrook Art Center, Tulsa, Oklahoma, Mrs. Chase, perhaps erroneously, dates the work to 1915. The confusion is likely traceable to the 1917 Chase estate sale catalogue, whose description of no. 196, *The Flame,* summarizes *The Blue Kimono* instead: "Full-length standing figure of a young woman in a deep blue kimono lined with a flame-red, rolled down at the neck, giving her a shawl-collar of the brilliant flame hue. She looks at the spectator, holding a brilliantly colored fan down at arm's length in her right hand while her left hand rests on her hip." The painting was not sold in the estate sale and remained in the Chase family until it was purchased by Newhouse Galleries, New York, at some point after which the present work became known as *The Blue Gown.* Included on

Peat's 1949 checklist of Chase's known work as *The Blue Kimono: The Blue Gown: Lady with Fan,* 80 by 36 inches, circa 1898, and as being owned by the Philbrook Art Center, Tulsa, Oklahoma. The painting *Girl in Blue Kimono* [Parrish Art Museum] is included in volume 4.

OP.268

Miss F. De Forest (A Lady in Brown), ca. 1898

Oil on canvas; 20⅜ x 16¼ in. (51.8 x 41.3 cm)
Signed: Wm. M. Chase (m.r.)

Location unknown

Exhibitions and Auctions: **NADLEx '99 #65** [lent by Mrs. Robt. W. De Forest]; **Csale '17 #182** as *A Lady in Brown.*

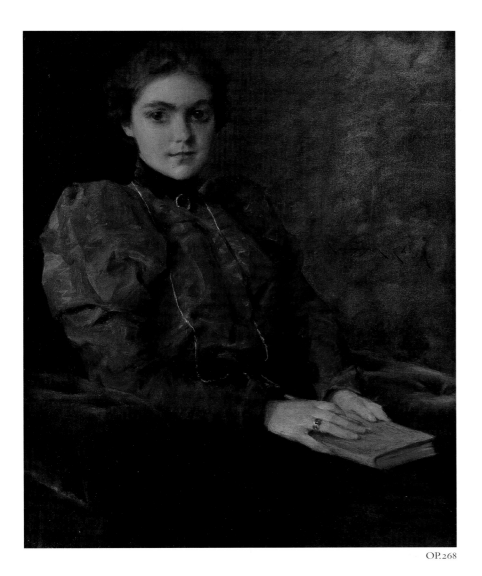

OP.268

chain, as it travels in labyrinthian course over the changing planes of drapery. This may be seen in his portrait of Miss De Forest. In addition, there is great individuality in the face, a soulful expression in the eyes, that marks this portrait as something more than a worthy piece of technique.

Interestingly, a nearly identical discussion of the painting appears two years later in an article on Chase (Ernest Knaufft, "An American Painter— William M. Chase," *International Studio* 21, no. 93 [December 1900]: 152–53, 151, illus.). The painting was owned by the De Forests as of 1898, but, given its appearance at the 1917 Chase estate sale, Chase must have reacquired it prior to his death. This painting, owner unknown, is included on Peat's 1949 checklist of Chase's known work as *Miss F. De Forest.*

OP.269

Portrait of a Young Woman, ca. 1898

Oil on canvas; 20 x 16 in. (50.8 x 40.6 cm)
Signed: Wm. M. Chase (m.r.) (signature was added at a later date)
There was a red wax seal affixed to the back of the work for the estate sale (these seals have been invariably lost due to cracking and lifting).

Location unknown

Auctions: **Csale '17 #181** as *Portrait of a Young Woman.*

This portrait depicts Miss Frances De Forest (b. 1878), whose parents, Mr. and Mrs. Robert W. De Forest, were instrumental in the founding and subsequent development of the American Wing at the Metropolitan Museum of Art, New York. The family had been involved with the museum since its early years; Mrs. De Forest was the daughter of John Taylor Johnston, the first president of the museum, and Mr. De Forest became its second president. The painting was likely commissioned by the De Forests and was only exhibited once during the artist's lifetime— at the National Academy's Loan Exhibition in 1899—a benefit for the [New York] Orthopaedic Hospital. The *International Studio* reviewed the exhibition, writing:

> In Mr. Chase's portrait of "Miss de Forest" (65) we find, as in the canvases of Whistler and Alfred Stevens, that the figure and background, hair and flesh, every detail, every accessory, takes its place in a decorative scheme. . . . The attention he gives to a head or figure, in regard to its place in space, is also bestowed upon every tiny link of a watch

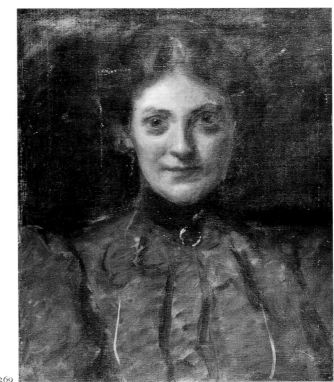

OP.269

Portrait of a Young Woman appears to be no. 181
from the Chase estate sale of 1917. In the cata-
logue entry, the work is listed as unsigned; the
signature is uncharacteristic and was probably
added at a later date. The painting is described
as follows: "A fair and blue-eyed young woman,
whose wavy hair is a warm brown, looks squarely
at the observer from the center of the canvas, the
breadth of which her figure fills, her large puff
sleeves extending beyond its borders. She is in a
brown silk gown easily fitting, high at the neck,
where a circular brooch appears, and she is seen
in a soft light distributed over hair, face and
figure—it is a head and shoulders portrait—
against a dark brown background." This painting
recalls Chase's portrait of *Miss F. De Forest (A
Lady in Brown)*, circa 1898 (OP.268), and may
have been a preliminary study for it that was
never completed. Since the painting was badly
abraded in a prior conservation, it is difficult to
determine how finished the original work was.

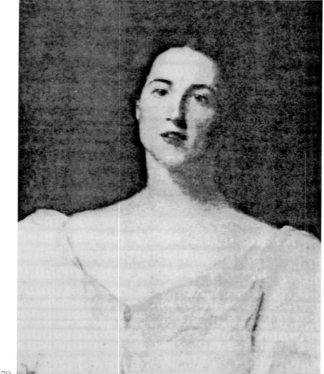

OP.270

OP.270

The Stately Model, ca. 1898

Oil on canvas; 22 x 18 in. (55.9 x 45.7 cm)
Signed: Wm. M. Chase (l.l.)

Location unknown

Exhibitions: **AAG '98 #314** (described and illus-
trated); **StLEx '98 #74.**

This painting may depict the same model that
Chase portrayed in several works, the most well-
known of which is *Portrait of Mrs. C. (Mrs. C.;
Woman with a White Shawl; Lady with a White
Shawl)*, 1893 (OP.194; see also OP.196-99). The
sitter is referred to in the various paintings as
either "Miss Clark," "Mrs. Clark," or "Mrs. C."
The Stately Model likely was painted later than
the other portraits of Clark, all of which were
created circa 1893. The work was auctioned in
the 1898 Chase sale, but it may not have sold
given that it was exhibited later that year at the
St. Louis Exposition. Or, if it had in fact sold,
the new owner may have agreed to let Chase
exhibit the work there. The current location of
the work is unknown, and the only extant image
is its illustration in the American Art Galleries
auction catalogue.

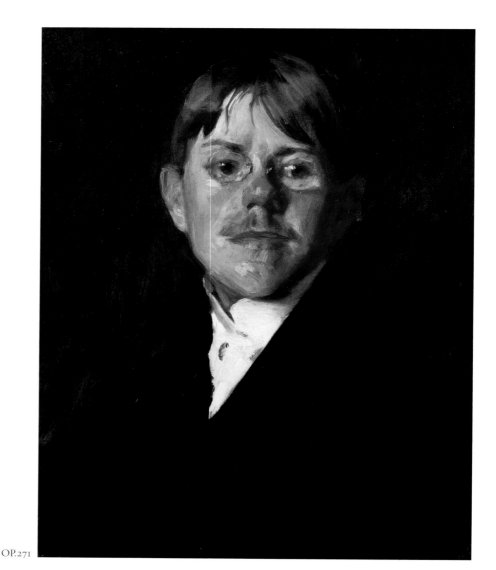

OP.271

OP.271

Portrait of Frank Wadsworth, ca. 1899

Oil on canvas; 20 x 16 in. (50.8 x 40.6 cm)
Signed: Wm. M. Chase (c.l.)

Collection of Remak Ramsey, New York

Exhibitions: CI '99 #38; PAFA '00 #5; AAA&L
'28 #19 [lent by Newhouse Galleries].

Frank Russell Wadsworth (1874–1905) was a
student of Chase's at the Shinnecock Summer
School of Art and a close personal friend of the
artist and his family. There are, in fact, many
photographs of Wadsworth with the Chase
family taken at the Chase home in Shinnecock
Hills. In 1903 Wadsworth joined the Chase
summer class in Holland, and in 1905 he was
a member of the Chase Summer School class
conducted in Spain, where he became ill and
died. The painting had been given to Wadsworth
by Chase, and bequeathed to the Chase family
after Wadsworth died, whereupon it remained in
the Chase family collection until 1927, when it
was purchased by Newhouse Galleries, St. Louis,
Missouri. It is illustrated in a book published by
Newhouse Galleries, *Paintings by William Merritt
Chase, N.A., LL.D.* (1927), no. 35. When the
painting was exhibited in the Chase memorial
exhibition held at the American Academy of
Arts and Letters in 1928, Childe Hassam urged
Mr. and Mrs. William Preston Harrison that
they purchase it from the lender (Newhouse
Galleries), which they did, later giving it to the
Los Angeles County Museum of Art, which in
turn sold the work at auction. It is included in
Peat's 1949 checklist of known work as being
in the collection of the Los Angeles County
Museum of Art.

OP.272

OP.272

Study of a Young Man, ca. 1899

Oil on canvas; 18 x 15 in. (45.7 x 38.1 cm)
Signed: Chase (u.r.)
Affidavit label (verso)

Collection of Richard J. Marlitt, Portland, Ore.

This portrait was likely done as a demonstration
piece by Chase at the Chase School (later
renamed the New York School of Art). The
affidavit, dated March 6, 1909, attesting to the
work's authenticity can be found on a number
of paintings left by the artist after he resigned
from the school.

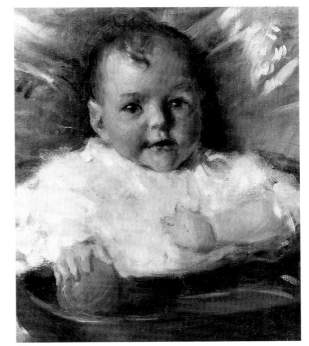

OP.273

OP.273

Bobbie: A Portrait Sketch, ca. 1899

Oil on canvas; 16 x 13¾ in. (40.6 x 34.9 cm)
Inscribed (verso): Bobbie
Remnants of red wax estate seal on stretcher

Location unknown

Auctions: Csale '17 #68 (fully described).

This work was said to have been purchased at
the Chase estate auction by a Chase student. The
portrait is of Chase's son Robert Stewart Chase,
born December 19, 1898 (died December 5,
1987). A similar portrait of Chase's son Roland
Dana Chase (1901–1980) holding a red ball is
in the collection of the Metropolitan Museum
of Art, New York.

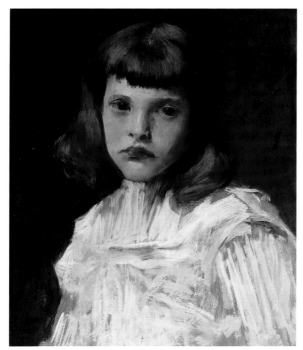

OP.274

(*Academy Notes* [June 1906]: 20); **CI** '07 #88 as *Portrait of Mrs. V*, illus. [lent by the artist]; **BFAA** '09 #47 [lent by the artist] (*Academy Notes* [February 1909]: 146); **NAC** '10 #124 as *Portrait of Mrs. V.* [*Bessie Potter Vonnoh*] [lent by Mr. Chase]; **BPL** '10; **PPIE** '15 #3760 as *Mrs. Vonnoh* [lent by the artist].

Bessie Potter Vonnoh (1872–1955) was a noted American sculptor. She was the first female sculptor to become a permanent member of the National Academy of Design, and her work is in the collections of museums worldwide. She studied with Loredo Taft and was one of a group of women nicknamed "the White Rabbits" who assisted Taft during the World's Columbian Exposition in Chicago in 1893. Potter opened her own studio in Chicago in 1894, and in 1895–96 she went on her first trip to Europe. It was in Taft's studio that she first met Robert Vonnoh (1858–1933), whom she married in 1899 after

OP.274

Portrait of a Child (Dorothy Brémond Chase), ca. 1899

Oil on canvas; 18½ x 14½ in. (47 x 36.8 cm)
Signed: Wm. M. Chase (u.l.)

Collection of Jean-Pierre and Barbara Guillaume, Atlanta

The model for this painting is Chase's daughter Dorothy Brémond Chase (1891–1953). For many years, this work was known only as *Portrait of a Child,* but the model has since been identified as Dorothy. As with other paintings similarly titled, it is difficult to arrive at an exhibition history for the present work.

OP.275

Portrait of Mrs. V. (Portrait of Mrs. Vonnoh; Portrait of Mrs. Robert W. Vonnoh; Mrs. Vonnoh), ca. 1899

Oil on canvas; 32 x 25⅝ in. (81.3 x 65.1 cm)
Signed: Wm. M. Chase (l.l.)

The Metropolitan Museum of Art, New York. Bequest of Bessie Potter Vonnoh Keyes, 1954 (55.118)

Exhibitions: **PAFA** '04 #235; **McCG** '05 #32 as *Portrait of Mrs. Vonnoh* [lent by the artist] (*American Art News* [March 11, 1905]: 3); **BFAA** '06 #24 as *Portrait of Mrs. Robert W. Vonnoh* [lent by the artist]

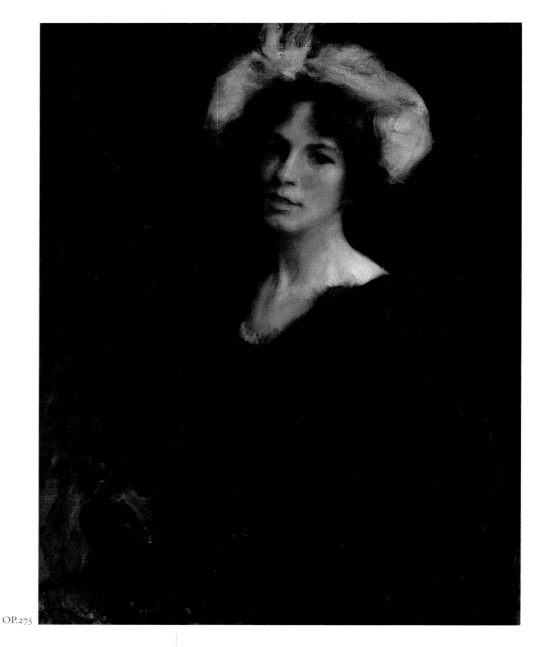

OP.275

years of friendship. The couple moved to New York that same year.

Assigned dates for the present work have ranged from 1895 to 1904. In a photograph of the west wall of Chase's studio circa 1899, one sees the unfinished painting of Bessie Potter Vonnoh on the easel, indicating that it was either begun in 1899 or earlier (*New York Times Illustrated Magazine* [July 23, 1899]: 3). Therefore, the work may have been completed by Chase around 1899; indeed, Chase may have created the work as a wedding present for the couple. Regardless of the work's actual date, Chase kept it in his collection throughout his lifetime, with the Vonnohs only acquiring the work in 1926. This work is included on Peat's 1949 checklist of Chase's known work as *Bessie Potter Vonnoh,* and as being owned by Mrs. Edward L. Keyes, New York. (Edward Keyes was Bessie Potter Vonnoh's second husband.)

OP.276

Portrait of the Artist's Daughter, Alice (Gitana), ca. 1899

Oil on panel; 17½ x 15½ in. (44.5 x 39.4 cm)
Signed: Wm. M. Chase (m.l.)

Location unknown

This portrait of Chase's daughter Alice Dieudonnée, which suggests the artist's *The Artist's Daughter,* circa 1897 (OP.259), captures her staring intently at the viewer. Such intensity pervades many of Chase's female portraits, but the characterization here is particularly effective. The painting is reproduced as *Gitana* by Margaret Cooper White (*Truth* 19, no. 7 [July 1900]: 157). There is a photograph of this painting in the Chase Family Archives at the Parrish Art Museum, Southampton, Long Island, New York.

OP.277

The Pink Bow (Hazel), ca. 1899

Oil on canvas; 20 x 16 in. (50.8 x 40.6 cm)
Signed: Chase (u.r.)

Location unknown

Auctions: **Csale '17 #281** as the *Pink Bow* (described), sold to Leroy Ireland, $60.

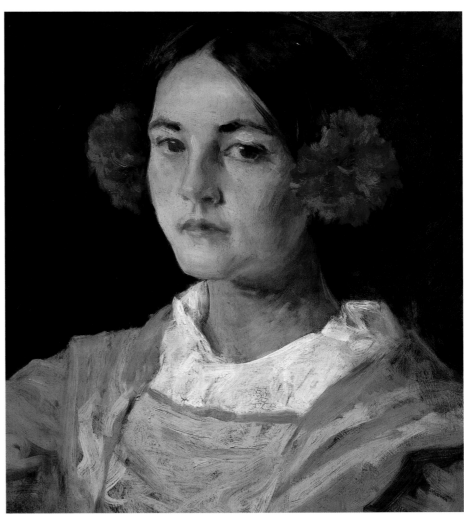

OP.276

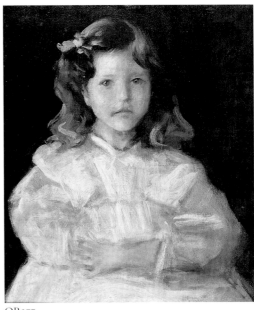

OP.277

This portrait depicts Chase's daughter Hazel (1893–1949). Unfortunately, Chase never finished the work—this can best be seen in the treatment of Hazel's hand—and it was considerably cut down (probably after his death in 1916). It is likely the painting that appears on the wall in a studio photograph of a corner of Chase's reception room (*New York Times Illustrated Magazine* [July 23, 1899]: 3). Here one sees the work in its original form as a full-length portrait. Titled *The Pink Bow* at the 1917 Chase estate sale, the painting was described as "a study, the lower part of the canvas uncompleted." It was unsigned at that time, and the present signature is likely forged. *The Pink Bow* first appears reproduced in its present state as an advertisement in *International Studio* (March 1926) for sale for $500. Included on Wilbur Peat's checklist as *Hazel Chase,* and as being formerly owned by Newhouse Galleries, New York.

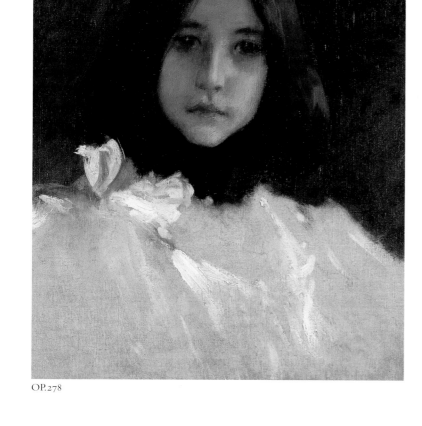

OP.278

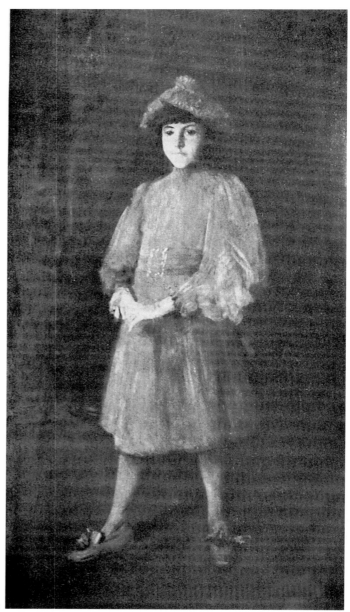

OP.279

OP.278

Head of a Girl (The Artist's Daughter), ca. 1899

Oil on canvas; 19 x 15½ in. (48.3 x 39.4 cm)
There was a red wax seal affixed to the back of the work for the estate sale (these seals have been invariably lost due to cracking and lifting).
Inscription verso: W. M. Chase in script (caps.)

North Carolina Museum of Art, Raleigh. Gift of the North Carolina Art Society, 1952. Robert F. Phifer Bequest (G.28.2.7)

Auctions: **Csale '17 #71** as *Head of a Girl* (fully described).

This work is likely circa 1897 given the age of the sitter, Alice Dieudonnée Chase (1887–1971). When questioned as to why he created so many paintings of her, Chase replied that it was in part because she reminded him so much of her mother, Alice Gerson Chase. With this comment in mind it is interesting to refer to an earlier portrait circa 1890, *Portrait of Mrs. Chase* (OP.170). The resemblance between mother and daughter is evident.

In both works, Chase sets off the faces by having his subjects wear clothing with a dark collar. Likewise, both works have a sketchlike quality, best seen in the brisk brushstrokes that suggest their dresses. Whereas Chase places a flower in his wife's hair, he has opted to place one on Alice's shoulder. As with other intimate works of the kind, this portrait was likely executed for the enjoyment of the family and there are no records of this work being exhibited during the artist's lifetime.

OP.279

Artist's Daughter (Portrait of My Daughter), 1899

Oil on canvas; 58 x 34 in. (147.3 x 86.4 cm)
There was a red wax seal affixed to the back of the work for the estate sale (these seals have been invariably lost due to cracking and lifting).

Location unknown

Auctions: **Csale '17 #187** as *Artist's Daughter* [purchased, Wm. Macbeth, $105].

This is a portrait of Chase's daughter Dorothy Brémond Chase (1891–1953) at about eight years of age. The catalogue for the 1917 Chase estate auction describes the work as follows: "Full-length portrait of a small bright eyed and dark haired girl, standing with feet well apart, facing the front and slightly toward the left, clad entirely in red from cap to shoes. Dull red background." Included on Peat's 1949 checklist of Chase's known work as *Portrait of My Daughter,* circa 1899, and as being owned by the Butler Art Institute, Youngstown, Ohio.

OP.280

Koto Chase, 1899

Oil on canvas; 30 x 25½ in. (76.2 x 64.8 cm)
Verso: "Tudor from Koto" [followed by Koto's name written in Japanese] and Pan American Exposition label
On stretcher in pencil: WM Chase 333-4th / case #1 . . . / Portrait of a Young Girl

Private collection

Exhibitions: **PAFA '00 #28** [lent by the artist]; **PPIE '15 #3757.**

In this painting Chase depicts his daughter Koto (1889-1956) seated in an elaborate dress with a large bow in back and a hat topped with flowers. Koto Robertine was Chase's second child and was named after his Japanese friend Koto and for the artist Robert Blum. This work was probably completed in Shinnecock, Long Island, in the summer of 1899. The inscription on the back of the canvas, "Tudor from Koto," indicates that the work was given away by the sitter herself. The notation in pencil on the stretcher, "333-4th," refers to the Tiffany Building in New York City, location of one of Chase's studios, which he occupied from 1908.

At the time of the work's exhibition at the Pennsylvania Academy of the Fine Arts in 1900, one critic praised "_Koto Chase_ by William M. Chase [as] in every respect an artist's conception and rendering of a child" (Charles Caffin, ed., _The Artist_ 27 [February 1900]: iii). _Koto_ was also illustrated in Margaret Cooper White, "William M. Chase, N.A.," _Truth_ 19, no. 7 (July 1900): 160.

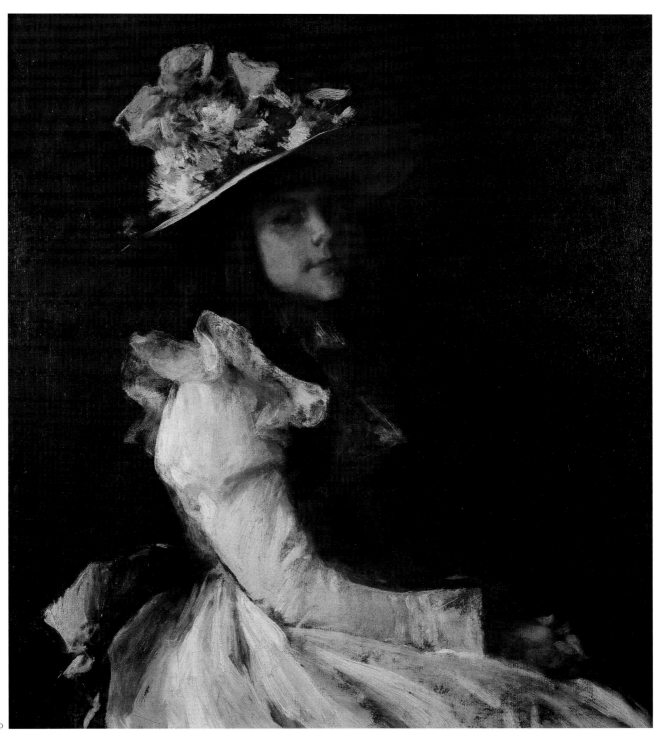

OP.280

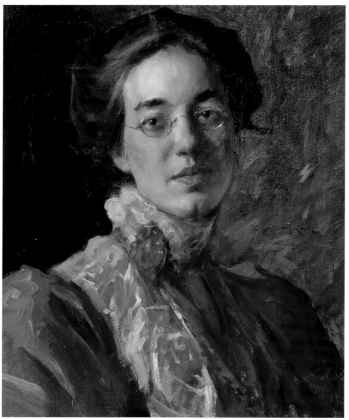

OP.281

OP.282

OP.281

Portrait of Elizabeth Fisher, 1899

Oil on canvas; 20 x 16 in. (50.8 x 40.6 cm)
Signed: Wm. M. Chase (c.r.)
Inscribed verso: To my Friends Dr. & Mrs. Fisher
from Wm. M. Chase

Location unknown

This portrait depicts Elizabeth (Betty) Fisher, the daughter of Chase family friends Dr. and Mrs. William Fisher, of whom Chase also completed portraits in addition to one of Elizabeth's sisters, Esther. Elizabeth reportedly was a creative young woman and is credited for designing many of the costumes used in the regularly scheduled, and much anticipated, "tableau vivant" productions held in the summer art colony of Shinnecock Hills, where both the Fisher and Chase families resided in the warm-weather months. Chase, his family, the Fishers, and many Chase students posed in the elaborate costumes that were created to represent famous paintings and characters drawn from literature, ranging from Shakespeare to *The Wizard of Oz*. Betty was especially close to Mrs. William M. Chase, "Pansy," whom she accompanied on a trip to Europe in 1907 as a traveling companion.

This sensitive portrayal of Elizabeth Fisher is characteristic of Chase's very personal rendering of his closest friends and of his own family members. Since the painting was presented directly as a gift to the sitter's parents, it is unlikely that it was ever exhibited by Chase. Included on Peat's 1949 checklist of Chase's known work as *Elizabeth Fisher,* and as being owned by Elizabeth and Esther Fisher, Swiftwater, Pennsylvania.

OP.282

The Infanta (My Little Daughter Helen Velázquez Posing as an Infanta), 1899

Oil on canvas; 30¼ x 24⅛ in. (76.8 x 61.3 cm)
Signed: Wm. M. Chase (l. l.)
Inscribed verso: My little daughter Helen Velázquez / posing as an Infanta / Painted by me at Shinnecock Hills / 1899. Wm. M. Chase

Collection of Joel R. and Mary Ellen Strote

Exhibitions: **CI '02** as *The Infanta* [lent by Mr. Henry Kirke Porter]; **PAFA '03 #16** [lent by Mrs. Henry Kirke Porter]; **MMA '17 #28** (Frances Lauderbach, ed., "Notes from Talks by William Merritt Chase," *American Magazine of Art* 8 [September 1917]: 435).

A portrait of Chase's daughter Helen Velázquez Chase at about four years of age dressed as Diego Velázquez's *Infanta Margarita* [1664–65; Museo del Prado, Madrid]. A photograph from the Chase Archives, Parrish Art Museum, Southampton, Long Island, New York, captures Chase at work on this portrait. Another photograph, circa 1899, in the Chase Archives shows Helen dressed as Velázquez's "Infanta" and standing behind a frame for a tableau vivant, with her father adjusting the frame. Chase's depictions of his children were greatly appreciated, and one critic noted that Helen "as a Velázquez Infanta, sheathed in her stiff crinolined skirt, is ever a flower of childhood" (Ernest Knaufft, "An American Painter—William M. Chase," *International Studio* 21, no. 93 [December 1900]: 155). According to the catalogue entry for this work upon its appearance in the Chase Memorial Exhibition in 1917, Chase painted this work at the request of Mrs. Henry Kirke Porter, an owner of many Chase paintings—including the present work—and a benefactor of the artist's Shinnecock Summer School of Art, "after seeing the artist's daughter posed in a tableau in this costume, which Mr. Chase brought from Spain" (Metropolitan Museum of Art, "William M. Chase Memorial Exhibition," 1917, cat. no. 28).

Included on Peat's 1949 checklist of Chase's known work as *An Infanta: A Souvenir of Velázquez (Helen Chase)*, and as being owned by the Carnegie Institute, Pittsburgh.

OP.283

William M. Evarts

Medium/support/dimensions unknown

Location unknown

The only reference to this work was found in Ernest Knaufft, "An American Painter—William M. Chase," *International Studio* 21, no. 93 (December 1900): 156, "Mr. Chase has, since his return from Munich, been esteemed one of America's leading portrait painters, and the number of celebrities he has painted makes a long catalogue; a partial list includes William M. Evarts." William Maxwell Evarts (1818–1901) was born in Boston, graduated from Yale University in 1837, and studied law at Harvard. He was admitted to the bar in New York City in 1841. He was attorney general under President Andrew Johnson, and served as his chief counsel during the impeachment proceedings in 1868. He was later appointed secretary of state by President Rutherford Hayes, and was elected to the U.S. Senate in 1885. It is likely that distinguished portrait commissions such as this one were instrumental in spreading the fame of Chase as a portraitist of the first rank.

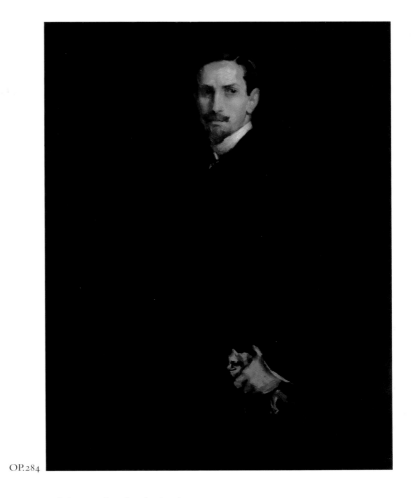

OP.284

OP.284

The Man with the Glove, ca. 1899

Oil on canvas; 48⅛ x 36¼ in. (122.2 x 92.1 cm)

The Parrish Art Museum, Southampton, Long Island, N.Y. Littlejohn Collection

This portrait was included in a photograph of Chase in his studio, seated with brush and palette in front of the work: *New York Times Illustrated Magazine* (July 23, 1899). A photograph of the painting is also included in the Frick Library files, given by F. A. Lawlor in 1938. It is also included in Peat's 1949 checklist of Chase's known work under "male figure studies" as *Portrait of a Man* (A), formerly owned by Mr. F. A. Lawlor, New York. A George W. Lawlor (b. 1878) was an artist who at one time was living in Brooklyn. It is possible that the portrait may be of him, or

another member of the Lawlor family (perhaps F. A. Lawlor). It has been suggested that the pose in the work is related to Titian's *Man with a Glove*. Chase was known to tell his students to borrow ideas from other artists, and he may have "borrowed" the pose from Titian.

OP.285

Emil Paur, 1899

Oil on canvas; dimensions unknown
Signature not visible in photograph

The Lotos Club, New York

Exhibitions: **K&C '03 #3**; **NAD '03 #286** (illus. in a review of this exhibition, "National Academy of Design Exhibition," *Brush and Pencil* 2 [February 1903]: 375); **NAC '10 #100** (illus.; mentioned in Katharine Metcalf Roof's review of the exhibition, "William Merritt Chase: An American Master," *Craftsman* 18 [April 1910]: 38, and in the *Bulletin of the Brooklyn Institute of Arts and Sciences* 3, no. 18 [January 8, 1910]: 462, "Mr. Chase's portrait brings back the personality of a great musician, a good conductor [of the Boston Symphony Orchestra], and a man whose solid qualities commanded him respect and admiration").

This work was painted in 1899 when Emil Paur was conductor of the Boston Symphony Orchestra. It was mentioned in Katharine Metcalf Roof's 1917 biography of the artist and included in Peat's 1949 checklist of Chase's known work as being owned by the Lotos Club, New York.

OP.285

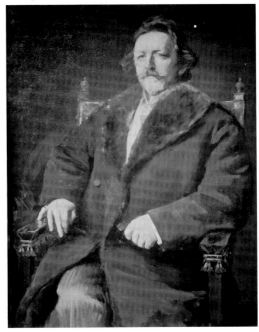

OP.286

Portrait of Thomas Eakins, ca. 1899

Medium/support/dimensions unknown
This work is said to have been destroyed.

Lloyd Goodrich notes in his monumental treatise on Thomas Eakins (*Thomas Eakins,* vol. 2 [Cambridge, Mass.: Harvard University Press for the National Gallery of Art, 1982], 221) that Chase painted Eakins's portrait—presumably in exchange for one Eakins had executed of Chase [Hirshhorn Museum of Art, Smithsonian Institution, Washington, D.C.] in 1899. Goodrich recounts a 1930 interview with Samuel Murray, former Eakins student and close friend, in which Murray stated that the Chase portrait of Eakins had been destroyed. This was confirmed in a 1931 interview with Eakins's wife, Susan McDowell Eakins. Goodrich noted that Susan Eakins "had strong feelings about portraits of her husband." It is possible that the portrait was destroyed in some misguided belief that Chase had tried to steer portrait commissions away from Eakins—Chase had set up his own portrait "factory" in Philadelphia in the early twentieth century.

At some point, Eakins gave Chase his painting *Arcadia* [c. 1883, Metropolitan Museum of Art, New York], which was sold in the Chase estate sale of 1917 as *Idyl* [*sic*]. Eakins also inscribed his painting *Sailing* [1873, Philadelphia Museum of Art] "To his friend, William M. Chase"—this painting was also included in the 1917 Chase estate sale. It is likely that Chase gave Eakins one or more of his paintings in return; however, there are no surviving records of such a transaction.

Interestingly, if digressively, both Chase and Eakins were known to be crack shots with a revolver, and they practiced target shooting together in a shooting gallery Eakins had set up in his cellar. It is said that Chase could hit a fifty-cent piece at fifty paces.

OP.287

Portrait of Clyde Fitch, ca. 1900

Oil on canvas; 20 x 16 in. (50.8 x 40.6 cm)
Signed: Chase (l.l.)
Inscribed and dated: To Virginia Gerson with affection from Wm Chase 1915

Museum of the City of New York, New York

Clyde Fitch (1865–1909) was a playwright and close personal friend of Virginia Gerson, Chase's sister-in-law, and was godfather to Chase's son Robert Stewart Chase. A photograph of this painting descended in the Chase family. Another portrait of Clyde Fitch is in the collection of Amherst College, Massachusetts (OP.328).

OP.288

Edward Everett Hale, ca. 1900

Oil on canvas; 24 x 21 in. (64.5 x 54.3 cm)

Fogg Art Museum, Harvard University Art Museums, Cambridge, Mass. Louise E. Bettens Fund (1955.19)

Edward Everett Hale (1822–1909) was a well-known clergyman and writer. As the work is unsigned, Chase may have painted the portrait on spec. Hale family history claims this work was given by Chase to the family at some point. There is another, larger portrait of Hale by Chase (location unknown) that is also unsigned (OP.499).

OP.289

Head of a Boy

Oil on canvas; 20 x 16 in. (50.8 x 40.6 cm)
Signed: Wm. M. Chase (l.r.)

Collection of Martin Kodner, St. Louis, Mo.

This work was said to have been given as a gift of the Chase estate (at the bequest of Mrs. Wm. M. Chase) through Newhouse Galleries, St. Louis, to Nan Sheets, ca. 1938. It was claimed that the estate had earmarked a number of paintings left in the care of Bertram Newhouse to present to museums or to individuals sponsoring an intensive program for American art and artists. By 1938, however, Mrs. Chase had been long deceased, and there is no other record of such a program. Nan Sheets sponsored an "educational program for art" (whatever that means) in Oklahoma. This painting was included in Peat's 1949 list of known works by the artist [*Head of a Boy* (C)] but listed as being unsigned.

OP.290

Louis M. Frank, ca. 1900

Oil on canvas; 30¼ x 25¼ in. (76.8 x 64.1 cm)
Signed: Wm. M. Chase (l.l.)

Newark Museum, N.J.

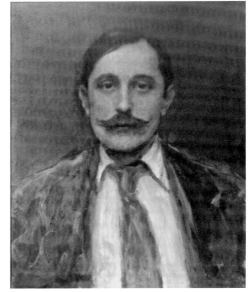

OP.287

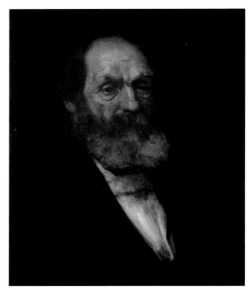

OP.288

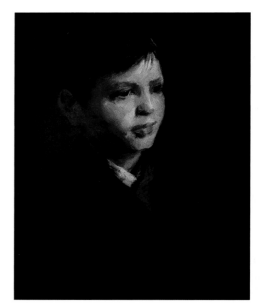

OP.289

Louis M. Frank was cofounder, with Louis Bamberger and Felix Flud, of L. Bamberger and Company. Frank died in 1910, after which this portrait was given to the Newark Museum by one of his nephews. Listed in Peat's 1949 checklist of known work as being in the collection of the Newark Museum, New Jersey.

OP.291

Profile Portrait Bust of a Man with Pipe, ca. 1900

Oil on canvas mounted on board; 6½ x 5½ in. (16.5 x 14 cm)

Location unknown

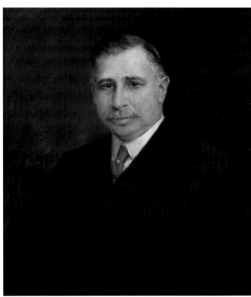

OP.290

OP.291

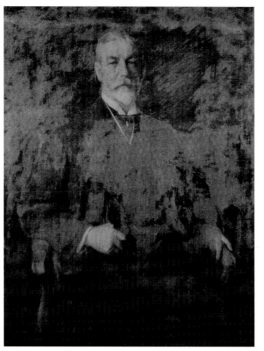

OP.292

This work was said to have been a gift from Chase to Ruby Pickens Tartt, a student either in Chase's class at the Pennsylvania Academy of the Fine Arts, the New York School of Art, or the Shinnecock Summer School of Art, as Chase was teaching at all three of these institutions at that time.

OP.292

Robert C. Pruyn

Oil on canvas; 46 x 34 in. (116.8 x 86.4 cm)
Signed: Wm. M. Chase (l.l.)

National Commercial Bank and Trust Company, Albany, N.Y.

Robert Pruyn (1847–1934) was a prominent Albany banker and businessman. Near the end of the nineteenth century, he purchased 12,500 acres in the town of Newcomb, in the Adirondack Mountains, where he built Camp Santanoni, the grandest of all the Adirondack "camps." The work is included in Peat's 1949 checklist as owned by the National Commercial Bank and Trust Co., Albany, New York.

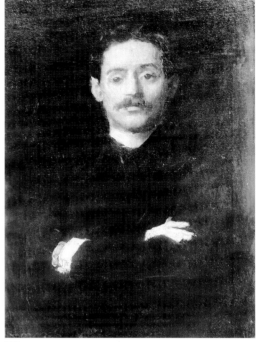

OP.294

OP.293

Anita, ca. 1897

Physical properties unknown

Location unknown

Exhibitions: AIC '97 #14; RISD '01 #6, for sale $350.

OP.294

Man with Folded Arms

Oil on canvas; 25½ x 18 in. (64.8 x 45.7 cm)
Signed: Wm. M. Chase (l.l.)

Location unknown

Auctions: Csale '17 #273 (fully described) [purchased, LeRoy Barnet, $55].

A photograph of this painting descended through the Chase family, and is included in Peat's 1949 checklist of Chase's known work as being owned by LeRoy Barnet, New York—it is possible that Peat simply recorded the 1917 auction information.

OP.295

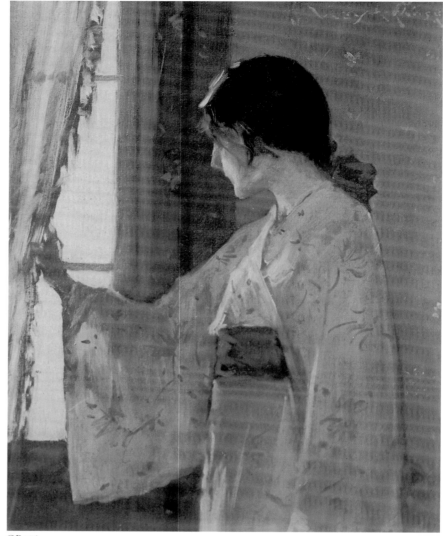

OP.296

OP.295

Half-Length Portrait of a Man, Hands Folded, ca. 1900

Medium/support/dimensions unknown

Location unknown

The only record of this work is a photograph that was included in a cache of photographs of Chase's painting that descended in the family.

OP.296

At the Window (Late Afternoon), ca. 1900

Oil on canvas; 15½ x 19 in. (39.4 x 48.3 cm)
Signed: Wm. M. Chase (u.r.)

Location unknown

Exhibitions and Auctions: **CM '01 #209** as *At the Window*; **AIC '01 #63** [lent by the artist]; **McCG '05 #36**; **MCP '05 #206** as *Am Fenster* (translation: *At the Window*) [lent by the artist]; **Csale '17 #359** as *Late Afternoon* [purchased, Macbeth Galleries, $210].

Though the present location of this work is not known, a visual image of the painting exists in the Chase family archives, which is labeled *Late Afternoon.* The following is a vivid description of the work given for the 1917 Chase estate sale catalogue: "Three-quarter-length standing figure of a dark-haired young girl in a semi-transparent kimono, her face turned three-quarters from the spectator as she looks out a window, one arm extended to push aside the curtain. The kimono is a pale but dark greenish-yellow, and the wall behind her a deep red." The model for the work appears to be Chase's daughter Alice Dieudonnée (1887–1971). Included on Peat's 1949 checklist of Chase's known work as *Late Afternoon,* and as being owned by J. J. Gillespie and Company, Pittsburgh.

OP.297

Portrait of a Chase Student, ca. 1900

Oil on canvas; 30 x 24 in. (76.2 x 61 cm)
Inscribed verso: "3 hour sketch by W. M. Chase"

Location unknown

The only extant image of this portrait is in the catalogue accompanying the Parrish Art Museum's 1957 *William Merritt Chase: A Retrospective Exhibition.*

OP.297

OP.298

OP.299

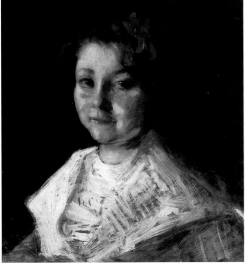

OP.300

OP.298

Portrait of a Lady, ca. 1900

Support/medium/dimensions unknown (presumably oil on canvas)

Location unknown

Portrait of a Lady, likely a demonstration piece, is a bust-length portrait of a middle-aged woman. The only extant image of this work is in a photograph that descended in the Chase family.

OP.299

Untitled (Portrait Sketch of Young Woman), ca. 1900

Oil on canvas; 19¾ x 16 in. (50.2 x 40.6 cm)
Signed: Wm. M. Chase (l.r.)—in script and in pencil

Location unknown

The sketchy format of the present work, with the sitter's face fully developed and all else left to mere suggestion, and the size (most of these were about 20 by 16 inches) indicate it was likely a demonstration piece. The signature, in pencil, is, however, full, rather than the short-hand "Chase" typical of such works; indeed, the hand may not have been Chase's.

OP.300

Dorothy, ca. 1900

Oil on panel; 16 x 14 in. (40.6 x 35.6 cm)
Inscribed: To Virginia with Love, Will (u.l.)

The Museum of Fine Arts, Houston. Wintermann Collection of American Art, gift of Mr. and Mrs. David R. Wintermann (85.161)

This painting depicts Chase's daughter Dorothy Brémond Chase (1891–1953). Chase gave this painting of his daughter to his sister-in-law Virginia Gerson. It descended in the Chase family until 1969, when it was exhibited in the Chapellier Gallery exhibition. It was not exhibited during the artist's lifetime.

OP.301

Girl in Red Coat (The Red Jacket), ca. 1900

Oil on panel; 25½ x 20¼ in. (64.8 x 51.4 cm)
Signed: Wm. M. Chase (l.l.)

Location unknown

Exhibitions and Auctions: **CM '06 #8** as *Girl in Red Coat*; **BFAA '09 #28** as *The Red Jacket* (*Academy Notes* 4 [February 1909]: 146); **Csale '17 #85** (fully described).

Girl in Red Coat was first reproduced as *For the Hunt* in Margaret Cooper White (*Truth* 19, no. 7 [July 1900]: 159). The work depicts Chase's daughter Alice Dieudonnée. Here, Alice's hat is the same as the one she wears in *Alice (Sketch of His Daughter Alice; Alice on Sunday),* 1896 (OP.246), but the feather and rose are replaced by another type of flower. Alice's pose is reminiscent of the depiction of her in *Dieudonnée,* circa 1897 (OP.254). The technique Chase used in this painting was described by a critic as "bold, simple and sketchy" (*Academy Notes* [February 1909]: 146). The 1917 Chase estate sale catalogue describes Alice in this portrait: "a self-composed young woman with dark eyes and delicate features, walking toward the right, is seen at half-length as she turns her head casually and looks across her right shoulder at the spectator, with the most entire composure. She wears a jacket of rich red, and a conical straw hat trimmed with a rich emerald ribbon and a pink bow or bouquet." This work is included on Peat's 1949

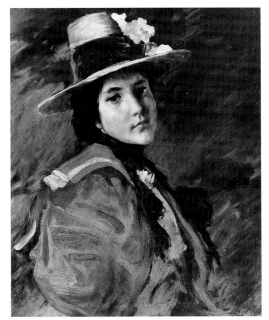

OP.301

checklist of Chase's known work as *Girl in Red,* and as being owned by A. S. Persky, Shrewsbury, Massachusetts.

OP.302

Portrait of a Woman, ca. 1900

Oil on canvas; 20 x 16 in. (50.8 x 40.6 cm)
Signed: Wm. M. Chase (c.l.)
Inscribed indistinctly on stretcher: CA Tilles

Location unknown

This bust-length *Portrait of a Woman* was likely a work Chase was commissioned to create since it is signed in a formal way ("Wm. M. Chase") rather than "Chase," the signature style preferred by the artist for his study pieces. The identity of the sitter is unknown, but the stretcher is inscribed indistinctly "CA Tilles." This likely refers to C. A. Tilles (1865–1951), a major businessman and philanthropist in St. Louis. Perhaps the sitter is a member of the Tilles family.

OP.303

Portrait of Helen (The Artist's Daughter Helen; My Daughter Helen), ca. 1900

Oil on canvas; 19⅜ x 15⅜ in. (49.2 x 39.1 cm)
Signed: Wm. M. Chase (l.l.)
Verso: Collection of C. Johnson

Location unknown

Exhibitions and Auctions: NAC '10 #17 as *Helen* [lent by Mr. Chase]; BPL '10; Csale '17 #178 as *Helen* (fully described) [purchased, Constance [*sic*] Johnson, $55].

This is a portrait of Chase's daughter Helen Velázquez Chase (1895–1955). There is no record of this work being exhibited during the artist's lifetime; however, there are several references to the work from 1909, when Chase had two solo exhibitions and was at the height of his popularity. James Pattison wrote of the work in *House Beautiful* (February 1909): 50, illus., as *The Artist's Daughter Helen*). William Howe Downes also noted it approvingly, writing: "*My Daughter Helen;* a half-length portrait of a lovely, chubby maid holding a doll, is a charmingly ingenuous head, with straight hair falling over the ears and stray locks coming down over the forehead; spontaneously and rapidly brushed with a light touch, it illustrates Chase's 'verve'" (William H. Downes, *International Studio* 39, no. 154 [December 1909]: 30, 36 illus., as *My Daughter Helen*). Chase completed several portraits of his daughter Helen, most with general titles, as in the present case. This has made it difficult to determine an exhibition history of the work. However, the painting was shown, as documented by its appearance in an installation view of an uncatalogued exhibition held at the Bridgeport Public Library in 1910. This show included fifty-four of the works from Chase's exhibition at the National Arts Club held earlier that year. The painting, owner unknown, is included on Peat's 1949 checklist of Chase's known work as *Artist's Daughter Helen (Helen Chase).*

OP.304

Study of a Girl's Head (Dorothy), ca. 1899

Signed: Chase (l.l.)

Location unknown

Exhibitions: K&C '03 #17; McCG '05 #35; MMA '17 #23, as *Dorothy* [lent by Mrs. W. M. Chase].

This painting of Dorothy (1891–1953) was first illustrated in a photo of Chase's studio, *New York Times Illustrated Magazine* (April 23, 1899): SM3. Next it appeared in Ernest Knaufft's article "William Merritt Chase: An American Painter," *International Studio* 121, no. 93 (December 1900): 157. There has been some confusion regarding the identity of the sitter. The work has also been identified as Chase's daughter Helen (1895–1965), but an installation photograph of the Chase Memorial Exhibition confirms that the painting is of Dorothy. One can see the work in the corner of the gallery in the photograph, and the entry *Dorothy* in the catalogue confirms the attribution. The work is described in the catalogue as "Dorothy—The head of a child with a white bow in her hair." It is reminiscent of a description of her in an earlier painting, ca. 1894, *Portrait of Dorothy Chase* (OP.218). Chase also painted another portrait of Dorothy circa 1900 (OP.300). In both of these works from circa 1900 Dorothy is posed the same way, the only difference being the position of the bow in her hair. This painting is included in Peat's 1949 checklist as *Dorothy* (B) *(Dorothy Chase): Study of a Girl's Head,* owner unknown.

OP.302

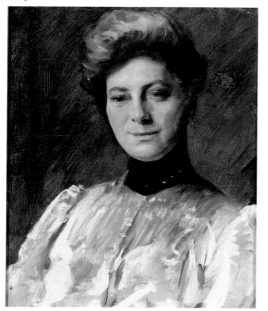

OP.303

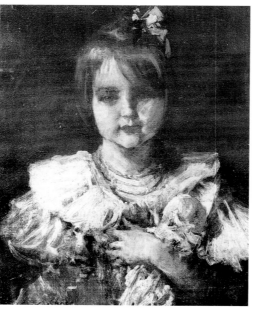

OP.304

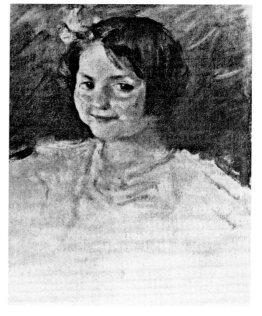

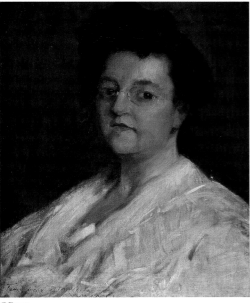

OP.305

This picture is likely a demonstration piece, perhaps depicting one of Chase's students. The date, circa 1900, was assigned to the painting based upon style and signature type. The painting was acquired at some point by Ellen Scripps Kellogg (1892–1983), a student who attended Chase's summer program at Carmel-by-the-Sea, California, in 1914; Kellogg owned at least two other portraits of women by Chase (see OP.116, OP.307).

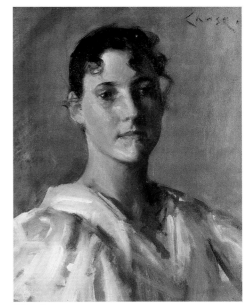

OP.306

OP.305

Portrait of a Lady (Helene Maynard White), ca. 1900

Oil on linen; 19½ x 16¼ in. (49.5 x 41.3 cm)
Signed: Wm. M. Chase (l.l.)
Inscribed: To my friend H. M. White (l.l.)

The Patricia & Phillip Frost Art Museum, Florida International University, Miami

This picture is inscribed "To my friend H. M. White" and depicts Chase's student Helene Maynard White, born in 1870 in Baltimore. She studied with Chase at the Pennsylvania Academy of the Fine Arts and then went on to be a painter of portraits and murals, actively exhibiting in New York, Philadelphia, and Detroit. Chase was an instructor at the academy from 1896 to 1908, so he probably completed this portrait of White during that period. The sitter's dress and the background of the work look quite similar to Chase's *Portrait of a Woman,* circa 1900 (OP.306), a demonstration piece that was owned by his student Ellen Scripps Kellogg. Perhaps Chase also painted the portrait of Ms. White circa 1900. This work might be that given as *Portrait of a Lady* (E), circa 1900, owner unknown, on Peat's 1949 checklist of Chase's known work.

OP.306

Portrait of a Woman, ca. 1900

Oil on canvas; 18⅞ x 15⅜ in. (48 x 39 cm)
Signed: Chase (u.r.)

Location unknown

OP.307

Portrait of a Young Girl, ca. 1900

Oil on canvas; 30 x 25 in. (76.2 x 63.5 cm)
Signed: Chase (u.m.l.)

Bruce Museum of Arts and Sciences, Greenwich, Conn.

This painting of a young girl was one of Chase's demonstration pieces. The model for the work was probably one of his female students. Customarily these paintings would be awarded to the student who had completed the best study of the day. Ellen Scripps Kellogg (1892–1983), a student of Chase's in 1914 at Carmel-by-the-Sea, California, who became the owner of the work, could not have been Chase's student in 1900 as she was only nine years old at that time, and thus must have acquired it at a later date (Eunice T. Gray, "The Chase School of Art at Carmel-by-the-Sea, California," *Art and Progress* 6, no. 4 [February 1915]: 120). There were at least three portraits of women by Chase created circa 1900 that became part of Kellogg's collection, but the details about the acquisitions are not known.

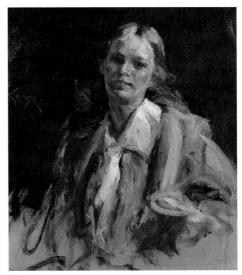

OP.307

OP.308

Helen Chase, ca. 1900

Oil on panel; 20 x 15 in. (50.8 x 38.1 cm)
Signed: Wm. M. Chase (u.r.)
Letter of authenticity signed by Mrs. Chase and dated April 21, 1923: Portrait of our daughter Helen Velázquez Chase by my husband

Location unknown

This is a portrait of Chase's sixth daughter, Helen Velázquez Chase (1895–1965). Chase completed another similar portrait of Helen holding a doll, but she appears to be slightly older in this version. The work is also similar to the unfinished portrait of Helen, *Little Empress (Unfinished Portrait of a Girl),* circa 1901 (OP.335).

OP.308

This work is included on Peat's 1949 checklist of Chase's known work as *Helen Chase,* and as being formerly owned by Newhouse Galleries, New York. This painting is reproduced in "Paintings by William Merritt Chase, N.A., LL.D.," Newhouse Galleries, Saint Louis, Missouri, 1927, no. 50.

OP.309

Portrait of Hilda Spong, ca. 1900

Oil on canvas; 84 x 40 in. (213.4 x 101.6 cm)
Signed: Wm. M. Chase (l.r.)
Note from Mrs. Chase: This was painted by my husband—of Hilda Spong, a very good canvas.—one we both loved— [dated November 25, 1925]

Virginia Museum of Fine Arts, Richmond. Gift of Ehrich-Newhouse Galleries in Memory of Walter L. Ehrich, 1936

Exhibitions: **GBV&C '01,** no catalogue (*New York Times,* April 9, 1901, 9); **PAEX '01 #610** [lent by the artist]; **SCI&WIE '01 #139** [lent by Miss Spong]; **ULC '10,** no catalogue (*New York Times,* January 14, 1910, 8); **FAM '13 #8** [lent by the artist].

The sitter for the portrait was the actress Hilda Spong (1875-1955). She was born in London to W. B. Spong, a well-known scene painter both in Australia and England. She decided to be an actress at an early age. After making her first stage appearance in Sydney, Australia, in 1890, she performed there in countless plays over the

OP.309A. Photograph of Hilda Spong in the same dress as in the painting. The Theater Collection, Museum of the City of New York (37.290.81)

OP.309

next few years. In 1896 she moved to London and established her career there. After two years, she moved to New York City in 1898 and made her first appearance, at the Lyceum Theater. Chase may have seen her perform in several plays, but he chose to depict her in the costume she wore for her role as Mrs. Onslow Bulmar in R. C. Carton's play *Wheels within Wheels,* which opened at Madison Square Theater on December 11, 1899. In a review of an exhibition of actresses' portraits held at the Union League in 1910, the writer commented that the costume Spong wore in *Wheels within Wheels* was the "star part" of the portrait (*New York Times,* January 14, 1910, 8). Hilda Spong left New York for the Australian stage in 1912 and remained there for fourteen years. This may have precipitated her return of the painting to the artist.

Hilda Spong is here depicted in a glittering green dress with a matching cape and standing before a green curtain, an apparent reference by Chase to her career on the stage. She looks at the viewer as she pulls the curtain back with her left hand, as if she is about to turn and go backstage. Chase's use only of varying shades of green is a virtuoso display of his mastery in creating three-dimensional space.

Considering its large scale, this portrait was most likely not commissioned and was probably created as an exhibition piece designed to showcase Chase's talents. According to exhibition records, the *Portrait of Hilda Spong* was exhibited three times in 1901 and thereafter not until 1910. One wonders why Chase did not show the painting more frequently. It is possible that it was, though under a different title, such as the more generic *Portrait.* Or, given Mrs. Chase's note, perhaps the Chases so enjoyed the work that they kept it for their private enjoyment. Included on Peat's 1949 checklist of Chase's known work as *Hilda Spong,* and as being owned by the Virginia Museum of Fine Arts, Richmond. Peat erroneously dates the work to 1904, an impossibility given the work's exhibition in 1901.

OP.310

Portrait of Miss D. (My Daughter, Dieudonnée), ca. 1900

Oil on canvas; 70 x 40 in. (177.8 x 101.6 cm)
Signed: Wm. M. Chase (l.l.)
There was an estate seal in red wax affixed to the back of this work (these have been invariably lost due to cracking and lifting).

Fine Arts Museums of San Francisco. Foundation Gift of George R. Roberts in memory of Leanne B. Roberts

OP.310

Exhibitions and Auctions: **PAEX '01 #609** as *Portrait of Miss D.* [lent by the artist]; **PAFA '02 #240** [lent by the artist]; **Csale '17 #386** as *Portrait of Miss D.* (fully described) (*American Art News,* May 19, 1917, 7) [purchased, J. E. McCarthy, $120].

This is a portrait of Chase's first child, Alice Dieudonnée (1887–1971). The hat she is wearing in *Portrait of Miss D.* recalls the Pilgrim-style hat worn by the model in his early masterpiece *Ready for the Ride,* 1877 (OP.47). The note of green around her neck draws the viewer's attention to her face as she looks confidently outward. This painting is included on Peat's 1949 checklist of Chase's known work twice, first as *Miss D.,* formerly owned by J. F. McCarthy, Quebec, and later as *My Daughter Dieudonnée* (B) *Dieudonnée Chase,* owned by the Los Angeles County Museum of Art.

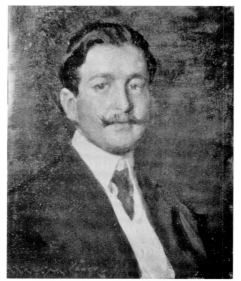

OP.311

OP.311

Bust-Length Portrait of a Man, ca. 1900

Medium/support/dimensions unknown

Location unknown

A photograph of this work descended in the Chase family.

OP.312

Bust-Length Portrait of a Man Turned Right, ca. 1900

Medium/support/dimensions unknown
Signed: Chase (u.l.)

Kate Freeman Clark Art Gallery, Holly Springs, Miss.

Kate Freeman Clark (1875–1957), from Holly Springs, Mississippi, completed her academic training in New York City in 1894, and began her study at the Art Students League in the fall of that year. She had been living with her mother on West 69th Street, near what was called the "Clique Quarter," the streets and avenues bordering Central Park South. Included in this "district" was the Arts Students League on West 57th Street. The following summer she attended the short-lived summer school of Irving R. Wiles and his father, located on the North Fork of Long Island, in Peconic. From 1896 until the summer of 1902, however, she studied at Chase's famous Shinnecock Summer

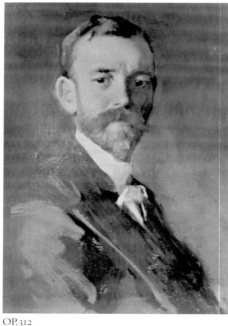

OP.312

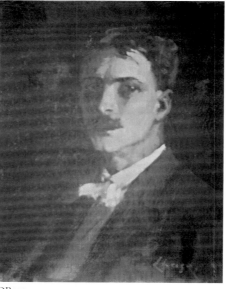

OP.313

School of Art. When Chase left the Art Students League to set up his own school in the fall of 1896, Clark was among the loyal band of students to enroll in the new school. In 1902 she was in charge of raising money from her fellow students to commission John Singer Sargent to paint Chase's portrait. It should also be noted that Chase painted at least three known portraits of Kate Freeman Clark.

OP.313

Portrait of a Man Wearing Moustache/ Tousled Hair, Head Turned Left, ca. 1900

Medium/support/dimensions unknown
Signed: Chase (l.r.)

Location unknown

The signature type is that used in signed classroom demonstration pieces. Such paintings were often awarded to pupils for meritorious classroom work. A photograph of the painting descended in the Chase family.

OP.314

Portrait of Daniel Chester French, Sculptor, ca. 1900

Physical properties unknown

Location unknown

Exhibitions: **AIC '00 #49; SAA '00 #81** [Daniel Chester French—owner].

Daniel Chester French (1850–1931) was one of the leading American sculptors of his generation. He was elected an associate of the National Academy of Design in 1900 (made a full academician the following year), and this portrait may have been proposed but not used as the diploma portrait required by the academy.

OP.315

Samuel T. Peters, Esq., ca. 1900

Physical properties unknown

Location unknown

Exhibitions: **K&C '03 #5** [Mrs. Samuel T. Peters—owner]; **NAC '10 #88** [Mrs. Peters—owner].

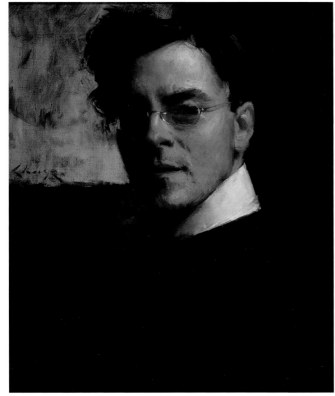

OP.316

OP.317

Wilber Peat's 1949 list of known work lists Mrs. Samuel T. Peters as the last recorded owner in 1903. She, of course, lent the work seven years later to Chase's major retrospective at the National Arts Club.

OP.316

Portrait of Louis Betts, ca. 1900

Oil on canvas; 20 x 16 in. (50.8 x 40.6 cm)
Signed: Chase (c.l.)

A. J. Kollar Fine Paintings LLC, Seattle

Louis Betts (1873–1961) studied with Chase at the Pennsylvania Academy of the Fine Arts, and it is likely that this painting is a classroom demonstration piece done at the academy, as these works are generally signed "Chase." Chase came to teach at the academy in 1896 and, except for brief periods, he taught there on and off until 1909.

OP.317

Twilight in the Studio (Self-Portrait), ca. 1900

Oil on canvas; 36 x 29 in. (91.4 x 73.7 cm)
Signed: Wm. M. Chase (l.r.)

The Parrish Art Museum, Southampton, Long Island, N.Y. Gift of Ira Spanierman

Exhibitions and Auctions: **VB '01 #54** as *Autoritratto,* possibly the above-cited work; **NAC '10 #20; Csale '17 #285,** sold to Henry R. Rittenberg, $150.

This work was illustrated in Frederic W. Coburn, "William M. Chase: His Art and Teaching," *Art Educator* (December 1900): 155. It is this reference that is used to date the work and, in turn, to suggest that the painting was sent to the Venice Biennale in 1901—the series of late Chase self-portraits did not begin until 1908 with the commission from the Uffizi Gallery. Henry Rittenberg, who purchased the painting from the Chase estate sale in 1917, was a student of the artist, and, in fact, Chase painted his portrait. A letter from F. Allen Whiting, director of the Cleveland Museum of Art, to Bryson Burroughs, curator of The Metropolitan Museum of Art, October 29, 1917, inquires about "a ¾ length self-portrait, entitled 'Twilight', which . . . has been exhibited in important exhibitions and which Mr. Chase himself considered very highly. This, as I understand it, is a canvas about 44 x 32 and is painted in a dark mirror with the artist seated in his studio with studio fittings about him." A notation on the bottom of this letter states, "Twilight was probably #285 in the Chase sale." The description of the work does not exactly match the image in *Twilight in the Studio,* and it would seem unlikely, though certainly possible, that Rittenberg would have turned around and sold the work in such a short period of time (the Chase estate sale took place in May 1917). Thus it opens up the possibility that the work referred to in Mr. Whiting's letter is yet another self-portrait. There is, in fact, another work, titled *Twilight Portrait of the Artist* (68 x 38 in.), that sold in the Chase sale of 1896. And there is always the possibility that *Twilight Portrait of the Artist* was, at some point, cut down and is in fact *Twilight in the Studio*—upon recent close examination of the work, now rebacked, in the Parrish Art Museum it was not possible to determine if the work had been cut down. However, there are no exhibition references to a work with the earlier title. *Twilight in the Studio* is included in Peat's 1949 list (under "Interiors") as having been formerly owned by Newhouse Galleries, New York.

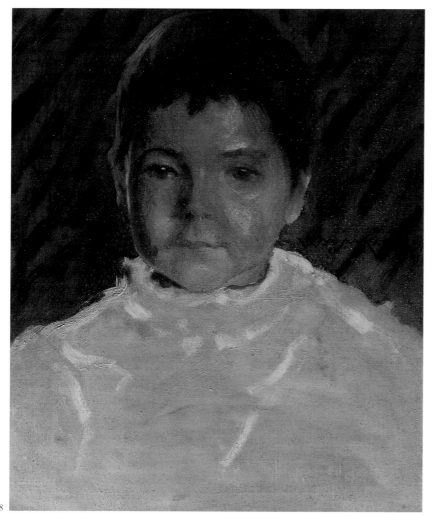

OP.318

OP.318

Study of a Boy's Head (Robert Stewart Chase), 1900

Oil on canvas; 15 x 12 in. (38.1 x 30.5 cm)
Signed: Chase (l.r.)

Robin Chase, Flushing, N.Y.

Although this painting was at one point described as a portrait of Chase's daughter, Hazel, it is clearly a portrait of his son Robert Stewart Chase (1898-1987). A letter from Mrs. Robert Chase to Ronald Pisano (April 9, 1990) discusses the mix-up: "There is no doubt that it is a painting of Bob. He looks to be about 3. It compares most favorably with a photograph of him when he was about 5. How in the world could the painting have been titled *Hazel* when the child is so obviously a male! We shall never know." In fact it was illustrated in an article by Ernest Knaufft, "An American Painter: William M. Chase," *International Studio* 21, no. 93 (December 1900): 156, as *Study of a Boy's Head*. A photograph of the painting, most likely taken by one of Chase's students, Frank Wadsworth, in the summer of 1900 at Shinnecock, is included in the files of Ronald Pisano. Included in Peat's 1949 checklist as being a portrait of Hazel, owned by Lewis Kayton, San Antonio, Texas.

OP.319

The Artist's Wife (Portrait of Mrs. Chase), ca. 1900

Oil on canvas; 21 x 14 in. (53.3 x 35.6 cm)
Signed: Chase (u.l.)

Brigham Young University Museum of Art, Provo, Utah

A depiction, from behind, of Chase's wife, Alice Gerson (1866-1927). Chase did countless paintings of his wife and many of these works were not meant to be exhibited, but rather enjoyed by the family. He often signed such portraits of family members with "Chase," as seen here, rather than with the more formal signature "Wm. M. Chase." The face, shoulder, and arms have been repainted on this work, so one can only imagine how it may have looked originally.

OP.320

The Japanese Book (Grey Kimona; Dieudonnée), ca. 1900

Oil on canvas; 41¾ x 28¾ in. (106.1 x 73 cm)
Signed: Wm. M. Chase (l.l.)

Location unknown

Exhibitions: **CM '01 #213** as *The Japanese Book*; **AIC '01 #60**; **SWA '04 #16** as *The Japanese Book*, $1500 ("14th Annual Society of Washington Artists," *Washington Post*, March 20, 1904, 39, *The Gray Kimona*, illus.); **McCG '05 #1**; **VGB '09 #1**; **NAC '10 #67** as *Grey Kimona* [owned by Mr. Chase]; **BPL '10**; **CM '11 #63**, illus. as *The Japanese Book*; **CI '22 #2** as *Dieudonnée* (*Academy Notes*, Buffalo Fine Art Academy, 18 [January-June 1923]: 5, illus.).

Chase's daughter Alice Dieudonnée (1887-1971) was one of his favorite models, and he captured her in several works wearing a kimono. This depiction of her appears to have been created as an exhibition piece and was shown and illustrated frequently. The work was first illustrated in Margaret Cooper White's article "William M. Chase, N.A." as *The Japanese Book* (Margaret Cooper White, "William M. Chase, N.A.," *Truth* 19, no. 7 [July 1900]: 160). Although the work seems to have been exhibited under the title *Gray Kimona* and *Grey Kimona,* it was referred to in articles as *Gray Kimono*. Early Chase biographer Katharine Metcalf Roof illustrated the work as *The Gray Kimono* in her article on Chase published in the *Craftsman* 18 (April 1910): 39.

OP.319

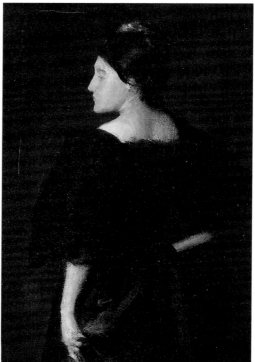

Roof mentions *Gray Kimono* in her discussion of Chase's successful use of color: "Most effective of all is his subtle, economical manner of using a small quantity of color in such a way that it tells for ten times its quantity and speaks more authoritatively than an overwhelming brilliance" (Katharine Metcalf Roof, *The Life and Art of William Merritt Chase* [1917; reprint, New York: Hacker Art Books, 1975], 282). She goes on to say that the "finely felt color note in the *Gray Kimono* lies in the blue touches in the gown and book" (ibid., 283). The painting was not exhibited in 1916, but that year it was illustrated as *The Japanese Kimono* in *Outlook* 114 (November 8, 1916): 547, and in D. Phillips, "William M. Chase," *American Magazine of Art* 8, no. 2 (December 1916): 49 as *The Japanese Kimono*. The painting stayed in the Chase family throughout the artist's lifetime and remained as part of the Chase Estate until 1923. It may have been sold that year for $4,000 through a Chase memorial exhibition at the Corcoran Gallery, Washington, D.C., under the title *Dieudonnée*. The work does not appear in the shows held at Ferargil or Newhouse Galleries in 1927, which included many works from the Chase family's collection.

There is a photograph circa 1902 showing the *Japanese Book* sitting on the easel and a painting of the artist Frank Wadsworth on the floor of the Chase home in Shinnecock Hills in the Chase Family Archives, Parrish Art Museum, Southampton, Long Island, New York. This photograph is the main visual record of the work. In addition, Chase executed another work entitled *Head of a Young Girl (The Gray Kimono)*, 1901 (OP.339), that again depicted his daughter Alice, which only adds to the confusion regarding both the work's title and its exhibition history. Peat includes this work in his 1949 checklist of Chase's known work as *Cosy (A) (Alice Chase); The Japanese Gown; The Japanese Kimono,* and as being owned by Albert R. Jones, Kansas City, Missouri. (Albert R. Jones is the last recorded owner of the work, and its current location is unknown.)

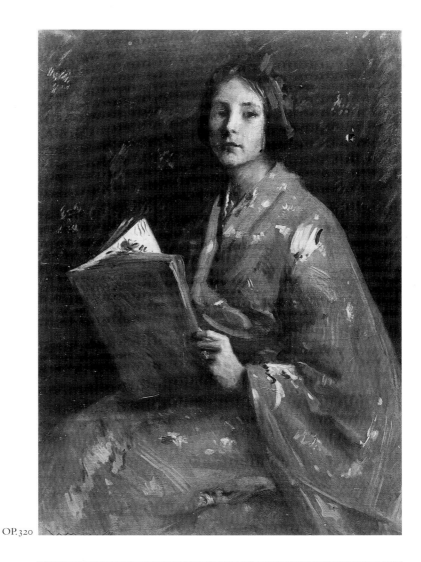

OP.320

OP.321

The Mirror, ca. 1900

Oil on canvas; 36 x 29 in. (91.4 x 73.7 cm)
Signed: Wm. M. Chase (l.l.)

Cincinnati Art Museum, Ohio. Museum Purchase (1901.44)

Exhibitions: **BAC '01 #23** as *The Mirror* [lent by the artist]; **GBV&C '01** ("Portraits by Wm. M. Chase," *New York Times*, April 9, 1901, 9); **CM '01 #212,** illus. [lent by the artist]; **LAA '09 #6.**

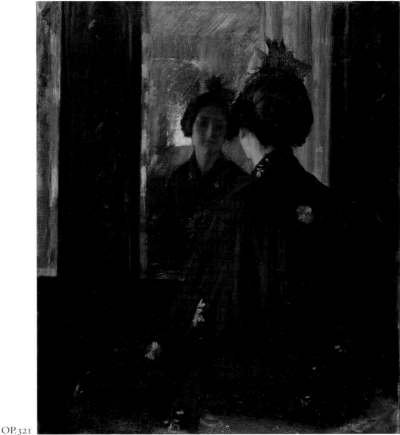

OP.321

This picture depicts Chase's daughter Alice Dieudonnée seated before the large cabinet in the hall of Chase's summer home in Shinnecock, Long Island. Her image appears to be reflected in the doors of the cabinet, rather than in a mirror. Early Chase biographer Katharine Metcalf Roof illustrates the work as *The Black Kimono* in "William Merritt Chase: His Art and His Influence," *International Studio* 60 (February 1917): cx, and in her book *The Life and Art of William Merritt Chase* (New York: Charles Scribner's Sons, 1917), facing p. 254. The work seems to be listed twice in Peat's 1949 checklist: once as *The Mirror*, oil on canvas, circa 1900, and again as *The Black Kimono,* owned by the Cincinnati Museum of Art, Ohio. Peat mistakenly records the work as being unsigned.

OP.322

The Open Japanese Book (The Japanese Book; Japanese Book), ca. 1900

Oil on canvas; 72 x 37 in. (182.9 x 94 cm)
Signed: Wm. M. Chase (l.l.)

The Hevrdejs Collection, Houston

Exhibitions and Auctions: **CM '01 #207,** illus. as *The Open Japanese Book*; **AIC '01 #59; BFAA '09 #43** as *The Japanese Book* ("The Paintings by Mr. Chase," *Academy Notes* 4 [February 1909]: 144, as *The Japanese Book*); **NAC '10 #64** as *The Open Japanese Book*; **BPL '10; WAM '12 #9,** illus.; **FAM '13 #3; K&C '15 #11** as *Japanese Book*; **DMA '16 #4; TMA '16 #104; Csale '17 #384,** sold to M. Knoedler and Company; **CGA '19 #8** as *The Japanese Book.*

A portrait of Chase's daughter Alice Dieudonnée (1887-1971) dressed in a black kimono, which she also wears in *Alice in Shinnecock Studio,* painted around the same time. Instead of having the red sash around her neck, in this work it is tied around her waist. One critic writing about the work described Alice as "draped in a rich-figured Japanese silk gown, one hand holding a book, which has unfolded its pages, covered with bright-colored prints in an impromptu sequence" (William H. Downes, "William Merritt Chase, A Typical American Artist," *International Studio* 39, no. 154 [December 1909]: 30). In addition to giving the work a visual dynamism, the collapsing pages also help Chase create a sense of three-dimensional space.

American interest in Japanese prints and illustrated books began in earnest around 1890. New Yorkers were introduced to Japanese illustrated books and prints in April 1889 when

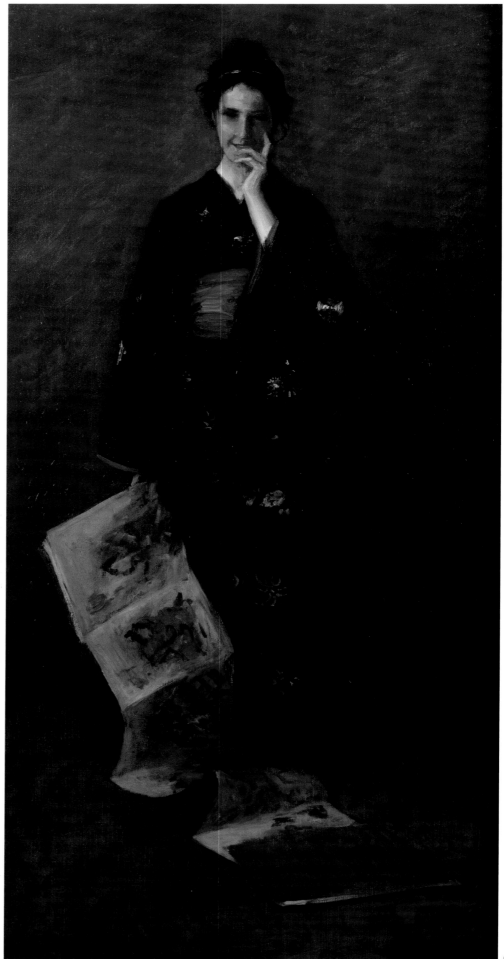

OP.322

Hiromichi Shugio, a Japanese collector and importer, had an exhibition at the Grolier Club. Chase and Shugio had known each other since the late 1870s, when they were both members of the Tile Club. (The author wishes to thank Bruce Weber for the information about Hiromichi Shugio.) A critic discussing works in the Chase exhibition at the Buffalo Fine Arts Academy saw *The Japanese Book* as "suggestive of Whistler in both subject and treatment. . . . In soft, sombre coloring, and in subtlety of technique, this work is quite Whistlerian" (*Academy Notes* [February 1909]: 144). Included on Peat's 1949 checklist as *The Japanese Book* and *Open Japanese Book,* and as being formerly owned by M. Knoedler and Company, New York.

OP.323

Lydia Field Emmet, 1900

Oil on canvas; 24 x 20 in. (61 x 50.8 cm)
Signed: Wm. M. Chase (u.r.)

Santa Barbara Museum of Art. Bequest of Margaret Mallory, 1998

A portrait of artist Lydia Field Emmet (1866–1952), a student of Chase's at the Art Students League in New York and at his Shinnecock Summer School of Art in Long Island. She went on to become a well-known artist specializing in children's portraits. Chase also executed a full-length portrait of the same sitter (OP.201).

OP.324

Portrait of Virginia Stewart (Jennie), 1900

Oil on canvas; 36 x 25½ in. (91.4 x 64.8 cm)
Signed: Wm. M. Chase (l.r.)

Collection of The Chase Family

This painting depicts Virginia Brémond Stewart (b. 1818), Alice Gerson Chase's great aunt. Included on Peat's checklist as *Jennie Stewart,* with the incorrect dimensions 36 by 28 inches, and as being owned by Robert S. Chase, Flushing, New York.

OP.325

Dorothy and Her Sister, ca. 1900

Oil on canvas; 41 x 41 in. (104.1 x 104.1 cm)
Signed: William Merritt Chase (l.r.)

Location unknown

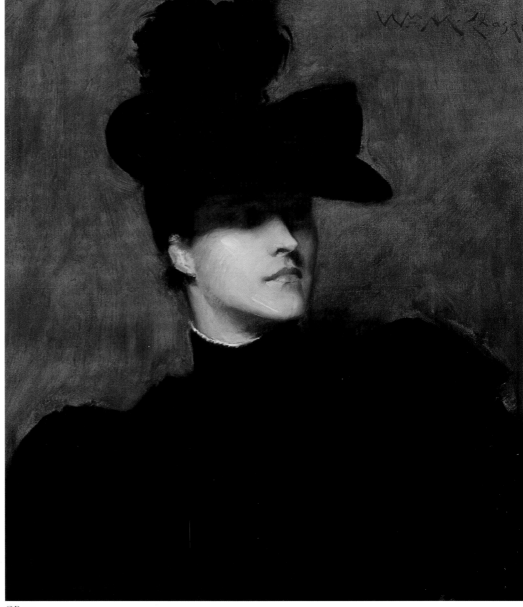

OP.323

Exhibitions: **GBV&C '01** ("Portraits by Wm. M. Chase," *New York Times,* April 9, 1901, 9); **CI '05 #43; BFAA '06 #22,** illus. p. 11 ("First Exhibition of Selected American Paintings at the Albright Gallery," *Academy Notes* 2, no. 1 [June 1906]: 1–2, 1, 2, illus.); **JHAI '06 #27; NAC '10 #63; WAM '10 #42** (E.M.C., "Thirteenth Annual Exhibition: The Figure Paintings," *Bulletin of the Worcester Art Museum* 1, no. 4 [September 1910], 5, illus.); **BPL '10; RAEx '11 #170; CGA '11 #89,** illus.; **MMA '17 #29.**

This portrait depicts two of Chase's daughters, Dorothy Brémond Chase (1891–1953), seated, and her sister Alice Dieudonnée (1887–1971), standing behind the chair, and was one of the most celebrated paintings of his mature period. It was widely exhibited and often referred to and illustrated in periodicals of the day. Chase's early biographer Katharine M. Roof saw it as "one of his most important paintings" ("William M. Chase: An American Master," *Craftsman* 18 [April 1910]: 33, 37, illus.; and Katharine Metcalf Roof, *The Life and Art of William Merritt Chase* [1917; reprint, New York: Hacker Art Books, 1975], 171, 305, illus. facing p. 306). One critic referred to the work as "showing great richness of color and tenderness of feeling" ("William M. Chase's Recent Work," *Harper's Weekly* 46 [November 8, 1902]: 1627, illus.). Another writer, referring to the work as the "artist's recently finished portrait of his little daughter," was simply captivated by it. He begins by describing Chase's use of color as "fine and refined," then calls attention to Chase's "blending of beautiful tints" (Ernest Knaufft, "An American Painter—William M. Chase," *International Studio*

21, no. 93 [December 1900]: 155, illus.). His further description verges on the rhapsodic:

> Over the chair is thrown a piece of soft blue Oriental silk—and what amplitude is suggested in that one piece of drapery covering a wicker chair!—that seems to have given the artist the color scheme for the whole composition: delicate blues, like doves' eggs in the twilight, interweave with browns from thrushes' wings; soft amber yellows fade into seaweed-green shadows that half hide threads of rain-cleansed emerald, coral red, and orchid lavender. No Japanese empress ever possessed an embroidered robe of more dulcet hues. Nor with all this sensual beauty of tinctured textures is the portrait sacrificed to the accessories; on the contrary, as a Velázquez Infanta sheathed in her stiff crinolined skirt, is ever a flower of childhood, so this little maiden, ensconced in the embrace of the ample chair, is at first glance the motive of the canvas, the blossom of the plant. No essential detail of characterization has been sacrificed to technique; the epitome of childhood is there. Her eyes regard you, yet modestly refrain from staring, and the childish hands, the fingers intertwining in her lap, lie in that perfect tranquility that only a child's hands can assume. Dependent from her throat is a necklace of coloured beads that sets off the brunette complexion of her throat and face and the mahogany brown of her hair (ibid., 155).

There is a photograph, circa 1899, in the Chase Archives of Dorothy wearing a dress that resembles or may have inspired the one she poses in for *Dorothy and Her Sister*. In addition to Chase's expert technique and use of color, other writers pointed to the touching sisterly relationship between the two girls. William Howe Downes saw the painting as "a decorative portrait group of distinct piquancy, where the small maiden in white seated in a big armchair is delightfully posed and characterized and where the caressing and protective attitude of the elder sister's form, as she bends over the back of the chair, is a beautiful touch" (William Howe Downes, "William Merritt Chase, A Typical American Artist," *International Studio* 39, no. 154 [December 1909]: 29). In addition to being well received, *Dorothy and Her Sister* was illustrated frequently, including in Sadakichi Hartmann, *A History of American Painting,* vol. 1 (1902; reprint, Boston: L. C. Page and Co., 1932), 227, illus., and Samuel Isham (with supplement by Royal Cortissoz), *The History of American Painting* (New York: 1905; reprint, 1927), 359, frontispiece to chapter 10, illus. Shortly after Chase's death in 1916, when the earliest important surveys of American art

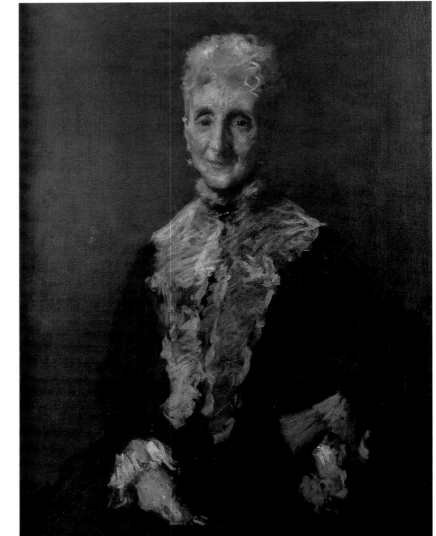

OP.324

began to be published, this painting was singled out and featured in most of these books as a major example of Chase's work. For example, Lorinda Bryant in *American Pictures and Their Painters* wrote:

> Let us look again at *Dorothy and her Sister,* Mr. Chase's idea of technique is wonderfully verified in this picture. Yes, it is the eloquence of his art that is holding us before his pictures. Was anything ever more ideal than this young girl sitting at ease as she listens to the older sister who leans over her shoulder? How perfectly they both fit into the setting and how exactly the setting fits them! "But," you may ask, "where is the setting? I see nothing but a chair." That is just the point. Mr. Chase makes us feel the room, the yard, the place, the common everyday surroundings in the aliveness of his figures and the quivering air that envelopes them (Lorinda Munson Bryant, *American Pictures and Their Painters* [New York: John Lane Co., 1917; reprint, 1920]: 116, illus. facing p. 115).

This painting was apparently going to be purchased in 1914 by the French government for the National Luxembourg Museum, Paris, but history intervened. Another anecdote had it going to France to be exhibited again at the National Luxembourg Museum in an "Exposition D'Artistes L'Ecole Americaine" ("Wm. M. Chase's Picture for the Luxembourg," *Boston Evening Transcript,* October 15, 1913, 21, illus.). Either or both of these were possibilities, but neither came to fruition because World War I broke out and then Chase died in 1916. The exposition, which finally happened in 1919, was for living artists and those already included in the Luxembourg Collection, so *Dorothy and Her Sister* could not be included. Also, it seems that no attempt was made by Mrs. Chase to reopen communication regarding the possible acquisition of the work by the Luxembourg Palace after the end of the war. Thus this masterwork has remained in America. Included on Peat's checklist as *Dorothy and Her Sister (Dorothy Chase); The Sisters,* and as being owned by Charles T. Davies, Wyomissing, Pennsylvania.

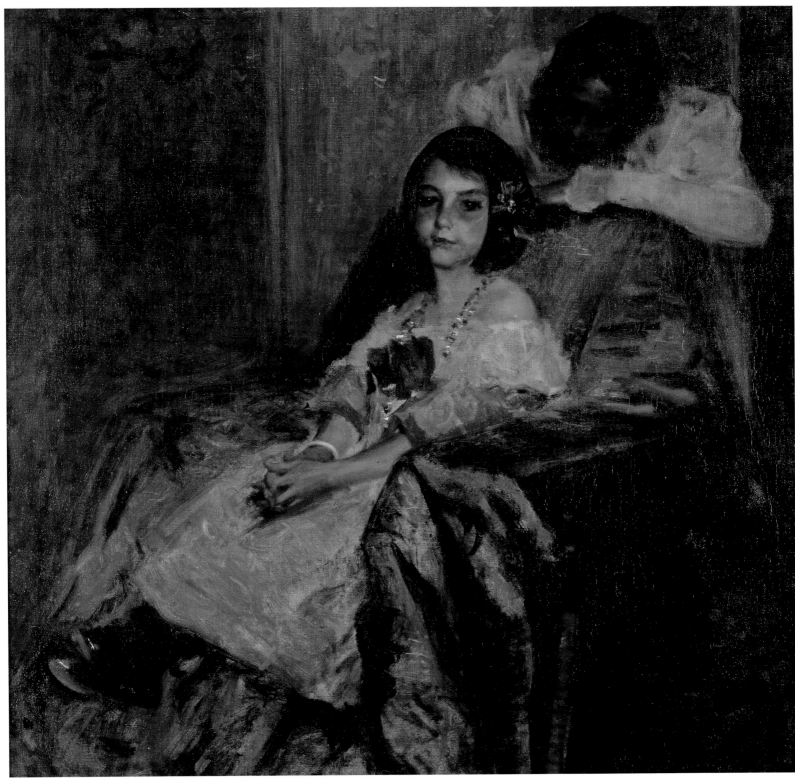

OP. 325

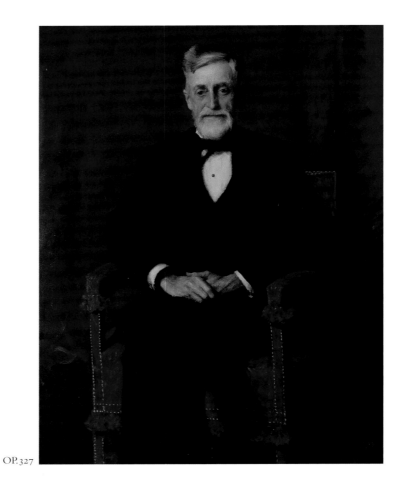

OP.326

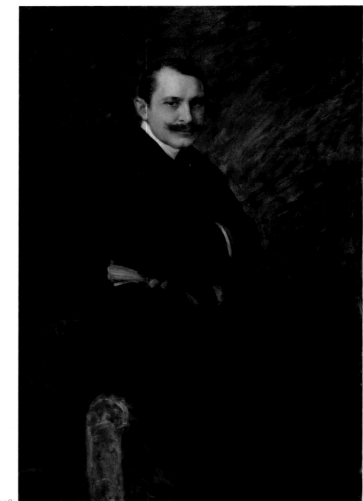

OP.327

OP.326

William Thorne, ca. 1900

Oil on canvas; 23 x 19 in. (58.4 x 48.3 cm)
Signature not visible on reproduction

Location unknown

Exhibitions: **K&C '03 #7.**

William Thorne (1864–1956) was a Paris-
educated artist who was an active member of
the New York art community around the turn
of the twentieth century. This work is included
in Peat's 1949 checklist of known work as being
in the collection of Mrs. William Thorne.

OP.327

Portrait of John Butler Talcott, ca. 1900

Oil on canvas; 48 x 36 in. (121.9 x 91.4 cm)
Signed: Wm. M. Chase (l.r.)

The New Britain Museum of Art, Conn. Gift of the
Talcott Family (1943.03)

John Butler Talcott (1824–1905) founded the
American Hosiery Company, New Britain,
Connecticut, and was one of New Britain's lead-
ing businessmen and civic leaders. The painting
was, in fact, commissioned by the American
Hosiery Company to hang in the company

OP.328

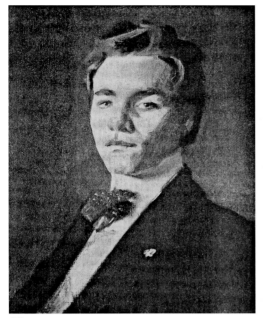

OP.329

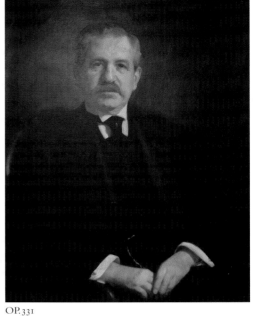

OP.330

OP.331

headquarters. Talcott was mayor of New Britain from 1880 to 1882, and a founder and president of the New Britain Institute, parent institution of the New Britain Museum of American Art. His portrait by Chase was likely painted around 1900 at the urging of Talcott's cousin Sarah Talcott, who had studied with Chase at the Art Students League.

OP.328

William Clyde Fitch, ca. 1900

Oil on canvas; 50¼ x 34 in. (127.6 x 86.4 cm)
Signed: Wm. M. Chase (u.l.)

Mead Art Museum, Amherst College, Mass.
Gift of Mrs. William G. Fitch (1914.3)

Exhibitions: **MMA '17 #34** [lent by Amherst College].

William Clyde Fitch (1865–1909), Amherst Class of 1886, was considered a leading playwright for the Broadway stage. He was also a very close personal friend of the Chase family and served as godfather to Chase's son Robert Stewart Chase, born in 1898. Most notably, he wrote *Captain Jinks of the Horse Marines* (Ethel Barrymore's first starring vehicle). Chase also completed a smaller canvas with Fitch as the sitter, *Portrait of Clyde Fitch* (OP.287), which dates from the same period. The portrait was listed in Katharine Metcalf Roof's 1917 biography of the artist, and is included in Peat's 1949 list as being owned by Amherst College.

OP.329

Portrait of Mr. Rittenberg, ca. 1900

Oil on canvas; dimensions unknown
Location unknown

Exhibitions: **PAFA '00 #1.**

The portrait artist Henry Rittenberg (1879–1969) studied with Chase at the Pennsylvania Academy of the Fine Arts, Philadelphia, and at the Shinnecock Summer School of Art. Katharine Metcalf Roof in her 1917 biography recounts Chase meeting his pupil during a brief visit to Munich in 1903. Rittenberg, along with another Chase student alumni, Eugene Paul Ullman (1877–1953), spent time with their master in the museums and galleries of Munich. *Portrait of Mr. Rittenberg* was reproduced in an article written by Ernest Knaufft, "W. M. Chase," *International Studio* 21, no. 93 (December 1900): 155. The painting is included in Peat's 1949 checklist of Chase's known work.

OP.330

Portrait of Mr. Duveen, ca. 1900

Oil on canvas; 9½ x 7¼ in. (24.1 x 18.4 cm)
Inscribed and signed: To my friend Mr. Duveen / Wm. M. Chase (l.r.—in script)
Inscribed: Bought by Mr. Pierce / from the Pendelton Collection / 1900 (verso)

Based on the inscription and the sitter's likeness to Lord Joseph Duveen, it is presumed that the subject is Lord Duveen, the English art dealer (1869–1939). However, Lord Duveen had two brothers who were also art dealers, Henry J. Duveen (1854–1919) and Louis J. Duveen (1875–1920), and there is always the possibility that the portrait is of one of these brothers. Although there are no references to Chase and Duveen being friends, it is certainly possible that they knew each other through mutual acquaintances. The small scale of the portrait and the personal inscription suggest it was an informal sketch done on the spot in one sitting and given to the sitter.

OP.331

Portrait of Postmaster General Charles Emory Smith, 1900

Medium/support/dimensions unknown
National Postal Museum, Smithsonian Institution, Washington, D.C.

This work is known by a brief notice in "Art," [Chicago] *Tribune,* April 8, 1900, 62: "William M. Chase has begun a portrait of Postmaster General Charles Emory Smith, which is to be sent to the Paris Exposition. It will finally be hung in the Post office department in Washington, although after the exposition it will be shown about the country." Chase was on the selection jury for American paintings for the Paris Exposition of 1900 and was represented

by three works, not including a portrait of Postmaster General Smith (1842–1908). In fact, there is no record of his ever exhibiting a portrait of the postmaster general. Smith was a graduate of Union College in 1861, after which he went on to become a journalist, diplomat and eventually postmaster general.

OP.332

Portrait of a Young Man (Edward C. Trego), 1901

Oil on canvas; 20 x 16 in. (50.8 x 40.6 cm)
Signed: Wm. M. Chase (c.r.)

Collection of Mrs. Dudley D. Johnson

Exhibitions and Auctions: **PAFA '01 #324; CGA '08 #21; AAG '09 #27; NAC '10 #69; C'sale '17 #269** (fully described).

This painting was first thought to be a portrait of William T. Trego (1859–1909), a portrait and genre painter living in Pennsylvania. However, the Chase portrait looks to be a circa 1901 work, and the sitter a very young man. It is possibly a portrait of Edward C. Trego, who studied with Chase at the Pennsylvania Academy of the Fine Arts for several years beginning in 1896. Edward was the son of William T. Trego, and the grandson of another artist, Jonathon K. Trego (1817–ca. 1888). It is impossible to say with certainty that the above-cited work was the same work exhibited in the four exhibitions noted. However, the work did stay in the possession of Chase until his estate sale in 1917, wherein it was catalogued with the same title.

OP.332

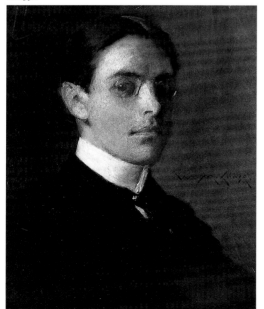

OP.333

OP.333

William Williams Keen, M.D., 1901

Oil on canvas; 70 x 54 in. (177.8 x 137.2 cm)
Signed: Wm. M. Chase (l.l.)

Thomas Jefferson University, Philadelphia

William Williams Keen (1837–1932) graduated from the Jefferson Medical College in 1862, after which he served on the faculty from 1866 to 1907. He also taught artistic anatomy at the Pennsylvania Academy of the Fine Arts. This work is included in Peat's 1949 checklist, dated 1901.

OP.334

Portrait of Julian Onderdonk, 1901

Oil on canvas; 20 x 16 in. (50.8 x 40.6 cm)

Witte Memorial Museum, San Antonio, Tex.

This work was painted at the Shinnecock Summer School of Art on July 30, 1901, the nineteenth birthday of the sitter, Julian Onderdonk (1882–1922), a student of the school that summer. The work was done as a demonstration piece on portrait painting. Today, Onderdonk is best known as a painter of Texas, his home state. He was the son of Robert Onderdonk, also an artist, and a classmate of Chase at the Royal Munich Academy in 1878. Included in Peat's 1949 checklist of Chase's known work as being in the collection of Eleanor Onderdonk (no location given).

OP.335

Little Empress (Unfinished Portrait of a Girl), ca. 1901

Oil on canvas; 19½ x 16½ in. (49.5 x 41.9 cm)
Signed: Chase (l.r.)
Inscribed: *Little Empress* (l.l.)

Location unknown

OP.334

OP.335

This painting depicts Chase's daughter Helen Velázquez Chase (1895–1965) in what would seem to be a demonstration piece. The face is most nearly finished, with the rest of the composition less developed. The work, typical for his demonstration pieces, is signed "Chase"; in this instance he also included a title for the work that reflected the attitude of the sitter, *Little Empress*. Helen appears to be about six years old, which would date the work circa 1901.

Ethel Pennewill Brown Leach (1878–1959), one of Chase's students, was the recipient of this particular work. Ethel Leach, born in Wilmington, Delaware, traveled to New York City and began her studies at the Art Students League in 1899. She remained in New York until 1903, but was forced to take a year off from school in 1902–3 on account of having contracted typhoid fever.

OP.336

Portrait of L. F. Roos, 1901

Oil on canvas; 20 x 16 in. (50.8 x 40.6 cm)
Signed: Wm. M. Chase (l.r.)

Mount Holyoke College Art Museum, South Hadley, Mass. Gift of Roger and Sarah Rusk

Exhibitions and Auctions: **BPL '10** (seen in photograph of gallery installation—no known catalogue); **Csale '17 #267** (fully described in auction catalogue) [purchased, LeRoy Ireland, $50].

For some reason, the larger portrait of Mr. L. F. Roos (OP.337) completed in the same year is one of the most exhibited works of the artist. In the 1917 Chase sale catalogue the sitter is described as the late art expert well known to New Yorkers. Based on size alone, the exhibition history has been assigned to the larger, more complete work. However, the exhibition history certainly suggests that perhaps both works were exhibited—for example, the Roos portrait was exhibited in the Cincinnati Museum of Art Annuals of both 1902 and 1903, and it is unlikely that an artist would submit the same work for two consecutive annuals. Again in 1915 and 1916 a Roos portrait was included in exhibitions held at the Detroit Museum of Art. The title was altered in 1904 to *Portrait—The Late L. F. Roos,* noting the death of the sitter. Without measurements or illustrations, it is difficult if not impossible to determine which version of the painting was exhibited. It is clear that at some point in the history of the larger painting, the work was reacquired by Chase from the sitter or his estate.

OP.336

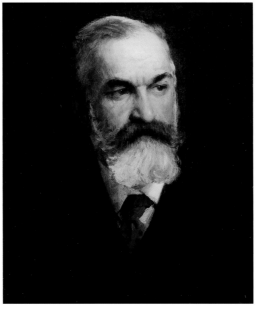

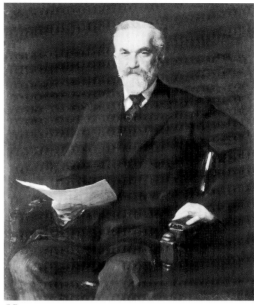

OP.337

OP.337

L. F. Roos, Esq., 1901

Oil on canvas; 44 x 36 in. (111.8 x 91.4 cm)
Signed: Wm. M. Chase (l.r.)

Location unknown

Exhibitions and Auctions: **PAEX '01 #608** as *L. F. Roos, Esq.* [lent by L. F. Roos]; **PAFA '02 #18** as *Portrait of L. F. Roos* [owner]; **CM '02 #40** as *Portrait of F. Roos, Esq.*; **BAC '03 #6** as *Portrait of L. Roos*; **CM '03 #6** as *L. F. Roos, Esq.*; **NAD '04 #279** as *Portrait—The Late L. F. Roos*; **McCG '05 #31** as *Portrait of L. F. Roos*; **MSAS '05 #36** as *Portrait of L. F. Roos, Esq.*; **BFAA '09 #48** as *Portrait of Mr. Roos*; **NAC '10 #52** as *Portrait—L. F. Roos* [lent by Mr. Chase]; **BPL '10** (seen in photograph of gallery installation—no known catalogue); **AAG '15 #39** as *Portrait of L. S. [sic] Roos* (illus. in exhibition catalogue); **DMA '15 #2** as *Portrait of L. S. [sic] Roos*; **DMA '16 #10** as *Portrait of L. F. Roos*; **Csale '17 #369** (fully described in auction catalogue) [purchased, M. Knoedler and Co., $250].

Chase also completed another portrait of Roos in the same year (OP.336). The present portrait is included in Peat's 1949 checklist of Chase's known work as being owned by Mrs. John Greeley Pierce, Boston.

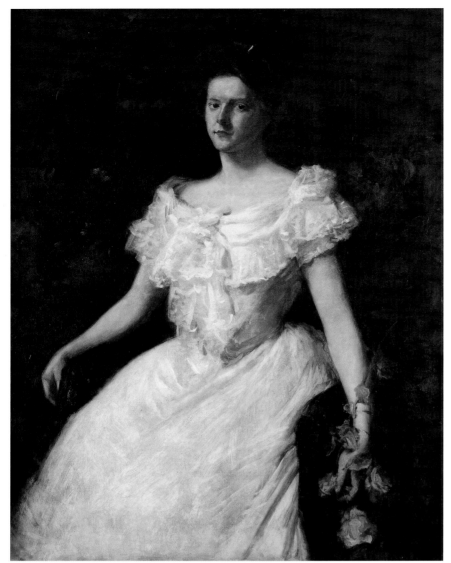

OP.338

decided to give up his position as an instructor at the academy in 1909, he continued to maintain his studio in Philadelphia through 1913.

Lady with a Rose was clearly painted as an "exhibition piece," intended not only to please his sitter but to impress the art world as well. The background of the painting deliberately does not detract attention from the sitter, and the strong light draws the eye to his expert technique in the depiction of her dress and the rose. The subject's reserved demeanor likely reflects the conservative standards of Philadelphia society, as does the fact that her jewelry is limited to two small gold bracelets on her left wrist and the slight indication of a gold pin in her hair. Chase would appear to utilize such elements for the purpose of enlivening his painting with simple but brilliant accents, rather than indicating the sitter's social station. Similarly, the rose held at the sitter's side, a standard symbol of youth and beauty, is elegantly used by Chase to anchor the composition. Included on Peat's 1949 checklist as *Lady with a Rose,* owner unknown.

OP.339

Head of a Young Girl (The Gray Kimono), 1901

Oil on canvas; 20 x 16 in. (50.8 x 40.6 cm)
Signed: Wm. M. Chase (m.l.)

Location unknown

Exhibitions: **McCG '05 #17** as *Head of a Young Girl;* **BFAA '09 #29** as *Head of a Young Girl* ("The Paintings by Mr. Chase," *Academy Notes* 4 [February 1909]: 146); **VGB '09 #17** as *Read* [*sic*] *of a Young Girl;* **NAC '10 #29** as *Head of a Young Girl* [lent by Mr. Chase]; **BPL '10.**

OP.339

OP.338

Portrait of a Lady with a Rose (Miss M. S. Lukens), ca. 1901

Oil on canvas; 48 x 36 in. (121.9 x 91.4 cm)
Signed: Wm. M. Chase (c.r.)

Location unknown

Exhibitions: **PAFA '01 #211,** illus., winner of Temple Gold Medal (*Philadelphia Inquirer,* January 27, 1901, illus.); **PAEX '01 #611** as *Miss. M. S. Lukens* (Charles Lukens); **NAD '02 #335** as *Miss S. L. Lukens* [*sic*] [lent by Chas. Lukens].

In 1896 Chase began teaching at the Pennsylvania Academy of the Fine Arts. Along with his teaching, Chase also pursued portrait commissions in Philadelphia. Although high society was reluctant to accept an "outsider" to paint their portraits, they gradually gave in to Chase's charm and his impressive reputation as a portrait painter,

and it was not long before he was reported to have gained "quantities" of friends and portrait commissions in Philadelphia. In 1901 Chase featured the present work in the Pennsylvania Academy of the Fine Arts annual exhibition. The identity of the sitter, Mary Shepard Lukens, would have been easily recognizable to Philadelphia society by her image alone, which was reproduced in the catalogue for the show. And, for those who might not recognize her by sight (since her name was not given in the title of the work), her identity would have been easily determined by the listing of the lender, Charles Lukens, her father. When this painting was awarded the honor of receiving the Temple Gold Medal in the show, it served as further evidence of Chase's endorsement by Philadelphia's social elite. The portrait was also referred to in the *American Art Annual* (1903–4: 233). Numerous portrait commissions followed, as wealthy Philadelphians arranged for appointments at Chase's elegant studio. And, although Chase

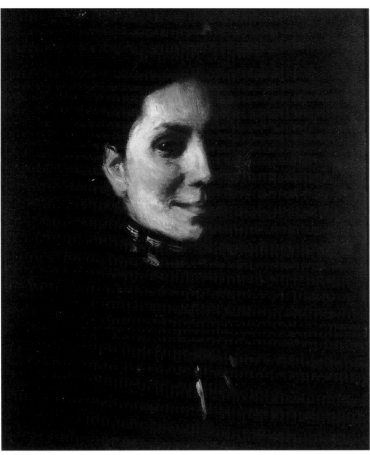

OP.340

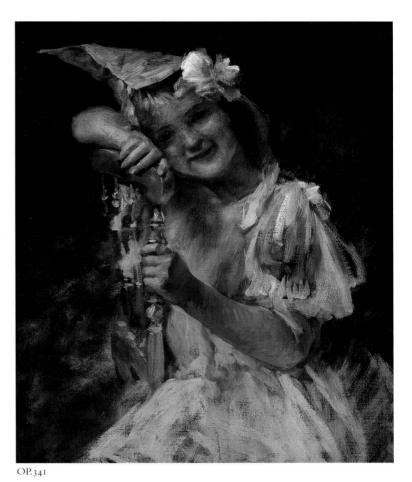

OP.341

The model for this work is Chase's eldest daughter, Alice Dieudonnée, in a gray and scarlet kimono. *Head of a Young Girl* is one of a number of paintings by Chase depicting women in kimonos, a theme he began exploring in the 1880s and returned to from time to time until 1914. A reviewer of the Buffalo Fine Art Academy exhibition in 1909 praised the work, noting that "as an exemplification of color harmony and high artistic quality, this work is scarcely surpassed by any other in the collection" (*Academy Notes* 4 [February 1909]: 146). The work was illustrated in the *Craftsman* 18 (April 1910), p. 39, as *The Gray Kimono*. Included on Peat's 1949 checklist of Chase's known work as *Portrait of Alice (Alice Chase); Head of a Young Girl; The Gray Kimono,* unsigned (erroneously), and owned by Mary E. Haverty, Atlanta.

OP.340

Portrait of Mrs. Goldberg, 1901

Oil on canvas; 20 x 16 in. (50.8 x 40.6 cm)
Inscribed: To my friend, B.H. Goldberg, W.M. Chase, 1901, New York (b.l.)

Location unknown

Likely a portrait of Mrs. Bertha Hess Goldberg (b. 1862), who studied with Chase at the Pennsylvania Academy of the Fine Arts, Philadelphia. It is inscribed "New York," but many of Chase's Philadelphia students also studied with him in New York, both at the Art Students League and at the Shinnecock Summer School of Art on Long Island. Also, the demeanor of the work and its personal inscription are similar to other documented portraits of Chase students. The work, probably given directly to Mrs. Goldberg, was not exhibited during the artist's lifetime.

OP.341

Helen, ca. 1902

Oil on canvas; 26 x 21½ in. (66 x 54.6 cm)
Signed: Wm. M. Chase (l.l.)

R. H. Love Galleries, Inc., Chicago

Exhibitions: **McCG '05 #37** as *Helen* [lent by the artist]; **BFAA '09 #42; PPIE '15 #3745; DMA '16 #2; TMA '16 #102.**

This portrait depicts the artist's daughter Helen Velázquez Chase (1895–1965) in a birthday dress; she would have been approximately seven years old when this painting was completed. Helen's sister Alice Chase Sullivan wrote with regard to this painting, "Father evidently enjoyed painting this picture of my sister Helen, inspired when he saw her at a birthday party." She continued, "He often called on us, his children, to pose for him when he just 'felt like painting.' This was painted in his studio in our summer home on Shinnecock Hills [Long Island]" (undated letter to Mr. Chapellier of Chapellier Gallery, New York; Chase Archives). Helen's husband, Roger J. Storm, recalled his wife's story about the painting, writing that her father said, "I must paint Helen in that hat. The Chase children knew that when he wanted to use them as a model there was nothing to [*sic*] important to come first. She added that she missed her ice cream as a result of this painting, very important to a young child" (letter dated November 15, 1969, from Roger J. Storm to Mr. Chapellier, Chapellier Gallery, New York; Chase Archives). An article in *Harper's Weekly* illustrates a detail of this painting and suggests, as Alice Chase Sullivan had, that it was painted at Shinnecock Hills ("William M. Chase's Recent Work," *Harper's Weekly* [November 1902]: 1627). This painting is included on Peat's 1949 checklist as *Artist's Daughter Helen (Helen Chase),* owner unknown.

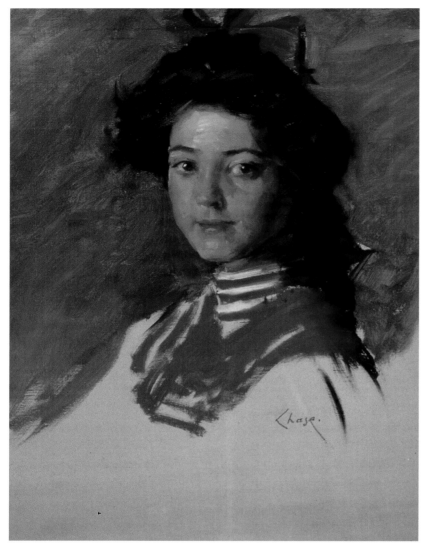

OP.342

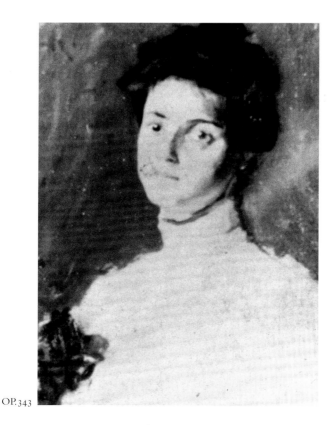

OP.343

OP.342

Portrait Sketch: Girl in a Middy Blouse, 1902

Oil on canvas; 24 x 18⅛ in. (61 x 46 cm)
Signed: Chase (l.r.)

Milwaukee Art Museum. Gift of Frida Gugler
(M1920.2)

Chase painted this work, a demonstration piece likely depicting a young female student in the naval regalia fashionable at the time, in the summer of 1902, the final session of his Shinnecock Summer School of Art. The work was given to Chase student Frida Gugler, a native of Milwaukee. Included on Peat's 1949 checklist of Chase's known work as *Portrait Sketch*, and as being owned by the Milwaukee Art Institute.

OP.343

Miss Bosler, ca. 1902

Medium/support/dimensions unknown

Location unknown

The current location of this painting is unknown. The only extant visual record is a photograph of the work in the Chase Archives at the Parrish Art Museum, Southampton, Long Island, New York. The inscription on the verso of the photograph reads: "Miss Bosler / pupil—Mr. Chase / before class." Nothing further is known about Miss Bosler other than she was a Chase student. This was surely a demonstration piece, executed by Chase during his last summer teaching at the Shinnecock Summer School of Art in 1902.

OP.344

Miss J. (Portrait of Miss J; Portrait—Content Johnson), ca. 1902

Oil on canvas; 64⅛ x 40⅜ in. (162.9 x 102.6 cm)
Signed: Wm M. Chase (u.r.)

Sullivan Goss, An American Gallery, Santa Barbara, Calif.

Exhibitions: **ULC '03 #5** as *Miss. J.* [lent by Mrs. J]; **K&C '03 #8** [lent by Mrs. Johnson] (*Art Amateur* [March 1903]: 107, as *Portrait of Miss. J*); **NAC '10 #4** as *Portrait—Content Johnson* [lent by Mrs. Johnson].

Miss J. is a classic example of Chase's formal portraiture, done in the manner of the great seventeenth- and eighteenth-century English

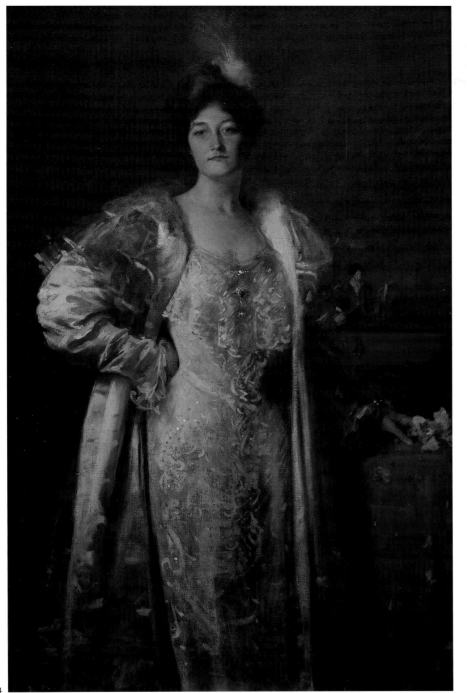

OP.344

OP.344A. Photograph of Content Johnson wearing the same dress as in the painting, visible behind her

The sitter for the painting is Content Aline Johnson (1871–1949), one of Chase's students both at the New York School of Art and at his Shinnecock Summer School of Art on eastern Long Island. Although there are no enrollment records for either school, Miss Johnson's presence at Shinnecock is documented by a letter she and other Chase students wrote to him on September 20, 1901, at the close of the school's season. Chase's portrait of her was probably done between this date and the time it was first exhibited in 1903. Photographs of Content Johnson dressed as she was in her portrait have descended within the Chase family (OP.344A). In one of the photographs she is standing in front of her finished portrait. The fact that the painting in the background is not yet framed suggests that Chase had just recently finished it. In another photograph she is standing in front of a contemporaneous painting, *Helen* (OP.341). This painting is unframed in the background. Completed around 1902, its presence in the photograph further suggests a date circa 1902 for the present work. Miss Johnson appears to be assuming the mirror image of her pose in Chase's portrait. Miss Johnson was a friend of the Chase family, and Chase's youngest daughter, Mary Content Chase (1903–1943), was named after her. Included on Peat's 1949 checklist of Chase's known work as *Content Johnson,* and as being owned by Content Johnson, Beverly Hills, California.

portraitists Anthony Van Dyck (1599–1641) and Thomas Gainsborough (1727–1788). A more contemporary prototype would be Chase's colleague the American expatriate painter John Singer Sargent (1856–1925). The pose of Chase's *Miss J.,* with the back of her right hand on her hip, is reminiscent of that employed by Sargent in his painting *Lady with a Rose,* 1882 [The Metropolitan Museum of Art, New York], which Chase would have known well. However, Chase cropped the figure at three-quarter length to create a more dramatic and direct composition. Chase also seems to have drawn upon one of his earlier works, *Portrait of Mrs. C. (Portrait of a Lady in Black),* circa 1888 (OP.161), in which the model, Mariette B. Cotton, assumes a stance similar to that of Content Johnson, the sitter for *Miss J.* As was also the case with *Lady in Black, Miss J.* was intended for show in important exhibitions. Chase here has created a tour de force of textures: for instance, in his depiction of the white plume in Miss Johnson's hair, the brilliant diamond and emerald pins on the bodice of her dress, and the various fabrics both in her dress and in the table covering. The painting was illustrated in the *New York Times,* March 21, 1905, SM3, and two years later in J. Walker McSpadden's *Famous Paintings of America* (New York: Thomas Crowell and Company, 1907), facing p. 336.

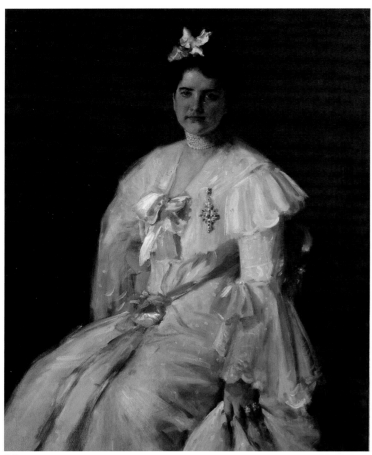

OP.345

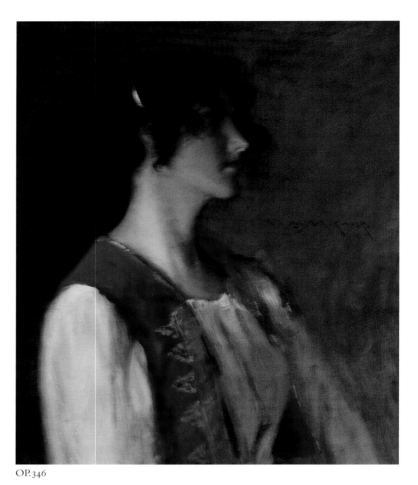

OP.346

OP.345

Mrs. Chase (Portrait of Mrs. Chase; Portrait of Mrs. C.), ca. 1902

Oil on canvas; 47¾ x 37¾ in. (121.3 x 95.9 cm)
Signed: Wm. M. Chase (u.l.)

Figge Art Museum, Davenport, Iowa. Gift of the
Friends of Art, 1927 (29.415)

Exhibitions: **K&C '03 #11** as *Mrs. Chase* [lent by the
artist]; **SLWF/UE '04 #128** as *Portrait of Mrs. Chase*
[lent by the artist]; **BFAA '09 #6** as *Portrait of Mrs. C.*
[lent by the artist] ("The Paintings by Mr. Chase,"
Academy Notes 4 [February 1909]: 149); **NAC '10 #28,**
#61, or #96 (all are portraits of Mrs. Chase); **BPL '10.**

Here Chase captures his wife, Alice Gerson
Chase (1866-1927), dressed as elaborately as any
of the society women he painted over the
course of his career. Her lace ball gown is rich in
decorative detail, with bows on the sleeves,
chest, and even the belt around her waist. She is
bedecked in jewels as well, wearing several rings,
a cross pin, and an elaborate pearl choker. He
completes the composition by placing a flower
in her hair. Her facial expression and hair are
reminiscent of earlier portraits of his wife, in

which she appears a mature woman, though not
without a certain youthful air. There is a photo-
graph that has descended in the Chase family of
the artist standing in front of the present work,
in which he holds his paint brush and palette as
if he were on the verge of completing the work.
The photograph dates to circa 1902, which
would suggest a similar dating for this painting;
an illustration of the work in the article
"William M. Chase's Recent Work," *Harper's
Weekly* 46 (November 8, 1902): 1627, confirms
the date of composition for the work, which
was likely executed at Shinnecock.

As often with Chase's portraits of his wife,
it is difficult in the present instance to determine
a precise exhibition history. *Portrait of Mrs. Chase*
is, however, mentioned in association with the
work's inclusion in a traveling exhibition in 1909
as depicting a woman "wearing a white dress
with pink ribbons and a jewelled cross" (*Academy
Notes* [February 1909]: 149). The work is also
illustrated in an article discussing artist's wives
by Elise Lathrop (Elise Lathrop, "A Group of
Artist's Wives," *Broadway Magazine* [March 1907]:
732). Included on Peat's 1949 checklist as *Mrs.
Chase in Pink* (A) *(Mrs. W. M. Chase),* and as
being owned by the Davenport Municipal Art
Gallery, Iowa.

OP.346

My Daughter (Artist's Daughter), ca. 1902

Oil on canvas; 26 x 21 in. (66 x 53.3 cm)
Signed: Wm. M. Chase (m.r.)

The Snite Museum of Art, University of Notre
Dame, South Bend, Ind. Gift of Peter C. Reilly

This picture depicts Chase's eldest daughter,
Alice Dieudonnée (1887-1971). He captures
Alice in profile, and from this perspective her
resemblance to her mother, Alice Gerson
(1866-1927), is quite striking. Indeed, if the
work had not been titled *My Daughter,* it would
be difficult to discern whether it was a portrait
of Alice Gerson Chase circa 1888 or of Alice
Dieudonnée Chase circa 1902. This work is
included on Peat's 1949 checklist of Chase's
known work as *Artist's Daughter (Chase),* and
as being owned by the Wightman Memorial
Art Gallery, University of Notre Dame, South
Bend, Indiana.

OP. 347

My Daughter Dorothy, ca. 1900

Oil on canvas; 17¾ x 14⅝ in. (45.1 x 37.2 cm)
Location unknown

This is a portrait of Chase's daughter Dorothy Brémond Chase (1891–1953). *My Daughter Dorothy* descended in the Chase family until at least 1927. It is included on Peat's 1949 checklist of Chase's known work as *My Daughter Dorothy (Dorothy Chase),* and as being owned by Dr. Paul R. Fletcher, St. Louis, Missouri. Peat erroneously lists the work as being signed on the upper left. There are traces of a signature, likely not in the artist's hand, in the upper-left corner.

OP. 348

Louis Windmüller, 1902

Oil on canvas; 54 x 44 in. (137.2 x 111.8 cm)
Signed: Wm. M. Chase (l.r.)

Location unknown

Exhibitions: **SAA '02 #16** [Reform Club—owner]; **NAC '10 #65** [Reform Club—owner]; **MMA '17 #20** [Reform Club—owner].

Chase obviously thought highly of his portrait of Louis Windmüller (1835–1913) for it to have been included in major exhibitions—certainly others shared his opinion of the work, as it was included in the Chase Memorial Exhibition held at the Metropolitan Museum of Art in 1917, quite likely at the urging of Mrs. Chase. The memorial exhibition catalogue included a brief biography of the sitter: "Born in Münster, Prussia, he came to the United States in 1853, settled in New York, and became a successful merchant. He was one of the founders of The Reform Club and its treasurer for more than twenty years; active in charitable and civic work." The catalogue also described the portrait as "life-size, seated figure with hands clasped; he is seen to the ankles." That same year it was mentioned in Katharine Metcalf Roof's biography of Chase as "a finely characterized portrait." In Peat's 1949 checklist of known work it is listed as having formerly been in the collection of the Reform Club.

OP. 349

A Long Island Fisherman (A Fisherman), 1902

Oil on canvas; 24 x 20¼ in. (61 x 51.4 cm)
Collection of Gary Brenner

Exhibitions: **McCG '05 #30; AAG '09 #35** as *A Fisherman;* **NAC '10 #43; BPL '10** (seen in photo of gallery installation, no known catalogue); **CM '15 #4** (illus.); **JHAI '16 #9** as *Long Island Fisherman;* **MAG '16 #9; DM '16 #39.**

This work was referenced in the Buffalo Fine Arts Academy publication *Academy Notes* (February 1909): 146. The painting is a portrait of Mr. Woodburn, a fisherman living near Chase's Shinnecock Summer School of Art, Southampton, Long Island, New York. There are at least two other portraits of Mr. Woodburn by Chase, one having the same 24-by-20-inch size. A photograph of this painting was included in a number of Chase family photographs given to the William Merritt Chase Archives, Parrish Art Museum, Southampton, New York, gift of Ronald G. Pisano—inscribed verso: "Old Mr. Woodburn

OP. 347

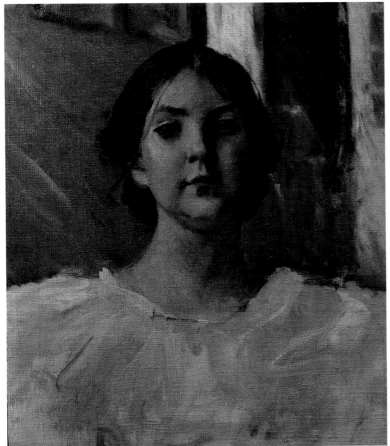

OP. 349

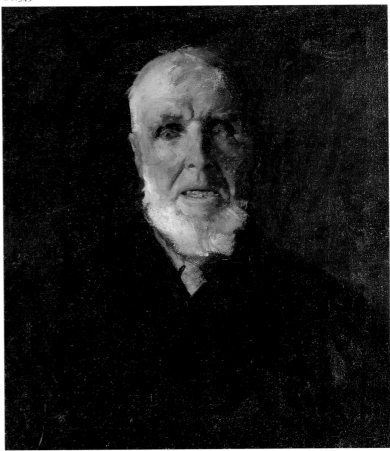

painted before class by W. M. Chase / 1902." In 1923 the estate sale of Annie Traquair Lang, a student and devoted friend of Chase, included thirteen canvases by Chase—no. 73 was *The Old Fisherman* (fully described, and clearly the above catalogued painting). The painting was also at one time in the collection of the Buffalo Fine Arts Academy, Albright Art Gallery (1928–61). The painting is included in Peat's 1949 checklist of Chase's known work as *Old Fisherman* (B), formerly owned by R. Glendenning (no location given). The ownership history of this work is somewhat cloudy, as are the histories of the other portraits of Mr. Woodburn (OP.350 and OP.351).

OP.350

Old Mr. Woodburn, 1902

Oil on canvas; 24 x 20 in. (61 x 50.8 cm)

Location unknown

Chase did several paintings of a local sea captain, Mr. Woodburn, at his Shinnecock Summer School of Art, variously titled *Captain of the Fishing Fleet, A Long Island Fisherman (A Fisherman)* (OP.349), *A Long Island Fisherman* (OP.351), and *Old Fisherman.* The ownership history of *Old Mr. Woodburn* is particularly interesting in that it was given by Chase to Nora Connah, wife of Douglas John Connah, managing director of the summer school, after which it was given to their son, William Connah. A letter in the Pisano files

from Mrs. Frederick W. Evans to Ethan Cascio (undated) discusses the painting: "Your present darling is the Chase painting of an old sea captain, that is on the living room mantle. It was painted for and given to Nana Connah. Nana gave it to her son, who gave it to me." A photograph of this painting is included in the Chase Archives, Parrish Art Museum, Southampton, Long Island, New York (no. 91.RGP/PS.23), sepia photograph, 1½ x 2 in., inscribed verso: "Old Mr. Woodburn / Mr. Chase before the class." The photograph was taken by a student, Frank Wadsworth, Shinnecock Hills, Long Island, New York, 1902. Demonstration pieces, such as *Old Mr. Woodburn,* were completed in about an hour's time and were often given to students as prizes, or as gifts to friends. Another photograph of the painting is included in a Chase family album (Baker/Pisano Collection).

OP.351

A Long Island Fisherman

Oil on canvas; 20 x 16 in. (50.8 x 40.6 cm)
Signed: Wm. M. Chase (l.l.)
Titled and signed (verso): A Long Island Fisherman painted by Wm. M. Chase (in script)

Location unknown

There are several paintings of the same subject, Mr. Woodburn, a local sea captain, painted by Chase at his Shinnecock Summer School of Art,

Southampton, Long Island, New York—likely done as demonstration pieces for his class. It is difficult to differentiate between at least two of these paintings, both titled *A Long Island Fisherman,* in terms of exhibition history (OP.349). The fact that this work is signed would suggest that it was the painting that Chase exhibited at various exhibition venues starting in 1905; however, another portrait with the same title (though unsigned) is definitely known to have been exhibited. As exhibition catalogues during these years did not include sizes, it is difficult to figure out which work was exhibited in which exhibition. This work is included in Peat's 1949 checklist as being in the collection of Dr. Frederick G. Oppenheimer, San Antonio, Texas.

OP.352

Portrait of a Girl (Miss Willard), ca. 1902

Oil on canvas; 24½ x 18½ in. (62.2 x 47 cm)
Signed: Chase (m.l.)

Location unknown

A photograph in the Chase Archives at the Parrish Art Museum, Southampton, Long Island, New York, has identified the sitter in the portrait as Miss Willard (OP.352A). The photograph is inscribed thus on the verso, "Painted before class, Miss Willard—student," and is dated circa 1902, the final year Chase taught at his Shinnecock summer art school. It is characteristic of

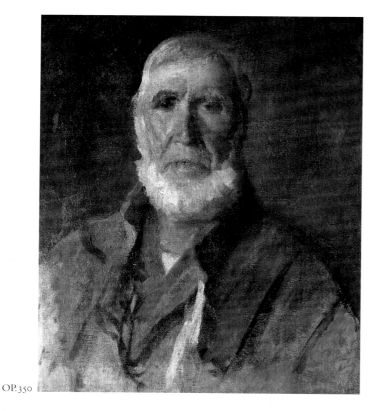

OP.350

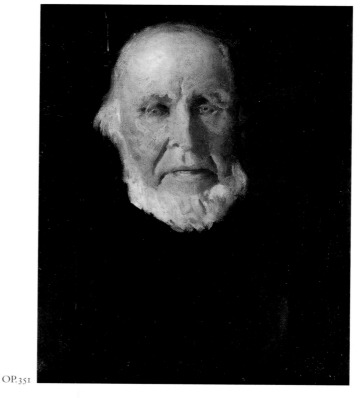

OP.351

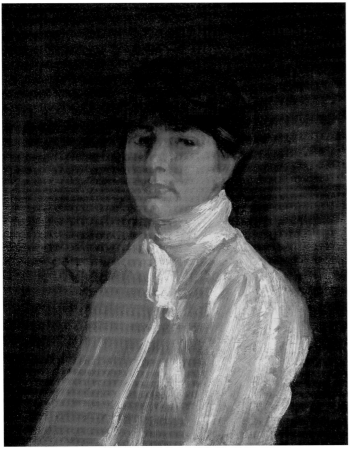

OP.352

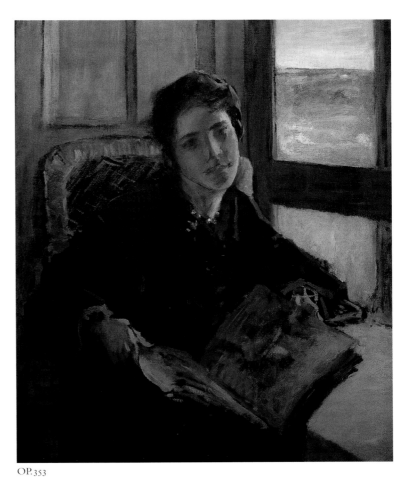

OP.353

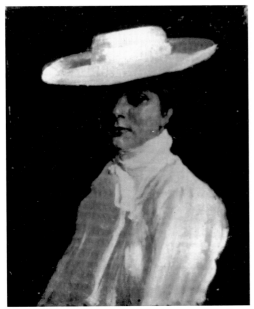

OP.352A. Photograph of Miss Willard, ca. 1902. The Parrish Art Museum, Southampton, N.Y. The William Merritt Chase Archives, Gift of Ronald G. Pisano (91.RGP/PS.2)

Chase's many demonstration pieces, though it is striking to note that the work has been altered since Chase completed it. The hat that Miss Willard wore when she posed for Chase was at some unknown point painted over, with hair added in its stead.

OP.353

Alice Dieudonnée Chase, Shinnecock Hills, ca. 1902

Oil on canvas; 22 x 18 in. (55.9 x 45.7 cm)
Inscribed and signed: To my friend & pupil, Eugene Ullman / Wm. M. Chase (l.l.)

Private collection

This painting depicts Chase's daughter Alice Dieudonnée (1887–1971) sitting in the family's summer home in Shinnecock Hills, Long Island, New York. Chase here conveys a sense of a single moment in time, as if Alice were being interrupted from viewing the art book in her lap by her father's question. She was a frequent model for her father. The light from the window illuminates part of her face, leaving the rest in shadow. Chase gave this work to his friend, student, and fellow artist Eugene Ullman (1877–1953). Ullman studied at the Chase School of Art, where he later became a teacher; he also worked with Chase at the Shinnecock Summer School on Long Island. It is thought that Chase was so fond of Ullman that he wanted him to marry his daughter Alice, which may have been part of the inspiration behind the gift.

OP.354

Portrait of a Woman, ca. 1902

Medium/support/dimensions unknown

Signed: Chase (m.r.)

Location unknown

OP.354

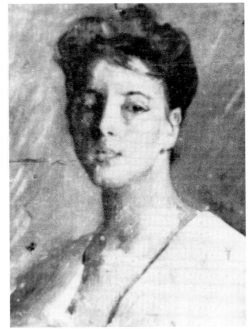

This painting, which has been lost, is likely a demonstration piece completed by Chase for his students at the Shinnecock summer art school. The model is Kate Freeman Clark (1875-1957), of whom Chase completed several portraits (see OP.355 and OP.436). A tiny photograph of the canvas, which Kate Freeman Clark had made and kept in a pocket-sized album, is this portrait's only extant visual representation. As was the case with material related to a number of Chase's demonstration pieces completed that summer at Shinnecock, the photograph was eventually deposited in the archives of the Kate Freeman Clark Collection of the Marshall County Historical Society in Holly Springs, Mississippi.

OP.355

Portrait of Kate Freeman Clark, 1902

Oil on canvas; 25 x 30 in. (63.5 x 76.2 cm)

Kate Freeman Clark Art Gallery, Holly Springs, Miss.

A portrait of former Chase student and artist Kate Freeman Clark (1875-1957), completed at the Shinnecock Summer School of Art during its final session in 1902. Chase completed another work featuring this sitter around this time (see OP.354) as well as one several years later, circa 1906 (OP.436). Freeman Clark left her home in Holly Springs, Mississippi, for New York City in 1894 and studied with Chase at the Art Students League later that year, eventually leaving to study at the Chase School of Art when it opened in 1896. She traveled with Chase's friend Irving Wiles to Shinnecock Hills, Long Island, in 1895, and formally enrolled for the summer art course in 1896, in which she took part for the next six years. There is a photograph of the present painting in the Chase Archives, Parrish Art Museum, Southampton, Long Island, New York, with an inscription on the verso that reads: "Model / Mr. Chase / before class."

OP.356

Portrait of a Woman, ca. 1902

Medium/support/dimensions unknown
Signed: Chase (u.l.)

Location unknown

This painting, which was surely a demonstration piece, has been lost. The only extant image of

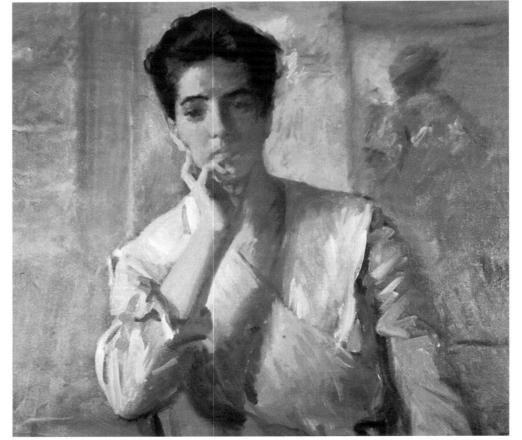

OP.355

the work is a photograph housed in the Kate Freeman Clark Collection, Marshall County Historical Society, Holly Springs, Mississippi. Part of the signature has been cut off, suggesting that the painting may have been cut down at some point, although the motivation for eliding the signature is unclear.

OP.356

OP.357

Portrait of a Woman, ca. 1902

Medium/support/dimensions unknown
Signed: Chase (u.l.)

Location unknown

OP.357

OP.358

OP.359

This painting by Chase has been lost, but there is a photograph of it in the Chase Archives at the Parrish Art Museum, Southampton, Long Island, New York. The verso of the photograph is inscribed, "Model / Mr. Chase / before class." The painting, like so many of Chase's demonstration pieces, is signed with the less formal "Chase."

OP.358

When One Is Young (a Portrait), ca. 1902

Oil on canvas; 58⅜ x 37 in. (148.3 x 94 cm)
Signed: Wm. M. Chase (u.r.)
Verso, upper corner of frame, torn exhibition label: Helena

The Parrish Art Museum, Southampton, Long Island, N.Y. Littlejohn Collection

Exhibitions: **K&C '03 #14** as *When One is Young (a Portrait)* [lent by the artist]; **CM '03 #4** [lent by the artist] (Cincinnati Museum, *Catalogue of the 10th Annual Exhibition of American Art* [May 23–July 6, 1903], 2, illus. facing p.); **CI '03 #20** as *When One is Young;* **SLWF/UE '04 #127; SWA '05 #7** [for sale, $1500]; **L&CCE '05 #303** [lent by Durand Ruel]; **BFAA '09 #21** ("The Paintings by Mr. Chase," *Academy Notes* 4 [February 1909]: 146, illus. as

When One is Young); **VGB '09** (not listed in catalogue, but mentioned in a review in an unidentified news clipping thought to be a review of the exhibition: Ronald Pisano Archives); **NAC '10 #49** [lent by Wm. M. Chase]; **BPL '10** [lent by artist] ("Chase Collection an Admirable One," [Bridgeport, Conn.] *Daily Standard,* March 3, 1910, 3); **FAM '13 #2** [lent by artist].

A full-length portrait of his sixth daughter, Helen Velázquez Chase (1895–1965). It was exhibited frequently and well received by the critics. An article discussing the traveling exhibition in 1909 describes the work thus: "a little girl of five or six years, in a white dress with a blue ribbon, represented full-length and almost life-size, standing in an attitude expressive of freedom and joyousness. This . . . work is painted with broad, effective strokes on a canvas with a heavy twill. Seen from the proper distance, the child seems almost real, and enveloped in atmosphere" (*Academy Notes* 4 [February 1909]: 146). The painting appears to have been purchased by Durand Ruel by 1905, but Chase must have bought it back since it is listed with him as the owner by 1910. This work is included on Peat's 1949 checklist of Chase's known work as *Little Helen Chase: When One is Young,* and as being formerly owned by the Metropolitan Galleries, New York.

OP.359

My Daughter Dieudonnée (Dieudonnée), ca. 1902

Oil on canvas; 72¾ x 36½ in. (184.8 x 92.7 cm)
Signed: Wm. M. Chase (l.l.)
Inscribed verso in pencil: My Daughter Dieudonnée

The Parrish Art Museum, Southampton, Long Island, N.Y. Littlejohn Collection

Exhibitions and Auctions: **CM '03 #2,** illus. as *My Daughter Dieudonnée;* **ISSPE '04 #23; MCP '05 #204** as *Dieudonnée* (K. Ruge, "Amerikanischer Maler," *Kunst und Kunst Handwerk* 6 [October 1903]: 406–13, 409, illus. as *Porträt einer jungen Dame*); **BFAA '09 #3** ("The Paintings by Mr. Chase," *Academy Notes* 4 [February 1909]: 149); **VGB '09 #18** (taken from unidentified clipping); **NAC '10 #35** as *My Daughter Dieudonnee* [sic] [lent by Mr. Chase]; **FAM '13 #9;** **Csale '17 #381** as *My Daughter Dieudonnée.*

A portrait of Chase's eldest daughter, Alice Dieudonnée (1887–1971), as a young woman dressed in all the finery of the era. She sits in a wicker chair in an elaborate dress with a boa draped around her shoulders and a feathered hat on her head. The painting won critical acclaim in 1905 at the Munich Crystal Palace Exhibition and in numerous other shows. In an unidentified news clipping from 1909, believed to be a review of an exhibition at the Vose Galleries, Boston, Alice is referred to as "a charming young woman, typically American, and characterized by an alert mentality tempered by gracious womanliness. From her father she inherits her marked artistic ability, while her literary skill is an inheritance from her mother's people." In the same account, Alice Dieudonnée is credited as a "skillful amateur actress" and is praised for the majestic effects of her costume and pose in this portrait, which are described as "worthy of a professional" (unidentified clipping, Ronald Pisano Archives, New York). Another critic noted it as "a beautiful work" possessing "a very charming simplicity and reserve" (*Academy Notes* 4 [February 1909]: 149). This painting is included on Peat's 1949 checklist of Chase's known work as *My Daughter Dieudonnee (Dieudonnée Chase),* and as being formerly owned by M. Knoedler and Company, New York. Peat erroneously dates the work circa 1908, but given the work's exhibition in 1903, an earlier dating circa 1902 is preferable.

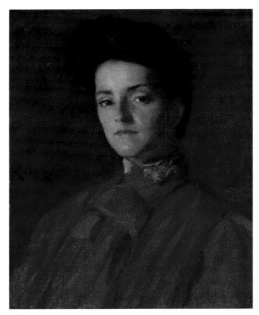

OP. 360

OP.360

A Lady in Red, 1902

Oil on canvas; 20 x 16 in. (50.8 x 40.6 cm)
Signed: Chase (m.l.)

Mr. and Mrs. F. Alton Tybout, Wilmington, Del.

Auctions: **Csale '17 #265.**

The 1917 Chase estate sale catalogue erroneously lists this work, a demonstration piece painted during Chase's final session at the Shinnecock Summer School of Art in 1902, as bearing the signature "Wm. M. Chase"; in fact, the portrait is signed "Chase" at the middle left. There is a photograph of the work in the Chase Archives, Parrish Art Museum, Southampton, Long Island, New York, which is inscribed on the verso: "Painted by Mr. Chase before class this summer / Miss Hall [?] is a student, 1902." Included on Peat's 1949 checklist of Chase's known work as *A Girl in Red* (B), and as being owned by Mrs. James Keith Symmers, Charlottesville, Virginia.

OP.361

Beatrice Claflin (Kinderporträt), 1902

Medium/support/dimensions unknown
Signed: Wm. M. Chase (l.l.)

Location unknown

Exhibitions: **K&C '03 #20** as *Miss Bertrice* [*sic*] *Claflin* [lent by Mr. Arthur B. Claflin] ("William M. Chase's Recent Work," *Harper's Weekly Magazine* 46 [Novem-

ber 8, 1902]: 1627, illus. as *Beatrice Claflin*; K. Ruge, "Amerikanischer Maler," *Kunst und Kunst Handwerk* 6 [October 1903]: 406–13, 406, illus. as *Kinderporträt*).

A photograph that has descended in the Chase family is the only extant visual image of this work. A review of the work at the Knoedler and Company exhibition in 1903 noted that the model for this picture was Beatrice, the daughter of Mr. John [*sic*] Claflin, and that the work was painted in Shinnecock, Long Island. The writer adds: "the subject is entirely in white of ivory tones against a background of pale, indefinite green. This portraiture has great naturalness, vivacity, and charm of composition" (*Harper's Weekly Magazine* [November 8, 1902]: 1627).

Beatrice Claflin (b. 1892) was the daughter of textile magnate Arthur B. Claflin. Miss Claflin married Robert Potter Breese (b. 1886), the son of photographer James L. Breese, in 1915. The Claflins lived in an estate located in the Shinnecock Hills between the two main roads of eastern Long Island's South Fork. Their property now houses Southampton College, part of Long Island University. Included on Peat's 1949 checklist of Chase's known work as *Beatrice Claflin,* and as being owned by Arthur B. Claflin.

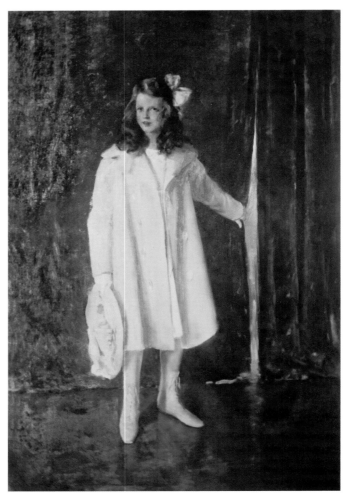

OP. 361

OP.362

Dorothy, 1902

Oil on canvas; 72 x 36 in. (182.9 x 91.4 cm)
Signed: Wm. M. Chase (l.l.)

Indianapolis Museum of Art. John Herron Fund, 1903 (03.4)

Exhibitions: **K&C '03 #15** [lent by the artist]; **THI '03 #72** as *Dorothy;* **JHAI '06 #31.**

A portrait of Chase's daughter Dorothy Brémond Chase (1891–1953) at about eleven years of age. *Dorothy* was illustrated in October 1903 as *Portrat eines jungen Mädchens (Portrait of a Child)* in K. Ruge, "Amerikanischer Maler," *Kunst und Kunst Handwerk* 6 (October 1903): 407. In 1909 *Dorothy* was illustrated in the *Catalogue of the Paintings and Sculpture in the Permanent Collection of the John Herron Art Institute, Indianapolis* (Fall 1909), 6. The following year *Dorothy* was illustrated in J. Walker McSpadden's *Famous Paintings of America* (New York: Thomas Crowell & Co, 1907), facing p. 350.

The work received numerous positive reviews. One historian, writing about *Dorothy*

and another Chase painting of a young girl, *Alice (Alice—A Portrait),* circa 1891 (OP.182), a portrait of Alice Evans, praised the artist's depiction, "When Mr. Chase combines portraiture and genre painting as in *Alice* and *Dorothy* . . . he makes pictures that are simply bewitching. Alice has a charm all her own as she skips away, laughing at her own power to please us; but *Dorothy* has more of the challenge of the young miss who feels her power, but wants you to know that she feels it. Both . . . with the awakened conscience of young girlhood just making itself felt" (Lorinda Munson Bryant, *American Pictures and Their Painters* [New York: John Lane Company, 1917; reprinted 1920], 115, illus. facing p. 114).

Dorothy and *Alice (Alice—A Portrait)* are very similar in their poses and overall composition. In both cases Chase may have been influenced by Whistler's painting *Harmony in Grey and Green: Miss Cicely Alexander,* circa 1872–73 [Tate Gallery, London], particularly in terms of dress style and foot placement. Other compositions related stylistically to the present work include *Portrait of My Sister (Hattie),* 1886 (OP.122), and *Girl in White,* 1898–1901 (OP.265). Included on Peat's 1949 checklist of Chase's known work as *Dorothy (Dorothy Chase); His Daughter Dorothy,* and as being owned by the John Herron Art Museum, Indianapolis.

OP.363

Lady in White, 1902

Oil on canvas; 29 x 19 in. (73.7 x 48.3 cm)
Signed: Chase (c.l.)

Indianapolis Museum of Art. Gift of Mrs. Albert E. Metzger in Memory of Albert E. Metzger (45.241)

A portrait of an unidentified sitter. There is a photograph, taken by Chase student Frank Wadsworth, of this painting in the Chase Archives, Parrish Art Museum, Southampton, Long Island, New York, which is inscribed on the verso: "Painted before class, 1902—model."

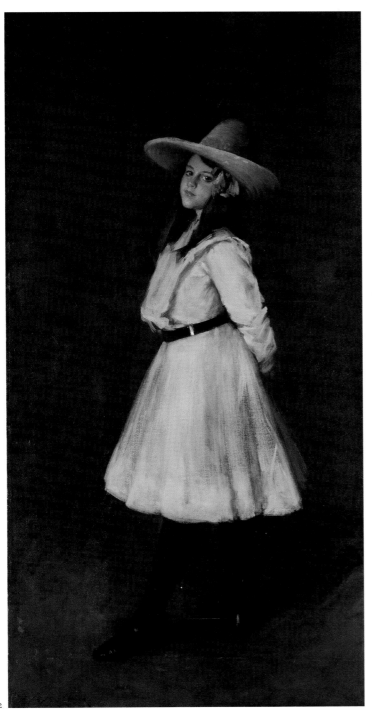

OP.362

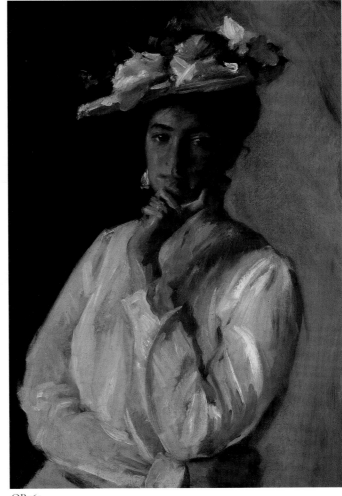

OP.363

Included on Peat's 1949 checklist of Chase's known work as *Lady in White* (B), (erroneously) circa 1910, and as being owned by the John Herron Art Museum, Indianapolis.

OP.364

Lady with Red Flower, 1902

Oil on canvas; 25 x 18 in. (63.5 x 45.7 cm)

Cornell Fine Arts Center, Rollins College, Winter Park, Fla. Gift of Gertrude Lundberg Richards, 1967

There is a photograph, taken by artist and Chase student Frank Wadsworth, of *Lady with Red Flower* in the Chase Archives, Parrish Art Museum, Southampton, Long Island, New York, that dates the painting as 1902 (OP.364A). Inscribed verso on the photograph is the following: "Miss Covert / model—Mr. Chase / before class." The photograph shows that this may have originally been a larger work, depicting the model from just below the waist. There is, however, no record that the work was cut down, though Chase had been known to crop his paintings.

The work's first owner, Mrs. George Richards (Gertrude V. Lundberg), a Chase student from 1904 to 1907, recalled in a 1970 interview that

OP.364

"the girl in *Girl with Red Flower* was a professional model brought in to be painted. Clothes supplied by somebody. A lovely girl. The actual roses were a tawny pink, not red as Chase painted them. He did the painting in a sitting of two hours. No touching up. Just wiped his brushes after

the session. Did not put toner on the canvas first. He started drawing with line and colors. Did not use burnt sienna. He did not make a complete sketch. He painted as he drew" (transcript of conversation between Mrs. George Richards and Mr. Hugh F. McKean [emeritus president and chancellor of Rollins College who was director of the Cornell Fine Arts Center at the time of its acquisition of the work, April 10, 1970]).

OP.365

Mrs. G. H. Earle, Jr. (Portrait), 1902

Oil on canvas
Signed: Wm. M. Chase (l.l.)
Dated: 1902 (l.l.)

Location unknown

Exhibitions: **K&C '03 #18** [lent by Mrs. G. H. Earle, Philadelphia, Pa.]; **PAFA '03 #203** as *Portrait* [lent by Mrs. George H. Earle, Jr.].

This portrait depicts Catherine Hansell French Earle (b. 1862). Chase also completed portraits of her husband, George H. Earle, Jr. (OP.477–78); his father, George H. Earle, Sr. (from photographs;

OP.364A. Photograph of *Lady with Red Flower*, 1902. The Parrish Art Museum, Southampton, N.Y. William Merritt Chase Archives, Gift of Ronald G. Pisano (91.RGP/PS.26)

OP.365

OP.479–80); and his grandfather, Thomas Earle
(from a daguerreotype; OP.481), as well as of
their daughters Miss Frances Earle (OP.434)
and Mrs. Catherine Earle Mather (OP.493). The
present painting exists in an engraving of the
work by Henry Wood that appeared in *Harper's
Monthly Magazine* (February 1905, as *Portrait of
a Lady*). This wood engraving of Mrs. Earle was
later exhibited at the Philadelphia Watercolor
Exhibition in 1906. The work was described in
1905 as follows: "This portrait of a lady is a
mosaic of values that delights the painter's soul.
The warm tones of the hair and the brilliant
complexion are so well rendered as to leave no
suggestion of difficulties overcome. The whole
conveys an intense sensation of life" (W. Stanton
Howard, "Portrait of a Lady by W. M. Chase,"
Harper's Monthly Magazine [February 1905]: 436).
Included on Peat's 1949 checklist of Chase's
known work as *Mrs. George H. Earle, Jr.*, circa
1900, and as being owned by George H. Earle,
Philadelphia.

OP.366

Portrait of Miss Bellemy (Miss Bellemy), 1902

Oil on canvas; 30 x 25 in. (76.2 x 63.5 cm)
Signed: Chase (m.l.)

Location unknown

A demonstration piece depicting one of Chase's
students at the Shinnecock Summer School of
Art during its final session in 1902. Chase also
used the same student model in *Portrait of Miss
B. (Miss B.; Miss Bellemy [of Springfield, Mass.])*,
circa 1903 (OP.381). There is a photograph of
the present work, taken by artist and Chase
student Frank Wadsworth, in the Chase Archives,
Parrish Art Museum, Southampton, Long Island,
New York. Another photograph, by an unidenti-
fied individual, shows Chase at his easel painting
this portrait with Miss Bellemy posed against a
large display board (OP.366A).

Chase gave the painting as a gift to its first
owner, Mr. Harrison Morris, the managing
director of the Pennsylvania Academy of the Fine
Arts. Morris recounts the event in his autobiog-
raphy: "One of the most engaging of the student
portraits that Chase used to paint came to us on
a generous impulse of his, when he told me that
if I saw anything I particularly liked, he would
present it to me. I could, of course, choose none
of his great canvases, but this single example is so
fresh and vital, so full of Chase and his 'first fine
careless rapture,' so cool in its black and flesh color,
that hardly any token from him would better

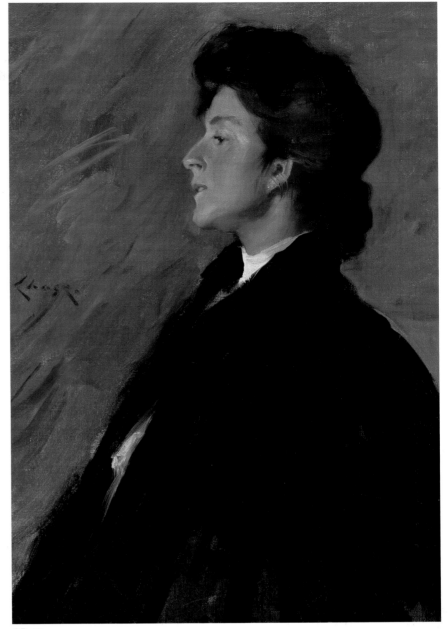

OP.366

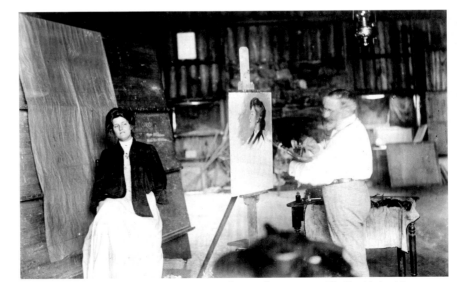

OP.366A. Photograph of Chase painting *Portrait of Miss Bellemy*, ca. 1902. The Parrish Art Museum,
Southampton, N.Y. William Merritt Chase Archives (75.C.3).

express himself" (Harrison S. Morris, *Confessions in Art* [New York: Sears Publishing Co., 1930], 97). Included on Peat's 1949 checklist of Chase's known work as *Miss Bellemy,* owner unknown.

OP.367

Portrait of Mrs. Piloty, 1902

Oil on canvas; 21 x 17 in. (53.3 x 43.2 cm)
On stretcher bar: Painted with light amber varnish and linseed oil. 1902. Painted over old canvas. [cleaned and restretched in 1984]

Paul Byron Bowman Collection

While Chase was studying at the Munich Royal Academy (1872–78) he was commissioned by Director of the Bavarian Academy of Fine Arts Karl von Piloty (1826–1886) to paint portraits of his five children (three daughters and two sons) (see OP.48–52). There is, however, no documentation regarding Chase having completed a painting of Mrs. Piloty during his years in Munich, and he surely was not in that city in 1902, the year noted on the stretcher; perhaps the work is of a different sitter with the same surname.

OP.368

Master Robert, ca. 1902

Oil on canvas; 46 x 36 in. (116.8 x 91.4 cm)
Signed: Wm. M. Chase (l.l.)

High Museum of Art, Atlanta. J. J. Haverty Collection (49.27)

Exhibitions: **K&C '03 #13; AAR '03 #34** as *Robert;* **SLWF/UE '04 #126; L&CCE '05 #302** [lent by Durand Ruel]; **AAG '09 #55** (?); **NAC '10 #138** (?).

This is a portrait of the artist's son Robert Stewart Chase (1898–1987) said to have been painted in the artist's Shinnecock studio the summer of 1902. The work was illustrated in "William M. Chase's Recent Work," *Harper's Weekly* 46 (November 8, 1902): 1627, as "Robert—Artist's elder son." The painting was also reproduced in a review of the 1903 exhibition at M. Knoedler and Company, *Mail and Express Illustrated Sunday Magazine* (March 7, 1903): 3. It is clear that Robert likely did not enjoy posing for his father: aside from a portrait when he was an infant, there are only three known oil portraits of him painted by his father. The painting was included in the 1927 Newhouse book, *William Merritt Chase,* no. 4, illustrated, and is included in Peat's 1949 checklist as being owned by Mary E. Haverty, Atlanta.

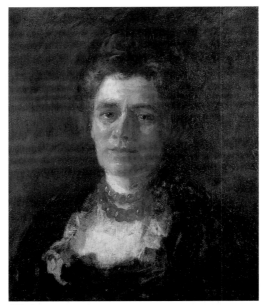

OP.367

OP.369

Roland (Chase), 1902

Oil on canvas; 20⅜ x 16¼ in. (51.8 x 41.3 cm)
Signed: Wm. M. Chase (u.l.)

The Metropolitan Museum of Art, New York. Bequest of Emma T. Gary, 1937 (37.20.1)

Exhibitions: **K&C '03 #12** (lent by Judge Garey [*sic*]).

This is a portrait of the artist's son, Roland Dana Chase (1901–1980). The painting was illustrated and discussed in *Harper's Weekly* 46 (November 8, 1902): 1627: "Witness the portrait of *Roland,* who is depicted with splendid brush-work as a rollicking brown rogue, holding in his admirable baby hand the note of color—a red ball." This is possibly the work titled *Roland,* owner unknown, in Peat's 1949 checklist that was given the wrong circa date of 1900.

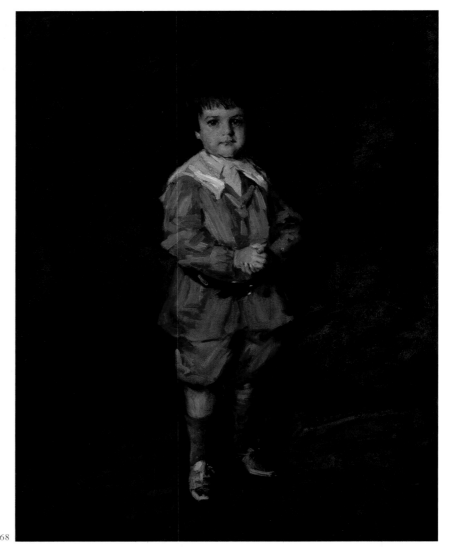

OP.368

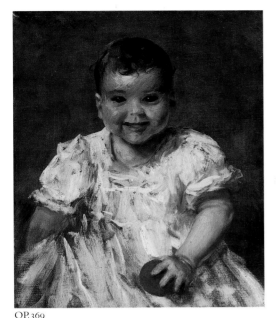

OP.369

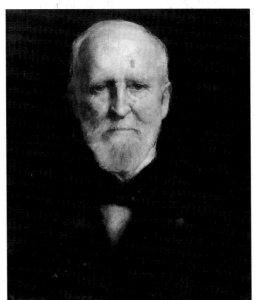

OP.371

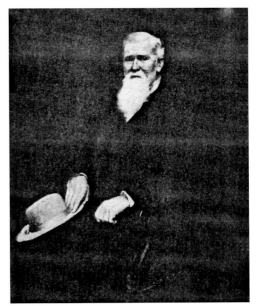

OP.372

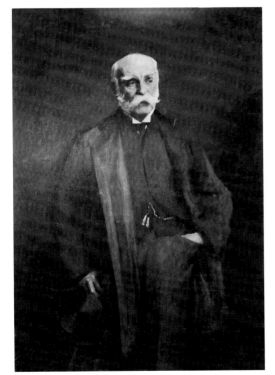

OP.370

OP.370

James Coolidge Carter, ca. 1902

Oil on canvas; 36 x 29 in. (91.4 x 73.7 cm) (not original size)

City Club of New York

Exhibitions: **K&C '03 #1** (described as a presentation portrait for the City Club of New York); **PAFA '10 #415.**

Mr. Carter (1827–1905) was a Harvard-educated lawyer, described as the most famous lawyer in the United States at the end of the nineteenth century, noted for helping to bring down the cabal of Boss Tweed. This work is included in Peat's 1949 checklist as being owned by the City Club of New York, and as being unsigned. However, the painting has definitely been cut down— a photograph of the original painting descended in the Chase family archives. Unfortunately, a signature is not visible in the photograph; however, it would have been very unlikely that Chase would not have signed the painting.

OP.371

Charles Lewis Tiffany, 1902

Oil on canvas; 20 x 16½ in. (50.8 x 41.9 cm) Signed: Wm. M. Chase (l.l.)

Tiffany and Co., New York

The portrait of Charles Lewis Tiffany (1812–1902) was commissioned by his son Louis Comfort Tiffany at the time of his father's death. The painting was given to the New York Chamber of Commerce in 1902, which deaccessioned the work in 1984. It is included in Peat's 1949 checklist of Chase's known work as being owned by the Chamber of Commerce of the State of New York.

OP.372

Jay Cooke, 1902

Oil on canvas; 50 x 39½ in. (127 x 100.3 cm) Signed: Wm. M. Chase (l.r.)

United States Department of the Treasury, Washington, D.C.

Exhibitions: **PAFA '03 #14** (illus. in a review of this exhibition, "The Fine Art Display at Philadelphia," *Brush and Pencil* 2 [February 1903]: 383); **K&C '03 #4; NAC '10 #56** [lent by Mr. J. Horace Harding].

Jay Cooke (1821–1905) was a noted financier of the Civil War. This painting was said to have been commissioned by James Horace Harding, New York. There is also said to be either another version of this painting by Chase, or a copy of the Chase portrait, that was presented to the United States government by James Horace Harding and that was at one time hanging in the Department of the Treasury by order of the then-Secretary of the Treasury, Mr. MacVeagh. The work was illustrated in a periodical, circa 1911 (unidentified clipping, Ronald G. Pisano files). The painting was included in Wilbur Peat's 1949 checklist as having been formerly owned by H. Horace Harding

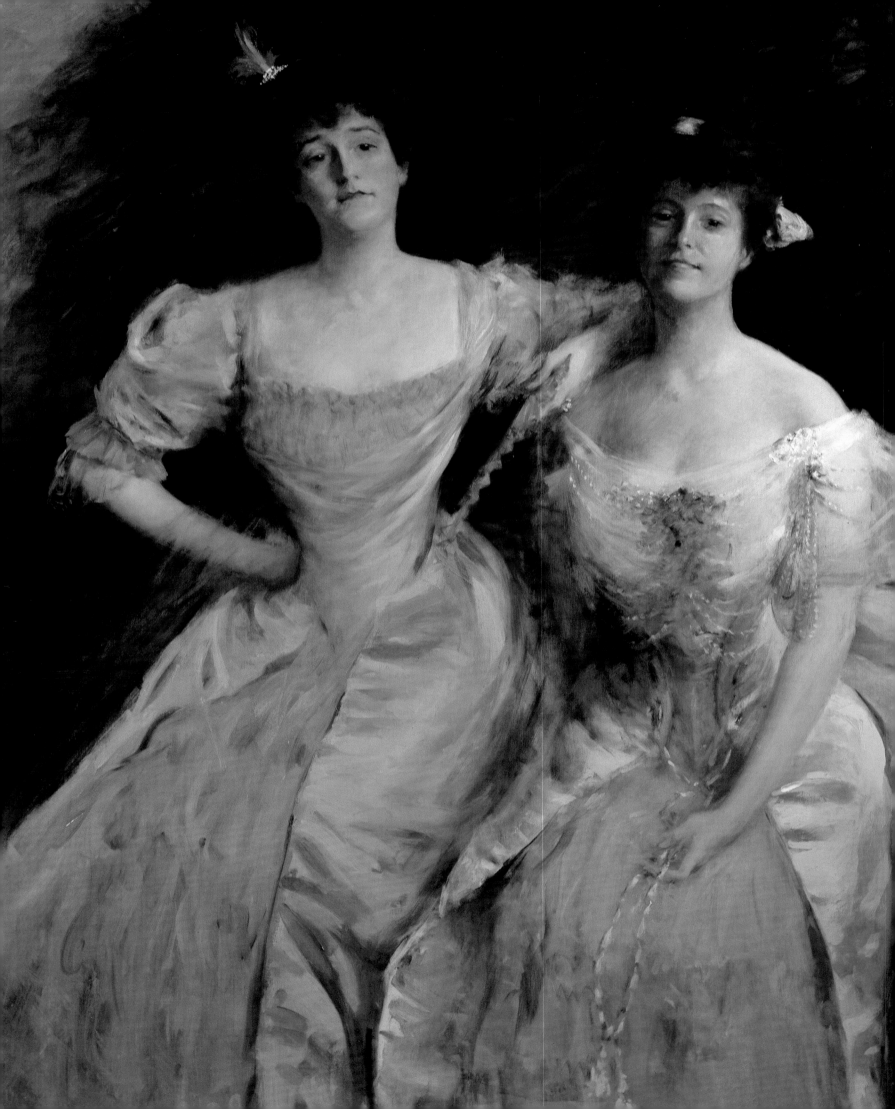

LATER YEARS IN NEW YORK AND PHILADELPHIA, 1903–1916

In addition to his studios in New York, Chase opened a studio in Philadelphia, where he painted the portraits of Philadelphia businessmen, politicians, assorted socialites, religious leaders, and doctors. It was a flourishing business, and more than half of all the portraits Chase painted were completed in the early twentieth century. While most are competent works that testify to Chase's talent for capturing likeness, a number of these later portraits are charged with introspective feeling and brilliance, most likely the result of Chase's interest in the sitter and his ability to endow the commonplace with energy and life. Many of his dramatic portraits of women combine the dash and flare so often associated with European portrait painters of the day, but still retain a certain element recognized as being particularly American, as in his portraits of Helen Dixon (OP.406) and Mrs. James Sullivan and Mrs. Oskar Livingston (OP.418). His portrait of the doyen of early American modernism, Alfred Stieglitz (OP.453), captures a lively character and serves as a link between Chase and many of his students who came to practice the new art of the early twentieth century under the aegis of Stieglitz. And his lively *Head of a Young Roman* (OP.484) displays a bravura brushwork that is as confident and dashing as his early portraits completed in Munich as a student.

Portrait painters, especially those whose talents are most in demand, often grow weary of the task. Swedish-born Anders Zorn (1860-1920) lamented, "Another commission—oh it is killing me." And John Singer Sargent (1856-1925) complained about "the damned abyss of portraiture." If Chase felt the same way, he wisely kept his counsel—painting portraits of the rich and famous (or at least local celebrities of sorts) was a lucrative business. His talent flagged at times toward the end of his life, but Chase carried on, and at his death he asked his friend Irving R. Wiles (1861-1948) to complete several portrait commissions that would otherwise have been left unfinished.

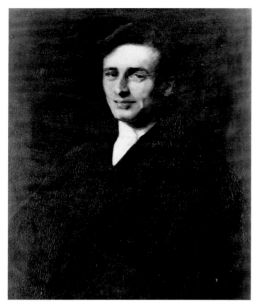

OP.373

OP.374

OP.375

OP.373

Edward J. Steichen, ca. 1903

Oil on canvas; 32 x 25 in. (81.3 x 63.5 cm)
Signed: Wm. M. Chase (l.r.)

The Nelson-Atkins Museum of Art, Kansas City,
Mo. Gift of Mr. and Mrs. Albert R. Jones (33-1600)

Exhibitions: **SAA '03 #52; PAFA '04 #13** (illus.);
**SLWF/UE '04 #129; L&CCE '05 #255; NAPP
'12 #111** (illus. #iv) (mentioned in a review of the
exhibition, *Arts and Decoration* [May 1912]: 250, "his
whimsical portrait of Edouard Steichen"); **JHAI '13
#32; PPIE '15 #3744.**

Edward Steichen (1879–1973) was a painter-
turned-photographer and is now recognized
as a seminal figure in American photography in
the early twentieth century. He was a close friend
of Alfred Stieglitz. Chase certainly thought well of
his portrait of the young artist in that it was fre-
quently exhibited. It is cited in a review of the
National Arts Club retrospective of 1910; how-
ever, the work is not listed in a catalogue for the
exhibition. Either the reviewer was mistaken as
to the identity of a portrait sitter, the work had
been added to the exhibition after the catalogue
was printed, or it was simply exhibited as *Portrait*
(a less likely option). The painting was also illus-
trated in *Brush and Pencil* 13 (February 1904):
387, and in *Fine Arts Journal* 27 (July 1912): 438.
The work is included in Peat's 1949 checklist.

OP.374

Daniel C. Robbins, 1903

Oil on canvas; 30 x 20 in. (76.2 x 50.8 cm)
Signed: Wm. M. Chase (l.l.)

Chamber of Commerce of the State of New York,
Albany, N.Y.

Daniel C. Robbins was a member of the Cham-
ber of Commerce of the State of New York
from 1872 until 1880. A photograph of this work
descended in the Chase family.

OP.375

Henry Morton, 1903

Oil on canvas; 31 x 24 in. (78.7 x 61 cm)
Signature not visible on photograph

Stevens Institute of Technology, Hoboken, N.J.

This work was illustrated in *Harper's Weekly* 47
(September 19, 1903): 1511, above the caption,
"A New Portrait by William M. Chase." Begin-
ning in 1870, Henry Morton was, for over thirty
years, president of the Stevens Institute of Tech-
nology, Hoboken, New Jersey. He was described
as a scientist and poet, and as a student was one
of the first to translate the Rosetta Stone at the
British Museum. This work is included in Peat's
1949 checklist.

OP.376

*Self-Portrait as Colonel Johan Claeszoon
Loo (Detail after Frans Hals, 1633),* 1903

Oil on canvas; 42 x 32½ in. (106.7 x 82.6 cm)

Baker/Pisano Collection, Heckscher Museum,
Huntington, Long Island, N.Y.

This painting was done in 1903 when Chase
conducted a summer class in Holland. The
diaries of Charles Sheeler (Archives of American
Art) recount Chase taking his class, of which
Sheeler was a member, to the Frans Hals Museum

OP.376A. Frans Hals, *Assembly of Officers and Subalterns
of the Civic Guard of St. Adriaen at Haarlem* (detail), 1633.
Oil on canvas, 81½ x 132⅝ in. (207 x 337 cm). Frans Hals
Museum, Haarlem

OP.376

OP.377

OP.378

Lady in White, ca. 1903

Oil on canvas; 48 x 38 in. (121.9 x 96.5 cm)
Signed: Wm. M. Chase (l.l.)

Milwaukee Art Museum. Gift of Mrs. Benjamin
Prinz, 1923 (M1923.2)

Chase completed countless formal portraits of
women over the years. These commissioned
works supplied a large share of his professional
income. In this painting he expertly captures the
rich texture and intricate detail of the dress of
the sitter, who has not been identified. Included
on Peat's 1949 checklist of Chase's known work
as *Lady in White* (A), and as being owned by
the Milwaukee Art Institute (now Milwaukee
Art Center).

in Haarlem and his students pointing out that
Hals had painted Chase's portrait in his painting
of the Officers of St. Adriaen, the full title of the
work being *Assembly of Officers and Subalterns of
the Civic Guard of St. Adriaen at Haarlem* (OP.376A).
Chase was obviously so inspired by his resem-
blance to Colonel Claeszoon Loo, seated far left
in the Hals painting, and the fact his students
noticed the likeness, that he painted this "self-
portrait"—an apt souvenir of his summer class
of 1903. Chase completed at least five copies of
various Hals paintings, this one having a special
meaning to the Chase family, as it remained in
the family well after his death in 1916. In
Katharine Metcalf Roof's 1917 biography of the
artist, four "copies from the old masters" in the
appendix "Location of Chase's Pictures" were
recorded as owned by the Chase estate—one
being *Detail from the Officers of St. Joris, Haarlem,
Rathhaus.* While identification of the Hals paint-
ing in the estate is not exactly the same as the
true source of the copy, it is likely that Roof was
referring to the same painting.

OP.377

George Inness, Jr., 1903

Oil on canvas; 20 x 16 in. (50.8 x 40.6 cm)
Signed: Wm. M. Chase (l.r.)

National Academy of Design, New York

Exhibitions: **SAA '03 #327** as *Portrait of George
Inness* [owner].

This painting was painted for the personal col-
lection of George Inness, Jr. (1853–1926). And it
remained in Inness's collection until October 16,
1923, when he exchanged it for his National
Academy of Design diploma portrait that had
been painted by C. F. Tuttle and given to the
National Academy of Design in 1893 to fulfill
his membership obligation. This work is in-
cluded in Peat's 1949 checklist of known work,
although is identified therein as depicting
"George Inness" and dated 1893.

OP.379

Lady with Orchids, ca. 1903

Oil on canvas; 20¾ x 15 in. (52.7 x 38.1 cm)
Signed: Wm. M. Chase (u.r.)

Location unknown

This portrait, with its dark setting and dramatic
spotlighting of the sitter's face, is typical of
Chase's work in portraiture in the first decade
of the twentieth century, qualities also seen in, to
take a single example, the *Portrait of Mrs. Goldberg,*
1901 (OP.340). The brilliant display of brush-
work in the lower right corner, which, it may be
ventured, has been utilized more to display the
artist's facile technique and enliven the image
than to truthfully render the orchid corsage, is a
typical device of Chase's in this period as well.
Lady with Orchids may depict international opera
sensation Adelina Patti (1843–1919), a native of
Madrid who made her operatic debut at sixteen
but who had toured the United States as a child
vocal prodigy when she was seven. Photographs
(OP.379A) show her in 1896–97, a few years
prior to Chase's uncommissioned portrait,
which was likely painted in 1903 during Patti's
last concert tour to New York City. Included on
Peat's 1949 checklist of Chase's known work as
Lady with Orchids, and as being owned by Joseph
Sartor Galleries, Dallas.

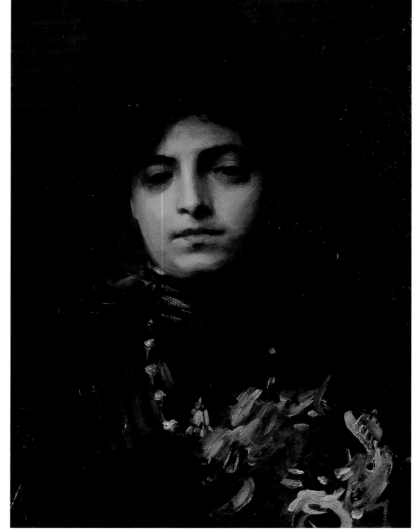

OP.379

OP.379A. Photograph of Adelina Patti

OP.380

Mrs. Wadsworth, ca. 1903

Oil on canvas; 20 x 16 in. (50.8 x 40.6 cm)
Signed: Wm. M. Chase (u.l.)
Verso: Notarized by Mrs. William M. Chase, 1926

Location unknown

Exhibitions: **K&C '03 #9** [owned by Mr. Frank
R. Wadsworth].

This painting depicts the mother of artist Frank
Russell Wadsworth (1874–1905), one of Chase's
students and a close friend of the family, whose
portrait Chase also painted (OP.271). The family
had a photo of the portrait of Mrs. Wadsworth
that is now in the Chase Archives, Parrish Art
Museum, Southampton, Long Island, New York.
Perhaps Frank Wadsworth commissioned this
painting of his mother, or Chase might have
given it to him as a gift. Frank Wadsworth joined
Chase for his summer class in Spain in 1905.

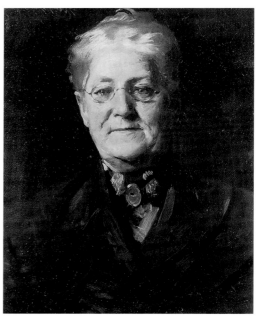

OP.380

While there, he became ill and died. It is interesting to note that the work did not remain in the Wadsworth family. Instead, the painting passed into the hands of another Chase student, Henry Rittenberg (1879–1969), but the location of the painting is not known at present. Included on Peat's 1949 checklist of Chase's known work as *Mrs. Wadsworth: Portrait of Wadsworth's Mother,* and as being owned by Henry R. Rittenberg, New York.

the identity of his model, shifting the focus instead to the aesthetic values of the work. Unlike the formally posed society portraits of the period, Chase here sought to cultivate a more naturalistic, "modern" image, which he achieved by presenting his model in a candid manner as she turns to acknowledge the presence of the artist (or viewer) while continuing to adjust her glove. The fold in her dress underscores the immediacy of the action. The gentility and strong character of the sitter constituted

something of a trope in Chase's portraiture, a "type" that he identified as typically American.

In 1909, in connection with its appearance in a traveling exhibition, the painting was described (under the mistaken title *Portrait of Miss E.*) as "a beautiful full-length portrait of a lady in a light canary-colored dress, standing, in the act of buttoning a glove" (*Academy Notes* [February 1909]: 146). *Miss B.* is included on Peat's 1949 checklist as *Woman in White,* and as being owned by the Fort Worth Museum of Art, Texas.

OP.381

Portrait of Miss B. (Miss B.; Miss Bellemy [of Springfield, Mass.]), ca. 1903

Oil on canvas; 72 x 36 in. (182.9 x 91.4 cm)
Signed: Wm. M. Chase (u.l.)
Details of labels verso: Newhouse Galleries of St. Louis, Missouri / Fort Worth Museum of Art Association, #1926.3 / University of Indiana, April 27–May 9, 1903 / Brigham Young University, 1982

Location unknown

Exhibitions: AIC '03 #81 as *Portrait of Miss B*; K&C '03 #10 as *Miss Bellemy (of Springfield, Mass)*; AAR '03 #35 as *Miss B*; GAAE '03 #26 as *Portrait of Miss B.*; CM '04 #2, illus. facing p. 12; SAA '04 #332 [lent by Mrs. B]; BFAA '09 #33 ("The Paintings by Mr. Chase," *Academy Notes* 4 [February 1909]: 146; misidentified as *Portrait of Miss E.*); NAC '10 #57 as *Portrait—Miss B.* [lent by Mr. Chase]; BPL '10 ("Chase Collection an Admirable One," *Bridgeport [Conn.] Daily Standard,* March 3, 1910, 3; misidentified as *Mrs. B.*) (this work can be seen in a gallery installation photo; there is no known checklist for this exhibition).

William M. Chase painted the present work in his Shinnecock Hills studio in Long Island during the first decade of the twentieth century (this according to Mrs. Chase in testimony dated November 25, 1925). Miss Bellemy had been a student of Chase's in his Shinnecock Summer School of Art, which operated from 1891 to 1902. Chase had completed at least one demonstration piece in the summer of 1902 (*Portrait of Miss Bellemy [Miss Bellemy]*; OP.366) using Miss Bellemy as the model. Unlike the demonstration piece of Miss Bellemy, which was bust-length and signed with the less formal "Chase," her portrait was created for exhibition and therefore was full-length and much more finished. Although this painting is most likely the same work Chase exhibited as *Miss Bellemy* at the Knoedler and Company exhibition in 1903, he thereafter gave it the more generalized title *Portrait of Miss B.* for more important shows. In doing so, Chase minimized the significance of

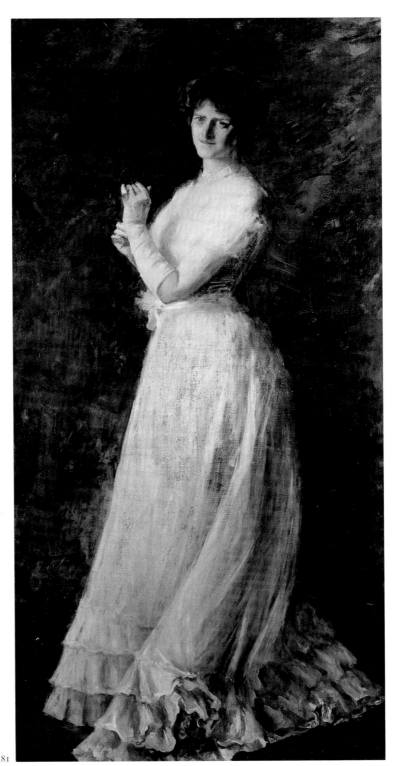

OP.381

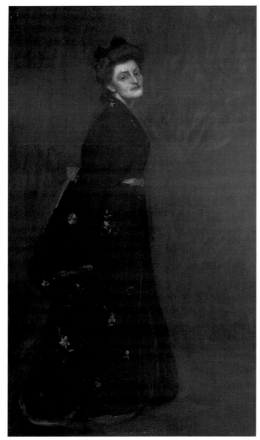

OP.382

The Black Kimono, ca. 1903

Oil on canvas; 72 x 40 in. (182.9 x 101.6 cm)
Signed: Chase (u.r.)

Location unknown

A work from Chase's "kimono series," which spans the period from the late nineteenth century through the first decade of the twentieth. The broad, heavy application of paint suggests the work was completed in the later years of that span. Characteristic traits are the pose of the model (looking over her shoulder directly at the viewer), the active background with the illusion of pictorial space achieved through tonal gradations, the strong light on the woman's face, and the limited palette enlivened by decorative accent colors in the red sash and pink, green, and gold embroidery in the woman's gown. The presence of the informal signature "Chase" suggests that the painting was likely a demonstration piece, albeit a slightly more ambitious one than usual for the artist. Chase usually awarded his demonstration pieces to students to thank them for posing or to reward their good work; however, in this case the work remained in Chase's possession after he left the school in 1907 to resume teaching at the Art Students League. It was later

given to a friend and fellow artist, Douglas John Connah, in 1910. Connah had been the managing director of the New York School of Art and of Chase's summer school on Long Island, the Shinnecock Summer School of Art (1891–1902). No definite exhibition record can be assigned to this painting under its present title, though it might have been exhibited under another name.

OP.383

Woman of Holland, ca. 1903

Oil on canvas; 24 x 18 in. (61 x 45.7 cm)
Signed: Chase (l.l.)

Location unknown

Auctions: AAA '23 #56

Woman of Holland was likely a demonstration piece, presumably painted in Haarlem, Holland, circa 1903 when Chase taught summer classes there (he would return for the same purpose in 1912). The focus of the class was plein air painting, of both landscapes and figure studies, but when weather was inclement the class would be held indoors; this work was probably completed on such a day. Woman of Holland became part of the collection of Annie Traquair Lang, a favorite student of Chase's who accompanied the artist to Holland in 1903 to take his classes. It was later purchased in the Lang estate sale in 1923 by Macbeth Galleries of New York for $240. Included on Peat's 1949 checklist of Chase's known work as Woman of Holland, and as being formerly owned by Macbeth Galleries, New York.

OP.384

Anna Heyward Taylor (1879–1956), 1903

Oil on canvas; 30 x 24 in. (76.2 x 60.9 cm)
Signed: Wm. M. Chase (u.l.)
Inscribed: To my friend Anna Heyward Taylor / Wm. M. Chase / 1903 (u.l.)
Verso: To my friend and pupil Anna Heyward Taylor / Wm. M. Chase, Columbia, S.C. 1903

Gibbes Museum of Art, Carolina Art Association, Charleston, S.C. (1937.03.01)

A portrait of Anna Heyward Taylor (1879–1956), a student at the New York School of Art in 1901 and daughter of a wealthy cotton-producing family in South Carolina; Chase painted portraits of her parents as well (OP.386–87). In 1903 Anna Heyward Taylor accompanied Chase on two of his summer classes abroad—one in Holland and then one in England. The 1903 summer class left for Holland (Haarlem) on June 24th. Chase had left early to stop in London and Paris and he made a short trip to Munich. Prior to leaving for the summer, Chase made a trip down to visit the Taylors and while he was there painted this portrait. Miss Taylor later recalled that he "painted very rapidly, completing this likeness in less than three hours" ("Notes on William M. Chase—as told to H. G. McCormick by Anna Heyward Taylor—1955," Chase Archives, Parrish Art Museum, Southampton, Long Island, New York). Included on Peat's 1949 checklist of Chase's known work as Anna Heyward Taylor, and as being owned by the Carolina Art Association, Charleston, South Carolina.

OP.383

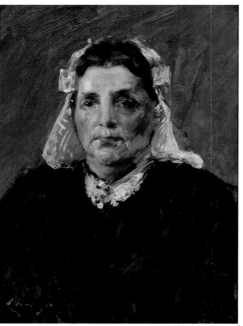

OP.384

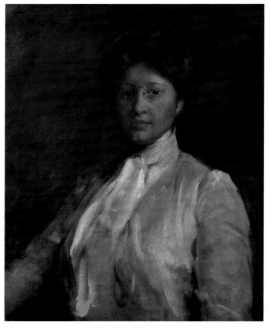

OP.385

OP.385

Mrs. Oliver Ames of Boston, Mass., 1903

Oil on canvas; 31 x 24½ in. (78.7 x 62.2 cm)
Signed: Wm. M. Chase (l.r.)
Dated: 1903 (l.r.)

Columbia Museum of Art, S.C. Gift of J. Henry Fair,
Jr., and Florence Burney Fair (CMA 1994.21.1)

This portrait depicts Anna Coffin Ray Ames
(b. 1840). Chase completed the work while
in South Carolina painting portraits of Mrs.
Marianna Taylor, Dr. Taylor, and Anna Heyward
Taylor. According to her family, Mrs. Ames was
not amenable to having her portrait painted:
"She was visiting here and refused to have hers
done. So Chase set up his easel upstairs and when
he got the portrait almost done from memory he
showed it to her and she sat for it" (Mrs. J. Henry
Fair to Ronald Pisano, February 8, 1978, Chase
Archives, Parrish Art Museum, Southampton,
Long Island, New York).

OP.386

Portrait of Mrs. (Marianna) B. W. Taylor, 1903

Oil on canvas; 31 x 24½ in. (78.7 x 62.2 cm)
Signed: Wm. M. Chase (l.r.)

Columbia Museum of Art, S.C. Gift of Mr. J. Henry
Fair, Jr. (CMA 1992.12.2)

OP.386

In a letter written to Ronald Pisano in February
1978, a family member states that Dr. and Mrs.
Taylor's son, Thomas, had commissioned Chase
to come down to Columbia, South Carolina, to
paint portraits of his parents and his wife's
mother (Archives of Ronald Pisano).

OP.387

Dr. Benjamin Welles Taylor, 1903

Oil on canvas; 31 x 24½ in. (78.7 x 62.2 cm)
Signed: Wm. M. Chase (l.r.)

J. Henry Fair, Jr., Charleston, S.C.

This portrait depicts Dr. Benjamin Welles Taylor
(b. 1834). Chase also completed a portrait of his
wife, his son's mother-in-law, and the Taylors'
daughter, Anna Heyward Taylor.

OP.387

OP.388

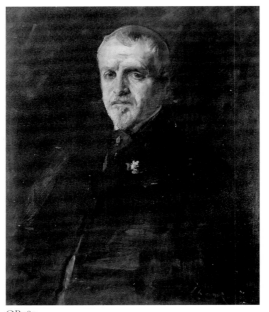

OP.389

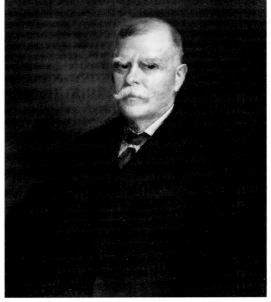

OP.390

OP.388

Portrait of a Girl, 1903

Oil on canvas; 24 x 18 in. (61 x 45.7 cm)
Signed: Chase (m.l.)
Inscribed: Chase, [indecipherable] 1903
Labels verso: [in writing] Hirschl and Adler;
label 120 So . . . , 2560 Blue, Lot #568; Cirker's
Lot # P4130, piece #5

Hirshhorn Museum and Sculpture Garden, Smith-
sonian Institution, Washington, D.C.

This portrait was likely a demonstration piece
completed by Chase while teaching his summer
class in Holland, the final stop on his European
sojourn in the summer of 1903.

OP.389

Ben Foster, ca. 1903

Oil on canvas; 30½ x 25 in. (77.5 x 63.5 cm)
Signed: Chase (l.r.)

National Academy of Design, New York

This work was painted in 1903 to fulfill the
membership obligation of Ben Foster (1852–
1926) upon his election as an associate of the
National Academy of Design. The National
Academy of Design council had accepted Foster's
first diploma portrait (artist unknown) in 1902;
however, the Chase portrait was exchanged for

this work and entered the National Academy
of Design collection on June 1, 1903. This work
is included in Peat's 1949 checklist of Chase's
known work.

OP.390

Carll H. DeSilver, Esq., ca. 1903

Oil on canvas; 30 x 25 in. (76.2 x 63.5 cm)
Signed: Wm. M. Chase (l.l.)

Brooklyn Museum, N.Y. Gift of Margaret de Silver
(43.139)

Exhibitions: **K&C '03 #6; NAC '10 #19.**

Carll H. DeSilver (1846–1913) was a Brooklyn
businessman, and trustee of the Brooklyn Art
Association and of the Brooklyn Institute of
Art and Science.

OP.391

Reverend Dr. Wm. M. Irvine, 1903

Oil on canvas; 64 x 40 in. (162.6 x 101.6 cm)
Signed: Wm. M. Chase (u.r.)

Mercersburg Academy, Pa.

Exhibitions: **K&C '03 #2.**

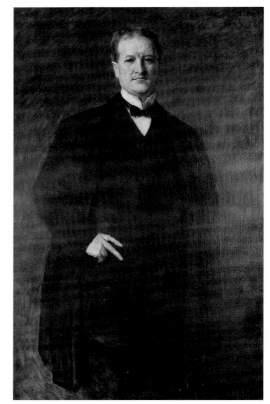

OP.391

This work was commissioned by alumni of, and
given to, Mercersburg Academy in 1903. The
painting was included on the list of important
portraits of men in William Howe Downes's
article "William Merritt Chase, A Typical Amer-
ican Artist," *International Studio* 39, no. 154 (Dec-
ember 1909): xxxii. Included with incorrect
measurements in Peat's 1949 checklist of Chase's
known work.

OP.392

Master Otis Barton and His Grandfather, ca. 1903

Medium/support/dimensions unknown (presumably oil on canvas)
Signature not visible

Currier Museum of Art, Manchester, N.H. Gift of Otis Barton, 1980 (1980.83)

Exhibitions: SLWF/UE '04 #130.

A titled photograph of this work descended through the artist's family. And it was Otis Barton, the young boy in the painting, who gave the work to the Currier Gallery. His grandfather, Otis Barton, Sr., owned and operated Barton and Company, a dry goods store in Manchester. But it was his son, Frederick Barton, living in New York, who commissioned the portrait—young Otis, in fact, remembers his grandfather having to travel down from Manchester to New York several times to pose in Chase's studio.

OP.393

Portrait of Elisha Benjamin Andrews, 1904

Oil on canvas; 59 x 39 in. (149.9 x 99.1 cm)
Signed: Wm. M. Chase (l.l.)

Brown University, Providence, R.I.

Elisha Benjamin Andrews (1844-1918) was the eighth president of Brown University (1889-98). This painting was commissioned and given to the university by the Class of 1893 at the 1904 commencement. The painting is noted in Katharine Metcalf Roof's 1917 biography of the artist and is included in Peat's 1849 checklist of Chase's known work.

OP.394

The Brothers (Sons of John Beatty), ca. 1904

Medium/support/dimensions unknown

Location unknown

Exhibitions: CI '04 #60.

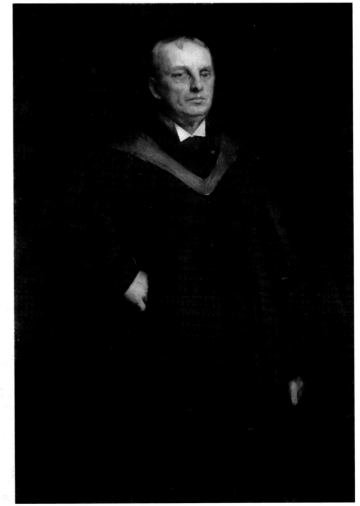

OP.394

This is a rare double portrait by Chase of the sons of John Beatty, director of the Carnegie Institute from 1896 to 1922. The work was reproduced in an unidentified clipping in the collection of the Art Division of the New York Public Library, clipping files for William Merritt Chase.

OP.392

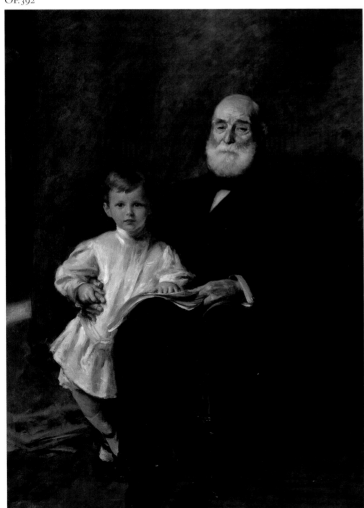

Master Otis Barton and His Grandfather

OP.393

OP.395

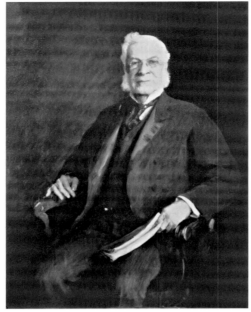

OP.396

OP.395

Portrait of Dr. Edwin Spottsville Ley Moyne (Lemoine), ca. 1904

Oil on canvas; 29¼ x 23¼ in. (74.3 x 59.1 cm)
Signature not visible in photograph of painting

Stephen Bemis Guy, St. Louis, Mo.

Exhibitions: **SLCAM '11 #11** [lent by W. E. Guy, Esq.].

In a 1976 letter to Ronald G. Pisano, Mrs. H. S. Fenimore Cooper identifies the sitter as her grandfather, although noting the spelling of his surname to be "Lemoine." In addition to this work, Mrs. Cooper states that Chase also painted Mrs. Cooper's father and mother, Mr. William E. Guy and Mrs. William E. Guy (OP.420), of St. Louis, Missouri. Although the owner did not note a signature on the Lemoine portrait, it is virtually impossible to believe that Chase would not have signed a commissioned work. This painting is included in Peat's 1949 checklist of known work; however, neither Guy portrait is listed.

OP.396

John S. Kennedy, Esq.

Oil on canvas; 48 x 38 in. (121.9 x 96.5 cm)
Signed: Wm. M. Chase (l.l.)

Presbyterian Hospital, New York

Exhibitions: **NAD '05 #58** [lent by Presbyterian Hospital].

This portrait is noted in Katharine Metcalf Roof's 1917 biography of the artist as John F. Kennedy. It is also included in Wilbur Peat's 1949 checklist of Chase's known work.

OP.397

Dr. Hurd

Oil on canvas; dimensions unknown
Signed: Wm. M. Chase (l.l.)

Location unknown

This work was included on William Howe Downes's list of important male portraits in "William Merritt Chase, A Typical American Artist," *International Studio* 39, no. 154 (December 1909): xxxii. The work is described as depicting Dr. Hurd of Johns Hopkins University, likely Dr. Henry M. Hurd, first superintendent of Johns Hopkins Hospital, for whom Hurd Hall was named. A photograph of this portrait descended in the Chase family.

OP.398

James McManes

Oil on canvas; dimensions unknown

City of Philadelphia

Known as "Boss McManes" and other times called "King James," McManes was head of the Gas Ring, a rogue association in Philadelphia and part of the corrupt administrations so

prevalent in various big cities of the country in the years following the Civil War. McManes was also a member, and no doubt one of the leaders, of the Philadelphia Republican Club.

OP.399

William Franklyn Paris

Oil on canvas; 20 x 16 in. (50.8 x 40.6 cm)
Inscribed and signed: To my friend W. F. Paris / Wm. M. Chase (l.l.)

Indianapolis Museum of Art. Gift of Dr. Steven Conant in honor of Mr. and Mrs. H. L. Conant

William Franklyn Paris was a mural painter, architect, writer, and lecturer. He studied at the Art Students League and was likely a Chase student at the school. He was known as W. Franklyn Paris, and it was through his initiative that Chase was honored by a memorial bust at New York University's collection of artists memorials, mainly due to the enthusiastic endorsement of Chase students. It is likely he is the son of Walter Franklyn Paris, a friend of Chase and one of the founders of The Tile Club, an art-social fraternity

OP.397

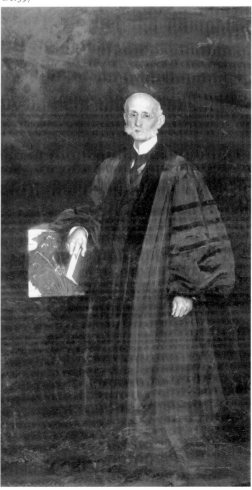

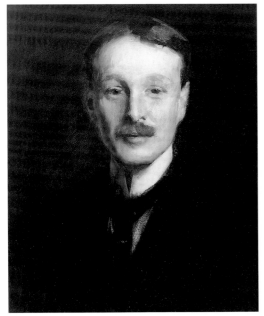

OP.399

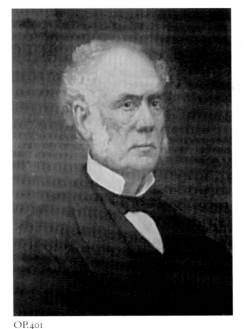

OP.401

Untitled (Portrait of a Young Woman),
ca. 1904

Oil on canvas; 24 x 20 in. (61 x 50.8 cm)
Signed: Chase (cut into canvas, m.r.); Wm. M. Chase
(written faintly, u.r.)
Inscribed (verso): From Chase Sale, size 24 X 20,"
No. 785? McCarthy?

Location unknown

This portrait was likely a demonstration piece.
Typically, such paintings displayed a limited color
palette set off by an accent of some brilliant
hue—in this case, the woman's bright red cor-
sage. There are several mysterious elements
regarding this painting. First, the work is signed
twice: "Wm. M. Chase," upper right, and
"Chase," which has been cut into the middle
right of the canvas. Second, inscribed on the
verso of the canvas is "From Chase Sale, size 24
X 20," No. 785? McCarthy?" but there does not
appear to be a corresponding work listed in any
of the Chase auction catalogues. Interestingly,
Chase completed several portraits of women
wearing a similar dress and depicted in a similar
pose, such as *Woman with a Large Hat* (OP.403),
also completed circa 1904.

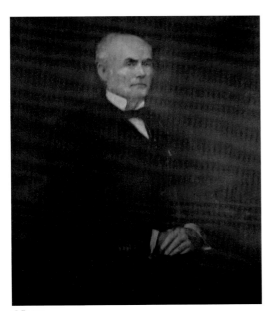

OP.400

OP.401

Joseph Hand Scranton

Oil on canvas; 20 x 16 in. (50.8 x 40.6 cm)

Collection of William W. Scranton, Scranton, Pa.

This portrait of Joseph Hand Scranton appears,
on the basis of facial characteristics, to be the
earliest of two portraits of the subject by Chase.
The sitter is the great-grandfather of William
W. Scranton, former governor of Pennsylvania.

of which Chase was an early and prominent
member. The painting is included in Peat's 1949
checklist of Chase's known work.

OP.400

Joseph Hand Scranton

Oil on canvas; 44 x 38 in. (111.8 x 96.5 cm)

Collection of William W. Scranton, Scranton, Pa.

Joseph Hand Scranton was the great-grandfather
of William W. Scranton, former governor of
Pennsylvania.

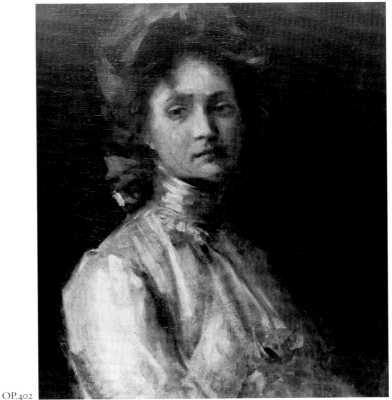

OP.402

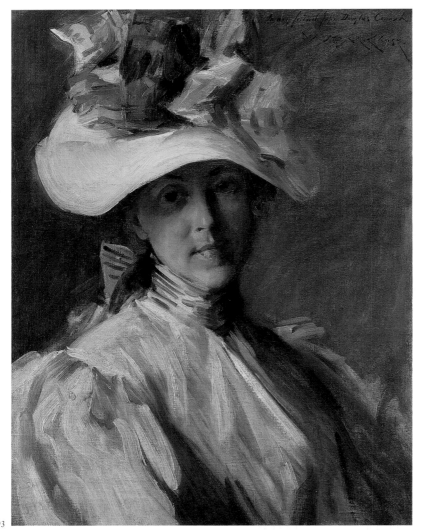

OP.403

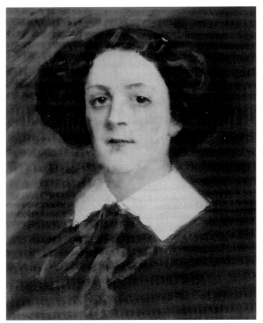

OP.404

OP.403

Woman with a Large Hat, ca. 1904

Oil on canvas; 18 x 24 in. (45.7 x 61 cm)
Signed: Wm. M. Chase (u.r)
Inscribed (u.r): To my friend Douglas Connah

Collection of Elizabeth Galia, Stony Brook, N.Y.

This painting depicts Nora Leslie Connah
(b. 1871), wife of the painter Douglas John
Connah, an associate of Chase both at the
Shinnecock Summer School of Art and the
New York School of Art. When Chase started
the Chase School of Art in 1896, he hired
Connah as one of his instructors. Then in 1898,
he turned over all administrative duties to Con-
nah. Connah eventually reorganized the school,
renaming it the New York School of Art, at
which Chase would remain a dominant figure
through 1907. According to an article in the
Sketchbook published about the New York
School of Art, Chase painted this portrait of
Connah's wife as a demonstration piece (Lolan
Read, Jr., "The NY School of Art," *Sketchbook* 3,

no. 8 [April 1904]: 221). Chase probably then
gave the portrait to Connah as a gift. Chase
painted at least two other portraits of women
that are very similar in terms of the sitter's dress
and pose (see OP.402).

OP.404

An English Bar Maid (Head of an English Girl; The Eton Collar), ca. 1904

Oil on canvas; 20 x 16 in. (50.8 x 40.6 cm)
There was an estate seal in red wax affixed to the
back of this work (these have been invariably lost
due to cracking and lifting).

Location unknown

Exhibitions and Auctions: **McCG '05, possibly as #4,**
An English Girl; **BFAA '09 #54** as *Head of an English
Girl* ("The Paintings by Mr. Chase," *Academy Notes* 4
[February 1909]: 149); **VGB '09, possibly as #4,** *An
English Girl*; **NAC '10 #7** as *Head of an English Girl*
[owned by Mr. Chase]; **BPL '10; DMA '16 #7** as *A
Young English Girl*; **Csale '17 #76** as *The Eton Collar.*

Chase probably completed this work while
teaching his summer school class in London in
1904. It was illustrated in the *New York Times,*
March 21, 1905, SM3. It is described in the cata-
logue for the 1917 Chase estate sale as a "study
of a young English girl, with rosy complexion,
and dark hair which stands out in wide puffs at
the sides of her head, while it is worn very flat
over her crown. She appears in head and shoul-
ders, turned slightly toward the left, and her
large eyes look quietly and directly at the specta-
tor. She is in black with a broad Eton collar
coming out in strong relief. Dark reddish-brown
background." In an article detailing the traveling
exhibition in 1909 it is described as "a recent
work of great refinement in color and handling"
(*Academy Notes* [February 1909]: 148), while
another critic commented that it "is so typically
sweet as to epitomize English girlhood" (*Times-
Star,* October 1909, n.p.). The only extant image
of the work is a photograph that descended in
the Chase family, on which the painting is
referred to as *An English Bar Maid.*

OP.405

Portrait Group (Dorothy, Helen, and Bob), ca. 1904

Oil on canvas; 72½ x 48 in. (184.2 x 121.9 cm)
Signed: William M. Chase (l.l.)

North Carolina Museum of Art, Raleigh. Gift of the
North Carolina Art Society (Robert F. Phifer Funds)
in Honor of Edwin Gill (G.73.3.3)

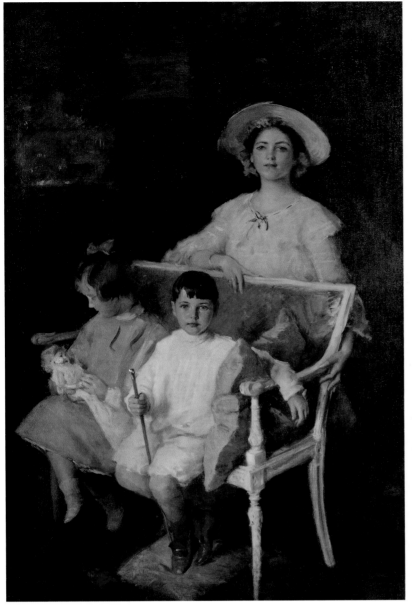

OP.405

OP.406

Exhibitions: **SAA '05 #398** as *Portrait Group*; **CM '05 #238,** illus. facing p. 12; **BFAA '09 #7** ("The Paintings by Mr. Chase," *Academy Notes* 4 [February 1909]: 149; *Cincinnati* [*Ohio*] *Commercial Tribune,* October 24, 1909, n.p., cover illus.); **CI '22 #4** [for sale, $3,000]; **NG '27 #22,** illus.; **AAA&L '28 #9,** illus. [lent by Harold R. Waken (*sic*)].

This work was originally exhibited under the title *Portrait Group.* As with many of his portraits, Chase here considered the identity of the sitters to be incidental. In such paintings, his children were used merely as models for works of art, rather than subjects for formal portraiture. In an article published in conjunction with the traveling exhibition of 1909, the reviewer described the painting as "a work of subdued coloring, representing a little boy with a little girl seated in a Louis XV sofa, with a young girl in a white dress and a straw hat standing behind it" (*Academy Notes* [February 1909]: 149).

Mrs. Chase, in testimony of November 25, 1925, noted that her husband painted this picture in his studio in Shinnecock, Long Island. Since Chase only painted there in the late spring and summer months, this work would have to have been completed in 1904, a year prior to its first exhibition at the Society of American Artists. If this is the case, then Dorothy would have been thirteen years of age, Helen nine, and Robert four and a half. The work remained in the Chase family until 1927 when it was purchased from Mrs. Chase by Newhouse Galleries, St. Louis, Missouri. Included on Peat's 1949 checklist of Chase's known work as *Dorothy, Helen, and Bob (Dorothy Chase); Portrait Group,* and as being owned by the Los Angeles Art Association.

OP.406

Helen Dixon, 1905

Oil on canvas; 60 x 36 in. (152.4 x 91.4 cm)
Label verso (ripped): Subject: Miss Helen / Artist: William M. / Description: Oil Portr. . . . / Date Received: October 16, 1923 / How Obtained: Deposited by Dr. Edward B. Krumbhaar
In black paint: B-29 (which must be an Academy registration number); Helen Dixon By Wm Chase

Location unknown

This painting, likely commissioned by the sitter's father, Thomas Henry Dixon of Philadelphia, depicts Helen Dixon (b. 1886). Miss Dixon's father probably commissioned the work as part of his daughter's entry into Philadelphia society. It is thus surprising that the portrait was not

signed by Chase. One thought was that the canvas was cut down and the signature was lost, but in looking at the canvas this was not the case. It is noted on the back of the canvas that the work is by "Wm. Chase," but nowhere on the front of the work. It is also unusual that the work was not exhibited, but perhaps the family did not want it to be. Miss Dixon was married in 1911 to Dr. Edward Bell Krumbhaar, who was a Professor of Pathology at the University of Pennsylvania School of Medicine. Dr. Krumbhaar loaned the painting to the Pennsylvania Academy of the Fine Arts in 1923. It appears that he and his wife were moving abroad to England. Included on Peat's 1949 checklist of Chase's known work as *Helen Dixon,* and as being owned by the Pennsylvania Academy of the Fine Arts, Philadelphia.

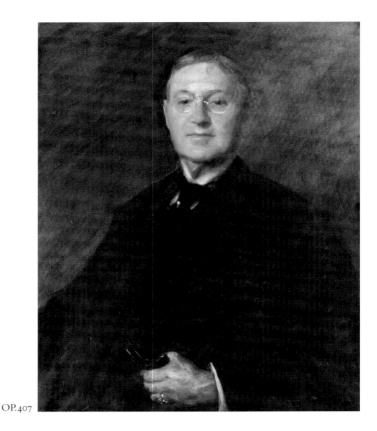

OP.407

OP.407

Portrait of Martin Joost, ca. 1905

Oil on canvas; 32⅛ x 26 in. (81.6 x 66 cm)
Signed: Wm. M. Chase (l.l.)

The Parrish Art Museum, Southampton, Long Island, N.Y. Gift of Mr. Sherman B. Joost

Exhibitions: **SAA '05 #42** as *Portrait of a Gentleman* [Mr. Joost—owner], possibly this work; **NAC '10 #13** [lent by Martin Joost]; **BAA '12 #69.**

Chase did portraits of both Martin Joost and his wife, Sarah Frances Joost (OP.408), the latter painting exhibited in 1906, which lends credence to the possibility that *Portrait of a Gentleman* lent by Mr. Joost in 1905 is, in fact, a portrait of Mr. Joost. Mr. Joost lived in Brooklyn and had a summer cottage in Southold, Long Island, New York. He was president of the Bond and Mortgage Company, and vice-president of the Port Jefferson Company, owner and developer of Belle-Terre Estates, a 320-acre parcel of land adjacent to Port Jefferson on the North Shore of Long Island.

OP.408

Portrait—Mrs. J (Portrait of Mrs. Martin Joost), 1905

Oil on canvas; 36⅛ x 29¼ in. (91.7 x 74.3 cm)
Signed: Wm. M. Chase (l.l.)
Verso frame (label for storage or exhibition): "Cartman Norman?" Title Portrait of . . . Artist Wm. M. Chase . . . Address 303 Fifth ____? Agent Mr. Martin ____st. (u.r.)

The Parrish Art Museum, Southampton, Long Island, N.Y. Gift of Mr. Sherman B. Joost

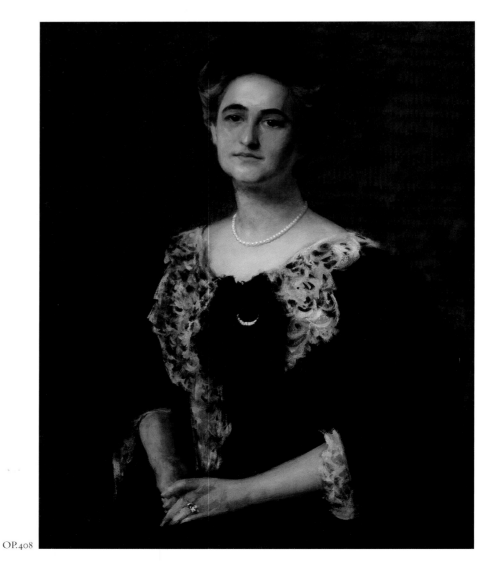

OP.408

Exhibitions: **NAD '06 #72** [lent by Mrs. Martin Joost]; **NAC '10 #11** as *Portrait of Mrs. Martin Joost* [lent by Martin Joost]; **BAA '12 #70.**

Chase was commissioned by Martin Joost to paint both his portrait (OP.407) and that of his wife, Sarah Francis Joost (b. 1862), perhaps in celebration of the couple's twenty-fifth anniversary. The Joosts were residents of Brooklyn, New York, and had a summer home in Quogue, Long Island, New York. In association with the work's exhibition at the National Arts Club in 1910, the work was praised as being "admirable in every respect" and as representing "the highest type of portrait painting in our country" (*Bulletin of the Brooklyn Institute,* January 8, 1910, 462, 465, illus.). *Mrs. Joost* is also mentioned in William Howe Downes, "William Merritt Chase, A Typical American Artist," *International Studio* 39, no. 154 (December 1909): 29-36, xxxii. Included on Peat's 1949 checklist of Chase's known work as *Mrs. Joost,* owner unknown.

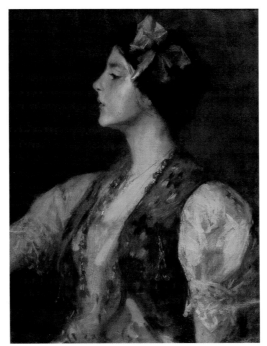

OP.409

OP.410

Girl in White, ca. 1905

Oil on canvas; 59 x 36 in. (149.9 x 91.4 cm)
Signed: Wm. M. Chase (u.l.) (only part of the signature is visible—appears to have overpainting, which covers all but the "W" of Chase's signature)

American Academy of Arts and Letters, New York. Gift of Archer M. Huntington, 1936

This painting is one of several Chase works donated to the American Academy of Arts and Letters by Archer M. Huntington in 1936. The identity of the sitter is not known. One factor assisting in dating the work is the elevated bustle, a dress style that was popular around the middle of the first decade of the twentieth century.

OP.409

Girl in Red, ca. 1905

Oil on canvas; 25⅜ x 18½ in. (64.5 x 47 cm)
Signed: Chase (l.l.)
Label verso: Victor Spark; (in red) C-67

The Parrish Art Museum, Southampton, Long Island, N.Y. Littlejohn Collection

Exhibitions: **NAC '10, possibly #119,** *Girl in Red* [lent by Mr. Chase]; **PAFA '11 #564** [possibly this work lent by the artist]; **FAM '13, possibly #5,** *Young Girl in Red;* **DMA '16 #17** [possibly this work lent by the artist].

This portrait depicts Chase's daughter Dorothy Brémond Chase (1891-1953). The work was illustrated as *Autumn* in a 1905 article ("'Get Together,' Says Mr. Chase to Fellow Artists," *New York Times,* March 21, 1905, SM3), which is an unusual title for Chase to assign a portrait. Perhaps the paper originally was going to illustrate a landscape there, or maybe Chase did title it *Autumn* for the *Times* to give a sense of the colors used. Whatever the case, the work at some point became known as *Girl in Red.* Due to the similarity of this work's title to numerous others, it is difficult to establish the painting's exhibition history with any certainty. Works of similar name are represented on Peat's 1949 checklist, including *Girl in Red* (A), *Girl in Red* (B), *Girl in Red Coat* (OP.301), and *The Red Kimono; Girl in Red* (C), and *The Red Gown* (OP.173), though this painting is not.

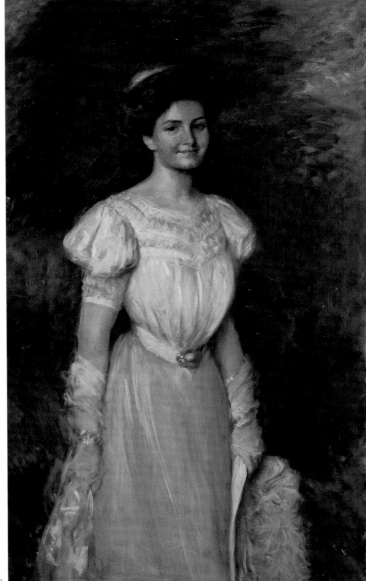

OP.410

OP.411

Harriet Albina (Hall) Shevlin, ca. 1905

Oil on canvas; 50 x 40 in. (127 x 101.6 cm)
Signed: Wm. M. Chase (l.l.)

Location unknown

Exhibitions: **SAA '05, possibly #299,** *Portrait of Mrs. S.*

A portrait of Harriet Albina (Hall) Shevlin (1871–1942), wife of Edwin C. Shevlin. This was a commissioned portrait executed circa 1905, when Chase was at the height of his popularity as a portrait painter, maintaining studios in both New York and Philadelphia. Particularly note-worthy in the present work are the expertly rendered textures of the sheer lace, satin, and glittering, jewel-bedecked dress. He successfully conveys a sense of her being seated in a vast room through his incorporation of a slit in the curtains, which allows the outside light to subtly illuminate the pictorial space.

OP.412

Mrs. James S. Cox, ca. 1905

Oil on canvas; 36 x 26 in. (91.4 x 66 cm)
Signed: Wm. M. Chase (l.l.)

Location unknown

Exhibitions: **PAFA '05 #213** as *Mrs. James S. Cox* [lent by the artist].

Chase painted a portrait of Mary F. Cox (b. 1836), the wife of James S. Cox (b. 1822), in Philadelphia in 1905 while at the height of his popularity as a portraitist. There is a photograph of Mrs. Cox in the Chase family archives, Parrish Art Museum, Southampton, Long Island, New York; it is simply labeled "Mrs. Cox," along with the number 1051, perhaps a negative number. Chase chose to depict Mrs. Cox with her finger inserted under the cover of a book that sits in her lap, thus imbuing the painting with a distinct sense of immediacy, as if Chase had interrupted her reading to capture her likeness. Included on Peat's 1949 checklist as *Mrs. James Cox,* and as being owned by John Lyman Cox (1866–1955; the couple's son) of Philadelphia.

OP.413

Portrait of a Lady, ca. 1905

Oil on canvas; 23 x 17 in. (58.4 x 43.2 cm)
Signed: Chase (l.l.)
Verso: Chase 18; (stamped note) Prepared by T.W. Devoe & Co., Manufacturers and Importers

Location unknown

This work was likely a demonstration piece painted during one of Chase's portrait classes at the New York School of Art (formerly the Chase School of Art), where he taught from 1896 to 1907. The painting was purchased from the artist by Ota Gygi, a well-known violin player of the era. Not included on Peat's 1949 checklist of Chase's known work.

OP.414

Margaret Scully Zimmele, ca. 1902

Oil on canvas; dimensions unknown
Signed: Wm. M. Chase (l.l.)

Location unknown

A portrait of one of Chase's students, Margaret Scully Zimmele (b. 1872), a Pittsburgh native who attended the Pennsylvania Academy of the Fine Arts in Philadelphia. She was a painter, illustrator, and sculptor active in the Washington, D.C., area in the first decade of the twentieth century. She married Harry Bernard Zimmele in 1905, and this portrait may have been given in celebration of her wedding.

OP.415

Portrait of a Woman (Eleanor Gilmore [Herr] Boyd), ca. 1905

Oil on canvas; 39 x 31 in. (99.1 x 78.7 cm)
Signed: Wm. M. Chase (l.r.)
Mailing label verso: (mailing address) Mrs. F. J. Haskin, 401 SIAS-AVE. NEWPORT, VT.; (return address) Jackson Boyd, 3903 Derry Street, Harrisburg, Pa. (Haskin was a relative of Boyd)

Location unknown

This appears to be a commissioned portrait of Eleanor Gilmore (Herr) Boyd (b. 1866) of Harrisburg, Pennsylvania, completed in the first decade of the twentieth century while Chase

OP.411

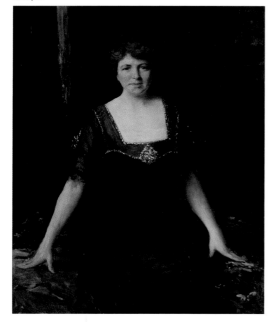

OP.412

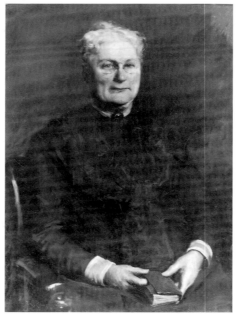

OP.413

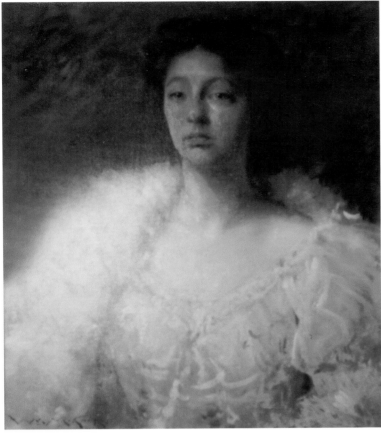

OP.414

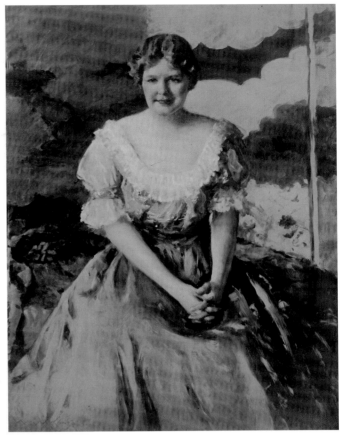

OP.416

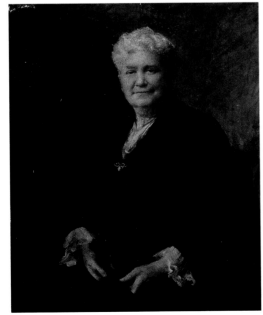

OP.415

was teaching at the Pennsylvania Academy of the Fine Arts. During this period, Chase had a studio in Philadelphia and regularly painted portraits of prominent Philadelphians as well as individuals in the surrounding area, in this case Harrisburg. Eleanor Gilmore (Herr) Boyd was married to John Yeomans Boyd, a coal magnate. Unfortunately Chase kept no record of these commissions (or at least none has surfaced). Although some can be documented through exhibition records or references in periodicals, most went directly to the homes of the sitters and have descended in those families through the years. Chase was a master at painting the subtle gradations of various tones of black, enlivened by the spontaneous treatment by lighter shades, as in the white lace seen here. The treatment owes a clear debt to the old Dutch masters, especially Frans Hals, whose work he first came to admire as a student in Munich in the 1870s and to which he would be reexposed during his summer classes given in Haarlem, Holland, in 1903 and again in 1912.

OP.416

Portrait of Miss S. (Portrait of a Smiling Young Lady), ca. 1905

Oil on canvas; 60 x 35½ in. (152.4 x 90.2 cm)
Signed: Wm. M. Chase (l.l.)
There was an estate seal in red wax affixed to the back of this work (these have been invariably lost due to cracking and lifting).

Location unknown

Auctions: **Csale '17** (fully described).

The only extant image of the present work is in a photograph in the Chase Archives, Parrish Art Museum, Southampton, Long Island, New York. The back of the photograph is labeled "Portrait of Miss S. by Wm. M. Chase." There are no records of a work of that title being exhibited during the artist's lifetime. However, the portrait appears to match the description of the painting *Portrait of a Smiling Young Lady* in the catalogue for the Chase estate sale of 1917: "three-quarter-length standing figure of a plump and handsome young lady in a greenish-white filmy gown with low neck and short sleeves, observed against a conventional background of landscape suggestion. She is in a broad light and looks at the observer smilingly." The cloud formations painted in the landscape background are unusual insofar as a great many of Chase's works utilize foliage for that purpose, as in *The Sisters* (OP.418), dating from the same year.

OP.417

OP.417

Portrait Study (The Woman Artist),
ca. 1905

Oil on canvas; 22 x 18 in. (55.9 x 45.7 cm)
Inscriptions/labels: Affidavit verso by Douglas John
Connah stating that this painting was done by
William Merritt Chase, signed by several people;
canvas bears stamp of its manufacturer, F. W. Devoe
and Company, NY

Location unknown

This painting was likely a demonstration piece.
Numerous such didactic works were hung on
the classroom walls of the Chase School. When
the school was ultimately reorganized following
Chase's departure in 1907, the paintings were
apparently disposed of. Those that were not
signed had affidavits attached to the back and
signed by Douglas John Connah, the director
of the school, attesting to the fact that Chase
painted them.

OP.418

The Sisters (The Sisters—Mrs. Sullivan and Mrs. Oskar Livingston; The Sisters—Mrs. Oskar Livingston and Mrs. James Francis Sullivan), ca. 1905

Oil on canvas; 70 x 60 in. (177.8 x 152.4 cm)
Signed: Wm. M. Chase (l.l.)

Private collection

Exhibitions: **ULC** '06 #5 as *The Sisters—Mrs. Sullivan and Mrs. Oskar Livingston* [lent by James Sullivan]; **AIC** '06 #74 as *The Sisters—Mrs. Oskar Livingston and Mrs. James Sullivan*; **PAFA** '06 #411, illus. as *The Sisters* [lent by James Sullivan, Esq.]; **CGA** '07 #13 as *The Sisters—Mrs. Oskar Livingston and Mrs. James Sullivan* (*International Studio* [March 1907]: v); **NAC** '10 #54 as *The Sisters* [owned by James F. Sullivan] (J.B.T., "Chase at the National Arts Club," *American Art News* 8 [January 15, 1910]: 6, as *Two Sisters*); **MMA** '17 #33 as *The Sisters* (Mrs. James B. Clews and Mrs. James F. Sullivan) [lent by Mr. James F. Sullivan] (Mr. James Blanchard Clews was Mrs. Livingston's second husband) ("An Exemplar of Technique, Pure and Simple," [New York] *Tribune*, February 18, 1917 [artist's clipping file, New York Public Library]).

In *The Sisters* Chase created a phenomenal "exhibition piece" that could draw attention to his prodigious talent. *Sisters* was first cited in a *New York Times* article on Chase: "Thereon [his easel] just at present stands a big canvas with a double portrait—two beautiful young married women of fashion who live in Philadelphia, painted with the arch look and somewhat bird-like grace one sees in Watteau" (*New York Times*, March 21, 1905, SM3). With the generous cooperation of the family of one of the sitters (who owned the work), it was widely exhibited and featured in major shows in Philadelphia, New York, Chicago, and Washington, D.C. Wherever it was shown it received wonderful reviews. The painting was praised as "one of the most elegant and vivacious of his interpretations of the American 'mondain' type of the Eternal Womanly" (William Howe Downes, "William M. Chase, A Typical American Artist," *International Studio* [December 1909]: 32, as *The Sisters*). The author also mentioned Chase's portrait of Mr. Francis Sullivan (presumably Mr. James Francis Sullivan) as among an "important series of portraits of men" (ibid., 32). Katharine Metcalf Roof maintained that "in Chase's portraits, one feels always that his subjects are receptively considered, not handled in a mannered way," and she singled out *The Sisters* as a prime example of this (*Craftsman* [April 10, 1910]: 37). When featured in the memorial exhibition of Chase's work at the Metropolitan Museum of Art in New York in 1917, the critic for the *New York Times* praised it for its "decorative grace" and astutely linked it to eighteenth-century English portraiture (*New York Times Magazine* [February 18, 1917]: 13). Although the prototype for Chase's society portraits was most definitely established by John Singer Sargent, Chase's own masterworks were

derived from more extensive and complex sources. One of the seminal works of John Singer Sargent's fashionable society portraiture was his *Millicent, Duchess of Sutherland* of 1904. Painted in the grand manner of English portrait painters of the seventeenth and eighteenth centuries, Sargent's subject is posed full-length in a (subtly classicized) outdoor setting. The influence can be traced to Sir Anthony van Dyke, and more directly to Thomas Gainsborough, as in his painting *Mary Countess Howe* of the 1780s. Chase was well aware of Sargent's *Millicent, Duchess of Sutherland,* having seen it during a visit with a group of his students to Sargent's studio the summer of 1904. Upon seeing the work Chase commented: "Wonderful, my dear fellow. Marvelous!" (Harrison Morris, *Confessions in Art* [New York: Sears Publishing Company: 1930], 272). The precedents provided by other painters were not overlooked by the critics of the time. With respect to Gainsborough, the *New York Times* described *The Sisters* as "two women in white against a background of architecture and landscape, an obvious essay in the English eighteenth century style" (*New York Times Magazine* [February 18, 1917]: section 5, 13).

In *The Sisters* Chase captures two women of obviously differing personality and yet bound by familial ties and united in Chase's decorative composition. Mrs. Livingston (on the left), although the younger of the two, assertively confronts the viewer, with her right hand boldly placed on her hip and left arm firmly set on her sister's shoulder. In contrast to the austerity of Mrs. Livingston, Mrs. Sullivan, although no less self-assured, appears the more approachable. At some point between the painting's execution and 1912, Oskar Livingston died and Mrs. Livingston subsequently remarried, becoming Mrs. Clews. The title of the painting was changed accordingly, and it is first recorded thus in 1912.

The Sisters was illustrated in several publications, including *American Art News* 4 (November 11, 1905); *Brush and Pencil* 17 (March 1906): 126; A. Hoeber, *Woman's Home Companion* (September 1910): 50, illus. as *The Sisters*; Gustav Kobbe, [New York] *Herald,* November 20, 1910, 11; and C. P. Townsley, "William M. Chase—A Leading Spirit in American Art," *Arts and Decoration* 2 (June 1912), 286, illus. as *Portrait of Mrs. Sullivan and Mrs. Clews.* This painting, owner unknown, is included on Peat's 1949 checklist of Chase's known work as *Mrs. Sullivan and Mrs. Clews: The Sisters.*

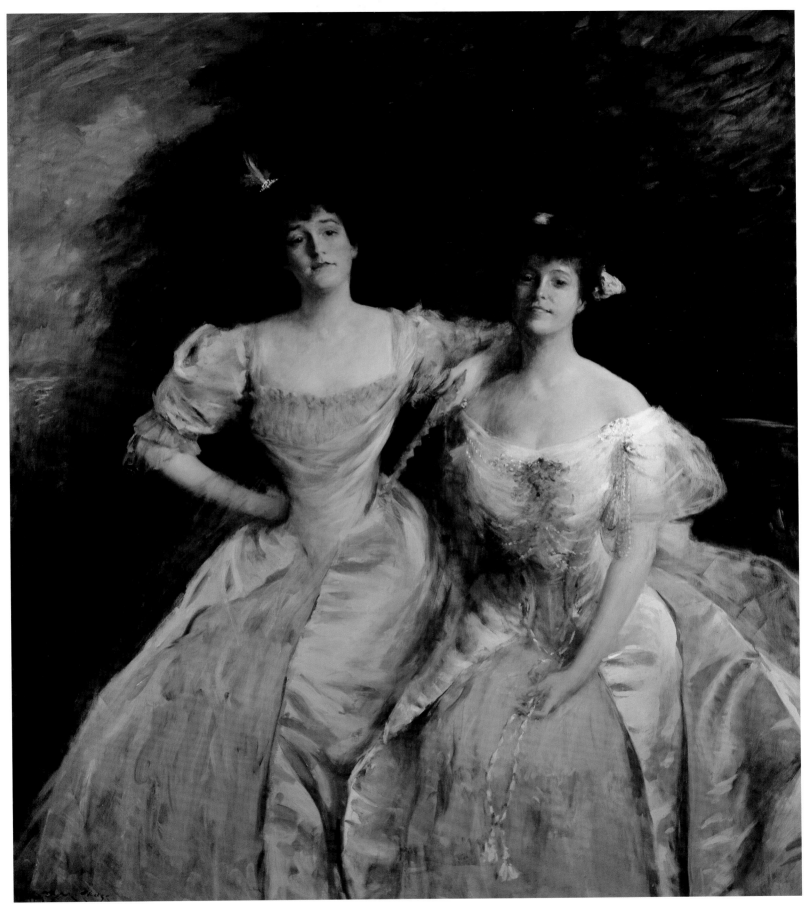

OP.418

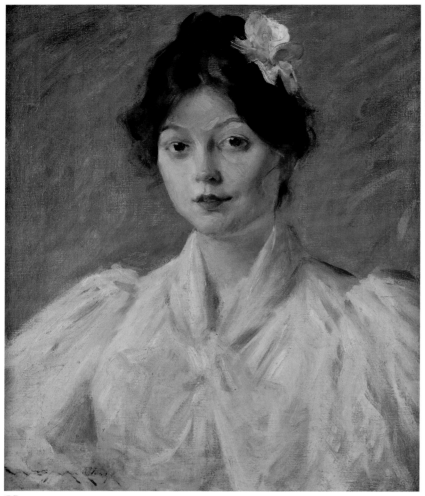

OP.419

(W. S. Howard, "A Portrait by W. M. Chase," *Harper's Monthly Magazine* 113 [October 1906]: 698-99, illus. as *A Portrait,* owned by William E. Guy, St. Louis, Missouri, engraving by Henry Wolf). The work is also briefly treated in William Howe Downes, "William Merritt Chase, A Typical American Artist," *International Studio* 39, no. 154 (December 1909): 32. There is a photograph of this portrait in the Chase family archives labeled *Mrs. William G. [sic] Guy.* Included on Peat's 1949 checklist as *Portrait of a Lady,* and as being owned by William E. Guy, St. Louis, Missouri.

OP.421

Portrait of the Artist's Daughter— Helen Velázquez Chase, ca. 1905

Oil on canvas; 19¾ x 14¾ in. (50.2 x 37.5 cm)
Signed: Chase (l.m.)

Location unknown

This painting depicts Chase's sixth child Helen Velázquez Chase (1895-1965). This work was owned by a Chase student, Alice Schille (1869-1955), a native of Columbus, Ohio, who began her formal art training at the Columbus School of Art (now the Columbus College of Art and Design) in 1891, then moved to New York in 1897 to continue her studies. She attended classes both at the Art Students League and the Chase School of Art (which in 1898 became the New York School of Art). At the Chase School, Schille won a scholarship to attend Chase's summer school located in Shinnecock, Long Island. She turned down

OP.419

Young Woman in Pink, ca. 1905

Oil on canvas; 22 x 18 in. (55.9 x 45.7 cm)
Signed: Wm. M. Chase (l.l.)

Location unknown

Young Woman in Pink, a portrait of an unknown sitter, neatly evinces several features typical of Chase's portraiture. The overall tonal quality, active and confident brushwork, and the manner in which the artist uses paint to "build" structure—most notably in the treatment of the girl's face—are all characteristic. In this work the strongly modeled forms of the girl's facial features are complemented by the more freely treated depiction of her dress. The light background, displaying active strokes of paint in muted tones, creates a convincing pictorial space and lends a sense of depth to the subject.

OP.420

A Portrait (Catherine Lemoine Guy), ca. 1905

Oil on canvas; 48 x 36 in. (121.9 x 91.4 cm)
Signed: Wm. M. Chase (l.r.)

Mrs. William L. Cary, New York

This is a portrait of Catherine Lemoine Guy (b. 1866). She is seated facing left wearing a black satin dress with puffy, rued, short sleeves and a white lace border on the neckline. Her wedding ring is prominently displayed on her left hand, which is placed against her chest. She wears a small band in her hair. The painting was likely a commissioned portrait given that it was owned by Mr. William Guy at least as early as 1906 and as late as 1949. *A Portrait* was illustrated and discussed at some length in a 1906 article, wherein the author highlights the work as marking a transition in Chase's pictorial approach: "There is increasing evidence of the emergence of the restless energetic worker into that maturer estate of the calm thinker whose performance is marked by greater deliberation and repose"

OP.420

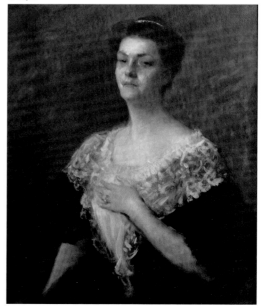

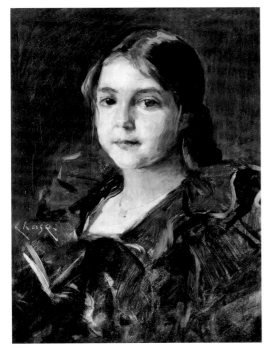

OP.421

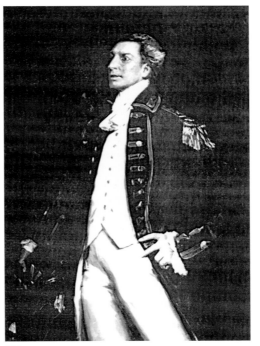

OP.422

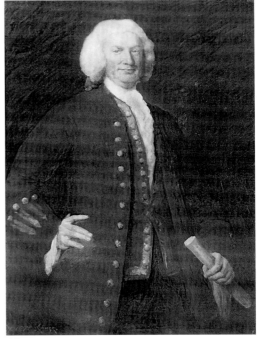

OP.423

the scholarship that summer saying that she felt "too much the responsibility of something for nothing." After another year of study in New York, Schille did enroll in Chase's summer school, though at her own expense. Chase continued to follow Schille's career and offer his support in later years. Schille recalled, "Later he wanted to buy one of my things but I said I would like to give it to him. He said 'Then we will exchange' and gave me a portrait of one of his children" (Alice Schille Papers, Archives of Keny and Johnson Gallery, Columbus, Ohio). This portrait of Helen may be the work that Chase gave to Schille at that time. Possibly included, owner unknown, on Peat's 1949 checklist of Chase's known work as *Artist's Daughter Helen (Helen Chase)*, circa 1900.

OP.422

Brigadier General Howe, 1905

Oil on canvas

University of Scranton, Pa.

This portrait is one of three historical figure paintings commissioned from Chase by William Walker Scranton for the library in his home in Pennsylvania, the others being portraits of Colonel William Prescott and Sir William Pepperell. General Howe (1729-1814) was the commander of British troops at the Battle of Bunker Hill. In 1775 he was elevated to

commander-in-chief of the British Army in America, and in this capacity he successfully led his troops in capturing New York City in 1776 and Philadelphia in 1777. He also won the major battles of the Brandywine and Germantown.

OP.423

Sir William Pepperell, 1905

Oil on canvas

University of Scranton, Pa.

In 1905 William Walker Scranton commissioned a series of portraits of Revolutionary and pre–Revolutionary War figures for the library of his newly built home. William Franklyn Paris arranged for Chase to execute three of the portraits, of which *Sir William Pepperell* (1697-1759) is one—the others being of Colonel William Prescott and the British commander Brigadier General Howe. Pepperell organized and led the expedition that captured the French fortress Louisbourg in Nova Scotia in 1745. He was also the subject of a book written by Nathaniel Hawthorne in 1833, and Pepperell, Massachusetts, is named after him.

OP.424

A Son of the Artist (Portrait of Roland Dana Chase), ca. 1905

Oil on canvas; 22 x 16 in. (55.9 cm x 40.6 cm)
Estate seal

Location unknown

Auctions: **Csale '17 #80** as *A Son of the Artist* (fully described).

OP.424

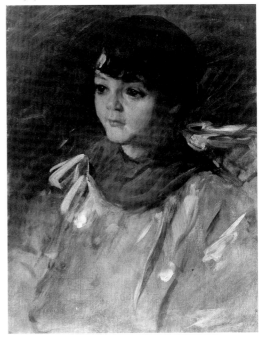

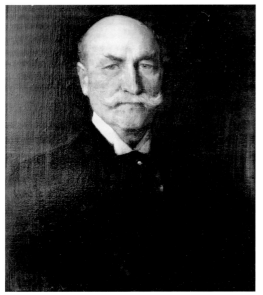

OP.425

This work was likely purchased from the estate auction by M. Knoedler and Company, New York, as there is a Knoedler photo of the painting in the files of Ronald G. Pisano. The photograph is titled *Portrait of His Son Roland*.

OP.425

Portrait of William Walker Scranton, ca. 1905

Oil on canvas; 24 x 20 in. (61 x 50.8 cm)
Signed: Chase (l.l.)

National Academy of Design, New York. Gift of W. Franklyn Paris, 1942

William Walker Scranton (1844–1916) was an industrialist and civic leader in Pennsylvania, Scranton being the seat of the family business. A major segment of the family business was steel. This work is included in Peat's 1949 checklist of known work, erroneously misidentified as a portrait of "William Worthington Scranton."

OP.426

William Walker Scranton, ca. 1905

Medium/support/dimensions unknown

Location unknown

This portrait of William Walker Scranton was painted around the time that Chase was awarded the commission to paint three Revolutionary War figures for the Scranton Library. Mr. Scranton (1844–1916) was a well-known industrialist and civic leader in Pennsylvania—his grandson William Scranton would later serve as governor

of the state. This full-length portrait was thought to have been destroyed. Another bust-length portrait of William Scranton is in the collection of the National Academy of Design, a gift of Franklyn Paris, friend and former Chase student, who had arranged the commission for Chase to paint the three historical figures for the library in the Scranton home.

OP.427

Charles William Eliot

Medium/support/dimensions unknown

Harvard University, Cambridge, Mass.

Charles William Eliot (1834–1926) was a descendant of Pilgrims who landed in Plymouth in 1631. His father was a treasurer of Harvard University, and also served as mayor of Boston. He briefly taught mathematics and chemistry at Harvard, and later became professor of chemistry at the newly formed Massachusetts Institute of Technology. In 1869 he was elected president of Harvard. After his retirement he edited the *Harvard Classics,* the fifty-volume series for which he is best remembered. This work is included in Peat's 1949 checklist of known work by the artist.

OP.426

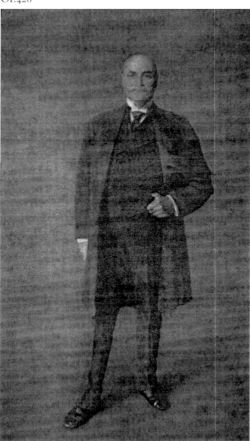

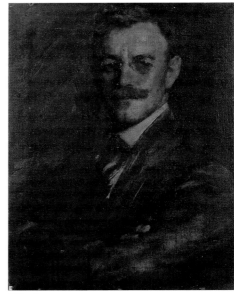

OP.428

OP.428

Portrait of a Man

Oil on canvas; 24 x 18 in. (61 x 45.7 cm)

American Academy of Arts and Letters, New York. Gift of Archer M. Huntington, 1936

Auctions: **Csale '17 #272** (fully described).

This is a classroom demonstration piece, included in Peat's 1949 checklist of Chase's known work as *Portrait of a Man* (A), formerly in the collection of F. A. Lawlor. It was Lawlor who bought this work as well as several other portraits from the 1917 Chase estate sale—works that were subsequently acquired by Archer M. Huntington and given to the American Academy of Arts and Letters. Huntington—art collector, poet, Spanish scholar, and academy member—was a major contributor toward the academy building on Audubon Terrace in New York City.

OP.429

Portrait of a Man

Oil on canvas; 20 x 16 in. (50.8 x 40.6 cm)
Signed: Chase (c.r.)

Location unknown

Auctions: **Csale '17 #180** (A tall, severe-looking man with refined features, somewhat clerical in aspect, clad in black, looks straight at the spectator from a gray-olive and brownish background. A high light strikes the center of his forehead, distributing varying shadows down the face and emphasizing his deep-set eyes. He is seen in head and shoulders, with standing collar, and large, dark tie held with a pin).

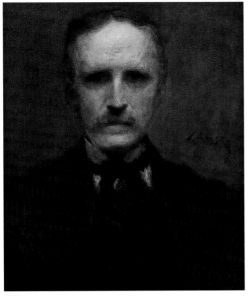

OP.429

This work is possibly the painting included in Peat's 1949 checklist of Chase's known work as that being formerly owned by F. A. Lawlor, New York. The signature style would suggest the painting was done as a classroom demonstration piece.

OP.430

Mr. Parsons

Oil on canvas; 30 x 25 in. (76.2 x 63.5 cm)

Private collection

A photograph of the painting in its original state descended in the Chase family (OP.430A). The work has since been cut down to its present size. It is likely the work was originally signed (not visible in the period photograph); however, it is not signed in the cut down version, which suggests it was reduced in size after Chase's death in 1916.

OP.431

Portrait of John Getz

Oil on canvas; 31¼ x 26½ in. (79.4 x 67.4 cm)
Signed: Wm. M. Chase (u.r.)

The Evansville Museum, Ind. Gift of Mr. Vernon Dawe (59.601)

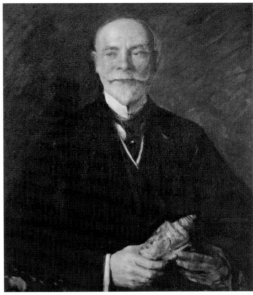

OP.431

John Getz was a noted connoisseur of, and writer on, ceramics, which Chase referenced by painting him holding a ceramic object. A photograph of this portrait descended in the Chase family.

OP.430A. Photograph of *Mr. Parsons* as a three-quarter-length portrait

OP.430

OP.432

OP.432

Three-Quarter-Length Portrait of a Seated Man with Hands in His Lap

Presumably oil on canvas; dimensions unknown
Signature not visible

Location unknown

A photograph of this work descended in the Chase family.

OP.433

Bust-Length Portrait of Man Wearing White Beard

Presumably oil on canvas; 20 x 16 in. (50.8 x 40.6 cm)
Signature not visible

Location unknown

OP.433

A photograph of this work descended in the Chase family. On the back of the photograph is the number 4162, likely a gallery stock number of some sort.

OP.434

Portrait of Miss Frances V. Earle (Miss Earle, of Philadelphia), 1905

Oil on canvas; 60 x 36 in. (152.4 x 91.4 cm)
Signed: Wm. M. Chase (l.l.)
Inscribed verso: Francis Von Lohr Earle / Daughter of George H. Earle, Jr. age 17 / painted by W. M. Chase / 1905

Location unknown

Exhibitions and Auctions: **PAFA '06 #516** as *Portrait of Miss. Frances V. Earle* [lent by George H. Earle, Jr.].

A portrait of Frances V. Earle (1889–1918), the daughter of a Philadelphia banker and financier George H. Earle, Jr., and the sister of George Earle, a governor of Pennsylvania. Writing about the work upon its exhibition at the Pennsylvania Academy of the Fine Arts in 1906, one critic noted that "Miss Earle of Philadelphia is a three-quarters-length standing figure of a slender, graceful elegant young lady in a white gown and a big hat with a white feather, the dark cloak being thrown back and lightly held by one hand. It is a work of distinct charm and of a lively personality" (William Howe Downes, "William Merritt Chase, A Typical American Artist," *International Studio* 39, no. 154 [December 1909]: 29–36, xxxii, xxxv, illus. as *Miss Earle, of Philadelphia*). Chase also completed portraits of her great-grandfather (from a daguerreotype; OP.481), grandfather (from photographs; OP.479–80), father (OP.477–78), and mother (OP.365), and her

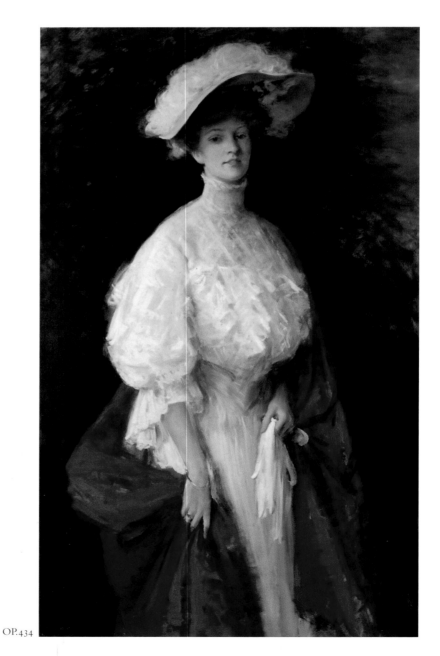

OP.434

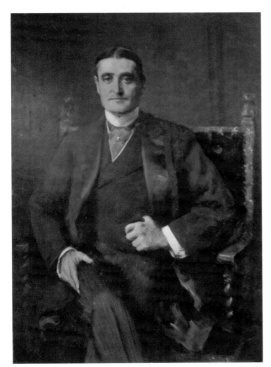

OP.435

sister Catherine Ann Earle Mather (Mrs. Victor Mather) (OP.493). The present painting is included, owner unknown, on Peat's 1949 checklist of Chase's known work as *Miss Earle.*

OP.435

Three-Quarter-Length Seated Man with Thumb in Vest

Presumably oil on canvas; dimensions unknown
Signature not visible

Location unknown

A photograph of this work descended in the Chase family.

OP.436

Portrait of Kate Freeman Clark, 1906

Oil on canvas; 20 x 16 in. (50.8 x 40.6 cm)
Verso: To My Friend and Pupil, Wm. M. Chase

Collection of Kate Freeman Clark Art Gallery, Holly Springs, Miss.

Chase completed at least two other portraits of Kate Freeman Clark (OP.354 and OP.355). Clark (1875-1957) was one of Chase's students at the Shinnecock Summer School in Long Island from 1896 until the school's final year in 1902.

During these years she also took classes at the Chase School of Art in New York City. It was in this period that Chase created one of the other portraits of Clark (OP.355). Chase painted this portrait of Clark several years later in 1906. One cannot help but notice the different mood of the two portraits. Both capture Clark as contemplative. However, whereas the earlier portrait is lighter in color, softer in the rendering of the lines of Clark's white shirt, and more vibrant in brushstrokes, the 1906 painting has a dark somber feel both in the background and in the style of her dress.

OP.437

Portrait of William A. Putnam, Sr.

Oil on canvas; 32½ x 25½ in. (82.6 x 64.8 cm)
Signed: Wm. M. Chase (u.l.)

Washington County Museum of Fine Art, Hagerstown, Md. Gift of Mr. and Mrs. Alfred T. Morris

This work was reproduced in *Some Reminiscences by Carolyn R. R. Putnam* (privately printed, 1941), seen hanging on the wall in the Putnam home at 70 Willow Street, Brooklyn. Carolyn Putnam was the wife of William A. Putnam, Sr.

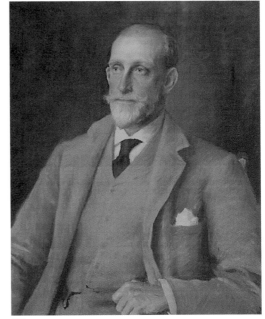

OP.437

OP.438

Peter Bonnard

Oil on wood panel; 19½ x 15½ in. (49.5 x 39.4 cm)
Signed: Wm. M. Chase (l.l.)

Location unknown

Mr. Peter Bonnard, of New York, was associated with the Henry-Bonnard Bronze Works, said to have been owned by U.S. Senator (Wyoming) William A. Clark.

OP.436

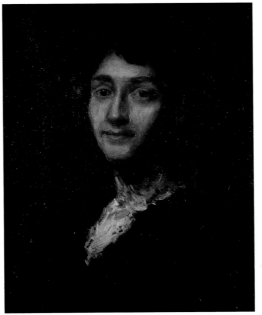

OP.438

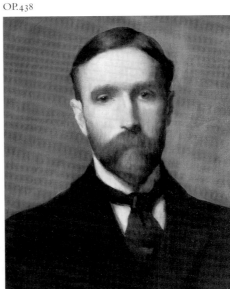

OP.439

Roland Dana Chase, 1905

Medium/support/dimensions unknown
No visible signature

Private collection

Exhibitions: **PAFA '05 #415; SAA '05 #382** as *Master Roland* [lent by Richard G. Cook, Esq.].

This is a portrait of the artist's son, Roland Dana Chase (1901–1980). The work was illustrated in an article by C. P. Townsley, "William Merritt Chase: A Leading Spirit in American Art," *Art and Decoration* 2 (June 1912): 285. A photograph of the painting descended in the Chase family, with the notation that it was owned by Mr. Cook of Philadelphia.

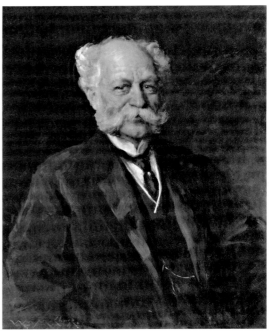

OP.439

OP.441

OP.440

Colonel William Prescott, 1905

Oil on canvas; dimensions unknown
Signed: Wm. M. Chase (l.l.)

University of Scranton, Pa.

This portrait of the Revolutionary War historical figure Colonel William Prescott was commissioned by William Walker Scranton for his library—Chase was one of a number of artists commissioned to paint historical portraits. Details of the project were included in *American Art News* (November 25, 1905): illus. p. 5:

> A remarkable portrait of Colonel William Prescott, who defended the American position at the battle of Bunker Hill, is now on exhibition in Boston. It is from the brush of William M. Chase, and represents Colonel Prescott in the flush of battle, his hand on his sword and the word of command on his lips. The man pictured by the artist, although forty-nine years old at the time of the battle of Bunker Hill, looks considerably younger. This is due to the fact that from descriptions in letters now in possession of the descendants of Colonel Prescott, it appears that the gallant commander was a man of great robustness and dash, and one upon whom the years left no mark. The putting of him in the blue and buff, adopted later as the distinguishing garb of officers in the Continental army, has excited some controversy on the score of historical accuracy, but [accounts of] the minute men who fought under him on that day bear out this contention that such a

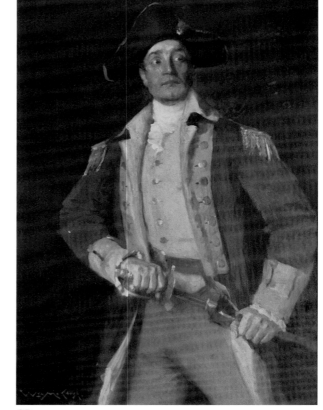

OP.440

uniform was worn by him. The painting is one of eight now being painted by William M. Chase, Hubert Vos, Robert W. Vonnoh, and Prince Troubetskoy.

It was also cited in "The World of Art and Artists," *New York Times,* Dec. 3, 1905, part 4, x8. The commission was arranged by William Franklyn

Paris, artist, architect, U.S. commissioner to the Paris exposition in 1900, and a friend of Chase. The Boston gallery was not noted in the review, nor is there any record of the exhibition in the Chase archival files. A photograph of the painting descended in the Chase family. The painting is listed on Peat's 1949 checklist of Chase's known work.

OP.441

Bust-Length Portrait of a Man with Large White Mustache and Mutton Chops

Presumably oil on canvas; dimensions unknown
Signed: Wm. M. Chase (l.l.)

Location unknown

A photograph of this work descended in the Chase family.

OP.442

Captain Francis G. Landon

Oil on canvas; 57 x 45 in. (144.8 x 114.3 cm)
Signed: Wm. M. Chase (l.l.)

Seventh Regiment Armory, New York

A photograph of this portrait descended in the Chase family. The work is included in Peat's 1949 checklist of Chase's known work as being owned by the Seventh Regiment Armory, New York.

OP.443

Portrait—Sitter Unknown, ca. 1905

Medium/support/dimensions unknown
No visible signature

Location unknown

A photograph of this painting descended in the Chase family.

OP.444

The Spanish Dude, ca. 1905

Oil on canvas; 20 x 16 in. (50.8 x 40.6 cm)
Estate seal

Location unknown

Auctions: Csale '17 #79 (A dark complexioned young man, manifestly proud of his good looks, with hair of rich black and a delicately twisted moustache, is portrayed in head and shoulders, facing the left, with head turned to the spectator, at whom he looks with a bold smile and brilliant eye. He is in dark brown, with a soft white shirt and red scarf).

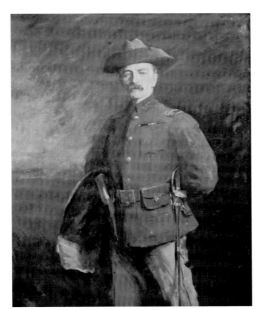

OP.442

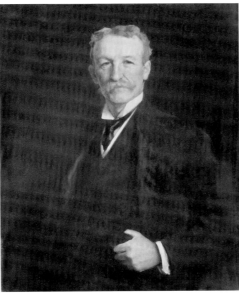

OP.443

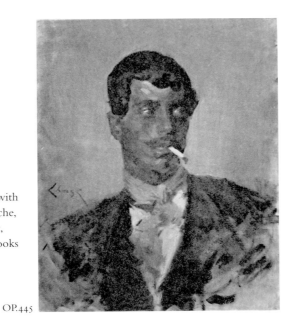

OP.445

OP.445

Spanish Man Smoking Cigarette, ca. 1905

Physical properties unknown
Signed: Chase (c.l.)

Location unknown

This portrait is likely one of a series of paintings of Spanish men that Chase painted while conducting his 1905 summer art class in Madrid. The signature style is associated with those works painted as class demonstration pieces. A photograph of the painting descended in the Chase family archives.

OP.446

Portrait of a Musician, 1905

Oil on canvas; 27¾ x 21¾ in. (70.5 x 55.3 cm)
Signed: Wm. M. Chase (l.l.)
Inscribed: Painted by Wm. M. Chase in Madrid, 1905 (verso)

Location unknown

Exhibitions and Auctions: TAP '06 #6 as *A Young Musician,* possibly this work; Csale '17 #89 (fully described).

This work was reproduced in *House Beautiful* 25 (February 1909): 52. Photographs of the painting descended in the Chase family. The portrait, owner unknown, is included in Peat's 1949 checklist of Chase's known work.

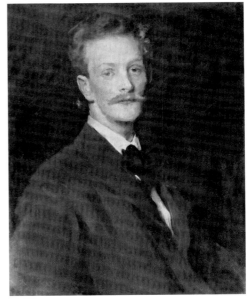

OP.446

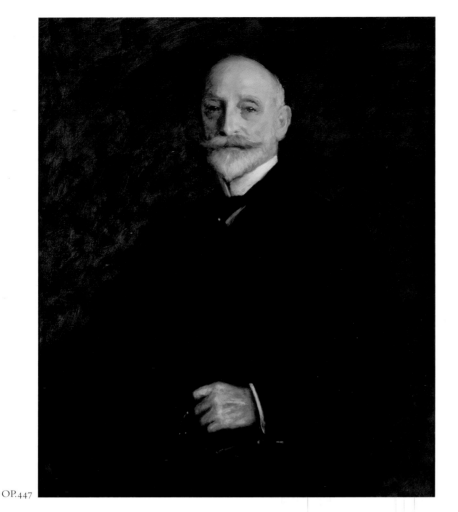

OP.447

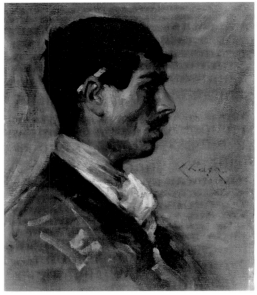

OP.448

have been done as a demonstration piece for the class and given as a prize to a student. There is another male portrait done in Madrid the same summer titled *A Gypsy Swell,* the subject having a cigarette in his mouth rather than behind his ear, as in the above-cited work.

OP.447

August B. Loeb, Esq., 1905

Oil on canvas; 36 x 29 in. (91.4 x 73.7 cm)
Signed: Wm. M. Chase (l.l.)
Inscribed, signed, and dated: August B. Loeb Esq. / Painted by Wm. M. Chase. / Philadelphia April 20 to 30 / 1905 (verso, before lining)

Pennsylvania Academy of the Fine Arts, Philadelphia. Gift of Mrs. Bella Loeb Selig (1954.9)

Exhibitions: **PAFA '06 #351.**

A photograph of this painting of August B. Loeb (1841–1915) descended in the artist's family. The painting was likely done in Chase's Philadelphia studio—the backing on the photograph is stamped "From / Haeseler Photographic Studios / 1513 Walnut Street / Philadelphia, U.S.A."

OP.448

A Spanish Gypsy, 1905

Oil on canvas; 19¾ x 16 in. (50.2 x 40.6 cm)
Signed: Chase (c.r.)

Cincinnati Museum of Art. Bequest of Mr. and Mrs. Walter J. Wichgar (1978.335)

There are many paintings of Spanish subjects and little or no documentary evidence to sort them out. Chase took his summer class to Madrid in 1905, and this work could very well

OP.449

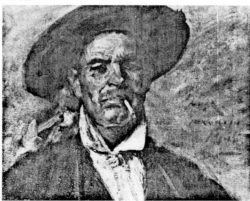

OP.449

Head of a Spaniard, 1905

Oil on canvas; 16 x 20 in. (40.6 x 50.8 cm)
Signed, noted, and dated: Chase / Madrid / 1905 (c.r.)

Location unknown

Exhibitions: **AAG '09 #11** (*Academy Notes,* Buffalo [February 1909], "the *Head of a Spaniard,* No. 11, is captivating in its looseness and simplicity of handling," illus. p. 145).

Chase was teaching a summer class in Madrid in 1905 and this work is one of several paintings of Spanish gypsy males completed that summer. Related works, among others, include *A Spanish Gypsy/A Gypsy Swell* (OP.450) and *The Spanish Dude* (OP.444).

OP.450

A Spanish Gypsy/A Gypsy Swell, 1905

Oil on canvas; 20 x 16 in. (50.8 x 40.6 cm)
Signed: Wm. M. Chase (l.l.)
Inscribed: A Gipsy [sic] Swell painted by Wm. M. Chase, Madrid, 1905 (verso)

Location unknown

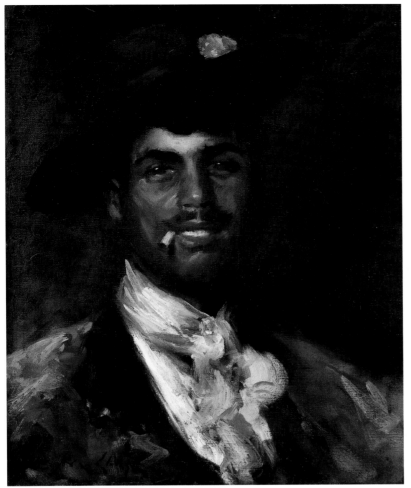

OP.450

Exhibitions and Auctions: **CM '07 #10** (illus.); **AAG '09 #15; NAC '10 #39; DMA '16 #29** as *A Gypsy Swell;* **Csale '17 #75** as *A Gipsy Swell* [*sic*] (fully described) [purchased, J. W. Young, $40].

This work was painted in the summer of 1905, when Chase was in Madrid conducting his summer art class. There has been some confusion regarding this painting as it was clearly exhibited under both titles; however, it should be noted that there are several related works with similar titles: *Head of a Spaniard* and *A Gypsy Dude* (also referred to as *The Spanish Dude*). This work is included in Peat's 1949 checklist of Chase's known work as being owned by Everette M. Schofield, Indianapolis.

OP.451

Henry Williams Biddle, 1910

Oil on canvas; 48 x 37 in. (121.9 x 94 cm)
Signed: Chase (l.l.)

The Mutual Assurance Company for Insuring Houses from Loss by Fire, Philadelphia

OP.451

Henry Williams Biddle (1849–1923) lived and worked in Philadelphia—likely with the Mutual Assurance Company. This work is included in Peat's 1949 checklist of Chase's known work as being owned by the Mutual Assurance Company, Philadelphia.

OP.452

OP.452

Walter Pach, 1905

Oil on canvas; 20 x 16 in. (50.8 x 40.6 cm)
Signed and dated: Wm. M. Chase Madrid 1905 (l.l.)
Inscribed: For my friend and my pupil Walter Pach, W. M. Chase, Madrid, July 30th 1905 (verso)

North Carolina Museum of Art, Raleigh. Purchased with funds from the State of North Carolina and the Museum Special Gift Fund

Exhibitions: **TAP '06 #5; NAC '10 #118.**

Walter Pach (1883–1958) was a Chase student who joined the Chase class trip to Spain in the summer of 1905. The work was illustrated the following year in an article on Chase written by H. St. Gaudens, "William M. Chase," *Critic* 48 (June 1906): 514, and cited in two reviews of the 1906 Ten American Painters exhibition: *Evening Mail,* March 21, 1906, p. 7; and *American Art Review* 4, no. 23 (March 17, 1906): 2. It was also included in a list of important male portraits by Chase in an article written by William Howe Downes, "William Merritt Chase, A Typical American Artist," *International Studio* 39, no. 154 (December 1909), pl. xxxii. While Pach never achieved lasting renown as an artist, he was an enthusiastic writer on modern art in the early twentieth century and he helped to organize the European section of the famous 1913 Armory Show, an exhibition to which Chase was pointedly not asked to participate. There is a most interesting chapter on Chase in Walter Pach's autobiography *Queer Thing Painting* (New York: Harper and Bros., 1938), in which Pach clearly expresses his admiration for his former teacher. This work is included in Peat's 1949 checklist of Chase's known work.

OP.453

Portrait of Alfred Stieglitz, 1905

Oil on canvas; 29 x 21¾ in. (73.7 x 55.3 cm)
Inscribed, signed, and dated: To my friend Alfred
Stieglitz / Wm. M. Chase 1905 (l.l.)

The Alfred Stieglitz Archive Collection of American
Literature, Beinecke Rare Book and Manuscript
Library, Yale University. Gift of Georgia O'Keeffe

Exhibitions: **TAP '08 #8; CI '08** as *Portrait of Alfred
Stieglitz* [*sic*] (illus., presumably in the catalogue);
AAG '09 #10 [traveling exhibition that went to
several museums; work lent by Chase]; **NAC '10
#120** [lent by Mr. Stieglitz].

Alfred Stieglitz (1864–1946) was arguably the
most important promoter of early-twentieth-
century modernism in America. He was a
famous photographer and his gallery exhibitions
included major modernist American artists, many
of whom were Chase students, most notably
Georgia O'Keeffe (who was also married to
Stieglitz). This portrait serves as an important
link between Chase and early modernism in that
while style changed, the fundamentals of good,
solid painting and the principle of "art for art's
sake" remained an important component of the
best American artists. Chase's portrait of Stieglitz
was mentioned in J. B. Townsend's review,
"Annual Exhibit of the Ten," *American Art News*
6 (March 21, 1908): 2, and the painting was
included in William Howe Downes, "William
Merritt Chase, A Typical American Artist," *Inter-
national Studio* 39, no. 154 (December 1909):
xxxii, in a list of his most important male por-
traits. In *Academy Notes,* "The Paintings by
Mr. Chase," 4 (February 1909): 145, the painting
is discussed in detail: "A portrait of Alfred
Stieglitz, the photographer, a young man with
intensely black eyes and hair, wearing gold eye-
glasses . . . is an excellent representation of char-
acter." The painting was reproduced in *Gazette
de Beaux Arts,* 4th pd. (October 1909): 329. The
work was also reviewed by Sidney Allen (pseu-
donym for Sadakichi Hartmann) for *Bulletin of
Photography and the Photographer,* December 15,
1909, "Contructive Criticism—No. 25, A Weekly
Pictorial Review." In his review Hartmann criti-
cizes the "likeness" of the image, but describes
the work as having some charm, with a "lumi-
nous quality [in] the fleshtints," and concludes,
"There is a certain breadth and depth to it
which it seems almost impossible to get in pho-
tography." The painting is included in Peat's 1949
checklist of Chase's known work.

OP.454

Portrait of William B. Dickson

Oil on canvas; 26¾ x 21¾ in. (68 x 55.3 cm)
Signed: Wm. M. Chase (l.l.)

Montclair Art Museum, N.J. Gift of the children
of Mr. and Mrs. William B. Dickson, in memory of
their parents (1976.20)

William B. Dickson (1864–1942) was a business-
man and civic leader in Montclair, New Jersey,
and a founder of the Montclair Art Museum.
From 1901 until 1911, he was vice-president
of the U.S. Steel Corporation.

OP.455

Portrait of a Young Man

Oil on canvas; 20 x 16 in. (50.8 x 40.6 cm)
Affidavit signed by Douglas John Connah, stating:
The work is by Wm. M. Chase, painted at the New
York School of Art—dated March 1909 (attached
verso)

Mr. Joseph Lee Weems, Easton, Md.

Chase was affiliated with the Chase School of
Art (later called the New York School of Art)
from 1896 to 1907. This work is likely a demon-
stration piece done while Chase was teaching
at the school, and left behind when he resigned
his teaching post. Douglas John Connah served
as director of the school and he prepared and
signed the affidavit certifying that the work was
indeed by Chase. This affidavit appears on other
works from the school.

OP.456

Portrait of a Young Man

Oil on canvas; 22 x 18½ in. (55.9 x 47 cm)
Signed: Chase (l.r.)

Location unknown

OP.453

OP.454

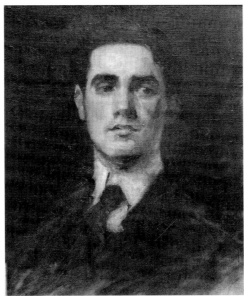

OP.455

From an essay by Ronald G. Pisano: "By [1905] Chase had become one of Philadelphia's most popular portrait painters. . . . And by 1907 his work in portraiture had become so much in demand in Philadelphia that he established a studio there to accommodate his many sitters." The portrait of S. Colesberry Purves was commissioned by the Philadelphia Fund Society in 1904 and completed in January 1905. Mr. Purves served as president of the society from 1903 until 1923. The portrait is one of several "important portraits of men" mentioned in William Howe Downes's article "William Merritt Chase, A Typical American Artist," *International Studio* 39, no. 154 (December 1909): xxxii.

OP.458

Sylvester S. Marvin

Oil on canvas; 48 x 32 in. (121.9 x 81.3 cm)
Signed: Wm. M. Chase (l.l.)

Location unknown

Sylvester Marvin was said to have been one of the founders of the Nabisco Corporation. The painting was included in Wilbur Peat's 1949 checklist of Chase's known work as being in the collection of the Carnegie Institute, possibly on extended loan, as it was said to have been sold later by a member of the Marvin family.

This work was originally owned by Lucy M. Taggart, Indianapolis, a Chase student—possibly at the Chase School, New York. Given the nature of the work, simply signed "Chase," it is likely a classroom demonstration piece, perhaps awarded to Miss Taggart for her work. Although Ala Story, who once owned the painting, assigned a date of 1876, based on the signature style it is clearly a later work, most likely from the 1890s. The painting was included in Peat's 1949 checklist of Chase's known work [*Head of a Young Man* (A)], and as being owned by Lucy M. Taggart, Indianapolis.

OP.457

G. Colesberry Purves, Esq., 1905

Oil on canvas; 50¼ x 40⅛ in. (127.6 x 101.9 cm)
Signed: Wm. M. Chase (l.l.)
Inscribed: G. Colesberry Purves / Painted by Wm. M. Chase / Philadelphia, Jan. 1905 (verso—as the work has been laid down on board, this inscription was most likely copied from the original inscription on the back of the canvas)

Collection of the Honorable Joseph P. Carroll, New York

Exhibitions: **PAFA '05 #725** [lent by the Philadelphia Savings Fund Society].

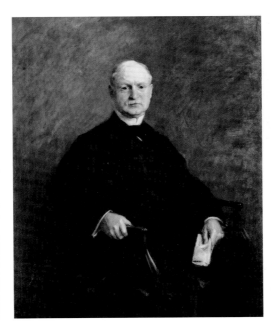

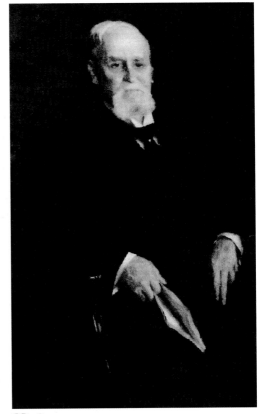

OP.456

OP.457

OP.458

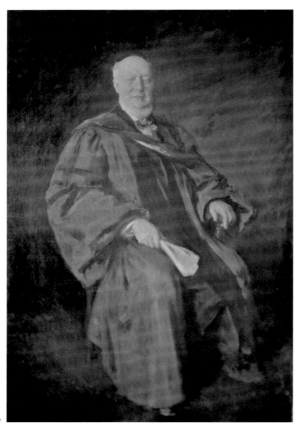

OP.459

Richard Y. Cook (1845–1917) was a financial advisor living in Philadelphia, and the portrait was no doubt painted in Chase's Philadelphia studio in the early twentieth century. Chase also painted a pendant portrait of Mrs. Richard Y. Cook (OP.461), also lent by Mr. Cook to the same exhibition, as well as a portrait of their daughter-in-law posed with their grandchildren (OP.463). In 1905 this work was referenced in *Brush & Pencil* 15 (March 1905): 152. It seems clear that Chase had become the leading portraitist in Philadelphia in the early twentieth century.

OP.461

Portrait of Mrs. Richard Y. Cook, ca. 1905

Oil on canvas; 36 x 29 in. (91.4 x 73.7 cm)
Signed: Wm M Chase (l.l.)

Private collection

Exhibitions: **PAFA '05 #652**, illus. ("Centenary Exhibition at Philadelphia," *Brush and Pencil* 15 [March 1905], 152, illus. as *Mrs. Roland Y. Cook* [*sic*]).

OP.459

Dr. James Burrill Angel of Ann Arbor

Oil on canvas; 72 x 48 in. (182.9 x 121.9 cm)
Signed: Wm. M. Chase (l.l.)

University of Michigan, Ann Arbor

A titled photograph of this painting descended in the artist's family. On the back of the photograph, in pencil, is written "Dr. Angel / of Ann Arbor / by Chase." James B. Angel (1829–1916) was born in Rhode Island. He was a graduate of Brown University, where he served for many years as a professor of literature and modern languages. He went on to become president of the University of Vermont (1866–71) and president of the University of Michigan (1871–1909).

OP.460

Portrait of Richard Y. Cook, ca. 1905

Medium/support/dimensions unknown

Location unknown

Exhibitions: **PAFA '05 #647** [Richard Y. Cook—owner].

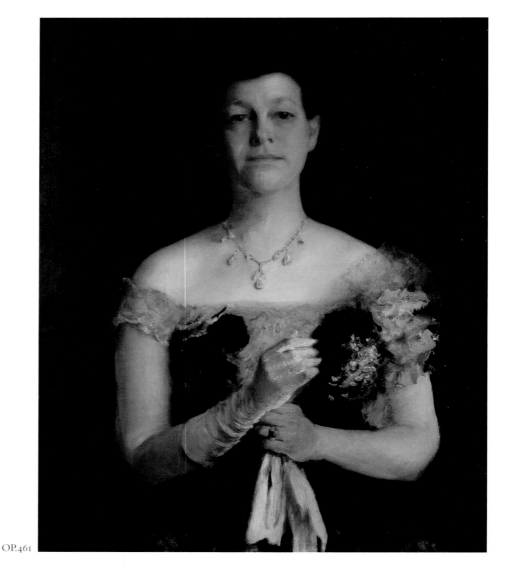

OP.461

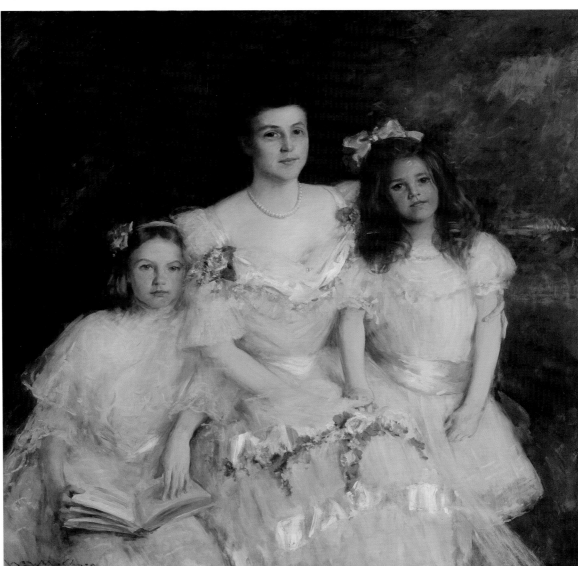

OP.463

This portrait depicts Lavinia Borden Cook (b. 1848); Chase also completed portraits of Mr. Cook (OP.460) and their daughter-in-law posed with their grandchildren (OP.463). The work was illustrated in the catalogue that accompanied the Pennsylvania Academy of the Fine Arts exhibition of 1905. Chase was at the height of his popularity as a portrait painter at this time and was, as in the present case, not infrequently commissioned to paint several members of a single family. The subject's status and wealth are evident in her diamond necklace, elaborate dress, corsage, and gloves. Included, owner unknown, on Peat's 1949 checklist of Chase's known work as *Mrs. Richard Y. Cook.*

OP.462

Henry Pepper Vaux

Oil on canvas; 20 x 16 in. (50.8 x 40.6 cm)

Image unknown

Location unknown

Vaux (1879-1953) was born in Philadelphia and was a member of its social circles. His name is included on a list of colonial families of Philadelphia. Chase also completed a portrait of his wife (OP.491) and father-in-law (OP.492). No doubt, Chase painted this portrait in his Philadelphia studio in the early twentieth century. There is no extant image of the work, which, owner unknown, is included in Peat's 1949 checklist of Chase's known work.

OP.463

The Mother (Mrs. Gustavas Cook, Lavinia Cook, Nancy Cook), 1906

Oil on canvas; 60 x 60 in. (152.4 x 152.4 cm)
Signed: Wm. M. Chase (l.r.)

Private collection

Exhibitions: **PAFA '07 #333** as *The Mother* [lent by Gustavus Cook].

Gustavus Wynne Cook commissioned Chase to paint his wife, Nannie Bright Cook (b. 1880), and their children, Lavinia and Nancy. Chase also completed portraits of Gustavus's mother (OP.461) and father (OP.460) in 1905, though there are no extant references to any portraits of Gustavus Wynne Cook himself. All of the portraits of the Cook family were exhibited either in the Pennsylvania Academy of the Fine Arts exhibitions of 1905 or 1907—those of Mr. and Mrs. Richard Y. Cook in 1905 and those of Mrs. Gustavus Cook and children in 1907. One reviewer wrote of *The Mother* upon its appearance at the Pennsylvania Academy of the Fine Arts in 1907 that he "did not appear to have lost any of his habitual facility of handling light and delicate colour schemes, and certainly succeeded in putting before us a beautiful representation of three charming personalities" ("Studio Talk," *International Studio* [April 1907]: 162, illus. as *The Mother*). *The Mother* was illustrated in several other periodicals during this period, including: *Cosmopolitan* 42 (April 1907): 604, as *Mothers and*

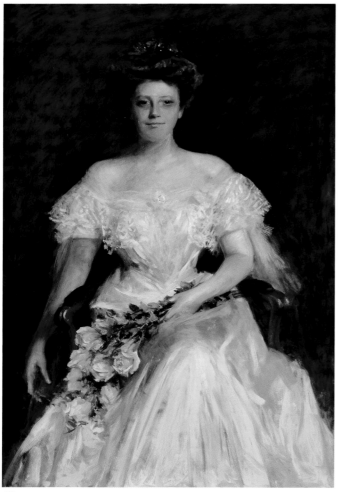

OP.464

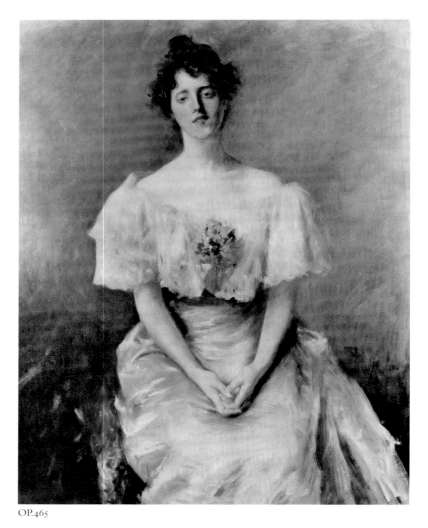

OP.465

Children; William Howe Downes, "William Merritt Chase, A Typical American Artist," *International Studio* 39, no. 154 (December 1909): 31; and A. Hoeber, "American Artists and Their Work: II/ William M. Chase, *Woman's Home Companion* 37 (September 1910): 50. A photograph of the present work descended in the Chase family. Included, owner unknown, on Peat's 1949 checklist of Chase's known work as *Mrs. Gustavus Cook and Children: The Mother*.

OP.464

Portrait of a Woman (Portrait of Miss Dickerman), 1906

Oil on canvas; 59½ x 39½ in. (151.1 x 100.3 cm)
Signed: Wm. M. Chase (u.r.)
Dated: 1906 (u.r.)

Milwaukee Art Museum. Bequest of William D. Vogel (M1980.161)

The sitter is Grace Beatrice Dickerman (1878–1953), daughter of prominent Wisconsin banker Charles H. Dickerman. She is shown seated in a chair dressed in a pink gown with lace trim at the shoulders. She holds roses on her lap in her left hand; her right arm dangles over the chair arm. A photograph of the work descended in the Chase family, which was labeled by Mrs. Chase as depicting "Miss Dickerman"; the verso of the photograph also bears the additional notation, "E. Lathrop," a possible reference to Elise Lathrop, who wrote the article "A Group of Artist's Wives" (*Broadway Magazine,* March 1907), which featured one of Chase's portraits of his wife. The present work was illustrated as "showing the finished style for which he is noted" in an article noting Chase's departure from the New York School of Art ("Wm. M. Chase Forced Out of New York Art School, Triumph for the 'New Movement' Led by Robert Henri," *New York American,* November 20, 1907, 3, illus.). There are no exhibition references to the work under this title.

OP.465

Lady in White, ca. 1906

Oil on canvas; 50½ x 40 in. (128.3 x 101.6 cm)
Signed: Wm. M. Chase (l.r.)

Location unknown

Exhibitions: **FG '27 #7; NG '27 #10; NG '33 #2.**

This is the only extant image of *Lady in White*; it was discovered with some other photographs of Chase paintings in an antique shop on Amelia Island, Florida. The photograph was probably taken by Newhouse Galleries of New York in the 1920s for the catalogue published in conjunction with the Chase memorial exhibition held there March 25–April 25, 1927. This painting is included in Peat's 1949 checklist of Chase's known work as *Lady in White* (C), and as being formerly owned by Newhouse Galleries, New York.

OP.466

Portrait of Mrs. Horace Jayne, ca. 1906

Oil on canvas; 60 x 40 in. (152.4 x 101.6 cm)
Signed: Wm. M. Chase (u.l.)

Location unknown

Exhibitions: **PAFA '07 #330,** illus. as *Portrait
Mrs. Horace Jane* [*sic*] [lent by Dr. Jayne].

Caroline Furness Jayne (1873–1909) was married
to Horace Jayne, a biology professor at the Uni-
versity of Pennsylvania and the daughter of a
Mr. Horace Howard Furness of Philadelphia.
Caroline Furness Jayne wrote a book called
String Figures, expanded to *String Figures and
How to Make Them: A Study of Cat's-Cradle in
Many Lands,* published in 1906. *String Figures* is,
as the title implies, a collection of native string
figures culled from cultures around the world.
The portrait might have been commissioned to
celebrate the publication of Jayne's book. Chase
depicts her as a society lady in an elegant ball
gown with a tiny tiara and seated in an ornate
chair. He places a long feather pen in her lap,
which could suggest her literary avocation. Her
right hand is open and holds an unidentifiable
object, perhaps a piece of string. A critic dis-
cussing the work upon its exhibition in 1907
noted that it "showed [Chase] at his best, and
gave one a most attractive impression of a beau-
tiful woman" (*International Studio* 5 [April 1907]:
162). The portrait is also mentioned in William
H. Downes, "William Merritt Chase, A Typical
American Artist," *International Studio* 39, no. 154
(December 1909): 32, as *Mrs. Dr. Jayne.* This
painting is included on Peat's 1949 checklist of
Chase's known work as *Mrs. Horace Jayne,* and as
being owned by Dr. Horace Jayne.

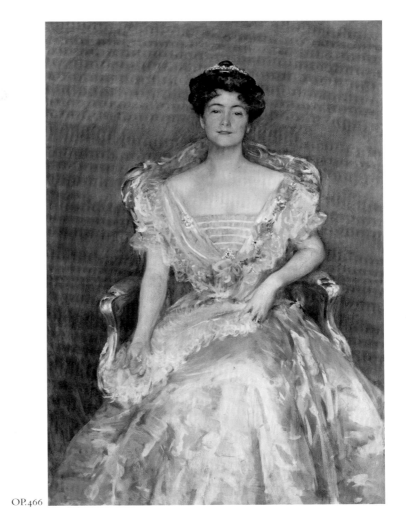

OP.466

OP.467

Portrait of a Woman, ca. 1906

Oil on canvas; 24 x 18 in. (61 x 45.7 cm)
Label verso: affidavit from Douglas John Connah
(Director of New York School of Art), dated Feb-
ruary 6, 1909, testifying that this painting was done
as a demonstration piece by Chase for the New York
School of Art

Location unknown

A demonstration piece by Chase, and one of
many whose attribution was later affirmed via
an affidavit by the director of the New York
School of Art (formerly the Chase School of
Art), Douglas John Connah, likely following the
work's removal from the walls upon the school's
reorganization, and Chase's departure, in 1907.
Demonstration pieces such as this were designed
to highlight the techniques of painting. Chase
would usually use one of his students as a model,
and works of this kind would be completed, in
bravura fashion, in an hour or less. After being
completed they were displayed at the school for
the students to admire and emulate, as well as
for inspiration.

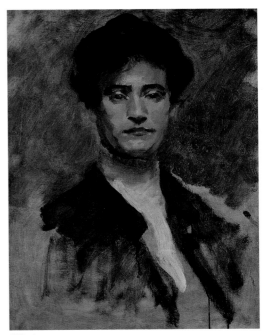

OP.467

OP.468

Portrait of Miss Amy Howe, ca. 1906

Oil on canvas

Location unknown

Exhibitions: **PAFA '07 #336** [lent by Dr. H. M. Howe].

This portrait of Miss Amy Howe (b. 1887) is one of the numerous commissions Chase received to portray socially prominent Philadelphians and their family members. Amy Howe was the daughter of Dr. Herbert M. Howe, who began his career in Philadelphia as a physician, but soon became a powerful figure in the coal and railroad industries. Chase executed the latter's portrait the same year (OP.474). The elder Howe also was an artist and was very involved with the workings of the Pennsylvania Academy of the Fine Arts, upon whose board of directors he served from 1898 until his death in 1916. Amy Howe married Alfred G. B. Steel, a sculptor who also served on the P.A.F.A. board of directors from 1923 until 1933, when he became its president, serving in that capacity until his death in 1949.

The portrait has been illustrated in several publications, including Ernest Knaufft, "Sargent, Chase, and Other Portrait Painters," *American Review of Reviews* 36 (December 1907): 692, illus., and in *The Bulletin of the Brooklyn Institute of Arts and Sciences* 3, no. 18 (January 8, 1910): 462, 463 illus. It is mentioned in William H. Downes, "William Merritt Chase, A Typical American Artist," *International Studio* 39, no. 154 (December 1909): 32. Included, owner unknown, on Peat's 1949 checklist of Chase's known work as *Amy Howe.*

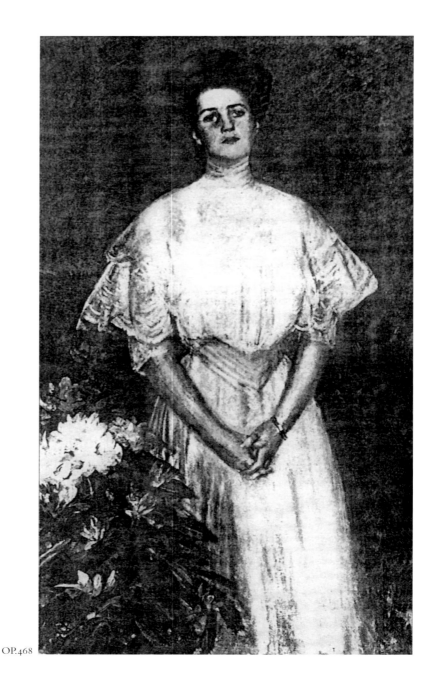

OP.468

OP.469

Portrait of Baroness Ida-Gro Dahlerup, ca. 1907

Oil on canvas; 20 x 16 in. (50.8 x 40.6 cm)
Signed: Wm. M. Chase (l.r.)

Location unknown

Ida-Gro Dahlerup (1899-1997) likely met Chase through her attending the same grammar school as Chase's son Robert Stewart (1898-1987). The Dahlerups had a letter from the Chases, dated August 12, 1907, requesting that the Dahlerup family come to their home in Shinnecock, Long Island, for the next weekend; the letter is signed "Bobbie's Mother" and "Bobbie's big sister

OP.469

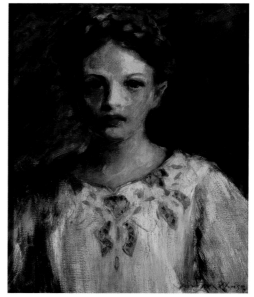

Alice," suggesting the friendship of the children. Ida-Gro Dahlerup remembered the painting's being completed in 1907. The dress in which she was depicted is owned by the Museum of the City of New York and is dated circa 1908, lending credence to Dahlerup's recollection. There are, however, a couple of stylistic factors that suggest a later date, circa 1915, among them the loose handling of the brush—seen most particularly in the treatment of the background—and the rather rough, somewhat heavy-handed application of paint used to create light and shadow on the girl's face. That said, Ida does not appear so old as sixteen in the portrait, and thus the earlier date, circa 1907, is more likely correct. *Portrait of Baroness Ida-Gro Dahlerup* remained in the possession of the sitter's family until 1990.

OP.470

Portrait of Mrs. B. J. Capon, 1907

Oil on canvas; 42 x 36 in. (106.7 x 91.4 cm)
Signed: Wm. M. Chase (l.l.)

Inscribed verso: B.J. Capon (or Capen) Painted by
Wm. M. Chase / New York / 1907

Maier Museum of Art, Randolph-Macon Women's
College, Lynchburg, Va. Gift of Lisa Russell Kurts
'81, 2003

A portrait, probably commissioned, of Mrs. B. J.
Capon, likely completed in New York in 1907.
The sitter holds her eyeglasses in her right hand
and a book in her left. Chase draws particular at-
tention to Mrs. Capon's head and hands through
his use of white in her collar and sleeves.

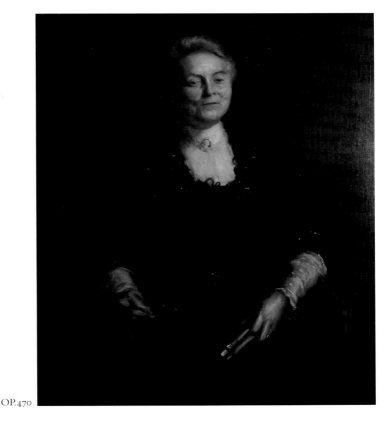
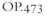
OP.470

OP.471

Robert Stewart Chase, ca. 1906

Oil on canvas; 16 x 13 in. (40.6 x 33 cm) (oval)
No visible signature

Location unknown

A photograph of this painting descended in a
Chase family photograph album. The sitter was
identified by Robin Chase, daughter of Robert
Stewart Chase. The photograph was taken in the
studio of the Chase Shinnecock home, where
Chase spent most of the summer of 1906, when
the work was likely painted. The work is a pen-
dant portrait to that of his son Roland Dana
Chase. As that portrait is signed center right, it is
most likely that this portrait is signed there as
well. Based on the date of 1906, Robert would
have been eight years old.

OP.472

Roland Dana Chase, ca. 1906

Oil on canvas; 16 x 13 in. (40.6 x 33 cm) (oval)
Signed: Wm. M. Chase (c.r.)

Location unknown

Both this portrait of Chase's son Roland Dana
Chase and that of his other son, Robert Stewart
Chase, are unusual in terms of their oval format.
Obviously the two works are pendant portraits.
Based on the date of around 1906, Roland
would have been six years old.

OP.473

Portrait of Pierce Archer, Esq., 1906

Oil on canvas; dimensions unknown
Signed and dated: Wm. M. Chase 1906 (l.l.)

Location unknown

Exhibitions: **PAFA '07 #351**.

Pierce Archer, Jr. (1838-1913), was a prominent
Philadelphia lawyer. This work was included in
William Howe Downes's list of important male
portraits by Chase in "William Merritt Chase, A

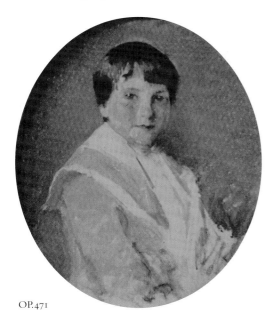
OP.471

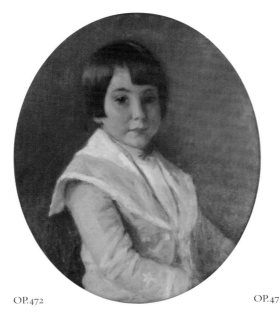
OP.472

OP.473

Typical American Artist," *International Studio* 39, no. 154 (December 1909): xxxii. A photograph of the painting descended in the Chase family and is ink-signed "Haeseler [a photographic studio in Philadelphia] / copy."

OP.474

Portrait of Dr. H. M. Howe, 1906

Oil on canvas; dimensions unknown
Signature not visible on photograph

Location unknown

Exhibitions: PAFA '07 #336.

OP.474

This painting is noted as being among Chase's important portraits of men in William Howe Downes, "William Merritt Chase, A Typical American Artist," *International Studio* 39, no. 154 (December 1909): xxxii. A photograph of the portrait descended in the Chase family. As no signature is visible in the photograph, it might have been taken before the portrait was finished, as Chase invariably signed portrait commissions. Chase also did a contemporaneous portrait of Dr. Howe's daughter Amy Howe (OP.468).

OP.475

Portrait of Rev. Dr. Sparhawk Jones, 1906

Oil on canvas; dimensions unknown
Signed: Wm. M. Chase (l.r.)

Location unknown

Exhibitions: PAFA '06 #44; SWA '06 #90; NAC '10 #16 [lent by Mrs. Jones].

The sitter was a Presbyterian clergyman in Baltimore and Philadelphia, and this work was likely painted in Chase's Philadelphia studio. His daughter was the painter Elizabeth Sparhawk-Jones—unlike her father, she chose to hyphenate her name—who discussed the portrait of her father in an oral interview with Ruth Gurin (Archives of American Art, April 26, 1964: "Chase did a magnificent portrait of my father. It's a little severe, a little aloof, but it's got his

brushwork, the eyes are beautifully done"). The portrait was reproduced in E. Knaufft, "Sargent, Chase and Other Portrait Painters," *American Review of Reviews* 36 (December 1907): 393, and J. W. Pattison, "William Merritt Chase, N.A.," *House Beautiful* 25 (February 1909): 50. William Howe Downes included the work as being among Chase's most important portraits in "William Merritt Chase, A Typical American Artist," *International Studio* 39, no. 154 (December 1909): xxxii, and it appeared in Katharine Metcalf Roof's article "William Merritt Chase, An American Master," *Craftsman* 18 (1910): 38. The painting, owner unknown, is included in Peat's 1949 checklist of Chase's known work.

OP.476

Sydney F. Tyler, Esq., 1906

Oil on canvas; 30 x 24½ in. (76.2 x 62.2 cm)
Signed: Wm. M. Chase (l.l.)
Inscribed (verso): Sidney F. Tyler, Esq. / Painted by WM Chase / 1906 / Phil[.] / Pa[.]

James R. and Annette M. Orosco Collection

Sydney F. Tyler (1850–1936) was a Harvard-trained lawyer and banker who lived in Philadelphia. The portrait was done at a time when Chase maintained a studio in Philadelphia, where he painted many portraits of the leading city denizens of the day. There is also a portrait of a Mrs. Tyler of Philadelphia, circa 1908 (OP.494), likely a relative of Sydney Tyler.

OP.475

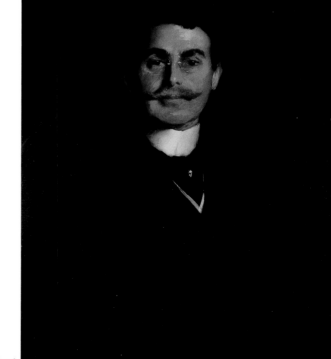

OP.476

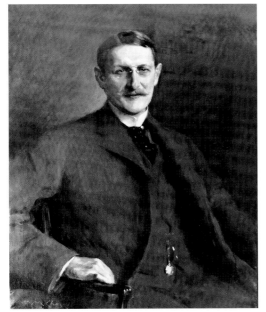

OP.477

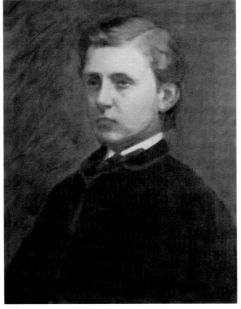

OP.478

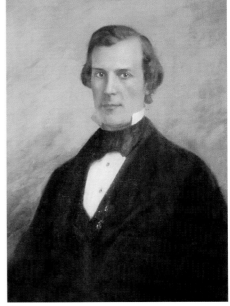

OP.479

OP.477

Portrait of George H. Earle, Jr., ca. 1907

Oil on canvas; 34 x 28 in. (86.4 x 71.1 cm)
Signed: Wm. M. Chase (l.l.)

Collection of Charles E. Mather III

Exhibitions: **PAFA '08 #175.**

George H. Earle, Jr. (1860-1929), was a Philadelphia businessman who in 1894 purchased the Choctaw Coal and Railway Company with several businessmen including Sydney F. Tyler, whose portrait Chase had also painted (OP.476). Earle was a member of the Philadelphia Art Club. He ran, unsuccessfully, for mayor of Philadelphia in 1911 on the Republican ticket. His son, George H. Earle, III, was, however, elected governor of Pennsylvania, albeit as a Democrat. This work was referenced in William Howe Downes, "William Merritt Chase, A Typical American Artist," *International Studio* 39, no. 154 (December 1909): xxxii, as being "an aristocratic elderly personage." A photograph of this painting descended in the Chase family.

OP.478

George H. Earle, Jr., ca. 1907

Oil on canvas; 22 x 17 in. (55.9 x 43.2 cm)
Signed: Wm. M. Chase (l.r.)

Collection of George Earle

George H. Earle, Jr. (1860-1929), descended from a line of prominent Philadelphia lawyers and politicians, and his son, George H. Earle III (1890-1974), was governor of Pennsylvania from 1935 until 1939. In 1911 George H. Earle, Jr., ran an unsuccessful campaign for mayor of Philadelphia. As he was a member of the Philadelphia Art Club, he would have known Chase and likely been aware of his work as a portraitist of other prominent Philadelphians. What is most interesting is the number of family-member portraits he commissioned from Chase, starting with the posthumous portrait of his grandfather, Thomas Earle (OP.481). While Chase also painted a contemporary portrait of George H. Earle, Jr., in 1907 (OP.477), he painted this portrait of the sitter at the age of twelve years old, after a photograph of circa 1872.

OP.479

George H. Earle, Sr., ca. 1907

Oil on canvas; 30 x 24 in. (76.2 x 63.5 cm)
Signed: Wm. M. Chase (l.r.)

Collection of George H. Earle

This portrait of George H. Earle, Sr. (1823-1907), is one of a series of portraits likely commissioned by the sitter's son. In this case, the painting is after a circa 1850 photograph of the sitter. George H. Earle, Sr., was a Philadelphia lawyer and son of Thomas Earle (see OP.481). Chase did a second portrait of George H. Earle, Sr., around the same time (OP.480).

OP.480

George H. Earle, Sr., ca. 1907

Oil on canvas; 30 x 24 in. (76.2 x 64.5 cm)
Signed: Wm. M. Chase (l.l.)

Collection of George Earle

This portrait of George H. Earle, Sr. (1823-1907), was likely commissioned by his son, George H. Earle, Jr.—it is either based on a late photograph, or was painted just prior to the sitter's death in 1907.

OP.480

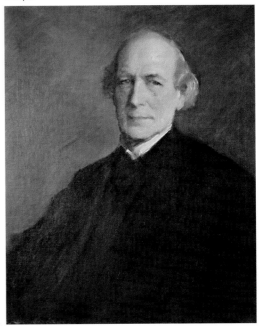

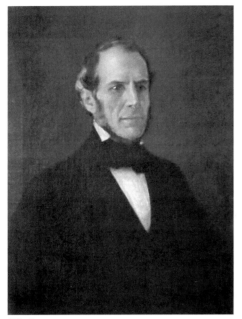

OP.481

OP.481

Thomas Earle, ca. 1907

Oil on canvas; 30 x 24 in. (76.2 x 64.5 cm)

Collection of George H. Earle

Around 1907 Chase likely was commissioned by George H. Earle, Jr., to paint a series of portraits of Earle family members. By family tradition, the commission also included this posthumous portrait after a daguerreotype, possibly circa 1845 (the first American-made daguerreotype dates to 1839), of the grandfather of George H. Earle, Jr., Thomas Earle (1796–1845). Thomas Earle was a prominent member on the political scene of Pennsylvania, and in 1840 ran unsuccessfully for vice-president of the United States on the Liberty Party ticket. He is best known as the father of the convention to revise the Pennsylvania constitution in 1838.

OP.482

Thomas J. Dolan, Esq., ca. 1907

Oil on canvas; dimensions unknown
Signature unknown

Location unknown

Exhibitions: **PAFA '07 #419** [lent by owner].

This work was referenced (p. xxx) and illustrated (p. xxxvi) in William Howe Downes, "William Merritt Chase, A Typical American Artist," *International Studio* 39, no. 154 (December 1909): "Another of his most successful portraits of men

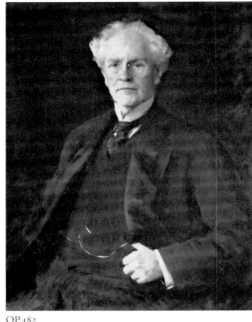

OP.482

is the *Thomas Dolan, Esq.,* in which the head is strongly and studiously characterized, and one receives the impression of a sagacious and well-balanced type of character, both shrewd and kindly." The portrait, owner unknown, was included in Peat's 1949 checklist of Chase's known work.

OP.483

Head of an Old Man, ca. 1907

Oil on canvas; 24 x 19½ in. (61 x 49.5 cm)
Signed: Chase (l.l.)

Location unknown

Auctions: **Csale '17 #274** (fully described).

OP.483

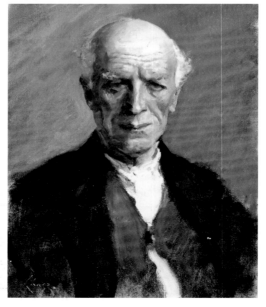

It is likely that this portrait was painted as a demonstration piece at the New York School of Art. This painting appears on Peat's 1949 checklist of Chase's known work as being owned by Charles F. Williams, Cincinnati.

OP.484

Head of a Young Roman/A Young Roman, ca. 1907

Oil on canvas; 28½ x 22 in. (72.4 x 55.9 cm)
Signed: Wm. M. Chase (l.r.)

Terra Museum of American Art, Chicago

Exhibitions: **CI '08; CGA '08 #70; TAP '08 #7** (illus. in a review of this exhibition by J. B. Townsend, "Annual Exhibit of the Ten," *American Art News* [1908]: 2, as *A Young Roman*).

This work is cited in William Howe Downes, "William Merritt Chase, A Typical American Artist," *International Studio* 39, no. 154 (December 1909): xxxii: "The *Young Roman* is a vivid, picturesque sketch of a keen-eyed Italian type; a frank, bold and attractive presentation of a decided temperament." The portrait was probably painted in the summer of 1907, while Chase was conducting a summer class for American students in Florence. He also visited Venice and most likely Rome that same summer. The painting is included in Peat's 1949 checklist of Chase's known work.

OP.485

Cadwallader Washburn, ca. 1907

Oil on canvas; 36 x 30 in. (91.4 x 76.2 cm)
Signed: Wm. M. Chase (l.r.)

The Parrish Art Museum, Southampton, Long Island, N.Y. Littlejohn Collection

Exhibitions: **TAP '07 #4** [lent by C. Washburn]; **PAFA '08 #172** (reproduced in exhibition catalogue, also illustrated in *International Studio* 34 [March 1908]: xxxvi, and in *Palette and Brush* 1 [October 1908]: 12); **AIC '09 #52** [owned by C. Washburn]; **AFA '16 #12.**

Cadwallader Lincoln Washburn (1866–1965) studied with Chase at the Art Students League and, starting in 1893, at the Shinnecock Summer School of Art, where he returned for several more summers. Because he was deaf and mute, he was known as the "silent artist." He later took up etching and today he is well known for his

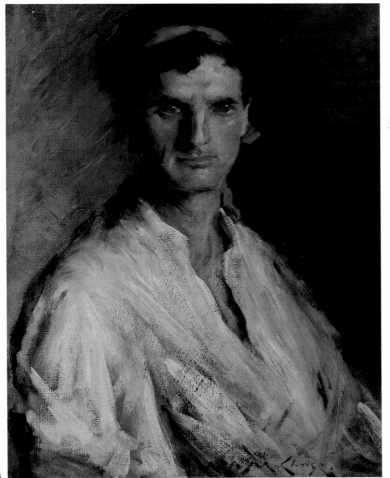

OP.484

work in this medium. In 1916 the American Federation of the Arts toured an exhibition titled "Portraits in Oil by American Painters," and one of the museums on the tour was the Minneapolis Institute of Arts. Washburn was born in Minneapolis and the museum *Bulletin* for 1916 noted in a review of the exhibition that "Chase's portrait of Cadwallader Washburn is of particular interest locally." The portrait is included in Peat's 1949 checklist of Chase's known work.

OP.486

James Monroe Taylor, D.D., President of Vassar College, 1907

Oil on canvas; 50 x 40¼ in. (127 x 102.2 cm)
Signed: Wm. M. Chase (l.l.)

Vassar College Art Gallery, Poughkeepsie, N.Y.

Exhibitions: **NAD '07** #40 [lent by Vassar College].

James Monroe Taylor was president of Vassar College, 1886–1914. A review of the Annual Spring Exhibition held at the National Academy of Design in 1907 noted that "Mr. Chase has a portrait of J. M. Taylor, D.D., President of Vassar College on line in the South Gallery" (C. Augusta Owen, "The Spring Exhibition at the Academy," *Town and Country,* April 6, 1907). The painting was referenced in William Howe Downes, "William Merritt Chase, A Typical American Artist," *International Studio* 39, no. 154 (December 1909): xxxii, as being one in an important series of portraits of men. It was also noted in

OP.486

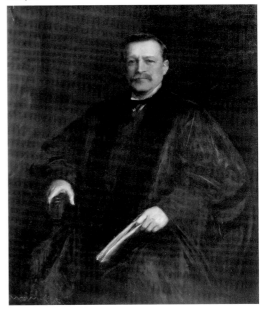

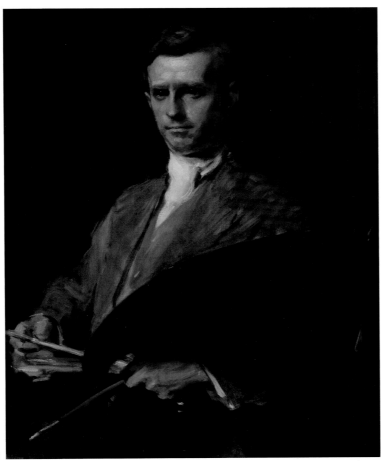

OP.485

an article by A. Hoeber, "American Artists and Their Work: II/William Merritt Chase," *Woman's Home Companion* 37 (September 1910): 51. The painting is included in Peat's 1949 checklist of known work. Chase's portrait of Dr. Taylor was said to have been repainted in 1938 by a Mr. Bye for "purposes of improvement." The work is mentioned in Katharine Metcalf Roof's 1917 biography of the artist.

traveled to New York to pose for the portrait. The class had raised enough money to pay for a head-and-shoulders portrait; however, Chase felt the sitter's hands needed to be included and he therefore painted them in for the "head-and-shoulders" price.

OP.489

W. J. Curtis, Esq.

Medium and dimensions unknown (presumably oil on canvas)
Image unknown

Exhibitions: **NAD** '08 **#183** [lent by W. J. Curtis].

There is another portrait of W. J. Curtis [Bowdoin College, Brunswick, Maine] that is dated 1915 on the canvas in the hand of the artist, which clearly denotes there are two portraits of W. J. Curtis.

OP.490

Portrait of Martha Walter, ca. 1908

Oil on canvas; 20 x 16 in. (50.8 x 40.6 cm)
Signed: Chase (m.r.)
Labels on back: David David, Inc., Philadelphia; Mr. Merton Shapiro, Philadelphia

Location unknown

This portrait depicts Martha Walter (1875–1976), who grew up in Philadelphia and studied with Chase at the Pennsylvania Academy of the Fine Arts. She then went to Paris and worked with

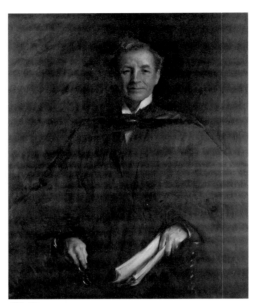

OP.487

OP.488

OP.487

William Rockhill Nelson, 1907

Oil on canvas; 70 x 36 in. (177.8 x 91.4 cm)
Signed and dated: Wm. M. Chase 1907 (l.l.)

The Nelson-Atkins Museum of Art, Kansas City, Mo. Gift of Mr. and Mrs. Albert R. Jones (34-316)

William Rockhill Nelson founded the museum in Kansas City, Missouri, that bears his name.

OP.488

William Waugh Smith, 1907

Oil on canvas; 30 x 25 in. (76.2 x 63.5 cm)
Signed: Wm. M. Chase (l.l.)

Maier Museum of Art, Randolph-Macon Woman's College, Lynchburg, Va. Gift of the Class of 1907

Dr. William W. Smith was a founder and the first president of Randolph-Macon Woman's College, Lynchburg, Virginia, from 1893 until 1912. The portrait was commissioned by the Class of 1907, and Dr. Smith was said to have

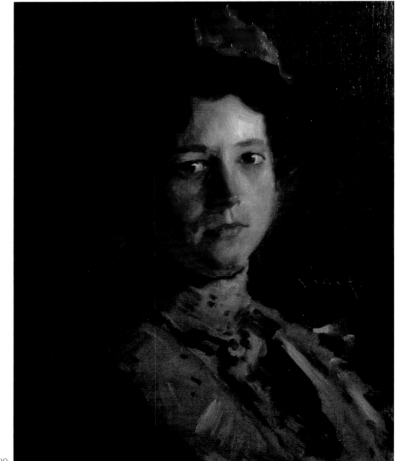

OP.490

Prinet, Menard, and Simon. Walter was one of Chase's most promising students, winning the Toppan Prize in 1902 and a two-year Cresson Traveling Scholarship in 1903. The latter award enabled her to travel to Italy, Holland, and Spain. In 1909 she won the Academy's Mary Smith Prize for the best work done by a woman. She exhibited in the annuals there for over fifty years, winning a gold medal in 1923. This portrait is a demonstration piece, executed during Walter's studies with Chase; it was not exhibited during the artist's lifetime, but rather remained in Walter's collection until her death in 1976.

OP.491

Mrs. Henry Pepper Vaux (Frances Alice Cramp), ca. 1908

Medium/support/dimensions unknown

Location unknown

Exhibitions: **PAFA '09 #137** [owned by Theodore W. Cramp].

This portrait is presumed lost and there is no extant image of it. The sitter is Frances Alice Cramp (1888–1953), who married Henry Pepper

Vaux (1879–1953), a banker descended from an old Philadelphia family, in 1907. Chase also executed a portrait of Henry Pepper Vaux (OP.462), likely intended as a companion portrait to the painting of his wife. The owner of the portrait of Mrs. Henry Pepper Vaux when it was exhibited at the Pennsylvania Academy of the Fine Arts in 1909 was Theodore W. Cramp (1861–1923), Frances's father, of whom Chase had also painted a portrait (OP.492), which was likewise included in this show. This portrait, owner unknown, is included on Peat's 1949 checklist of Chase's known work.

OP.492

Portrait of Theodore W. Cramp, ca. 1908

Oil on canvas; dimensions unknown
Signed: Wm. M. Chase (l.l.)

Location unknown

Exhibitions: **PAFA '09 #162.**

A photograph of this portrait descended in the Chase family. Theodore W. Cramp worked in the family business, Wm. Cramp and Sons Ship and Engine Building Company, Philadelphia. His

home, on Rittenhouse Square, now serves as the library for the Curtis Institute of Music. As the house was built in 1908, it is possible his portrait was commissioned to hang in a designated space in the house. Cramp was also a member of the Art Club of Philadelphia and thus would have been very aware of Chase's talents. Chase also completed a portrait of the sitter's daughter, Frances Alice Cramp (OP.491), and her husband, Mr. Henry Pepper Vaux (OP.462). This work is included in William Howe Downes's list of important male portraits by Chase in "William Merritt Chase, A Typical American Artist," *International Studio* 39, no. 154 (December 1909): xxxii, and the sitter noted as being from Philadelphia. The portrait, collection unknown, is included in Peat's 1949 checklist of Chase's known work.

OP.493

Portrait of Mrs. Victor Mather, ca. 1908

Oil on canvas; 60 x 35½ in. (152.4 x 90.1 cm)

Private collection, Sewickley, Pa.

Exhibitions: **PAFA '08 #616** [lent by George H. Earle, Jr.].

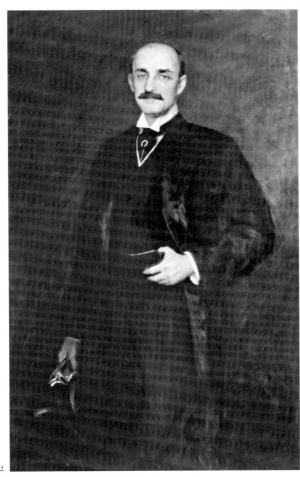

OP.492

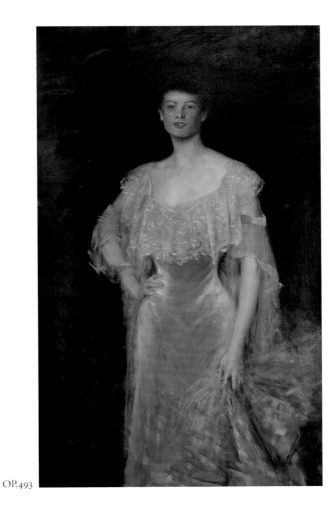

OP.493

The subject of this portrait is Mrs. Catherine Earle Mather (b. 1883), a daughter of George H. Earle, Jr. (1860–1929), and wife of Victor Mather (1880–1943). Chase completed numerous portraits of members of the Earle family (see OP.365, 434, and 477–81). The painting is included on Peat's 1949 checklist of Chase's known work as *Mrs. Victor Mather,* owner unknown.

OP.494

Mrs. Tyler of Philadelphia, ca. 1908

Medium/support/dimensions unknown
Signed: Wm. M. Chase (m.l.)

Location unknown

This oval painting, likely a commissioned work, depicts Mrs. Stella Elkins Tyler (b. 1884) of Philadelphia, a painter, sculptor, and well-known patroness of the arts in that city who was likely a relative of Sydney F. Tyler, whose portrait Chase painted in 1906 (OP.476). William Howe Downes described the present work as "An oval bust portrait of a pretty young woman, with fine eyes, who wears a décolleté white gown with a rose at the corsage, a pearl collar and chain. Her face is piquant, alert and spirited in its expression, with a faint hint of latent mockery" ("William Merritt Chase, A Typical American Artist," *International Studio* 39, no. 154 [December 1909]: 30). The painting was also illustrated in James Pattison, "William Merritt Chase, N.A.," *House Beautiful* 25, no. 3 (February 1909): 49, illus. on cover. Included, owner unknown, on Peat's 1949 checklist of Chase's known work as *Mrs. Tyler.*

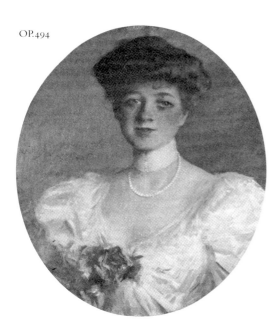

OP.494

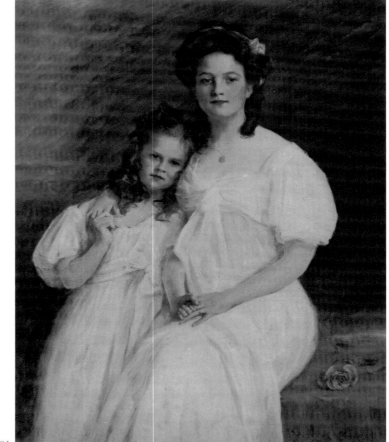

OP.495

OP.495

The Misses Gribell [sic], ca. 1906

Medium/support/dimensions unknown
Signed: Wm. M. Chase (l.r.)

Location unknown

This painting is likely a commissioned portrait of the two Gribbell sisters, Idella (b. 1888) and Elizabeth (b. 1897), of Pennsylvania. The painting was illustrated in the *New York Times,* Dec. 16, 1906, x4. William Howe Downes described the painting as "two sisters in white, the younger girl leaning against her elder sister's shoulder. The easy girlish poses are not too formally disposed, and the interlocked fingers of all the hands provide a pleasant hint of the reality of the relationship thus candidly proclaimed" ("William Merritt Chase, A Typical American Artist," *International Studio* 39, no. 154 [December 1909]: 32, illus.). The work was illustrated in James W. Pattison, "William Merritt Chase, N.A.," *House Beautiful* 25, no. 3 (February 1909): 51, illus. There are two photographs of the painting in the Chase Archives, Parrish Art Museum, Southampton, Long Island, New York, one of which is labeled "'The Misses Gribell' [sic] by Wm. M. Chase." This painting is included on Peat's 1949 checklist.

OP.496

The Red Kimona (A Girl in Red), ca. 1908

Oil on canvas; 33½ x 28¾ in. (85.1 x 73 cm)
Cut down after Chase's death from a full-length picture to just below the sitter's hips; measurements of the original work were 78½ x 36 in.; original work was signed "Wm. M. Chase" (l.l.)

Private collection

Exhibitions and Auctions: **BFAA '09 #8** as *The Red Kimona* [lent by the artist] ("The Paintings by Mr. Chase," *Academy Notes* 4 [February 1909]: 149); **NAC '10 #142** [lent by the artist]; **PAFA '11 #564** as *A Girl in Red*; **DMA '16,** probably as #17 (traveled to **TMA '16 #117** as *A Girl in Red*; **Csale '17 #385** as *A Girl in Red* [purchased, M. Knoedler and Company, N.Y., $260]; **CI '22 #46,** illus. as *Girl in Red* (full-length).

The model for this painting was the artist's daughter Dorothy Brémond Chase (1891–1953). The painting was probably executed circa 1908, at which point Dorothy would have been about seventeen years old. This work is one of a series of paintings of models posed in Japanese costumes, beginning as early as the late 1880s, for which Chase gained critical acclaim. In this example Chase dramatically contrasted the

bright red hue of the kimono against a black background, adding delicate gold patterns on the young woman's garment. Chase used a particularly coarse canvas for many of his larger works during this period, and the present work is no exception. His likely intent in doing so was to have the heavy weave of the canvas break up the pigment, thereby giving the work something of an effect similar to that achieved by the Impressionists. The painting was cut down, likely after 1949, though a photograph of the full-length version (labeled *A Girl in Red* on the verso and providing the original dimensions) descended in the Chase family (OP.496A). It was not uncommon for Chase to cut down paintings later in his career, likely in an effort to bestow upon them a more modern effect associated with the French Impressionists, as well as to make them more practical for hanging in private homes; the practice was carried on even after the artist had died, often at the recommendation of fellow artists and friends of the painter. The portrait

is included, owner unknown, on Peat's 1949 checklist of Chase's known work as *The Red Kimono: Girl in Red* (C) and with its original dimensions.

OP.497

Portrait of Rockwell Kent, 1908

Oil on canvas; 22 x 18 in. (55.9 x 45.7 cm)

Location unknown

A photograph of this work, identified as being a portrait of Rockwell Kent and dated 1908 (verso), was given to Ronald Pisano by Dick Larcada, whose gallery at the time represented the estate of Rockwell Kent. This second portrait of Kent—the first was completed circa 1898 (OP.262)—was referenced in a 1969 interview of Kent by Paul Cummings that was published in the Archives of American Art *Journal* 12, no. 1 (January 1972).

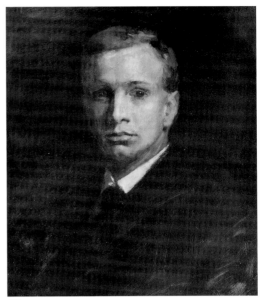

OP.497

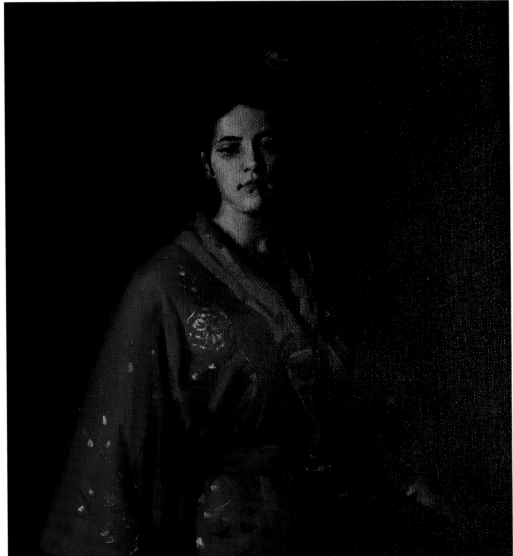

OP.496

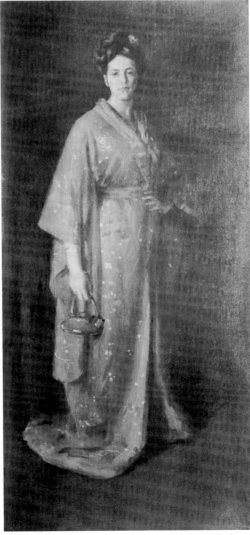

OP.496A. Photograph of *The Red Kimona* as a full-length portrait

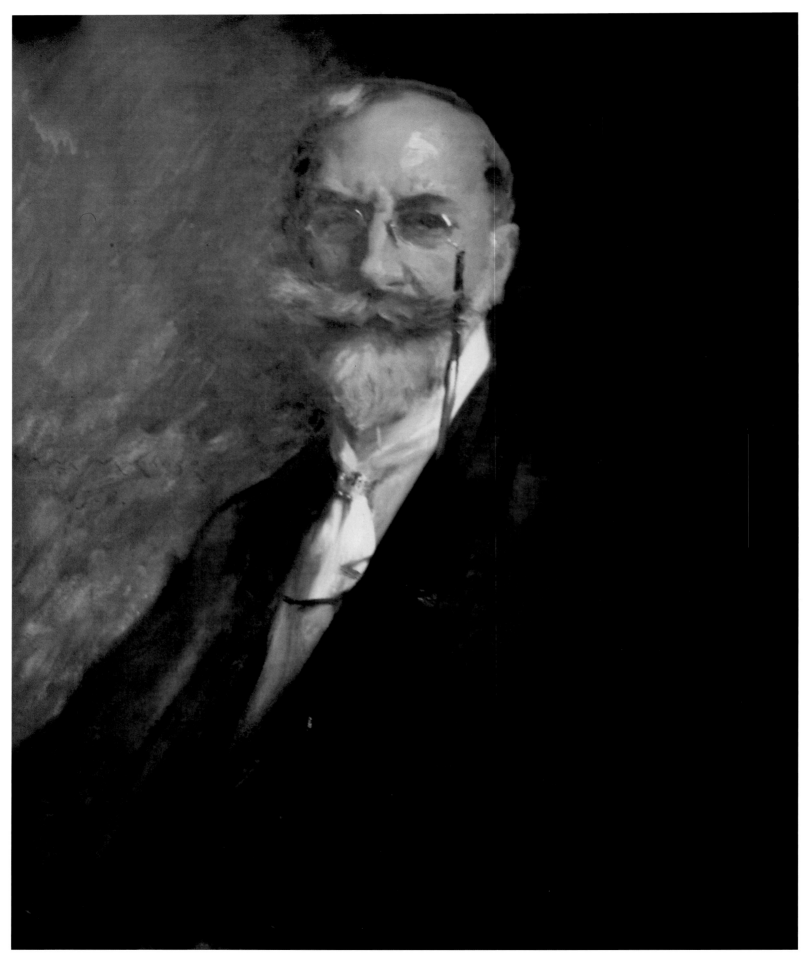

OP.498

Kent stated, "I have a portrait in our bedroom done by Chase then [referring to the three summers he studied at the Shinnecock Summer School of Art, 1900-1902]." The original transcript of the interview also included Kent's observation, "I think it doesn't look much like [me], but it's a good picture" (Archives of American Art, RKP 5194/409) (this information was generously supplied by Kent scholar Jake Milgram Wien). The circa 1901 portrait of Kent had been sold in the Chase estate sale of 1917, and later, in 1923, given to the Portland Museum of Art, Maine, making it abundantly clear that Kent was referring to the second, and later, portrait—although the date given this second portrait of 1908, if correct, means it was not done at the Shinnecock Summer School of Art, which held its last session in 1902.

OP.498

Self-Portrait (Auto-ritratti), 1908

Oil on canvas; 29 x 23 in. (73.7 x 58.4 cm)
Signed and dated: Wm. M. Chase / 1908 (c.l.)

Uffizi Gallery, Florence, Italy

An article in *Putnam's Magazine* 5 (December 1908): 372, discusses the circumstances behind the painting of this self-portrait: "While driving to the railway station in Florence, in the summer of 1907," writes an old friend and contributor, "I came suddenly upon the familiar face and figure of William M. Chase, who looked as much at home under Italian skies as on Broadway or Fifth Avenue. I hadn't time to stop and hail him, and I didn't see him again till we were both back in New York. I then mentioned the incident to him, and in the course of a little chat about the city of the Medici and Michelangelo, he told me that he had just received the very great compliment of being asked to paint his portrait for the Uffizi Gallery" (illus. p. 373). The Chase portrait, painted in the summer of 1908, was the third self-portrait by an American artist to enter the Uffizi self-portrait collection, the two others being self-portraits by G.P.A. Healy and John Singer Sargent, though another of Chase's self-portraits did find its way into the Uffizi (see OP.502). The work was also illustrated in "Letters and Art," *Delineator* (December 1908): 967; William Howe Downes, "William Merritt Chase, A Typical American Artist," *International Studio* 39, no. 154 (December 1909): xxxiv; *Putnam's Magazine* 7 (March 1910): 757; and *American Art News* 11 (October 12, 1912): 3. The painting is included in Peat's 1949 checklist of Chase's known work as *Self-Portrait* (E).

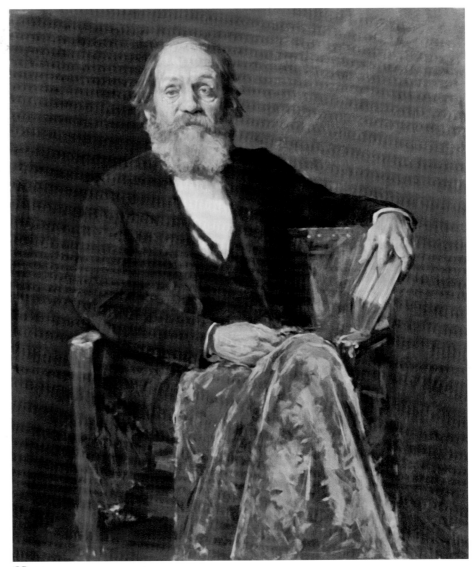

OP.499

OP.499

Edward Everett Hale

Oil on canvas; 48 x 31 in. (121.9 x 78.7 cm)

Location unknown

Auctions: **Csale '17 #186** [purchased, Thomas P. August, $110].

This work—Chase's second portrait of this sitter; the first was completed circa 1900 (OP.288)—was sold in the 1917 Chase sale and is fully described in the auction catalogue. The entry noted the work had been painted in the Tenth Street Studio. Edward Everett Hale (1822-1909) was a noted clergyman and writer, perhaps best remembered as the author of "A Man Without a Country," *Atlantic Monthly* (December 1863). He was also chaplain of the U.S. Senate from 1903 until 1909. On a more arcane note, he and fellow Harvard student Samuel Longfellow, brother of Henry Wadsworth Longfellow, were reported to have been the first Americans to make a photographic image (1839) via Talbot's calotype process. Chase's painting of Hale was purchased from the estate sale by Thomas P. August. As the work was unsigned, the family seal in red wax was to have been affixed to it; a letter from the American Art Association (auctioneers) dated May 18, 1917, to Mr. August discusses the seal: "We are enclosing herewith the official Chase family seal in wax, and ask that you kindly glue this seal to the painting you purchased, authenticating the sale from which the painting was bought." The following year, a notarized statement from H. A. Hammond Smith was sent to the owner: "This painting of which this is a photograph, which was sold at the American Art Association by the executors of the Estate of Wm. M. Chase, is undoubtedly by Mr. Chase—although it does not bear his signature. I knew the painting while

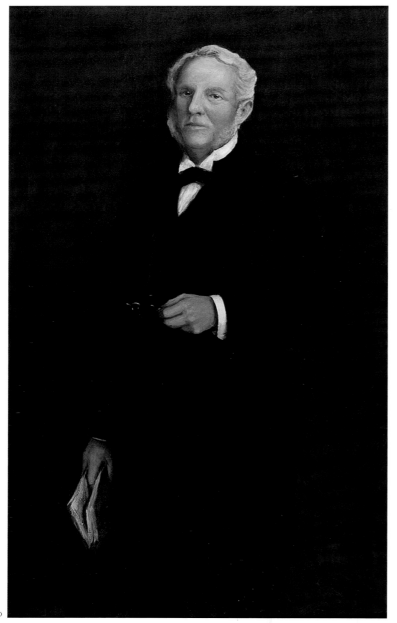

OP.500

Auctions: **Csale '17 #72** (Head and shoulders of a man in the prime of life, with chestnut hair and light moustache and rosy complexion, facing front. He wears a blue suit and dark red scarf, and is placed against a dark brown background. *Note:* Canvas is stretched at 23 x 19 inches, but a memorandum and the painting of the background indicate Mr. Chase's intention to cut it down to the figures given above).

John Gilmer Speed (1854–1909) was general manager of the *World,* and a grandnephew of the poet John Keats. This portrait is included in Peat's 1949 checklist of Chase's known work as being owned by Young's Art Gallery, Chicago.

OP.502

Self-Portrait

Oil on canvas; dimensions unknown
Signed: Wm. M. Chase (u.r.)

Uffizi Gallery, Florence, Italy. Gift of Sir Harold Acton

A photograph of this work descended in the Chase family with the following notation on the back: "Wm. M. Chase painted by himself in Florence." The photograph also includes an embossed stamp, "FOTOGRAFIA REALI." In the early 1990s Ronald G. Pisano was in touch with Sir Harold Acton, who owned a villa in the hills of Fiesole, next door to the Villa Silli. Sir Harold told Pisano that the family owned a Chase self-portrait, and it is possible that this is that paint-ing. After the death of Sir Harold the painting was given to the Uffizi Gallery, Florence, owner of another of Chase's self-portraits (OP.498).

it was in his possession as it was one of a number of his portraits which he asked me to clean and varnish some years ago. While he usually signed his canvases he did not invariably do so as I recall his once coming to my studio to affix his signa-ture to a portrait he had painted some thirty years previously, having been requested to do so by the owner for whom I had just lined and cleaned it." The statement is dated January 14, 1918. The work was reproduced in the *New York Tribune,* November 4, 1917, as being owned by Mr. August, and on loan to the Boston Museum of Fine Arts. Edward Everett Hale's son, Philip Leslie Hale, and his daughter, Ellen Day Hale, were both artists. Of added note, Philip studied with Chase privately in about 1883; his wife, Lil-lian Westcott Hale, studied under Chase at the Shinnecock Summer School of Art. The paint-ing, owner unknown, is included in Peat's 1949 checklist of Chase's known work.

OP.500

Portrait of Albert Harkness, 1908

Oil on canvas; 59½ x 35½ in. (151.1 x 90.2 cm)
Signed: Wm. M. Chase (l.l.)

Brown University, Providence, R.I. Gift of Alfred Williams Anthony, 1908

Albert Harkness (1822–1907) taught Greek at Brown University from 1855 to 1892.

OP.501

Portrait of John Gilmer Speed

Oil on canvas; 20 x 14 in. (50.8 x 35.6 cm)
Estate seal

Location unknown

OP.503

De Forrest Willard

Oil on canvas; 36 x 29 in. (91.4 x 73.7 cm)
Signed: Wm. M. Chase (l.l.)

University of Pennsylvania Art Collection, Philadelphia

This work is noted as being owned by the Uni-versity of Pennsylvania in Katharine Metcalf Roof's 1917 biography of the artist. It is also included in Peat's 1949 checklist of Chase's known work. De Forest Willard (1846–1910) was born in Connecticut, and received his medical degree from the University of Pennsylvania, where he served on the faculty for most of his life, becoming professor of Orthopedic Surgery in 1903. He was lame himself, which no doubt

OP.501

OP.503

OP.502

prompted him to specialize in orthopedic surgery for children. He was, in fact, one of the organizers of the Agnew ward for crippled children at the university hospital, and he advised Peter A. B. Widener in the planning of the Widener Memorial Industrial Training School for Crippled Children, for which he served as surgeon-in-chief.

OP.504

John Brock, Esq.

Physical properties unknown

Location unknown

This work was included on the list of "an important series of portraits of men," in William Howe Downes, "William Merritt Chase, A Typical American Artist," *International Studio* 39, no. 154 (December 1909): xxxii.

OP.505

Portrait of Mr. Foltz, ca. 1909

Physical properties unknown

Location unknown

Exhibitions: **NAD** '10 #8 [Mr. Foltz—owner].

OP.506

OP.506

Portrait of Frederick Augustus Guild, ca. 1909

Oil on canvas; 27 x 22 in. (68.6 x 55.9 cm)
Signed: Wm. M. Chase (l.l.)

Michael Connors Gallery

Frederick Guild was a chemist who worked for the Colgate Company for almost fifty years, and was very well known at the time as the person who developed the "cashmere bouquet" scent. Although the family believed the portrait to have been painted in the mid-1880s, it was more likely painted about 1909, the year Mr. Guild died.

OP.507

Portrait of Spencer Kellogg, Esq.

Oil on canvas; dimensions unknown
Signature unknown

Location unknown

Exhibitions: **NAC '10 #12** [lent by the sitter] (Katharine Metcalf Roof mentions this work in an article "William Merritt Chase: An American Master," *Craftsman* 18 [April 1910], in her review of the NAC exhibition: "Spencer Kellogg—excellent technically—portrays 'unmistakably the environment and atmosphere' of the sitter"); **NAD '10 #229**; **BFAA '10 #31** (exh. cat. illus. p. 19) [lent by the sitter].

Spencer Kellogg, Jr. (1861–1938), of Buffalo, New York, was expected to join the family business, which involved the production of linseed oil.

However, he instead wanted to become a book-shop owner and own a hand-printing press. He studied briefly at the Art Students League, likely under Chase, and had the financial wherewithal to eventually own the bookshop he always wanted. More important, he purchased the hand press, once owned by William Morris, on which the "Kelmscott Chaucer" had been printed. Today Kellogg is best remembered as an artistic printer. This painting, owner unknown, appears in Peat's 1949 checklist of Chase's known work.

OP.508

Ethan Allen Hitchcock, ca. 1909

Oil on canvas; 61½ x 40 in. (156.2 x 101.6 cm)
Signed: Wm. M. Chase (l.l.)

Office of the Secretary, United States Department of the Interior, Washington, D.C.

The sitter was secretary of the interior from 1899 until 1907. The work was illustrated in the *Bulletin of the Institute of Arts and Sciences* (Brooklyn) 3 (January 8, 1910): 461, and there is a biography of the sitter on pages 462–64. The painting no doubt was meant to commemorate the sitter's tenure as secretary of the interior, starting in the administration of President William McKinley (1897–1901) and ending during that of Theodore Roosevelt (1901–9). The work, owner unknown, is included in Wilbur Peat's 1949 checklist of Chase's known work.

OP.509

Mrs. Charles Scott, Jr., ca. 1909

Oil on canvas; 50½ x 36 in. (128.3 x 91.4 cm)
Signed: W M Chase (l.l.)

Pennsylvania Academy of the Fine Arts, Philadelphia. Gift of the Misses Scott, Philadelphia, 1935 (1935.1)

Exhibitions: **PAFA '09 #603** as *Mrs. Charles Scott, Jr.*

1909 marked Chase's final year as an instructor at the Pennsylvania Academy of the Fine Arts, though he maintained a studio there through 1913. The portrait, doubtless a commissioned work, depicts Ellen M. Scott (Mrs. Charles Scott, Jr.; b. 1866). The painting remained in the Scott family until the daughters of the sitter,

OP.507

OP.508

OP.509

Alice and Letitia Scott, donated the work to the Academy. The painting, owner unknown, is included on Peat's 1949 checklist of Chase's known work as *Mrs. Charles Scott*.

OP.510

Attilla Cox, Esq., 1909

Oil on canvas; 38½ x 33¼ in. (97.8 x 84.5 cm)
Signed: Wm. M. Chase (l.r.)
Noted (verso): Attilla Cox Esq. Painted by
W. M. Chase, New York, 1909

Carrie A. Moore, Ridgefield, Conn.

Exhibitions: **LAAE '13** (illustrated on cover of exhibition catalogue).

Attilla Cox was one of the founders, in 1909, of the Louisville Art Association, Kentucky, whose purpose was to "open up vistas of art and art appreciation to a city which had been deprived of what should have been a natural enrichment

OP.510

of its life." The founding of the Louisville Art Association no doubt occasioned the portrait of Cox. It has descended in the family of Attilla Cox to its current owner. The work is included in Peat's 1949 checklist of Chase's known work.

OP.511

Mr. Francis Sullivan, ca. 1909

Presumably oil on canvas; dimensions unknown
Signature not visible

Reference to this painting was made in the article "William Merritt Chase, A Typical American Artist," by William Howe Downes, *International Studio* 39, no. 154 (December 1909): xxxii, cited as being among "an important series of portraits of men." It is possible that the sitter is the father of, or in someway related to, the twin brothers Arthur White Sullivan and Francis William Sullivan, who married respectively Chase's daughters Alice Dieudonnée and Koto Robertine Chase. A photograph identifying the sitter descended through Chase's family.

OP.512

George Keats, 1910

Oil on canvas; 28 x 22 in. (71.1 x 55.9 cm) (oval)
Signed verso

Location unknown

Included in Peat's 1949 checklist of Chase's known work as being in the collection of Mrs. Arthur White Sullivan, Chase's daughter Alice.

OP.513

Master Roland Dana Chase, 1910

Oil on canvas; 72 x 36 in. (182.9 x 91.4 cm)
Signed: Wm. M. Chase (u.r.)

The Parrish Art Museum, Southampton, Long Island, N.Y. Littlejohn Collection

Auctions: **Csale '17 #383** (fully described).

This is a portrait of the artist's son, Roland Dana Chase (1901-1980). A photograph of Chase standing next to the painting appeared in Arthur Hoeber, "American Artists and Their Work: William Merritt Chase," *Woman's Home Companion* 37 (September 1910): 50, as owned by M. Knoedler and Company, New York, erroneously dated 1904. The painting was also illustrated in the *New*

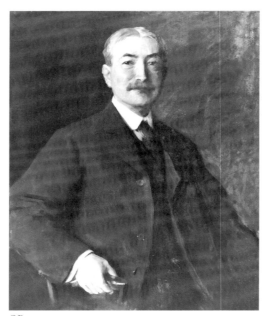

OP.511

York Times, June 27, 1915. A letter from Roland's daughter, Susan C. Kennedy, to Doreen Bolger (December 6, 1978) discusses the work: "He [my father] recalls his mother 'painting' some black shoes white for one painting of him that hangs in the Parrish Art Museum in Southampton."

OP.514

Professor William Osler M.D., 1910

Oil on canvas; 48 x 40 in. (121.9 x 101.6 cm)
Signed: Wm. M. Chase (c.l.)

University of Pennsylvania Art Collection, Philadelphia

William Osler was a Philadelphia-based physician, described by William Howe Downes in "William Merritt Chase, A Typical American Artist," *International Studio* 39, no. 154 (December 1909): xxx, as "the famous surgeon of the John

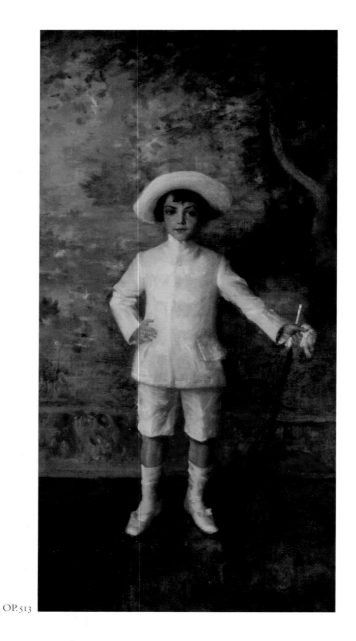

OP.513

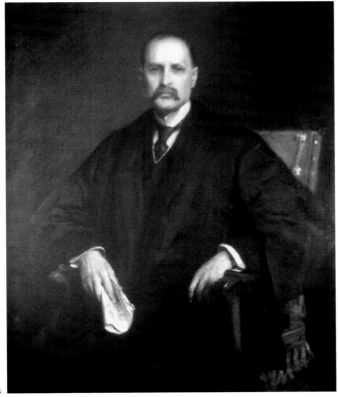

OP.514

Hopkins University faculty." The work was reproduced in Arthur Hoeber, "American Artists and Their Art: II. William M. Chase," *Women's Home Companion* 37 (September 1910): 51; and in *Century Magazine* 82 (May 1911): 56. A photograph of this portrait (with an impressed mark "Haeseler"—a Philadelphia photographic studio) descended in the Chase family. This portrait was listed in Katharine Metcalf Roof's 1917 biography of the artist as Sir William Osler. The painting is included in Peat's 1949 checklist of Chase's known work as being the property of the University of Pennsylvania, Philadelphia.

OP.515

Minnie Maddern Fiske, 1910

Oil on canvas; 30 x 24 in. (76.2 x 61 cm)
Signed: Wm. M. Chase (l.r.)
Inscribed: Mrs. Minnie Maddern Fiske
Label verso: Mrs Minnie Maddern Fiske by Wm. Chase / Painted for Actors Fund / Copyrighted by Wm. Chase 1910

Museum of the City of New York (41.50.1325)

A portrait of Minnie Maddern Fiske (1865–1932), considered one of the finest actresses of her time and instrumental in promoting the work of dramatist Henrik Ibsen in the United States. Born in New Orleans to a family of actors and

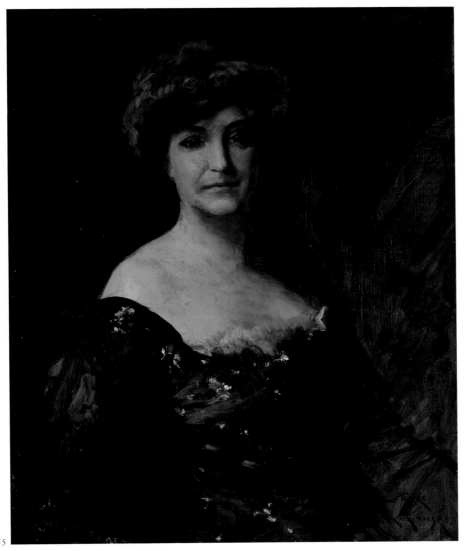

OP.515

OP.515A. Photograph of Minnie Maddern Fiske wearing the same dress as in the painting. The Theater Collection, Museum of the City of New York

actresses, she began performing as a child and married Harrison Grey Fiske, the wealthy and sophisticated editor of the *Dramatic Mirror,* in 1890. Included on Peat's 1949 checklist of Chase's known work as *Minnie Maddern Fiske,* owner unknown.

OP.516

Carrie, ca. 1910

Medium/support/dimensions unknown
Signature: Chase (m.l.)

Location unknown

A portrait of Carrie Riebling, an employee at the Art Students League, New York, during

OP.516

OP.517

Chase's second tenure there (1907-11). The work, whose informal signature indicates that it might have been a demonstration piece, has been lost, and the only extant image is a reproduction in the *Catalogue of the 50th Annual Exhibition of the Art Students League.* In the catalogue, Carrie is warmly described: "Those of us whose student period came somewhere between 1900 and 1918 in Fifty-seventh Street feel that ours was the rare experience, and that to us was given the special boon of knowing 'Carrie.' Mrs. Carrie Riebling came to the League originally to preside over the Lunch Room, to cook. Before long her great genial expansive personality had enveloped the institution and she became Regent, never forsaking for a moment her duties before the hearth but at the same time acting as Counsellor, critic, matchmaker, adviser, politician and mother to all" (*Catalogue of the 50th Annual Exhibition of the Art Students League,* January 22-February 2, 1925, 44, illus. 45).

OP.517

An Italian Girl, ca. 1910

Oil on canvas; 23½ x 19½ in. (59.7 x 49.5 cm)
Signed: Chase (m.r.)
Verso: Notarized by Mrs. William M. Chase, 1924

Location unknown

Auctions: **AAA '23 #61**

The only extant image of this work, now lost, is courtesy of a photocopy in the Chase artist file at the Frick Art Reference Library, New York. This painting, a demonstration piece, was probably completed circa 1910-11 during one of Chase's summer classes in Florence. Chase student Annie T. Lang, a favorite of the artist's, accompanied Chase and fellow students to Italy for classes both summers, and as the work was part of her estate upon her death in 1923, it can be assumed that Chase executed the work in one of those two years and presented it to her upon its completion. The painting, numbered 61 in the catalogue of the Lang estate sale, is described as follows: "Head and shoulders of a young woman in three-quarter to left; dark brown hair, white lace [ruff] at neck, blue gown with locket suspended by slender chain, gray background" (Lang Estate Sale, American Art Galleries, New York, April 12, 1923). It was purchased in the sale by Leroy Ireland, New York, for $60. Included on Peat's 1949 checklist of Chase's known work as being formerly owned by Leroy Ireland, New York.

OP.518

OP.518

Miss Mary Margaret Sweeney, ca. 1910

Oil on canvas; 24¼ x 18½ in. (61.6 x 47 cm)
Signed: Wm. M. Chase (l.l.)

Location unknown

This painting depicts Mary Margaret Sweeney, about whom nothing is known at present: research of the listings of Chase's many patrons and students reveals no one by that name. Given the serious attitude of the woman and the formal nature in which she is posed, it seems likely that this painting was a commissioned portrait. Stylistically the portrait and signature conform with other works done by Chase in the early twentieth century. Miss Sweeney wears a reddish brown dress with an off-white, transparent collar and red streamer.

OP.519

Lady in Pink (Mrs. Chase in Pink), ca. 1910

Oil on panel; 10⅛ x 7⅜ in. (25.7 x 18.7 cm)
Signature: Wm. M. Chase (l.r.)
There was an estate seal in red wax affixed to the back of the work for the sale (these seals have been invariably lost due to cracking and lifting).

Location unknown

Exhibitions: **NAC '10** [lent by Edward Page]; **AIC '12, possibly #48** as *Lady in Pink*; **MMA '17 #22** as *Mrs. Chase in Pink* (described) [lent by Edward Page].

There are no extant images of the present work. It is, however, described in the catalogue accompanying the Chase Memorial Exhibition in 1917: "[Mrs. Chase] is seated and seen full-face and to the waist; she wears a pink dress and the corner of a red cushion appears at the right; [in] back of her is a window with a view of water and distant shore" (*Memorial Exhibition* [New York: Metropolitan Museum of Art, 1917], 13). The catalogue entry also mentions that the work was exhibited at the National Arts Club in 1910, thus confirming it also was exhibited as *Lady in Pink*. Included on Peat's 1949 checklist of Chase's known work as *Mrs. Chase in Pink* (B), and as being owned by George Calvert, Indianapolis.

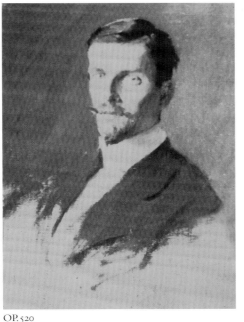

OP. 520

OP. 522

OP. 520

Unfinished Portrait of a Young Man with Mustache and Van Dyke Beard, ca. 1910

Physical properties unknown

Location unknown

A photograph of this work was included in a photo scrapbook of Helen Chase Storm. The image is similar to another photograph of a painting (sitter identified only as Mr. D) that was included in a cache of photographs also once owned by Helen Chase Storm, but possibly the portrait of Edwin Lester Dana, husband of Fra Dana, a Chase student whose portrait was painted by Chase. The similarity of facial characteristics between the above-cited work and the portrait of Mr. D could mean that this unfinished portrait was abandoned for the completed version, or, the sitters are not the same person, but look alike.

OP. 521

Portrait of a Young Girl, ca. 1910

Oil on canvas; 20 x 16 in. (50.8 x 40.6 cm)
Signed: Wm. M. Chase (l.l.)

Location unknown

Portrait of a Young Girl was likely created as a demonstration piece. The signature, although conforming stylistically to a dating circa 1910, appears to have been added as an afterthought, perhaps at the request of the student who was given the painting. The broad, heavy strokes of paint and simplicity of the treatment of detail and texture point toward the painting's didactic origins.

OP. 522

Granger Farwell, ca. 1910

Oil on canvas; 27 x 22 in. (68.6 x 55.9 cm)
Signed: Wm. M. Chase (l.l.)

Collection of Granger F. Kenly

Granger Farwell (1857–1919), a graduate of Yale University, was a Chicago businessman, active in not only business but also in the civic affairs of the city. He was at one time president of the Chicago Bureau of United Charities, and twice president of the Chicago Stock Exchange.

OP. 521

OP.523

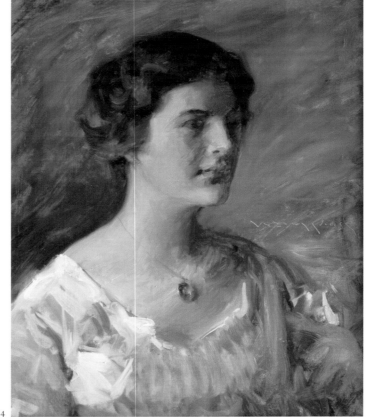

OP.524

OP.523

Mrs. Charles Stillman (Elizabeth Pamela Goodrich), ca. 1910

Oil on canvas; 47¼ x 37½ in. (120 x 95.3 cm)
Label verso: Portrait of E. P. S. by W. M. Chase. Head painted out and made possible by C. F. S. (written by Clara Francis Stillman, daughter of the sitter)

Private collection, New York

This painting depicts Elizabeth Pamela Goodrich (b. 1828), Mrs. Charles Stillman, shortly before her death in 1910. The sitter's head was painted over by Mrs. Stillman's daughter, Clara Francis Stillman. According to Chauncey Stillman, great-grandson of the sitter, the head was painted over because "the Chase head, though beauti-fully executed, gave the subject the appearance of a benign good witch. The head that appears [courtesy of] Miss Clara Stillman is far more like the other portraits and photographs that exist of the subject" (Chauncey Stillman to Ronald Pisano, letter dated November 28, 1977, Chase Archives, Parrish Art Museum, Southampton, Long Island, New York). The painting has descended through the Stillman family and there are no records of its having been exhibited during the artist's lifetime.

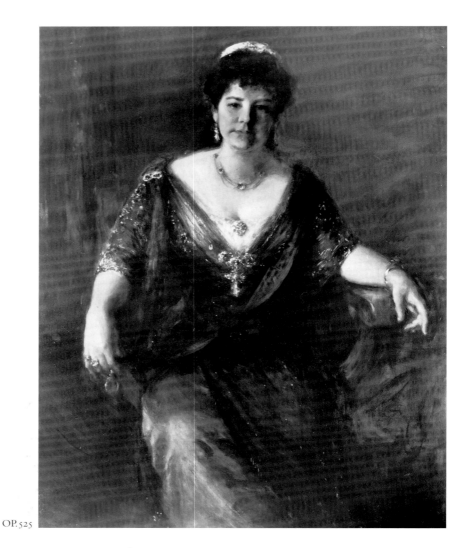

OP.525

OP.524

Portrait of a Young Woman, ca. 1910

Oil on canvas; 22½ x 18⅞ in. (57.2 x 47.9 cm)
Signed: Wm. M. Chase (c.r.) (incised)

A. J. Kollar Fine Paintings LLC, Seattle

Portrait of a Young Woman was probably completed by Chase during the first decade of the twentieth century, when Chase was at the height of his popularity as a portraitist. The work displays many traits characteristic of Chase's later portraiture: an active and open background with broad diagonal strokes of paint, somewhat spontaneous treatment of the dress, the use of color in the necklace to accent the composition, and an incised signature. Given its size and degree of finish, the work seems to have been less the product of a formal commission than a somewhat informal sitting, its subject perhaps the relative of a friend or an acquaintance of the artist.

OP.525

Portrait of Mrs. Chase, ca. 1910

Oil on canvas; 52 x 40 in. (132.1 x 101.6 cm)
Signed: Wm. M. Chase (l.l.)

Location unknown

Chase painted this portrait of his wife, Alice Gerson (1866-1927), in 1910. Included on Peat's 1949 checklist of Chase's known work as *Portrait of Mrs. Chase* (C) *(Mrs. C.),* and as being owned by the High Museum of Art, Atlanta.

OP.526

OP.526

Thomas E. Kirby

Presumably oil on canvas; dimensions unknown
Signature not visible

Location unknown

A photograph of this painting descended through the artist's family. On the back of the photograph is written (in pencil) "Kirby." Thomas E. Kirby was the manager of The American Art Association, New York, the venue for most auctions of American paintings— in fact, the 1917 Chase estate sale was conducted by Thomas Kirby and his assistant, Mr. Otto Bernet.

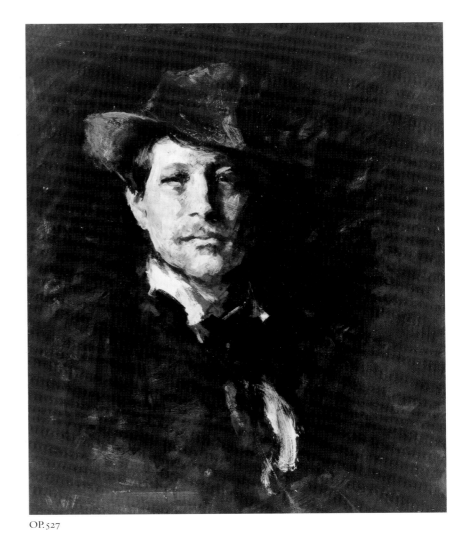

OP.527

OP.527

A Young Dane, 1911

Oil on canvas; 24 x 20 in. (61 x 50.8 cm)
Signed: Chase (l.r.)

Philadelphia Museum of Art. Bequest of Annie Lovering Perot, 1936 (1936-1-2)

Exhibitions: PAFA '12 #674.

This work hearkens back to the style of portrait sketches painted by Chase while a student at the Royal Munich Academy in the 1870s. It was, however, painted in 1911, and was, to judge from the signature style, likely a classroom demonstration piece. By 1911 Chase had stopped teaching at the Pennsylvania Academy of the Fine Arts, and by the end of that year he had ended his long association of teaching at the Art Students League in New York. In the summer of 1911 he had taken his summer class to Florence, and while it is possible *A Young Dane* was painted during that sojourn, it is more likely that it was painted to demonstrate the quick portrait sketch technique for his class at the Art Students

League. The exhibition catalogue for the 107th Annual Exhibition of the Pennsylvania Academy of the Fine Arts, held February 4-March 24, 1912, notes that Chase was chairman of the jury of selection and hanging committee that year. The catalogue also includes the notice: "Most of the pictures in this exhibition are for sale at studio prices. Information in regard to sales may be had from the salesman or from any attendant in the galleries or at the office." It is tempting to conjecture that Philadelphia-born Annie Lovering Perot (b. 1854), who gave this work to the Philadelphia Museum of Art, purchased it from the 1912 Pennsylvania Academy of the Fine Arts Annual Exhibition. She had been a student of Chase's, though he last taught at the academy in 1909, and it was not uncommon for students to purchase works by their revered teacher. This painting is included in Peat's 1949 checklist of Chase's known work as *Unknown Dane,* owned by the Philadelphia Museum of Art.

OP.528

Butler Williamson, 1911

Oil on canvas; 36 x 28 in. (91.4 x 71.1 cm)
Signed, noted, and dated (verso): Butler Williamson Painted by Wm. M. Chase, New York 1911

Private collection, Ohio

According to the grandson of the sitter, Butler Williamson was a close friend of Chase. No information was provided regarding a signature on the painting, other than the inscription on the verso. However, it is unlikely that Chase did not sign the front of the canvas—it is possible that the work darkened and the owners did not see the signature.

OP.528

OP.529

OP.529

Mrs. William Clark Mason (Mrs. Mason; Portrait of Miss M.; Miss Mary; Mary Mason), ca. 1911

Oil on canvas; dimensions unknown
Signed: Chase (m.r.)

Location unknown

Exhibitions: **PAFA '12 #652** as *Mrs. William Clark Mason;* **PPIE '15 #3761** as *Mrs. Mason;* **DMA '16 #20** as *Portrait of Miss M.;* **NAD '16 #90** as *Miss Mary* [lent by Henry G. Snyder]; **BMAG '19 #105** as *Mary Mason;* **FG '22 #17** as *Miss Mary;* **CI '22 #7; GA '23 #16** as *Miss Mary* [for sale, $2000].

There is a photograph of this work—a demonstration piece likely completed by Chase during his final year as an instructor at the Art Students League in New York in 1911—that has descended in the Chase family; an attached note in Alice Gerson Chase's hand reads, "'Miss Mary' by Wm. M. Chase for his Memorial Exhibition at Southampton, L.I." The exhibition referred to was likely the "Tribute to William M. Chase" held at Memorial Hall, Southampton, Long Island, August 17-September 5, 1922, which comprised works by Chase and several of his students; there does not appear to have been a catalogue published in conjunction with the show. The work was illustrated as *Mrs. William Clark Mason* in the [Philadelphia] *Public Ledger* on February 4, 1912, and as *Miss Mary* in a review of the National Academy of Design exhibition in 1916 in the *New York Times,* in which it was described as depicting "a sunny young woman in blue who banishes all thought of death and symbol by

looking so beautiful" ("Academy Exhibits Its Prize Paintings," *New York Times,* March 18, 1916, 9, illus.). Another critic, writing for the *New York Mail,* praised it as being "painted with more command of the medium than many of his recent pictures in this genre" (*New York Mail,* March 18, 1916, 3, illus. as *Miss Mary*).

The ownership history of the painting is somewhat unclear. The present work, upon its appearance at the National Academy of Design exhibition in New York in 1916, was listed as being owned by Henry Snyder, suggesting that, for whatever reason, Chase might not have given the work to the sitter upon its completion. Interestingly, Chase also completed a portrait, circa 1915, of a Mary Taylor Snyder (OP.568), perhaps a relation of the Henry Snyder who owned the present work in 1916.

OP.530

Miss Gertrude McMannis (Ptr. Gertrude McMannis), ca. 1911

Medium/support/dimensions unknown

Location unknown

Exhibitions: **CI '11 #44,** illus. [lent by the artist]; **TAP '11 #3** as *Ptr. Gertrude McMannis.*

OP.530

This portrait of Miss Gertrude McMannis, about whom little is known, was likely a commissioned work. The only extant image of the work is an illustration in the catalogue for the 1911 exhibition at the Carnegie Institute, in which the sitter, seated indoors, is dressed, somewhat oddly, for the out-of-doors—in a coat with fur trim at the sleeves, a fur scarf, and a fur hat. Included on Peat's 1949 checklist as *Gertrude McMannis,* owner unknown.

OP. 531

Portrait of a Lady in Black (Annie Traquair Lang), 1911

Oil on canvas; 59½ x 47½ in. (151.1 x 120.7 cm)
Signed: Wm. M. Chase (u.r.)
Dated: 1911 (u.r.)

The Alex Simpson, Jr., Collection, Philadelphia Museum of Art. 1928 (1928-63-4)

Exhibitions: **NAD '11 #314** as *Portrait of a Lady in Black* [lent by the artist]; **PAFA '12 #484,** illustrated [lent by the artist]; **BFAA '12 #16** [lent by the artist]; **FAM '13 #10; MIA '15 #152** [lent by the Metropolitan Museum of Art].

Annie Traquair Lang (1885–1918) was Chase's student and close friend. She was born and raised in Philadelphia and attended the Pennsylvania Academy of the Fine Arts, where she first studied with Chase. It is probably during this period that she learned about his Shinnecock Summer School of Art, which she attended during the 1901 summer session. Beginning in 1910, she studied with Chase in several of his European summer school classes, in both Belgium and Italy. *Portrait of a Lady in Black* was completed by Chase during the summer of 1911 at his Villa Silli, in Fiesole, outside of Florence. The depiction of the villa in the painting *A Memory: In the Italian Villa* (see vol. 4) confirms that the villa is the setting for this portrait of Lang. The interior is a similar composition, with the floral arrangement and table in front of the couch in that painting rather than behind it as in the Lang portrait. In the portrait, the door is closed, thus keeping Lang as the focal point of the composition. The portrait was well received by critics. A writer reviewing the National Academy of Design exhibition in 1911 wrote: "Chase gives no sign of weakness; in fact, the portrait here is one of his best" ("At the Academy and Elsewhere," *The Independent* 70 [March 30, 1911]: 664). The work was illustrated in "The American Artist Series," *The Century* 85 (March 1913): 721 as *Portrait of Annie Traquair Lang.*
 Lang had a promising career, receiving a Silver Medal at the Panama Pacific Exposition, Cali-

OP. 531

fornia, in 1915, and having a solo exhibition at Knoedler's Gallery, New York, in 1917. But her career was cut tragically short by her untimely death in 1918. The Metropolitan Museum of Art had purchased Chase's portrait of Lang in 1913. But after his death, Mrs. Chase approached the museum to request that the work be returned to her in exchange for Chase's painting *For the Little One* (see vol. 4), in which she is seen seated in their home in Shinnecock Hills. It has been suggested that Mrs. Chase was jealous of her husband's relationship with Lang and preferred that the museum have a portrait of herself rather than Lang. The work is included in Peat's 1949 checklist as *Annie Traquair Lang,* owned by the Philadelphia Museum of Art. Chase also completed another, smaller portrait of Lang (OP. 594).

OP. 532

Max Bensel, 1912

Oil on canvas; 25⅝ x 21¼ in. (65.1 x 54 cm)
Signed, inscribed, and dated: Wm. M. Chase / Bruges 1912 / Bensel (l.l.)
Inscribed (verso): M. Max Bensel / Painted by Wm. M. Chase / Bruges 1912

Location unknown

There is no evidence that Max Bensel was a student of Chase's; in fact his name does not appear on any list of Chase students, or on any list of American artists in general. It is still possible, however, that for some reason or other Bensel joined the 1912 Chase Summer School trip to Bruges.

OP.532

Chase also painted a portrait of a woman described (later) as the former Mrs. Bensel (OP.542)—it, too, was painted in Bruges, 1912, as was a study (OP.539) and portrait of Mme. E. H. Bensel (OP.543), the whereabouts of both of these works unknown. Given the more formal properties of his portrait of Max Bensel, it could also be that Mr. Bensel was in Bruges with his wife and mother in the summer of 1912 and commissioned these portraits from Chase at the time.

OP.533

Robert Underwood Johnson, ca. 1912

Oil on canvas; 60 x 46½ in. (152.4 x 118.1 cm)
Signed

American Academy of Arts and Letters, New York.
Gift of Mrs. Johnson, 1934

Exhibitions: **NAPP '13 #v** as *Portrait of R. U. Johnson* (M. Knoedler and Company exh. cat. illus. p. 31) [lent by the Century Club]; **AIC '13 #64; PPIE '15 #3763; AAA&L '28 #54** [lent by the sitter].

Robert Underwood Johnson (1853–1937) was assistant editor of the *Century Magazine,* and, along with Chase, a founding member of the National Institute of Arts and Letters in 1898 (Johnson served as the first permanent secretary of the organization). Both Chase and Johnson were elected to the Academy of Arts and Letters in the same year, 1908. It was Johnson who was instrumental in forming an art collection for the academy. It is unclear, however, just when and how the painting was acquired by Johnson, it presumably having been commissioned by the

OP.533

Century Company—in 1913 it was lent by the Century Company to an exhibition of the National Association of Portrait Painters. However, that same year it was sent to an exhibition at the Art Institute of Chicago, and two years later to the Panama-Pacific International Exposition without a lender credit line, which usually means it was lent by the artist. At some point it came to be in the collection of Mrs. Johnson (assumed to be the wife of the sitter) who gave it to the American Academy of Arts and Letters in 1934. The painting, owner unknown, is included in Peat's 1949 checklist of Chase's known work.

OP.534

Edwin Lester Dana, ca. 1912

Physical properties unknown

Location unknown

Exhibitions: **BAA '12 #72.**

A photograph that descended in the Chase family was identified as depicting a "Mr. D." Another photograph of the same portrait was included in the family scrapbook of Helen Chase Storm, the artist's daughter. It is certainly

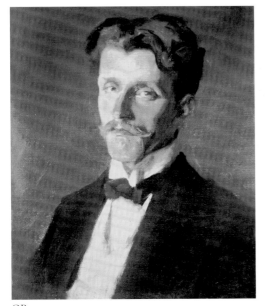

OP.534

possible the "Mr. D." is Edwin Lester Dana, said to have been a Wyoming rancher and married to Chase student Fra Dana, whose portrait he painted in 1897 (OP.257).

OP.535

The Very Rev. William M. Grosvenor, Dean St. John the Divine, ca. 1912

Oil on canvas; 56 x 42 in. (142.2 x 106.7 cm)
Signed: Wm. M. Chase (l.l.)

The Cathedral Church of St. John the Divine, New York

OP.535

OP.535A. Photograph of Chase painting *The Very Rev. William M. Grosvenor*

Exhibitions and Auctions: TAP '12 #4; CI '12 #63; DMA '16 #14; PAFA '17 #60; Csale '17 #376 (fully described).

As this work remained in the collection of the artist, it most likely was undertaken to be an exhibition work, intended to display not only Chase's bravura portrait painting style but his association with leading dignitaries of the day. A photograph of Chase painting this portrait in the cathedral descended in the Chase family (OP.535A). The painting was noted in Katharine Metcalf Roof's 1917 biography of the artist and was included in Peat's 1949 checklist of Chase's known work as being in the collection of the Cathedral Church of St. John the Divine, New York.

OP.536

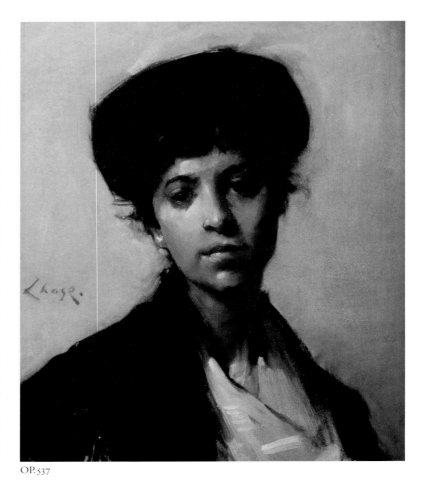

OP.537

OP.536

Portrait of Mrs. H. (Mrs. H.; Lady in Black), ca. 1912

Oil on canvas; 60 x 50 in. (152.4 x 127 cm)
Signed: Wm. M. Chase (l.r.)
There was a red wax seal affixed to the back of the work for the estate sale (these seals have been invariably lost due to cracking and lifting).

American Academy of Arts and Letters, New York. Gift of Archer M. Huntington, 1936

Exhibitions and Auctions: **NAD '12 #379** as *Mrs. H* [lent by Mrs. H] (awarded Thomas R. Proctor Prize for best portrait); **BFAA '13 #18** as *Portrait of Mrs. H,* 42, illus. [lent by Mrs. H] (*Academy Notes* 8 [July 1913]: 123); **Csale '17 #378** as *Lady in Black* [purchased, F. A. Lawlor, $145].

It is likely that Chase was commissioned to paint *Portrait of Mrs. H.* as the painting was already in her possession when the work was first exhibited at the National Academy of Design in 1912, though, for unknown reasons, the work was back in the artist's possession shortly thereafter and appeared in the 1917 Chase estate sale. There is a photograph of *Portrait of Mrs. H.,* labeled "A Portrait in Black," that is part of the Peter

A. Juley and Son Collection, Smithsonian American Art Museum, Washington, D.C. Included on Peat's 1949 checklist of Chase's known work as *Lady in Black,* and as being formerly owned by F. A. Lawlor, New York.

OP.537

Portrait of a Woman, ca. 1912

Oil on canvas; 19 x 16¼ in. (48.3 x 41.3 cm)
Signed: Chase (m.l.)

Private collection

A demonstration piece eventually acquired by ex-Chase student and artist Verona Arnold Kiralfy (1893-1946), though it is unknown if she was in fact the sitter for this portrait. Kiralfy began exhibiting her own work in 1912 at the age of nineteen when she showed a painting at the Carnegie Institute. The sitter's hat and black jacket are reminiscent of Chase's 1886 work *Sketch of A Spanish Girl (A Spanish Girl)* (OP.140).

OP.538

Miss Helen Sharpless [sic], ca. 1912

Medium/support/dimensions unknown

Location unknown

Exhibitions: **CI '12 #62,** illus. as *Miss Helen Sharpless* [sic].

OP.538

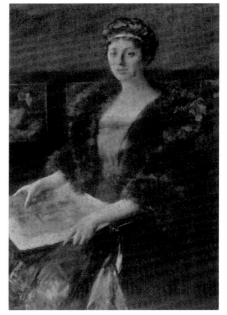

This is a portrait of Helen Sharples (1885–1922), an artist who studied with Chase at the Pennsylvania Academy of the Fine Arts. She is depicted here probably in Chase's Philadelphia studio in the Bailey Building, though the studio could be her own. There are paintings lining the wall behind her, and she has a work on paper in her lap. These elements could reflect her identity as an artist, but considering her elaborate dress and lavish fur coat, Chase could also be suggesting her status as a collector of art. Her father, Philip M. Sharples (1857–1944), was the owner of one of Chase's most significant Japanesque paintings, *The Red Box* (see vol. 4), while her mother, Helen Brinton Sharples (1853–1911) of Pennsylvania, was an artist. Included, owner unknown, on Peat's 1949 checklist of Chase's known work as *Helen Sharpless* [sic].

OP. 539

Lady at the Window (Portrait Study of Mme E. H. Bensel), ca. 1912

Oil on canvas; 20 x 16 in. (50.8 x 40.6 cm)

Location unknown

No work by this title was exhibited during the artist's lifetime, though it is possible the work was shown under another. The work would appear to be a preliminary sketch in oil of the larger and more finished *Portrait of Madame E. H. Bensel* (OP. 543). If that is indeed the case, the procedure would have been atypical for Chase at that point in his career. Since the *Portrait of Madame E. H. Bensel* as well as two portraits of Max Bensel (OP. 532) and Mrs. Max Bensel (OP. 542) descended in the Bensel family until 1983, while the painting under consideration remained in Chase's possession until the time of his death, it is not inconceivable that the smaller painting was done as a demonstration for Mme Bensel prior to the actual commission of the three works. Also possible is that after Chase had completed the smaller work, Mme Bensel requested a work of a grander scale. In any event, all of these paintings were done in Bruges, Belgium, while Chase was conducting a summer art class there in 1912. The portrait is included on Peat's 1949 checklist of Chase's known work as *Lady at the Window*, an unsigned work formerly owned by Newhouse Galleries, New York. Given Peat's observation regarding the lack of a signature, the present signature, "Wm. M. Chase" (l.c.), becomes a source of some curiosity and perhaps a point of further study.

OP. 539

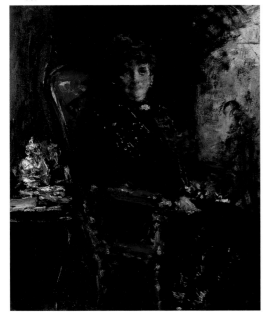

OP. 540

Alice Chase Sullivan (Mrs. Arthur White Sullivan), ca. 1912

Oil on canvas; 36 x 29 in. (91.4 x 73.7 cm)
Signed: Wm. M. Chase (l.r.)

Location unknown

Exhibitions: **TAP '13 #7** as *Mrs. Arthur White Sullivan* [lent by the artist]; **PPIE '15 #3768** as *Mrs. Sullivan* [lent by the artist].

A portrait of Chase's daughter Alice following her marriage to Arthur White Sullivan. Included on Peat's 1949 checklist of Chase's known works as *Mrs. Arthur White Sullivan,* and as being owned by Mrs. Arthur White Sullivan, Glen Head, Long Island, New York.

OP. 540

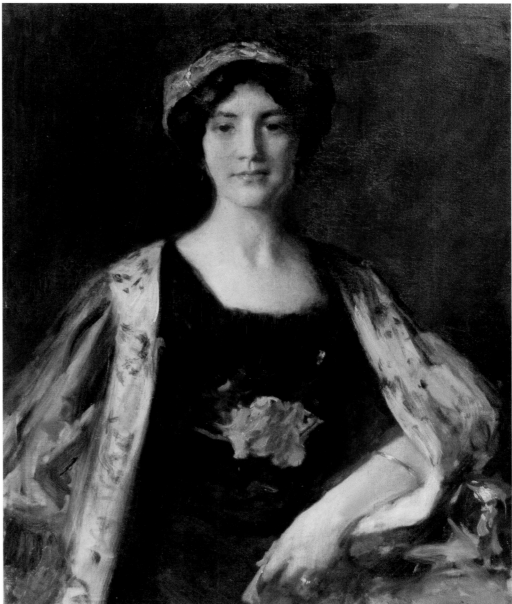

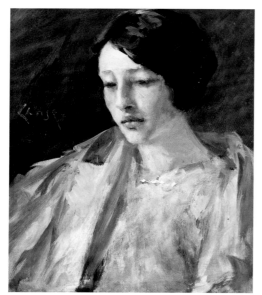

OP.541

OP.541

Esther M. Groome, ca. 1912

Oil on canvas; 21⅝ x 18¼ in. (54.9 x 46.4 cm)
Signed: Chase (m.l.)

Location unknown

This portrait, thought to be of Esther M.
Groome (1857-1929), was likely a demonstration
piece completed during Chase's summer school
sessions abroad in Holland and Belgium in 1912.
According to Chase student Harriet Blackstone,
Groome was "the class monitor for the group"
(see OP.544 for citation). Confusion as to the
identity of the sitter revolves around the fact that
Ms. Groome would have been about fifty-five
years old in the year the portrait was completed,
while the model for this portrait appears to have
been substantially younger. It is of course possi-
ble that she was not the sitter, but rather
received the painting at some later date.

OP.542

Portrait of Madame Bensel (The Former Mrs. Bensel), 1912

Oil on canvas; 25⅝ x 21¼ in. (65.1 x 54 cm)
Signed: Wm. M. Chase (l.l.)
Inscribed verso: Madame Painted by
Wm. M. Chase / Bruges 1912 (m.c.)

Location unknown

Chase painted portraits of Madame Bensel,
Mr. Bensel (OP.532), and Mme E. H. Bensel
(OP.543) during the summer of 1912 while he

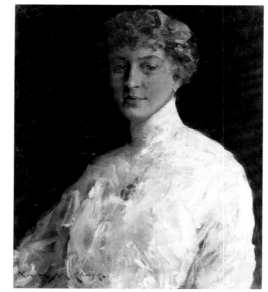

OP.542

was conducting a summer art class in Bruges,
Belgium. There are no exhibition references for
any of these portraits and they do not appear to
have been exhibited during the artist's lifetime.

OP.543

Portrait of Madame E. H. Bensel, 1912

Oil on canvas; 59¼ x 54 in. (150.5 x 137.2 cm)
Signed: Wm. M. Chase (l.r.)
Inscribed verso: Mme. E. H. Bensel / Painted by
Wm. M. Chase / Bruges / 1912 (u.c.)

Location unknown

Chase was commissioned to paint three portraits
of members of the Bensel family (see OP.532
and 542). The present work was painted by
Chase in 1912, while the artist was conducting a

OP.543

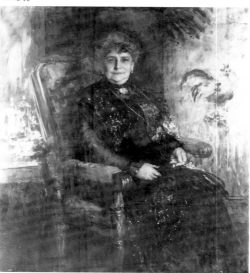

summer art class in Bruges, Belgium. All three
works remained in the Bensel family and there is
no record of their having been exhibited during
the artist's lifetime.

OP.544

Portrait of Miss L. (Isabella Lothrop), 1912

Oil on canvas; 51 x 38 in. (129.5 x 96.5 cm)
Signed: Wm. M. Chase (l.l.)

Location unknown

Exhibitions: AIC '13 #66 [lent by the artist]; CI '13
#56, illus. [lent by the artist] (L. Merrick, "Annual
Carnegie Display [Second Notice]," *American Art
News* 11 [May 3, 1913]: 2, 1, illus.); JHAI '14 #14,
illus. [lent by the artist]; CM '14 #5, illus. [lent by
the artist]; MAGR '15 #27 [lent by the artist].

Portrait of Miss L. depicts Isabella Lothrop
(b. 1890) of Detroit, the daughter of the artist
Isabella Graham Stewart Lothrop (b. 1858).
Isabella Lothrop studied with Chase, Thomas
Eakins, and Frank Vincent DuMond at the
Pennsylvania Academy of the Fine Arts in
Philadelphia. In 1912 mother and daughter
traveled to Europe with Chase, studying with
him in Bruges and Haarlem. As a prize for the
best costume at a costume ball held that sum-
mer, Chase offered to paint a portrait of the
winner. According to Harriet Blackstone,
another student in Chase's summer class, the
prize was awarded to "Belle Lathrope [*sic*]"
("The Painter's Bruges," Harriet Blackstone
Papers, Archives of American Art, Smithsonian
Institution, Washington, D.C., roll 1617); this
is, presumably, the "prize painting," which
accounts for the eighteenth-century costume
worn by the model (an unusual feature in a
Chase portrait). Originally intended as a bust-
length (or half-length) portrait, Chase was
apparently inspired to go further, making it a
three-quarter-length portrait.

Upon returning to the United States, Chase
immediately began exhibiting this painting,
which he evidently prized quite highly. For the
next several years it was featured in major
museum shows throughout the country, and
illustrated in the leading art magazines of the day.
A reviewer of the Carnegie Institute exhibition
of 1913 spoke of this work as a "new production"
and "one of the most interesting features of the
exhibition" (*American Art News,* May 3, 1913, 1).
The work was illustrated in *International Studio*
50 (September 1913): 231.

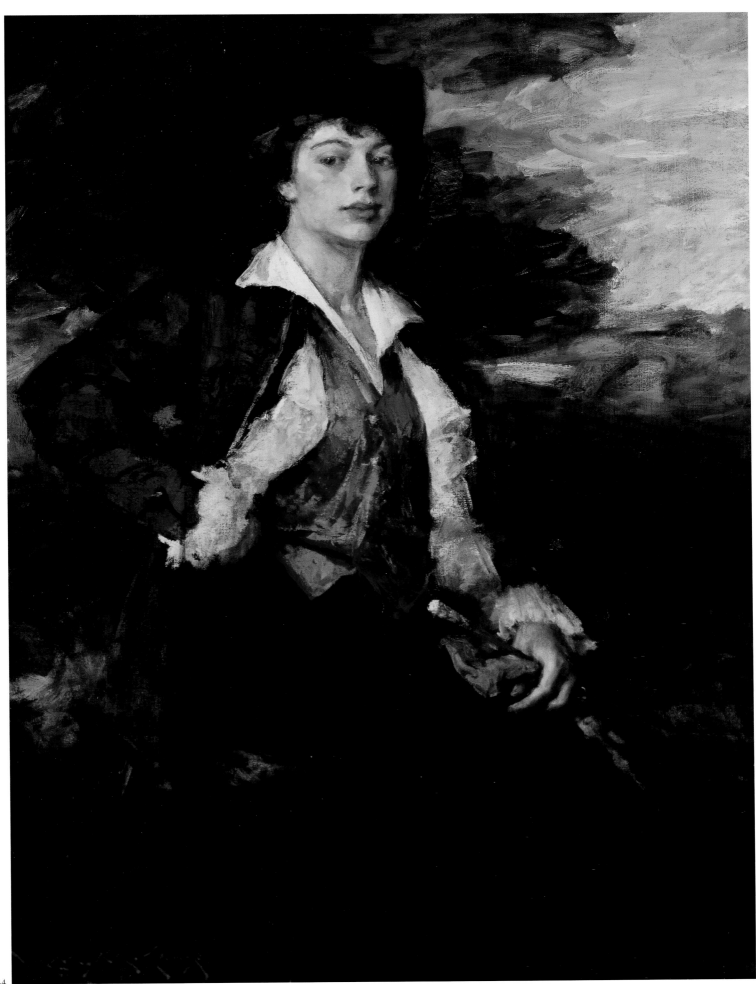

OP. 544

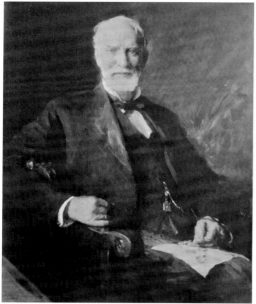

OP. 545

The Honorable James Wilson

Medium/support/dimensions unknown

U.S. Department of Agriculture, Washington, D.C.

A photograph identifying the sitter descended in the Chase family. While a signature was not visible in the photograph, the lower left corner of the image was missing. James Wilson (1835–1920)

served as secretary of agriculture from 1897 until 1913, serving in the administrations of Presidents McKinley (1897–1901), Theodore Roosevelt (1901–9), and Taft (1909–13). The portrait is said to be in the collection of the U.S. Department of the Interior, Washington, D.C.

OP. 546

Self-Portrait, 1913

Oil on canvas; 24 x 20 in. (61 x 50.8 cm)
Signed: Wm. M. Chase (l.l.)

Private collection

Exhibitions: **NAPP/K&C '14 #vi** as *Portrait* and illus. (reviewed in "Portrait Painters," *International Studio* 57 [1914]: illus. p. xxvi); **CI '14; FG '22 #3** (illus. in *Art News* 21, no. 1 [Oct. 14, 1922]: 1); **CI '22/CM '22/BFAA '23 #14** (traveling exhibition); **CGA '23 #21,** probably this work; **FG '27** (illus. on cover of exhibition brochure).

A photograph of this work descended in the Chase family. The portrait is included in Peat's 1949 checklist of Chase's known work as *Self-Portrait* (K), owned by the Rogers Memorial Library, Southampton, Long Island, New York, and was purchased by local citizens to honor the memory of Chase in his association with Southampton.

Mr. Arthur White Sullivan, 1913

Oil on canvas; 36 x 29 in. (91.4 x 73.7 cm)
Signed: Not noted

Location unknown

Exhibitions: **TAP '13 #6; PPIE '15 #3765** as *Mr. Sullivan.*

Arthur White Sullivan (1887–1957) was married to Alice Dieudonnée Chase, and a portrait of Alice was exhibited alongside that of her husband in both of the exhibitions cited above. A photograph of this painting was included in a Chase family album (collection of Robin Chase). Although a relatively young man wearing a monocle might seem somewhat arcane, Arthur may have thought it to be a nod to his monocle-wearing father-in-law. The portrait is included in Peat's 1949 checklist of Chase's known work as being owned by Mrs. Arthur White Sullivan, Glen Head, Long Island, New York.

OP. 547

OP. 546

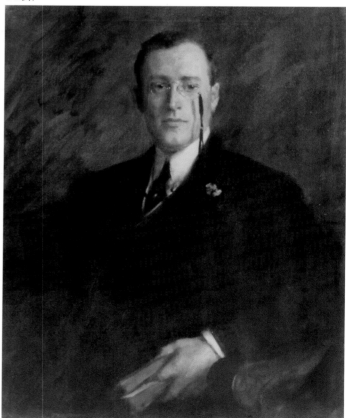

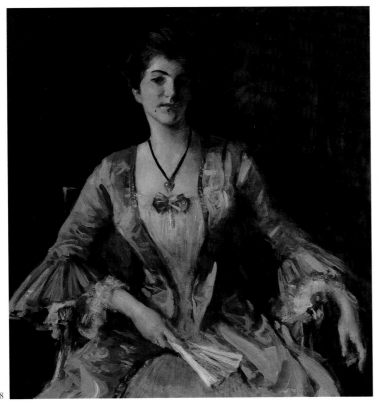

OP.548

Painters exhibition of 1913, one reviewer thought the work nothing short of Chase "at his best," describing it as a "striking three-quarter length seated portrait of his daughter . . . as good as a Sargent" ("Chase's Fine Exhibit," *American Art News* 12 [March 21, 1914]: 3, 1, illus. as *Portrait*). Another writer mentioned that the work was "seen last year at Montross Gallery" (*Evening Post,* December 17, 1914, n.p.), confirming that this was indeed the portrait of *Dorothy* included in the Ten American Painters exhibition of 1913. Included on Peat's 1949 checklist of Chase's known work as *Dorothy in Pink (Dorothy Chase); Lady in Pink* (B), and as being owned by Joseph Katz, Baltimore.

OP.549

Study of Clara Stephens, 1913

Oil on canvas; 21½ x 25¾ in. (54.6 x 65.4 cm)
Signed: Wm. M. Chase (u.r.)
Inscribed: To my friend and pupil Clara Stephens / Venice 1913 (u.r.)
Verso: Whitney Museum of American Art

Location unknown

A demonstration piece depicting Chase student Clara Jane Stephens (1877–1952). She grew up in Portland, Oregon, and first studied art locally there in the 1890s before pursuing her studies at

OP.548

Dorothy (Portrait: Dorothy in Pink; Portrait; Portrait of Miss C.; Portrait of Miss Dorothy Chase; Dorothy B. Chase; Dorothy in Pink), ca. 1913

Oil on canvas; 42½ x 38½ in. (108 x 97.8 cm)
Signed: Wm. M. Chase (u.l.)
Labels verso: Baltimore Museum of Art, Loan No. L.49.6; The Milch Galleries, NY

Santa Barbara Museum of Art, Calif. Gift of Mrs. Sterling Morton for the Preston Morton Collection (1960.53)

Exhibitions: **TAP '13 #9** as *Dorothy*; **AAEL '14 #48,** illus. as *Portrait of Miss C.*; **TAP '14 #9** as *Portrait: Dorothy in Pink* [lent by the artist]; **CGA '14 #207** as *Portrait of Miss C* [lent by Mrs. Chase] ("Studio Talk," *International Studio* 54 [November 1914]: 49, 46, illus. as *Portrait of Miss C.*); **BMA '15 #22** as *Portrait of Miss Dorothy Chase*; **DMA '16 #21** as *Dorothy Drummond* [*sic*] *Chase*; **MMA '17 #41** as *Dorothy B. Chase.*

This is a painting of Chase's daughter Dorothy Brémond Chase (1891–1953). She much resembled her mother and this picture might have been painted as a pendant to a slightly larger, earlier portrait, *Mrs. Chase in Pink* (OP.519). Both are kneepieces of approximately the same size, and the poses are similar. According to Chase's first biographer, Katharine Metcalf Roof, Chase purchased the eighteenth-century pink-satin costume specifically for Dorothy to wear in the portrait. The picture was probably painted in early 1913 when Chase was in his early sixties; though Chase kept it for the enjoyment of the family, he did exhibit it widely. When it was shown at the Ten American

OP.549

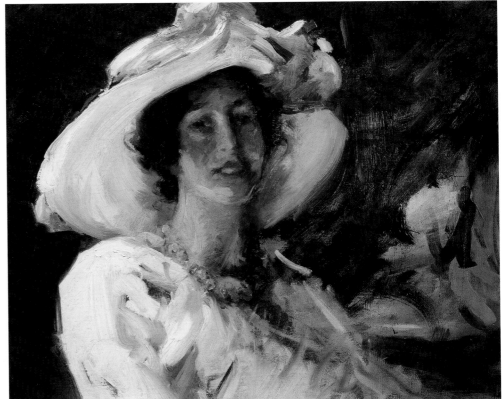

the Art Students League under Chase and Kenyon Cox; she accompanied Chase to Venice for his summer art course in 1913, over the course of which the present work was likely completed.

OP.550

Miss N., ca. 1914

Medium/support/dimensions unknown

Location unknown

Exhibitions: **NGA '15 #4**, illus. as *Portrait of Miss N.*

A portrait of Elsie Nicoll (b. 1887) likely commissioned by her father, Mr. Benjamin Nicoll. The only extant illustration of the work is in an undated clipping that reads, "Lent by Benjamin Nicoll for the Coming Exhibition of the National Association of Portrait Painters at the [Jacques] Seligmann [and Company] Galleries for the Benefit of the Families of French Artists Now in the Army" (Chase artist file, Frick Art Reference Library, New York). Another painting with a similar title (OP.573), which remained in the Chase family until the 1917 estate sale, is included on Peat's 1949 checklist of the artist's known work. The present work is not.

OP.551

C. P. Townsley, 1914

Oil on canvas; 21⅜ x 18⅜ in. (54.3 x 46.7 cm)
Signed (u.l.)

Location unknown

This work is included in Peat's 1949 checklist as being owned by C. P. Townsley, Los Angeles. Channel Pickering Townsley organized the Chase European summer school trips starting in 1902 with the class trip to Holland. Townsley was also involved with the New York School of Art. In 1914 Chase traveled to Carmel-by-the-Sea, California, to teach his first and only summer class on the West Coast. While there he painted this portrait of Townsley, who was once again involved with organizing the summer school. An article written by Eunice T. Gray, "The Chase School of Art at Carmel-by-the-Sea, California," *Art and Progress* 6, no. 4 (February 1915): 118–20, discussed the role played by Townsley: "Mr. Townsley arrived from New York in May, and formed the classes in preparation for Mr. Chase's criticism when he arrived

OP.550

early in July. . . . Mr. Townsley, himself a painter and teacher, held successful exhibitions during the summer in California, and will remain here, associated with Mr. Jean Mannheim in the Pasadena Art School." Thus it is likely that

Townsley relocated to California, or at least returned to the state late in life, as he still owned his portrait by Chase in 1949; he was recorded on the Peat checklist as residing in Los Angeles.

OP.552

Portrait of Professor T. U. Taylor, 1914

Oil on canvas; 45³⁄₁₆ x 35⅝ in. (114.8 x 90.5 cm)

Blanton Museum of Art, University of Texas, Austin. Gift of Ex-Students, College of Engineering: Transferred from the College of Engineering, 1987 (1987.34)

Exhibitions: **NAD '14 #278** [University of Texas— owner] (*New York Times,* Mar. 22, 1914, SM11).

This portrait was commissioned by ex-engineering students and the Engineering Department of the University of Texas at Austin in 1913. It was completed the following year. Thomas U. Taylor was dean of the School of Engineering at the University of Texas from 1888 to 1938.

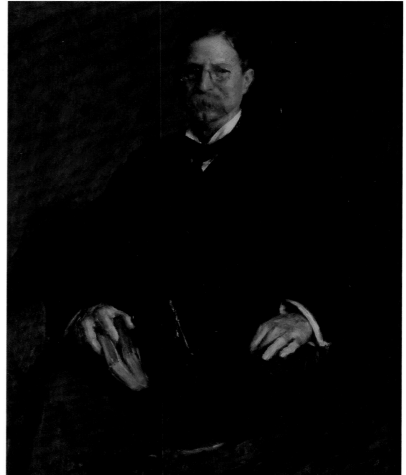

OP.552

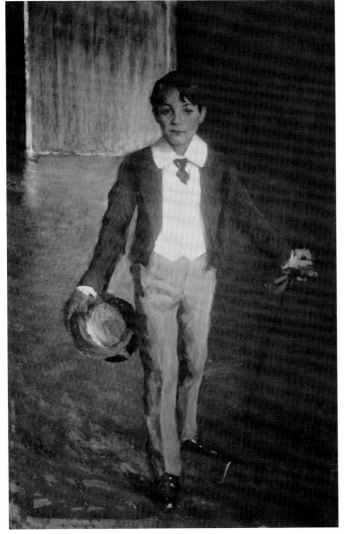

OP. 553

OP. 554

OP.553

Master Roland, 1914

Oil on canvas; dimensions unknown
Signed: Wm. M. Chase (l.l.)

Location unknown—possibly destroyed

Exhibitions: **CI '14 #52; DMA '14 #5** (?); **BFAA '15 #12** (illus.); **NAPP '15 #viii, MAGR '15 #12** (traveling exhibition) (illus.; also reviewed and illustrated in "Pittsburgh International 1914," *International Studio* 52 [1914]: cx: "This of his youngest son, dressed in Etons, full of animation and dashing out of the canvas as through an open door. The lad's bright face, dark hair, and olive complexion have been finely handled, better, a great deal, than the advancing right leg which is just a little unconvincing in the action"); **DMA '16 #22** (?); **MAGR '16 #6.**

This is a portrait of Roland Dana Chase (1901-1980), the artist's youngest son. The exhibition records for various portraits of Roland are con-

fusing as often there is no evidence as to which portrait was included. The work was illustrated in *Art and Progress* 5 (August 1914): 345, and in an article by Duncan Phillips, "William M. Chase," *American Magazine of Art* 8, no. 2 (December 1916): 48. It is possible that this painting is the entry in Peat's 1949 checklist of Chase's known work given as *Master Roland,* circa 1913, and as having been destroyed by fire.

OP.554

Koto Robertine Chase Carr Sullivan (Mrs. Francis W. Sullivan), ca. 1914

Oil on canvas; 43 x 34 in. (109.2 x 86.4 cm)
Signed: Wm. M. Chase (u.r.)
Chase sticker on back of frame with address:
333 Fourth Avenue, New York.

Paine Art Center and Arboretum, Oshkosh, Wis.
Gift of Morris J. Kaplan

This painting depicts Chase's daughter Koto Robertine Chase (1889-1956). She was married to Francis W. Sullivan, whose brother Arthur married Koto's sister, Alice Dieudonnée. As in *Alice Chase Sullivan (Mrs. Arthur White Sullivan)* (OP.540), we here see one of Chase's daughters as a grown woman. She is dressed in a formal gown with a fur-trimmed wrap, holding a fan in her right hand while her left is draped over the arm of a chair. This painting does not appear to have been exhibited during the artist's lifetime. Included on Peat's 1949 checklist of Chase's known work as *Mrs. Francis W. Sullivan,* and as being owned by Julius H. Weitzner, New York.

OP.555

OP.556

Portrait of Mrs. Hale, ca. 1914

Oil on canvas; 48 x 37 in. (121.9 x 94 cm)
Signed: Wm. M. Chase (l.l.)
Inscribed verso: Mrs. Philip Hale painted by
William M. Chase
There was an estate seal in red wax affixed to the
back of the work for the estate auction (these wax
seals have been invariably lost due to cracking and
lifting).

Watson Gallery, Wheaton College, Norton, Mass.
Gift of Marion Lewis Lothrop, Class of 1907

Exhibitions and Auctions: **NAPP/K&C '14, #via,**
added in errata; **Csale '17 #370** as *Portrait of
Mrs. Philip Hale* [purchased, Alfred Rose, $120].

This portrait depicts Lillian Westcott Clark
(1881–1963) of Hartford, Connecticut, who
married Chase's friend and fellow artist Philip
Leslie Hale on June 11, 1902; it is the second of
two Chase portraits for which she sat, the other
being *Lady in Black* (OP.555). She studied paint-
ing both at the Hartford Art School and then
with Chase at his summer school on Shinne-
cock, Long Island. She then received a scholar-
ship to the School of the Museum of Fine Arts
in Boston and went on to have a successful
career as a portrait painter. This painting does
not appear to be a commissioned piece because
the Hales never owned it. Included on Peat's
1949 checklist of Chase's known work as
Mrs. Philip Hale, and as being formerly owned
by Alfred Rose, New York.

OP.555

Lady in Black (Lillian Westcott Hale),
ca. 1914

Oil on canvas; 30¼ x 24¼ in. (76.8 x 61.6 cm)
Signed: Wm. M. Chase (l.l.)
Verso: VK (in charcoal)

Location unknown

This is thought to be a portrait of artist Lillian
Westcott Hale (1881–1963), who began her
studies locally at the Hartford Art School in
Connecticut and then attended Chase's summer
school classes in Shinnecock, Long Island. In
1900 she was awarded a scholarship by the Hart-
ford Art School to attend the School of the
Museum of Fine Arts in Boston, where she stud-
ied with Edmund Tarbell and Philip Leslie Hale,
whom she married on June 11, 1902. Chase
made another painting of her, *Portrait of
Mrs. Hale,* completed circa 1914 (OP.556). She
appears to be wearing the same black dress in
both paintings, which, taken with a similarity in
the facial features, further confirms her to be the
sitter in the present work. The portrait remained
in the Chase family collection until 1926,
whereupon it was purchased first by Newhouse
Galleries, New York, and thereafter by ex-Chase
student Martha Simpkins of Texas in 1931. The
initials "VK" could refer to a number of people,
though one interesting possibility would be
ex-Chase student Verona (Arnold) Kiralfy (1893–
1946). Included on Peat's 1949 checklist of
Chase's known work as *Lady in Black* (B), and as
being formerly owned by Newhouse Galleries,
New York.

OP.556

OP.557

one of several of her mentor's works that were included in the 1923 auction of her estate. Included on Peat's 1949 checklist as *A Young Woman,* formerly owned by Leroy Ireland, New York. (The work was later purchased from Ireland by Lewis J. Merritt as a gift for his son Hewlett C. Merritt, who eventually handed it down to his assistant, Mr. William Woodward.)

OP.558

Self-Portrait, ca. 1914

Oil on canvas; 24 x 20 in. (61 x 50.8 cm)
Signed: Wm. M. Chase (l.l.)

The Detroit Institute of Arts. Gift of the artist

Exhibitions: **PPIE '15 #3740; DMA '16 #1; BFAA '17 #29** (illus.).

This self-portrait was given by Chase to the Detroit Museum of Art in 1916 to inaugurate its Gallery of Self-Portraits by American Artists. No doubt, it was also given in appreciation of the 1916 one-person exhibition given Chase by the museum. The work was illustrated in an article, "Painting by William M. Chase," *American Magazine of Art* 18 (December 1916): 51. The work was also noted in the *DIA Bulletin* 10, no. 9 (May 1916). The article was reproduced in a brochure produced in conjunction with an address given by Chase at the annual dinner of the American Federation of Arts, Washington, D.C., on the evening of May 19, 1916. A photograph of the portrait descended in the Chase family with the following inscription on the reverse of the backing for the photograph: "Self[-]Portrait exhibited at Pan American Exhibition, San Francisco." The work is included in Peat's 1949 checklist of Chase's known work as *Self-Portrait* (I).

OP.557

Helen (Portrait Sketch), ca. 1914

Oil on panel; 11¾ x 9 in. (29.9 x 22.9 cm)
Signed: Wm. M. Chase (l.r.)
Inscribed on verso: HELEN; 4426 Port. of Daughter by WM Chase (in pencil); portrait of Miss Chase presented to Miss. Annie Lang by W. M. Chase—purchased from the Lang Estate.
Inscribed later: To my beloved son Hewlett Merritt on my 75th Birthday; (signed) Lewis J. Merritt
There was an estate seal in red wax affixed to the back of the work for the estate auction (these wax seals have been invariably lost due to cracking and lifting).

Location unknown

Auctions: **Csale '17 #171** as *Portrait Sketch* (fully described); **AAA '23 #27** as *Young Woman* (fully described).

A portrait of Chase's daughter Helen Velázquez Chase (1895–1965) likely executed shortly after Chase's return from teaching a summer class in Carmel-by-the-Sea, California. During this summer, Chase resumed making monotypes (mainly in black or brown printer's ink); he first experimented with this medium as early as the 1880s. The monochromatic features of this painting of Helen may represent Chase's continued exploration of these ideas. Though a notation on the back of the work indicates that it was given by Chase to ex-student Annie Traquair Lang (1885–1918), its presence in the 1917 Chase estate sale makes it somewhat more likely that she acquired the work at this venue. The work was

OP.558

OP.559

Master Roland Dana Chase, 1914

Oil on canvas; 32 x 25 in. (81.3 x 63.5 cm)
Signed: Wm. M. Chase (l.l.)
Dated: 1914 (verso)

Private collection

Exhibitions: **BFAA '14 #25** (illus. in exhibition
catalogue, p. 30; also illustrated in the *Academy Notes*
9 [July 1914]: 104); **NAD '14 #167** [lent by Mrs.
Chase]; **BMA '15 #23; New York, Arden Studios
Exhibition of Children's Portraits '16; MMA '17
#40** (fully described).

This is a portrait of the artist's son Roland Dana
Chase (1901–1980). It was illustrated in *Fine Arts
Journal* 34 (November 1916): 100, perhaps on the
occasion of its inclusion in the 1916 Arden Studios
Exhibition of Children's Portraits. The painting
was later lent to several exhibitions, including
BMAG '19 #101, FG '22 #2, CGA '23 #28
(NFS), also traveled to several museums, and ap-
peared in **AAA&L '28 #35**. The work remained
in the family after the artist's death and was illus-
trated in Katharine Metcalf Roof's 1917 biogra-
phy facing p. 272 (incorrectly noted as having
been painted the year before the artist's death).
In 1969 it was exhibited and reproduced in the
accompanying catalogue, "William Merritt
Chase 1849 to 1916," Chapellier Galleries, New
York, no. 29—most likely lent by Roland Dana
Chase as it was not available for sale. The portrait
is included in Peat's 1949 checklist of Chase's
known work as being owned by R. Dana Chase,
Jackson Heights, New York.

OP.560

Portrait of Myron A. Oliver, 1914

Oil on canvas; 14 x 19 in. (35.6 x 48.3 cm)
Inscribed, signed, and dated: To my friend Oliver /
Wm. M. Chase / 1914 (incised script)

Location unknown

In 1914 Chase traveled to Carmel-by-the-Sea,
California, to conduct a summer painting class.
One of the students was Myron Angelo Oliver
(1891–1967). Myron Oliver's father, John Kurtz
Oliver (1863–1943), was also an artist and a
teacher who owned a local art supply store and
gallery; it is likely that John Oliver supplied
paints, canvases, and so forth for the Chase class
that summer. The work has all the spontaneity of
Chase's demonstration pieces done before his
class to illustrate the technique of painting. It

also displays the very personal nature of his por-
traits of his students and close friends. Chase's
California paintings done in the summer of
1914 are rare, as most of his time was taken up
with teaching.

OP.559

OP.561

Lieutenant Theodore Monell, 1914

Oil on canvas; 60 x 36 in. (152.4 x 91.4 cm)
Signed: Wm. M. Chase (l.l.)

Location unknown

OP.560

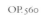

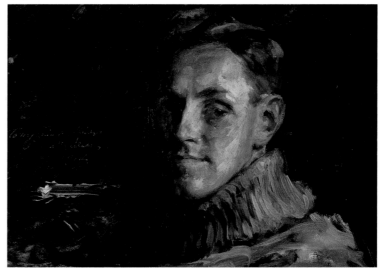

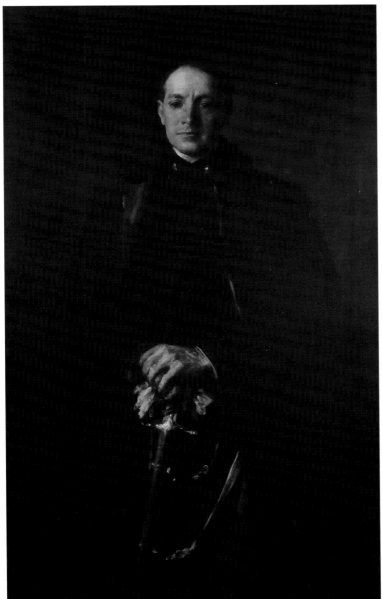

OP. 561

Exhibitions: **DMA '16 #24** [owned by Mrs. Monell]; **MMA '17 #38** [lent by Theodore Monell].

A letter from Mrs. William Short, the sitter's daughter, to Ronald G. Pisano discusses this painting. Theodore Monell is in the dress uniform of the United States Marine Corps. He lived in the town of Southampton, "Baybrook," Shinnecock Hills, and his wife was a student of Chase's during the last season of the Shinnecock Summer School of Art, 1902, and accompanied the Chase class during its summer sojourn to Holland in 1903. In this letter Mrs. Short claims the work was exhibited in the Pan American [*sic*] Exposition in San Francisco, 1915; however, it is not listed in the 1915 catalogue of the Pan-Pacific International Exposition, San Francisco. This painting is included in Peat's 1949 checklist of Chase's known works as being owned by Mrs. Theodore Monell, New York.

OP. 562

The Flame, 1914

Oil on canvas; 72 x 36 in. (182.9 x 91.4 cm)

Location unknown

This portrait has been confused with *The Blue Kimono* (OP.267), perhaps on account of the two works being confused in the catalogue accompanying the Chase estate sale of 1917. Chase completed this work during his last summer session teaching at Carmel-by-the-Sea, California, in 1914. In a letter to his wife, Chase mentioned that he was working on a full-length portrait of a "Miss Townsley" entitled *The Flame,* which would prove to be the last of his kimono portraits (Katharine Metcalf Roof, *The Life and Art of William M. Chase* [New York: 1917; reprinted 1975]: 248). Chase added, "I believe it is one of

my best things. The students are quite enthusiastic about it. When you see it you will tell me if it is any good" (ibid.). In a letter to his wife a few days later, Chase again referred to the enthusiasm of his students over the painting, adding, "I think myself it is a canvas you will care to have me exhibit" (ibid., 249). He described the portrait: "The dress is old gold color and a blue kimona background. I think you will like the combination. The girl is rather pretty" (ibid., 250). Chase did not mention *The Flame* again in his letters home, and there is no record of the work being exhibited during the artist's lifetime. Perhaps the painting was sold shortly after Chase completed it.

The sitter for *The Flame,* Miss Townsley, is most likely one of the daughters of Channel Pickering Townsley (1867-1921). Townsley managed Chase's Shinnecock Summer School of Art and helped organize Chase's summer art classes in Europe. Included on Peat's 1949 checklist of Chase's known work as *The Flame,* 72 by 36 inches, signed by the artist, and as being owned by F. L. Grunewald, Jr., New York.

OP. 563

Frederick S. Sturges

Oil on canvas; 40 x 38 in. (101.6 x 96.5 cm)

Signed: Wm. M. Chase (u.l.)

Presbyterian Hospital, New York

This work was noted in Katharine Metcalf Roof's 1917 biography of the artist, and is included in Wilbur Peat's 1949 checklist of Chase's known works.

OP. 563

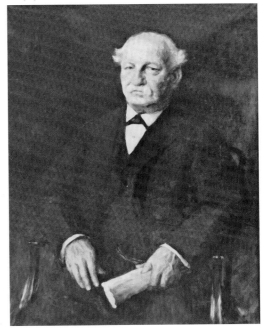

OP.564

Senator William A. Clark, 1915

Oil on canvas; 50½ x 40¼ in. (128.3 x 102.2 cm)
Signed: Wm. M. Chase (l.l.)

Corcoran Gallery of Art, Washington, D.C. Gift of
William Andrews Clark, 1917 (17.3)

Exhibitions: **TAP '15 #4** [lent by Senator Clark];
CGA '16 #259 [illus., lent by W. A. Clark] (illus.
in *American Magazine of Art* 5 [February 1917] in
a review of this exhibition: "William M. Chase's
admirable portrait of former Senator William A.
Clark, a much more vital and veracious portrait
of Mr. Clark than the well-known portrait of
Mr. Clark by Besnard"; additional references to the
work in the Corcoran exhibition include *American
Art News* [January 13, 1917]: 5, and *Art and Archeology*
[March 1917]: 157).

William A. Clark (1839–1925) was a senator from
Montana and a trustee of the Corcoran Gallery
of Art from 1914 until his death in 1925. In 1921
he established "The William A. Clark Prize
Awards," which, in addition to prizes given to
works exhibited in the Biennial Exhibitions of
Contemporary American Oil Paintings, were
used to purchase paintings by American artists.
Upon his death he bequeathed his considerable
art collection to the Corcoran, and his family
donated funds for a memorial wing to the
gallery to house the collection. It is also reported
that Clark owned the Henry-Bonnard Bronze
Company, New York. This painting is included
in Peat's 1949 checklist of Chase's known work
as being owned by the Corcoran Gallery of Art,
Washington, D.C.

OP.565

August Janssen, Esq., ca. 1915

Physical properties unknown

Location unknown

Exhibitions: **NAD-W '15 #220** [Mrs. August
Janssen—owner].

An Arthur August Janssen (b. 1890) was a Chase
student, and this portrait may either be of him
or a family member.

OP.566

Self-Portrait, 1915

Oil on canvas; 24 x 20 in. (61 x 50.8 cm)
Inscribed, signed, and dated: To my friend Annie T.
Lang / Wm. M. Chase / 1915

Corcoran Gallery of Art, Washington, D.C.

Exhibitions: **NAC '17 #1** as *Portrait of Himself* [Miss
Annie T. Lang—owner]; **ABAC '48 #10** [Corcoran
Art Gallery—owner].

Annie Traquair Lang (1885–1918) was a favorite
student of, and owned several works by, Chase.
Her estate sale in 1923 included thirteen paint-
ings by Chase. This inscribed self-portrait of
1915 was not in this sale, and was no doubt sold
separately to the Corcoran Gallery in 1923. The
painting, as *Self-Portrait* (F), was included in Peat's
1949 checklist of Chase's known work and listed
as being owned by the Corcoran Gallery of Art,
Washington, D.C.

OP.567

Portrait of Mrs. Eldridge R. Johnson, ca. 1915

Oil on canvas; 70 x 60 in. (177.8 x 152.4 cm)
Signed: Wm. M. Chase (l.l.)

Philadelphia Museum of Art. Gift of Eldridge
R. Johnson, 1922 (1922-87-1)

Exhibitions: **PAFA '15 #386,** illus. [lent by the
artist]; **RISD '16 #13** as *Mrs. Eldridge Johnson.*

Chase here depicts Elsie Reeves Fenimore Johnson
(b. 1872), wife of a prominent Philadelphia

OP.564

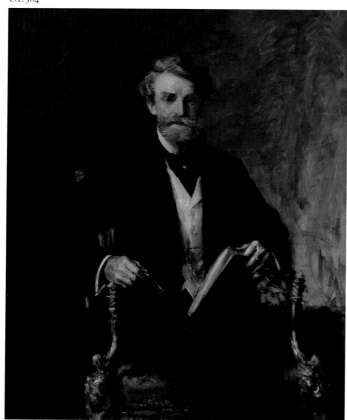

OP.566

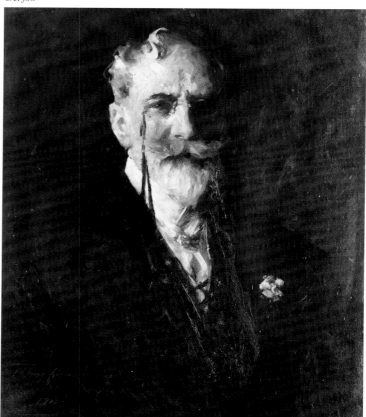

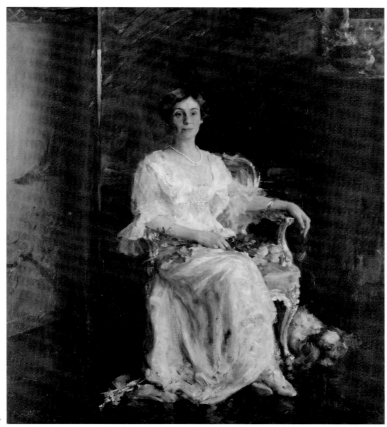

OP.567

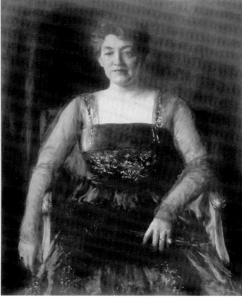

OP.568

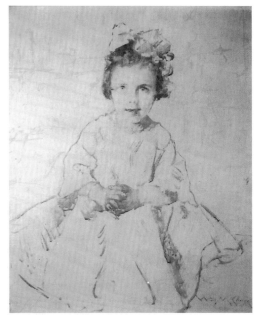

OP.569

inventor and businessman. Mr. Eldridge Reeves Johnson (1867-1945) was the inventor of a spring-driven gramophone motor (1896) and founder of the Victor Talking Machine Company (1901). The slogan "His Master's Voice," accompanied by a dog listening intently to a gramophone, became the company's logo in 1901 and would become famous around the world. The company continued to prosper until the late 1920s, when it was acquired by Radio Corporation of America in 1929, becoming RCA Victor.

In the portrait, the sitter is posed regally in an ornate chair and wears an elaborate gown topped by a pearl necklace and gold bracelets on each arm. Her somewhat serious expression is offset by the playful countenance of a dog peaking around the corner of the chair, surely a reference to the mascot of the Victor Talking Machine Company.

The painting was illustrated in Arthur Hoeber, "Exhibitions in the Galleries—Pennsylvania Academy of the Fine Arts," *Arts and Decoration* (1915) and was praised by another critic who wrote, "The remarkable contribution of Wm. M. Chase entitled 'Portrait of Mrs. Eldridge R. Johnson' has painter-like quality in a most marked degree. It has all the dash and spirit of a work by a young man with the experience and restraint of a veteran. Textures are handled in a skillful manner. Tones and harmonies are

an incessant joy, while the masses are grouped and held as only a great master could conceive" (W. H. de B. Nelson, "Philadelphia's Hundred and Tenth Annual," *International Studio* 55 [March 1915]: iv). Included on Peat's 1949 checklist of Chase's known work as *Mrs. Eldridge Reeves Johnson,* and as being owned by the Philadelphia Museum of Art.

OP.568

Mary Taylor Snyder, ca. 1915

Oil on canvas; 42½ x 34 in. (108 x 86.4 cm)
Signed: Wm. M. Chase (l.l.)

Location unknown

The only extant image of this work comes from a photograph of this portrait, labeled *Mary Taylor Snyder* on the verso, that descended in the Chase family. There are no exhibition records for this work. It is interesting to note that another work, *Mrs. William Clark Mason (Mrs. Mason; Portrait of Miss M.; Miss Mary; Mary Mason)* (OP.529), was shown at the 1916 exhibition of the National Academy of Design in New York, its owner at that time being listed as Henry Snyder, perhaps a relation of the sitter for the present portrait.

OP.569

Mary Content (A Child [Mary Content Chase]), ca. 1915

Oil on canvas; 31 x 26 in. (78.7 x 66 cm)
Signed: Wm. M. Chase (l.r.)

Collection of Edward Chase Matthews

Exhibitions: **NAPP '15 #10** as *Mary Content* (*New York Times,* Nov. 7, 1915, SM21); **MMA '17 #43** as *A Child (Mary Content Chase)* [lent by Mrs. W.M. Chase].

This painting, which descended through the Chase family, depicts Chase's youngest daughter,

Mary Content (1904–1943). The work was illustrated in its day accompanied by a quotation from William Wordsworth, "Her eyes as stars of twilight fair, Like twilights too her dusky hair, / But all things else about her drawn From May-time and the cheerful dawn" (*Craftsman* [December 1915]: n.p.). It is included on Peat's 1949 checklist of Chase's known work as *A Child (Mary Content Chase),* and as being of unknown ownership, though the painting had remained in the Chase family.

OP.570

Miss Savageau, 1915

Oil on canvas; 38½ x 28¼ in. (97.8 x 71.8 cm)
Signed: Wm. M. Chase (u.r.)
Label verso: Buffalo Fine Art Academy, with the title "Miss. S," lender William Merritt Chase, and insurance value $20. Another label with "25" and "Miss Savageau"

Denver Art Museum. Gift of Gertrude Savageau Freeman, 1992 (1992.116)

Exhibitions and Auctions: **PPIE '15 #3738** as *Miss Savageau* [lent by the artist].

Miss Gertrude Savageau Freeman (b. 1892) was a student of Chase's. She sat for this painting, aged twenty-three, in 1915. According to Ms. Freeman, she sat for Chase for seven sessions, each lasting for two hours. The portrait was not commissioned by the Savageaus. Although Miss Savageau's father thought the portrait made her look too old, he eventually purchased it from Mrs. Chase (Jack Kunin, Denver, from a conversation with Gertrude Freeman, n.d., Ronald Pisano Chase Archives). Despite the inscription on the verso of the painting, there is no extant record the work was ever exhibited at the Buffalo Fine Art Academy.

OP.571

Mrs. Chase, 1915

Oil on canvas stretched on cardboard; 15⅞ x 11¹⁵⁄₁₆ in. (40.3 x 30.3 cm)
Signed: Wm. M. Chase (l.r.); Chase (scratched in paint, l.r.)
Verso: signed and dated 1915

Location unknown

Exhibitions and Auctions: **MMA '17 #42** [lent by Mrs. Chase].

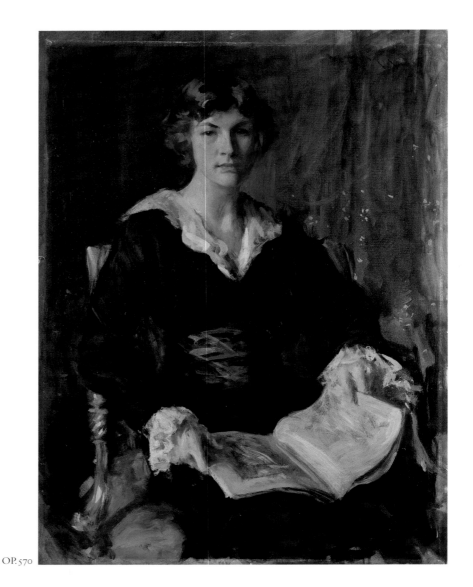

OP.570

OP.571

The Frick Art Reference Library, New York, has a black-and-white photograph of this depiction of Mrs. Chase. The work is also visible in a photograph of an installation view of the Chase Memorial Exhibition in 1917, confirming that the present work is the one described in the catalogue entry, which reads as follows: "[The sitter] wears a black dress and a brown hat and is seated with her left hand resting on a red book; an open window is [in] back of her." It is included, owner unknown, on Peat's 1949 checklist of Chase's known work as *Portrait of Mrs. Chase* (D), owner unknown.

OP.572

Portrait of a Lady, ca. 1915

Oil on canvas; 28 x 24 in. (71.1 x 61 cm)

Private collection

Auctions: **Csale '17 #191**, unsigned/estate seal.

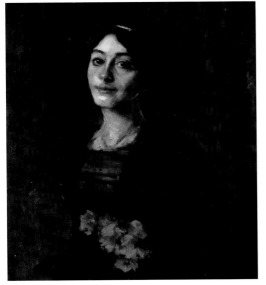

OP.572

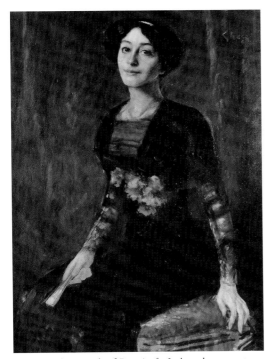

OP.572A. Photograph of *Portrait of a Lady* at three-quarter-length state

This work was originally a full-length portrait measuring 56 by 42 inches. It was described in the 1917 estate sale catalogue: "A black-haired woman with large serious eyes is depicted at full length, seated on a green stool and facing somewhat toward the left. She is in black with transparent sleeves and corsage, and wears a bouquet of red flowers." Since the painting was unsigned, an estate seal in red wax was affixed to the back of the work; these seals invariably have been lost due to cracking and lifting. A photograph of the work (OP.572A), said to measure 45 by 32 inches, is included in the Chase Archives, Parrish Art Museum, Southampton, New York; the photograph shows that an

apocryphal signature, "Chase," had been added in the upper right. On the back of this photograph is a stock number, 5957 (presumably an inventory number of Newhouse Galleries). However, when the painting was included in a book published by Newhouse Galleries in 1927, the work had been cut to 28 by 24 inches, retaining the spurious signature. In addition, there is a photograph (also with the stock number 5957) of the painting in this final state that is inscribed on the verso: "This was painted by my husband Wm. M. Chase of a pupil of his— Mrs. Wm. M. Chase/1927." As Mrs. Chase died March 31, 1927, it is possible that she was not in a clear state of mind to recognize that the painting had been tampered with—not only was the original painting cut down and a fake signature added, but the arms of the sitter were repositioned and repainted at some point during the ten-year period following the work's first appearance in the 1917 estate sale. Prior to 1927, for unknown reasons, the sitter was identified as Alice Fernandez, although this may have been pure speculation. Another portrait said to be of Alice Fernandez was at one time ascribed to Chase. However, that work has since been determined not to have been painted by him.

OP.573

Portrait of Miss N., ca. 1915

Oil on canvas; 33 x 24½ in. (83.8 x 62.2 cm)
Signed: Chase (u.l.)
Label verso: F. A. Lawlor, NY

American Academy of Arts and Letters, New York. Gift of Archer M. Huntington, 1936

Auctions: **Csale '17 #279** as *Portrait of Miss N.* [purchased, F. A. Lawlor, $80].

The catalogue accompanying the Chase estate sale of 1917 describes the work, likely a demonstration piece, as the depiction of "a young woman with loosely dressed golden-brown hair, dark eyebrows and blue eyes, clad in a low-necked filmy white gown with orange girdle, . . . portrayed a little more than half-length, standing, with wrists at her waistband, hands behind her, in a soft light against a neutral brownish background." Chase completed at least one other portrait with a similar title (OP.550), and perhaps also of this sitter. Included on Peat's 1949 checklist of Chase's known work as *Miss N.,* and as being formerly owned by F. A. Lawlor, New York.

OP.574

Portrait of Willona B. Sewell Lang, ca. 1915

Oil on canvas; 20 x 16 in. (50.8 x 40.6 cm)
Location unknown

A portrait of the mother of one of Chase's prized students, Annie Traquair Lang (1885–1918), this painting may offer a very late example of Chase's portraiture (as indicated by the information provided by the descendants of the sitter), though it more likely represents the work of an artist suffering from extreme illness and therefore unable to rally the forces necessary to complete a successful work. The fact that it was not signed indicates that Chase considered it unfinished,

OP.573

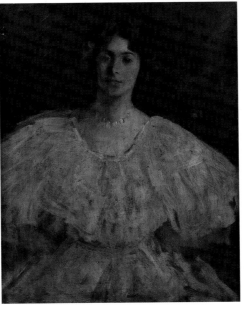

OP.574

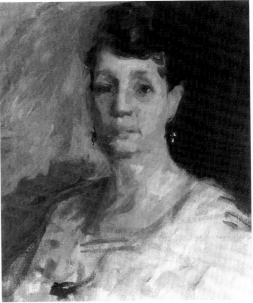

unsuccessful, or both, and is especially note-worthy given the artist's closeness to the sitter's daughter. Chase also painted the sitter's daughter on two occasions (see OP.531 and OP.594).

OP.575

Portrait of Thomas Moran, N.A.

Oil on canvas; 55 x 36 in. (139.7 x 91.4 cm)

Gilcrease Museum, Tulsa, Okla.

Auctions: **Csale '17 #188** (fully described) [purchased, McDonough Gallery, $260].

The circumstances behind Chase's portrait of Thomas Moran (1837–1926) are unknown. Moran was, of course, one of the most important American landscape artists of the nineteenth century. Through many artist organizations, Chase and Moran undoubtedly knew one another. The painting, however, has an unfinished quality, and the fact that it was unsigned

tends to confirm that Chase never completed the portrait. The painting, owner unknown, is included in Peat's 1949 checklist of Chase's known work.

OP.576

John C. Ferguson

Oil on canvas; dimensions unknown
Signed: Wm. M. Chase (l.l.)

North Carolina Museum of Art, Raleigh. Gift of Mr. and Mrs. Peter Ferguson (98.2)

John C. Ferguson (1866–1945) was a noted Chinese scholar who lived in China from 1887 until 1914. In 1897 he had been appointed to head a new academy in Shanghai, and in 1902 he became foreign secretary to the Chinese Mission of Commerce. He held several other jobs of importance in China before returning to the United States, after which he continued to be involved with Chinese writings and various

Chinese cultural matters, living from time to time in China. He also advised Charles Lang Freer on the availability of an important hand-scroll that was purchased by the collector. Ferguson assembled his own collection of Chinese antiquities, many of which were given to the Metropolitan Museum of Art, although the bulk of his collection was donated to the University of Nanjing, China.

OP.577

Francis Guerin Lloyd, ca. 1915

Oil on canvas; 38⅜ x 29 in. (97.5 x 73.7 cm)
Signed: Wm. M. Chase (l.l.)

Location unknown

Francis G. Lloyd (1846–1921) was, for many years, president of Brooks Brothers, New York. He had, at various times, summer homes in Quogue, Long Island, New York, and Bernardsville, New Jersey. Mr. Lloyd was said to have had

OP.575

OP.576

the largest collection of Japanese prints of his day. The portrait is most unusual in that Chase included, presumably, Mr. Lloyd's dog. There is an old label on the back of the painting, "L. Goddyn, Bruges." Chase taught a summer class in Bruges, Belgium, in 1912; however, it seems unlikely that this portrait is connected to this trip. Chase also painted the sitter's wife, Matilda Herbert Lloyd (OP. 578). His daughter, Mrs. Owen Winston, gave the painting to the Newark Museum; it was later sent to auction (Christie's, 1986, unsold).

OP. 578

Matilda Herbert Lloyd (1855–1945),
ca. 1912

Oil on canvas; 36¼ x 29 in. (92.1 x 73.7 cm)
Signed: Wm. M. Chase (u.l.)

Location unknown

OP. 578

OP. 577

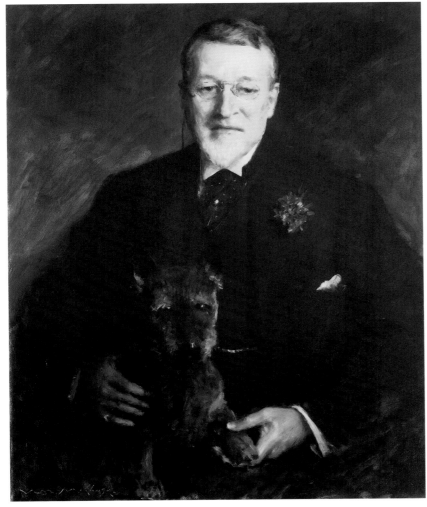

In 1875 Matilda Hedenberg Herbert (1855–1945) married Frances Guerin Lloyd (1846–1921), the first president of Brooks Brothers, of whom Chase also completed a portrait (OP. 577). Although the dimensions of the two portraits are slightly different, they were almost certainly commissioned as a pair. The paintings appear not to have been exhibited during the artist's lifetime.

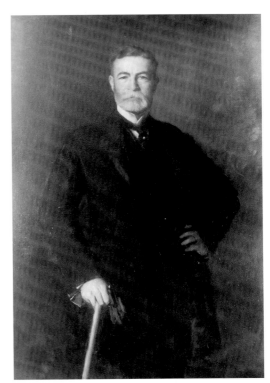

OP. 579

OP. 579

William John Curtis, 1915

Oil on canvas; 59½ x 39½ in. (151.1 x 100.3 cm)
Signed: Wm. M. Chase (u.l.)
Dated: 1915 (u.l.)

Bowdoin College, Brunswick, Maine

This work, depicting William John Curtis (1854–1927), appears on Wilbur Peat's 1949 checklist as being in the collection of Bowdoin College Museum of Fine Arts, Brunswick, Maine. It was a gift to the college by Mrs. William J. Curtis in 1927. It is curious that Chase painted a portrait of a W. J. Curtis in 1908 (exhibited at the National Academy of Design that same year), and were it not for the date on the Bowdoin College painting it would have been assumed that this work was, in fact, the same painting.

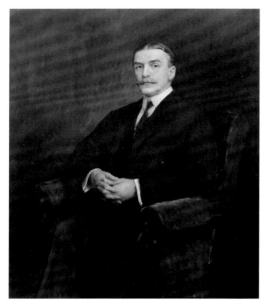

OP.580

OP.580

William Nimick Frew, 1915

Oil on canvas; 48 x 40 in. (121.9 x 101.6 cm)
Signed: Wm. M. Chase (l.r.)

Carnegie Museum of Art, Pittsburgh. Purchase: Fine
Arts Department Commission (15.1)

Exhibitions: **CI '16.**

Chase was commissioned by the board of
trustees of the Carnegie Institute, Pittsburgh, on
January 19, 1915, to paint a portrait of William
N. Frew (1854–1915), past secretary (1890–94)
and president (1894–1914) of the institute.
Mr. Frew was a personal friend of Andrew
Carnegie, who appointed him president in 1894.
A letter from Chase, dated January 23, 1915, dis-
cusses the work, which was apparently painted
after a photograph of the sitter: "My Dear
Mr. Church, The photograph of Mr. Frew is
here. I find it very good. I am only sorry not to
have a print in which the plate was not so much
retouched. Do you mind finding out if a proof
may not be had from the same negative with no
retouching. I am sorry to trouble you in the
matter and I thank you in advance. Most
respectfully yours, Wm. M. Chase." The letter
was sent to Colonel Samuel Harden Church,
president of the Carnegie Institute at that time.
William Nimick Frew was born in Pittsburgh,
the son of a wealthy Pittsburgh oil businessman.
After graduating from Yale University in 1876,
he attended Columbia University Law School.
In 1880 his father died, and he fell heir to exten-
sive business interests. He eventually became a
prominent member of the Pittsburgh business

community, and was also affiliated with educa-
tional, religious, and cultural institutions of the
city. As a lifelong friend of Andrew Carnegie,
William Frew was very involved with
Mr. Carnegie's philanthropic activities, and
it was Frew who made known Mr. Carnegie's
plans for the construction of the Carnegie Insti-
tute. Under Frew's presidency, the original
Carnegie building, the library institute building,
and eight libraries were completed. The work
is included in Peat's 1949 checklist of Chase's
known work as being unsigned.

OP.581

Portrait Sketch, ca. 1915

Oil on canvas; 27 x 22 in. (68.6 x 55.9 cm)
There was an estate seal in red wax affixed to the
back of the work for the estate auction (these wax
seals have been invariably lost due to cracking and
lifting).

Collection of Barbara Guillaume, Atlanta

Auctions: **Csale '17 #90** as *Portrait Sketch* (fully
described) [purchased, J. W. Young Galleries,
Chicago].

According to a letter written by J. W. Young,
who owned the gallery of that name in Chicago
that purchased this work at the 1917 Chase
estate sale, "Mr. Chase showed it to me and
advised me that he considered it one of the
finest lay-ins for a portrait he had ever done.
He told me that it pleased him so much as an

OP.581

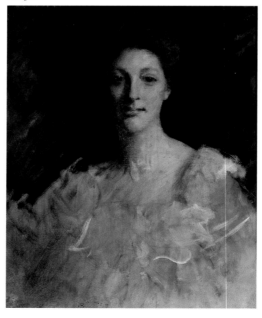

example of his way of laying in portraits, that
he asked the lady if she would permit him to
keep it for himself and to come back the next
day and he would make a new lay-in for her
which he afterwards made to her satisfaction"
(Letter of J. W. Young, J. W. Young Galleries,
Chicago, December 19, 1930, Ronald Pisano
Archives). The nearly monochromatic palette is
similar to that in one of Chase's portraits of his
daughter Helen, *Helen (Portrait Sketch)* (OP.557).
The sitter for the present work remains
unidentified.

OP.582

Double Portrait: A Sketch (Sketch for the Portrait of Mother and Child), ca. 1915

Oil on canvas; 22½ x 15½ in. (57.2 x 39.4 cm)
Signed: Chase (u.l.)
Inscription (verso): Sketch for portrait of Mother
and Child Wm. M. Chase (in artist's hand); 73

Location unknown

Auctions: **Csale '17 #73** as *Double Portrait: A Sketch*
(fully described).

Chase completed this portrait of his daughter
Alice Dieudonnée (Chase) Sullivan (1887–1971)
and her daughter Dorothy "Bunny" Sullivan
toward the end of his life. A photograph from
the Chase Archives, Parrish Art Museum,
Southampton, Long Island, New York, shows the
mother and daughter in 1916, or nearly a year
after the execution of the portrait; they are easily
identified as the sitters. The catalogue accompa-
nying the 1917 Chase estate sale describes the
work as follows: "Figures observed nearly at full
length of a black haired young girl and a golden
haired very young girl, both in white and facing
front, looking squarely at the spectator. The
elder's fluffy summer frock is edged with black
at the breast, and her neck and waist are encir-
cled by golden-yellow ribbon, while the pink-
cheeked infant appears in a pale gold bonnet
with orange strings."
 Although the inscription on the back of
the work suggests that the present work was
intended as a sketch for a more "finished"
portrait, no other version is extant. Also, it was
uncharacteristic for Chase to do oil sketches for
pending portraits at this stage in his career. He
might, however, have been so pleased with this
sketch of his daughter and granddaughter that
he planned to make a more finished version for
exhibition purposes. But the artist, who died in
1916, was short on time and the plan, if it
existed, did not come to fruition.

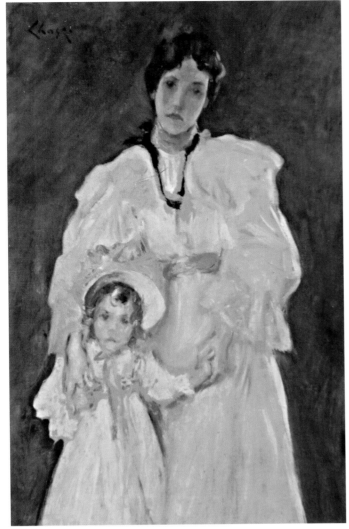

OP.582

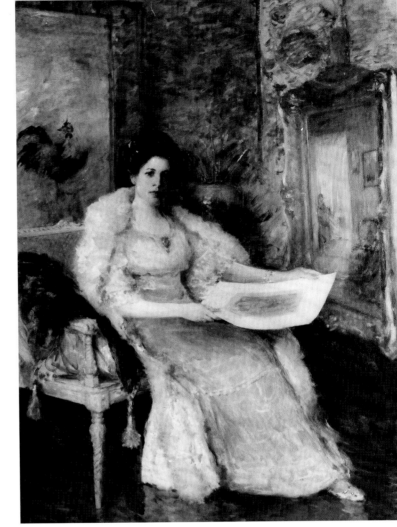

OP.583

OP.583

Susan Watkins Serpell, ca. 1915

Oil on canvas; 74⅞ x 52 in. (190.2 x 132.1 cm)
Signed: Wm. M. Chase (l.l.)

Serpell Collection, Chrysler Museum, Norfolk, Va.

This is a posthumous portrait of artist Susan Watkins Serpell (1875–1913), who came from her native California to study in New York at the Art Students League. In 1896 she traveled to Paris, where she spent the next fourteen years. She returned to New York City in 1910 and was elected an associate member of the National Academy of Design. Unfortunately, her health was failing, and in 1913, only one year after she married Goldsborough Serpell and moved to Norfolk, Virginia, she passed away.

Sometime in 1915, Goldsborough Serpell commissioned Chase to complete a posthumous portrait of his wife. Serpell had any number of reasons to choose Chase for this commission—not least his unimpeachable reputation as a portraitist—but it is possible that Susan Watkins Serpell may have been one of Chase's students at the Art Students League, giving added impetus to his request.

In the portrait, Serpell appears to have been studying an artwork she is holding in her hands when she looks up to greet a figure reflected in the mirror, a common artistic prop for Chase and one traceable back to its use by one of his favorite painters, Diego Velázquez. The painting of the rooster that is visible behind Serpell appears also in Chase's 1912 *Portrait of Madame E. H. Bensel* (OP.543). The work is freely painted, with great attention paid to ornament, fine fabrics, and decorated elements—all traits typical of Chase's portraits of the period. Since it was a posthumous portrait, Chase likely worked from a photograph of Serpell. Included on Peat's 1949 checklist of Chase's known works as *Susan Watkins Serpell,* and as being owned by the Norfolk Museum of Arts and Sciences, Virginia.

OP.584

Self-Portrait, 1915–16

Oil on canvas; 20 x 16 in. (50.8 x 40.6 cm)
Signed: Wm. M. Chase (l.l.)

Location unknown

Exhibitions: **AAA&L '28 #17** [W. F. Collins—owner].

There are no documented exhibition records for this work during the artist's lifetime. It is one of seven known late self-portraits, the style of which can be traced to the 1908 self-portrait that Chase painted for the Uffizi Gallery, Florence. The self-portrait first surfaced in a 1927 book published by Newhouse Galleries, St. Louis, Missouri (illus. no. 8), in conjunction with an exhibition of works for sale by Chase. It was apparently purchased by Mr. W. F. Collins who, the following year, lent it to an exhibition in New York, American Academy of Arts and Letters, "Exhibition of the Works of William Merritt Chase," April 26–July 15, 1928, no. 17.

That same year it was illustrated in the *New York Social Calendar,* May 14, 1928. And the next year it appeared in an article, "The Art Market," *Parnassus* 1, no. 4 (April 1929): illus. p. 17. A photograph of this painting descended in the Chase family. It is included in Peat's 1949 checklist of Chase's known work as *Self-Portrait* (H), and as being the property of Mr. W. F. Collins, Fort Worth, Texas.

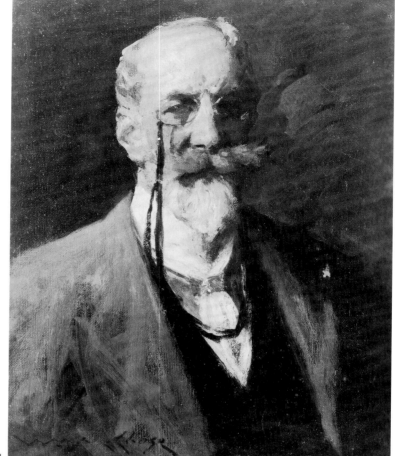

OP.584

OP.585

Self-Portrait, 1916

Oil on canvas; 20 x 16 in. (50.8 x 40.6 cm)

Memphis Brooks Museum of Art, Tenn. Gift of the Memphis Art Association (22.1)

Exhibitions: **MMA '17 #45** (illus. as frontispiece) [lent by Mrs. Wm. M. Chase]; **BMAG '19 #104.**

In the 1917 memorial exhibition at the Metropolitan Museum of Art, the catalogue entry for this work notes that it was painted in the spring of 1916. As such it is the last self-portrait by the artist. The work was illustrated in *American Art Annual* 14 (1917): facing p. 325. It was included in Peat's 1949 checklist of Chase's known work as *Self-Portrait* (G), and as being owned by the Brooks Memorial Art Gallery, Memphis, Tennessee.

OP.586

Self-Portrait in the Studio, 1916

Oil on canvas; 52½ x 63½ in. (133.4 x 161.3 cm)
Signed: Wm. M. Chase (l.l.)

Richmond Art Museum, Ind.

Exhibitions: **TAP '16 #2; AIC '17 #45; CI '17 #45; PAFA '17 #277** (illus. in catalogue; "The One Hundred and Twelfth Exhibition of the Pennsylvania Academy," *International Studio* [August 1917]: illus. p. 63); **JHAI '18 #18** (catalogue cover illus.).

In 1913 Mrs. Melville F. Johnston, director of the Art Association of Richmond, Indiana, commissioned a self-portrait from the artist; it was finished in 1916. An image of the work was used on the program cover for an art department luncheon, May 26, 1916, of the General Federation of Women's Club, as Mrs. Johnston was chairman of the art department of the Federation. The luncheon, held at the Hotel Astor in New York, featured several speakers on the subject of

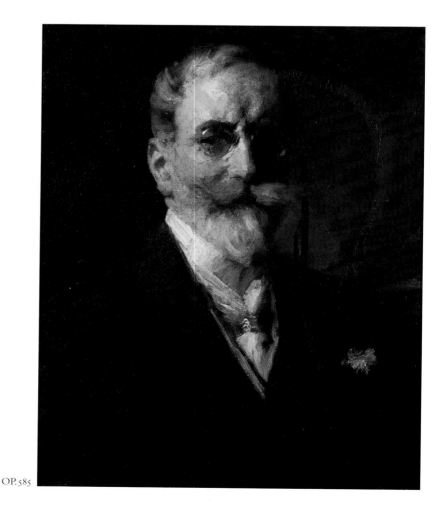

OP.585

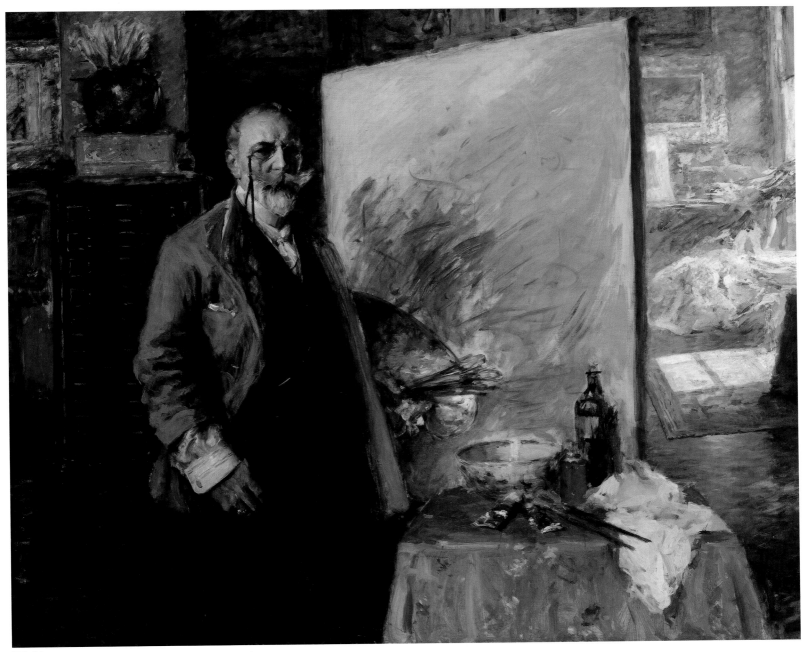

OP.586

"Hope for Art in America." One of the "five-minute talks" was given by William M. Chase on the subject of foundations. The painting was also illustrated in *American Art News* 15 (October 28, 1916): 3; Katharine Metcalf Roof, "William Merritt Chase: His Art and His Influence," *International Studio* 60, no. 240 (February 1917): cvi; and Frances Lauderbach, "Notes from Talks by William M. Chase: Summer Class, Carmel-by-the-Sea, California, Memoranda from a Student's Note Book," *American Magazine of Art* 8 (September 1917): 432. The story of how this commission came to be was published in *Parnassus*, the journal of the College Art Association

(March 1936): 39-41: A Mr. L met Chase while traveling in Europe in 1912 [most likely in Belgium as that was where Chase was teaching a summer class]. As Mr. L was from Richmond, Indiana, and knowing that Chase was born in that state, upon his return he offered to pay half of what he assumed to be the $500 fee—the other half to be paid for by the Art Association of Richmond. Mrs. Johnston had first met Chase in 1906, and she dutifully made yearly trips to Chase's Fourth Street Studio to check on the progress of the portrait commission. Finally, four years later, she arrived with Mr. L to see the completed work. Chase told her that

the empty canvas in the painting represented his masterpiece, yet to be painted. In fact he had first titled the Richmond portrait *My Masterpiece,* but he felt the title might be misleading. As the painting was much more monumental than the commissioned "head" portrait, Chase explained that he painted it for Mrs. Johnston "for all she has done for art in Indiana and the West." The painting is reproduced as the frontispiece in Katharine Metcalf Roof's 1917 biography. The work is included in Peat's 1949 checklist of Chase's known work.

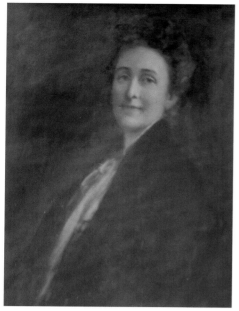

OP.587

Chase had not completed this painting of his wife and son Roland Dana (1901–1980) prior to his death in 1916. He had previously said that the only person whom he would trust to touch up his paintings was his friend Irving Wiles (1861–1948). At the Chase family's request Wiles painted in the head of Mrs. Chase in the present work. As Chase's biographer Katharine Metcalf Roof recounted: "A few days before his death, while he was still able to talk, his friend Irving Wiles came to see him, the only person outside the family to see him after his return to New York. Although very weak and near the end, he had sent to his studio for some pictures which he requested to have hung upon the wall to show his painter friend. An artist to his innermost soul, that last characteristic act has a touching significance to those who knew and loved him. Before he died he expressed his wish that Wiles

should finish his unfinished portrait commission" (*The Life and Art of William M. Chase* [New York: 1917; reprinted 1975], 324–25). Chase not only influenced his style, but also became a lasting friend, choosing Wiles to complete the portrait commissions left unfinished at his death. In 1882 he went to Paris as a student of Carolus-Duran, Boulanger, and Jules Lefebvre, attending the Académie Julien. In addition to studying with Chase at the Art Students League, Wiles also traveled with him in Spain (1905) and Italy (1910) and was an instructor at the Chase School of Art.

Mrs. W. M. Chase and R. D. Chase was illustrated in *American Art News* 16 (March 16, 1918): 1, and the *American Magazine of Art* 9 (May 1918): 289. The painting, owner unknown, is included on Peat's 1949 checklist of Chase's known work as *Mrs. Chase and Son Dana*.

OP.587

Portrait of Caroline Demming Ostrom, 1916

Oil on canvas; 30 x 22 in. (76.2 x 55.9 cm)
Signed: Wm. M. Chase (l.l.)

Location unknown

Caroline Demming Ostrom (b. 1846) was a Chase student at his Shinnecock Summer School of Art in 1891. Chase executed this portrait as a commission by the sitter's husband and did so from a photograph. The painting was probably completed by Chase when he was extremely ill, and it is not characteristic of his work, not least in the treatment of surfaces, which distinctly lack the dexterity and bravura typical of Chase's better paintings. Also, the expression of the subject is unusually sweet and sentimental, which could be attributable to the painting's depiction of someone already deceased. Chase's signature is strikingly weak and uncharacteristically low in the composition.

OP.588

Mrs. W. M. Chase and R. D. Chase, 1916

Oil on canvas; 62 x 50¼ in. (157.5 x 127.6 cm)
Signed: painted by Wm. M. Chase and Irving R. Wiles (l.r.)

Location unknown

Exhibitions: **BMAG '19 #118** as *Mrs. W. M. Chase and R. D. Chase* by W. M. Chase and I. R. Wiles.

OP.588

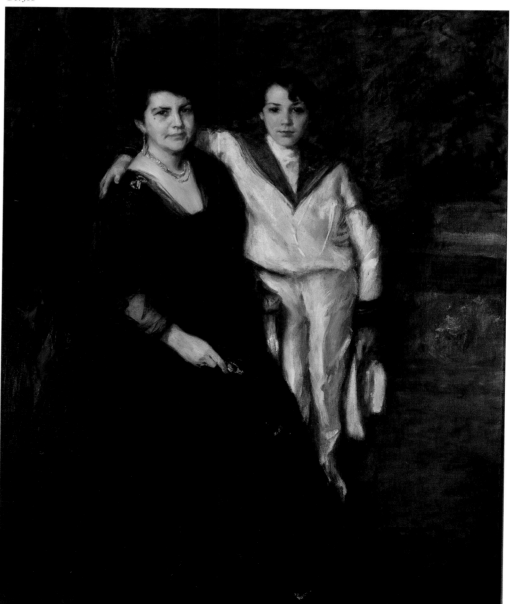

OP.589

A. B. Gwathmey, 1916

Oil on canvas; 40 x 30 in. (101.6 x 76.2 cm)
Signed: Wm. M. Chase (l.r.)

Location unknown

Exhibitions: **MMA '17 #44** [lent by A.B. Gwathmey].

This is the last known painting by William Merritt Chase. It was illustrated in Katharine Metcalf Roof's article "William Merritt Chase: His Art and His Influence," *International Studio* 60, no. 240 (February 1917): cvii. It was also discussed in Roof's 1917 biography of Chase, *The Life and Art of William Merritt Chase*, 322, "The portrait of Mr. Gwathmey . . . was his last work," illus. facing p. 322. During World War I, J. Temple Gwathmey, president of the New York Cotton Exchange, and A. B. Gwathmey, Jr., donated a car to the American Field Service in France, the New York Cotton Exchange A. B. Gwathmey ambulance. It is likely that A. B. Gwathmey was their father. The work, owner unknown, is included in Peat's 1949 checklist of Chase's known work.

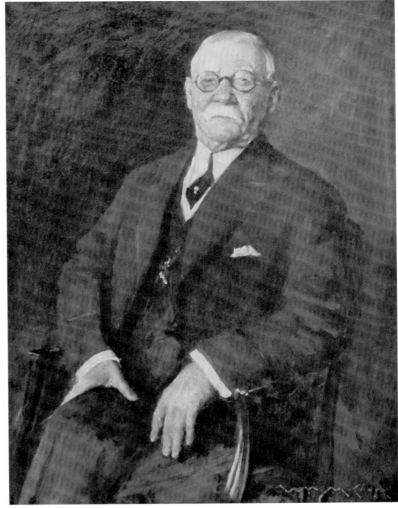

OP.589

ADDENDUM

Every effort has been made to arrange the entries in chronological order. However, in a few cases, it was impossible to determine even an approximate date. In addition, information regarding some portraits arrived after the catalogue numbers had been assigned and the works could not be incorporated chronologically. These works are included in this addendum.

OP.590

Study of a Boy's Head

Oil on canvas; 20 x 16 in. (50.8 x 40.6 cm)
Signed: Wm. M. Chase (l.r.)
Image unknown

Location unknown

Auctions: **Csale '17 #179** (Head and shoulders portrait of a thoughtful boy with pinkish complexion and blond hair, which falls loosely over his forehead and temples. The light falls upon the left side of his face, as he faces the front while turned slightly toward his right. His white shirt has a soft, rolling collar, and he wears a black necktie, brown suit, and black overcoat with collar carelessly rolled up).

Works with this title were exhibited many times during the artist's career. However, without substantiating evidence it is impossible to trace the exhibition history of the above-cited painting.

OP.591

A Boy's Head

Oil on canvas; 20 x 16 in. (50.8 x 40.6 cm)
Signed: Wm. M. Chase (l.l.)

Location unknown

Auctions: **Csale '17 #78** (Head and shoulders portrait of a red-cheeked youth of foreign type, brown hair falling carelessly over his brow, seen against a dark neutral background with a warm and softly glowing light concentrated on his face, which with the figure is turned slightly toward the right. He wears a black coat and brown undercoat and a soft white scarf appears at his neck).

The 1917 sales catalogue also states, "On the back is a paster in the artist's writing, with title and signature." This painting might possibly be the 1949 Peat checklist entry *Head of a Boy,* 19 by 15 in., formerly owned by the Newhouse Gallery, New York.

OP.592

Charles B. Curtis, 1905

Oil on canvas; 29 x 23½ in. (73.7 x 59.7 cm)
Signed: Wm. M. Chase (l.l.)

Collection of the Thor Lonning Estate

Charles Boyd Curtis (1827–1905) was born in Penn Yan, New York. He was a lawyer by profession, as well as founder and major shareholder of the Tarrytown National Bank. He was a benefactor of the Metropolitan Museum of Art and a recognized expert on Velazquez and Murillo; in fact, he wrote comprehensive catalogues on the work of both of these artists. He also became known for the catalogue he wrote on the etchings of Rembrandt. According to family history, this portrait was done posthumously from an 1894 photograph.

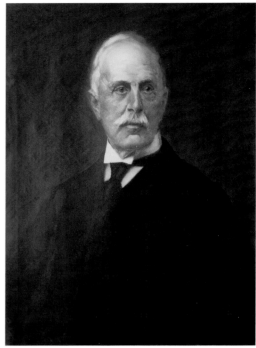

OP.592

OP.593

Spanish Man, 1881

Medium/support/dimensions unknown
Signed: Chase (c.r.)
Date: 1881 (c.r.)

Location unknown

The only record of this work is a print made of it by Frederick Juengling, in which the lower right corner notes: NY 81/FREDERICK/JUENGLING /SCULP. Although Juengling obviously made the print in New York, the Chase work was either painted in Spain or inspired by his trip to Madrid in 1881—the first trip he made to Europe after returning to the United States in 1878 from his studies in Munich.

OP.594

Annie Traquair Lang, ca. 1911

Oil on canvas; 24 x 20 in. (61 x 50.8 cm)

Location unknown

Chase completed two portraits of his student Annie Traquair Lang (1885–1918). This is a bust-length portrait while the other is nearly full-length. Chase also painted a portrait of Lang's mother, Willona B. Sewell Lang (OP.574), circa 1915. There are no extant images of this

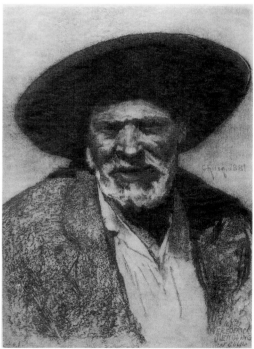

OP.593

painting; indeed, the only record of any kind is its appearance on Peat's 1949 checklist of Chase's known work as *Annie Traquair Lang* (B), and as being owned by J. S. Carpenter, Des Moines, Iowa.

OP.595

Portrait of Miss B., ca. 1888

Physical properties unknown

Location unknown

Exhibitions: **NAD '88 #214** [lent by The Lady].

This work appeared in the 63rd Annual Exhibition of the National Academy of Design, 1888, the sitter possibly the daughter of, or related to, Mrs. B. (OP.596).

OP.596

Portrait of Mrs. B., 1888

Physical properties unknown

Location unknown

Exhibitions: **NAD-A '88 #386** [lent by Mrs. B.].

This work appeared in the 1888 fall exhibition of the National Academy of Design, the sitter possibly being the mother of Miss B. (OP.595).

OP.597

Meditation, ca. 1886

Oil on panel; 13¼ x 9 in. (33.7 x 22.9 cm)
Signed: Wm. M. Chase (l.r.)
Label verso: "Bought by Frederick H. Clark for Mr. L. T. Hannum at a sale of Mr. Chase's painting at the Fifth Avenue Galleries, New York City about the year 1888."

Private collection

Exhibitions and auctions: **BAC '86 #44; Csale '87 #92.**

The figure in this painting may possibly be Chase's sister-in-law Virginia Gerson, who appears in several early figure studies by Chase (OP.85, OP.130, and OP.98). There also is a pastel portrait of Chase's wife Alice Gerson (vol. 1, P.31) with the same title. This small panel painting exhibits Chase's mastery in depicting patterns and fabrics.

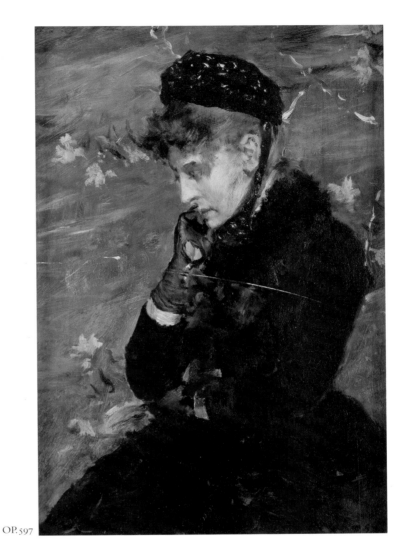

OP.597

OP.598

La Belle Munichoise, 1873

Oil on canvas; 27½ x 21¼ in. (70 x 54 cm)
Signed: Will M. Chase (u.r.) (appears to be incised)
Inscribed: Munich 1873

Private collection, Paris and Geneva

Chase painted *La Belle Munichoise* during his Munich Period, when he was a student at the Royal Academy from 1872 to 1878. This painting was owned by the artist William Turner Dannat (1853-1929) and then by his descendants for many years. Dannat undoubtedly knew Chase while he was a student at the Royal Academy in Munich in 1875, and might have acquired the work at that time. Dannat also later exhibited at the Society of American Artists in New York, where Chase was an active member and served as the organization's president (1880 and 1885-95); Chase owned one of Dannat's works, *Man Singing,* which was sold in his estate sale in 1917.

OP.598

OP.599

OP.601

OP.600

OP.599

Portrait of Alice Gerson, ca. 1883

Oil on panel; 15½ x 13 in. (39.7 x 33 cm)
Signed: Chase (l.l.)

Collection of Jamie M. Martin

This painting appears to depict Chase's wife, Alice Gerson (1866–1927), at age seventeen. Chase and many of his artist friends congregated at the Gerson home in New York, often using Alice and her sisters, Virginia and Minnie, as models for the many portraits and figure studies they completed during these years. Alice later became Mrs. William M. Chase.

OP.600

Portrait of a Child, ca. 1884

Oil on canvas; 13 x 8 in. (33 x 20.3 cm)
Signed: Chase (u.r.)

New Britain Museum of Art. Harriet Russell Stanley Fund

Signed with only his surname, this work possibly was a demonstration piece that Chase completed during one of the classes he taught at the Art Students League. In terms of brushwork and palette, this painting is related to *Woman with Guitar* (OP.119). While there are no lifetime exhibition or auction records for a work with the title *Portrait of a Child,* this work possibly could be *Study of a Young Girl,* exhibited in Chase's first solo exhibition at the Boston Art Club in 1886 (#25) and sold in the Chase sale of 1887 (#44). *Portrait of a Child* is included in Peat's 1949 checklist as *A Little Girl,* owned by Kleeman Galleries, New York.

OP.601

Portrait of a Woman, ca. 1902

Oil on canvas; dimensions unknown
Signed: Chase (u.r.)

Location unknown

This painting probably is a classroom demonstration piece and the sitter likely was a student in the class. The sitter's dress offers a clue to the approximate date of the painting, as several portraits show young ladies wearing similar dresses, such as *Lady with Red Flower,* 1902 (OP.364), and *Untitled (Portrait of a Young Woman),* ca. 1904 (OP.402).

Portrait of President Theodore Roosevelt

A feature article in the February 7, 1931, issue of the [New York] *Sun,* "25 Years Ago Today," noted that "William M. Chase, famous portrait painter of Philadelphia, has been commissioned by President Roosevelt to paint his portrait for presentation to King Edward of England"—the year would have been 1906. As there is no further reference to this painting, it must be assumed that the portrait was never executed, for surely Chase would have capitalized on the publicity of such a prestigious portrait commission. Furthermore, Jonathan Marsden, director of the Royal Collection, Buckingham Palace, reported that no such painting is in the Royal Collection. It should be noted, however, that Theodore Roosevelt and his wife, Edith, did know of Chase, having attended a performance of Carmencita dancing in Chase's Tenth Street Studio, April 1890—Roosevelt was Civil Service commissioner at the time. It is curious that Chase was described as a Philadelphia portrait painter, though he did have a studio in that city during these years and completed a good number of portraits there. There was a portrait of President Roosevelt done in 1906 by Irving R. Wiles, which was presented to the University of Berlin to commemorate a chair in history named for the president (this work was destroyed in World War II; however, a replica was made and hangs in Theodore Roosevelt's birthplace in New York City). It is certainly possible that the *Sun* reporter in 1906 mistakenly identified the proposed portraitist as Chase rather than Wiles, although the reference to Philadelphia would even be more remote in that case.

Portrait of President Woodrow Wilson

An article that appeared in the *New York Times,* January 6, 1913, p. 9, headlined: "W. M. Chase to Paint Wilson's Portrait. Noted Artist to Begin Work as Soon as Governor Can Find Time for Sittings." The occasion was the recent election of New Jersey Governor Woodrow Wilson as twenty-eighth president of the United States. The article noted that Seymour Thomas had painted a campaign portrait of the president-elect and was working on a life-size portrait, said to have been commissioned when Wilson was president of Princeton University. Chase would not discuss the portrait commission with the *New York Times* reporter, and the entire episode may very well have been simply an error of reporting. In fact, the article went on to state: "The news created much interest in art circles, as Mr. Chase has been looked upon by many as the foremost American portrait painter since the death of John S. Sargent." Sargent was, of course, very much alive in 1913. For the record, Seymour Thomas (1868–1956), of whom little is known today, was a Chase student at the Art Students League from 1885 to 1888. It is virtually unbelievable that a portrait of President Wilson by Chase would not have been reproduced or exhibited soon after completion, leading to the conclusion that if indeed Chase had been approached to paint the portrait of President Wilson, the work was never executed. Incredibly, the work was mentioned in an obituary of the artist, "William M. Chase Dead," *American Art News* 15 (October 26, 1916): 3, "Among the many portraits by Chase is one of President Wilson." There are no exhibition records of the work during Chase's lifetime; the work is not included in the listing of reproduction of works by William Merritt Chase in *The Index of Twentieth Century Artists, 1933–1937* (New York: Arno Press, reprint 1970), nor is the work included in Peat's 1949 checklist of Chase's known work.

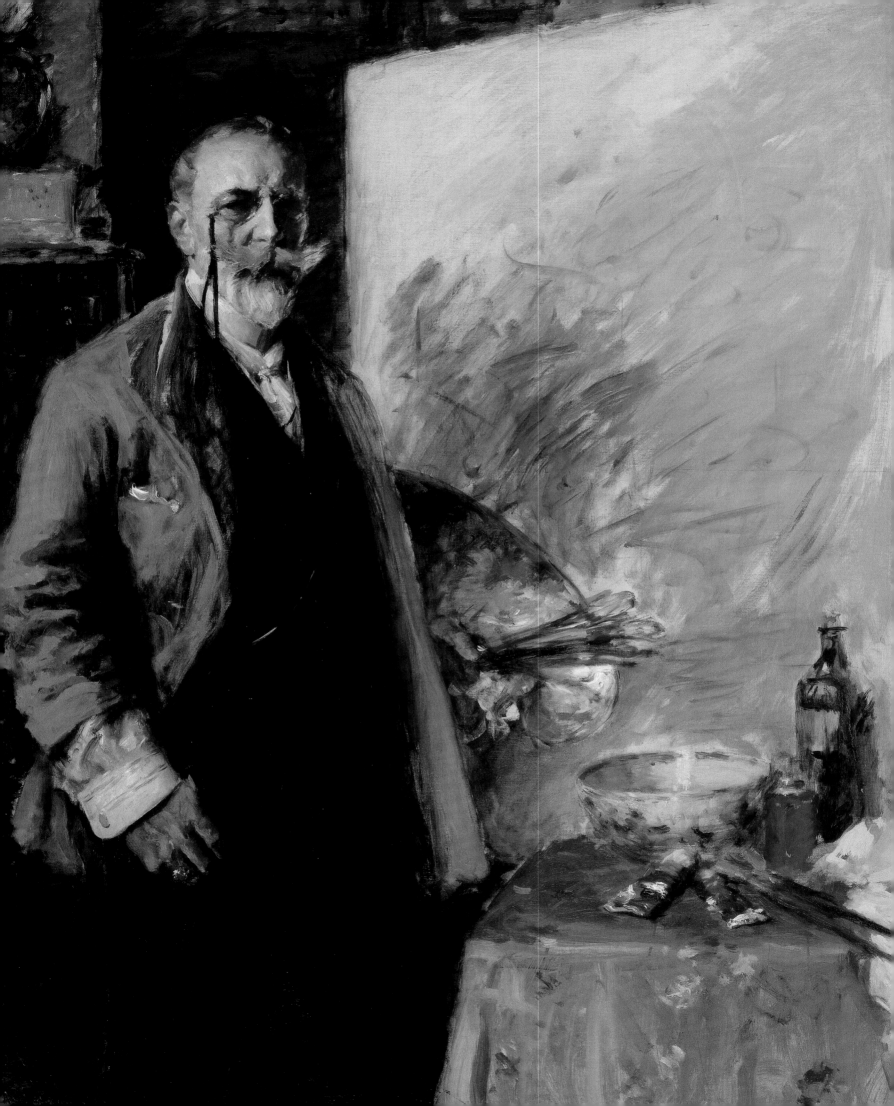

KEY TO EXHIBITION AND AUCTION ABBREVIATIONS

NAD '71 New York, National Academy of Design, 46th Annual Exhibition, 1871

StLA&M '71 St. Louis, Mo., Agricultural and Mechanical Association, 1871

NAD '75 New York, National Academy of Design, 50th Annual Exhibition, 1875

MCP '76 Munich Crystal Palace (Glaspalast), 1876

BAA '77 Brooklyn Art Association, Annual Exhibition, Dec. 1877

IIEC '77 Chicago, Interstate Industrial Exposition, 1877

LCE '78 New York, The Lotos Club, Apr. 22, 1878

BAA '78 Brooklyn Art Association, Apr. 22–May 8, 1878

CIIE '78 Chicago, Interstate Industrial Exposition, 6th Annual Exhibition, 1878

SAA '78 New York, Society of American Artists, 1st Annual Exhibition, Kurtz Gallery, 1878

BAC '79 Boston Art Club, Annual Exhibition, Jan. 15–Feb. 8, 1879

NAD '79 New York, National Academy of Design, Annual Exhibition, 1879

SAA '79 New York, Society of American Artists, 2nd Annual Exhibition, Kurtz Gallery, 1879

GAAE '79 Springfield, Mass., Gill's 2nd Annual Art Exhibition, 1879

SAA '80 New York, Society of American Artists, 3rd Annual Exhibition, Art Gallery, 845 Broadway, 1880

SSC '80 New York, Salmagundi Sketch Club Exhibition of Black and White Art, National Academy of Design, Dec. 18, 1880–Jan. 1, 1881

BAA '80 Brooklyn Art Association, Fall Exhibition, Dec. 7, 1880–Jan. 1, 1881

IIEC '81 Chicago, Interstate Industrial Exposition, 1881

PS '81 Paris Salon, 1881

SAA '81 New York, Society of American Artists, 1881

SAA '82 New York, Society of American Artists, Annual Exhibition, 1882

PS '82 Paris Salon, 1882

MCP '83 Munich Crystal Palace (Glaspalast), 1883

PS '83 Paris Salon, 1883

TCE '83 New York, American Art Association, Private Collection of Thomas Clarke, Dec. 28, 1883–Jan. 12, 1884

BLV '84 Brussels, Le Vingt, 1884

CCNY '84 New York, Calumet Club, Annual Exhibition, 1884

SAA '84 New York, Society of American Artists, 1884

WENO '84/85 New Orleans, World Exposition, 1884–85

BAC '86 Boston, Exhibition of Pictures, Studies and Sketches by Mr. Wm. M. Chase under the Auspices of the American Art Association, Boston Art Gallery, Nov. 13–Dec. 4, 1886

SAA '86 New York, Society of American Artists, Annual Exhibition, 1886

ULC '86 New York, Union League Club, 1886

Csale '87 New York, Moore's Art Galleries, Paintings by Mr. William M. Chase (cat. nos. 1–95 for sale, nos. 99–123 on loan), Mar. 2–3, 1887

MAG '87 New York, Chase Sale, Moore's Art Gallery, Mar. 2–3, 1887

SAA '87 New York, Society of American Artists, Annual Exhibition, 1887

CI '87 Pittsburgh, Carnegie Institute, Annual Exhibition, 1887

IAA '88 Indianapolis Art Association, 5th Annual Exhibition, May 9–30, 1888

NAD '88 New York, National Academy of Design, Annual Exhibition, Spring 1888

AIC '88 Art Institute of Chicago, 1st American Exhibition of American Pictures, 1888

NAD-A '88 New York, National Academy of Design, Autumn Exhibition, 1888

AAA '88 New York, Prize Fund Exhibition, 1888

SAA '88 New York, Society of American Artists, 10th Annual Exhibition, Yandell Gallery, 1888

IIEC '88 Chicago, Interstate Industrial Exposition, 16th Annual, Sept. 5–Oct. 20, 1888

RAC '88 Rochester, N.Y., Rochester Art Club, 9th Annual Exhibition, 1888

IIEC '89 Chicago, Interstate Industrial Exposition, 17th Annual Exhibition, Sept. 4–Oct. 19, 1889

AIC '89 Art Institute of Chicago, Annual Exhibition, 1889

AAA '89 New York, American Art Galleries, 5th Prize Fund Exhibition, 1889

NAD '89 New York, National Academy of Design, Annual Exhibition, 1889

SAA '89 New York, Society of American Artists, Annual Exhibition, 1889

ExUP '89 Paris, Exposition Universelle, 1889.

StLEx '89 St. Louis Exposition and Music Hall Association, 6th Annual Exhibition, 1889

NYAC '90 New York Athletic Club, 4th Annual Exhibition of American Paintings, Mar. 1890

FAAG '90 New York, Fifth Avenue Art Galleries, American Pictures on Sale, Mar. 20–21, 1890

NAD '90 New York, National Academy of Design, 65th Annual Exhibition, Apr. 10–May 17, 1890

AAG '90 New York, American Art Galleries, Exhibition of Six Artists, opened Apr. 17, 1890

ULC '90 New York, Union League Club, New York, Paintings and Antique Silver, Nov. 1890

AIC '90 Art Institute of Chicago, International Exposition, 1890

IIEC '90 Chicago, Interstate Industrial Exposition, 18th Annual Exhibition, 1890

IAA '90 Indianapolis Art Association, 1890

SAA '90 New York, Society of American Artists, Annual Exhibition, 1890

GWM '90 Round Lake, N.Y., George Webb Museum of Art and Archaeology, 1890

StLEx '90 St. Louis Exposition and Music Hall Association, 7th Annual Exhibition, 1890

AAG '91 New York, American Art Galleries, George I. Seney Sale, Feb. 11-13, 1891

Csale '91 New York, Fifth Avenue Art Galleries, Ortgies and Co., Sale of Works by William M. Chase, Mar. 6, 1891

NAD '91 New York, National Academy of Design, 66th Annual Exhibition, Apr. 6-May 16, 1891

SAA '91 New York, Society of American Artists, Annual Exhibition, Apr. 27-May 23, 1891

GDRP '91 Paris, Durand-Ruel Gallery, June 1891

BMFA '91 Boston, Museum of Fine Arts, Society of American Artists, June 4-July 2, 1891

TCE '91 Philadelphia, Pennsylvania Academy of the Fine Arts, the Thomas B. Clarke Collection of American Pictures, Oct. 15-Nov. 28, 1891

BFAA '91 Buffalo Fine Art Academy (no catalogue for this exhibition, which supposedly had seventy-three works, as per newspaper reviews), 1891

StLEx '91 St. Louis Exposition and Music Hall Association, Art Department, 1891

PAA '91 Pittsburgh Art Association, 1891

MCPIE '92 Munich, Crystal Palace 6th International Exhibition, June 1-Oct. 31, 1892

SAA '92 New York, Society of American Artists, 14th Annual Retrospective Exhibition Fifth Avenue Art Galleries, Dec. 5-24, 1892

NYCC '92 New York, Loan Exhibition: N.Y. Columbian Celebration of 400th Anniversary of the Discovery of America, 1892

NAD '92 New York, National Academy of Design, Annual Exhibition, 1892

PAFA '92 Philadelphia, Pennsylvania Academy of the Fine Arts, Annual Exhibition, 1892

CAL '92 Pittsburgh, Carnegie Art Library, Important Collection of Oil Paintings and Water Colors, 1892

StLEx '92 St. Louis Exposition and Music Hall Association, 9th Annual Exhibition, 1892

FAAG '93 New York, Fifth Avenue Art Galleries, Auction of Blakeslee and Co., Apr. 4-5, 1893

CWCE '93 Chicago, World's Columbian Exposition, 1893.

SAA '93 New York, Society of American Artists, 15th Annual Exhibition, Apr. 17-May 13, 1893

PAFA '93 Philadelphia, Pennsylvania Academy of the Fine Arts, 63rd Annual Exhibition, 1893

AAG '94 New York, American Art Galleries, Sale of Estate of George I. Seney, Feb. 7-10, 1894

FAAG '94 New York, Fifth Avenue Art Galleries, A Summer Art Exhibition, 1894

NADLEx '94 New York, National Academy of Design, Portraits of Women: Loan Exhibition for the Benefit of St. John's Guild and the Orthopaedic Hospital, Nov. 1-Dec. 1, 1894

NAD '94 New York, National Academy of Design, Annual Exhibition, 1894

SAA '94 New York, Society of American Artists, 16th Annual Exhibition, American Fine Arts Society Gallery, 1894

FASAG '94 New York, The Fine Arts Society Art Galleries, Group Exhibition, 1894

PAFA '94 Philadelphia, Pennsylvania Academy of the Fine Arts, 64th Annual Exhibition, Dec. 12, 1894-Feb. 23, 1895

CAA '95 Cleveland Art Association, 1st Annual Exhibition, Jan. 22-Feb. 22, 1895

NAD '95 New York, National Academy of Design, 70th Annual Exhibition, Apr. 1-May 11, 1895

NADLEx '95 New York, National Academy of Design, Loan Exhibition of Portraits For the Benefit of St. John's Guild and the Orthopaedic Hospital, 1895

SAA '95 New York, Society of American Artists, 17th Annual Exhibition, 1895

PAC '95 Providence Art Club, 95th Exhibition Loan Collection of Portraits of Women, 1895

StLEx '95 St. Louis Exposition and Music Hall Association, 12th Annual Exhibition, 1895

Csale '96 New York, Chase Sale, American Art Galleries, Jan. 7, 1896

BAC '96 Boston Art Club, Pictures, Studies and Sketches by Mr. Wm. M. Chase, of New York City, under the Auspices of the American Art Association, Nov. 13-Dec. 4, 1886

CI '96 Pittsburgh, Carnegie Institute, Annual Exhibition, 1896

BAC '96 Boston Art Club, 55th Exhibition of Oil Paintings and Sculpture, Dec. 5, 1896-Jan. 9, 1897

PAFA '96 Philadelphia, Pennsylvania Academy of the Fine Arts, 66th Annual Exhibition, Dec. 21, 1896-Feb. 22, 1897

RISD '97 Providence, Rhode Island School of Design, Paintings and Engravings, Mar. 11, 1897

NAD '97 New York, National Academy of Design, 72nd Annual Exhibition, Apr. 5-May 15, 1897

AIC '97 Art Institute of Chicago, Paintings by William M. Chase, Nov. 23-Dec. 26, 1897

CM '97 Cincinnati Museum, 4th Annual Exhibition, 1897

SAA '97 New York, Society of American Artists, Annual Exhibition, 1897

CI '97 Pittsburgh, Carnegie Institute, Annual Exhibition, Nov. 4, 1897-Jan. 1, 1898

AAG '98 New York, American Art Galleries, Auction, Mar. 9-11, 1898

StLEx '98 St. Louis Exposition and Music Hall Association, 15th Annual Exhibition, Sept. 14-Oct. 29, 1898

SAA '98 New York, Society of American Artists, Annual Exhibition, 1898

PAFA '98 Philadelphia, Pennsylvania Academy of the Fine Arts, Annual Exhibition, 1898

CI '98 Pittsburgh, Carnegie Institute, Annual Exhibition, 1898

TBCsale '99 New York, American Art Galleries, Private Art Collection of Thomas B. Clarke, Feb. 1899

NAD '99 New York, National Academy of Design, 74th Annual Exhibition, Apr. 3-May 13, 1899

BFAA '99 Buffalo Fine Art Academy and Albright Art Gallery, Annual Exhibition, 1899

CM '99 Cincinnati Museum of Art, Annual Exhibition of American Art, 1899

ISSPE '99 London, The International Society of Sculptors, Painters and Engravers, 1899

NADLEx '99 New York, National Academy of Design, Loan Exhibition of Portraits for the Benefit of the Orthopaedic Hospital, 1899

PAFA '99 Philadelphia, Pennsylvania Academy of the Fine Arts, Annual Exhibition, 1899

IEFA '99 Paris, International Exhibition of the Fine Arts, 1899–1900

CI '99 Pittsburgh, Carnegie Institute, 4th Annual Exhibition, Nov. 2, 1899–Jan. 1, 1900

PAFA '00 Philadelphia, Pennsylvania Academy of the Fine Arts, 69th Annual Exhibition, Jan. 15–Feb. 24, 1900

AAG '00 New York, American Art Galleries, American Paintings Belonging to William T. Evans, Jan. 31, 1900

AIC '00 Art Institute of Chicago, 13th Annual Exhibition, Oct. 30–Dec. 9, 1900

AAR '00 Art Association of Richmond, Indiana, 1900

BFAA '00 Buffalo Fine Art Academy and Albright Art Gallery, Annual Exhibition, 1900

MSFA '00 Minneapolis, Society of Fine Arts, Annual Exhibition, 1900

SAA '00 New York, Society of American Artists, 22nd Annual Exhibition, 1900

ExUP '00 Paris, Exposition Universelle, 1900

PS '00 Paris Salon, 1900

BAC '01 Boston Art Club, 63rd Exhibition, Jan. 5–Feb. 2, 1901

PAFA '01 Philadelphia, Pennsylvania Academy of the Fine Arts, 70th Annual Exhibition, Jan. 14–Feb. 23, 1901

GBV&C '01 New York, Galleries of Boussod, Valadon and Co., Portraits, Apr. 1901

RISD '01 Providence, Rhode Island School of Design, Autumn Exhibition, Oct. 22–Nov. 12, 1901

AIC '01 Art Institute of Chicago, Annual Exhibition, 1901

PAEX '01 Buffalo, Pan American Exposition, 1901

CM '01 Cincinnati Museum, Annual Exhibition, 1901

PSAG '01 South Poland, Maine, 7th Annual Exhibition of Paintings and Sculpture, Prominent Painters and Sculptors, Poland Springs Art Gallery, Maine State Building, 1901

VB '01 Venice Biennale, 1901

SCI&WIE '01 Charleston, S.C., Interstate and West Indian Exposition, 1901–2

CI '01 Pittsburgh, Carnegie Institute, 6th Annual Exhibition, Nov. 1901–Jan. 1, 1902

PAFA '02 Philadelphia, Pennsylvania Academy of the Fine Arts, Jan. 20–Mar. 1, 1902

EFMSale '02 New York, E. F. Milliken Sale, Feb. 14, 1902

CM '02 Cincinnati Museum, 9th Annual Exhibition, May 17–July 7, 1902

NAD '02 New York, National Academy of Design, Annual Exhibition, 1902

SAA '02 New York, Society of American Artists, 24th Annual Exhibition, 1902

CI '02 Pittsburgh, Carnegie Institute, Loan Exhibition, 1902

BAC '03 Boston Art Club, 67th Exhibition of Oil Paintings and Sculpture, Jan. 3–31, 1903

NAD '03 New York, National Academy of Design, 78th Annual Exhibition, Jan. 3–31, 1903

PAFA '03, Philadelphia, Pennsylvania Academy of the Fine Arts, 72nd Annual Exhibition, Jan. 19–Feb. 28, 1903

ULC '03 New York, Union League Club, Portraits of Americans, Feb. 1903

K&C '03 New York, M. Knoedler and Co., Exhibition of Portraits by Wm. M. Chase, Mar. 5–21, 1903

CM '03 Cincinnati Museum, 10th Annual Exhibition, May 23–July 6, 1903

AAR '03 Art Association of Richmond, Indiana, 1903

AIC '03 Art Institute of Chicago, 1903

THI '03 Indianapolis, Tomlinson Hall, Exhibit of Indiana Art, 1903

SAA '03 New York, Society of American Artists, 25th Annual Exhibition, 1903

CI '03 Pittsburgh, Carnegie Institute, Annual Exhibition, 1903

GAAE '03 Springfield, Mass., Gill's 26th Annual Art Exhibition, 1903

PAFA '04 Philadelphia, Pennsylvania Academy of the Fine Arts, 73rd Annual Exhibition, Jan. 25–Mar. 5, 1904

FSGA '04 New York, Auction: Collection of Frederick S. Gibbs, Feb. 24–26, 1904

CM '04 Cincinnati Museum Association, Annual Exhibition of American Art, May 21–July 11, 1904

CI '04 Pittsburgh, Carnegie Institute, 9th Annual Exhibition, Nov. 3, 1904–Jan. 1, 1905

AIC '04 Art Institute of Chicago, Portrait Exhibition, 1904

ISSPE '04 New York, The International Society of Sculptors, Painters and Engravers, Annual Exhibition, 1904

NAD '04 New York, National Academy of Design, 79th Annual Exhibition, 1904

SAA '04 New York, Society of American Artists, Annual Exhibition, 1904

SLWF/UE '04 St. Louis World's Fair/Universal Exposition (Louisiana Purchase Exposition), 1904

SWA '04 Washington, D.C., Society of Washington Artists, 14th Annual Exhibition, 1904

NAD '05 New York, National Academy of Design, 80th Annual Exhibition, Jan. 1–28, 1905

PAFA '05 Philadelphia, Pennsylvania Academy of the Fine Arts, 100th Annual Exhibition, Jan. 23–Mar. 4, 1905

McCG '05 Philadelphia, McClees Gallery, Exhibition of the Work of William M. Chase, Mar. 1905

MSAS '05 Minneapolis Society of Fine Arts, 2nd Annual Exhibition, Beard Art Galleries, Apr. 13–29, 1905

BFAA '05 Buffalo, Inaugural Loan Exhibition, Albany Art Gallery, May 31–July 1, 1905

CM '05 Cincinnati Museum of Art, Annual Exhibition of American Art, 1905

MCP '05 Munich, Crystal Palace International Exhibition (Glaspalast), 1905

SAA '05 New York, Society of American Artists, 27th Annual Exhibition, 1905

CI '05 Pittsburgh, Carnegie Institute, 10th Annual Exhibition, 1905

L&CCE '05 Portland, Ore., Lewis and Clark Centennial Exposition, 1905

SWA '05 Washington, D.C., Society of Washington Artists, 15th Annual Exhibition of the Society of Washington Artists, 1905

PAFA '06, Philadelphia, Pennsylvania Academy of the Fine Arts, 101st Annual Exhibition, Jan. 22–Mar. 3, 1906

TAP '06 New York, Ten American Painters, 9th Annual Exhibition, Montross Gallery, Mar. 14–31, 1906

SWA '06 Washington, D.C., Society of Washington Artists, 16th Annual Exhibition, Mar. 19–Apr. 7, 1906

BFAA '06 Buffalo Fine Art Academy, 1st Exhibition of Selected American Paintings, Albright Art Gallery, May–Sept. 1906

ULC '06 New York, Union League Club, Portraits by Contemporary Artists, June 24, 1906

AIC '06 Art Institute of Chicago, Annual Exhibition, 1906

CM '06 Cincinnati Museum, Annual Exhibition, 1906

JHAI '06 Indianapolis, John Herron Art Institute, Inaugural Exhibition, Art Association of Indianapolis, 1906

NAD '06 New York, National Academy of Design, Annual Exhibition, 1906

SAA '06 New York, Society of American Artists, 28th Annual Exhibition, 1906

PAFA '07 Philadelphia, Pennsylvania Academy of the Fine Arts, 102nd Annual Exhibition, Jan. 21–Feb. 24, 1907

CGA '07 Washington, D.C., Corcoran Gallery of Art, Annual Exhibition of Oil Paintings by Contemporary Artists, Feb. 7–Mar. 9, 1907

NAD '07 New York, National Academy of Design, 82nd Annual Exhibition, Mar. 16–Apr. 20, 1907

TAP '07 New York, Ten American Painters, 10th Annual Exhibition, Montross Gallery, Mar. 19–Apr. 6, 1907

CM '07 Cincinnati Museum 14th Annual, May 18–July 17, 1907

AAR '07 Art Association of Richmond, Indiana, Annual Exhibition, 1907

BFAA '07 Buffalo Fine Art Academy, Catalogue of the Permanent Collection of Sculpture and Paintings with Some Additions, 1907

CI '07 Pittsburgh, Carnegie Institute, Annual Exhibition, 1907

PAFA '08 Philadelphia, Pennsylvania Academy of the Fine Arts, 103rd Annual Exhibition, Feb. 4–Mar. 24, 1908

NAD '08 New York, National Academy of Design, 83rd Annual Exhibition, Mar. 14–Apr. 18, 1908

TAP '08 New York, Ten American Painters, 11th Annual Exhibition, Montross Gallery, Mar. 16–Apr. 4, 1908

PAFA/TAP '08 Philadelphia, Pennsylvania Academy of the Fine Arts, Exhibition of Ten American Painters, Apr. 11–May 3, 1908

BFAA '08 Buffalo Fine Art Academy, 3rd Annual Exhibition, Paintings by American Artists, Albright Art Gallery, Apr. 30–Aug. 30, 1908

CI '08 Pittsburgh, Carnegie Institute, 12th Annual Exhibition, Apr. 30–June 30, 1908

CM '08 Cincinnati Museum, 15th Annual Exhibition of American Art, May 27–July 20, 1908

CGA '08 Washington, D.C., Corcoran Gallery of Art, 2nd Biennial Exhibition, Oil Paintings by Contemporary American Artists, Dec. 8, 1908–Jan. 17, 1909

BFAA '09 Buffalo, "A Collection of Oil Paintings by William M. Chase, N.A.," Albright Art Gallery, Jan. 15–Feb. 14, 1909; John Herron Art Institute, Indianapolis, Mar. 3–28, 1909; St. Louis Art Museum, Apr. 1909; Cincinnati Museum of Art, Oct. 9–Nov. 6, 1909

PAFA '09 Philadelphia, Pennsylvania Academy of the Fine Arts, 104th Annual Exhibition, Jan. 31–Mar. 14, 1909

AAG '09 New York, American Art Galleries, Paintings and Watercolors . . . of the Late James S. Inglis, of Cottier and Co., New York, Mar. 1909

CI '09 Pittsburgh, Carnegie Institute, 13th Annual International Exhibition, Apr. 29–June 30, 1909

LAA '09 Louisville, Ky., Louisville Art Association, 1st Exhibition of the Louisville Art Association, June 1–19, 1909

AIC '09 Art Institute of Chicago, 22nd Annual Exhibition, Oct. 19–Nov. 28, 1909

VGB '09 Boston, Vose Gallery, Exhibition of Paintings by William M. Chase, Dec. 1909

CAA '09 Charleston, S.C., Carolina Art Association, 1909

DMA '09 Detroit Museum of Art, 1909

AAR '09 Art Association of Richmond, Indiana, Annual Exhibition, 1909

STCAM '09 St. Louis City Art Museum, Annual Exhibition of Paintings by American Artists, 1909

ULC '10 New York, Union League Club, Exhibition of Actresses' Pictures, Jan. 1910

NAC '10 New York, National Arts Club, Exhibition of Paintings by William Merritt Chase, Jan. 5–13, 1901

PAFA '10 Philadelphia, Pennsylvania Academy of the Fine Arts, 105th Annual Exhibition, Jan. 23–Mar. 20, 1910

BPL '10 Bridgeport, Conn., Bridgeport Public Library, Exhibition of Fifty-four Paintings by William M. Chase, Mar. 1910

NAD '10 New York, National Academy of Design, 85th Annual Exhibition, Mar. 12–Apr. 17, 1910

BFAA '10 Buffalo Fine Art Academy, 5th Annual Exhibition Selected Paintings by American Artists, Albright Art Gallery, May 11–Sept. 1, 1910

WAM '10 Worcester, Mass., Worcester Art Museum, 13th Annual Exhibition, June–Sept. 1910

RAL '10 London, Royal Academy, Exhibition of American Art, 1910

CI '10 Pittsburgh, Carnegie Institute, Annual Exhibition, 1910

EIBA '10 Santiago, Chile, Exposicion International de Belles Artes, 1910

PSAG '10 South Poland, Maine, 16th Annual Exhibition of Paintings and Sculpture, Prominent Painters and Sculptors, Poland Springs Art Gallery, Maine State Building, 1910

CGA '11 Washington, D.C., Corcoran Gallery of Art, Third Biennial Exhibition of Paintings by Contemporary American Artists, Dec. 1910–Jan. 1911

CI '11 Pittsburgh, Carnegie Institute, 5th Annual Exhibition, Apr. 27–June 30, 1911

CM '11 Cincinnati Museum of Art, Annual Exhibition, May 24–Sept. 8, 1911

WAM '11 Worcester, Mass., Worcester Art Museum, 14th Annual Exhibition of Oil Paintings by American Painters, May 28–Sept. 18, 1911

SLCAM '11 St. Louis City Art Museum, The Home Exhibition, Paintings Owned in St. Louis and Lent to the Museum, June 25–Oct. 31, 1911

NAD '11 New York, National Academy of Design, Winter Exhibition, 1911

TAP '11 New York, Ten American Painters, 14th Annual Exhibition, Montross Gallery, 1911

PAFA '11 Philadelphia, Pennsylvania Academy of the Fine Arts, Annual Exhibition, 1911

RISD '11 Providence, Rhode Island School of Design, Annual Exhibition, 1911

RAEx '11 Rome Art Exposition, Catalogue of the Collection of Pictures and Sculptures in the Pavilion of the United States of America, 1911

TMA '12 Toledo, Ohio, Toledo Museum of Art, Inaugural Exhibition, Jan. 17-Feb. 12, 1912

PAFA '12 Philadelphia, Pennsylvania Academy of the Fine Arts, 107th Annual Exhibition, Feb. 4-Mar. 24, 1912

OS '12 New York, Oehme Sale, Feb. 29-Mar. 1, 1912

BAA '12 Brooklyn Art Association, Loan Exhibition, Mar. 1912

TAP '12 New York, Ten American Painters, 15th Annual Exhibition, Montross Gallery, Mar. 2-Apr. 5, 1912

NAPP '12 New York, National Association of Portrait Painters, Mar. 18-Apr. 16, 1912

CI '12 Pittsburgh, Carnegie Institute, 16th Annual Exhibition, Apr. 25-June 30, 1912

WAM '12 Worcester, Mass., Worcester Art Museum, 15th Annual Exhibition, Oil Paintings, June 7-Sept. 15, 1912

AIC '12 Art Institute of Chicago, Annual Exhibition, 1912

BFAA '12 Buffalo Fine Art Academy, 7th Annual Exhibition, Albright Art Gallery, 1912

CM '12 Cincinnati Museum, 19th Annual Exhibition of American Art, 1912

NAD '12 New York, National Academy of Design, Annual Exhibition, 1912

CGA '12 Washington, D.C., Corcoran Gallery of Art, Annual Exhibition of Oil Paintings by Contemporary Artists, 1912

FAM '13 Wellesley, Mass., Farnsworth Art Museum, Wellesley College, Exhibition of Paintings by Mr. William M. Chase, Feb. 17-Mar. 13, 1913

AAG '13 New York, American Art Galleries, Collection of the Late T. M. Lichtenauer, Esq., Feb. 27-28, 1913

RISD '13 Providence, Museum of Art, Rhode Island School of Design, Memorial Exhibition of Works of Art Given by Isaac Comstock Bates, Feb. 28-Apr. 13, 1913

JHAI '13 Indianapolis, John Herron Art Institute, 6th Annual Exhibition of Works by Indiana Artists, Mar. 4-30, 1913

TAP '13 New York, Ten American Painters, 16th Annual Exhibition, Montross Gallery, Mar. 12-Apr. 5, 1913

AIC '13 Art Institute of Chicago, 26th Annual Exhibition, Nov. 14-Dec. 25, 1913

LAAE '13 Louisville, Ky., Louisville Art Association, 13th Exhibition, Oct. 17-Nov. 7, 1913

BFAA '13 Buffalo Fine Art Academy, 8th Annual Exhibition, Albright Art Gallery, 1913

NAPP '13 New York, National Association of Portrait Painters, 3rd Annual Exhibition, M. Knoedler & Co., 1913

CI '13 Pittsburgh, Carnegie Institute, Annual Exhibition, 1913

JHAI '14 Indianapolis, John Herron Art Institute, Annual Exhibition of Paintings and Sculpture, Jan. 1-Feb. 1, 1914

NAPP/K&C '14 New York, National Association of Portrait Painters, M. Knoedler & Co., Feb. 2-14, 1914; Carnegie Institute, Pittsburgh, Feb. 16-Mar. 9, 1914

NAD '14 New York, National Academy of Design, 89th Annual Exhibition, Mar. 21-Apr. 26, 1914

CI '14 Pittsburgh, Carnegie Institute, 18th Annual Exhibition, Apr. 30-June 30, 1914

BFAA '14 Buffalo Fine Art Academy, 9th Annual Exhibition, Albright Art Gallery, May 16-Aug. 31, 1914

CM '14 Cincinnati Museum, 21st Annual Exhibition of American Artists, May 23-July 31, 1914

DMA '14 Detroit Museum of Art, Exhibition of Paintings by American and European Artists, Oct. 3-26, 1914

NAA '14 Lincoln, Nebraska Art Association, 21st Annual Exhibition, Dec. 1-21, 1914

AAEL '14 London, Anglo-American Exposition, 1914

TAP '14 New York, Ten American Painters, 17th Annual Exhibition, Montross Gallery, 1914

NAD-W '14 New York, National Academy of Design, Winter Exhibition, Dec. 19, 1914-Jan. 17, 1915

CGA '14 Washington, D.C., Corcoran Gallery of Art, Annual Exhibition, Dec. 15, 1914-Jan. 24, 1915

BFAA '15 Buffalo Fine Art Academy, Exhibition of Paintings by American and European Artists, Albright Art Gallery, Mar. 6-Apr. 4, 1915

NGA '15 Washington, D.C., National Gallery of Art, Exhibition of Paintings, Mar. 6-31, 1915

TAP '15 New York, Ten American Painters, 18th Annual Exhibition, M. Knoedler & Co., Mar. 15-27, 1915

BMA '15 Brooklyn Museum of Art, Contemporary American Paintings, Apr. 4-May 3, 1915

DMA '15 Detroit Museum of Art, 1st Annual Exhibition, Selected Paintings by American Artists, Apr. 9-May 31, 1915

CM '15 Cincinnati Museum, 22nd Annual Exhibition, May 22-July 31, 1915

SLCAM '15 St. Louis, City Art Museum, An Exhibition of Paintings Owned in St. Louis, July-Oct. 1915

AAG '15 Buffalo Fine Art Academy, 10th Annual Exhibition of Selected Paintings by American Artists, Albright Art Gallery, May 1915

MIA '15 Minneapolis Institute of Art, Inaugural Exhibition, 1915

K&C '15 New York, M. Knoedler and Co., 8th Annual Exhibition, 1915

PPIE '15 San Francisco, Panama-Pacific International Exposition, 1915

NAD-W '15 New York, National Academy of Design, Winter Exhibition, Dec. 18, 1915-Jan. 16, 1916

MAGR '15 Rochester, N.Y., Memorial Art Gallery, An Exhibition of Paintings from the Fellowship of the Pennsylvania Academy of the Fine Arts, Mar. 10-Apr. 6, 1915

PAFA '15 Philadelphia, Pennsylvania Academy of the Fine Arts, Annual Exhibition, 1915

NAPP '15 New York, American Fine Art Society, National Association of Portrait Painters 5th Annual Circuit Exhibition, 1915-16, traveled to Corcoran Gallery of Art, Washington, D.C.; Carnegie Institute, Pittsburgh; and Memorial Art Gallery, Rochester, N.Y.

JHAI '16 Indianapolis, 31st Annual Exhibition of Paintings and Sculpture, John Herron Art Institute, Jan. 11-Feb. 13, 1916

CI '16 Pittsburgh, Carnegie Institute, Portraits from the National Association of Portrait Painters, Jan. 29-Feb. 23, 1916; Memorial Art Gallery, Rochester, N.Y., Mar. 1916

AFA '16 St. Louis, City Art Museum, Exhibition of Paintings by American Artists Originated by the American Federation of the Arts, opened Feb. 6, 1916

DMA '16 Detroit Museum of Art, Paintings by Wm. M. Chase, N.A., and Paintings by Wm. Ritchel, N.A., Mar. 1916; Toledo Museum of Art, Ohio, Apr. 1916

TAP '16 New York, Ten American Painters, 19th Annual Exhibition, M. Knoedler and Co., Mar. 6-18, 1916

DM '16 Detroit Museum of Art, Exhibition of Paintings by Men Who Painted the Far West/ Twelve American Artists/and Sandor Landeau, Apr. 1916

TMA '16 Toledo, Ohio, Toledo Museum of Art, Paintings by William M. Chase, N.A., Apr. 1916

RISD '16 Providence, Rhode Island School of Design, Portraits in Oil by American Portrait Painters, Organized by the American Federation of the Arts, Apr. 5-25, 1916

MAG '16 Rochester, N.Y., Rochester Memorial Art Gallery, Annual Exhibition of Paintings by Twelve Contemporary American Artists, May 1916

NAD '16 New York, National Academy of Design, Annual Exhibition, 1916

NAC '16 New York, National Arts Club, Paintings from the National Academy of Design, 1916

PSAG '16 South Poland, Maine, 22nd Annual Exhibition of Paintings and Sculpture, Prominent Painters and Sculptors, Poland Springs Art Gallery, Maine State Building, 1916

CGA '16 Washington, D.C., Corcoran Gallery of Art, 6th Biennial Exhibition of Oil Paintings by Contemporary American Artists, Dec. 17, 1916–Jan. 21, 1917

NAC '17 New York, National Arts Club, Exhibition of Artist Members, Jan. 1917

CI '17 Pittsburgh, Carnegie Institute, National Association of Portrait Painters, Feb. 3-27, 1917

MMA '17 New York, Metropolitan Museum of Art, William M. Chase Memorial Exhibition, Feb. 19-Mar. 18, 1917

BFAA '17 Buffalo Fine Art Academy, 11th Annual Exhibition, Albright Art Gallery, Mar. 12-Sept. 17, 1917

Csale '17 New York, American Art Galleries, The Paintings and Other Artistic Property Left by the Late William Merritt Chase, N.A., May 14-17, 1917

AIC '17 Art Institute of Chicago, 30th Annual Exhibition of Oil Paintings and Sculpture by American Artists, 1917

K&C '17 New York, M. Knoedler and Co., 10th Annual Exhibition, 1917

PAFA '17 Philadelphia, Pennsylvania Academy of the Fine Arts, 112th Annual Exhibition, 1917

JHAI '18 Indianapolis, 33rd Annual Exhibition of Paintings, John Herron Art Institute, Jan. 5-Feb. 3, 1918

AIC '18 Art Institute of Chicago, First Exhibition of Works of Former Students, 1918

BFAA '18 Buffalo Fine Art Academy, Albright Art Gallery, Twelfth Annual Loan Collection of Paintings, May 11-Sept. 9, 1918

BFAA '19 Buffalo Fine Art Academy, Thirteenth Annual Exhibition: Selected Paintings by American Artists, Albright Art Gallery, May 24-Sept. 8, 1919

BMAG '19 Memphis, Brooks Memorial Art Gallery, Paintings by Wm. M. Chase, 1919

CGA '19 Washington, D.C., Corcoran Gallery, Ten American Painters, 1919

YAG '20 Chicago, Young's Art Galleries, Exhibition of Paintings by William Merritt Chase, Jan. 12-24, 1920

AAG '21 New York, Collection of an Amateur: The Private Gallery of American and Foreign Paintings formed by W. G. Peckham of Westfield, N.J., Mar. 29, 1921

FG '22 New York, Ferargil Galleries, Mr. T. H. Russell Presents an Important Exhibition of Paintings by William M. Chase from the Family, Oct. 1922

DAA '22 Dallas Art Association, Third Annual Exhibition: American Art, Adolphus Hotel, Nov. 16-30, 1922

CI '22/CM '22/BFAA '23 Pittsburgh, Carnegie Institute, Exhibition of Paintings by William M. Chase, Nov. 3-30, 1922; Cincinnati Museum, Cincinnati, Ohio, Dec. 1922; Albright Art Gallery, Buffalo, N.Y., Jan. 13-Feb. 1, 1923

K&C '22 New York, M. Knoedler and Co., Inc. 15th Annual Exhibition, 1922

CGA '23 Washington, D.C., Corcoran Gallery of Art, Special Memorial Exhibition of Paintings by the Late William M. Chase, Mar. 6-Apr. 1, 1923

AAA '23 New York, American Art Association, Auction, Apr. 12, 1923, Estate of Annie T. Lang

FG '27 New York, Ferargil Galleries, Paintings by William M. Chase, Mar. 1927

NG '27 Fine Arts Gallery of San Diego, A Collection of Paintings by William Merritt Chase, lent by Newhouse Galleries, Los Angeles, California, Nov. 11-30, 1927

AAA&L '28 New York, American Academy of Arts and Letters, Exhibition of the Works of William Merritt Chase, Apr. 26-July 15, 1928

MacG '32 New York, Macbeth Galleries, Macbeth Special Sale Exhibition, Oct. 17-Nov. 7, 1932

NG '33 New York, Newhouse Gallery, William Merritt Chase, Feb. 28-Mar. 25, 1933

ABAC '48 New York, American British Art Center, William M. Chase Retrospective, Nov. 9-Dec. 4, 1948

INDEX OF SITTERS AND TITLES

McCormick, Henry
 Colonel Henry McCormick, OP.175
McCormick, Mrs. Henry
 Portrait of Mrs. McCormick, OP.174
McDougall, Mrs. Robert P.
 A Lady in Pink, OP.230
McFadden, James B.
 James B. McFadden, OP.3
McManes, James
 James McManes, OP.398
McMannis, Gertrude
 Miss Gertrude McMannis, OP.530
McMurtie, Richard Coxe
 Richard Coxe McMurtie, OP.192
Meditation, OP.597
Memories, OP.127
Merritt, OP.166
Millar, Mrs. Addison Thomas
 Portrait (possibly Mrs. Millar), OP.216
Miller, Juanita
 Portrait of Miss Juanita Miller, OP.124
The Mirror, OP.321
The Misses Gribell, OP.495
Mona, Daughter of Mrs. R., OP.217
 Mona
Moran, Thomas
 Portrait of Thomas Moran, N.A., OP.575
Morning After the Ball. See *Girl Reading*, OP.95
The Morning Paper, OP.129
The Moroccan Girl, OP.139
 A Study—Head
Morton, Henry
 Henry Morton, OP.375
The Mother (Mrs. Gustavas Cook, Lavinia Cook, Nancy Cook), OP.463
Mother and Child, OP.151
 The First Portrait
 His First Portrait
 Mother and Daughter
Mother and Child, OP.185
 Mother's Love
Mother and Daughter. See *Mother and Child*, OP.151
A Mother's Joy, OP.164
Mother's Love. See *Mother and Child*, OP.185
Muhrman, Henry
 Mr. Muhrman, OP.53
Mundé, Paul Fortunatus
 Portrait of Dr. Mundé, OP.225
Munich Head, OP.41
Munson, William Gurley
 William Gurley Munson, OP.6
My Daughter (Artist's Daughter), OP.346
My Daughter Alice. See *Dieudonnée*, OP.251
My Daughter Dieudonnée, OP.359
My Daughter Dorothy, OP.347
My Daughter Dorothy. See *Portrait of My Little Daughter Dorothy*, OP.219
My Daughter Helen. See *Portrait of Helen*, OP.303
My Little Daughter Dorothy. See *Portrait of My Little Daughter Dorothy*, OP.219

Nelson, William Rockhill
 William Rockhill Nelson, OP.487
Newbold, Edith
 Portrait of a Lady in a White Dress, OP.186
Nicoll, Elsie
 Miss N., OP.550

Normannisches Mädchen (Girl in The National Dress of Normandy), OP.39

Old Cavalier, A Study, OP.18
Old Mr. Woodburn, OP.350
Oliver, Myron Angelo
 Portrait of Myron A. Oliver, OP.560
Onderdonk, Julian
 Portrait of Julian Onderdonk, OP.334
The Open Japanese Book, OP.322
 Japanese Book
 The Japanese Book
Orbison, William
 William Orbison, OP.5
The Orphan. See *The Young Orphan*, OP.106
Osler, William
 Professor William Osler M.D., OP.514
Ostrom, Caroline Demming
 Portrait of Caroline Demming Ostrom, OP.587

Pach, Walter
 Walter Pach, OP.452
Palmer, William Launt
 William Launt Palmer, OP.146
Paris, William Franklyn
 William Franklyn Paris, OP.399
Parrish, Sarah Redwood
 Sarah Redwood Parrish, OP.202
Parsons, Mr.
 Mr. Parsons, OP.430
The Patrician, OP.34
Patti, Adelina
 possibly *Lady with Orchids*, OP.379
Paur, Emil
 Emil Paur, OP.285
Pepperell, Sir William
 Sir William Pepperell, OP.423
The Pet Bird. See *The Pet Canary*, OP.141
The Pet Canary, OP.141
 The Pet Bird
Peters, Samuel T.
 Samuel T. Peters, Esq., OP.315
Peterssen, Eilif
 Portrait of Eilif Peterssen, OP.40
Piloty, Karl Theodore von
 portraits of his five children
 Portrait of a Young Girl (Piloty), OP.49
 Portrait of a Young Girl (Piloty Child), OP.50
 Portrait of a Young Lady (Portrait of Piloty's Daughter), OP.48
 Portrait of Piloty's Son, OP.51
 Son of Karl von Piloty, OP.52
Piloty, Mrs.
 Portrait of Mrs. Piloty, OP.367
The Pink Bow (Hazel), OP.277
Portrait. See *A Spanish Girl in White*, OP.123; *Dorothy (Dorothy in Pink)*, OP.548
Portrait of a Bearded Gentleman, OP.55
Portrait of a Chase Student, OP.297
Portrait of a Child, OP.600
Portrait of a Child (Dorothy Brémond Chase), OP.274
Portrait of a German Boy, OP.31
Portrait of a Girl, OP.13, OP.388
Portrait of a Girl, OP.128
 Study of a Child with an Orange
Portrait of a Girl in White, OP.176
 Portrait of a Young Girl

Portrait of a Lady, OP.68, OP.87, OP.198, OP.229, OP.247, OP.298, OP.413, OP.572
Portrait of a Lady (A Lady in Evening Dress), OP.196
Portrait of a Lady (possibly The Fur Wrap), OP.199
Portrait of a Lady against Pink Ground (Miss Virginia Gerson), OP.130
Portrait of a Lady in Black (Annie Traquair Lang), OP.531
Portrait of a Lady in Brown, OP.155
Portrait of a Lady in Pink, OP.167
 Lady in Pink
 Woman in Pink
Portrait of a Lady in Street Costume, OP.131
 Lady in Street Costume
 The White Hat
Portrait of a Lady in a White Dress, OP.186
Portrait of a Lady with a Rose, OP.338
 Miss M. S. Lukens
Portrait of a Little Girl, OP.233
Portrait of a Man, OP.15
 A Russian
 A Russian Type
Portrait of a Man, OP.180, OP.428, OP.429
Portrait of a Man Wearing Moustache / Tousled Hair, Head Turned Left, OP.313
Portrait of a Musician, OP.446
Portrait of a Nun, OP.46
Portrait of a Smiling Young Lady. See *Portrait of Miss S.*, OP.416
Portrait of a Woman, OP.57, OP.59, OP.116, OP.302, OP.306, OP.354, OP.356, OP.357, OP.467, OP.537, OP.601
Portrait of a Woman, OP.236
 Portrait of Mrs. D.
Portrait of a Young Girl, OP.21, OP.307, OP.521
Portrait of a Young Girl. See *Portrait of a Girl in White*, OP.176
Portrait of a Young Girl (Piloty), OP.49
Portrait of a Young Girl (Piloty Child), OP.50
Portrait of a Young Lady (Portrait of Piloty's Daughter), OP.48
Portrait of a Young Man, OP.455, OP.456
Portrait of a Young Woman, OP.237, OP.269, OP.524
Portrait of a Youth, OP.86
Portrait of an Artist, OP.252
Portrait of an Assyrian Girl, OP.137
Portrait of an Old German Man, OP.24
Portrait of Elderly Man Wearing Large White Collar, OP.32
Portrait of Helen, OP.303
 The Artist's Daughter Helen
 Helen
 My Daughter Helen
Portrait of Himself. See *Self-Portrait*, OP.566
Portrait of John Getz, OP.431
Portrait of John Gilmer Speed, OP.501
Portrait of Joseph Lasell, OP.213
Portrait of Jules Turcas, OP.210
Portrait of Julian Onderdonk, OP.334
Portrait of Kate Freeman Clark, OP.355
Portrait of L. F. Roos, OP.336
Portrait of Little Miss H. See *Portrait of Little Miss Howell*, OP.134
Portrait of Little Miss Howell, OP.134
 Little Miss H.
 Portrait of Little Miss H.
Portrait of Little Miss K., OP.160
Portrait of Miss D. (My Daughter, Dieudonnée), OP.310

PHOTOGRAPHY CREDITS

Photography by Greg Heins, Boston, MA/Addison Gallery of American Art, Phillips Academy, Andover, Massachusetts. All rights reserved (OP.38)

Photo Courtesy of Adelson Galleries, New York (OP.67, OP.159, OP.187, OP.189, OP.214, OP.246, OP.353)

Courtesy of A. J. Kollar Fine Paintings, LLC, Seattle, Washington (OP.418)

Alinari/Art Resource, NY (OP.498)

Reproduction, The Art Institute of Chicago (OP.182)

Courtesy of Babcock Galleries (OP.280)

Courtesy of Berry-Hill Galleries, Inc. (OP.134, OP.136)

Photo by E. Irving Blomstrann (OP.327)

Christie's (OP.255)

© The Cleveland Museum of Art (OP.251)

© 2006 Paul Czitrom (OP.142)

Photograph © 1996 (OP.219, OP.558), © 2001 (OP.236), © 2002 The Detroit Institute of Arts (OP.23, OP.235)

Photo by Frick Art Reference Library (OP.425)

© Frye Art Museum, Seattle, WA (OP.130)

Photography by John Gemblin (OP.263)

© Gilcrease Museum, Tulsa, OK (OP.575)

Photo by John R. Glembin (OP.464)

Photography by Erik Gould (OP.167, OP.250)

Photo by Rich Hall (OP.552)

Photograph courtesy of Hirschl & Adler Galleries, New York (OP.213)

International Studio: An Illustrated Magazine of Fine and Applied Art 39, no. 154 (1909): xxx (OP.494)

Photo: Gary Mamay (OP.202, OP.239A, OP.243, OP.284, OP.317, OP.352A, OP.358, OP.359, OP.364A, OP.366A, OP.408, OP.485, OP.513)

Photograph © 1978 (OP.172), © 1982 (OP.161), © 1984 (OP.369), © 1993 (OP.108), © 1998 (OP.275), © 2006 The Metropolitan Museum of Art (OP.209)

Photo by Bernard C. Meyers, meyersphoto.com (OP.262)

Photograph by Jamison Miller (OP.26, OP.373, OP.487)

Photograph by Patrick Müller, Paris (OP.598)

© The Newark Museum (OP.290)

The Parrish Art Museum, Southampton, NY, William Merritt Chase Archives, Gift of Mrs. A. Byrd McDowell, photo: Gary Mamay (OP.304, OP.339)

© The Philbrook Museum of Art, Tulsa, Oklahoma (OP.267)

Photo © Don Queralto (OP.305)

Réunion des Musées Nationaux/Art Resource, NY (OP.240), photo by Gerard Blot (OP.172A)

Photo: Rose & Sands (OP.309A)

© Shelburne Museum, Shelburne, Vermont (OP.73)

Photo © Sheldon Memorial Art Gallery (OP.185)

Photograph © 2006 courtesy of The David and Alfred Smart Museum of Art, The University of Chicago (OP.180, OP.264)

Smithsonian American Art Museum, Washington, DC/Art Resource, NY (OP.176)

Photo by Richard Stoner (OP.171)

Tate Gallery, London/Art Resource, NY (OP.122A)

Terra Foundation for American Art, Chicago/Art Resource, NY (OP.117)

© Courtesy Thomas Jefferson University, Philadelphia, Pennsylvania. All rights reserved (OP.333)

Photography by Ed Watkins (OP.9, OP.12, OP.16, OP.18, OP.20, OP.27, OP.30, OP.32, OP.35, OP.40, OP.42, OP.52, OP.55, OP.63, OP.64, OP.73, OP.74, OP.78, OP.87, OP.88, OP.93, OP.101, OP.102, OP.105, OP.109, OP.112, OP.114, OP.135, OP.141, OP.173, OP.180, OP.197, OP.226, OP.228, OP.242, OP.255, OP.279, OP.285, OP.287, OP.291, OP.292, OP.294, OP.295, OP.308, OP.311–13, OP.324, OP.326, OP.329, OP.335, OP.337, OP.344, OP.355, OP.365, OP.370, OP.372, OP.374, OP.375, OP.387, OP.391, OP.392, OP.394–97, OP.400, OP.401, OP.413, OP.422, OP.423, OP.426, OP.430, OP.430A, OP.431, OP.432, OP.435, OP.437, OP.439, OP.441–43, OP.445–47, OP.449, OP.451, OP.455, OP.456, OP.459, OP.471–74, OP.477–82, OP.486, OP.492, OP.499, OP.501, OP.507, OP.511, OP.514, OP.519, OP.520, OP.524, OP.526, OP.528, OP.533–35, OP.545, OP.547, OP.553, OP.563, OP.569, OP.582, OP.589, OP.592, OP.593)

Photo: Katherine Wetzel, © Virginia Museum of Fine Arts (OP.309)

E. W. Wilcox, *Poems of Passion* (Chicago: W. B. Conkey Company, 1883) (OP.95A)